20th Century Art Museum Ludwig Cologne

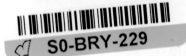

Front cover: Tom Wesselman, *Bathtub 3, 1963 (detail)*
Book back: Roy Lichtenstein, *M-Maybe (A Girl's Picture), 1965*
Back cover: Piet Mondrian, *Tableau I, 1921*

Conception: Marc Scheps
Coordination: Evelyn Weiss, with the assistance of Barbara Herrmann
and Christiane Schillig
Documentation: Ingrid Kolb
Authors of essays on artists: Iris Bruckgraber, Stephan Diederich,
Alfred M. Fischer, Gérard A. Goodrow, Barbara Herrmann,
Gerhard Kolberg, Adam C. Oellers, Ursula Peters, Christiane Schillig,
Martin Spantig, Evelyn Weiss; also Nadia Abbas, Jens Bove,
Rebekka Fuchs, Judith Geisler, Dietke Heckenroth, Christiane Pracht,
and Eszter Viragh
Reproductions of works of art: Rheinisches Bildarchiv, Cologne
Editing deadline: November 1997

Layout and editing: Simone Philippi, Cologne
Design: Mark Thomson, London
English translation: John William Gabriel

Printed in Italy
ISBN 3-8228-8647-5
GB

20th Century Art
Museum Ludwig
Cologne

TASCHEN

KÖLN LISBOA LONDON NEW YORK PARIS TOKYO

The Museum Ludwig, Cologne: A Century of Modern Art

Marc Scheps

For Peter Ludwig
(1925–1996)

The story of art in the present century is about to come to a close.
It is time for taking stock. Naturally the development of art cannot be
divided into neat, chronological compartments; rather, it is character-
ized by a certain uniformity of content at certain periods, which are
named accordingly. The twentieth century has without doubt been the
century of modernism. One could argue about the precise point in time
when the Modern Movement began, and there is still a great deal
of uncertainty about the possible end of this chapter in art history.
The collection of the Museum Ludwig in Cologne begins with the turn
of the century, and it covers the key aspects, phases and approaches
of modern art. Although encyclopaedic exhaustiveness was never
a goal, those who compiled the collection always concentrated on
placing emphases, on attempting to understand the workings of
artistic creativity, and on recognizing and ultimately documenting the
spirit of each development. Seen in this light, collecting means asking
questions, the answers to which take the form of acquisitions of works
of art. Collecting, in other words, implies an active involvement in a
very broad range of artistic activities, and an evaluation which is not
free of risk, and which carries with it a high degree of responsibility.
A public collection of modern art is a project in which not only those
immediately concerned participate. It envolves out of an active and
open dialogue with artists, collectors, gallery owners, art critics and art
historians, and naturally also with colleagues. The possibilities open to
a public collection are also influenced by the place and period of its
formation. In the end, such a collection represents a synthesis of the
intellectual and artistic energies that have come together to shape what
might be called a collective memory of our visual culture. In order to
understand the specific character of any collection, we must know
something of its development. In our own case, this takes us back to
the establishment of the first museums in Cologne, in the latter half of
the nineteenth century.

Early History of the Museum

With the inauguration of the Museum Ludwig in 1976, modern art received the status of an autonomous and independent institution within the cultural life of the city of Cologne. Until then, modern art had been the domain of a department of the Wallraf-Richartz-Museum. Founded in 1824, this museum of art from the medieval period to the present day stood at the beginning of a series of new institutions which owed their existence to the commitment and collecting passion of farsighted private citizens. Strongly convinced of the importance of culture and ambitious in vision, they provided the means to create a museum landscape of high rank which to this day has contributed materially to the quality of life in the city, for inhabitants and visitors alike. But not only foresight and ambition have made Cologne the cultural center it now is. The city was fortunate enough to be home to a number of connoisseurs of art who brought together major collections and later bequeathed them to their town. Canon Ferdinand Franz Wallraf was the first of these civic-minded collectors. He can be said to have called into being a Cologne tradition, which has remained vital to this day.

The Museum of Applied Art was established in 1887, followed in 1906 by the Rautenstrauch-Joest Museum of Ethnology. That same year saw the inauguration of the Schnütgen Foundation, which was converted into a museum in 1910. The year before, 1909, Adolf Fischer had bequeathed his collection of Far Eastern art to the city of Cologne, and in 1913 the museum was opened. The early years of the century were especially propitious for the emergence of new cultural institutions and the development and expansion of already existing museums. One such was the Wallraf-Richartz-Museum, which in 1908 received a new director, Alfred Hagelstange. An enthusiastic advocate of the art of his day, it was Hagelstange who laid the groundwork for a public collection of modern art in Cologne. This was by no means a matter of course, for at that time, there were few museums anywhere in Europe that showed an interest in the new art, or even considered it worthy of museum presentation. This early phase ended with Hagelstange's death in 1914, and would not find a continuation until several years after the First World War.

Nevertheless, prior to 1914, Cologne had become a center of modern art, largely due to the key event of those years. This was the "Inter-

national Art Exhibition of the Special League of German Art Lovers and Artists of Cologne" – better known by its short title, "Sonderbund Exhibition" – which took place in 1912. The exhibition was organized by a group of people from the Rhineland area who were interested in art, including Karl-Ernst Osthaus (later the founder of the Museum Folkwang, in Essen), the collector Josef Feinhals, and the well-known art dealer Alfred Flechtheim. The exhibition, comprising 577 paintings by a range of artists from Auguste Renoir and Vincent van Gogh to Pablo Picasso and Georges Braque, confirmed Cologne's reputation as a metropolis of modernism. Among the crowds of visitors was New York art historian Walt Kuhn, who came to Cologne with an eye to selecting pictures for the world-renowned "Armory Show". This exhibition, held in 1913, was to play an enormous part in triggering the emergence of modern art in the United States.

The war years shook Germany, and its art, to their foundations, and cost the lives of many promising artists. One was Franz Marc, killed at Verdun in 1916. That same year, Herwarth Walden mounted a commemorative exhibition for Marc at his Berlin gallery, Der Sturm. Despite the war, the art scene in the capital remained vital. A young law student from Cologne, Josef Haubrich (born in 1889), saw the Marc show, which made a deep impression on him. Having already visited the Sonderbund Exhibition in Cologne and seen recent art in Munich, Haubrich now discovered Franz Marc and the other artists of the Blauer Reiter (Blue Rider) and Die Brücke (The Bridge) groups. Shortly thereafter he began to collect Expressionist paintings. During the 1920s, Haubrich became one of the major collectors in the city, alongside such men as Küchen and Vowinckel. He played an active and diverse role in the artistic life of Cologne.

During the Depression, and especially in the wake of the National Socialist takeover, very little modern art continued to be acquired for the museum's collection. Modern art came increasingly under pressure, was threatened, and finally prohibited altogether. Artists were persecuted, forbidden to work or exhibit, stripped of their posts in the academies. Many had no other choice but to emigrate; some had to flee overnight; others tried to adapt or grew silent. Jewish painters such as Felix Nussbaum, but also artists of other creeds, such as Otto Freundlich, were murdered in Nazi concentration camps.

July 6, 1937, was the day of the desecrators in Cologne. By order of the "Reichskammer der bildenden Künste" (Division of visual arts of the German Reich), as part of its Germany-wide campaign against "degenerate art," Hitler's officials confiscated 47 works from the modern department of the museum. These included a number of masterpieces, such as Paul Gauguin's *Riders on the Beach in Tahiti*, Vincent van Gogh's *Portrait of a Young Man*, Pablo Picasso's *Soler Family*, André Derain's *Motif of Cagnes*, Ernst Ludwig Kirchner's *Park Landscape (The Bosquet)*, Oskar Kokoschka's *Dents du Midi*, Franz Marc's *Horse in a Landscape*, Otto Dix's *The Artist's Parents*, and Max Beckmann's *View of the Blue Sea*. To this day, the painting by Max Beckmann is the only one which the museum has succeeded in reacquiring – and that not until 1993.

At one fell swoop, the Wallraf-Richartz-Museum lost on that day in 1937 the core of a department of modern art that had taken three decades to build. Some of the confiscated works have remained missing; others were sold by the Nazis, particularly in other countries, and are now in public and private collections around the world. The loss of these works of Classical Modernism was a terrific blow. But a much greater loss for cultural life in Germany was the destruction and collapse of the entire art scene, the fact that an entire generation of talent was wasted, and that the chain of creativity was broken beyond repair. Although the Nazis did not succeed in entirely smashing modern art, the years of forced silence and inactivity could never be made good, and they show what barbaric tyranny holds in store for art – namely the threat of its imminent demise.

At the end of the war, not only did the city of Cologne and its museum buildings lie in ruins, but its cultural life as well. A completely new beginning had to be made. For the second time in the present century, the Wallraf-Richartz-Museum set out to build a department of modern art. Taking up the venerable Cologne tradition, private collectors joined with the city administration and the museum to undertake this task. Josef Haubrich, even during the darkest hours of the Third Reich, had not ceased to expand his collection of Expressionist and Classical Modern painting. Opportunities to do so were available, but courage and cunning were needed to take advantage of them. Haubrich's professional and private life had been profoundly disrupted. His Jewish wife had committed suicide to escape the Gestapo. Despite the obstacles and dangers he faced, Haubrich managed to bring his treasures safe

through the war. Just less than a year after the capitulation, on May 2, 1946, Haubrich donated his collection to the city of Cologne. It was presented to the public for the first time that October, in rooms of the old Cologne University. Hundreds of works of Classical Modernism, including masterpieces by Erich Heckel, Karl Schmidt-Rottluff, August Macke, Otto Mueller, Otto Dix, Ernst Ludwig Kirchner, and Marc Chagall, suddenly emerged like a revelation into the light of day.

Among the visitors to this legendary exhibition was a student of art history, who had come with his professor from Mainz. His name was Peter Ludwig, and he was 21 at the time. He was not only deeply impressed by the works on display (of a kind he knew only from illustrations in art books lent to him by a boyhood friend in Koblenz). What intrigued Ludwig perhaps even more was the personality of the collector, Josef Haubrich. Ludwig still frequently talks about the great influence Haubrich's example had on his decision to collect art, with the express intention of passing it on to the public. Perhaps only some-one to whom the experience of art has been denied during his youth can develop such a profound sense of the human need for aesthetic pleasure.

At this period Cologne was the first German city to set its sights on the rebuilding of a collection of modern art. The Haubrich Collection not only restored the modern art department of the Wallraf-Richartz-Museum to its prewar level, but in several areas even surpassed it. The Haubrich is still one of the best and most renowned public collections of German art. Apart from the paintings, the collection of prints and drawings is a true treasure trove of pioneers of European modernism. During the postwar years Josef Haubrich, an attorney by profession, was not only active as a collector but was engaged in local political affairs, and thanks to an agreement with the city and his own efforts, the collection could be considerably expanded. In collaboration with Gert von der Osten, then director of the museum, the city succeeded in convincing further collectors to pledge to the museum.

In 1957, an extraordinarily important group of works by Max Beck-mann was promised, the Donation of Georg and Lilly von Schnitzler, which would finally take its place in the collection in 1979. In 1958, the museum was able to acquire the Willy Strecker Collection, containing major works by Picasso, Matisse, Kokoschka, and Klee, among others. Günther and Carola Peill were further passionate collectors during

these postwar years. Encouraged by their friend, the internationally known painter Ernst Wilhelm Nay, who lived in Cologne, they brought together a unique collection which, in addition to key works by Max Ernst, Alexei von Javlensky, and Willi Baumeister, included a group of Nay paintings and a remarkable range of graphic art.

Significant portions of this collection were gradually passed on to the museum in the form of donations, in 1976, 1977, 1983, 1987 and 1988. Such protracted relationships between a museum and its collectors are a gratifying example of the ways in which a public collection can expand despite limited internal means. Nevertheless, key works were acquired with public funds during this period, and many gifts came from private collectors who are mentioned by name in this volume. The period was characterized by a widespread interest in the Ecole de Paris, which in turn was reflected in the museum's acquisitions and donations.

From the end of the war, a new building for the museum had been urgently needed to make the works in stock accessible to the public once again. In 1953, the day finally came. A competition was won by the Schwarz/Bernards firm of architects, and construction got underway. On May 27, 1957, the new Wallraf-Richartz-Museum was inaugurated – ninety-six years after the original building had opened on the same site. The normal functioning of a museum with collections ranging from the medieval period to the present day had been restored. This phase of development came to a close with Haubrich's death in the year 1961. For forty years he had committed himself to the art scene in Cologne, and after the Second World War he had materially contributed to the venture of giving modern art a new start in a devastated city.

Founding of the Museum Ludwig (1976)

At the close of the 1950s the international art scene came to a great watershed. The Nouveaux Réalistes discovered the poetry of the urban landscape. Jean Tinguely created useless, witty, and self-destroying machines; Yves Klein celebrated the void with his "International Klein Blue". Klein maintained close contacts with the Rheinland, where he exchanged ideas with artists of the Zero group. The same period saw Italian artist Piero Manzoni producing his *Achromes*, or colorless paintings, and Lucio Fontana developing his *Spatial Concepts*. Shortly thereafter Germany became a key nexus of a new avant-garde, the inter-

national Fluxus movement, which for many observers represented an offshoot of Nouveau Réalisme. This movement was extremely active in the Rhineland, and Wolfgang Hahn, then head of the Wallraf-Richartz-Museum restoration department, was an avid collector of Fluxus works.

While the work of Richard Hamilton and incipient English Pop still received little attention here, American art suddenly emerged from its isolation. Hardly had Abstract Expressionism been discovered when a phalanx of new heroes charged to the forefront of the European stage. Their names were Jasper Johns and Robert Rauschenberg, followed by Andy Warhol, Roy Lichtenstein, James Rosenquist, Claes Oldenburg, George Segal, and many more. Labelled Pop Art in 1962, the style quickly vanquished America and shortly thereafter Europe. Wolfgang Hahn had awakened Peter Ludwig's interest in the new American developments at an early date. Ludwig was fascinated and excited by the way artists of his own generation were striving to bring about a new and closer relationship between art and life. He began buying the works of these artists, and in a few years, Peter and Irene Ludwig had amassed the most significant Pop Art collection anywhere in the world. In New York the name Ludwig became a legend. But the Ludwigs collected not only Pop; their interest extended to the whole range of contemporary art, with the goal of creating a comprehensive record of the generation to which they themselves belonged.

Meantime, the city of Cologne was fast developing into a center of modernism. The first Art Fair took place in 1967, in the Gürzenich, a medieval festival hall, and that same year saw the inauguration of the city's contemporary museum, the Josef-Haubrich-Kunsthalle, near the Neumarkt. A year later the Wallraf-Richartz-Museum mounted an exhibition of the Hahn Collection, an important step towards opening museum doors to the avant-garde. Immediately thereafter, borne by the zeitgeist in Cologne, came a great hour for contemporary art. Peter Ludwig described it in the catalogue, *Kunst der sechziger Jahre, Sammlung Ludwig* (Art of the 1960s: The Ludwig Collection), published on the occasion of the exhibition and now a document of historical rank:

"In autumn 1968 I met Wolfgang Hahn, conservator of the Wallraf-Richartz-Museum and impassioned art collector, in New York. We were glad to see each other again, and went on several excursions through

the galleries and studios. In our enthusiasm the idea began to take shape of giving Cologne a home for the collection of recent art which my wife and I had compiled. The Director General of the Cologne Museums, Prof. Dr. von der Osten, developed the concept and convinced us that the Wallraf-Richartz-Museum was the best place to present contemporary art, hand in hand as it were with the marvellous masterpieces of so many centuries."

Ludwig went on, "What lends the art of the 1960s such great significance is the entry of the North Americans as a style-shaping force for the first time." And in conclusion he wrote a sentence that had the sound of a credo, and that has retained its validity for Ludwig over the decades, down to the present day: "The fascination of being a part of this moment, of experiencing, here and now, the way in which people we know and with whom we speak give expression to the dreams and the anxieties, the hopes and fears of their era, which is our era, is thrilling and gratifying." We should not forget that prior to their commitment to the new, Peter and Irene Ludwig had for twenty years been collecting pre-Columbian art, the classical art of Greece and other Mediterranean countries, and Christian art of the Middle Ages in Europe.

The success and the echo of "Art of the 1960s" were overwhelming, and had a profound influence on the international art and museum scene. Before that point in time, no museum had dared to commit itself so deeply to contemporary art as to integrate it in its collection. By so doing, the Wallraf-Richartz-Museum took a leading position in the struggle for museum recognition of the vanguard, a role which, at the time, was unusual and highly controversial. The acquisitions from the Ludwig Collection bolstered existing areas of the collection and expanded its range to include the most recent manifestations of the current scene. Ever since, the Museum Ludwig has remained true to this policy, attempting in collaboration with collectors and with the aid of supporters' associations and municipal funds to pursue the latest developments and to expand the collection by works of key contemporary artists. But let us return to the generous loan of the Ludwig Collection, which made it rapidly apparent that the existing museum spaces were hopelessly insufficient. Kurt Hackenberg, chief cultural adviser to the city of Cologne, whose ability to transform visions into reality made him a legendary figure of the postwar years, advocated

the construction of a new building as early as 1969. This became an ever more urgent priority as the collection expanded, due, for example, to the gift, on the part of Marguerite Arp-Hagenbach, of a group of sculptures by Hans Arp in 1973.

The time had come to provide an independent venue for modern art, to allow the continually growing collection to unfold. On February 5, 1976, a donation contract between Peter and Irene Ludwig and the city of Cologne was signed, thereby calling into being the Museum Ludwig, devoted to the art of the twentieth century. Before the year was out two Cologne architects, Peter Busmann and Godfrid Haberer, won the design competition for the new building. About 400 works from the Ludwig Collection were united with the complete stocks of twentieth-century art from the Wallraf-Richartz-Museum, to form what at the time was already the most significant collection of modern and contemporary art in the Federal Republic of Germany. The foundation had been laid for the further development of the collection over the next two decades.

In the middle of the 1970s, the Ludwigs had discovered the art of the Russian avant-garde. With the aid of the Cologne art dealer Antonina Gmurzynska, and through many direct contacts made during their trips abroad, they supplemented the museum's collection in this field to the point that now, with over 600 catalogued items, it is the most significant public collection of Russian avant-garde art in the Western World.

A further emphasis of the Museum Ludwig collection was created in 1977, with the acquisition of the renowned photographic collection of Professor L. Fritz Gruber, a pioneer in the field who gave important impulses to photography in Germany.

In 1978 Karl Ruhrberg was appointed the first director of the Museum Ludwig. One year later, Marc Scheps was able to show the Ludwig Collection at the Tel Aviv Art Museum, of which he was director at the time. Subsequently the museum developed a schedule of travelling exhibitions, which has since become a key tradition. The Tel Aviv exhibition was a retrospective of the art of the 1960s. Now the time had come for an interim assessment of postwar art as a whole. The resulting exhibition, "Westkunst, Zeitgenössische Kunst 1939–1981" (Western Art: Contemporary Art from 1939 to 1981), curated by Kasper König, took place in 1981 at the Cologne-Deutz trade fair grounds.

It was a great international event, a dialogue between Western Europe and America that was celebrated by the entire art world. The time for the inclusion of the regions to the east and south had yet to come.

The New Building (1986)

In 1984, Siegfried Gohr was appointed director of the Museum Ludwig. As the new building was approaching completion, the Cologne museums began to prepare themselves for a move. The opening took place on September 6, 1986, in the presence of guests from around the world. The impressive structure rising between the cathedral, central station, and the Rhine attracted crowds of visitors who wished to view the collections in their new rooms, which are especially well-suited to displaying the large formats of contemporary art. The 1980s had brought widespread recognition for German art, and the museum had acquired major works by Georg Baselitz, Jörg Immendorf, Per Kirkeby, A.R. Penck, Sigmar Polke, Gerhard Richter, and others. In addition, the Pop Art collection was expanded and the department of Classical Modernism augmented, in particular with works by Max Ernst, Kurt Schwitters, Fernand Léger, Pablo Picasso, and numerous Russian artists. The collection had achieved equilibrium, as it were. It had become a comprehensive, internationally recognized collection of modern art, and its new home was acclaimed in Germany as no institution of its kind had ever been before. A series of exhibitions was then devoted to the main tendencies in contemporary art. The most important of these was doubtless "Bilderstreit – Widerspruch, Einheit und Fragment in der Kunst seit 1960" (Imagery in Conflict – Contradiction, Unity and Fragment in Art since 1960). Curated by Siegfried Gohr and Johannes Gachnang, it was held in 1989 in the Rheinhallen at Cologne's trade fair grounds. The exhibition had the character of a "temporary museum", and at the same time it prompted thought about the further development of the collection over the coming years.

The Museum Takes on New Contours

The 1980s had come to an end, and with them almost a century of modern art. In 1991, Marc Scheps became the new director of the Museum Ludwig. Five years after the two former museums had been united in the new building, the shortage of space again became acute. The idea of converting an industrial facility into a center of contempo-

rary art began to be seriously considered when the city acquired several factory buildings in Cologne-Kalk. In the meantime conversion plans have progressed to the implementation stage, and when the buildings are opened, a new and exciting chapter in the museum's history will begin. The spaces are superbly suited to showing recent art, and the groundwork will be laid there for the museum of the twenty-first century. Many works have been acquired with an eye to the new spaces over the past three years. Peter and Irene Ludwig have made a major donation of contemporary works, lending concrete form to their support for the new institution.

After long and careful preparations, the Ludwigs' entire Picasso collection was put on display at the museum in 1993. A highly successful European tour followed. Cologne audiences were astonished at the richness of the collection, and after protracted negotiations, a donation and long-term loan contract between the Ludwigs and the city of Cologne was finalized in June 1994. Over 150 original works and 700 prints, brought together by the Ludwigs over the course of forty-five years, illustrate the œuvre of the most brilliant artist of the twentieth century in all its facets. Only a handful of other cities in the world, such as New York, Paris and Barcelona, possess Picasso collections of comparable scope and quality.

The agreement with the city also covered the construction of a new building for the Wallraf-Richartz-Museum. On its completion, the Museum Ludwig will obtain the entire facility on the Rhine to house its continually growing collections of modern art. This is the final phase of a development that began in 1976 with the inauguration of the museum.

After the collection of Russian art was shown in 1993 at the Josef-Haubrich-Kunsthalle and artists of the second Russian avant-garde were integrated in the collection for the first time, a further expansion of the collection could be considered. With a strong focus on Europe, we are now working on the conception of an international art collection which will take account of the most significant developments around the world. This emphasis on "art without frontiers" found expression in a series of new acquisitions, which were introduced to the public in the summer of 1995 in an exhibition held in all the museum's various spaces. Curated by Marc Scheps under the title "Unser Jahrhundert. Menschenbilder – Bilderwelten" (Our Century:

Images of Man – A World of Images), and held on the occasion of Peter Ludwig's seventieth birthday, the exhibition illustrated innovative possibilities in the museum presentation of art.

The progress we have made in recent years would have been inconceivable without the city of Cologne and its traditional receptiveness to new developments in art and readiness to create a framework within which they can unfold. The efforts of former cultural affairs adviser Peter Nestler and his successor, Kathinka Dittrich van Weringh, contributed materially to giving highest priority to the development of a museum landscape in Cologne. Chief municipal executive Lothar Ruschmeier has not only supported these efforts, but personally contributed to them. Irene and Peter Ludwig, though their heart certainly belongs to the Museum Ludwig, have also done a great deal for the other Cologne Museums, becoming real and true partners of the city in its endeavor to create and maintain a dynamic arts policy.

This handbook was developed by the entire museum team. I should like to express my special thanks to Evelyn Weiss, who coordinated the work, and also to Alfred M. Fischer and Gerhard Kolberg, who, with myself and in close collaboration with Simone Philippi of Benedikt Taschen Verlag, assumed responsibility for the publication. I am extremely grateful to all those members of the museum staff who took it upon themselves to prepare the texts and illustrations. We chose for this handbook a format similar to that of 1976/1979, which has long been out of print. Yet the present volume is larger, the information on the works more complete, and the photographs, in large part, are new. The Rheinisches Bildarchiv contributed a great deal in this regard, and I am grateful to their staff for their commitment and hard work. Our aim and hope is that a wide public will be reached and encouraged by the present book. For some it may serve as preparation for a future visit to the museum; for others, already familiar with the collection, it might provide a challenge to learn more. We hope we have succeeded in bringing the spirit of the collection to life in these pages, and that they will be a source of aesthetic enjoyment to everyone who reads them.

The Ludwig Collection, the Museum Ludwig and Their History
A Chronology 1968–1995

Evelyn Weiss

The 1970s and 1980s are now past history. The 1990s are coming to a close, and with them a century and a millennium. Since 1976, our museum has witnessed the coming and going of two directors, four directors general, and two cultural affairs advisers to the city of Cologne. In 1969 the Ludwig Collection entered what was then still the Wallraf-Richartz-Museum. The figure of collector Peter Ludwig, in the late 1960s still shrouded in mysterious reserve, soon emerged into the spotlights of publicity at their dazzling brightest. With growing amazement and interest the public began to realize the scope of Irene and Peter Ludwig's activities, and the content and geographic extent of their collections and patronage of art are now evident to all. Not only the much-discussed art of our own day, but that of the past, the medieval period, the pre-Columbian cultures of the Americas, and of ancient Greece, are now distributed among a dozen public museum facilities in Aachen, Cologne, Koblenz, Oberhausen, and Saarbrücken. New institutions such as the Ludwig Museums in Budapest and St. Petersburg have been established. The Museum Ludwig, Cologne, was inaugurated as an independent institution in 1976. In 1986, together with the Wallraf-Richartz-Museum, it moved into new premises next to the cathedral. In the near future, the planned relocation of the Wallraf-Richartz collection will make the entire space of the museum building available for the enormously expanded stocks of the Museum Ludwig. The following chronology records the dates and events that led to the establishment of the museum, and briefly reviews the activities which have transformed the former modern art department of the Wallraf-Richartz-Museum into an institution known throughout the world. For reasons of space, exhibitions and new acquisitions are listed on a selective basis only.

1968

In late October 1968, an initial conversation takes place between Gert von der Osten, then director general of the Cologne Museums, and Peter Ludwig concerning the possibility of presenting long-term loans of contemporary art in the Wallraf-Richartz-Museum. A small ad hoc committee (Gert von der Osten, Horst Keller, Wolfgang Hahn, Horst Vey, and Evelyn Weiss) agrees on an initial selection based on photographs and lists of works. Potential objections to the ambitious project are shelved, and unfamiliar criteria of judgement are accepted.

When I go to Aachen to make transportation arrangements for the works, most of which are in depot, I am overwhelmed by the extent, quality and sheer presence of the collection. It becomes clear that any presentation will require not only a few rooms but an entire wing of the museum, now occupied by other departments. We also realize that the special nature of the collection should be reflected in a publication. The best solution is evidently to commission an artist with the task, and when Wolf Vostell agrees to design the catalogue, his suggestion is accepted.

1969

After just less than four months, in late February 1969, the first showing of the Ludwig Collection and the first edition of the catalogue, *Kunst der sechziger Jahre* (Art of the 1960s), are presented to the public. The voluminous object-book (plexiglass back, bolted binding, weight two kilograms) is greeted with acclaim. (Five further, expanded editions, totalling about 20,000 copies, are published within the next two years.) Exhibition and catalogue comprise approximately 100 works. The reaction is enthusiastic on the part of audiences, critics, and the media alike.

By the end of August, 200,000 people have seen the Ludwig Collection at the Wallraf-Richartz-Museum. By September a new wing (Ludwig II) has already been opened; in the course of six months 70 additional works have entered the display, including rooms devoted to James Rosenquist (*Horse Blinders*) and Robert Rauschenberg (*Sonar Findings*). Many artists come from the U.S. to install their works and attend the inauguration of the new wing.

As early as March 1, 1969, an article entitled "Cologne Needs a New Museum of Modern Art" is published in the daily *Neue Rheinzeitung*. The author quotes cultural affairs adviser Kurt Hackenberg: "Since

the Wallraf-Richartz-Museum is bursting at the seams, I would like to build a museum of twentieth-century art, near the station, if possible." That June an expert commission convenes to discuss the construction of a new Wallraf-Richartz-Museum.

1970

Award of the Jabach Medal to Irene and Peter Ludwig.
Exhibition:
Recent Acquisitions of the Ludwig Collection, Works on Paper I .
Spectacular acquisition of Max Ernst's painting *The Friends' Rendezvous*.

1971

Ludwig Collection expands since February 1969 by approx. 100 works.

Planning work on competition guidelines for the new Wallraf-Richartz-Museum building continues until 1975. A room devoted to the work of J. Beuys is opened.
Exhibition:
Recent Acquisitions of the Ludwig Collection, Works on Paper II – Roy Lichtenstein.

1972

Ludwig Collection:
J. Johns, *Map*
R. Hamilton, *My Marilyn*

Acquisition:
J. Pollock, *Black and White No. 15*

Conversion of the hall and first installation of J. Johns's large-format *Map*.
Exhibition:
James Rosenquist, Paintings, Sculptures, Drawings, Prints at Kunsthalle Köln (first large retrospective of the American artist's work, later taken over by the Whitney Museum, New York).

1973

Ludwig Collection:
J. Johns, *Untitled*
R. Lichtenstein, *Still Life with Net, Shell and Rope*
J. Olitski, *4th Step*

Acquisitions:
R. Delaunay, *Endless Rhythm*
K. Schwitters, *Relief*

Rearrangement and expansion of the rooms of the Ludwig Collection. Volume 9 of the scholarly catalogues of the Wallraf-Richartz-Museum of 20th-Century Art: E. Weiss and R. Budde, *Images and Objects*.
City of Cologne receives donation of a group of Arp sculptures from Mrs. Marguerite Arp-Hagenbach, and an Arp room is inaugurated.
Exhibition:
Dan Flavin – Light Rooms at Kunsthalle Köln.

1974

Ludwig Collection:
J. Johns, *Passage*
P. Picasso, *View
of Notre-Dame de
Paris – Ile de la Cité*
R. Rauschenberg,
Axle, etc.

Acquisitions:
P. Klee, *Highroad
and Byroads*
(previously on loan)
R. Magritte,
The Giantess
N. de Staël,
The Shelf
S. Polke, *Head*

Volume 7 of the scholarly catalogues of the Wallraf-Richartz-Museum of 20th-Century Art: E. Weiss, *20th Century Paintings. The Older Generations.*

Opening of a new department of the Ludwig Collection, containing works by Bernd and Hilla Becher, Hanne Darboven, Jan Dibbets, Douglas Huebler, Klaus Rinke, et al.

Exhibitions:

Project '74 (a much-discussed presentation of international contemporary art at Kunsthalle Köln, Wallraf-Richartz-Museum, and Römisch-Germanisches Museum. Comprises installations, sculptures, paintings, performances, musical compositions, videotapes, and video sculptures by over 100 artists, including Anselmo, C. Boltanski, M. Broodthaers, D. Buren, H. Darboven, Gilbert & George, Les Levine, M. Merz, B. Nauman, D. Oppenheim, G. Richter, S. Polke, L. Weiner, P. Glass, J. Jonas); *Hans Hartung – Works from Five Decades.*

1975

Ludwig Collection:
D. Hanson,
Woman with a Purse
Four paintings
by G. Baselitz

Publication of competition guidelines for new museum facility, *Competition for urban redevelopment ideas in the Cathedral/Main Station area incorporating a new building for the Wallraf-Richartz-Museum.* In the course of the year, entries submitted are reviewed by the museum and city planning authority in turn with regard to design of structure and site.

Peter Ludwig is named honorary citizen of Cologne. Director General Gert von der Osten retires, to be succeeded by Gerhard Bott.

Exhibitions:

New Acquisitions of the Ludwig Collection (R. Lichtenstein, J. Johns, N. Graves, R. Rauschenberg); *Ernst Wilhelm Nay. Works on Paper.*

1976

Donation of
**Günther and Carola
Peill Collection,**
with 23 major
paintings and
drawings by
Baumeister,
Beckmann, Ernst,
Feininger, Javlensky,
Kandinsky, Kirchner,
Nay, et al.

Signing of donation contract between Irene and Peter Ludwig and the city of Cologne. Stipulations include the conversion of the twentieth-century department of the Wallraf-Richartz-Museum into an independent museum of modern art, to be named "Museum Ludwig (Moderne Galerie)". The autonomous museum is to receive its own director and staff.

No director is initially nominated. Curators will be Evelyn Weiss (department of painting and sculpture, and provisional directorship) and Dieter Ronte (commissioner for the new facility and head of the print collection). Horst Keller remains director of the Wallraf-Richartz-

Museum, his deputy director Rainer Budde. Stocks are apportioned between the Wallraf-Richartz-Museum (medieval period to 1900) and the Museum Ludwig (after 1900), recatalogued, and redistributed within the building, the Wallraf-Richartz receiving hall, upper floor, and intermediate floor. Publication of a donation catalogue with list and reproductions of the paintings, objects, drawings, and prints which are to pass to the city (including tributes by Federal President Walter Scheel, Minister of the Interior Werner Maihofer, et al.).

Conversion of east wing into an exhibition space, and installation of *Contemporary German Art*, an exhibition selected from the collection to introduce the *20th Century Studio-Galerie* series.

A decision is taken in the competition to design the new Wallraf-Richartz building. First prize goes to Cologne architects Peter Busmann and Godfrid Haberer.

Volume 8 of the scholarly catalogues: E. Weiss, *Paintings of the 20th Century. The Younger Generations.*

Reorganization of the modern collection at the newly established Museum Ludwig.

Award of Jabach Medal to Carola Peill.

1977

Ludwig Collection:
P. Delvaux,
The Dryads
L. Popova, *Portrait of a Woman (Relief)*
G. Severini, *Collage*
F. Stella, *Bonin Night Heron No. 1*

Acquisitions:
W. Kandinsky,
White line
F. Léger,
The Country Outing (Trustees and Supporters Association of the Wallraf-Richartz-Museum and Museum Ludwig)

Evelyn Weiss continues interim management of Museum Ludwig. After protracted negotiations, the Museum Ludwig acquires the renowned L. Fritz Gruber collection of photographs, and a long-planned photographic department is established (initially as a subdepartment of the print collection).

Exhibitions:
Franz Erhard Walther, New Sculptures; Andy Warhol, Paintings and Prints from the Artist's Collection, Studio-Galerie; *Photographic Artist Portraits from the Gruber Collection*, Studio-Galerie.

1978

The directorship of the Museum Ludwig, a post established in 1976, is assumed by Karl Ruhrberg in May.

Gerhard Kolberg begins his activities, which in 1982 will be extended to the fields of sculpture and environments.

Exhibitions:

Jasper Johns, Paintings and Objects, Drawings and Prints at Kunsthalle Köln (a retrospective in collaboration with the Whitney Museum, New York); *Joseph Beuys, The Cologne Portfolio*, drawings, Studio-Galerie; *Alexander Rodchenko, The Photographic Œuvre*, Studo-Galerie; *Objective Photography from the Gruber Collection*, Studio-Galerie.

1979

Peter Nestler succeeds Kurt Hackenberg after twenty-four years of highly successful activity as cultural affairs adviser to the city of Cologne.

Exhibitions:

Wols, The Photographic Oeuvre (including watercolors from the Ernst Fischer Collection, Krefeld), Studio-Galerie; *Photojournalism. A Selection from the Gruber Collection*, Studio-Galerie; *The Museum of Modern Art, New York, at Museum Ludwig, Cologne*, Studio-Galerie, hall, portions of upper floor; *C.T. Oldenburg – The Mouse Museum/Ray Gun Wing*, hall; *A.R. Penck, Drawings*, upper floor.

Preparation, shipment, and installation of the exhibition *Museum Ludwig at the Museum of Tel Aviv*, comprising 80 loans, primarily from the Ludwig Donation.

Completion of negotiations begun in 1975 concerning the acquisition of the Werner Mantz Photo Archive.

1980

Hugo Borger, director of the Römisch-Germanisches Museum, succeeds Gerhard Bott as director general of the Cologne Museums. The entire stocks of the Museum Ludwig are rehung according to a new concept. The main concern is to present the Haubrich Collection more extensively and in a better light, as well as to integrate the new Department of Russian art in the overall presentation of art of the 1920s.

Succeeding Dieter Ronte, Christoph Brockhaus assumes the curatorship of the print collection. Reinhold Misselbeck becomes curator of the photography department.

Acquisitions:
W. Baumeister,
Monturi, Discus I A
(on loan to the
museum since
1966)
D. Smith,
Ink Drawing

Exhibitions:
Stieglitz Photographic Collection from The Metropolitan Museum, New York; Russian Art from the Semionov Collection; Marcel Broodthaers – Retrospective (in collaboration with the Tate Gallery, London);
E.L. Kirchner Retrospective at Kunsthalle Köln.
Rearrangement of the print collection in the display rooms and depot; compilation of an alphabetical list of drawings.

1981

Ludwig Collection:
N. Suetin,
Composition
H. Trier, *Midsummer Night's Dream*

Acquisitions:
A. Jorn, *The Blow*
Man Ray, *Retour à la raison*

Rainer Budde succeeds Horst Keller as director of the Wallraf-Richartz-Museum.
The new display, carried out in 1980, is improved in various areas.
Due to lack of storage space a part of the east wing (three rooms) must be closed and reserved for depot purposes.
Exhibitions:
New Acquisitions 1980–1981, Paintings, Sculptures, Drawings; Christo – Urban Projects. 1961–1981 (travels to Städelsches Kunstinstitut, Frankfurt; Künstlerhaus Bethanien, Berlin, and Musée des Beaux-Arts, Lausanne).
The major exhibition event of the year takes place at the trade fair grounds in Cologne-Deutz: *Westkunst, Contemporary Art 1939–1981*. The show of paintings, sculptures, and objects covers 10,000 square meters. Its selection of exemplary, consistent groups of works arranged in five "chapters" compellingly illustrates the development of the avant-garde in Western Europe and North America. Exhibition curators are Kasper König, Laszlo Glozer, and Karl Ruhrberg. The selection of artists and supervision of the exhibition are carried out in conjunction with the Museum Ludwig (Wolfgang Hahn, Christa Steinbüchel, Evelyn Weiss).

1982

Acquisitions:
G. Richter, *War*
G. Klauke,
Formalization of Boredom
E. Schumacher, *Deli*

Seven exhibitions, including:
Werner Mantz – Architectural Photography in Cologne 1926–1931, Studio-Galerie; *Roy Lichtenstein – Paintings, Drawings, Sculptures from 1970–1980* at Kunsthalle Köln; . . . *with Photography by 7 Cologne Artists* (Bonvie, Klauke, Blume, Klein, Gruber, Vedder, Tillmann), at Kölner Stadtmuseum.
Ludwig Collection: Expansion of the department of Russian avant-garde art, which grows continually over the next three years (K. Vialov, A. Bogomazov, M. Larionov, K. Malevich, et al.); R. Lichtenstein, *Landscape with Figures and Rainbow;* A. Warhol, *Flowers.*

1983

Ludwig Collection:
Russian avant-garde
(A. Exter, X. Ender,
I. Kudriashov)

Loans:
G. de Chirico,
Two Nudes and
Roman Comedy
(VAF-Foundation,
Switzerland)

Eight exhibitions, including

Chargesheimer – Photographs 1949–1972, Studio-Galerie;
New Acquisitions and Permanent Loans at Museum Ludwig 1982–1983,
Studio-Galerie; *Alex Colville – Paintings, Drawings and Prints.*
The following works are acquired this year:
R. Horn, *The Peacock Machine,* J.L. Byars, *The Golden Speaking Hole,*
P. Klee, *Preliminary Drawing for Highroad and Byroads.*

1984

Ludwig Collection:
Considerable
expansion of the
Russian Avant-Garde
Department
(V. Stepanova,
A. Lentulov,
P. Filonov,
N. Goncharova,
I. Kliun,
N. Kogan,
M. Matiushin,
L. Popova,
I. Chaschnik,
N. Udaltsova)

Karl Ruhrberg retires from directorship of the museum. Siegfried Gohr
becomes his successor. Christoph Brockhaus retires as head of the
Graphic Art Collection.
Top-floor exhibition spaces are redesigned to house a large department
of Russian art.
Six exhibitions, including:
*Braco Dimitrijevic – Gemälde und Installationen; Stephan von Huene –
Klangskulpturen; Marcel Duchamp, Retrospektive.*
Spectacular acquisition of Max Ernst's painting *The Virgin Spanking the
Christ Child before Three Witnesses: André Breton, Paul Eluard, and the
Painter,* and of R. Long's *A Crossing Place.*

1985

Ludwig Collection:
Russian art of the
avant-garde
(I. Puni, K. Redko,
O. Rozanova,
V. Burliuk)
K. Schwitters, *Sculp-
ture from the Third
Merz-Bau*
P. Picasso, *Head of a
Woman (Dora Maar)*

Acquisitions:
S. LeWitt, *Red
Square, White Letters*
J. Villeglé, *Untitled*
J. Reineking,
*Edge Cut/Core
Cut/Remainder*

Interior planning of new building adjacent to the cathedral; logistic
preparation of move; lending stoppage. The collection is closed in the
course of the year to permit arrangements for transportation.
Alfred Fischer takes over the position of head of the print collection.
Founding of the "Gesellschaft für Moderne Kunst am Museum Ludwig"
(Association for Modern Art at the Museum Ludwig).
Seven exhibitions, including
Eduardo Paolozzi – Return of Themes; Kurt Schwitters – The Late Years;
preparation and implementation of travelling exhibition *Art of the
Russian Avant-Garde 1910–1930, Paintings, Drawings, Photographs,
Ludwig Collection* (for Fundacion G. March, Madrid; Fundación Miró,
Barcelona; Louisiana Museum of Modern Art, Humlebaek; finally,
in 1986, Kunsthalle Köln).

1986

Ludwig Collection:
G. Richter,
48 Portraits
K. Schwitters,
The Big Me Picture
and *Glass-Flower*
G. Baselitz,
Pastorale (Night)
A. Kiefer,
Tree with Wing
J. Johns, *Painted*
Bronze (Ale Cans)
J. Pollock,
Unformed Figure
A. Warhol, *Brillo* and
Campbell Boxes
P. Picasso, *Harlequin with Folded*
Hands and *Woman*
with Baby Carriage

Move into the new premises, installation of collections. Inauguration in September. Ingrid Kolb assumes new documentation management post. In just short of four months, approximately 800,000 visitors to the new facility are counted.

Publication of Museum Ludwig Stock Catalogue with plates volume.

Five exhibitions, including

Europa/America – History of a Fascination in Art since 1940; Michael Buthe – The Sun in Taormina – Works after Photos by Wilhelm von Gloeden.

Acquisitions and inauguration gifts:

E. Mataré, *Grazing Horse;* M. Rotella, *Cinemascope;* M. Duchamp, *Bicycle Wheel* (Association for Modern Art at the Museum Ludwig); F. Léger, *The Divers* (Irene and Peter Ludwig); H. Trier, *Triumph of Painting* (Association of Friends of the Wallraf-Richartz-Musuem and Museum Ludwig); as well as paintings by E.W. Nay and B. Schultze.

1987

Ludwig Collection:
G. Baselitz,
Pastorale (Day)
P. Kirkeby, *Untitled*
R. Trockel, *Untitled*

Donation of 53 prints
by E.W. Nay from
Günther and Carola
Peill Foundation

Lending activity rapidly increases, a tendency that will continue over the coming years.

Ten exhibitions, including

Miró – The Sculptor; Per Kirkeby Retrospective; Jürgen Klauke Retrospective.

Exhibition prepared for showing abroad:

Arte Americana Anni Sessanta/American Art of the 60s from the Museum Ludwig, Ca' Pesaro, Venice.

1988

Ludwig Collection:
A.R. Penck, *Me in*
Germany (West)
J. Immendorff,
Lehmbruck Saga
J. Fautrier, *71 prints*

Acquisitions:
F. Picabia, *The Fool*
(Association for
Modern Art in the
Museum Ludwig)
A. and B. Blume,
Mealtime
J. Klauke, *Autoerotic*
Projection (Hypo-
Kultur-Stiftung,
Munich)

Thirteen exhibitions, including

Incidentally, it is always the others who die – Marcel Duchamp and the Avant-garde since 1950; Mark Rothko 1903–1970. The Painter of Silence, Retrospective; Franceso Clemente. Watercolors and Drawings 1971–1986; Pablo Picasso. The War Years in Paris 1939–1945; Photographic Memories to mark the 80th Birthday of L. Fritz Gruber; Soviet Art Today, Paintings, Prints and Sculptures from the Neue Galerie – Ludwig Collection, Aachen; "photokina" photography exhibition; "Zeitprofile" – celebrating 30 years of Awards by the Deutsche Gesellschaft für Photographie; Cologne Collections, A Selection of Works from Private Collections of Contemporary Art (Curator Rudolf Zwirner).

1989

Thirteen exhibitions, including

Gerhard Marcks, Sculptures, Drawings, Woodcuts; "Bilderstreit" – Unity and Fragment in Art since 1960, exhibition of the Museum Ludwig in the Rheinhallen at Cologne's trade fairgrounds (curated by Siegfried Gohr and Johannes Gachnang). This key event found a great echo in the international media.

Andy Warhol Retrospective (in conjunction with the Museum of Modern Art, New York); large travelling exhibition *From the Revolution to Perestroika, Soviet Art in the Ludwig Collection from the Avant-Garde to the Present Day* (in conjunction with Neue Galerie –Ludwig Collection, Aachen; Kunstmuseum Luzern; Palau de la Virreina, Barcelona; Musée d'Art Moderne, Saint-Etienne; Musée de l'Etat, Luxembourg; Liljevalchs Konsthall, Stockholm); *Gruber Collection – 20th Century Photography* (217 works, shown at the Hochschule für Graphik und Buchkunst, Leipzig); *Master Photographs* (230 works, shown at the Louisiana Museum of Modern Art, Humlebaek).

1990

Following the retirement of Hugo Borger, Hiltrud Kier assumes director generalship of the Cologne Museums.

Thirteen exhibitions, including

Gerhard Richter – Atlas of Photos, Collages and Sketches; Max Ernst – Prints and Illustrated Books (travels to Pfalzgalerie, Kaiserslautern, Kunstverein, Wiesbaden, and Neue Galerie, Linz); *African Skulptur – The Invention of the Figure; Images of Germany – Art of the GDR with Painting, Sculpture and Prints from the Ludwig Collection,* at Kunsthalle Köln; *Capolavori su carta, Drawings from the Haubrich Foundation,* for Castello Rivoli, Turin.

The following works are acquired this year:

M. Vitlatshil, *Stand 43 – Myself 9* (from a private collection);
C. Buchheister, *Untitled, No. 16* (donation from artist's estate).

1991

Ludwig Collection:
Paintings by
A. Drevin,
A. Lentulov, I. Kliun,
N. Udaltsova
G. Baselitz,
The Great Friends
K. Schwitters,
Charming Portrait

Acquisitions:
H. Arp, *Torso-Leaf*
L. Fontana,
Spatial Conception,
Nature
(gift of Karsten
Greve, Cologne)

In April, Siegfried Gohr steps down as director of the Museum Ludwig. Marc Scheps assumes the position in September.

Ten exhibitions, including

Hans Arp – The Metamorphosis of the Figure; Max Ernst – The Friends' Rendezvous – A Centenary Exhibition; Liubov Popova – Daughter of the Revolution (in cooperation with the Museum of Modern Art, New York); *Robert Lebeck – Photojournalism; Arnold Schönberg as Visual Artist.*

1992

Ludwig Collection:
M. Beckmann,
The Battle
J. Schnabel,
Ignatius of Loyola
G. Baselitz, *The Last Kurt, Kurt, Kurt;*
approx. 100 works of
Russian avant-garde
art, in the fields of
painting, drawing
and photography,
including
K. Malevich,
I. Kabakov, and
70 photographs by
G. Zelma,
M. Nappelbaum,
G. Petrussov et al.

Reorganization of the collections. Replacement of previous chronological arrangement – art to the 1960s upstairs, art of the 1970s and 1980s downstairs – by a geographical division into European art (upper floor) and American art (lower floor).

Exhibitions:

Pop-Art-Show (travelling exhibition in conjunction with the Royal Academy, London. Further venue: Museo Reina Sofia, Madrid. The show gives a review of Pop Art of the 1960s as practiced in England, the United States, and other European countries as well);

Lisette Model – Photographs 1933–1983; Rosemarie Trockel – Works on Paper; Ars pro domo – contemporary art from private collections in Cologne, an exhibition of the Association for Modern Art in the Museum Ludwig; *Dani Karavan – Urban Projects; Lee Miller – Photographs 1929–1964.*

Acquisitions:

D. Karavan, *Ma'alot* (a later, small version of the outdoor sculpture of 1968); M. Beckmann, *View of the Blue Sea* (the first successful attempt, thanks largely to the efforts of the trustees of the Wallraf-Richartz-Museum and Museum Ludwig, to reacquire one of the works confiscated from the museum in 1937); H. Nitsch, *Flagellation Wall* (gift of Dr. Arend Oetker); F. Droese, *Painting of the Children Who Refuse to Eat Any More* (gift of Dr. Heidi Klöck and Prof.Dr. Friedrich Karl Klöck).

1993

Ten exhibitions, including

Latin American Art in the 20th Century (an exhibition curated by the Museum of Modern Art, New York, comprising over 350 works by about 100 artists. The first major retrospective of the fascinating development of modern art in Latin American nations, from the beginning of the twentieth century to the present day. Shown at Josef-Haubrich-Kunsthalle, Cologne); *Pablo Picasso – The Ludwig Collection* (on the twentieth anniversary of Picasso's death, the Museum Ludwig, Cologne, and the Museo Picasso, Barcelona, compiled an exhibition of 170 paintings, drawings, collages, sculptures, original ceramics, and printing blocks and plates from the Irene and Peter Ludwig Collection. Further venues: Museo Picasso, Barcelona; Germanisches National-museum, Nuremberg (as part of the *Ludwigslust* retrospective); Ludwig Museum, Budapest; and Museum moderner Kunst – Stiftung Ludwig, Vienna); *Felix Droese – Bombay-Bombay* (video installation and 100 drawings); *Projekt Bill Fontana* (in cooperation with WDR West German Broadcasting); *Photography In Contemporary German Art; From Malevich to Kabakov. The Russian Avant-Garde in the 20th Century. The Ludwig Collection, Cologne* (first presentation of entire collection of Russian art, only a fifth of which is normally on view, comprising 600 works by 100 artists, with K. Malevich represented by a full 63 examples); *Christian Boltanski. These Children are Searching for Their Parents* (held at Museum Ludwig, Cologne Central Station, and Klein St. Martin Church); *Albert Renger-Patzsch: Late Industrial Photography 1949–1965.*

On the occasion of his eightieth birthday L. Fritz Gruber presents 523 photographs to the museum, including works by C. Beaton, R. Capa, H. Claasen, H. Erfurth, A. Feininger, J. Klauke, A. Leibovitz, D. Michals, H. Newton, I. Penn, Man Ray, A. Sander, and L. Strelow.

1994

Kathinka Dittrich van Weringh becomes the successor of cultural affairs adviser Peter Nestler.

Nine exhibitions, including

Lyonel Feininger – Notes from Nature, Watercolors and Drawings; Unknown Modigliani – The Collection of Dr. Paul Alexandre (400 Modigliani drawings collected prior to 1914 and never publicly exhibited before 1993); *Richard Avedon Retrospective 1944–1994* and *Avedon – Fashion Work; Yves Klein – The Leap into the Void* (in cooperation with the Kunstsammlung Nordrhein-Westfalen, Düsseldorf. Klein, who died at a very young age in 1962, maintained close ties with the Rhineland scene and the Zero group. The exhibition travelled to London and Madrid); *Bernard Schulze – Das grosse Format* (the exhibition concentrated on the artist's dynamic late work, which found public and critical acclaim alike. Further venues: Bologna, Budapest and Antwerp); *Chargesheimer – Chaos Form Urform.*

The most spectacular event of the year is Peter and Irene Ludwig's donation of 90 works (31 paintings and sculptures, 59 works on paper) by P. Picasso, and 83 works of contemporary art, some of which were already on loan in the museum (incl. R. Artschwager, G. Baselitz, I. Kabakov, A. Kiefer, B. Marden, W. Mattheuer, C. Oldenburg, N. J. Paik, B. Palermo, A. Rainer, G. Richter, R. Trockel).

Worthy of special mention in the Picasso donation are the paintings *Harlequin with Folded Hands* and *Woman with an Artichoke*, and the sculptures *Woman with Baby Carriage, Seated Woman* and *Woman Combing her Hair.*

In parallel with the donation, 53 Picasso works (three paintings, seven sculptures, 43 works on paper) as well as 696 prints are provided to the museum on long-term loan. Following the presentation of the Picasso donation, an agreement is reached between Peter and Irene Ludwig and the city of Cologne, stipulating that after 1997, the existing museum facility shall be used by the Museum Ludwig alone. Planning for a new Wallraf-Richartz-Museum commences immediately.

1995

Reorganization of the collections, taking account of recently acquired large-scale installations (by M. Abakanowicz, B. Kruger, A. Kiefer, Komar & Melamid, et al.).

Irene Ludwig is nominated honorary citizen of Cologne.

Eight exhibitions, including

Our Century. Images of Man – A World of Images (organized to commemorate Peter Ludwig's seventieth birthday, the exhibition focusses on the theme of the human image in the present century. It contains works by 124 artists, displayed in all of the museum spaces).

Kasimir Malevich (thanks to a cooperation agreement with the Russian State Museum, St. Petersburg, which possesses the largest Malevich collection in the world, we are able to show a retrospective with 100 paintings and 80 drawings, supplemented by loans from the Museum Ludwig, Cologne, from Amsterdam, and from the U.S.A.).

A comprehensive travelling exhibition of 75 masterpieces from the Museum Ludwig, from Expressionism to Beuys, takes place in Japan. The show goes to five cities, including Nara, Tokyo and Yokohama, and is a great success.

On the occasion of the founding and inauguration of the Museum Ludwig branch in the Russian State Museum, St. Petersburg, the Cologne museum shows *Picasso – Die Sammlung Ludwig* with 180 original works.

Uwe Scheid Donation of 210 works by various photographers.

Abakanowicz, Magdalena

1930 Falenty,
Warsaw, Poland
Lives in Warsaw

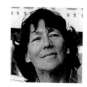

Magdalena Abakanowicz, trained in Warsaw, was strong-willed enough to resist the dogmatic Socialist Realism that was then the order of the day in Eastern Europe. In the great Polish tradition of tapestry-making she found a creative niche. Although cut off from developments beyond the Iron Curtain, she began to use natural, organic materials in a similar way to some proponents of Arte Povera in Western Europe, to evoke processes of growth, transformation, and decay. Gradually her wall-hangings, made of sisal, hemp, and horsehair, developed into reliefs. In the late 1960s Abakanowicz dispensed with the wall as support altogether, to produce free-hanging, biomorphic configurations titled *Abakans*. These subsequently burgeoned into monumental, highly expressive figurative sculptures, larger-than-life pieces evoking seated figures, embryos, human backs, or masks, which were often exhibited outdoors, in an interplay with the natural environment.

Armless Backs of 1992 is among the best-known of the artist's multi-figure works. The torsos with their fissured, as if tormented surface

possess a strange, very moving vitality. This is a compelling, emotionally charged work which, depending on the site, can invoke concentration camps in Poland, the victims of Hiroshima, or archaic rituals.

Another work in the Museum Ludwig, Cologne, is *Androgynous VII*. It dates to 1985, the year in which the artist produced a series of individual, gutted torsos that led to *Armless Backs* – some encaged, others perched on massive, primeval wagon axles of wood and iron. In both works, as in virtually all of the artist's figurative pieces, the gender of the figures represented remains indeterminate. Abakanowicz focusses on the torments men inflict on their own kind, the tragedy of the human condition, a theme she has continued to explore during the 1990s.

▲ **Magdalena Abakanowicz**
Armless Backs, 1992

Burlap fixed with synthetic resin 51 parts, each 77 cm in height

Ludwig Collection

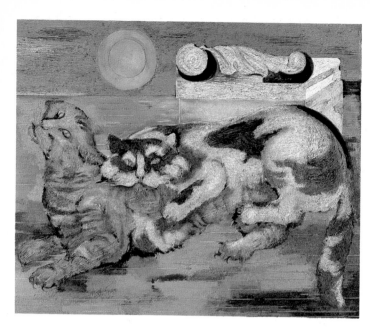

Jankel Adler moved to Germany from Poland prior to World War I. Before entering the Barmer School of Applied Art, Wuppertal, in 1914, he completed an apprenticeship as goldsmith and engraver. In the 1920s, Adler was a member of the Junges Rheinland (Young Rhineland) group in Düsseldorf, belonged to the Rheinische Sezession, and had close ties with the Gruppe Progressiver Künstler (Group of Progressive Artists) in Cologne. His psychologically penetrating portrait of Cologne artist Franz Wilhelm Seiwert dates from this period (1923). Adler was influenced by the rigorous, constructivist approach and social utopianism of Seiwert, Heinrich Hoerle, and their group. Yet his work, like that of Marc Chagall, continued to reflect his Eastern European, Jewish heritage, with its underlying melancholy and emphasis on the metaphysical. In fact, some of Adler's early paintings bore distinctly Chagallesque traits.

Adler, Jankel

1895 Tuszyn, Poland
1949 Aldbourne, England

His *Cats*, done in 1927, appear in an indeterminate space suggested only by two planes of color. The aura of mystery is increased by the stylized sun disk and the starkly geometric architectural fragment. The animals themselves, in contrast, show evidence of careful life-study: their lithe bodies and expectantly poised heads are the quintessence of agility, power, and affectionateness in one. Adler experimented with new means of expression, such as building up a low-relief surface by adding sand to the paint, which further heightened the effect of the motif.

Cats was awarded the gold medal at the exhibition "Deutsche Kunst" (German Art), held in Düsseldorf in 1928. In 1933 Adler emigrated to Paris, but in 1935 returned to Poland for two years. He travelled in Italy and lived for a time in the Soviet Union, before settling in Cagnes-sur-Mer, France, in 1938. When war broke out in 1939, he volunteered for service in the Polish Army, which eventually took him to Scotland and the British Isles.

"Adler's œuvre," wrote Anna Klapheck, "is a grand torso, which bears the marks of the vicissitudes under which it was created."

Albers, Josef

1888 Bottrop,
Germany

1976 New Haven,
Connecticut

Josef Albers is one of the most outstanding German representatives of geometric abstraction. After working as a schoolteacher in his home town of Bottrop, Albers attended the Berlin Academy of Art and a school of decorative art in Essen. He then went on to Munich, to study painting with Franz von Stuck. But the key influence on his development came with his training at the Weimar Bauhaus. There, in 1922, at the behest of Walter Gropius, Albers became teacher of the preliminary course. In 1929, twenty of his glass-paintings were included in a Bauhaus masters exhibition in Basel and Zurich. Albers also worked in the technique of stained-glass, making windows that were initially composed of myriads of varicolored shards. Soon, however, they began to evince the precisely defined forms and carefully balanced color schemes which would come to dominate his later work.

Albers gained an international reputation as an art teacher during his Bauhaus period. When the Nazis abolished the school in 1933, he emigrated to the United States, where he was offered a post at the recently inaugurated Black Mountain College, in Ashville, North Carolina. Albers's renown as a teacher attracted young painters working in a variety of styles to the college, including Willem de Kooning and Robert Motherwell. His characteristic ability to combine theoretical concerns with artistic practice had a strong influence on the younger generation of American artists. Robert Rauschenberg once said that Albers was the best teacher he had ever had.

After leaving the faculty of Black Mountain and Yale, where he also lectured, Albers published his investigations into a new theory of color. Titled *Interaction of Color* (1963), his book had a profound impact on contemporary art. Based on the premise that color was governed by its own, intrinsic laws, Albers argued that if artists were to use it successfully, they would have to grasp its continually deceptive, illusory nature.

Albers's own painting culminated in the famous sequence collectively titled *Homage to the Square*, begun in 1950. Employing this single form, a basic element of constructivist art since Kasimir Malevich, Albers launched into a series of oils, offset prints, and silkscreens in which painstakingly rendered squares of various sizes and color gradations were symmetrically superimposed. The panel in our collection, done in 1963 and subtitled *Green Scent*, consists of three squares in shades of pure green. In its reduction of form and color to a minimum,

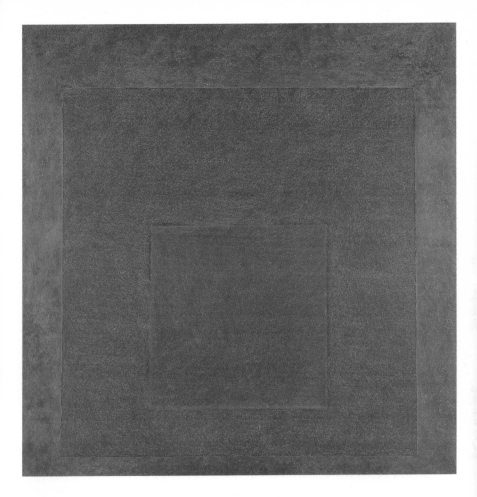

the image vividly confirms what we know from experience: that one and the same color can apparently change in hue, depending on the value of the adjacent color, and that colors can appear to recede or advance in space. This visual effect compellingly illustrates what Albers meant by an interaction of color, the fascinating interplay set up between "physical fact and mental effect." Such works stimulate the visual imagination by appealing simultaneously to our sense of objective proportions and to our ability to enter contemplatively into the illusion of depth and motion induced by deceptively simple means.

▲ **Josef Albers**
Homage to the
Square: Green
Scent, 1963

Oil on hardboard
121 x 121 cm

Ludwig Donation,
1976

Alechinsky, Pierre

1927 Brussels
Lives in Bougival,
France

Like Karl Appel and Corneille, Pierre Alechinsky was active in a group of Danish, Belgian and Dutch artists who called themselves Cobra (1948–1950). Alechinsky's background was in book illustration and typography, which he studied in 1944 at the Ecole Nationale Supérieure d'Architecture et des Arts Décoratifs in Brussels. This training in the principles of design remained a key factor in his later work. After a phase of emotionally charged, gestural painting in the mode of European Art Informel, a trip to Japan in 1955 brought a changeover. Alechinsky's style grew more tranquil, contemplative, and ornamental, probably under the influence of Japanese calligraphic ink-painting, about which he even made a film in Tokyo and Kyoto. This may also have been the source of his increasing preference for the color black, and perhaps even of the idea of including written texts in his prints and drawings of the period, which were eloquent in every sense of the word.

A turn from impasto oils to smoothly applied acrylic paint, in 1965, contributed to a stylistic change in Alechinsky's work. *Coupe Sombre* (Dark Chalice) is a characteristic example. The composition consists of a central field of color flanked by black and white scenes that provide narrative variations on the central motifs. The configurations emerging from the agitated color fields and arabesque lineatures may be ambiguous, but this only increases their capacity to stimulate the viewer's imagination and trigger free association. The dreamlike atmosphere of Surrealist art fascinated Alechinsky from the beginning. He especially admired André Breton, Surrealist poet, philosopher, and explorer into the creative forces of the subconscious mind.

▲ **Pierre Alechinsky**
Dark Chalice, 1968
Coupe Sombre

*Acrylic and parch-
ment on canvas*
100 x 244 cm

▶ **Natan Altman**
Head of a Woman
(Portrait of Anna A.
Achmatova), c. 1913

Oil on canvas
70 x 70 cm

Ludwig Collection

During his student years in Paris, 1910–1912, Natan Altman was influenced by Cubism and worked intensively in a Futurist vein. Elements of both styles continued to inform his painting approach. In 1912 Altman returned to Russia. Between 1918 and 1923, caught up in the fervor of a new, revolutionary art, he created a series of abstract paintings and reliefs which, as regards treatment of materials, show parallels to the work of Vladimir Tatlin and Ivan Puni. Altman also did great numbers of portraits; but here, achieving verisimilitude and likeness were of prime importance to him.

His *Head of a Woman* (c. 1913), in the Museum Ludwig, Cologne, evinces a degree of abstraction unusual for Altman in this genre. It was done immediately following his Paris sojourn. In terms of composition, facetting of forms, and palette, this portrait shows strong similarities to a portrait of 1913, which bears the inscription "Anna Achmatova" on the reverse.

The facial features and hairstyle, too, recall those of the famous poetess whose life and work, in the eyes of many Russian artists and writers, symbolized liberty and resistance to an oppressive regime. At the time the portrait was executed, Altman was a close friend of Anna Achmatova (1889–1966).

Altman, Natan

1889 Vinnica, Russia
1970 Leningrad
(now St. Petersburg)

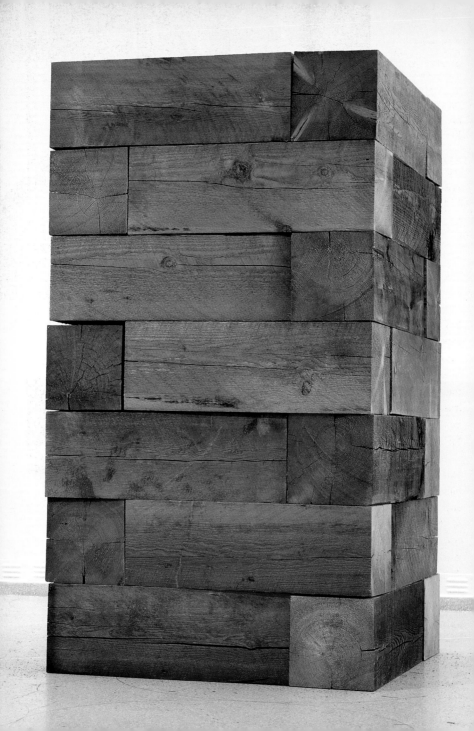

◄ **Carl Andre**
Timber Piece (Well)
Destroyed 1964,
reconstructed 1970

Wood, 28 parts
213 x 122 x 122 cm

Ludwig Donation,
1976

► **Carl Andre**
Lock Series, 1967

36 steel plates,
100 x 100 cm each

Ludwig Donation,
1976

In Carl Andre's work, the principles of Minimal Art find quintessential expression: the use of the simplest possible materials, shaped into the most elementary possible forms, to produce an objectivity bordering on the anonymous. In direct relationship to their reduction of formal means, Minimal artists have increased the dimensions of their works. It is precisely this factor of size, which relates the work to architecture and the natural environment, that marks the distinction between Minimal Art and its great model, Constructivism.

Another characteristic of the style is the strongly conceptual approach adopted by its proponents. Andre, for instance, concerns himself with the theoretical problems involved in representing structure, motion, and symmetry. One result has been his concept of "non-axial symmetry." Regarding the element of motion, he has compared the idea for a sculpture to a street, which does not disclose itself either in and of itself or when seen from a certain, fixed point.

Like a street, Andre's *Lock Series* is both mutable and enterable. The piece includes a drawing that shows five possible arrangements of its steel plates, in combinations ranging from a square (6 x 6) to a row (36 x 1). Like the *Lock Series*, the artist's timber sculpture, *Well*, uses rough, unfinished materials and translates structures that pervade the phenomenal world into a radically reduced language of form.

Andre, Carl

1935 Quincey,
Massachusetts
Lives in New York

de Andrea, John

1941 Denver,
Colorado
Lives in Denver

One of the principal subjects of American realist painters of the 1960s and 1970s was the human figure; or, to quote Udo Kultermann's more precise definition, the "exactly known, unique, actually existing human being." John de Andrea, too, represents people from his own environment, friends, acquaintances, studio models. He is concerned with depicting the physical appearance of the individual as authentically as possible, and in all its uniqueness.

Compared to this aim, de Andrea finds the fragmentary representation of persons by photography insufficient. As he once said, the photograph was already a step away from the model, adding that it was the real person he was after, not the way they looked in a photo. In order to overcome the borderline between actual and represented figure, de Andrea makes plaster casts directly from the model, then fills these molds with polyester resin and fiberglass. In this way, every pore of the body is reproduced; artificial hair is inserted later with a pointed tool.

This procedure is the subject of the studio scene illustrated here. We see the artist behind his model, who is seated on a chair and whose body is already partially covered with the plaster mold material. Activity is the one thing that seems to be missing from the tableau. The figures stand in calm, absolutely motionless poses, facing the viewer. De Andrea avoids any gesture that might appear momentary or accidental, in order to concentrate our attention on the sheer, physical existence of those represented. Correspondingly, the figures are painted in a neutral hue. Nothing detracts from their physical presence, which seems ensconced in a timeless permanence.

De Andrea's art belongs to the school of American Hyperrealism, which, in painting, also goes by the name of Photorealism. In contrast to his other sculptures, whose naturalism even extends to the color of the complexion, the gray tone of the figures in the studio scene was consciously intended to reduce the sense of trompe l'œil. The result is an objective effect similar to that of a black and white photograph.

Generally speaking, de Andrea's life-size nudes are reduced to sheer nakedness, and apart from the physically faithful and convincingly real imitation, they express no emotional message – at least none intended by the artist.

► John de Andrea
Untitled, 1977

*Fiberglass, PVC,
plaster, fabric, paint
Male figure, height
185 cm (standing)
Female figure, height
115 cm (seated)*

Ludwig Collection

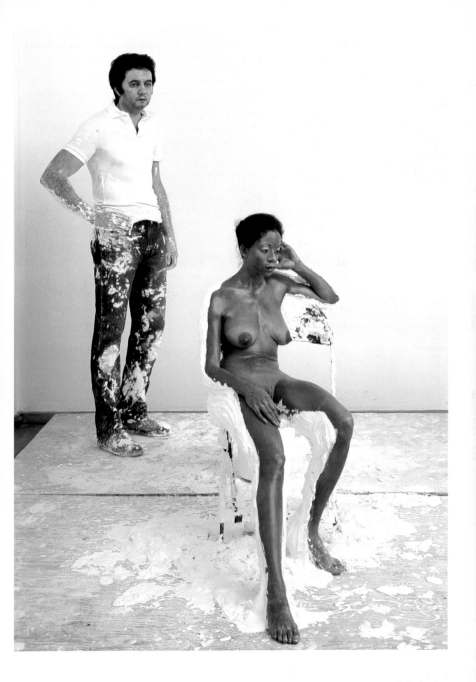

◀ **Horst Antes**
Third Landscape
Painting, 1968
Drittes Landschafts-
bild

Aquatec on canvas
129.5 x 196.5 cm

Ludwig Donation,
1976

Antes, Horst

1936 Heppenheim,
Germany
Lives in Wolfarts-
weier

The predominant theme in the work of Horst Antes, who studied with
HAP Grieshaber at the Karlsruhe Academy from 1957 to 1959, is the
human figure. His early style was strongly determined by color, but after
stays in Florence (1962) and Rome (1963), he reduced his palette and
increased the dimensions of his closed-contoured figures until soon they
dominated a pictorial space filled with textured fields of thinly applied
paint. Against this foil, the figures appeared to be propelled forward
toward the viewer, as H. Pée has written, by the "increasingly geometric-
ally fixed color planes which derived their doubtless correct function in
the pictorial organism from the spatial experiences of late Cubism."

In *Third Landscape* (1968), expansive fields of white and strong colors
serve to heighten the expressiveness of the composition. This is one
of a series of similar paintings in which variations are rung on Antes's
"artificial figures," including the idol-like "cephalopod." Symbolically
condensed human images, the figures stand out as if in low-relief
against a spacious landscape, which was inspired by Sienese painting
of the Trecento. Antes calls these canvases "space-figure paintings,"
adding that "The figures are always artifices that have a certain serenity
as well. One should not view them solely as demonic creatures or
monstrosities from hell, or who knows what all." Still, one cannot help
but believe that Antes's figures do embody certain reactions on his part
to the evils of contemporary society, for they reveal a critically ironic
viewpoint that stimulates us to stop and think.

From 1940 to 1943, Karel Appel studied at the Rijksacademie voor Beeldende Kunsten, or Royal Academy of Art, in Amsterdam. Together with Pierre Alechinsky and Corneille, he was a co-founder of Cobra (1948–1950), a group of Danish, Belgian, and Dutch artists who were inspired by the Art Brut of Jean Dubuffet. Like Dubuffet, they employed banal subject matter, subconscious imagery, and a purposely naive, grotesque figuration. The group also adopted elements from folk and primitive art, and despite their Abstract Expressionist tendency, they never ruled out the validity of objective depiction. In brief, the Cobra artists attempted to combine the rational with the irrational, abstraction and figuration in their work.

 Among them, Appel was perhaps the most persistent in his search for a pure painting, employing an impulsive, gestural approach in which the workings of the subconscious imagination could flow spontaneously into the process of painterly improvisation.

Appel, Karel

1921 Amsterdam
Lives in Molesnes-
Yonne, France

Archipenko, Alexander

1887 Kiev, Russia
1964 New York

▼ A. Archipenko
Flat Torso, 1914

Bronze
height 38.2 cm

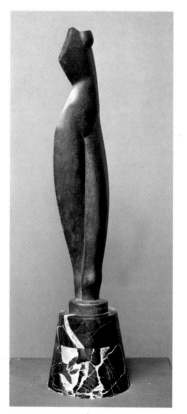

Archipenko was one of several Russian sculptors who, in Paris prior to the First World War, were instrumental in shaping the Cubist and Constructivist approaches to sculpture. Long an admirer of Leonardo da Vinci's art and science, after his arrival in Paris in 1908 Archipenko studied the Egyptian, Assyrian, Greek, and Early Gothic art in the Louvre. He had his first one-man show in 1912, at the Folkwang-Museum in Hagen, Germany, and another the following year, at the Sturm gallery in Berlin. He returned to that city to run his own art school, from 1920 to 1923.

It was no longer the agitated modelling of Impressionist sculpture but the simplified volumes and tectonic forms of archaic and primitive art that fascinated the young Russian. Archipenko reduced the human body to elementary, basic shapes, which he recombined into plastic masses. His frequent use of concavities and apertures to allow the surrounding space to enter into the sculpture would prove to be of revolutionary significance for the development of modern sculpture.

Flat Torso (1914), one of Alexander Archipenko's most frequently reproduced works, employs material as an aesthetic element in its own right. Variants of the piece exist in marble, aluminum, gilded plaster, bronze, and silver-plated bronze. The smooth, polished forms take on a life of their own, striving upwards in gentle curves, buckling, then abruptly breaking off. The motif of the torso offered the artist a superb opportunity to express the tension between the human image and the abstract elements of sculptural design in an original language of form.

As Archipenko himself explained, "Since the year 1912 I have united the ineffables – space, transparency, light, and reflection – in a single form. This has developed into modern sculpture, along with the concave (negative form)."

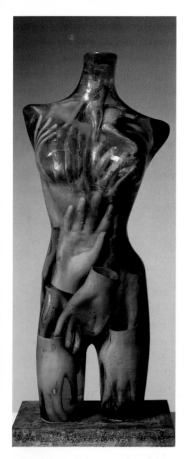

After studying art at the Ecole National des Arts Décoratifs and attending the Ecole du Louvre in Paris, in 1955 Arman began a series of abstract paintings collectively called *Cachets* (rubber-stamp impressions). *Nominatif*, in the Museum Ludwig, Cologne, belongs to this early phase, and reflects the gestural style of European art informel. Arman's style changed profoundly when he joined the Nouveaux Réalistes. The group, founded in 1960 by French critic Pierre Restany, included artists Yves Klein, Jean Tinguely, Daniel Spoerri, and Martial Raysse. They focussed on the banal realm of consumer goods, sought a mutual inter-penetration of art and life, and revived a number of Dadaist ideas. One of the first works of Arman's new phase was *Garbage Can*. "Arman discovered the true material for his art," wrote Herta Wescher, "in dustbins, whose contents he transferred, without sorting or aesthetic arrangement, to transparent plexiglass containers. The 'social content' of these works differs, depending on whether the rubbish came from a middle-class household or was gleaned, say, from the refuse bins of the Halles. In the same vein, Arman did 'portraits' of his friends by appropriating their wastepaper baskets, which, in his eyes, contained things that provided a key to their personalities." Arman himself explains, "I maintain that the expressive power of junk and unusable objects does possess its own, intrinsic value, in a very direct sense. There is no need to look for aesthetic forms in rubbish, which would only water it down and make it equivalent to the paints on a palette."

Arman
(Armand Fernandez)

1928 Nice, France
Lives in Nice and
New York

◄▲ **Arman**
Torso with Gloves,
1967
Torse aux gants

*Plastic hands
in polyester resin*
85 x 35 x 26 cm

Ludwig Donation,
1976

Accumulation of Cans, done in 1961, consists of actual, everyday objects — enamelled pitchers of various colors — lined up in two rows before a blank panel. Found in the garbage and deprived of their original function, the pitchers are presented behind glass to underscore their intrinsic value, quite independent of their usefulness. In his treatment of the object Arman takes what was then a radically new stance, for he was the first artist to accept and employ reality just as he found it. He neither attempted to manipulate real things to conform with some aesthetic ideal, nor to heighten or apotheosize them. The water pitchers not only represent water pitchers; they *are* water pitchers.

The idea for *Box of Tonics* (1964) goes back to 1961, the year in which Arman purchased the box of springs at the Pélerins d'Emmaus store in Nice. The piece of brown resin, mounted above the box on the white wooden panel, contains stones and leaves from Nice and Cologne. This element was added by Arman in 1967, during restoration work on the piece at the Wallraf-Richartz-Museum, just after its acquisition. The title is a good example of the multifarious mental associations which trivial things are capable of triggering.

The sculpture *Torso with Gloves* belongs to a series of six very similar works, in which various objects (such as pieces of a violin) are cast into a polyester-resin torso. The dual fragmentation of the human body in this case — torso and hands, from plastic mannequins — create a surrealistic effect that is both formal and substantial in nature: The traumatic motif of being touched by a multitude of hands is transposed inside the female body. The transparent torso, consciously given an aesthetically pleasing form, makes an immediate and unmistakeable appeal that distinguishes this piece from the artist's earlier works, which were not always comprehensible at first glance. In terms of its direct message, *Torso with Gloves* bears affinities with the contemporaneous approaches of American Pop Art.

**Arp, Hans
(Jean)**

1886 Strasbourg
1966 Basel

Hans Arp is considered one of the major sculptors of the classical modern period. He was trained in art in Weimar (1905–1907) and in Paris, at the Académie Julian (1908). In 1916, with Hugo Ball, Tristan Tzara, and others, he founded the Cabaret Voltaire – the first manifestation of Dada. During the 1920s, which he spent mostly in Paris, Arp figured as one of the leading protagonists of French Surrealism, alongside André Breton and Max Ernst.

In 1930 Arp began working on free-standing sculptures, producing a series of pieces in which human, animal and plant forms were reduced to quintessential organic volumes. His *Female Torso* with its burnished, snow-white marble skin and swelling curves recalls some fertility idol from an archaic past. Arp favored roundness as a sculptural equivalent to natural, organic growth.

The same formal idiom was employed in his animal or vegetable-based configurations, such as *Alou aux griffes*, *Garland of Buds II*, or *Serpentine Motion II*, as well as in hybrid creatures like *Cobra-Centaur*. Arp even envisioned a reverse metamorphosis, of art into nature, as evoked in his notes on the sculpture *Torso-Leaf*: "Out of a billowing

▶ **Hans Arp**
Relief Nadir I, 1959

Pavatex on wood
152.5 x 130.5 cm

Gift of Marguerite
Arp-Hagenbach,
1973

Hans Arp
Serpentine Motion II, 1955
Configuration aux mouvements de serpent II

Original plaster
44 x 60 x 80 cm

Gift of Marguerite Arp-Hagenbach, 1973

Hans Arp
Cobra-Centaur, 1952

Original plaster
78 x 43 x 30 cm

Gift of Marguerite Arp-Hagenbach, 1973

Hans Arp
Alou aux griffes, 1942

Original plaster
56.5 x 39.5 x 29.5 cm

Gift of Marguerite Arp-Hagenbach, 1973

Hans Arp
Garland of Buds II, 1936
Couronne de bourgeons II

Original plaster
54 x 42.5 x 42 cm

Gift of Marguerite Arp-Hagenbach, 1973

Hans Arp
The Little Theater, 1959
Le petit théâtre

Original plaster
110 x 68 x 18 cm

Gift of Marguerite Arp-Hagenbach, 1973

celestial fleece rises a leaf. The leaf changes into a vase. An enormous navel appears. It grows, it becomes larger. The billowing celestial fleece dissolves in it."

Apart from organic form, Arp's works often rely on a reinterpretation of the Surrealist principle of the dialectic relationship between formal development and thematic association. Examples are *Relief Nadir I*, in which the firmament with its heavenly bodies is projected onto the plane, or *The Little Theater*, in which the stage, as scene of world events, is reduced to the microcosm of a peep-show whose actors appear as schematic silhouettes against a bottomless gulf.

◄ **Hans Arp**
Female Torso, 1953

White marble
88 x 34 x 27 cm

Haubrich Collection

► **Hans Arp**
Torso-Leaf, 1963
Torse-feuille

Bronze, polished
235.5 x 50 x 35 cm

Acquired with
the aid of the
Trustees and
Supporters
Association of the
Wallraf-Richartz-
Museum and the
Museum Ludwig,
and of the Cultural
Foundation,
Nordrhein-Westfalen

◄ Richard
Artschwager
Blue Logus, 1967

Formica on wood
97 x 129 x 127 cm

Ludwig Donation,
1994

► Richard
Artschwager
Apartment House,
1964

Liquitex on Celotex
and Formica
177 x 126.5 x 16 cm

Ludwig Donation,
1976

Artschwager, Richard

1924 Washington D.C.
Lives in Hudson,
New York

Richard Artschwager took the motif of *Apartment House* (1964) from a mundane photograph, but unlike other Pop artists, he transferred the image to canvas by hand. Despite the limitation to black and white, he used subtle gradations of tone and impasto textures to lend the surface a surprisingly painterly effect. This strongly contrasts with the smooth, imitation wood grain of the frame, which is an integral part of the picture. The bizarre situation of reproducing a natural material on the one hand, while on the other transforming a reproduction into a handpainted image, corresponds to Artschwager's theme: that something is very awry in a world in which an apartment house supposedly designed to be lived in (or was it only designed to be photographed?) may be extremely inviting, but ultimately proves to be only a desolate place, devoid of human life.

Artschwager, who in the 1950s built furniture to make a living, has transformed the frame into a kind of sculpture. Three years later, he used blue, marbled Formica to transform a wooden sculpture, *Blue Logus* (1967), into an abstract piece of furniture which, lacking any functional purpose, ironically combines the concrete with the conceptual.

Bacon's Surrealist-influenced paintings of the early 1930s already presaged a theme that would dominate his later œuvre: that of the crucifixion. Inspired by a Picasso exhibition he saw in Paris in 1926, Bacon began to paint in 1929. Self-taught as an artist, he made his living in London by designing interiors. In 1942 he destroyed a large part of his previous work. It was not until after the war that Bacon's personal, inimitable style emerged, in large-format depictions of suffering, self-despairing human beings, often crassly shocking visions of anxiety and hopelessness.

Painting of 1946, now in the Museum of Modern Art, New York, marked the beginning of this new stylistic phase. Bacon began to blur the contours of figures and faces, drawing swaths of paint across their features and distorting them. The individual represented became secondary, interchangeable, as the general theme of damaged life, a damaged reality, came to the fore. Despite his insistence that he pursued purely aesthetic aims, Bacon's paintings eloquently testify to the fact that his subject was indeed man in jeopardy.

The canvas in the Museum Ludwig, Cologne, done in 1971, is a second version of the 1946 *Painting*, which established the artist's international reputation. In the earlier image, the figure appeared as a speaker in a black robe, haranguing his audience. In the later version, this association with tyranny, typical of the postwar period, was shifted into an everyday, contemporary setting. Yet the pervading sense of brutality remained.

The analogy between crucifixion and butchering present in the early version is continued in the cross-shaped animal cadaver. The male figure seated in front of it, seemingly protected by a canopy, now wears normal street clothes; his mouth is no longer distended in a scream but nearly effaced by a paint smear, as in a blurred photograph. This is a man who has lost his bearings. The sense of human isolation suggested by the balustrade in the earlier version has deepened. A cooler palette and simplified background lend the later composition greater concision, while the movement of the figure is more strongly emphasized.

Bacon, Francis

1909 Dublin, Ireland
1992 Madrid, Spain

◄ **Francis Bacon**
Painting 1946,
Second Version,
1971

Oil on canvas
198 x 147 cm

Ludwig Donation,
1976

Balkenhol, Stephan

1957 Fritzlar,
Germany
Lives in Meisenthal

▲ **Stephan Balkenhol**
Untitled (Female
and Male Head),
1982
Ohne Titel
(Weiblicher und
männlicher Kopf)

Poplar wood, painted
95 x 66 x 62 cm
(female head)
96.5 x 66 x 67 cm
(male head)

Ludwig Donation,
1994

Stephan Balkenhol studied under sculptor Ulrich Rückriem at the Hochschule für Bildende Künste, Hamburg, from 1976 to 1982. His realistic, mostly polychrome wood sculptures, devoted to the classical subjects of man and animals, won Balkenhol early recognition. The monumental male and female heads of 1982, now in the Museum Ludwig, Cologne, are made of poplar, rough-hewn in a way that retains a sense of the original outlines of the block. Hair, eyes, eyebrows, and lips are emphasized with color. The couple's gaze is directed earnestly and expectantly into the distance, not as if they were looking at anything in particular, but as if they were awaiting something or someone they know will come. Balkenhol's first full-figure sculptures, done in 1983, were conceived, like the heads, either in three dimensions or in relief. They appear individually or in groups, occasionally in veritable series. The figures reflect no narrative intention, nor do they convey a symbolic or mythological message. "They seem," writes Rückriem, "to be waiting for their meaning, without visible effort, and simply growing older."

▶ **Giacomo Balla**
Flags for the Altar
of the Fatherland,
1915
Bandiere all'altare
della patria

Oil on canvas
31.5 x 29.7 cm

Loan of
VAF-Foundation,
Switzerland

Giacomo Balla came into contact with Futurism as early as 1907, and soon advanced to become the movement's major proponent and spokesman. The year 1910 saw the publication of the first *Futurist Manifesto,* over the signatures of Balla, Umberto Boccioni, Carlo Carrà, Luigi Russolo, and Gino Severini. Balla exhibited with the Futurists in spring 1913; that same autumn he participated in major shows at the Sturm gallery in Berlin, where alongside Wassily Kandinsky, Paul Klee, Piet Mondrian, Fernand Léger, Francis Picabia, Hans Arp, and others, the Italian Futurists were presented to a broad public for the first time.

The canvas *Warship + Widow + Wind* (1916) belongs to a series of paintings which may be seen in the context of the patriotic enthusiasm which gripped the Futurists during the First World War. The immediate stimulus for the painting came from a brief encounter, as Balla was walking in the park of the Villa Borghese in Rome, with a war widow dressed in mourning. The dark hue, and the shades of gray, indeed evoke mourning; but they also contain hints of the grayish-green finish and metallic glint of a warship's hull, suggestions of which also occur in the forms of the landscape and clouds. Yet an equally strong mental association is called up with a long, translucent, black veil, fluttering in the wind.

Balla, Giacomo

1871 Turin, Italy
1958 Rome

◀ **Giacomo Balla**
Numbers in Love,
c. 1925
Numeri innamorati

Oil on canvas
76.5 x 54 cm

Loan of
VAF-Foundation,
Switzerland

▶ **Giacomo Balla**
Warship + Widow
+ Wind, 1916
Corrazzata + vedova
+ vento

Oil on canvas
99.5 x 109 cm

Loan of
VAF-Foundation,
Switzerland

Numbers in Love was shown at the 1926 Venice Biennale, in a room
in the Soviet pavilion devoted to Italian art. The display was intended to
demonstrate the revival and further development of Futurism. Perhaps
the most striking feature of this work is the artist's transmutation
of numbers into architectural projections, evoking three dimensions
by means of superimposed and juxtaposed planes whose cool hues
call machinery to mind. Cylinders, cubes, semicircles, and triangles
are assembled into a composition that has a simultaneously static and
dynamic effect. The relationship of the numbers to one another, how-
ever, is not entirely clear. Although five plus three makes eight, so that,
in addition to the number four in the picture, we have two eights, the
simple numerical relationship would not seem as deep as the love-tie
referred to in the title. Be this as it may, in the discussion concerning
art and fascism in Italy, *Numbers in Love* has been cited as an example
of a non-conformist work which eluded the strictures of the art theory
and political policy then in sway.

◄ Vladimir
Baranov-Rossiné
Mauve-colored
Table, 1912

Oil on canvas
130 x 160 cm

Ludwig Collection

**Baranov-
Rossiné,
Vladimir**

1888 Cherson,
near Odessa,
Ukraine
1944 Germany

Imagination and a love of experiment were prime personality traits
of Vladimir Baranov-Rossiné. The Ukrainian painter, sculptor, and
inventor made an original contribution to a synthesis of the arts when,
in 1924, at a Bolshoi Theater performance in Moscow, he demonstrated
his optophonic piano, which produced sound and colored light simul-
taneously. Baranov-Rossiné began painting in 1902, in Odessa. In 1908
he participated in various exhibitions of the Russian avant-garde then
emerging in Kiev. During a four-year sojourn in Paris, he met Robert
and Sonia Delaunay, launched into a scientific study of color and light
theory, and regularly exhibited in France.

 The artist's *Mauve-colored Table* of 1912 reflects the influence of
the French avant-garde – Cubistic elements reminiscent of Cézanne,
and circular shapes and arc segments similar to those found in
Delaunay's Orphism. The framing of the motif, choice of perspective,
the flower arrangement and statuette on the table, all show Baranov-
Rossiné's familiarity with the art of Henri Matisse.

During his studies at the Dresden Art Academy (1891–1895, with Robert Diez), Barlach's early work in sculpture still had strongly naturalistic traits. This changed with periods spent in Paris (1885–1896) and Berlin (1899–1901), centers of Art Nouveau that left their mark on Barlach's style as the new century began. In 1901 he started to work in ceramics, producing a series of sculptures, and in 1904–1905, he taught the technique at a school specializing in ceramics, the Westerwälder Keramikfachschule, Höhr.

Barlach, Ernst

1870 Wedel,
Holstein, Germany
1938 Rostock

The year 1906 saw Barlach in Russia, a journey that would prove crucial to his development. As he wrote in his autobiography, *Ein selbst-erzähltes Leben*, "In Russia I found this amazing unity of body and soul, this symbolic... form – mere form? No, it was an incredible insight, which said: You can dare to do anything that is in you, without holding back – the most public things and the most intimate, gestures of piety and gestures of wrath, because for everything... there is an expression, since in Russia, one or both have evidently come to realization." The profound emotional expressiveness of Eastern European culture, and the mythology of the Nordic peoples, left a deeper impression on Barlach than the art of the Mediterranean world.

With the advent of National Socialism, Barlach's public monuments in Lübeck, Güstrow, Kiel, and other cities became a target of attack. He was declared a "degenerate artist" and forbidden to exhibit. After the war, Barlach's work took on a popularity he himself would never have expected. The Barlach Society was established, and three memorials to him were erected. Yet he was always chary of the clichés that attached to his work. "They're trying to put me in a rubric in terms of creed," Barlach wrote as early as 1932. "They say I'm a seeker of God. But what does that mean, a seeker of God? I would call it downright arrogance if someone were to refer to themselves as such. They stick the labels 'cultic' and 'mystical' on my works, and worry their heads

◄ **Ernst Barlach**
From a Modern
Dance of Death,
1916
Aus einem neuzeit-
lichen Totentanz

*Charcoal and pencil
on paper*
28.5 x 20 cm (image)
33 x 24.7 cm (sheet)

Haubrich Donation,
1946

about what riddles I depict and how clever I am in making them difficult to solve. And yet the only thing I desire is to be an artist, pure and simple."

Barlach expressed the mental states of his figures by means of starkly simplified, almost rustic forms, sometimes heightened to the point of expressionist distortion. The pose of *Singing Man* (1928), seated with outspread legs, leaning back and grasping one knee with his arms for support, exudes the same sense of concentration and peace of mind as the facial expression. The preliminary drawing of 1912 emphasizes the mood of complete relaxation; the head itself probably goes back to realistic studies Barlach made while in Russia. The realistic, human qualities of *Singing Man* did not escape an acute observer like Bertolt Brecht: "He is singing alone, but evidently has listeners. Barlach's humor demands that he be a trifle vain, but no more so than is compatible with the performing arts."

In contrast, the tapered, advancing forms in the figure of *The Avenger* (1914) evoke the terrible dynamics of war. The piece is one of three Barlach collectively titled *Berserkers*. In a charcoal drawing, published in a lithograph version under the title *The Holy War* in Cassirer's periodical *Kriegszeit,* the figure is associated with the idealism and optimism with which many Germans, including Barlach, greeted the outbreak of what they considered a just war. While the position of the arms, indeed the entire pose, recall the earlier *Ecstatic Man*, the radial configuration of the cloak and the soaring torso anticipate Barlach's *Angel* in Güstrow, a bronze replica of which hangs in the Antoniter-Kirche, Cologne. *The Refugee* (1920) and *Hovering God the Father* (1922), a sculpture in stoneware, might also be considered to reflect preliminary ideas for *Hovering Angel*. Aesthetically, *The Avenger* shows an approximation to Cubist facetting of form, but its style bears an even closer affinity to the Futurist emphasis on kinetic movement.

In diametrical opposition to the extreme and agitated pose of *The Avenger*, the figure of *Crouching Old Woman* has been reduced to terms of closed contour and static volume. The woman seems immobilized by the heavy coat, against which her emaciated hands and feet, and care-worn features, seem even more moving by contrast. What one commentator called her "Norn-like" pose already appeared in an early drawing, *Three Witches*, just as the self-contained block of the volume points back to stylistic elements of Barlach's work around 1910.

▶ **Ernst Barlach**
Crouching
Old Woman, 1933
Hockende Alte

Wood
height 56 cm

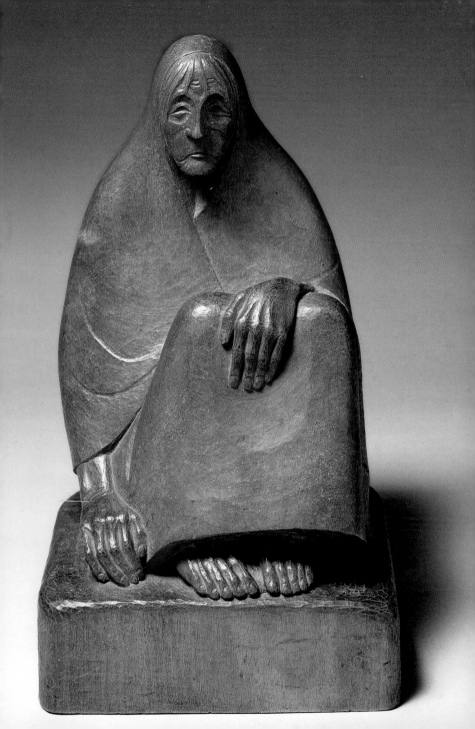

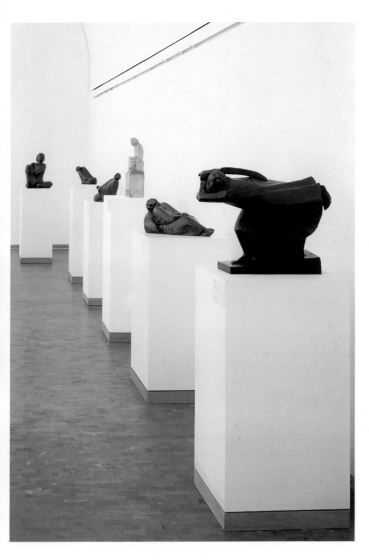

His late style is characterized by a geometric abstraction of overall contour, combined with graphically incised, precise physiognomic detail. But "early" or "late" – do such chronological terms really mean anything in Barlach's case? His *Old Woman Laughing* of 1937 seems merely amused by the banality of such all-too human conceptions of time.

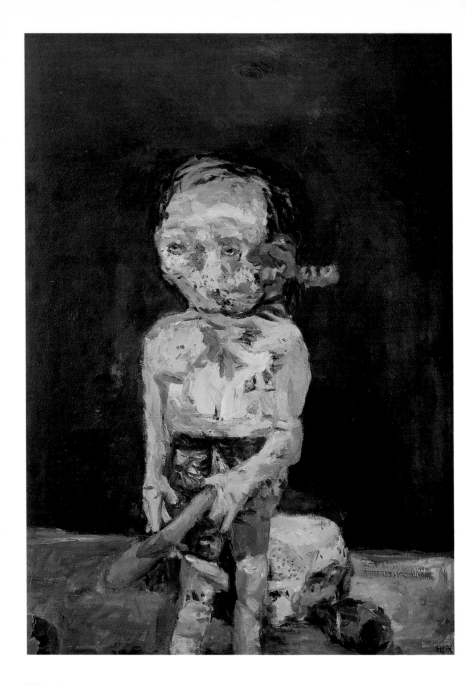

Georg Baselitz adopted the name of the small town in Eastern Germany where he was born in 1938. Growing up in what was then still the German Democratic Republic, he enrolled in 1956 at the Kunstakademie in East Berlin, but only to be expelled after two semesters for "socio-political immaturity." Shortly thereafter Baselitz moved to West Berlin, where he completed his studies at the Staatliche Hochschule für Bildende Kunst in 1964.

Baselitz, Georg
(Hans-Georg Kern)

1938 Deutsch-baselitz, Germany
Lives in Holle

Especially his early work of the 1960s, but also the later, more abstract compositions of the 1980s and 1990s, are marked by the physical – and psychological – division of Germany into two opposing political ideologies and artistic traditions.

Baselitz's early work revolves around the human figure. Frequently depicted only fragmentarily, the figures seem caught in a process of decomposition, destruction – or, in the artist's own graphic words, "mashed to a pulp." Dirty, grayed colors serve to underscore the effect of spongy amorphousness. *Big Night Down the Drain* (1962–1963) is a

◀ **Georg Baselitz**
The Big Night
Down the Drain,
1962–1963
Die grosse Nacht
im Eimer

Oil on canvas
250 x 180 cm

Ludwig Donation,
1976

▼ **Georg Baselitz**
Model for
a Sculpture, 1980
Modell für eine
Skulptur

Linden wood, painted
176 x 248 x 150 cm

Ludwig Collection

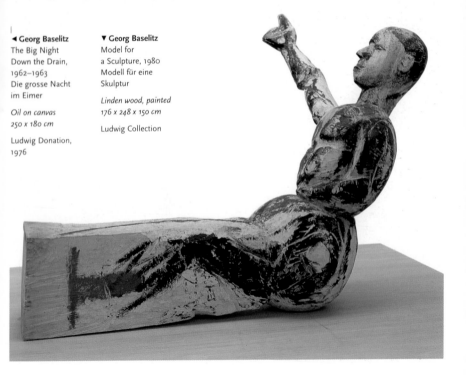

disturbing picture. So much so that the West Berlin police confiscated it, together with the canvas *Naked Man*, on October 9, 1963, shortly after a vernissage at Galerie Werner and Katz. In 1964, Baselitz and the art dealers Michael Werner and Benjamin Katz were convicted on two counts of "commonly exhibiting lewd depictions." The verdict was overturned in the court of appeals, and later all charges were dropped.

In the late 1960s Baselitz distanced himself from his previous work, calling his early phase "pubescent crud." Determined to cleanse his painting of form and content externally imposed upon it, he hit upon the idea of turning the subjects upside down. *Forest upside-down* (1969) was the first painting to employ this device. By means of inversion, motifs that were innocuous in themselves were relegated to absolute non-significance.

The objective reference was retained, but only, according to the

▲ **Georg Baselitz**
The Great Friends,
1965
Die grossen Freunde

Oil on canvas
250 x 300 cm

Ludwig Donation,
1994

◄ **Georg Baselitz**
The Whip Woman,
1965
Die Peitschenfrau

Oil on canvas
162 x 130 cm

Ludwig Donation,
1976

▲ Georg Baselitz
Pastorale (Night),
1985–1986
Pastorale
(Die Nacht)

Oil on canvas
330 x 330 cm

Ludwig Collection

artist, as means of control, to prevent him from falling into an arbitrary, subjective style, contrived relationships of abstract color and form. The object would serve to establish an overall framework for the composition, within which a liberated handling of form and color, what Baselitz calls a "sensuous process," could come about. Canvas, paint, and forms no longer served the ends of description but represented only themselves, embodying sensory qualities such as density or porosity, hardness or softness, warmness or coldness, calmness or agitation, smoothness or roughness.

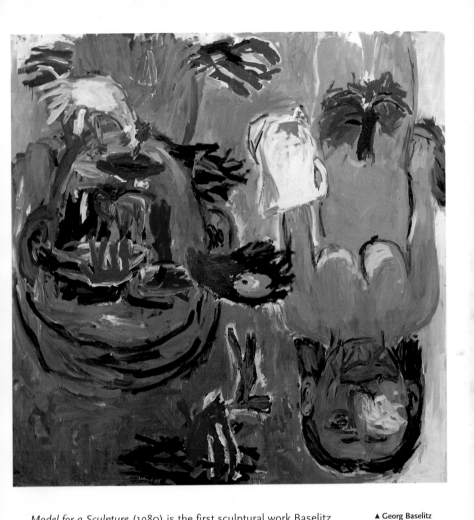

Model for a Sculpture (1980) is the first sculptural work Baselitz executed. As in his paintings and works on paper, a characteristic aggressiveness of approach is evident here. The tree trunk has been veritably hacked into shape, with no attempt to conceal the process of making. The polychrome treatment situates the work somewhere in the intermediate zone between sculpture and painting.

In his most recent paintings, Baselitz has dispensed with the figure altogether, to produce dynamic, abstract compositions. *The Last Kurt, Kurt, Kurt* (1991) attests to his long-time admiration for American

▲ **Georg Baselitz**
Pastorale (Day),
1985–1986
Pastorale
(Der Tag)

Oil on canvas
333 x 330 cm

Ludwig Collection

▲ **Georg Baselitz**
Forest upside-down, 1969
Der Wald auf dem Kopf

Oil on canvas, 250 x 190 cm

Ludwig Donation, 1976

Abstract Expressionism, as represented by Jackson Pollock, Mark Rothko, and others, which he saw as a student in various travelling exhibitions of the Museum of Modern Art, New York. Like Pollock, Baselitz has covered the entire canvas surface with a wild frenzy of spontaneous strokes, sometimes even abandoning the brush to apply the paint with his hands and feet.

▲ **Georg Baselitz**
The Last Kurt, Kurt,
Kurt, 1991
Der letzte Kurt, Kurt,
Kurt

Oil on canvas
290 x 290 cm

Ludwig Collection

Baumeister, Willi

1889 Stuttgart
1955 Stuttgart

▼ Willi Baumeister
Monturi, Discus I A,
1953–1954

Oil on sand
on hardboard
185 x 135 cm

From 1905 to 1907 Willi Baumeister completed a training in painting and decorating, which was likely the source of his lifelong sense of a fitting use of materials, and his enjoyment of experiment. Admitted in 1906 to the drawing class at the Akademie der bildenden Künste, Stuttgart, he became a student in Adolf Hölzel's composition class there in 1910. "In 1919–1920," Baumeister noted, "I made paintings conceived for an architecture that did not yet exist at the time. In contrast to Archipenko, I strove not for an isolated, colored relief but began with a component of architecture, the wall. The result was paintings with actual, raised surfaces, which, as it were, hesitatingly grew out of the wall, without controverting its laws... I called these pictures 'wall paintings,' to emphasize the contrast with 'easel paintings'." Many of Baumeister's wall paintings contain rough-textured passages obtained by adding sand to the paint, a technique he would continue to use all the way down to the late *Monturi* pictures. Color and form were treated in accordance with the law of perfect harmony and clarity, for Baumeister's intent was to expunge all subjectivity from his art. In the early 1930s he recurred to archaic configurations, which lent his style reminiscences of neolithic cave painting.

Monturi, Discus I A, from the *Monturi* sequence, is a work from the artist's final years. Focus of the composition is the circular, white form in the center – the discus of the title – surrounded and intersected by multicolored arabesques, which seems to converge on an expansive, rock-like shape. According to Baumeister's statements, images of this kind address the fundamental issues of life, through symbols of the female principle and the forces at work in nature.

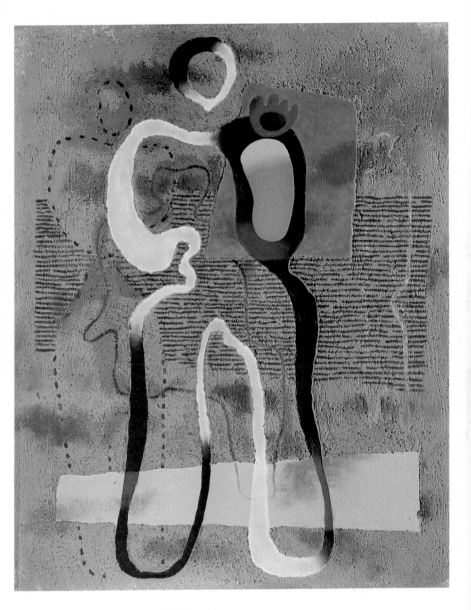

▲ **Willi Baumeister**
Standing Figure with Blue Plane, 1933
Stehende Figur mit blauer Fläche

Oil and sand on canvas
82 x 65.5 cm

Haubrich Collection

**Bazaine,
Jean René**

1904 Paris
Lives in Paris

▼ Jean René Bazaine
The Diver, 1949
Le plongeur

Oil on canvas
147 x 115 cm

The painting of Jean Bazaine has little in common with the *art informel* prevalent in Europe after the war. Instead of relying on the spontaneous gesture or viewing the painting as an arena in which the artist acted out his inmost urges, Bazaine took a careful, well-considered approach to composition, condensing memories of his impressions of nature into ordered rhythms of color and form.

His search for what he termed the "secret structure of the whole range of realities" led Bazaine to abstraction. In the *Diver* paintings, the human individual is entirely integrated into the natural surroundings. The diver's motions and the water swirling around him are evoked by a vortex of forms moving diagonally upwards, rendered in agitated strokes of bluish-red applied over white, with scattered accents of light yellow and green.

The underwater scene gives the impression of having been translated from matter into light. The gridlike structures reveal the influence of the artist's own work in stained glass, for like the leading in a stained glass window, they serve to consolidate and articulate the composition.

"We do not like to plunge into the waves," Bazaine once wrote of his fellow-artists; "and those who dare to go in are all-too-good swimmers – what painting needs is drowning men. Then, it is important for the painter to occasionally forget his highly specialized, promptly functioning eye, that all-too clearsighted, intellectually sharpened eye, with which he tempts both trees and faces into a trap. The painter should recall that he sees with his entire body as well, even more than with his eye. His task is to rediscover, in what is formed, the secret and the magic of the unformed, unuttered."

► **Max Beckmann**
Landscape with
Balloon, 1917
Landschaft mit
Luftballon

Oil on canvas
75.5 x 100.5 cm

After graduating from the Weimar Academy and making several trips abroad, Max Beckmann settled in Berlin in 1907. While in Paris he was impressed by Henri Rousseau and the "Primitives," but he also admired artists of earlier epochs. His early work was influenced above all by Lovis Corinth and the German Impressionist painters. Gradually a key motif in Beckmann's art emerged: disaster, both individual and collective, a subject to which he devoted variation after variation. A key example is *The Battle* of 1907, a monumental canvas in which Beckmann's affinity with Corinth is very much in evidence.

Profoundly shaken by his war experiences in 1915, Beckmann began to develop an expressive style which bore similarities to the razor-sharp objectivity of George Grosz or Otto Dix. From 1915 to 1933, the artist lived in Frankfurt am Main, where, from 1925, he taught at the Städelsche Kunstschule. His *Landscape with Balloon* (1917), probably representing a street in the Sachsenhausen district of Frankfurt, still shows stylistic reminiscences of Art Nouveau and Post-Impressionism. Matt, cool colors, the silently hovering balloon, and the solitary woman with an umbrella contribute to the eerily unreal atmosphere.

Spring Landscape would seem almost naive, were it not for the stylization introduced by the sinuous lines of the leafless trees. The subject is Louisa Park in Sachsenhausen, not far from the apartment

Beckmann, Max

1884 Leipzig
1950 New York

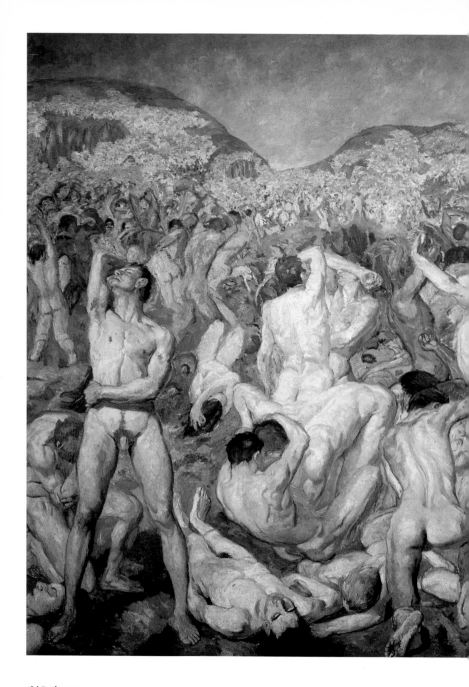

where Beckmann lived at the time. Over the following years, he began to concentrate on depicting the depravity of the big city, which he looked upon as a "human landscape," a world in microcosm. Beckmann's style grew simpler, his drawing more relaxed, the colors stronger.
In about 1924–1926 he began to surround the lightest hues with heavy black contours, which often stood in strange contradiction to the motifs themselves – carefree young girls, scenes in bars, ballrooms, or the circus, landscapes and portraits. An example from the period is his *View of the Blue Sea*, framed by a window (1928). In 1937 this painting was confiscated from the Wallraff-Richartz-Museum, Cologne, during the Nazis' campaign to expunge what they termed "degenerate art." It returned to the city of Cologne in 1992, when the board of trustees and supporters of the Wallraff-Richartz and Ludwig museums were able to reacquire it for the Museum Ludwig collection.

After being stripped of his teaching post in 1933, Beckmann began to concentrate on images of human beings alone and abandoned in an apocalyptic world, helplessly threatened by powers beyond their control. His palette grew more intense, and strong

◄ **Max Beckmann**
The Battle, 1907
Die Schlacht

Oil on canvas
294 x 330 cm

Ludwig Collection

◀ **Max Beckmann**
Portrait of Reber,
1929
Bildnis Reber

Oil on canvas
140.5 x 72 cm

Gift of
Farbenfabriken
Bayer-Leverkusen,
1955

▶ **Max Beckmann**
Self-portrait with
a Black Cap, 1934
Selbstbildnis mit
schwarzer Kappe

Oil on canvas
100 x 70 cm

light-dark contrasts more frequent. A work from the beginning of this period is *Self-portrait with a Black Cap*, also known – without the artist's permission – as *Gilles*, after Antoine Watteau's pierrot figure of that name. The large-format canvas *The Hurdy-Gurdy Man* also dates to this period. The composition was based on a concept drawn from mythology, the eternal cycle of birth and death.

In 1937 Beckmann and his wife emigrated to Amsterdam, where they remained until 1947. *Two Women* (1940) depicts a slice of life on the big-city streets, the world of the *demi-monde*. The woman in the middle is decked out in the latest, grotesquely elegant fashion, but still stands for real life, while to her right appears, as if encaged, a vision of unearthly beauty. Watching them both from the left is a man whose silhouette bears a likeness to the artist, which was probably intended.

"Oh, what a senseless place the world is," wrote Beckmann in 1943. Yet just a year later, in connection with *Still Life with Three Glasses*, he could make the optimistic diary entry, "30 June 1944. Finished still life with three green glasses. It's good to be painting again."

Bell, Larry

1939 Chicago,
Illinois
Lives in Taos,
New Mexico

Larry Bell's glass cube, its interior tinted with platinum, gold, and rhodium vapor, stands on the tall, transparent plexiglass pedestal like some enigmatic monument that suggests the cool perfection of technological design and the world of advertising while at the same time instilling a meditative mood.

This ambiguous effect is particularly strong in the case of the cubes made of chrome and mirrored glass, engraved with minimalist geometric shapes. As the viewer moves around these pieces, the surfaces elicit a sense of illusory depth and movement. Like Bell's large-scale, walk-in minimalist glass environments, they convey new experiences of space through translucent materials, layerings, variations in density, reflections, and empty spaces given form.

Depending on our point of vantage and the source of the impinging light, for instance, we may either see a glittering reflection of the surrounding space or be able to look, as through a veil, into the interior of the cube. In its grace and playful elegance, Bell's work is typical of the art of the American West Coast, which developed along lines quite different from East Coast art during the 1960s.

The present piece is a replacement for *Cube No. 5* of 1967 (36 x 36 x 36 cm), which was destroyed in an accident in 1977. This similar, somewhat larger work was purchased in 1980.

▶ **Larry Bell**
Untitled (Cubus)

*Glass box on
plexiglass pedestal
46 x 46 x 46 cm*

Ludwig Donation,
1976

Berlin sculptor Rudolf Belling studied with Peter Breuer at the Berlin Academy and was a founding member of the Novembergruppe, which fought the cause of progressive art in Germany after the First World War. Belling must be counted among the great innovators and pioneers of modern sculpture. He was early to recognize the significance of concavities, openings, and negative spaces as means of plastic design. In his own words, sculpture could emerge only from a synthesis between the "spatial body" and the "plastic body." In his famous Cubo-Futurist sculpture *Triad* of 1919, Belling attempted to couch the sculptural event in purely abstract terms, giving equal weight to the solid mass and the volume of empty space. His "organic forms," which combine stylistic principles from Cubism (especially as practiced by Alexander Archipenko), Futurism, and Expressionism, might be said to bridge the gap between nature and technology. Among Belling's major works were what he called his "character studies," highly simplified

Belling, Rudolf

1886 Berlin
1972 Krailling,
near Munich

portraits of the 1920s, of which the *Portrait of Alfred Flechtheim* (1927) is perhaps the best known. Flechtheim (1878–1937), an art dealer in Berlin and Düsseldorf, was portrayed by several artists of the period, including Otto Dix and Hermann Haller. He had an expressive face, which the artist reduced to essentials: eyes and forehead, nose, and mouth, evoking the senses of vision (and thought), smell, and taste. The head appears to grow out of the base substituted for neck and shoulders. The contours of the piece delineate shapes in the surrounding space, which with a little imagination can be perceived as negative, sculptural volumes.

◄ **Rudolf Belling**
Portrait of Alfred
Flechtheim, 1927
Bildnis Alfred
Flechtheim

Bronze
18.7 x 12 x 13 cm

Haubrich Collection

Beuys, Joseph

1921 Krefeld
1986 Düsseldorf

▶ ▲ Joseph Beuys
Searcher (Fat Corner,
Stag Hunt), 1963
Sucher (Fettwinkel,
Hirschjagd)

*Oil and pencil on
cardboard, brush
and fat in galvanized
metal case*
63.5 x 87 x 42 cm

Ludwig Donation,
1976

▶ ▼ Joseph Beuys
Double Aggregate,
1958–1969
Doppelaggregat

Bronze
108 x 314 x 78.5 cm

Ludwig Donation,
1976

▶ Joseph Beuys
Destroyed Battery
S → Sulfur, 1969
Zerstörte Batterie
S → Schwefel

*Wood, pottery bowl,
three bicycle pumps,
sulfur*
28 x 112 x 44 cm

Ludwig Donation,
1976

During his studies with Ewald Mataré, Joseph Beuys already delved into mythology, religion, and the esoteric anthroposophical teachings of Rudolf Steiner. His first appearance on the art scene was as a member of the Fluxus movement, which in the 1960s sought a new, fluid unity of art and life, often with the aid of happenings and performances, to which they referred simply as "actions". In this context, Beuys arrived at an expanded definition of art that took its political aspects into account. Considering every human being to possess creative potential and a will to help shape culture and society, he concentrated his efforts on furthering these capabilities. All human activities and their products were subsumed under the term "social sculpture". Beuys' philosophy, anti-materialistic and anti-rationalistic in thrust, envisaged individual self-determination within a social organism based on the three fundamental concepts of liberty, democracy, and socialism. Nor did he hesitate to put his theories into political and pedagogical practice. In order to defend freedom against what he considered a threat of dictatorship by the political-party machine, Beuys in 1971 founded the "Organization for Direct Democracy through Plebiscite". In 1973, after his teaching appointment at the Düsseldorf Academy was discontinued, he challenged the bureaucratic national art education system by bringing a "Free International College for Creativity and Interdisciplinary Research" into being.

One of Beuys' strengths was his ability to blend motifs and ideas drawn from highly diverse traditions and mythologies. A good example of this is his early bronze, *Sibylla* (1957). It calls up mental associations

◄ Joseph Beuys
Halved Felt Cross with Dust Image "Magda", 1960/1965
Halbiertes Filzkreuz mit Staubbild "Magda"

*Paper, felt, picture frame with image in handwriting and dust,
wire, nails, under glass, in metal frame, 108 x 68 cm*

Ludwig Donation, 1976

▲ Joseph Beuys
King's Daughter Sees Iceland, 1960
Königstochter sieht Island

*Pencil and gouache on paper, with felt, under glass,
in metal frame, 114 x 98.5 cm*

Ludwig Donation, 1976

ranging from the spheres used for divination by ancient Greek and Roman seers and prophets like Sibylla, all the way to the scales of Justice. Like this piece, the multipartite sculpture *Double Aggregate* (1958–1969) points to divergent yet interrelated concepts. The piece can be interpreted as an altar, but also as a repository for energy and heat – a sort of power plant, as it were.

In fact, the generation and conservation of heat and energy is a motif that runs like a thread through Beuys' entire œuvre. It can be traced back to 1943, when his Stuka dive bomber was shot down over the Crimea, and his life was saved by Tatars who covered him in layers of tallow and felt. This dramatic incident in the Russian steppes can be viewed as a formative experience with regard to Beuys' subsequent development.

The elements mounted on the boxes and plates of *Double Aggregate* can be associated with electrical coils on the one hand, or with beehives on the other. The bee, with hare and stag, was a key symbol from the animal realm employed by Beuys. To his way of thinking, the incessant activity of bees in producing and storing energy in the hive, held healing, even sacred connotations. The stag played an important role in *Searcher (Fat Corner, Stag Hunt)* of 1963. Explaining his attraction to this animal in 1972, Beuys said, "The stag has always had one and the same basic

▼ Joseph Beuys
Val, 1959/1969

Bronze
26 x 128 x 75 cm

Ludwig Donation, 1976

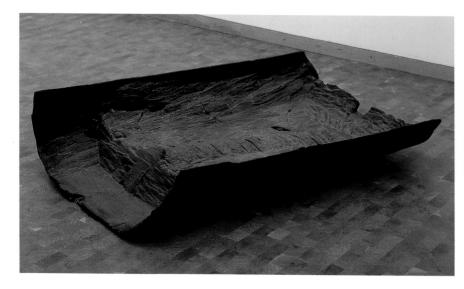

▲ Joseph Beuys
Sibylla (Justice), 1957
Sibylla (Justitia)

Bronze
24 x 50 x 185 cm

Ludwig Donation,
1976

configuration... as a companion in the underworld or companion of souls, or materializing when overwhelming danger threatens. When you review the figures in fairy-tales, the white stag always comes in as the positive, good element, and the white stag has some sort of magical power."

In the sculpture *Val* (1959/1969), the artist presents, to again use his own words, the "primordial symbol of the earth as a human figure". The sculptural, formative power of mountains, and concomitantly, of valleys ("val" is French for "valley") is evoked by the skeletal ridges on the piece, which allude to the organic similarities between natural and human forms.

The collage-painting *King's Daughter Sees Iceland* (1960) is another example of the frequent reference to heat and cold in Beuys' art. At the left we see a head in profile, and to its right, a hand embellished with symbols. Above them is a sundisk and an area of felt (signifying warmth), beneath which a schematic sled (signifying cold) appears. This primordial vehicle was one of the symbols most frequently used by Beuys. To him it stood for the North, for cold, a nomadic existence, and for atavistic structures. Reminiscences of Nordic legends and Christian motifs blend in the image of the *King's Daughter* into a landscape of fateful human processes in which nature and myth, idea and object, merge into a mystical unity.

Halved Felt Cross with Dust Image "Magda" (1960/1965) is one of the earliest examples of the artist's use of the bisected cross motif, which would play a significant role in *Eurasia*. This performance/action of 1966 began with a symbolic division of the cross. Kneeling down, Beuys pushed two small crosses across the floor, towards a blackboard. Here he drew a cross, then partially erased it again. The halved cross has been interpreted in many ways: as symbolizing the rift between East and West, Rome and Byzantium; political division (of the Roman Empire, or between capitalist and communist worlds); and the ecclesiastical schisms of religious history. However, the artist also saw the bisected cross in positive terms, as symbol of a reunited Europe and Asia, the sign of the ancient Christian principles which both still share in common.

Blake, Peter

1932 Dartford
Lives in London

▶ Peter Blake
Bo Diddley,
1963–1964

Acrylic on hardboard
122.4 x 76 cm

Ludwig Donation,
1976

▼ Peter Blake
ABC Minors, 1955

Oil on hardboard
77.5 x 49 cm

Ludwig Collection

In the early 1950s, before anyone could conceive of Pop Art and everyone was working in an Abstract Expressionist vein, Peter Blake began to devote himself to figurative painting. In 1954–1955 he did a series of portraits of girls and boys, one of which was *ABC Minors*. The title refers to a film club for youngsters, to which Blake himself belonged during World War II.

The two schoolboys, hands dug nonchalantly into their pockets, are evidently doing their best to appear grown-up. This impression is underscored by the badges on their jackets, proud emblems of a political stance – and of membership in two dog clubs. With the aid of stylistic borrowings from naive art (overlarge heads, strict frontality), Blake describes coming of age in a wittily realistic manner. Yet rather than making light of the trials of puberty, he takes the boys quite seriously, and puts himself on their side.

Bo Diddley (1963–1964) shows Blake's development into a depictor of the popular culture already anticipated in *ABC Minors*. Bo Diddley was the stage name of Elias McDaniel, a rock-and-roll singer and guitarist whose fame began with appearances, in 1955, at the Apollo Theater in Harlem. His first hit song, "I'm a Man", came to symbolize a new self-confidence on the part of black ghetto youth. The fact that

music-fan Blake did not depict Bo Diddley from the life, but from the photograph on a record jacket, illustrates a typical trait of Pop Art in general – the quotation, in altered form, of already existing, mass-media imagery, the creation of "art at second hand". The composition retains certain visual devices of advertising, aimed at maximum effect: the guitarist's characteristic hunching posture, the dazzlingly vivid contouring and flat, bright red plaid pattern, and the garish yellow lettering. Yet in the treatment of the face, Blake has not waived his personal touch. This is a passage of painterly skill and psychological penetration that lends the portrayal great individuality.

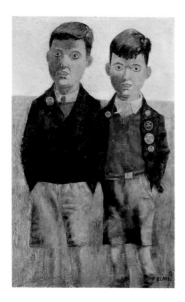

Bogomazov, Alexander

1880 Jampol, Russia
1930 Kiev

▼ Alexander
Bogomazov
Townscape,
1913–1914

Oil on canvas
36 x 34.5 cm

Ludwig Collection

The work of Ukrainian painter Alexander Bogomazov, whose style might be described as a blend of Rayonism and Cubo-Futurism, was hardly known outside Russia until a few years ago. His artistic training began in 1902, at the art school in Kiev, where Bogomazov's fellow-students included Alexander Archipenko, Alexandra Exter, and Aristarch Lentulov. In 1907–1908 he worked in various Moscow artists' studios, then returned to Kiev for good in 1910.

Bogomazov's early paintings, done in 1910 after seeing the first Kiev salon, were highly indebted to Kees van Dongen, Henri Le Fauconnier, Wassily Kandinsky, and Alexei von Javlensky. His development was lastingly influenced by the Rayonism of Mikhail Larionov and by Italian Futurism, an essay on both of which Bogomazov published in 1914. The key feature of his style was a concentration on rhythmic energies, out of which he expected a "new art – pure painting" to emerge.

A year before Kasimir Malevich, Bogomazov stated that the black square represented the totality of all symbols in art. Still, he himself never took the step to complete non-objectivity, retaining figurative elements in his art. The Italian Futurist influence began to make itself felt in 1912, when Bogomazov's friend Alexandra Exter, introduced him to the style she had seen in Italy and Paris. A characteristic example of the result is the dramatically dynamic *Townscape*, done in the years 1913 to 1914. Bogomazov, who unlike his artist-friends hardly ever left Kiev after his return from Moscow, projects no nostalgic picture of the old town and its sleepy, historic squares, but the image of a modern metropolis with tall, soaring buildings.

"In its plastic contours," the artist once wrote, "Kiev is full of beauty, variety, and great dynamism. The city streets bulge

towards the sky, the forms have tension, the lines have energy – they fall, shatter, sing and play."

Sleeping Woman, done about 1915, depicts the artist's wife, Wanda, whom he had married in 1913. In terms of the characteristic hairdo with twin ribbon, and the three-quarter profile view of the face, the picture bears strong similarities to another portrait of his wife, done the same year.

▲ **Alexander Bogomazov**
Sleeping Woman (the Artist's Wife, Wanda), c. 1915

Oil on canvas
67 x 65 cm

Ludwig Collection

Boltanski, Christian

1944 Paris
Lives in Malakoff,
near Paris

Two principal themes recur again and again in Boltanski's work: childhood and death. He views these fundamental aspects of human life – its beginning and end – through the dark glass of memory, investigating the way in which we all remember our childhood, and commemorate our dead. The artist is interested in childhood, he says,

because it is the first part of us that "dies". The transition from childhood to adulthood is analogous to the transition from life to death; and in the end, the only thing we possess is memory. Individuals keep their memories alive in photo albums, diaries, old toys, heirlooms. Nations and communities commemorate people and events of importance in monuments and museums.

For years now, Boltanski has been concerned with the interrelationship between personal memory and the collective memory known as history. His series of large-format photographs, *These Children are Searching for Their Parents* (1993–1994), was originally part of an exhibition devoted to the fate of children who lost track of their parents during the Second World War. The event took place at the Museum Ludwig, Cologne Central Station, and Klein Sankt Martin church in Cologne. Boltanski took account of the special traits of these three sites, which he felt represented the cultural, economic, and spiritual nuclei of the city. At the station, leaflets with pictures of several children, reproduced from the original posters of the Children's Search Service, were distributed to travellers. They were asked whether they recognized any of the children's faces, and to forward to the artist any information they might have on the whereabouts of their parents. The same photographs were hung on a wall of the Children's Chapel in Klein Sankt Martin. They were framed and lighted by small lamps which threw a circle of light on the face, giving them the appearance of icons.

In the spacious hall of the Department of European Art at Museum Ludwig, Boltanski presented thousands of pieces of old clothing, to evoke a "landscape of memory". Each piece of clothing stood for the body of a child that had disappeared – children whose parents were still being searched for, and children who had died in Nazi concentration camps.

Boltanski's work is based on contradictions. He purposely blends public with private, collective with individual. In *These Children are Searching for Their Parents* he also addresses the issue of art in the public realm. Like many other works, this one is both a monument to a collective history and, at the same time, a memento of personal fates.

◀ **Christian Boltanski**
These Children
are Searching
for Their Parents,
1993–1994
Diese Kinder suchen
ihre Eltern

*Installation of
15 framed black and
white photographs
and 15 lamps,
photographs
150 x 97.5 cm each*

Ludwig Collection

A co-founder of Cubism, to which his style remained beholden through-
out his career, Braque had to wait a relatively long time for the recog-
nition that was due him. Initially, around 1905, his friendship with
Raoul Dufy brought him into the circle around Henri Matisse, known
as the Fauves. The year 1907 marked his first encounter with Pablo
Picasso, who had just finished the painting that would spark the devel-
opment of Cubism, the famous *Les Demoiselles d'Avignon*. Braque's first
Cubist picture, still strongly influenced by Cézanne, was done in 1908,
in L'Estaque. In November of that same year Braque exhibited in the
Paris gallery of the young Daniel-Henry Kahnweiler, which would become
the forum of Cubism.

In his initial Cubist phase, the Analytical style developed in con-
junction with Picasso, Braque pursued the aim of "taking complete
possession of things". Objects were taken apart, split, as it were, like
crystals along the lines of fracture, and rearranged in the form of super-
imposed planes. "When fragmented objects appeared in my pictures
in about 1909", Braque stated, "they gave me an opportunity to come

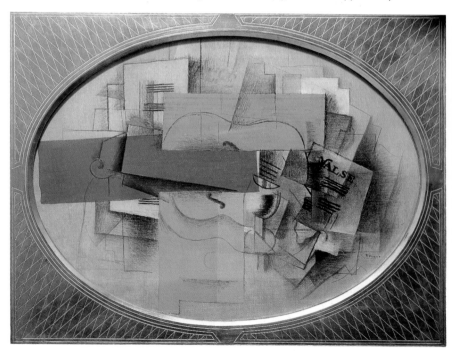

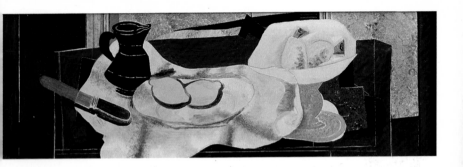

as close to an object as painting permitted". Space and volumes were evoked not by means of perspective but solely through a multiplicity of aspects, for it was an essential feature of Cubism to show things from several points of view simultaneously, seemingly leading to a compression of time and space. In about spring 1912 Braque began to employ, as Jean Leymarie has written, an "oval format that circumscribed right-angled refraction and lent the picture plane a greater concision and perceptible internal vibration". The oval composition in our collection, *Glass, Violin, and Sheet of Music* (1912), evinces the Cubists' penchant for musical instruments, and also the gray and ocher hues that dominated their work during the Analytical phase. By about 1912–13, a transition was underway to the Synthetic phase of Cubism, in which actual objects were introduced into abstract compositions – by the technique of collage.

In August 1914, Braque and Picasso were separated by the war. Braque entered the French army, and was seriously wounded in combat in 1915. It was not until 1917 that he had recuperated to the point of being able to resume painting. "I am concerned with orienting myself to nature, not with copying her", Braque aptly described the creative phase that now began. His style, initially retaining collage-like elements, grew more individual, his pictures more colorful, painterly, and more closely based on reality. The Cubist still life became Braque's favorite motif. *Carafe, Lemons, Fruit Bowl* dates from the period 1924–1928, during which the artist began to emphasize the factor of depth and space in his compositions and to explore "how far one could go in combining volumes and color". It is one of four pictures in the same format of which mosaic versions were made for the collector Paul Rosenberg.

▲ **Georges Braque**
Carafe, Lemons,
Fruit Bowl, 1928
Pichet, citrons,
compotier

Oil on canvas
40.5 x 121 cm

◄ **Georges Braque**
Glass, Violin,
and Sheet of
Music, 1912
Verre, violon et
papier à musique

Oil and charcoal
on canvas
64.5 x 91.5 cm

Bequest of Trustees
and Supporters
Association,
Wallraf-Richartz-
Museum and
Museum Ludwig,
with aid of State of
Nordrhein-Westfalen

Broodthaers, Marcel

1924 Saint-Gilles,
Brussels, Belgium
1976 Cologne

In 1940, Marcel Broodthaers met René Magritte, the Belgian Surrealist, whose work left an abiding impression on him. Associated from 1945 onwards with the Groupe Surréaliste-revolutionaire in Brussels, Broodthaers remained a lifelong advocate of what they termed a "concrete utopia" for society. In the 1950s he worked as a freelance journalist, poet, and film-maker, not beginning to devote himself entirely to art until the mid 1960s. Similarly to the French Nouveaux Réalistes, Broodthaers concerned himself with banal, everyday things, *objets trouvés*, which he assembled into three-dimensional pieces of great poetic effect. His *Toy Wagon*, holding twenty-one egg shells partially painted red, reddish-orange, and black, is one such imaginative, thought-provoking assemblage. To Magritte's famous caption under a painted pipe, "Ceci n'est pas une pipe" (This is not a pipe), an ironic inquiry into the relationship between existence and appearance, Broodthaers provocatively replied, "This is a work of art."

Written language, poetry, and the ironies and paradoxes these contain, were to become a key focus of his art. As Pierre Restany noted, Broodthaers "objectified the word, demystified its meaning, and subjected it to the entire range of his richly inventive humor". By means of irritation, the sense of having been mistaken about what we think

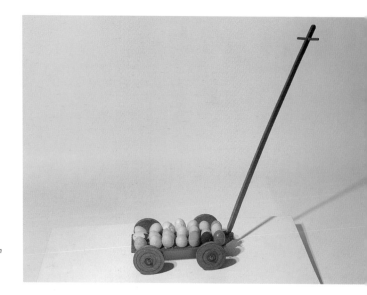

► Marcel
Broodthaers
Toy Wagon with
Eggshells, 1966
Petit chariot avec
œufs

Wood
21.8 x 34 cm
overall length 125 cm

Collection of
Dr. Reiner Speck

► **Marcel Broodthaers**
A Toss of the Dice,
1969
Un coup de dés

Oil, gold enamel and felt pen on canvas
165 x 122 cm

Collection of
Dr. Reiner Speck

we see, the artist opened our eyes (and other senses) to the poetry and contradictions of reality. Novalis' romantic search for the miraculous "blue blossom" seems to be reflected in the art of the widely-read Broodthaers, to the extent that the romantic irony which refers the viewer back to the real world reverberates in his poetically inventive imagery.

A profound insight into the artist's mind was provided by the "Musée d'Art Moderne, Département des Aigles", which Broodthaers installed in his Brussels apartment in 1968 and exhibited at the Düsseldorf Kunsthalle in 1972. Pierre Restany ironically described the purpose of this fictitious museum as follows: "The eagle, symbol of the museum's power, overcomes the anonymity and contingency of artistic creation. An object that is accepted into the museum is *ipso facto* a work of art. The public power of the museum allies itself with the private power of the creative personality."

◀ Peter Brüning
Picture No. 108,
1962
Bild Nr. 108

Oil on canvas
120 x 145 cm

Brüning, Peter

1929 Düsseldorf
1970 Ratingen

Picture No. 108 belongs to the early phase of Peter Brüning's career, marking his initial essays in an abstract expressionist style inspired, in Paris, by the spontaneous and impulsive brushwork of Tachisme. Later Brüning would turn to more referential and clearly articulated shapes distributed across the picture plane, to finally arrive, in about 1962, at a relaxed, calligraphic approach. "Brüning's canvases," wrote Heinz Fuchs, "are time made real, and they fill time like music. But since time can be perceived, and can take aesthetic effect, only through movement and change in forms, through variations, transformations and repetitions, verses and versions, one must enter into their meta-morphoses, shifts, vibrations, and rhythms. It is difficult for the artist to overcome that state of indifference before work begins. Just as before the start of a concert, as the orchestra tunes up, the air is filled with certain passages on various instruments, commencing at random and breaking off before reaching fruition, here and there certain brush-strokes, a few bars (touches) are almost recklessly exposed to the white field of the canvas. Then these initial traces are wiped away again. But the field is no longer uncultivated at this point; it has been taken possession of."

Grisha Bruskin belongs to the last, pre-perestroika generation of Russian artists. Since the early 1970s he has occupied himself with mythologies and ideologies, first Soviet, then Jewish – philosophies that claim to be able to provide answers to basically all of life's questions. The compositions *Alefbet No. 1* and *Alefbet No. 2* (both 1987) are typical of Bruskin's approach, in that they are based on ideal, prototype figures from Jewish religious and cultural history. Each work consists of four sections. In each, the background is covered with letters from the Hebrew and Russian alphabets, which generally form no legible text. Arranged against this background in regular rows are idealized personifications, accompanied by typical attributes of Judaism that lend them a symbolic, mythological character. These archetypes by no means represent historical personalities; rather, they stand for societal functions.

The way in which Bruskin employs texts in his paintings can be attributed largely to his membership, in the early 1980s, in a group of writers and artists that included Dimitri Prigov. Like Prigov, and like Erik Bulatov, Bruskin uses texts on two levels: as aesthetic devices, and as communicators of social content. However, the formal aspect plays a much more important role than the substantial one in Bruskin's work.

Bruskin, Grisha

1945 Moscow
Lives in New York

▲ ◄ **Grisha Bruskin**
Alefbet No. 1, 1987

Oil on canvas
116 x 88 cm

Ludwig Collection

▲ **Grisha Bruskin**
Alefbet No. 2, 1987

Oil on canvas
116 x 88 cm

Ludwig Collection

Buchheister, Carl

1890 Hanover
1964 Hanover

▶ **Carl Buchheister**
Composition Blue-
Yellow Gradation,
Model Painting,
1926

Oil on canvas
99.5 x 63 cm

Gift of Elisabeth
Buchheister, 1968

▼ **Carl Buchheister**
Untitled, No. 16,
c. 1951

Mixed media on card-
board, 62.5 x 34 cm

Estate of Elisabeth
Buchheister, 1990

After an initial business training, Carl Buchheister turned to art, becoming an early proponent of Constructivism. He was a friend of Wassily Kandinsky, and felt a close affinity with the Bauhaus artists and their ideas. In a logical development of the thesis of the social mission of art during the technological age, Buchheister began, as early as 1925, to produce paintings of a standardized, serial character.

One of these "model paintings", as he called them, is the famous *Blue-Yellow Gradation* of 1926. The composition consists of rectangles and squares of various sizes, interlocked into a larger form that stands out against a black background. Although the pictorial structure and rigorously geometric shapes clearly indicate the influence of Dutch De Stijl, a comparison with any picture by Piet Mondrian will point up the differences. Mondrian concentrated on achieving an equilibrium among a small number of sharply defined, harmoniously balanced planes, limited his palette to the three primary colors plus black, and created a tectonic order from which all movement seems banned. Buchheister, in contrast, was concerned with modulating the painting surface by means of planes and color gradations. The rectilinear forms in our example are finely articulated and varied in size, the paint applied in delicate nuances of blue, gray, green, pink, and yellow, engendering a sense that the planes slightly advance or recede in space.

This relaxation of Constructivist discipline was characteristic of Buchheister, and suggests the direction in which his art developed from this point. He became interested in the Dada movement, which he had discovered in the course of a collaboration with Kurt Schwitters. Consequently, in about 1930, Buchheister began to expand his range of media to include materials such as plexiglass, aluminum, wood and twine. But it was not until after World War II and the pause forced on him and other progressive artists by the Third Reich that Buchheister was able to air his new style. In keeping with postwar Art Informel, he began to give his imagination free rein, relying strongly on improvisation to produce an insouciant play of forms in compositions suffused with dynamic movement.

Buchholz, Erich

1891 Bromberg
1973 Berlin

▼ Erich Buchholz
Relief Painting, 1922
Reliefbild

Oil on wood
60.4 x 45 cm

A pupil of Lovis Corinth, Erich Buchholz initially taught school (1911–1915) and worked as a production assistant at the Bamberg Theater before beginning to concentrate on painting, in 1918. By the end of his career, his œuvre would include not only paintings but sculptures, designs for architecture, stage sets, and industrial products, and works of applied art. Buchholz's *Relief Painting* (1922) dates from the period prior to his leaving Berlin, in 1925, and ostracism in 1933. Basic geometric elements (circles, squares, bar-like rectangles) have been developed into volumes and concave shapes, rendered with a variety of surface textures, and composed into a vital interplay of form and color (black-red-gold).

In the artist's view, the Constructivist framework of a picture recorded the workings of certain fixed physiological laws. "Form brings its formula along with it," he maintained. And, "during the creative process, square and circle emerge in dependence on physiological conditions. The form these crystallization factors take, in accordance with the laws of physio-logical existence, is grounded (1) in the structural nature of the eye, as square; and (2) in the function-al processes of the optic nerves, as circle." *Relief Painting*, also known as *Three Red Squares* or *Large Gold Circle*, reflects the artist's increasing concern with architecture, and the contacts he made at the time (apart from the Berlin Dadaists) with architects Ludwig Mies van der Rohe, Hans Poelzig, and the brothers Max and Bruno Taut, as well as with Constructivist artists László Moholy-Nagy, Theo van Doesburg, El Lissitzky, and the Russian Suprematists. The influence of the last-named artists, together with the combination of shimmer-ing gold and warm wood, trans-formed *Relief Painting* into an icon of Constructivism.

▶ **Erik Bulatov**
Trademark, 1986

Oil on canvas
200 x 200 cm

Ludwig Collection

Erik Bulatov belongs to the first generation of artists who were involved in what has come to be termed the second Russian avant-garde: an underground movement opposed to official Socialist Realism, active in Moscow from the late 1950s. Like other Soc-Art artists, Bulatov employs images and symbols taken from State-authorized art and the Soviet mass media, and translates them into a new, contemporary idiom aimed at deconstructing the official myths. A good example is the work in our collection, *Trademark* (1986). There is an affinity between Bulatov's work and that of the Russian avant-garde of the 1920s: an endless fascination with the phenomena of light and motion. While the early compositions of the 1960s still show him experimenting with abstract scaffoldings, later works, such as *Melting Clouds* (1982–1987) and *New York* (1989), increasingly rely on an evocation of depth, and employ spatial markers in the form of objective, architectural, or natural elements generally depicted in extreme perspective foreshortening.

Bulatov, Erik

1933 Sverdlovsk,
Ural, Russia
Lives in Moscow
and Paris

Burliuk, Vladimir

1886 Chernyanka, Ukraine
1917 near Salonika, Greece

Vladimir Burliuk came of a family of authors and artists. Two of his brothers especially, Nikolai and David, gained a high reputation as poets, artists and critics. But Vladimir's fame as a painter spread widest, his achievements including the consolidation of the traditionally close ties between Munich and Moscow.

The Russian avant-garde always looked west, to the progressive groups in other art centers such as Munich and Paris. Burliuk was no exception. In 1903 he went to Munich for a two years' stay, studying with Anton Ažbé, whose pupils also included Wassily Kandinsky. In 1910 Burliuk participated in the Neue Künstlervereinigung (New Artists' Association) exhibition, and in 1911 in that of Der Blaue Reiter (Blue Rider), both in Munich. Mikhail Larionov's *Portrait of a Man*, painted in 1910, very probably represents Burliuk.

Burliuk's *Landscape* of 1909 is one of his rare surviving pre-Cubist paintings. It contains echoes of the new, so-called "primitive" style based on the simplified contouring of Russian folk art, but also has stylistic elements reminiscent of Art Nouveau. Another version of the painting is now in the Costakis Collection, Moscow.

▲ **Vladimir Burliuk**
Landscape, 1909

Oil on cardboard
59.8 x 94.8 cm

Ludwig Collection

During the war, Alberto Burri worked as a physician in Africa, where, in 1943, he was taken prisoner of war by the American forces. While interned in a Texas camp, he made his first experiments in painting. Burri's first show took place in Rome, in 1947. The large-format, abstract compositions of this period reflected his experiences of the Texan land-scape, especially in terms of their color range. Yet by 1949 his work had already begun to display features that anticipated later developments: circular configurations and black-grounded apertures, opening on inde-terminate voids. In the early 1950s, at a time when Art Informel had seemingly lost momentum, Burri's personal style emerged full blown.

He began to integrate various materials such as remnants of burlap bags, old boards, or pieces of sheet metal in his paintings. His approach combined a waiver of decorativeness with great sophistication and freedom in combining diverse raw, coarse-textured materials. These elements possessed the same value as traditional colors; yet since they were often ragged and perforated, they counteracted the flatness of the picture plane, catching the light and casting changing shadows that increased the effect of depth. *Jute Sack* (1954) consists of heavy burlap roughly affixed to canvas stretchers. Rents, holes, and seams are employed as compositional elements – holes as round shapes, threads as lines, dirt and paint clinging to the fabric as design elements. Later,

the rents and sutures of the *Sacchi* were supplemented by deep black marks made with a torch. In *Wood Combustion with Black* (1956), the flames have eaten into the wood and canvas to engender an unprecedented aesthetic effect, in which the charred passages mediate between the color values of the material and those of the black paint. In his subtle collages, Burri combined banal *objets trouvés* of the type familiar from Dadaism and Surrealism, with the compositional finesse of the skilled painter.

Burri, Alberto

1915 Città di Castello, near Arezzo, Italy
1995 Nice, France

◄ **Alberto Burri**
Wood Combustion
with Black, 1956
Combustione legno
e nero

*Oil on canvas, wood,
and burlap*
150 x 99 cm

Private loan

▲ **Alberto Burri**
Jute Sack, 1954
Sacco

Burlap and canvas
130 x 116 cm

Private loan

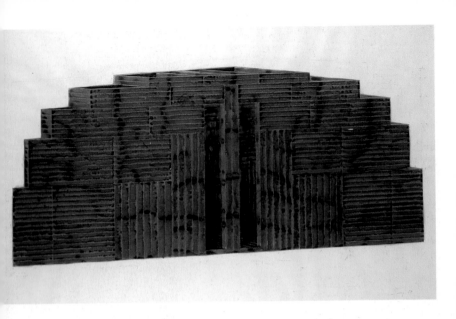

Claus Bury has been involved since 1975 in the design and execution of large-scale sculptural objects, for locations in rural and urban settings, but also in interior spaces. In 1980 he began working primarily in wood, a material of which his architectural sculptures in the public domain exclusively consist. Bury prepares his projects by making scale models in wood, detailed construction drawings, and expressive gouache renderings. The construction drawings permit a sculpture to be repeated at any time. Frequently Bury bases his pieces on the mathematical laws set forth in the numerical systems of the Italian mathematician Leonardo Fibonacci (c. 1180–1250). One such system postulates that every member of a series be the sum of the two preceding members (1, 1, 2, 3, 5, 8, 13, etc.).

The painstaking configuration of a sculpture according to this Fibonacci series was impressively demonstrated in Bury's *Temple*, a piece of 1984–1985 sited on the banks of the Rhine in Cologne-Deutz. The proportions of the architectural wooden sculpture, abstracted from Fibonacci (15 x 5.7 x 6.3 m), can be perceived in terms of length and height, and of the overall arc-segment contour, to describe the fifteenth part of a circle, a configuration also indicated by the geometrical, Constructivist patterns on the surface.

Bury, Claus

1946 Meerholz,
Germany
Lives in Frankfurt
am Main

▲ **Claus Bury**
Fibonacci's Temple,
1984
Fibonaccis Tempel

Gouache on paper
124 x 198 cm

Buthe, Michael

1944 Sonthofen
1994 Cologne

A proponent of the tendency known as Individual Mythologies, Michael Buthe projected his own, highly personal world in paintings, sculptures, and installations. Dividing his time between Cologne and Marrakesh, Morocco, he immersed himself in North African mythology and collected material that led to the making of *Homage to the Sun*, a tentlike environment exhibited at documenta V in 1972. It was characteristic of Buthe and other representatives of Individual Mythologies that their approach to indigenous cultures was less intellectual than emotional and direct in nature. Their aim was to make primitive, alien myths their own, and to set these, as an antidote, against the coldness of contemporary society.

Buthe collected relics of these cultures – fetishes, bits of paper and fabric, feathers and emblems. He created calligraphic paintings employing Moroccan French, and made series of photographs documenting North African life-styles and customs (including the integration of artists in society there). In 1977, Buthe's *Museum Echnaton*, comprised of a number of self-contained environments, opened in Cologne.

Magical and metaphysical factors played a predominant role in Buthe's work from the beginning. His paintings are covered with innumerable tiny dots and points, recalling the tesserae of a mosaic, or the characteristic dot-patterns of Australian Aboriginal art. The comparison, however, is misleading. To Buthe, the dots represented mirrors in which the soul of the viewer – and the artist – was reflected.

Another recurring motif in Buthe's art is the imprint of a hand. This stands for the hand of the artist, the creator, and by analogy for the hand of God; but it also refers to the Moroccan custom of painting a red hand next to the front door of a house, to ward off the evil eye.

Buthe's art was inextricably intertwined with his life. Every work was like an arena in which opposing principles and ideas met and clashed – rationalism with intuition, male with female, familiar with exotic, collective with private. The goal of his art, as of his life, was to achieve an equilibrium, a unity of body and soul. For Buthe, art was ultimately a religion, in the truest sense of the word.

▶ **Michael Buthe**
Untitled, 1979–1980
Ohne Titel

Oil and diverse materials on canvas
184 x 140 x 12 cm

Gift of
Dr. Michael and
Dr. Eleonore Stoffel,
1992

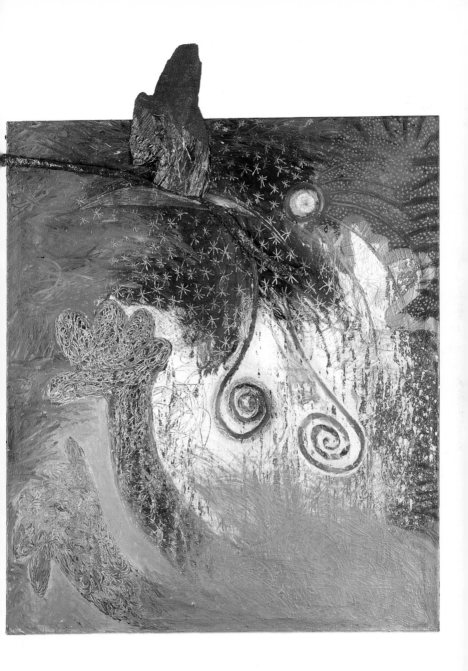

**Byars,
James Lee**

1932 Detroit,
Michigan
Lives in Santa Fe,
New Mexico, and
Venice, Italy

James Lee Byars is an artist who eludes classification. He has never painted a picture – only written letters, frequently and preferably on colored tissue, in black and gold. He is not a Conceptual artist, for he makes no preparatory drawings and composes no scores for his nonetheless precisely calculated appearances. Nor can he be called a performance or happening artist, because he comes and goes quietly and undramatically. However, Byars is a performer in the sense that he plays himself, uses his own physical presence in a show-like event to communicate an idea, be it written in air, less tangible than a drawing made in sand and erased by the wind. At the Berkeley University Art Museum, Byars once showed *The Perfect Kiss*. Dressed in black, his hat pulled deep over his eyes, he stood on a floodlit podium, pursed his lips in a kiss and held it for seconds of extreme concentration before silently leaving the room. In November 1994, at the Museum Ludwig, Cologne, the artist, clad in a golden suit, demonstrated *The Perfect Smile* with similar temporal and mimetic reduction. *The Golden Speaking Hole* – also known as *The Large Glass* or *The Refinement of Perfection* – was first exhibited in 1974, outside Galerie René Block in Berlin. During the event, Byars appeared in a black cloak and wearing

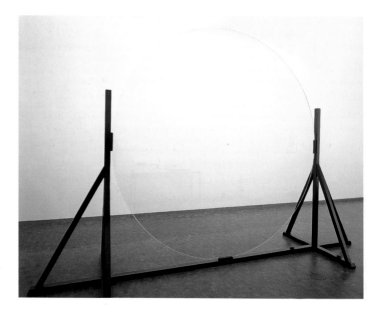

▶ **James Lee Byars**
The Golden
Speaking Hole, 1982

*Glass and gold
diameter 280 cm*

a black blindfold, directed viewers behind the glass, and asked them to speak on the topic of "the refinement of perfection" through the golden hole. Imagine, he said, you could say, I can change my mind only through the Golden Hole (1982).

A mystical forcefield of thought is the phrase suggested by Byars's installation *The Thinking Field of 100 Spheres Shown in a Cubic Room*. It was displayed for the first time in 1989, during the Bilderstreit exhibition held at Cologne's trade fair grounds. The piece consists of one hundred white marble spheres, each measuring 20 cm in diameter, distributed evenly across the floor of a large room. Yet despite their number, each ball can be perceived as an individual phenomenon as well, a notion similarly thought-provoking to Byars's minimalist, "neoclassical" presentation of *The Head of Plato* in 1986. One white marble sphere is displayed in a showcase, and thus singled out as particularly valuable, an embodiment of the immaterial or spiritual per se. The sphere is considered the perfect form. It symbolizes the cosmos, because its surface is unbounded, without beginning or end. Byars, the perfectionist, has asked us the "perfect question".

▲ James Lee Byars
The Thinking Field
of 100 Spheres
Shown in a Cubic
Room, 1989

*White marble,
100 spheres,
each 20 cm
in diameter*

Loan of
Association for
Modern Art at the
Museum Ludwig,
Cologne

**Calder,
Alexander**

1898 Philadelphia,
Pennsylvania

1976 New York

Thanks to his invention of mobiles and stabiles, American sculptor Alexander Calder holds a significant place in twentieth-century art. Calder initially studied engineering before enroling in painting and drawing courses at the Art Students' League in New York, which he attended from 1923 to 1926. Later that year, at the age of 28, he went to Paris, where he remained until 1934. Then Calder returned to the United States.

While in Paris Calder made friends with Hans Arp, Fernand Léger, and Joan Miró, and did his first, wonderfully humorous wire sculptures and now-famous cycle of miniatures (1927). In 1931 he joined the Abstraction-Création group, whose members included Robert Delaunay, Jean Hélion, Arp, Antoine Pevsner, and Piet Mondrian. That same year saw Calder's first abstract metal constructions, which were later dubbed *Mobiles* and *Stabiles*. His greatest source of inspiration at the time was Mondrian, whom Calder had met the previous year. Mondrian not only encouraged him to work in an abstract mode, but to make kinetic sculptures along the lines of his, Mondrian's, own Neo-Plasticism.

The result, as Calder put it, was "Mondrians that moved" – the term *Mobile* was suggested by Marcel Duchamp. Suspended on a wire, the sculptures hover in space. Their motions, on the one hand, are irregular and uncontrollable, at the mercy of drafts or physical impetus. On the other, they rely on a subtly calculated system of balance and leverage. The possibility of making slight changes in weight distribution, altering the shape of the elements, and the number and arrangement of the arms, placed a well-nigh infinite number of configurations at the artist's disposal.

In *Thirteen Spines* (1940), thirteen rods in three groups of different length are suspended stepwise, in parallel one beneath the next, such that the sheet-metal form at the bottom keeps them in equilibrium. It is an extremely delicate equilibrium, however, because the rods can swing upwards or downwards, to the left or right. The sculpture has no front or back, being equally effective from every vantage point. It is continually mutable and never reaches stasis. Also, its design exhibits a very effective contrast between lightness at the top and heaviness at the bottom – thin, black, graphic lines set against a closed black shape. In between, a transition is established by the two, smaller, dark surfaces, which appear to float freely in space.

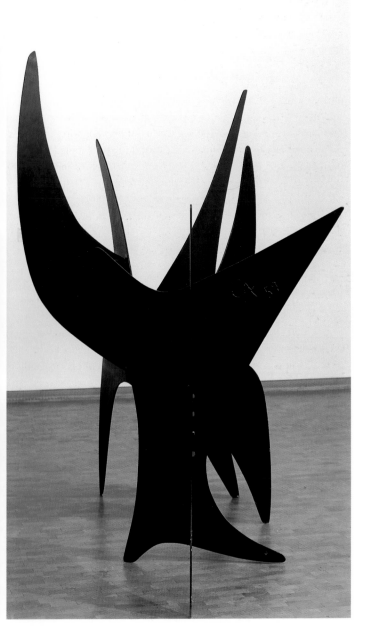

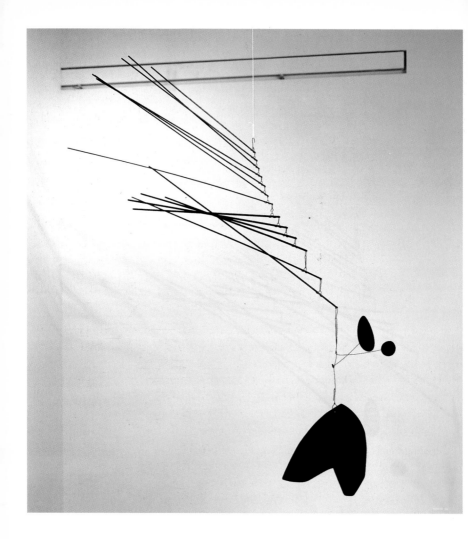

▲ **Alexander Calder**
Thirteen Spines,
1940

*Suspended mobile
of sheet metal,
aluminum, iron
wire, steel rods;
painted black*
220 x 220 cm

A sharp contrast to the kinetic, airy mobiles is seen in Calder's static, tectonically solid sculptures, to which Arp gave the name of *Stabiles*. The hovering mobiles and earthbound stabiles embody two, opposing principles at work in the universe, evoking a cosmic metaphor for innocent, undirected play and decisive, conscious act.

► **Massimo Campigli**
Violins, or
The Concert, 1934
Violini o concerto

Oil on canvas
88 x 115.5 cm

Loan of
VAF-Foundation,
Switzerland

Three women, clad in timeless robes reminiscent of classical togas, playing the violin, their gaze directed into the distance yet also musing, introspective. Behind them, a fourth figure listens, hand cupped behind her ear, a sign of undivided attention. One might detect an allusion here to the old allegory of the five senses – especially to that of hearing. Be this as it may, Massimo Campigli's *Violins, or The Concert* (1934) exudes a profound and concentrated calm. No hasty movement disturbs the harmony of the composition. The heads of the two foreground figures and that of the listener form a diagonal, extending from lower left to upper right, which in turn is paralled by the fourth figure's violin and bow. Muted colors, in all gradations of ocher to brownish-red and dull green, increase the impression that what we have before us is in fact a section of an Early Renaissance fresco.

In 1933, Campigli collaborated with Giorgio de Chirico and Mario Sironi on a large fresco in the Palazzo dell' Arte in Milan (later destroyed). However, his confrontation with Etruscan art in 1928 had already awakened a desire to depict a classical, sometimes even seemingly archaic world, which demanded the development of a very personal, inimitable style.

**Campigli,
Massimo**

1895 Florence, Italy
1971 Saint-Tropez,
France

Caro, Anthony

1924 London
Lives in London

Anthony Caro was educated at Charterhouse School, Christ Church College in Cambridge, and at the Royal Academy Schools in London. He worked as assistant to Henry Moore in 1952–1953. In 1959 he met the American sculptor David Smith, whose steel sculptures, some partially composed of already existing objects, left a profound impression on Caro. His first abstract sculpture, based on prefabricated industrial metal parts of various configurations, was executed in 1960. The painted steel sculpture *Prospect*, 1964, perfectly illustrates Caro's intention to overcome static mass and open the sculpture to the surrounding space – a design characteristic already seen in the work of his admired predecessors Henry Moore and David Smith.

Caro himself stated that he attempted to exclude allusions and make truly non-objective sculptures by fitting the individual parts of the pieces together like notes in music. Just as a sequence of notes resulted in a melody, he would take anonymous units and compose them in an open way into a sculptural whole. If he could succeed, Caro added, in letting the floor work as a component of the sculpture rather than merely as a pedestal, the work would appear to hover. This is why Caro preferred to mount his works directly on the ground or floor. It was ideal, he said, because then the pieces would look as if they were resting not in the ground but on it.

This effect of near-weightlessness is engendered, in *Prospect*, by the dynamic diagonals of the sculptural elements, which rest only on their edges, and is amplified by the distribution of the four colors of lacquer paint. The sapphire blue and leaf green on the two lower steel surfaces enter into an active correspondence with each other and with the floor; above them, their complementaries red and orange appear to pull away from the cool colors, their brilliance augmenting the upward thrust of the diagonal, intersecting iron beams. In 1993, after a visit to the Museum Ludwig, Cologne, Caro informed the management that the sculpture's monochrome red finish, applied in the late 1960s, had resulted from an error. That same year he arranged to have the original color scheme restored.

▶ Anthony Caro
Prospect, 1964

Steel
260 x 280 cm

Ludwig Donation, 1976

◄ **Carlo Carrà**
The Carriage, 1916
La carrozzella

Oil on canvas
51.6 x 66 cm

Loan of VAF-Foundation
Switzerland

▶ **Carlo Carrà**
Lot's Daughters, 1919
Le figlie de Loth

Oil on canvas
110 x 80 cm

Loan of VAF-Foundation
Switzerland

Carrà, Carlo

1881 Quargnento,
Piemonte, Italy
1966 Milan

Italian painter and graphic artist Carlo Carrà moved in 1895 to Milan, where he earned his living as a decorator and took evening courses in art at the Accademia di Brera. His rather introverted life changed markedly in 1909, when he came in contact with Umberto Boccioni, Emilio Filippo Tommaso Marinetti, and their circle. The next year found Carrà among the signatories – with Giacomo Balla, Luigi Russolo, Gino Severini, and Boccioni – of the *Technical Manifesto of Futurist Painting*. During a stay in Paris in 1911, Carrà met Guillaume Apollinaire and the Cubists, whose approach strongly influenced him towards a simplification of form, and with whom he exhibited in 1912–1913. By 1915 Carrà had distanced himself from the Futurist movement, and turned to a consciously primitive, archaic style. *The Carriage*, of 1916, marks the culmination of this primitivistic phase, which was brief but very important to Carrà's development.

In 1916 in Ferrara, he met Giorgio de Chirico, with whom he collaborated in developing a style they termed Pittura Metafisica (Metaphysical Painting). At that time Carrà was immersing himself in Italian art of the trecento and quattrocento, especially in the works of Giotto and Masaccio. This is the context in which his painting *Lot's Daughter* of 1919 emerged, a key work in Carrà's development and the culminating point of his involvement with the Early Renaissance. "Thus the whole of Carrà's art," wrote Werner Haftmann, "was nourished by the idea of defining the essential grandeur of things by means of archaic simplification."

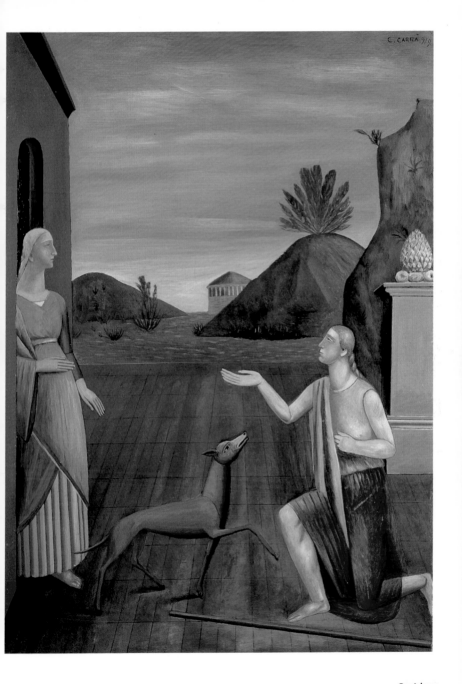

César

1921 Marseille
Lives in Paris

▼ **César**
Compression, 1981

Automobile body
162 x 56 x 53 cm

Loan of Ford-Werke
AG, Cologne

The connection between sport and art is as old as Western civilization. Discus throwers, wrestlers, boxers, and the proud ranks of the charioteers have been subjects of European sculpture and poetry. César Baldaccini, founding member of the Paris group Nouveaux Réalistes, has raised a monument to the vehicle of a latter-day charioteer – the Ford Zakspeed with which Klaus Ludwig won the German Motor Racing Championships in 1981. Named Car of the Year at the 1981 Essen Motor Show, the racecar was honored, for once, not with a trophy but by being transformed into a work of art. One might expect the idea to have come from some art historian or collector, but it was actually a former racing driver, Jochen Neerpasch, who advocated it. The result, César's *Compression*, is on long-term loan to the Museum Ludwig, Cologne, from the Ford Motor Company.

The Nouveaux Réalistes worked with things and objects taken from the real, existing environment. In addition to César, John Chamberlain and Arman have also concerned themselves intensively with the automobile. Chamberlain would seem to view it as a product of civilization, a monument to the rabid consumption and planned obsolescence of an affluent society. Arman, in his *Accumulations*, demonstrates what beauty can inhere in a random collection of automobile parts. César is intrigued by the magic concealed in the technology of our secularized world, the metaphysical aura of actual, existing things. Generally invisible to the superficial glance, this magic is revealed in César's work. He too transforms the automobile into a thought-provoking monument – not, as in Chamberlain's case, into a *memento mori*, but into a contemporary stele, a monument to the covert dignity of mundane reality.

The term "compression" implies reducing something to a more compact, condensed form. César has condensed – both literally and figuratively – a real and highly complex object fraught with mental associations by divesting it of every anecdotal factor and reducing it to the essentials of form and color, texture and volume.

Against the will of his parents, who hoped he would pursue a business career, Marc Chagall decided to become an artist. In the winter of 1906–1907 he went to St. Petersburg, where he attended several small art schools. He earned his living by painting signs and retouching photographs. In 1908, Chagall succeeded in being accepted into the progressive Svanseva School, where Leon Bakst became his teacher. Bakst was a member of the St. Petersburg avant-garde, which stood under the influence of international Art Nouveau. The decorative principles of this style are strongly evident in Chagall's 1909 *Portrait of the Artist's Sister*, which represents his sister Mania. The figure, brought into the very near foreground, is intersected by the edge of the picture, and appears as if compressed into the rectanglar field. The effect of flatness is underscored by the blue-and-white pattern of both background and skirt. Thanks to this interplay of color and form, a close link is established between the figure and the pictorial space, which appear fused and unified by a pervading atmosphere dominated by gradations of red and blue.

Bakst drew Chagall's attention to modern French painting. Thanks to the support of a patron, the young artist was able to move to Paris in the summer of 1910. One of the first pictures he did there was *Sabbath* (1910).

The tendency to create a certain atmosphere or mood through color, already apparent in Chagall's St. Petersburg phase, culminated in this work. His experience of the Fauves, but especially of the work of Vincent van Gogh, which he studied in Paris, is clearly evident in the palette of *Sabbath*. The colors, as if liberated from the solid,

Chagall, Marc

1887 Vitebsk, Russia
1985 Saint-Paul-de-Vence, France

▲ ◄ **Marc Chagall**
Portrait of the Artist's Sister, 1909

Oil on canvas
92.5 x 48 cm

Haubrich Donation, 1946

compositional framework, seem to hover in the pictorial space, pure, expressive, luminous pigments. Another striking feature of the painting is the strange stillness that pervades the room. Although all the persons gathered there seem occupied with their own thoughts, they are linked with one another by the peaceful mood of Sabbath, which seems to be distilled in the weightlessly floating veils of red, green, and yellow.

Two further early works from the Paris phase are *Man at a Table with Cat* (c. 1911) and *Old Jew* (c. 1912). The subject of the drinker, seen in the former painting, preoccupied many artists around the turn of the century, for the drinker symbolized loneliness. In Chagall's image, the emotional content of the theme is heightened by the distorted perspective, by the inordinately large foreground figure and his grimacing face, as well as by the strong contrast between the bright red hues in the left half of the picture and the black and white gradations on the right. Loneliness also plays a role in the drawing of the *Old Jew*, who gives the impression of being completely withdrawn within himself.

Both images rely on certain expressionistic means. *Old Jew* is the less dramatically conceived of the two. There is no overt plot or event depicted, although a covert one may be present – the green cast of the old man's face might be interpreted as a sign of his being lost to the world.

Chagall's gouache *Over Vitebsk* was created in 1914, the year of his return to Russia. In it, he depicted the figure of the man floating over the town as if it were the most natural thing in the world, thus anticipating, by a decade, the psychological and visual innovations of Surrealism. The hovering figure was to become a frequent theme in Chagall's work, in which rational and tangibly perceptible reality blended with dreams and memories to produce a reality heightened by imaginative vision.

In 1923, Chagall left Vitebsk and returned to Paris again. Now he began to involve himself in landscape painting, as witnessed by his canvas *Yellow House*. Yet instead of depicting a French landscape, the artist once again turned back to his memories, this time of summer in his hometown of Vitebsk. The feathery strokes of emerald green and ultramarine, light lemon yellow and light vermilion, vividly evoke the shimmering heat of a summer's day.

▲ **Marc Chagall**
Sabbath, 1910

Oil on canvas
90.5 x 94.5 cm

Haubrich Donation,
1946

From 1950 onwards, Chagall lived in the small resort town of
Saint-Paul-de-Vence, near Nice, for whose "Chapelle du calvaire"
he created a sequence of works on Old Testament subjects. *Moses
Breaking the Tablets of the Law* (1955–1956) was originally conceived
as part of this sequence. The composition is divided in half by the
imposing figure of Moses. To the right, his people dance around
the Golden Calf. Above them is a vignette showing Moses receiving,
for the second time, the Divine Covenant which was to determine
the life of coming generations, who are depicted in the left half of the
picture. People gather at the bottom of the slope, waiting expectantly

◄ **Marc Chagall**
Man at a Table
with Cat, c. 1911

Gouache
on packing paper
20 x 28.5 cm

Haubrich Donation,
1946

► **Marc Chagall**
The Old Jew, c. 1912

Watercolor and
gouache over
charcoal on paper
50.4 x 37.7 cm

Haubrich Donation,
1946

► **Marc Chagall**
Over Vitebsk, 1914

Gouache and chalk
on cardboard
34.5 x 42.8 cm

Haubrich Donation,
1946

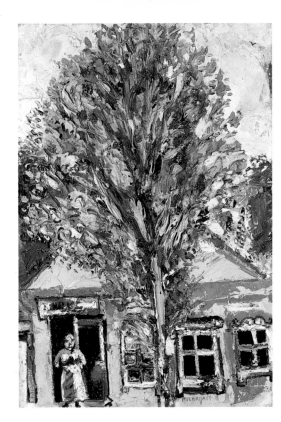

for the breaking of the tablets. Above them rises the figure of a priest, holding the torah containing the covenant over the heads of a young couple being married under a canopy. Thus the wild, heathen revelry at the right is contrasted with a future of peace and plenty under the laws of God. Chagall does not depict the Bible story as an event that is past and gone, but as embodying a divine promise that takes effect in the here and now. Past and present appear as an indissoluble unity.

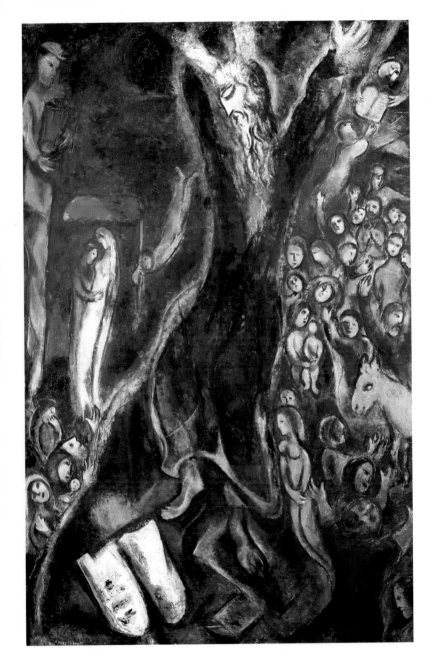

Chaissac, Gaston

1910 Avallon, France
1964 La Roche-
sur-Yon, Vendée

▼ Gaston Chaissac
Iris Totem (Portrait
of Iris Clert), 1961

Oil on wood
height 286 cm

Gift of Dr. Arend
Oetker, 1991

At the age of twenty-four Gaston Chaissac went to Paris, where he worked in the shoemaking trade. His decision to devote himself to art came after meeting the painter Otto Freundlich in 1937. As he suffered from tuberculosis, Chaissac was compelled to spend month-long periods in a sanatorium, which gave him an opportunity to do paintings and drawings for his first Paris show. In 1940 Chaissac met his future wife, Camille Guibert. They moved to a village in the province of Vendée, where Camille worked as a schoolteacher. The villagers looked askance on the eccentric artist and his free-thinking wife, but Chaissac escaped their maliciousness by immersing himself ever further in his drawing, painting, writing, and montages. His isolation was relieved by a lively correpondence with other artists and intellectuals, above all with Jean Dubuffet, who excitedly discussed Chaissac's "uncouth modern painting" (the words are his own).

Uninfluenced by academic training, Chaissac's gouaches, painted objects, collages, and monumental figures possess a primitive, expressive force which prompted Dubuffet to associate them with the ideas of his own Art Brut movement. Among his most puissant works are the *Totems*, frequently larger-than-life human figures, the majority of which were created during the last seven years of the artist's life. Nailed together of long, brightly painted boards and scrap wood, these images enabled Chaissac to liberate his painting from the bounds of flatness and the frame, and expand it into three dimensions. Impressive alone on account of their sheer size and striking colors, the *Totems* also each have a quite individual expression and personality. *Iris Totem* was executed in 1961, as a portrait of Paris gallery owner Iris Clert, whom Chaissac had visited in 1956.

► **John Chamberlain**
White Shadow, 1964

Automobile parts,
welded
height 172 cm

Ludwig Donation,
1976

Chamberlain,
John

1927 Rochester,
Indiana
Lives in Sarasota,
Florida

One day in 1957, out of money but in need of material, sculptor and painter John Chamberlain stumbled across the car parts lying around Larry Rivers' studio in New York. He began assembling the pieces of painted scrap metal into sculptures. Respecting the information already contained in the material and its tortured forms held first priority for Chamberlain. He attempted to preserve its intrinsic life while at the same time transcending it – an approach that shared much in common with Abstract Expressionist ideas. Like the painters of that school, Chamberlain views the process of making as an essential factor in his work. In terms of its integration of the environment in art, in the shape of manmade, once utilitarian materials, Chamberlain's work also bears similarities to object art, or assemblage. However, he sometimes reworks the scrap, and flatly denies any interpretation of a literary or symbolic nature, let alone the glorification associated with the terms Surrealist or Dadaist.

White Shadow, then, is completely abstract, despite the objective nature of its component parts. One would not wish to contradict the artist and see it as a Vanitas symbol for an automobile-obsessed society. Such interpretations apart, the compelling effect of the sculpture derives from its baroque extension into the surrounding space, and the dynamic effect of the impinging and projecting forms.

Chaschnik, Ilya

1902 Liuchite,
Lithuania
1929 Leningrad
(now St. Petersburg)

▼ Ilya Chaschnik
Suprematism,
c. 1923–1924

Oil on canvas
85.5 x 74.5 cm

Ludwig Collection

Ilya Chaschnik was among the younger artists in Kasimir Malevich's circle, having studied with him at the Vitebsk School of Art. In 1922 Chaschnik accompanied his teacher to Leningrad, to assist him in creating the *Architectona-Constructions*. After his untimely death – at twenty-seven, from the consequences of an appendicitis operation – Chaschnik was well-nigh forgotten. With few exceptions, his works remained in the Soviet Union, and were not rediscovered until the 1970s. Chaschnik was an ardent follower of Malevich and his Suprematist theory. His paintings, designs for porcelain, and great numbers of unexecuted project drawings, show him to have been a master who successfully adapted Suprematist principles and motifs to a variety of artistic media.

After strictly adhering to Malevich's ideas for years, Chaschnik began to rethink his aesthetic stance. While remaining basically a Suprematist, he diverged from his mentor in 1922 by announcing the innovative principle of "breaking up symmetry and rendering it transparent". At about the same time, Chaschnik developed designs for reliefs that represented a new brand of Suprematist composition. His *Suprematist Relief* in the Museum Ludwig, Cologne, dates from about 1922–1923. Here, the conventionally two-dimensional Suprematist constellation of geometric shapes has been transformed into what might be termed an "architectural painting". The square, relief shape, displaced from the central axis, recalls an architectural model. The black color serves to emphasize the three-dimensional reality of the situation, which calls to mind a bird's-eye-view of a city square. Chaschnik's relief designs form a transition between his early, Suprematist studies and the architectural designs he did in collaboration with Malevich, beginning in about 1924.

The artist's canvas *Suprematism* dates from the years 1923–1924. In terms of its complexly intersecting horizontal and vertical elements, combined with a circular form, the painting clearly illustrates that reduction to basic geometric shapes and pure colors which was the formal basis of Suprematist composition.

▲ **Ilya Chaschnik**
Suprematist Relief,
c. 1922–1923

Oil on wood
111.8 x 111.8 x 7 cm

Ludwig Collection

de Chirico, Giorgio

1888 Volos, Greece
1978 Rome

▼ Giorgio de Chirico
Two Nudes, 1926
Due nudi

Oil on canvas
130 x 89.5 cm

Loan of
VAF-Foundation,
Switzerland

Although his early, metaphysical phase (to about 1917) was long considered Giorgio de Chirico's finest achievement, his work of the 1920s has recently come in for a reevaluation. Influenced from the beginning by Italian Renaissance painting, it was not until 1925 that de Chirico consciously adopted subjects from classical icono-graphy. To many, this seemed an uncritical, nostalgic reversion to the eclectic approach of nineteenth-century art. Yet as we know at the latest since Freud, the figures and legends of antiquity can embody primal patterns of human anxiety and neurosis. It was for this reason that such motifs experienced a renaissance in early twentieth-century art. De Chirico's depictions of eerily empty city squares populated by *manichini* – half human, half machine – and

objects seemingly out of place in a strange environment, have justifiably been seen as visions of human alienation and fear.

The first of these composi-tions, *The Roman Comedy*, was painted in 1926. It shows two enigmatic, composite figures, perched on a small wooden stage in the middle of a great, empty amphitheater. The seated figure on the right is a personification of tragedy; the standing figure, left, embodies comedy.

A long series of iconographi-cally related depictions followed in the 1920s, all of them based on subjects from ancient Greece or Rome. The two figures on the beach in *Two Nudes*, and the Greek temples on the hill in the background, go back to illus-trations in the archaeological textbook *Répertoire de la statuaire ancienne romaine et grecque*.

▲ **Giorgio de Chirico**
The Roman Comedy, 1926
La comédie romaine

Oil on canvas
146.5 x 114.5 cm

Loan of VAF-Foundation, Switzerland

Christo & Jeanne-Claude

Christo
1935 Gabrovo,
Bulgaria
Lives in New York

Jeanne-Claude
Born 1935
Lives in New York

Familiar objects and views are hidden from sight when Christo and Jeanne-Claude wrap or obscure them – be they things of everyday use, display windows or entire public buildings, a section of the seacoast or the view into a valley. A second skin is drawn over these things, stimulating our imagination and joy in discovery, and prompting the question as to the meaning of wrapping and packaging per se. The objects elude familiar uses and handling, and their functions have to be reconsidered; beneath the veil that lets only their contours shine through they seem to tingle with imaginary life. While Christo and Jeanne-Claude's large-scale projects are of only temporary nature, the *Packages* remain a continuing stimulus to the mental and haptic

▶ **Christo**
Package, 1963

Wood,
fabric and twine
81 x 45 cm

© Christo 1963

curiosity of the viewer. Also permanent are the documents of various actions, such as *The Pont-Neuf Wrapped* in Paris, or, to name the most recent work of art, the much-discussed *Wrapped Reichstag, Berlin*, in the form of numerous preparatory drawings and sketches with which Christo painstakingly plan his projects.

Package was done in Düsseldorf, during Christo's early phase, when he wrapped such things as automobiles, traffic signs, furniture, and even a live woman. For several years the object was displayed in a frame, but the neoclassical frame was removed at the artist's request in 1970. The object belongs to a larger series of similar ones, collectively titled *Packages*, done between 1958 and 1963.

▲ Christo
Wrapped Calculating
Machine, 1963

Calculating machine,
plastic sheet, cord,
rubber
46.5 x 88.9 x 73.6 cm

Ludwig Collection

◄ **Alex Colville**
Truck Stop, 1966

Acrylic on hardboard
91.5 x 91.5 cm

Ludwig Donation,
1976

Colville, Alex

1920 Toronto
Lives in Wolfville,
Nova Scotia

To be a good realist, Alex Colville admits, he must invent everything. As much as his paintings resemble photographic snapshots, he uses no photographs in his work. Quite the contrary: Colville constructs reality. This lends him a greater affinity with the twentieth-century American realists of the 1920s (Edward Hopper, Charles Sheeler, Charles Demuth) than with the Photorealists who came in the wake of Pop Art. Colville's imagery is perhaps best described by the term "magic realism", for its undifferentiated sharpness of detail and emphasis on human isolation and loneliness link Colville's work with Neue Sachlichkeit, the New Objectivity in German art of the 1920s. His cool, fixating gaze indeed seems to intensify reality, lending it a magical, almost mystical air. Colville's *Truck Stop* has accordingly been interpreted in terms of Christian parables or Zen Buddhist analogies, and associated with earlier art as diverse as Caspar David Friedrich's spiritualized landscapes and René Magritte's ironic Surrealism.

From 1940 to 1943 Corneille took drawing courses at the Amsterdam Academy. In 1947 he travelled to Paris. Initially part of the Dutch Reflex group (1947–1948), Corneille became a founding member of Cobra, to which Pierre Alechinsky and Karel Appel also belonged. The group, named after the cities of the artists' origin (Copenhagen, Brussels, Amsterdam), worked in an abstract expressionist style that was leavened with conscious naivety and figurative elements.

Corneille's painting to some extent reflected the Cobra artists' approach – freeform, spontaneous, drawing on subconscious imagery in a way similar to European Tachisme and American Action Painting. By comparison to their impulsive attack, however, Corneille's method was considerably more controlled. The Cobra artists' intention to combine abstraction and figuration, or objective representation – something most tachistes and action painters would reject out of hand – is reflected in the subject matter and themes of Corneille's paintings.

Corneille
(Cornelis
van Berverloo)

1922 Liège, Belgium
Lives in Paris

▼ **Corneille**
Bird Nesting
Place, 1960
Terrain propice
à l'oiseau

Oil on canvas
162 x 130 cm

A good example is *The White City*, of 1955. Its compositional structure, built up of clearly outlined, seemingly architectonic shapes, recalls the bird's-eye-view of a city. Yet despite this objective reference, the flatness of the picture plane is retained. The inspiration for the canvas may well have come from a trip to Africa the artist made in 1949. Corneille's *Bird Nesting Place* (1960) is similarly determined by a structure composed of clearly defined forms, separated and articulated by means of loosely brushed contours.

Cornell, Joseph

1903 Nyack,
New York
1972 Flushing,
New York

▲ Joseph Cornell
Hotel de l'Océan,
1959–1960

*Wooden box,
clay pipe,
children's block,
postage stamp,
several paper
clippings from
unknown sources,
four brass rings
on metal rod,
metal sun
21.5 x 36 x 10.2 cm*

Joseph Cornell did not come across the objects used in his picture-boxes by chance. He was a fanatical collector, who combed New York bookstores and junk shops for relics of mundane life, city maps, tourist brochures, illustrated books, and celestial charts. A visionary loner who never left the United States, Cornell gradually transformed his house on Long Island into a treasure trove. His *Hotel de l'Océan* was done in the 1950s, at a time when the "good old days" of the grand hotel particularly intrigued him. Although he was inspired by the framed and glazed reliefs and *objets trouvés* of Surrealist Max Ernst and Marcel Duchamp, Cornell worked in a more poetic and private vein that had little in common with their aggressive, ironically caustic approach.

The title *Hotel de l'Océan* refers to a former luxury hotel in Ostend, Belgium, the only relic of which Cornell discovered was a baggage sticker. The objects arranged behind the glass in the weathered frame include a children's building block, a piece of driftwood, stamps from Ecuador, brass rings, and a laughing metal sun, inset in the back wall of the miniature diorama. Charts of the planet Jupiter's orbit call a universal reference to mind. The things ensconced in this closed, self-contained microcosm spirit the viewer into a realm of dreams, awaken a longing for distant retreats, or nostalgia for a childhood that will never return.

Of all the many students of Joseph Beuys, Walter Dahn and his friends and companions Felix Droese and Johannes Stüttgen are among the few who still adhere to their mentor's conviction that art has a sociopolitical responsibility to fulfil. In Dahn's eyes, political awareness is an essential criterion of artistic quality. Art, he believes, should function as a catalyst for societal involvement and political critique.

In the early 1980s Dahn joined forces with Georg Jiri Dokoupil and Peter Bömmels to found a group called Mülheimer Freiheit, after the street in Cologne where they had their studios. Dahn's paintings from this period, such as *Drinker* (1982) and *Copyright Man* (1985), are highly expressionistic in approach. The paintings and drawings of these years are dominated by individual, schematized, sometimes huge figures and symbols, a repertoire of elements to which the artist recurs again and again: copyright man, stag, a globe, death's heads. This reduction to simple pictorial motifs was intended to insure clarity of statement. "The important thing for me – or for us, I should say," explained Dahn, "was to make content really intelligible. I mean, there are certain things you understand relatively quickly, and tend not to forget so fast. The

thing presented shouldn't be blurred, at any rate ... What interested me was visual ideas that would be as concisely formulated as possible – sometimes even to the verge of abstraction – things that come out extremely clearly and are pregnant with meaning. Just as pregnant as a traffic sign, or any of the other signs that surround us. Which I wouldn't consider exploiting for my own style, but which I understand as analogous objects existing in the outside world."

By the middle of the 1980s Dahn had begun to question the activity of painting itself.

Dahn, Walter

1954 St. Tönis, Niederrhein, Germany
Lives in Cologne

◄ **Walter Dahn**
Copyright Man, 1985

Acrylic on canvas
250 x 150 cm

Collection of
Dr. Michael and
Dr. Eleonore Stoffel

He experimented in photography and, in works like *Untitled* (from
the *Ex Voto* sequence), with the silkscreen technique. The clear legibility
of his imagery was no longer a prime concern. Various works remained
untitled, only the sequence in which they occurred being given a name.
In the *Ex Voto* series Dahn alluded to the Christian tradition of placing
a votive tablet in a reliquary shrine as a sign of a pledge or vow.
The purpose of the vow remained obscure.

At about this time, definite political ideas and aims began to play
a key role in Dahn's art. The mutual relationship between the
First and Third Worlds, and the possibility of direct democracy
in Germany, came to preoccupy him especially. Dahn participated
in projects such as the "Omnibus for Direct Democracy in Germany"
and, later, in *Baumkreuz*, a continuation of Beuys's documenta project

7000 Oaks. At the latest with the joint establishment by Dahn, Droese, and Stüttgen of "Enterprise Economics and Art – Expanded" in 1990, Dahn's environmental committment metamorphosed into a sort of art-in-life, a vitalistic approach very much in keeping with his mentor, Beuys.

The Station of Perpignan (1965) holds a key position in Dalí's œuvre. The figures of a farmer and his wife at prayer, flanking the central field, were taken from the painting *Angelus* by Jean-François Millet. It was a work that preoccupied Dalí continually from the 1920s onwards. Inspired by Sigmund Freud's psychoanalytical interpretation of Leonardo da Vinci's *The Virgin, Child, and St. Anne,* hidden in which Freud discovered the shape of an eagle he read as a sexual symbol, Dalí likewise discovered a covert form in Millet's *Angelus.* Based on an X-ray photograph, a geometric shape was detected between the man and woman which Dalí interpreted as the coffin in which the Son of God lay between his father and mother.

Dalí, Salvador

1904 Figueras, Spain
1989 Figueras

The female figure's attitude may appear devout and humble, but to Dalí it represented the pose someone takes before committing an act of aggression, like the praying mantis before the act of mating. In his image father and son become a single person, a victim of mating and fertility.

The sacrifice of the son, in the form of the hovering figure of Christ, is located at the exact center of the composition. In parallel with Jesus, Dalí has depicted himself. On the vertical axis a direct link is established with his wife, Gala, standing below; on the horizontal axis Dalí is related to the figures of mother and father, implying that he represents son, victim, and Christ in one. In the midst of his vision, Dalí appears twice over on the central axis. He is depicted in a state of falling, a motif that evokes the transition from waking to sleep, from reality to dream.

Port Lligat, where Dalí lived, is suggested by the seascape with ship in the lower half of the picture. Visible opposite, in the upper half, is a freight car that stands for Perpignan Station, where the artist spent a great deal of time. He discovered that the waiting room there had the same shape as the student's room Freud had depicted in a sketch. The station became a sacred locale to Dalí, and a rich source of inspiration.

► **Salvador Dalí**
The Station
of Perpignan, 1965
La gare
de Perpignan

Oil on canvas
295 x 406 cm

Ludwig Donation,
1990

Darboven, Hanne

1941 Munich
Lives in Hamburg
and New York

▶ **Hanne Darboven**
1/10/71 – 31/10/71,
1970

*Index and
eight sheets
from a series
of 35 pen and
ink drawings
India ink on paper,
each sheet
41.4 x 30 cm*

Ludwig Donation,
1976

The theme of visual experience, that is, the way in which we become conscious of our perceptions, is central to Minimal Art, whose pre-conditions of clarity, logic, standardization, order, directness, and impersonality are all fulfilled by Hanne Darboven's drawings.

Yet since she herself is primarily concerned with a systematic analysis of artistic conceptions and a recording of the process of making itself, Darboven's work is perhaps best viewed in the context of Conceptual Art. She employs constructions that represent logical, self-contained systems.

The 35-part work *1/10/71–31/10/71* represents a condensed graphic system in which the course of a certain time period, indicated by the dates in the title, is recorded in tabular form. The key to reading this record of October 1971 is provided in the four-page index that is part of the work. As it tells us, the system rests on the addition of the numbers occurring in the date of each day in the month, including the integers of the year "71" (7 + 1). On three index pages, cross-sums of the thirty days are taken, ten days or "entries" to a page. The cross-sum of the first day is 19 (1 + 10 + 7 + 1), and that of the last day 49 (31 + 10 + 7 + 1), explaining why the numbers "19" and "49" appear in the title, connected by an arrow. On the fourth index page, the 31 days of the month of October are visualized in various ways: as numbers from 1 to 31 entered in boxes, as the cross-sums 19 to 49, and in written form, one to ten (or nine) per row. In the following 31 drawings each page represents one day, the date of which appears in the title. Below this is the cross-sum of its integers.

As the month progresses, the longer and longer rows of numbers cause the writing on the page to grow ever more dense. It is a perfect visual illustration of the temporal extension we tend to feel in October, despite the fact that the days actually grow continually shorter and the hours of darkness increase. However, Darboven's works cannot be said to represent time; they embody time, real, continually progressing time, to whose mercilessly consecutive nature the artist lends an absolutely logical and therefore beautiful structure.

Delaunay, Robert

1885 Paris
1941 Montpellier

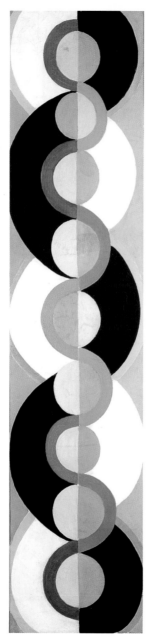

► **Robert Delaunay**
Endless Rhythm,
1934
Rythme sans fin

Oil on canvas
208 x 51.9 cm

Robert Delaunay was the principal representative of the style known as Orphism. By way of Post-Impressionism and the work of Paul Cézanne, he arrived in 1909 at a variant on Cubism, augmented by simultaneous color contrasts that wonderfully evoked movement and rhythm. The fanlike shapes and luminous hues of these compositions seemed like embodiments of light and motion. They especially impressed the Blaue Reiter (Blue Rider) artists, with whom Delaunay exhibited in Munich in 1911.

In 1913 circular and disk-shaped elements entered his art, predominating until 1921 and returning again in 1930, this time with a geometric precision that marked the artist's final adoption of abstraction.

Between 1933 and 1936 Delaunay created a series entitled *Endless Rhythms*, to which the 1934 painting illustrated here belongs. It was originally intended to grace a folding screen for the artist's wife, Sonia.

The colors of the spectrum, resolved in arc segments, induce a sense of rotating motion that evokes an endless, yet self-contained, movement. "A painting designed in accordance with these organizational laws," remarked Delaunay, "is a minature universe partaking of the rhythms of cosmos."

▶ Sonia
Delaunay-Terk

Color Rhythm, 1968
Rythme couleur

Oil on canvas
140 x 200 cm

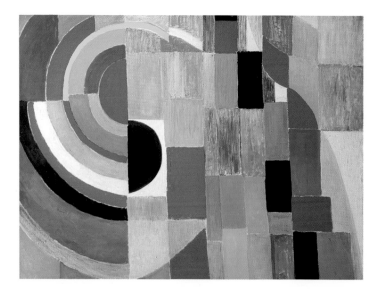

Russian artist Sonia Terk went to Paris in 1905. Inspired by the work of Vincent van Gogh and Paul Gauguin, she began to concentrate on the expressive values of color. Her marriage in 1910 to Robert Delaunay marked the beginning of a long artistic collaboration. She developed her own brand of abstraction based on simultaneous color contrasts and the lyricism of color. In 1912, she employed this style in paintings, clothing designs, and textile patterns. Especially effective were her book bindings for authors such as Guillaume Apollinaire, Stéphane Mallarmé, Blaise Cendrars, and Arthur Rimbaud, whose work she admired and with whom she shared a concern with the effects of simultaneity. She subsequently also designed stage sets, gobelins, carpets, stained-glass windows and ceramics.

Compared to the rigorous reduction of her husband's compositions, Sonia Delaunay-Terk's Orphism evinces a greater variety of form and more detailed articulation, as in *Color Rhythm*, an image built up of diverse compositional elements rendered in richly differentiated gradations of color. The left-hand side of the painting is reserved for progressively expanding, concentric arc segments, whereas the right is dominated by rectangular shapes. Their point of convergence forms a transitional zone. *Color Rhythm* is one of a series of large-format paintings on the same theme which the artist began in 1960.

Delaunay-Terk, Sonia

1885 Gradieste, Russia
1979 Paris

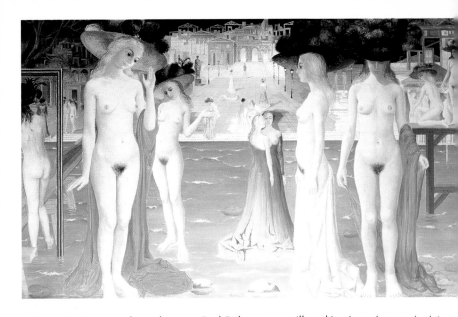

Delvaux, Paul

1897 Antheit, Belgium
1994 Furnes, Belgium

▲ Paul Delvaux
The Dryads, 1966
Les dryades

Oil on canvas
149.5 x 237.5 cm

Ludwig Collection

In the early 1920s Paul Delvaux was still working in an Impressionist vein. Later he came under the influence of James Ensor and the Belgian Expressionists Constant Permeke and Gustave de Smet. But it was a visit to a Brussels fair in 1932 that proved crucial to Delvaux's development: "I walked through the marketplace ... where the extraordinary stall of the Musée Spitzner had cast a spell over me – red velvet in the windows, two skeletons, and a sleeping, mechanical Venus in *papier mâché*. It was a quite sad and strange thing in the midst of the spectacle of the carousel, that artificial, thundering gaiety that characterizes the great fairs." The path to Surrealism was open, and Delvaux was further encouraged to take it by seeing "Minotaure", a 1934 Brussels exhibition that included works by Giorgio de Chirico, Max Ernst, René Magritte, and Salvador Dalí.

Distrusting visible reality, Delvaux countered its familiar aspect by means of Surrealist alienation, extreme perspectives, or absurd arrangements. The figures in his paintings, mostly female nudes, stand silently and self-absorbed, or glide somnambulistically through enigmatic, stage-like architectural settings. Mythological themes frequently echo in Delvaux's compositions, as in *The Dryads*, which alludes to the ancient myth of perpetual youth.

▶ André Derain
View of
St. Paul-de-Vence,
1910

Oil on canvas
60.5 x 80.5 cm

In the summer of 1905, André Derain and Henri Matisse painted the brilliantly colored, expressive compositions that, when they were shown at the Salon d'Automne, brought them the name "Fauves", or wild beasts. Maurice de Vlaminck, a close friend of Derain's since 1900 and another advocate of pure color, also had a strong influence on his development. Yet by the early months of 1908, Derain had already put Fauvism aside and turned to the Cubism of Pablo Picasso and Georges Braque. Concurrently he studied the late work of Paul Cézanne, whose rendering of refracted light and simplification of spatial factors highly interested him. This was the period in which Derain's Cagnes landscapes emerged, including *View of St. Paul-de-Vence*. The picture is instructive as regards the differences between the pure Cubists and Derain.

Unlike Picasso and Braque, Derain adhered comparatively closely to visual appearances, attempting, in Cézanne's sense, to "realize the motif". Hence he never transformed nature into geometric elements, as the Cubists did. In fact, in 1911 his painting took on an even more objective character. A study of Renaissance art then led, in 1912–1914, to Derain's "Gothic period", which was determined by a reduction of palette to nuances of grey and by a structural solidification of form. The year 1918 marked the first of a series of Derain's stage designs for Sergei Diaghilev's Russian Ballet.

Derain, André

1880 Chautou,
near Paris
1954 Garches,
France

Despiau, Charles

1874 Mont-
de-Marsan,
France
1946 Paris

Assia illustrates the way in which French sculptors after 1900 overcame Auguste Rodin's Impressionist treatment of volumes, which had had a strong influence on the young Charles Despiau. Despiau met Rodin in 1903 in Paris, and in 1907 he executed several pieces in marble for him. Similarly to Aristide Maillol, Despiau replaced an evocation of movement and agitated surfaces by a new emphasis on stasis and voluminous mass. Yet his figures possessed a greater degree of individuality than Maillol's. In *Assia*, the relaxed position of the arms, the slight displacement of the feet, and the turning aside of the head, lend the figure a sense of expectancy combined with a certain grace. "Is Assia, this Artemis," asked W. George, "the quintessential image of the modern woman whose anatomy has changed due to frequenting gymnasiums and sports arenas? Whether a swimmer, dancer, or nymph, she is physically hardened. She has muscles of steel and embodies the disciplined resiliency of a creature that shrinks at no exertion of strength. Her power can be seen in the flex of her knee, the swell of her thighs, and the effortless swing of her arms. The face, though individualized, remains expressionless. This head disturbs neither the unity nor the noble harmony of a slender and sinewy body."

▶ Charles Despiau
Assia, 1938

Bronze
height 185 cm

Walter Dexel studied art history in Munich, and had no formal training as a painter. By way of Cubist landscapes and cityscapes, and the influence of Lyonel Feininger, he arrived at a Constructivist style as early as 1917–1918. The theme of architecture dominated Dexel's work from the beginning. In a number of transitional paintings which led to compositions like *The Big H* of 1924, he addressed motifs related to industry and technology, such as mine pit-heads, locomotives, airplanes, and sailing ships. By about 1923 the artist had pared down his Constructivist style to a minimum. Still, he rejected the purism of the De Stijl movement, accepting the full range of colors and – unlike Piet Mondrian – employing circular and horseshoe-shaped forms to relieve the strict horizontals and verticals.

The forms in the small-format glass-painting *The Big H* seem as if gripped solidly in the surrounding blackness. Against this heavy, neutral background the interior shapes, representing a variation on the letter "H" and anchored at three edges of the field, appear to hover at different depths within the pictorial space.

Dexel, Walter

1890 Munich
1973 Brunswick

Dias, Antonio

1944 Campina
Grande, Paraíba,
Brasil
Lives in Cologne
and Milan

▲ Antonio Dias
Caramuru, 1992

Acrylic, graphite,
malachite, gold leaf
on canvas
195 x 325 cm

Antonio Dias is one of a number of Brasilian artists who were influenced by Euro-American Conceptual Art of the 1960s and 1970s. Since the late 1960s, his work has developed from a conceptually based minimalism towards what, by analogy, might be called maximalism – spiritually inspired and fraught with symbolic reference. *Caramuru* (1992) is characteristic of Dias's most recent group of works, whose imagery oscillates between chaos and order. Although on first sight they might seem to revise the artist's earlier mathematical, scientific approach, the new works are actually based on contemporary chaos research, which over the past 30 years has influenced many areas of science – not to mention art and culture.

In Dias's view, chaos represents a wellspring of creativity, a life-giving force. His visually inventive, often playful works are composed of various natural and synthetic materials, superimposed on canvas like layers of skin. Like *Caramuru*, these works generally consist of two sections, which complement and contrast to one another. The surface of the painting is covered with acrylic paint, gold and copper leaf, and oxidized metal, producing a strangely fascinating pattern reminiscent of Action Painting, planetary landscapes, or even the natural camouflage markings on wild animals' fur.

The greatest influence on his work, Jim Dine once admitted, was his grandfather, who owned a hardware store. From the age of nine to eighteen, Dine worked there as a clerk, selling housepaints, tools, and plumber's equipment. The color tables displaying the range of paint tones struck the young Dine as "sheer jewel lists", and he was fascinated by the juxtaposition of tools with respect to the floor or to the air.

Confrontations with artists Allan Kaprow and Claes Oldenburg, in 1959 in New York, and later with Jasper Johns and Robert Rauschenberg, helped point him the way to the linkage of life and art he envisaged. The mundane objects Dine now began to employ in art were primarily the tools which had so impressed him as a boy. For instance, he would take a saw, hang it on a nail in the canvas, and confront this real object with painted renderings of it, likewise suspended from real nails. Dine's concern was to jolt our habitual perception of the outside world, but also to redefine the relationship of art to reality.

A juxtaposition of objective and aesthetic realities is also seen in *Pleasure Palette*. Pure and mixed colors have been applied in mostly circular strokes, sometimes in several layers, evoking the way that paints are mixed and jumbled on a palette. Occasionally the paint has been squeezed direct from the tube, or stippled with a sponge. In many places, especially towards the bottom, the paint has been allowed to form runs. To increase the tangibility of the surface texture, bits of paper, canvas, and plexiglass were cemented to the canvas. The only precisely defined shape on the palette is the flesh-colored heart. The lower part of the palette turns out to be transparent. At the top, a suggestion of a cloudy sky seems to reveal a view of

Dine, Jim

1935 Cincinnati, Ohio
Lives in Los Angeles and Aspen, Colorado

▼ Jim Dine
Six Big Saws, 1962

Oil, saw,
nails on canvas,
four sections
122.5 x 368 cm

Ludwig Donation, 1976

▶ Jim Dine
Pleasure Palette,
1969

Oil, glass,
paper on canvas
152 x 102 cm

Ludwig Donation,
1976

▼ Jim Dine
Angels for Lorca,
1966

Fiberglass,
aluminum,
three parts,
each 185 x 61 cm

Ludwig Donation,
1976

the outside world, which calls the objective nature of the palette into question.

The visual representation of the pleasure of artistic activity is only one side of this painting. An insight into another side was provided by Dine himself, when he said that the canvas was the last point of contact with non-reality. For him, this non-reality was part of the special mystery intrinsic to painting. By concentrating on the unreality of the canvas or painting surface, he saw an opportunity to raise the sphere of the trivial to the status of art, and at the same time, to deal with issues of identity, especially that of the identity of an object with its depiction. Thus *Pleasure Palette* indeed confronts us with several levels of meaning, and of perception.

This toying with shifting levels of reality points up Dine's penchant for Surrealism. As in René Magritte's work, Dine's representations of images within the image evoke manifold strata of reality. Yet while Magritte emphasizes the enigmatic and strange to create an awareness of the illusory nature of conventional concepts of reality, Dine accepts the manifold nature of reality and the reciprocal effects of its levels on one another as givens.

The Surrealist element is much more obviously present in Dine's enigmatic sculpture *Angels for Lorca*. The articles of clothing might allude to the equipment required by an actor in his work, or indeed by every human individual in daily life. The work was executed in 1966, thirty years after the death of Federico García Lorca (1898–1936), Spanish poet and dramatist, who was brutally murdered by the Falangists during the Spanish Civil War. The year 1966 also marked the inextricable involvement of the United States in the Vietnam War, and the rising tide of protest this set off.

Dix, Otto

1891 Gera, Germany
1969 Singen
am Hohentwiel

Otto Dix belonged to a generation of artists who, in the wake of the First World War, radically rejected bourgeois conventions in art and life by joining the Dadaist revolt.

His training began with courses in decoration and applied arts in Gera and at the School of Arts and Crafts in Dresden (1909–1914). Portraits done at the time showed the influence of Renaissance art on Dix, while his landscapes reflected an involvement with Expressionism. A first-hand experience of war then led, in 1915, to a decided, if temporary, Futurist thrust in Dix's work.

His shocking pictures of disabled veterans and of the netherworld of poverty and vice, such as *Suburban Scene* of 1922, brought the young Dresden art student early fame. During his attendance at the Düsseldorf Academy (1922–1925), which brought him into contact with the Young Rhineland group, Dix increasingly adopted the cool, objective Neue Sachlichkeit approach. After a period in Berlin, he returned to Dresden in 1927, where he held a professorship until it was rescinded by the Nazis in 1933. An emigrant within his own country, Dix continued to work, but it was not until after the war that he found some of his old verve in a late, again more expressionistically oriented style.

Dix's precise, mercilessly sharp observation and description of the world around him largely shaped the veristic stream within Neue Sachlichkeit in the 1920s. These qualities were still very much in evidence in his 1931 *Self-portrait*.

The artist's mastery of technique, and his ability to combine physiological details and attributes with psychological penetration of character, made Dix one of the major portraitists of the 1920s. In his 1921 portrait of Dr. Hans Koch, urologist, art collector, and the artist's brother-in-law, Dix shows him as the grotesque caricature of a doctor, sleeves rolled up on burly arms, surrounded by the metallically glinting instruments of his métier.

In contrast, the monumental figure of the visionary Expressionist poet Theodor Däubler is depicted with gentle irony. The massive head set against a backdrop of misty clouds, the silk scarf as contrasting accent to the bulging volumes of the body, or the set piece of elaborate public architecture (Dresden Academy on the riverside Brühl's Terrace), are all motifs that attest to Dix's sarcastic approach to the conventions of portrait iconography.

▶ **Otto Dix**
Portrait of the Poet
Theodor Däubler,
1927

Tempera on plywood
150 x 100 cm

Haubrich Donation,
1946

Speaking about his portraits, Otto Dix once noted, "Every person has his own, very special color, which affects the entire picture …

The essence of an individual is expressed in his 'exterior'; the 'exterior' is an expression of the 'interior'; that is, surface is identical to substance."

▲ **Otto Dix**
Self-portrait, 1931

*Oil and tempera on
wood, 100 x 80 cm*

Haubrich Donation, 1946

◄ **Otto Dix**
Girl in a Pink
Blouse, 1923
Mädchen mit rose
Bluse

*Watercolor and
gouache over pencil
on rough wove paper
54 x 51 cm*

Haubrich Donation,
1946

► **Otto Dix**
Suburban Scene,
1922
Vorstadtszene

*Watercolor and
pen and ink on
Bristol board
49.3 x 39.7 cm*

Haubrich Donation,
1946

► **Otto Dix**
Portrait of
Frau Dr. Koch, 1923

*Watercolor over
pencil and ink on
rough wove paper
60.6 x 48.2 cm*

Haubrich Donation,
1946

van Dongen, Kees

1877 Delfshaven,
near Rotterdam,
Holland
1968 Monaco

After arriving in Paris in 1900, Kees van Dongen began to paint in a style influenced by the Impressionists and by his idols, Henri Toulouse-Lautrec and Vincent van Gogh. By 1905 his work already evinced a highly original and unorthodox approach to color.

That year van Dongen was living at the Bateau-Lavoir studios, with Pablo Picasso for a neighbor. It was there that he became the only non-French member of the Fauves. These artists, instead of continuing to give precedence to the motif or the traditional repertoire of forms, took their cue from Paul Cézanne and relied on color to structure the composition. The illusion of depth was reduced, permitting the two-dimensional pictorial field to develop its own autonomy. In addition to schematic drawing, stylization of form, and a waiver of shadows and halftones, a preference for luminous, impasto colors was a prime trait of van Dongen's Fauvist paintings. His favorite motifs were female figures from the world of circus and fairs, for instance the frequently portrayed *Anita, the Gypsy Woman* (not to be confused with his *Portrait of Ana*). Portraiture played a major role in van Dongen's œuvre, and established his fame. By about 1912 he had ceased to apply great swaths of paint direct from the tube and begun to mix his colors but this change in technique did not lead van Dongen to entirely relinquish Fauvism. Female nudes, portraits, still lifes, and landscapes retaining obvious stylistic links with his early approach continued to predominate throughout his career.

Two of van Dongen's statements from the early phase are revealing: "Painting is not nature, it is something essentially artificial." And: "In a picture, art begins where nature and logic leave off."

▼ **Kees van Dongen**
Portrait of Ana,
c. 1905–1906

Oil on canvas
55 x 46.4 cm

After studying painting at the art school in Riga (1908–1913), Alexander Davidovitch Drevin moved to Moscow, where he held a professorship at the Higher State Institute of Art and Technology from 1920 to 1930. His work has only rarely been shown outside the Soviet Union, nor is it discussed in most Western publications on Russian art.

Drevin's landscape impressions from the Altai region, where he and his wife-to-be, Nadeshda Udalzova, travelled from 1929 to 1932, are wonderfully spontaneous and expressive in approach. *The Bathers* shows a similar emphasis, for instead of naturalistic representation Drevin has strived to capture the carefree mood of a beach scene. "To my mind," he once said, "it is not sheer seeing that is crucial to art but the emotional excitement caused by what is seen... In 1930 I began ... to paint the same Nature, but now in the studio, and it was strange: [Nature] gradually began to metamorphose into something else; it vanished, and yet the language of painting grew stronger, and a different reality emerged."

**Drevin,
Alexander**

1889 Wenden
(now Zesis),
Latvia
1938 in exile

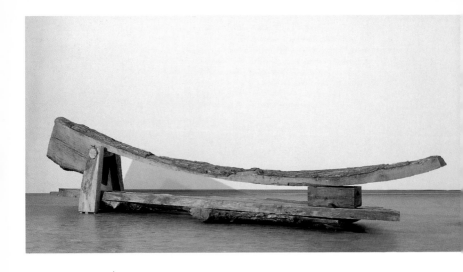

Droese, Felix

1950 Singen am
Hohentwiel, Germany
Lives in Mettmann,
Germany, and
Paesens, Netherlands

▲ Felix Droese
The Go-Between,
1985–1989
Der Zwischenträger

*Oak, tea chest and
printing block*
115 x 510 x 120 cm

Gift of
Dr. Heidi and
Prof. Dr. Friedrich
Karl Klöck, 1994

Felix Droese was a student of Joseph Beuys, who focussed on the individual's role within society, declaring "We are the revolution". Droese, who sees himself as "the concerned contemporary", has an awareness of history and political commitment that have led him to give the natural environment and religious thought a key role in his work. This expansion into the spiritual is not secondary, but represents a generating force in his imagery. A good example is Droese's 1985 *Painting of the Children Who Refuse to Eat Any More*.

The large-format triptych calls to mind a medieval altarpiece, expanded into monumental, contemporary form. The work is part of a series in which religious motifs and attitudes are distilled into imagery of great originality and power. Suffering, guilt, sacrifice, and salvation are treated in a visual vocabulary in which innovative form combines with echoes of Christian iconography. Flanked by what is apparently a male figure at the right and the figure of a pregnant woman at the left, the central panel shows two young persons, opposite one another and bent over as if in prayer. The scene is apparently set on a ship, suggesting a voyage or rite of passage. Are these children mounting a protest against their jeopardized existence, as indicated by the painting's title? Does the image, as Annelie Pohlen has said, contain "memories of the buried energies of the non-violence, liberty, wholeness, inviolability of life"?

A religious reference is also evident in *The Go-Between*, a sculpture in wood of 1985–1989. Gerhard Kolberg describes it as "a printing block lying at the base, with a stooping figure supporting himself on a staff (and distantly recalling medieval, low-relief grave slabs). Over this extends a largely unworked length of curved oak with bark, in the form of a barrier or a lever, the end of which, as in the printing process, would descend on the printing block, were it not for the insertion between the two of an old tea box which supports the upper element."

Like all of Droese's works, *The Go-Between* combines references to tradition, to the wellsprings of faith, and to the signposts of human development, with a direct involvement in contemporary social reality. His œuvre is characterized by a rawness and primitiveness that arise from authentic feeling, and by a convincing congruence between form and content.

▲ **Felix Droese**
Painting
of the Children
Who Refuse
to Eat Any More,
1985
Bild von den
Kindern, die nicht
mehr essen wollen

Pig's blood,
soil, chlorophyll,
oil on canvas
three parts,
334 x 642 cm overall

Gift of
Dr. Heidi and
Prof. Dr. Friedrich
Karl Klöck, 1992

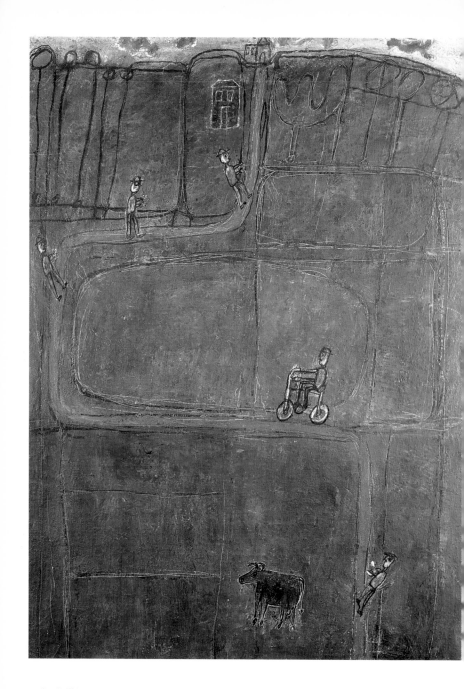

ike his biography, his initial vacillation between a business career and rt, Jean Dubuffet's work is not free of self-contradictions, protests, nd radical turnabouts. It was not until he was over forty, in 1942, nat he finally began to devote himself wholly to painting.

In the course of the decade the direction Dubuffet would take ecame apparent, in his "Foyer de l'art brut" – a collection of the brutal" pictorial products of the mentally ill, naive paintings, and raffiti. Dubuffet set out to make such primitive forms of expression vailable to fine art, as an antidote to what he called the "miseducated" sion of the public.

The spontaneous creativity of such imagery even prompted him to new conception of art: "I conceive of paintings," Dubuffet stated 1 1946, "which would be made quite simply of primeval, monotonous ud, without any variation either in tone or in color, nor even in terms f gloss or arrangement, and whose effect would depend solely on the any varieties of signs, traces, and living impressions which the hand

Dubuffet, Jean

1901 Le Havre
1985 Paris

▲ Jean Dubuffet
The Dog on the
Table, 1953
Le chien sur la table

Oil on canvas
89.7 x 116.5 cm

◄ Jean Dubuffet
Road with Men,
1944
La route aux
hommes

Oil on canvas
129 x 96 cm

Ludwig Donation,
1976

leaves when it manipulates pulp." Accordingly, Dubuffet began to employ a thick, viscous, dun-colored paint mass, into which he incised sketchy objects and figures.

A direct influence both of Art Brut and of the relief-paintings, to which critic Clement Greenberg enthusiastically referred as trashy, is found in the paintings *Road with Men* (1944) and *The Dog on the Table* (1953). The naive, doll-like character of Dubuffet's figures and objects takes on a special significance here. In the former painting, country life is viewed with an innocent, childlike vision – five men in hats, walking towards a house and a church in the woods along a winding road past a cow in the meadow.

▼ Jean Dubuffet
The Old Man
in the Desert, 1955
Le vieux au desert

Paper collage and ink
140 x 58 cm

Ludwig Donation,
1976

In *The Dog on the Table*, it is the domestic atmosphere in which the artist uses his partly naive and descriptive, partly ironic style to reveal a drastic truth. Yet a stylistic change was in the making, as may be seen from the assemblage of printed material *The Old Man in the Desert* (1955) and the canvas *The Legend of the Steppes* (1961).

In the 1950s Dubuffet employed the technique of lithography or of ink-transfer impressions to combine the negative shapes found in reality into a new reality on the picture plane. With the direct impressions, of which the artist had a large collection, he returned to a more strongly graphically oriented idiom, which in turn found entry into his oil painting In *The Legend of the Steppe*, the image is populated by seven figures of different size, some of them cut off at the picture edge. Due to their linear configuration by means of interlocking "cells" on the one hand, and the gradations of pink and blue in which they are rendered on the other, the figures stand out like symbolic, phantom actors against the homogenously hued background. In the 1961 gouache *Montparnasse Bus Station – Porte de Lilas*, Dubuffet recurred to the simplicity of children's drawings, with which he had already experimented in the early 1940s.

After exploring the rural environment, Dubuffet now began to con-
centrate on what he called the "circus of Paris", and the absurd forms
brought forth by modern civilization. In 1963, in an introduction to
a show of the resulting series of works, Dubuffet declared: "Enough of
the mystical jewel above the physical world... What now delights me
is the unreal; I am hungry for the non-real, the false life; the anti-world;
my works are striving towards unrealism."

Dubuffet's art took a new direction in 1962, when he began a
series of paintings collectively titled *Hourloupe*. These employed
an invented graphic language composed of free-form cells, whose
grotesque connotations were suggested by the onomatopoeic neo-
ogism "hourloupe", to translate the world of appearances into an
imaginary, conceptual visual idiom. As a logical consequence Dubuffet
then extended this idiom into the medium of sculpture, producing
pieces such as *Portable Landscape* of 1968. Here the structure of an

▲ **Jean Dubuffet**
Portable Landscape,
1968
Paysage portatif

*Polyurethane,
cut and painted,
14 parts*
103 x 140 x 90 cm

Ludwig Donation,
1976

◄ **Jean Dubuffet**
Montparnasse
Bus Station –
Porte des Lilas, 1961

Gouache
67 x 100 cm

Ludwig Donation,
1976

▼ **Jean Dubuffet**
The Legend of the
Steppes, 1961

Oil on canvas
114.5 x 146 cm

Ludwig Donation,
1976

actual landscape has been projected into a personal system of aesthetic formulas and signs.

 The assemblage *Generalized Activity (No. 14)* of 1976 belongs to a series of 96 works titled *Theater of Memory*, which had its point of departure in works on paper of 1975, on the theme of *Lieux abrégés*. The title refers to a book by Francis Yates, published in French as *L' Art de mémoire*, in which the author discusses the art of memory as described by Cicero and as practiced in the Middle Ages particularly. Dubuffet's image is not concerned with autobiographical recollections, but with the evocation of situations that remained real and present in his mind, and which he has condensed into a single, present-moment time frame.

▲ **Jean Dubuffet**
Generalized Activity
(No. 14), 1976
Activité géneralisée
(No. 14)

Mixed media
221 x 249 cm

Ludwig Collection

Duchamp, Marcel

1887 Blainville, France
1968 Paris

"Anartistic" was one term used by Marcel Duchamp to characterize his œuvre, which profoundly influenced the development of art in the latter half of the twentieth century. First it was his Cubo-Futurist painting *Nude Descending a Staircase*, shown at the 1913 Armory Show in New York, that, so to speak, pulled the rug out from under the art world's feet. Shortly thereafter Duchamp redoubled the shock by exhibiting "ready-mades", trivial everyday objects that expressed his nihilistic, anti-art philosophy: a *Bicycle Wheel* mounted on a wooden stool in 1913, a *Bottle Rack* in 1914, and a urinal exhibited in 1917 under the title *Fountain*.

The bicycle wheel, made in Paris, represented the prototype of Duchamp's ready-mades. The funny apparatus had no purpose, he maintained, except that of ridding art of aesthetic character. It was subsequently lost, as was the second version, made in 1916 in New York. After various replicas were produced beginning in 1951, Duchamp in 1964 had a new bicycle wheel built, based on old photographs of the original and a blueprint. With his ready-mades, Duchamp declared traditional aesthetic values in art null and void. It was not the work of the artist's hand that determined the artistic status of an object, but solely the fact that the artist selected it and declared it to be art.

Subsequently Duchamp collected all of his previous works, in the form of miniature reproductions and replicas, in a case covered

▲ Marcel Duchamp
The Portable
Museum,
1935–1941/1966
La boîte en valise

*Wood, paper, glass,
plastic, photographs;
83 pieces in box
covered with
red leather
41 x 37.8 x 10.5 cm
One of 75 copies
of Series F*

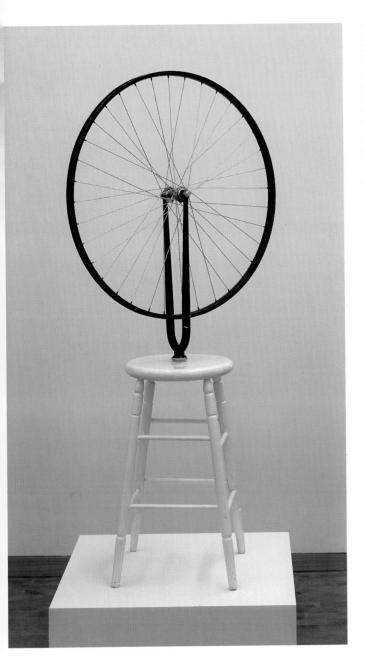

◄ **Marcel Duchamp**
Bicycle Wheel,
1913/1964
Roue de bicyclette

Cycle fork with wheel,
mounted on a stool
height 126.5 cm
Copy number 7
of an edition of 8

Donation of the
Association for
Modern Art at the
Museum Ludwig,
Cologne, 1986

with red saffian leather. The idea first occurred to him in 1935. It may have been impending war and emigration, the necessity of packing up his artistic belongings to take them with him, that prompted the *Portable Museum*. Be this as it may, it is a truly original invention that expressed all of the artist's disdain for the original work of art and his ironic detachment from his own œuvre.

The first *Boîte en valise* was executed in Paris in 1941. It contained everything of importance he had done, declared Duchamp – everything, one should add, except the enormous influence and stimulus his work would exert on future developments and approaches, from those of Richard Hamilton, Jasper Johns, Robert Rauschenberg, and Claes Oldenburg ("soft sculpture"), to Object and Pop Art, all the way down to Conceptual Art (whose cerebral nature was anticipated by Duchamp's *The Bride Stripped Bare by Her Bachelors, Even*). All of these trends owed their aesthetic stance to Duchamp's pioneering theory and practice.

Duchamp-Villon, Raymond

1876 Damville, France
1918 Cannes

Sculptor Raymond Duchamp-Villon still stands in the shadow of his famous younger brother, Marcel Duchamp, inventor of the "ready-made". Yet he was a gifted innovator, and one of the first to introduce the machine aesthetic into modern art. In 1911, Duchamp-Villon was a co-founder with Juan Gris, Alexander Archipenko, Fernand Léger, Albert Gleizes, and his brothers Marcel Duchamp and Jacques Villon, of the Cubist-influenced Groupe de Puteaux.

Seated Female Figure of 1914–1915, like *The Horse* of the same year, can be counted among Duchamp-Villon's major sculptures. It gives the impression of being additively composed of separate parts, the limbs having been simplified in the Cubist manner to their basic structure. The statuette resembles a lay figure of the type artists use to study human anatomy and movement. Duchamp-Villon has translated the doll into a precisely and smoothly functioning mechanized creature.

Yet the impression of cold inanimateness is counteracted by the gilding, which lends the bronze seated figure an archaic, hieratic dignity. The pose, reminiscent of Rodin's *Thinker*, is marked by an unstable equilibrium, a detectable tension between movement and calm. Like the Futurists of the day, Duchamp-Villon attempted to incorporate the kinetic factor into sculpture.

**Raymond
Duchamp-Villon**
Seated Female
Figure, 1914–1915
Femme assise

Bronze, gilded
Height 73 cm

Ludwig Collection

◀ **Raoul Dufy**
Harbor, c. 1925
Port

Oil on canvas
24 x 41 cm

Dufy, Raoul

1877 Le Havre,
France
1953 Forcalquier,
France

Initially Raoul Dufy attended the Ecole des Beaux-Arts, in his home town of Le Havre. After going to Paris to study under Pierre Bonnard at the Ecole Nationale Supérieure des Beaux-Arts, where Henri Matisse, Albert Marquet, and Henri-Achille Friesz were fellow-students, Dufy launched in 1905 upon a successful Fauvist period under the influence of Matisse. By 1908, his acquaintance with Georges Braque and admiration for Paul Cézanne had brought a more geometric thrust to Dufy's style.

Drawing on stylistic elements from Fauvism and Cubism, Dufy developed an inimitable, if much imitated style that he continued to employ almost unaltered throughout his career. It was characterized by joyful color, sketchy, flowing contour, and flat color planes in interplay with a rhythmic framework of rapidly rendered graphic abbreviations.

In the 1920s and 1930s Dufy attempted to liberate painting from drawing by divesting color of objective detail and relying solely on the effect of pure hues. His sketch *Harbor* dates from the beginning of this period. Also titled *Steamships and Sailboats*, it is stylistically and iconographically comparable to Dufy's large canvas *Ship Festival in the Harbor* of 1925. In his late years, the artist concentrated on "color tints", paintings composed in gradations of a single color.

Edgar Ende
The Barque, 1933
Die Barke

Oil on canvas
110 x 150 cm

Ludwig Collection

The realm of magic and mysticism exerted a lifelong fascination on Edgar Ende. Already in his early youth he joined with friends to found a secret society, Der weisse Schwan (The White Swan), devoted to a study of metaphysical and occult phenomena. Ende's exploration of a spiritual world beyond sensory perception was never-ending, and he was continually on the search for new visions. In the solitude of his darkened studio he attempted to achieve a state of mental emptiness, voiding his mind of all mundane concerns and concentrating on nothingness. The images that appeared to him in this state were rapidly recorded, but it was not until some time later that he translated a selection from his numerous sketches into oil on canvas. These works reflect a mysterious and melancholy realm of forbidding landscape vistas, inhabited by anxiety-ridden, disturbed human beings. *The Barque* (1933) shows just such a scene: a boat, packed with people, being pulled across a dark lake by a hovering sphere.

When asked about the intention behind his pictures, Ende invariably replied, "I didn't think anything as I was painting them. You're supposed to do the thinking." His imagery truly does stimulate mental associations and personal interpretations on the part of every viewer.

Ende, Edgar

1901 Altona,
Germany
1965 Baiern, near
Ebersberg

◀ **Xenia Ender**
Spatial Composi-
tion, 1918

*Oil on cardboard
48.5 x 56.5 cm*

Ludwig Collection

Ender, Xenia

1895 St. Petersburg,
Russia
1955 Leningrad
(now St. Petersburg)

Born into a family of artists, Xenia Ender and her siblings Boris, Maria,
and Juriy formed an active and creative group in Mikhail Matiushin's
painting class. They tended less towards the philosophical approach
of Kasimir Malevich's Suprematism and the subsequent Constructivist
movement than towards the organic abstraction represented by
Matiushin and his wife, Elena Guro. Their interest focussed on the
primeval forces of nature, and the energies, colors, and molecular
structures they saw embodied there. Between 1918 and 1923 Matiushin
developed the theories of SORWED (Vision – Knowledge), which
advocated an expansion of human visual perception, both in everyday
life and in art.

"The sense of the earth's gravity vanishes," wrote A. Povelichina,
"the experience of a new, spatial dimension emerges, a space in which
there is no up or down or sides. A new feeling takes shape . . . Earth
and heaven intermerge, because the visible sky is not an empty space
but the most vital body in the universe." This cosmic experience goes
far to explain Ender's *Spatial Composition* (1918), which gives the
impression of an energy-charged, luminous vortex of cloudlike colored
forms and intertwining lineatures, turbulently rotating and then coming
to rest.

> **Erbslöh, Adolf**
>treet with
Jew Building, 1910
itrasse mit Neubau

)il on cardboard
1.5 x 54.5 cm

At the age of seven, Adolf Erbslöh came with his family to Germany, where they settled in Barmen, now a suburb of Wuppertal. In 1904, fter a brief stint at the Karlsruhe Academy, he went to Munich o continue his studies at the academy there.

Erbslöh's *Street with New Building* belongs to the Expressionist arly phase of one of the co-founders of the Munich New Artists' Asso-iation, to which Franz Marc also belonged until 1911, when he helped stablish the Blauer Reiter (Blue Rider) group. Erbslöh's landscapes and ityscapes are rendered in saturated, luminous color. In the present omposition, the street with its housefronts, skeleton of a new build-ng, vehicles and pedestrians are seen from a very high vantage point, nd merely suggested by means of broad, nervous brushstrokes. Expansive fields of color predominate over line. The tension created between the red wall, yellow patches of sunlight, and passages of ntermerging green and blue is psychologically evocative, and seems o lend the colors a life of their own. The small painting is very probably dentical with *Construction Site*, which Erbslöh showed in 1911 at the Sonderbund exhibition in Cologne. That it represents Ohmstrasse in Aunich is known from the fact that the painting was exhibited under hat title there in 1947.

Erbslöh, Adolf

1881 New York
1947 Irschenhausen,
Germany

Ermilov, Wassily

1894 Charkov,
Ukraine
1968 Charkov

▶ **Wassily Ermilov**
Experimental
Composition, 1922

Wood relief, painted
70.7 x 46.4 cm

Ludwig Collection

▼ **Wassily Ermilov**
Memorial Plaque,
Day of Lenin's Death,
21 January 1924,
6:50 a.m., 1924

Metal and enamel
on wood
79 x 79.5 cm

Ludwig Collection

Wassily Ermilov was one of the protagonists of the avant-garde in Ukraine, a region long considered an artistic satellite of Moscow. In the late 1920s, as the avant-garde in the big cities was growing increasingly paralyzed, the Charkov journal *The New Generation*, whose contributors included Mikhail Matiushin and Kasimir Malevich, became the last publication in the Soviet Union to provide information on artistic activities in the West, for instance on the Bauhaus.

Ermilov was at the center of these developments. He put his art in the service of his political convictions, believing wholeheartedly in its function to educate and enlighten the entire Russian people. Nevertheless, Ermilov also developed a highly original version of Constructivism, using sparing typographical means to produce compositions of great effect. A famous example is *Memorial Plaque, Day of Lenin's Death, 21 January 1924, 6:50 a.m.*. The rigorous geometry of the forms is offset by the brilliant red; the frontality and flatness of the composition exude a quiet dignity recalling that of icons, as indeed this is a Lenin icon couched in the new visual language of the revolution.

On the fifth anniversary of the October Revolution in 1922, Ermilov created an upright-format relief that conveyed a political message by avant-garde means. On the right of *Experimental Composition* we see a semi-abstract figure representing a reformist guard with rifle, and on the left a hammer and sickle and the designation "5 years". The schematic depiction has the character of a three-dimensional poster, completely in keeping with Soviet propaganda during the early phase of revolutionary art. When this idiom grew increasingly unpopular with the powers that were, Ermilov's work fell into disgrace as well. This may well explain his turning, in the late 1930s, to a neoclassical style.

Ernst, Max

1891 Brühl, near
Cologne, Germany

1976 Paris

▼ Max Ernst
Crucifixion, 1913
Kreuzigung

*Oil on cardboard
mounted on
hardboard*
50.5 x 43 cm

Haubrich Collection

While a student of philosophy, psychology, and art history at Bonn University (1909–1912), Max Ernst came in contact through his friend August Macke with the Rhenish Expressionists in 1910. As an artist Ernst was self-taught, but he had close ties with many key representatives of the avant-garde, including Guillaume Apollinaire, Robert Delaunay (whom he met in 1913), and Hans Arp (1914).

An example of Ernst's expressionist early phase is *Crucifixion* of 1913. Critics of the period found iconographical affinities with Matthias Grünewald in this painting. "The center of the medium-format picture is empty", wrote O. Metzger. "The central axis is intersected by the forked cross on which the dead Christ hangs with widely outstretched arms. The fingers of the right hand are spread in agony. One is put in mind of the nail-pierced, cramped hands in the Isenheim Altarpiece, and of artists' discovery of Grünewald prior to the First World War." A much more plausible iconographical comparison, however, would be with El Greco's *John the Baptist*. Ernst had seen this painting in the *Blauer Reiter Almanach*, published on the occasion of the group's first exhibition in 1912, in Munich. The composition of the background and the figure drawing in *Crucifixion* are strikingly similar to El Greco's depiction. A further parallel is seen in the treatment of the heavenly signs.

Ernst's expressionist view of *Laon* was done in 1916, when he was stationed as a war artist near the French city. The composition may well have been inspired by one of Delaunay's *Laon* paintings of 1912, which Ernst possibly saw at a Delaunay show in Cologne in 1913.

After returning to Cologne, Ernst joined forces in 1919 with Hans Arp and Johannes Baargeld to found the Dada group Zentrale W/3 and launched into numerous Dada activities. In August 1922,

LAON

Max Ernst
Laon, 1916

Oil on canvas
65.6 x 100.5 cm

Haubrich Donation,
1946

rnst moved to Paris, where he found a new circle of like-minded
rtists and intellectuals in the Paris Dadaists. His friends Paul and
;ala Eluard invited him to share their apartment, where artists and
vriters regularly gathered to air their ideas and read poetry, organize
ongresses and exhibitions – and pave the way for one of the most
ignificant streams in twentieth-century art: Surrealism. This was
he period when Ernst began one of the key programmatic paintings
f that movement, *Au rendez-vous des amis*. It was no coincidence
hat his first large-scale canvas (130 x 195 cm) was a group portrait
hat recurred to a form of depiction known since the Renaissance,
he friendship painting. Ernst depicted his friends gathered on a rocky
eak in the midst of snow-covered mountains, during an eclipse
f the sun. As in the stiffly ceremonious portrait photographs of
ne day, each person is given a number which refers to his or her
ame.

Several compositional elements have apparently been borrowed
om Raphael's famous *La Disputa*, in the Vatican. Others recall
atures of *The Last Supper* by Leonardo da Vinci, in whose art and

1 René Crevel
2 Philippe Soupault
3 Arp
4 Max Ernst
5 Max Morise
6 Fédor Dostojewski
7 Rafaele Sanzio
8 Théodore Fraenkel
9 Paul Eluard
10 Jean Paulhan

◀ **Max Ernst**
The Friends'
Rendezvous, 1922
Au rendez-vous
des amis

Oil on canvas
130 x 195 cm

11 Benjamin Péret
12 Louis Aragon
13 André Breton
14 Baargeld
15 Giorgio di Chirico
16 Gala Eluard
17 Robert Desnos
Decembre
1 9 2 2

▶ Max Ernst
The Virgin
Spanking the
Christ Child before
Three Witnesses:
André Breton,
Paul Eluard,
and the Painter,
1926
La Vierge corrigeant
l'Enfant Jésus
devant trois témoins:
André Breton,
Paul Eluard
et le peintre

*Oil on canvas
196 x 130 cm*

▼ Max Ernst
The Leaf, 1925
La feuille

*Pencil frottage with
watercolor wash,
heightened with
white tempera
43 x 26 cm*

writings Ernst had immersed himself. Such covert references to great art of the past were intended to emphasize the significance of the depiction. But its most striking feature is the strange gesticulations indulged in by the figures. The Surrealists, Ernst seems to be saying, have their own rules and secret language. Much speculation has been devoted to ferreting out the secret code used here – is it that of freemasonry, cabbalism, or spiritism? Actually it reflects experiences of the artist's boyhood in Brühl, where his father was an instructor at a home for the deaf and dumb. Everyone there was fluent in sign language and the manual alphabet. It was a matter of course for Ernst to link the idea of an arcane sign language with an early, formative experience. The picture's message may be enciphered, but it is clear nonetheless: The elect have gathered on the highest peak, during a solar eclipse (which from time immemorial has been a symbol of epochal change and historical watersheds). Masters of an arcane language, they are on familiar terms with past greats, and lead the way for those to come – the endless column of as yet anonymous followers extending to the horizon behind them.

In 1925, during a stay in Brittany, Ernst discovered the technique of frottage. An early example is *The Leaf*, a preliminary design for

Histoire naturelle, a portfolio of 34 frottage-drawings published in 1926. The leaves represented are neither naturalistically imitated nor shown in the context of their natural environment. The character of their surroundings, and their physical inter-relationship in space, remain indefinite, an additional provocation to the viewer's habitual perception. To produce just such visual provocation was in fact a prime aim of Surrealism.

The year 1926 also saw the emergence of *The Virgin Spanking the Christ Child before Three Witnesses: André Breton, Paul Eluard, and the Painter*. Here the realms of the sacred and profane literally and resoundingly clash. The motif itself can be traced back to the iconographical theme of "Venus Chastizing Cupid". Ernst's anticlerical attitude is clearly reflected in the painting, with which he settled his accounts with his strict Catholic upbringing.

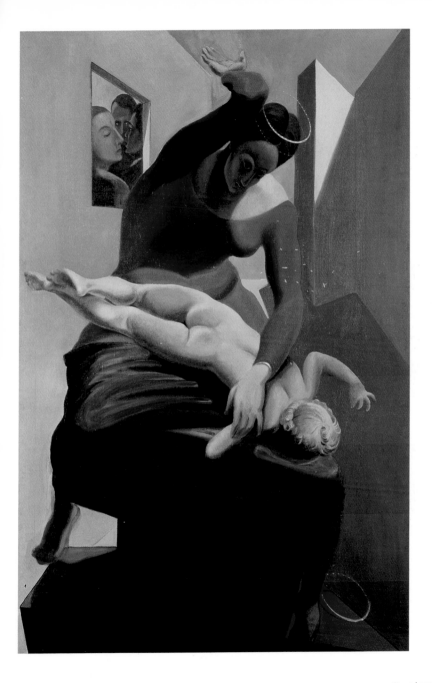

► **Max Ernst**
Spring in Paris, 1950
Printemps à Paris

Oil on canvas
115 x 89 cm

Loan of the
State of
Nordrhein-Westfalen

▼ **Max Ernst**
Appeasement, 1961
Apaisement

Bronze
68 x 31.5 x 24 cm

Shell-Flowers, a canvas of 1929 evocative of biological and geological phenomena, gives Surrealistic associations free rein.

After the war, Ernst's style grew increasingly geometrical in character. This is seen in *The Birth of Comedy* (1947), whose title recalls Friedrich Nietzsche's essay *Die Geburt der Tragödie aus dem Geiste der Musik* (The Birth of Tragedy Out of the Spirit of Music), and whose forms were in part suggested by the masks in ethnographic collections. During this period, which Ernst spent in Sedona, Arizona (1946–1950), he became intensively involved in non-European, primitive cultures. Already interested in ethnography during his university days, he now began collecting wooden sculptures from Papua-New Guinea, objects from the Easter Islands, and North American Indian art. The angular facial features in the Cologne painting recall the giant heads of the Easter Islands. *Spring in Paris* was done in 1950, after Ernst's return to Europe. "We seem to be confronted with a figurine", wrote H. Keller, "whose shape is intermediate between a water-worn stone and a thick-stemmed aquatic plant, with exaggerated constrictions and projections. It stands before a window-like aperture, and on its head, resembling a huge leaf, the expression of a sleeping face is just detectable". *Song of the Cicadas to the Moon* dates from 1953. According to W. Krüger, it represents a vision of a landscape devastated by an atomic explosion, and repopulated by insects. The 1961 bronze sculpture *Appeasement*, a dual-figure piece built up of disk shapes, reflects Ernst's increasing employment of geometric forms, yet it also still echoes the Surrealist device of employing existing objects, or *objets trouvés*.

In the 1960s America was inundated by photographic imagery to an extent never before known – advertising photos blown up to billboard proportions, photo-reportages filling the glossy magazines, ad spots and films flickering across movie and television screens. Many artists of the day involved themselves with such mass-produced, artificial imagery, including Hyperrealists like Richard Estes. Yet instead of merely reproducing existing imagery and realities, Estes raised the issue of truth and appearances, addressed the relationship between reality, photograph, and painting, between perception, representation, and image.

Estes' paintings are based on photographs he took himself. Though the motifs may appear banal at first sight, actually they are carefully selected and composed slices of the New York cityscape. *Food Shop* shows the artist's penchant for playing on the visual phenomena of reflection and refraction, transparency and opacity, the effects of light and visual superimpositions, interferences, and reflections on smooth surfaces like glass, metal, and lacquer – a world in which as much is concealed as it is revealed, a world of images within the image.

As much as *Food Shop* may recall a cool, pure, sharp-focus reproduction of a single photograph, it was actually constructed in a complex process of visual montage aimed at eliciting a certain atmosphere intended by the artist. Estes transferred various photos of different focal length to various areas of the canvas, but all with an equal sharpness, such that every object, no matter how far or near, appears with a heightened, almost surreal precision, and frequently even from multiple points of view. The artist added appropriate objects, but eliminated human figures.

The pervading silence of the composition puts one in mind of the empty city squares in Giorgio de Chirico's metaphysical painting. Even transitory and momentary phenomena such as the flickering of neon signs are rendered with a metallic sheen that seems to freeze them in time. Estes amplifies the illustrative factors intrinsic to photography and employs them consciously to the ends of painting. With his cool, clear, documentary hyperrealism, the artist transcends the technical, impersonal possibilities of photography, and proves once again that painting is an irreplaceable human activity.

Estes, Richard

1936 Kewanee,
Illinois
Lives in New York

◄ Richard Estes
Food Shop, 1967

Oil on canvas
166 x 123.5 cm

Ludwig Donation,
1976

Exter, Alexandra

1882 Belostok,
near Kiev, Russia
1949 Fontenay-
aux-Roses, Paris

► Alexandra Exter
Composition (Genoa),
c. 1912–1914

Oil on canvas
115.5 x 86.5 cm

Ludwig Collection

▼ Alexandra Exter
Costume Design for
Herodes, c. 1917

Oil on canvas
81 x 57 cm

Ludwig Collection

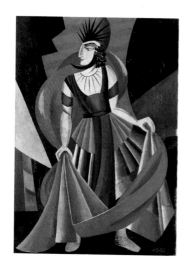

Alexandra Exter's unique style, which eludes theoretical classification, and her spiritualized, poetic treatment of color, led art critics early on to assign her a special place in twentieth-century art. What distinguished Exter's work from that of other Russian women artists of the day was pointed out by her biographer, J. Tugendhold, in 1922: "In their case, the masculine aspect achieves a certain rustic crudity, which partially explains their penchant for Russian primitivism (icons, popular pictorial motifs, gingerbread, etc.). Alexandra Exter's work, in contrast, has been refined by contact with Western European culture. This artist has seen, become familiar with, and assimilated a great deal."

Exter played an important role in the cultural life of Kiev prior to the First World War, and due to her wide contacts, she was highly respected by the Russian avant-garde as an authority on artistic developments in the West.

In 1908 she studied at the Académie de la Grande Chaumière in Paris, where her predilection for strong colors caused her instructor to refuse to continue teaching her. In France Exter worked alongside Cubist painters and poets, including Fernand Léger, Pablo Picasso, Guillaume Apollinaire, Robert Delaunay, and the Futurist painter Ardengo Soffici. Her friendship with artist David Burliuk subsequently led to contacts with the Russian Cubo-Futurist movement.

Composition (Genoa), dating from about 1912–1914, shows the Cubist and Futurist influence in an exemplary way. Despite the facetting of planes, spatial relationships are still suggested, by means of overlapping architectural motifs silhouetted against a bay just discernable in the background. At the right, colored shapes coalesce into a dynamic, abstract composition.

The symmetrical arrangement of forms in *Cubo-Futurist Composition (Harbor)* from about 1912–1914, the interpenetrating shapes that accumulate to form a central pyramid flanked by diagonals evoking the wings of a stage set, and the flat arch above, all inadvertently suggest a proscenium stage. This painting too contains reminiscences of Italian cities, such as the round

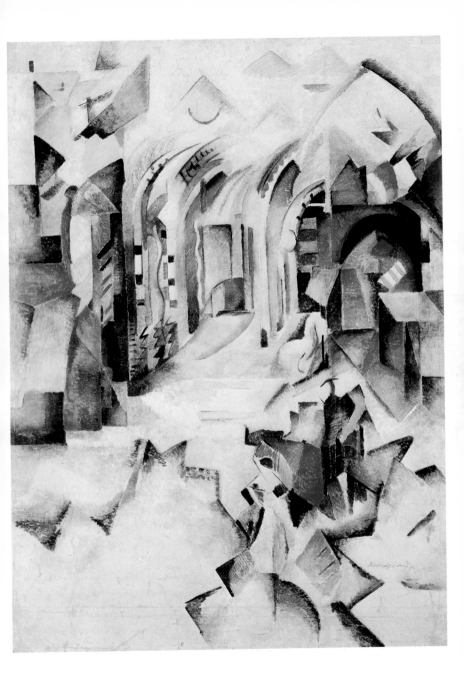

▲ Alexandra Exter
Cubo-Futurist
Composition
(Harbor),
c. 1912–1914

Oil on canvas
129 x 200 cm

Ludwig Collection

cupola and sunlit campanile in the middle, or the architectural fragment with volutes at the left.

The work *Dynamic of Color* (1916–1917) belongs to the artist's Suprematist phase. The freedom of the composition, the lavish palette, and the dynamic movement that seems to develop in a spiral from the center outwards, again reveal Exter's inimitable touch.

This form of Suprematism verging on the baroque was to be superseded, after 1920, by a more rigorously Constructivist approach. Before this changeover, however, Exter designed stage sets and costumes for a 1917 performance of Oscar Wilde's play *Salomé*, directed by A. Tairov at the Moscow Chamber Theater. It was a tremendous success, not least on account of the artist's innovative designs. The costume sketches included *Costume Design for Herodes*, now in the Museum Ludwig, Cologne. With her sets and costumes Exter introduced an unprecedented vitality into the performance, using colors to convey an emotional message within the dramatic medium.

▶ Alexandra Exter
Dynamic of Color,
1916–1917

Oil on canvas,
89.5 x 54 cm

Ludwig Collection

Fabbri, Agenore

1911 Barba,
near Pistoia, Italy
Lives in Albisola,
Capo and Milan

Agenore Fabbri went in 1932 to Florence, to study at the Accademia
delle Belle Arti. In 1947 he met Pablo Picasso in Vallauris, France,
where Picasso had just begun to devote his attention to ceramics as
well. Fabbri showed Picasso his ceramic sculpture of a female figure,
which the great artist spontaneously dubbed *Woman of the People*.

From an initial naturalism Fabbri's art developed over the course
of the next few years towards increasing expressiveness. His terracotta
sculptures of fantastic creatures and, later, visionary evocations of what
the future held in store, covertly conveyed the aggressions, anxieties,
and foibles of twentieth-century man. Fabbri's sculptures were the result

of a deeply held commitment to humanity, his identification with the poor and dispossessed given three-dimensional form. The fact that human beings look upon their fellows as competitors, or at the worst as enemies, found compelling expression in Fabbri's works. *The Hound of War* (1949–1950) embodies in an almost surrealistic way the horrors and consequences of war, which dumb creatures must suffer as much as man. The emaciated, cruelly wounded body of the dog becomes a universal symbol of the sacrifices caused by violence and need. In a psychological sense, Fabbri's art verges on behavioral research, and its exaggeration and distortion of form links it with Surrealism.

After making his early terracottas at the La Fiamma company in Albisola, Fabbri shifted his production in 1970 to the Sant Giorgio workshop in Albisola Mare. The human figure still continued to be the focus of his work, even down to the tiny figurines that clamber up the sides of the most recent pieces.

All of Fabbri's terracotta sculptures have a polychrome surface treatment. Whether brilliant and glossy or matte and tone-in-tone, the hues serve to underscore the message of the sculpture and heighten its effect.

◄◄ **Agenore Fabbri**
The Hound of War,
1949–1950
Il cane della guerra

Terracotta, painted
34 x 24.5 x 34 cm

Loan of
VAF-Foundation,
Switzerland

◄ **Agenore Fabbri**
Woman of the
People, 1947
Donna del popolo

Terracotta, painted
58 x 18 x 21 cm

Loan of
VAF-Foundation,
Switzerland

Fahlström, Öyvind

1928 Sao Paulo, Brazil
1976 Stockholm

▼ Öyvind Fahlström
Roulette, Variable
Painting, 1966

*Oil on photograph,
paper, vinyl,
cardboard;
magnets*
152.5 x 166 cm

Ludwig Donation,
1976

Taking his point of departure in the hackneyed forms and symbols of comic strips, Öyvind Fahlström, a protagonist of New Realism, developed an original style of composite painting in which he criticized the mechanisms of modern consumer society and the marionette-like behavior of those who live in it with an irony reminiscent of Dada and Surrealism.

The collage-painting *Roulette, Variable Painting* evokes the manipulability of modern man by means of two central figures whose poses can be changed at will. These are surrounded by partially alienated, partially overpainted motifs from newsreels, war and adventure movies (*Tarzan*), and illustrated magazines. The media continuously expose us, consciously and subconsciously, to two key topics: sex and violence. As Fahlström once said, Picasso reacted to the atrocity of Guernica by using expressionist formal distortion to heighten the emotional effect of the figures in his painting. Fahlström, for his part, attempted to "orchestrate data" to rouse viewers' emotional response and understanding. He asked himself whether such imagery could be made both sensually and aesthetically effective, whether a pattern of facts could become poetry. Whether he succeeded, Fahlström concluded, was for the viewer to decide.

In his later works, to which the varicolored *World Maps* belong, the artist began to delineate and describe a "conglomeration of figures" which took on clearer definition from work to work. With the introduction of a completely colored background, Fahlström stated, he had embarked on a kind of historical painting in which all types of data and ideas – historical, economic, poetic, current – were depicted in a homogeneous style. For the sake of clarity he recorded and visually coded both the data and their interpretations. Shades of blue designated the U.S., violet tones Europe, red to yellow the Socialist countries, and green to brown the Third World.

► **Fang Lijun**
Group Two, No. 2,
1992

Oil on canvas
200 x 230 cm

Ludwig Collection

Fang Lijun belongs to the youngest generation of China's contemporary avant-garde. His imagery is populated with larger-than-life, mostly bald hybrid figures apparently devoid of all individuality. The loneliness of the individual in the crowd is Fang's principal theme. Although his paintings are based on photographs of friends and sometimes even self-portraits, frequently made during vacations or excursions, Fang depersonalizes faces and figures, amplifying this effect by means of baldness and an artificially colored complexion.

Born in China, the most populous country in the world, the artist is familiar not only with the masses but with the repressive levelling characteristic of the Chinese version of Communism. Are the figures he depicts laughing or crying? The question must remain open. For as the artist says, "These people are like rolling balls, which, when they hit the slightest obstacle, immediately change direction; or they are like stationary balls, which begin to roll on the slightest incline. Humans are neither cruel nor kind; their behavior always depends on the conditions under which they act."

Fang Lijun

1963 Handan,
Hebei Province,
China
Lives in Fuyuanmen,
near Beijing

Lyonel Feininger's parents were both musicians, of German descent. They sent their son to Germany to study music, but he decided on painting instead. Feininger attended the Hamburg School of Applied Arts, then transferred in 1888 to the Berlin Academy. In 1892 he left for Paris, to study in the life class of Colarossi. Feininger's earliest drawings were primarily depictions of fantastic cities, denizens of a shadowy realm, and fairy-tale illustrations.

Back in Berlin in 1893, he began a successful career as a caricaturist and satirist for the humor magazines *Ulk* and *Lustige Blätter*. Feininger's confrontation, in Paris in 1906–1908, with Cubist painters and with Robert Delaunay, founder of Cubism-derived Orphism, led to the development of his own, characteristic style, which came to fruition in about 1911–1912. Other influences included J. M. W. Turner, Georges Seurat, and – with regard to certain motifs – Caspar David Friedrich.

For Feininger, who never became a Cubist, the visual language of Cubism nevertheless embodied a long-sought confirmation of his search, for he had always been driven by a "passionate yearning for rigorous spatial design – without painterly intoxication."

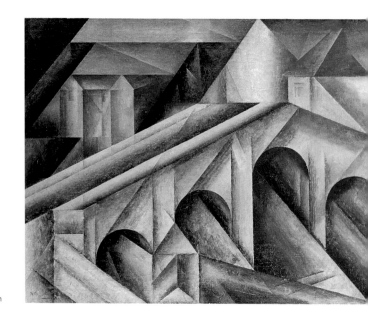

▶ **Lyonel Feininger**
Bridge III, 1917
Brücke

Oil on canvas
80.5 x 100 cm

Haubrich Collection

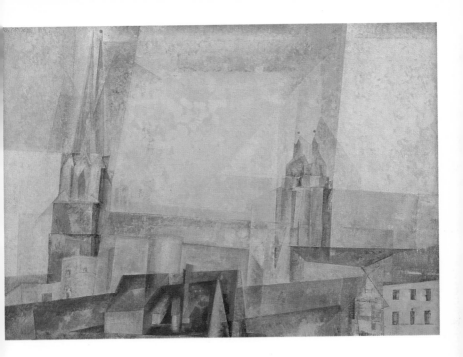

The concretization of form which he shared with the Cubists always remained allied to real space and light in Feininger's work. The transparency of the planes and their delicate colors lent his paintings a lyrically romantic atmosphere and depth, despite their strict, geometric articulation. Architectural motifs were Feininger's most frequent theme. Between 1912 and 1919 he painted a series of six bridge pictures, which beyond the comparatively solid composition *Bridge III* gradually led to a dissolution of forms.

In 1919 Feininger became one of the co-founders of the Bauhaus, where he taught and headed the graphic-art workshops until the school was abolished in 1933. His years at the Bauhaus, where he enjoyed the close friendship of Paul Klee and Wassily Kandinsky, were the most prolific in Feininger's career. A commission from the city of Halle led to several sojourns there during the years 1929 to 1931. *Towers Over the City*, the last of the artist's eleven views of Halle, shows the "Roter Turm" or Red Tower (destroyed during World War II) and the "Marktkirche" or Market Church.

▲ **Lyonel Feininger**
Towers Over the City
(Halle), 1931
Türme über der
Stadt (Halle)

Oil on canvas
88.3 x 124 cm

Haubrich Collection

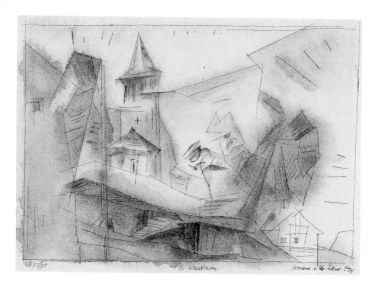

When his art was declared "degenerate", Feininger returned to America in 1937. The shock of ostracism was so great that he was not able to paint for two years. Yet as the themes of his work from 1941 onwards indicate, Feininger still cherished fond memories of Germany.

The relationship of intellect to psyche, analysis to intuition, was a central focus of Pavel Filonov's theory of art, and accordingly, his compositions should be viewed as symbolic and philosophical statements. The complex, multilayered works of his early period, to about 1913, of which *Horsemen* of 1911 is a good example, contain reminiscences of the old frescoes, teeming with figures, in Russian churches. The color scale of the painting, based largely on gradations of white, red and blue, is characteristic of the artist's œuvre.

Anticipating a favorite theme, the motifs in *Humans and Fish* (c. 1914–1915) – cells, fish, crystals, and dismembered limbs – seem as if viewed through some diabolical microscope. For the anatomy of the body parts, Filonov consulted a surgical handbook. As a teacher, the detail-obsessed, persistent, and thorough artist recommended biology lectures to his students, encouraging them to dissect their "object of study" and paint it as if with a scalpel. With the anthropomorphic fish in the foreground of the painting, Filonov apparently alluded to the fact that he considered humanity decadent, and not necessarily higher on the evolutionary scale than the lower species.

Filonov, Pavel

1883 Moscow
1941 Leningrad
(now St. Petersburg)

▲ **Pavel Filonov**
Horsemen, 1911

*Cardboard,
mixed media,
mounted on wood
43 x 63 cm*

Ludwig Collection

▲ Pavel Filonov
Humans and Fish,
c. 1914–1915

Watercolor on paper
25.5 x 39.5 cm

Ludwig Collection

Like many of his paintings, *Humans and Fish* actually turns evolution around, making it lead back from *homo sapiens* to simpler forms of life, such as fish, snails, and worms. Filonov's pictures can be read inch by inch, for they contain endless stories; yet when viewed from a distance, they coalesce into larger, clearly articulated units, with a core of meaning around which are ranged marginal episodes.

A further fundamental element in his work is the combination of the human head – frequently his own self-portrait – with the labyrinth of the city. As M. Lamac writes, "It is as though we were present during the continual finding and losing of the artist's self, in his perpetual striving to find the center of the labyrinthine universe... The artist enters this labyrinth, merges with it, dissolves in it, in order to grow familiar with it, and finally to return to himself." The majority of Filonov's compositions with heads, including *Head* in the Museum Ludwig, Cologne, date to around 1924. Among its most striking features are the nose extended to almost snout-like proportions, and the eyes that practically merge with the texture of the background.

▲ **Pavel Filonov**
Head, 1924

Oil on paper
49.2 x 39.2 cm

Ludwig Collection

Flavin, Dan

1933 New York
1996 New York

Dan Flavin is considered one of the pioneers of sculpture in light. In 1963 the self-taught artist made fluorescent lamps the sole component of his art, though he also continued to draw – mainly with an eye to recording his ideas. Since he entirely excluded the personal touch and always insisted on the absolute clarity and logic of the structures underlying his work, Flavin was grouped with the Minimal artists. Later he set his strict geometric arrangements and "non-rational" serial pieces in relationship to the surrounding space, thus creating environments. American sculptor Donald Judd, a friend of Flavin's, has named three main aspects of his work: The fluorescent tubes as light sources; the light they project into the surrounding space or cast on adjacent surfaces; and the arrangement or placement on surfaces of the lamps or fixtures. These, Judd added, primarily represented a certain visible state of a phenomenon.

Monument 7 for Tatlin is the first of a total of 39 works in the series titled *Pseudo-Monuments*, which is devoted to the Russian Constructivist artist Vladimir Tatlin (1885–1953). Flavin used the prefix "pseudo" to indicate that his "monuments" were not executed in traditional materials such as marble or bronze, but consisted of ordinary fluorescent lamps. The numbering of the pieces was arbitrary, the digit "7" merely standing for the number of tubes employed in this case.

The piece exhibits a symmetrical arrangement, the upward-striving, rocket-like configuration of the seven cool white gleaming tubes being a symbolic allusion to the *Letatlin* flying machine designed in 1930–193' by the Russian painter and sculptor. This dramatic arrangement, said Flavin in 1965, served as a basis for the young tradition of a revolution in sculptural approach that gripped Russian art just 40 years ago. Like Tatlin, Flavin seems out to integrate science and technology into art. While Tatlin attempted this with a glider (that never got off the ground), Flavin has created a sort of "ready-made" sculpture that combines physical substance with immateriality (light rays).

▶ **Dan Flavin**
Monument 7
for Tatlin,
1964–1965

*Seven fluorescent
tubes of various
lengths, mounted
on metal frame
300 x 58 cm overall*

Ludwig Donation,
1976

Fontana, Lucio

1899 Rosario
di Santa Fé,
Argentina
1968 Comabbio,
near Varese, Italy

▶▶ **Lucio Fontana**
Spatial Concept,
Nature, 1959–1960
Concetto spaziale,
Natura

Bronze
74 x 80 cm

Loan of
Karsten Greve

Lucio Fontana
Spatial Concept,
Nature, 1959–1960
Concetto spaziale,
Natura

Bronze
46 x 56 cm

Gift of
Karsten Greve

▶ **Lucio Fontana**
Harlequin, 1949
Arlecchino

Ceramic, polychrome
55.5 x 35 x 25 cm

Loan of
VAF-Foundation,
Switzerland

▶▶ **Lucio Fontana**
Columbine, 1949
Colombina

Ceramic, polychrome
55 x 30 x 21 cm

Loan of
VAF-Foundation,
Switzerland

Lucio Fontana, son of a Milanese sculptor, was born in Argentina, where from 1921 to 1927 he assisted in his father's stonemasonry shop. On his second trip to Milan in 1925, Fontana entered the Accademia di Brera to study sculpture until 1929. The following year already saw him represented at the Venice Biennale, with two sculptures.

In 1931 Fontana executed numerous terracotta reliefs with human silhouettes seemingly in a process of dissolution, abstract sculptures that combined a Constructivist approach with figuration. These were followed in 1936 by a series of terracottas made in Tullio Mazzotti's ceramic workshop in Albisola, and in 1937 by works in porcelain executed at the Sèvres factory near Paris. That same year Fontana had his first one-man show of ceramic works, at Galerie Jeanne Bucher-Myrbor in Paris. He met Joan Miró, Tristan Tzara, and Constantin Brancusi.

After working in a non-objective vein during the early 1930s, Fontana returned in about 1936 to a more representational approach, creating sculptures that stood in the tradition of the Italian Novecento

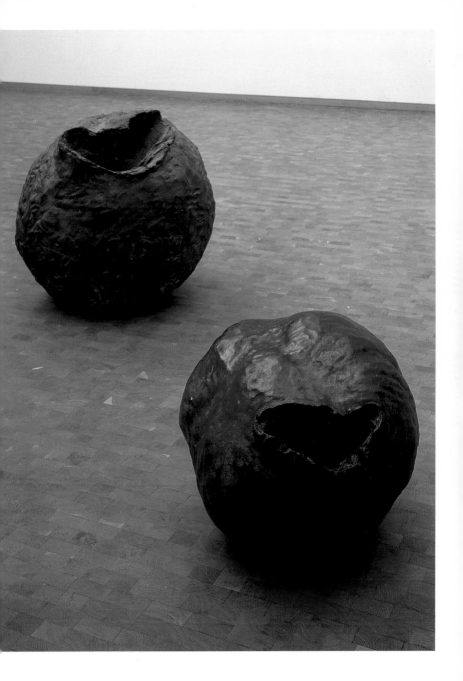

group around Medardo Rosso and Arturo Martini. He also clearly relied on certain design elements of Futurism, a style that attempted to find means of representing movement in art.

In 1939 Fontana returned to Argentina, where he worked in Buenos Aires, Rosario de Santa Fé, and other places. From 1940 to 1946 his work was primarily figuratively oriented, if with an increasing proportion of expressive elements. Finding that the commercial success of his figurative work assured him of a living, Fontana soon began to concern himself with more experimental directions.

► **Lucio Fontana**
Spatial Sculpture,
1957
Scultura spaziale

Bronze
150 x 52 cm

Ludwig Donation,
1976

The artist's series of polychrome terracotta sculptures, their Futurist-inspired dance movements leading almost to a dissolution of form, is exemplified by *Harlequin* and *Columbine*. Based on two popular Commedia dell'arte characters, the pieces were done after Fontana's return to Italy in April 1947. Later that year he signed the first *Manifesto spaziale* (Manifesto of Space). There followed, in 1949, the artist's first perforated canvases, which included *Spatial Concept: Marriage in Venice*. As *Spatial Sculpture* of 1957 shows, Fontana was able to translate his concept of letting space penetrate matter into the terms of bronze sculpture. The *Concetto Spaziale* series was expanded from 1958 to 1966 by a group collectively titled *Tagli*, or incision paintings. With a sure hand, the artist made diagonal to vertical cuts in monochrome canvases to reveal the infinite space behind the painting surface. The *Spatial Concept: Expectation* sequence superbly embodies Fontana's aim not to depict space illusionistically but to lend it actual presence within the painting.

In summer 1959, working in Albisola, Fontana modelled a series of terracotta sculptures titled *Natura*. That same year he participated in the Kassel Documenta II, and in the Fifth Sao Paulo Biennale. A few examples of the *Spatial Concepts: Nature* done in Albisola were installed on the Paseggiata degli artisti, in Albisola Mare. Several of these terracottas were also cast in bronze. Of irregular spherical shape, their richly textured surface exhibits great gaps and incisions intended to permit the surrounding space to enter and become an integral part of the sculpture. In his last interview, Fontana explained, "Well, if any of my discoveries was of any importance, it was the 'hole.' By 'hole' I mean breaking through boundaries, such as those set by a picture frame, and at the same time the fact that everyone is free in their understanding of art. I didn't make holes in order to ruin the picture. Quite the contrary: I made holes to find something different... I'm thinking of another dimension. The 'hole' is this dimension... I make a hole in the canvas in order to put the received visual forms behind me, the painting and the traditional definition of art. I escape the prison of the smooth flat surface in a symbolic sense, but also in a material one."

◄ Sam Francis
Composition in
Blue, 1954
Composition bleue

Oil on canvas
97 x 130 cm

Loan of
pro-Museum-
Stiftung,
Frankfurt am Main

► Sam Francis
Untitled,
c. 1956–1959

Mixed media and
collage on paper
55.3 x 37 cm

Gift of
Dr. Andreas and
Lore Becker, 1979

Francis, Sam

1923 San Mateo,
California
1994 Los Angeles

Sam Francis studied medicine before, bedridden for two years by
a back injury, he taught himself to paint. In 1950 he went to Paris,
joining the circle of American painters who had gathered around
Canadian artist Jean-Paul Riopelle. Though his early works still showed
Abstract Expressionist influence, Francis soon arrived at the original
idiom, inspired by Zen Buddhism, seen in the white and grey abstract
compositions of the period.

By about the middle of the 1950s this monochrome approach had
been superseded by work in luminous color, Francis' *In Lovely Blueness*
paintings. *Composition in Blue* belongs to this series of painterly trans-
formations of experiences of nature, which were inspired by Hölderlin's
poem *In lieblicher Bläue*. The paint consistency grew thinner, allowing
the forms within the gridlike structure of the composition to flow into
one another and interpenetrate.

In making the collage *Untitled*, Francis used a simple technical
device, dripping, spraying, and pouring the paint on the sheet of paper,
then folding it to produce a symmetrically patterned result. This
process and the visual effect of the mirror-image texture relates the
painting to Rorschach tests, images used in psychology to probe
subconscious mental associations.

Freundlich, Otto

1878 Stolp, Germany
1943 Majdanek, Poland

▼ Otto Freundlich
Female Bust, 1910
Frauenbüste

Plaster, tinted
52 x 34 x 29 cm

Haubrich Donation, 1946

Painter and sculptor Otto Freundlich played a key role in the exchange between German and French art in the early twentieth century. Before beginning to practice art himself, Freundlich studied art history in Berlin, Munich, and Florence (1905–1906). His first stay in Paris (from 1908) already brought him into contact with the artists working at the famous Bateau Lavoir, as well as with Robert Delaunay and the Cubists. Freundlich's early, abstract, strongly ornamental compositions (1911) were followed, after his return to Germany, by expressionistic figurative depictions which, under the impression of his war experiences, were pervaded by religious and symbolic allusions. The desolate postwar political and economic situation in Germany caused Freundlich, like many others, to embrace socialism.

As G. Aust writes, socialism "hoped to improve the world by liberating humanity and encouraging fraternity among men. In a community of this type [Freundlich] saw the fulfillment of a higher, indeed a universal law. To render symbolically visible the workings of these forces was the express aim of his art."

During the 1920s Freundlich oscillated between Germany and Paris, belonging not only to the Abstraction-Création group, but to the Sturm and the Novembergruppe, and to the Group of Progressive Artists in Cologne. The period brought a return to a rigorous, geometrically precise approach to composition. When the Nazis came to power, Freundlich was among those artists branded as "degenerate". He was arrested in France in 1943 and, being of

► **Otto Freundlich**
Green-Red, 1939
Grün-Rot

Oil on canvas
65 x 54.5 cm

Jewish extraction, was deported to Majdanek concentration camp
in Poland. His composition *Green-Red*, from the late Paris period,
well illustrates Freundlich's attempt to symbolize a universal reality
by means of tensions among colors and forms. To this end he employs
a contrast between rectangular and arc-shaped "building blocks",
brushstrokes in opposing directions, impasto paint application, and
a wide range of color.

The monumental *Ascension* exemplifies the artist's work in
sculpture, which developed from an initial reliance on Cubist models
to complete abstraction. Above the base and a narrow intermediate
element rises a mass of bulging, interpenetrating volumes. The organic
energies evoked here, as if striving towards the light, are augmented by
the agitated texture of the surface, which opens it out to the surround-
ing space. The title is symptomatic of Freundlich's conception of
sculpture: "The tenseness of contour in a work of sculpture," he stated,
"is an expression of the expansive force of the energies latent within
three-dimensionality."

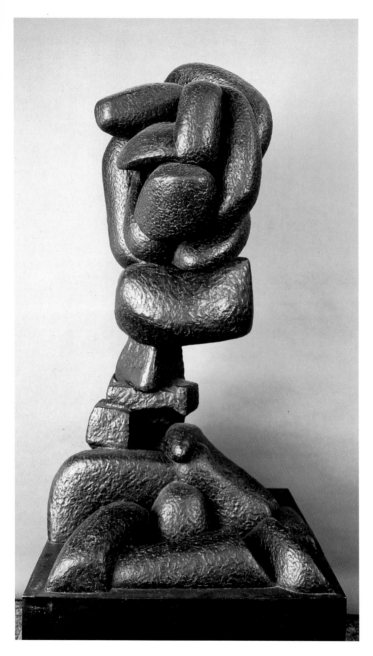

Katsura Funakoshi
Water without Sound, 1995

Painted camphor wood, marble
Height 89 cm

Ludwig Collection

Since the early 1980s, a series of figures in camphor wood has emerged from the tiny studio of Japanese artist Funakoshi. They are naturalistically depicted, clad in contemporary garb, partially painted, and life-sized.

Water without Sound is one of these figures, whose faces reveal an unusual strength of character. Their dignified presence seems surrounded by an intense, if enigmatic aura, an effect which is amplified especially by the eyes, made of marble and inset into the wood. Despite the artist's emphasis on the texture and feel of the material of which they are made, each half-figure is a faithful likeness of the model, a portrait sculpture. *Water without Sound* dominates the space in which it stands, emanating a calm which invites meditative contemplation. Withdrawn within itself, the figure draws us into it, as to an island of stillness and tranquillity.

Funakoshi, Katsura

1951 Morioka, Japan
Lives in Tokyo

◄ Naum Gabo
Construction in
Space (Crystal), 1937

Plexiglass
57.2 x 57.2 x 46 cm

Gabo, Naum
(Naum Pevsner)

1890 Bryansk,
Russia
1977 Middleburg,
Connecticut

Like many Russian intellectuals of the day, Naum Gabo went to Western
Europe for his education. The well-founded knowledge that made him
the principal theoretician of Constructivism was acquired in polytechnical
training, studies in art history (with Wölfflin and Worringer), and through
contacts with the avant-garde in art (The Blue Rider and the Cubists).

After returning to Russia in 1917, Gabo began to design, among
other works, kinetic, motor-driven sculptures (he himself preferred
the term "constructions"). In the *Manifesto of Realism* jointly issued
by Gabo and Antoine Pevsner in 1920, they maintained that "every
thing has its own, intrinsic, essential image." A scientific analysis of
the faculty of perception led to a definition of the means of art as
comprising color, line, volume, and mass. "Color is accidental", stated
Gabo and Pevsner. "It has nothing to do with the intrinsic essence
of bodies. We maintain that depth is the sole form of painterly and
plastic space. We reject mass as a plastic spatial form in sculpture."

Construction in Space (Crystal) is part of a series of similar works
in plexiglass.

Swiss artist Franz Gertsch attended the Max von Mühlenen school of painting in Berne from 1947 to 1950. A realist, Gertsch works from slides projected onto the canvas. But unlike photorealist painters, who often spray-paint their work to produce completely smooth surfaces devoid of all personal touch, Gertsch uses a small brush to stipple the paint, dot by dot, onto his huge canvases, thus lending them a painterly character.

Gertsch is not concerned with pure imitation or reproduction. Rather than showing reality as it is, his sharp-focus, extreme close-ups lend the scenes depicted an ambiguity and strangeness much greater than they would possess when seen from a distance. *Marina Making Up Luciano* shows Swiss artist Luciano Castelli, a member of the Transformer group of transvestite artists, being prepared for a performance by his then-girlfriend, Marina. The great degree of enlargement and extreme close-up view lend the scene a compelling immediacy, vitality, and fidelity to life.

Gertsch, Franz

1930 Mörigen, near Berne, Switzerland Lives in Rüschegg, near Berne

▲▲ **Franz Gertsch**
Marina Making Up Luciano, 1975
Marina schminkt Luciano

Acrylic on unprimed cotton 234 x 346.5 cm

Giacometti, Alberto

1901 Borgonovo
1966 Chur

▶ **Alberto Giacometti**
The Nose, 1947
Le nez

Bronze
38 x 7.5 x 66 cm

Ludwig Collection

▼ **Alberto Giacometti**
Seated Man, 1953

Pencil
50.5 x 32.5 cm

Alberto Giacometti received his first training from his father, artist Giovanni Giacometti. After brief studies at art schools in Geneva, he went to Paris in 1922 and spent five years in the sculpture class of Emile-Antoine Bourdelle. Despite this traditional schooling, Giacometti was influenced by modern sculpture from an early date, his initial works bearing affinities with Cubism and Constantin Brancusi. By 1929 Giacometti was creating open, cage-like, sometimes movable structures whose composition employed elements from Constructivism and whose details recalled the formal idiom of Surrealism. This Surrealistic period in Giacometti's work ended in about 1935. In the 1940s he went on to develop an approach in which figures, or parts of figures, were pared down to emaciated, elongated, often veritably skeletal configurations with roughened, as if tormented surfaces. After the war, apart from his work in sculpture and the large-scale projects which recognition had brought, Giacometti devoted himself to oil painting and printmaking as well. His drawings were based on complex skeins of line, gradually and rhythmically condensed into an image, and heightened by painterly halftones made with fingers or stump.

The Nose combines structural elements with a male bust rendered with extreme distortion and a highly textured, as if dissolved surface. The bronze head is suspended within a rectangular box made of thin rods. The nose, elongated to an almost sword-like shape, protrudes from the enclosed space, and the mouth seems open in a scream. The elongated neck provides compositional – and physical – balance. Sculptural and psychological factors are wonderfully interwoven in this work.

Giacometti had already begun to experiment with box and cage configurations before the war. The interplay between a spatial enclosure of objects, which in view of the open grid implies a mental, psychological process, and an actual penetration of this illusionistic barrier, was also something that intrigued the Surrealists.

The French title of *Place* can connote place, plaza, or city square, but the subtitle is straightforward: *Composition with Three Figures and a Head*. Though the four elements indeed define a situation in space,

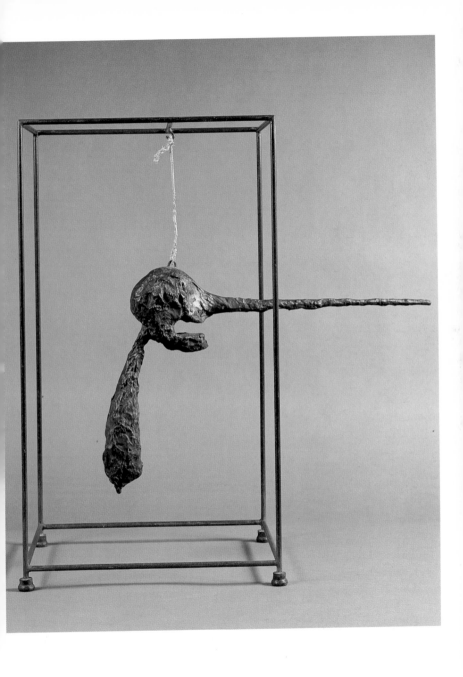

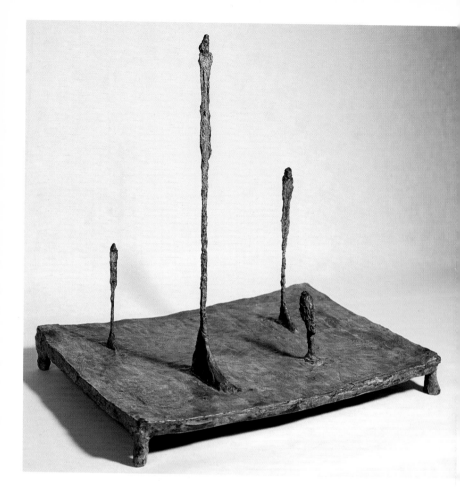

▲ **Alberto Giacometti**
Place, 1950

Bronze, painted
56.2 x 56 x 42.5 cm

Ludwig Collection

t is not so much a topographically localizable "place" as an intellectual concept. The figures occupy a common space, which suggests the emergence of social relationships. The definition of a "place", we might conclude, is predicated on human presence and initiative. The figures stand on a rectangular, slightly convex plate, an odd configuration that neither evokes the site of an actual event nor merely functions as a static base. It serves as a locale for an imaginary, imaginative process.

British artists Gilbert & George made their debut in the late 1960s as "living sculptures". Since the early 1970s the two have produced large-format, multipartite photographs in which their self-portraits play an important role. In *Drunk with God* (1983) Gilbert & George provide a new interpretation of the redeemer, a god that bears more resemblance to Bacchus, god of wine and sexual potency, than to the Judeo-Christian Almighty. "The word 'drunk' in the work's title," wrote Wolf Jahn in 1989, "should be understood in its literal connotations of liquid flow, flux, animation. In more than one sense, fluids and fluidity stand in direct relationship to the emergence of life. The flux of life corresponds to the divine process – nothing other than the Creation of Man."

Sexuality plays just as significant a part in this monumental image as in many other of the artist's works. Sex is something to celebrate, they seem to say, not only as a source of new life but as an act of personal liberation and sheer joy. Alcohol, by liberating us from acquired inhibitions and morality, can help us to enjoy the pleasures of the body for their own sake.

After all, alcohol is just as much of an escape as religion, and can lead to a state of ecstasy. Although *Drunk with God* has often been called blasphemous, it is nothing of the sort. Actually it brings people closer to God (if not to the God of the Vatican). The work depicts God as someone with whom one can celebrate and let loose, not as a judge or arbiter to be feared.

Drunk with God is a self-portrait, but no longer one of the traditional kind in which the artist represents himself standing at the easel or in the shadow of his model, as in John de Andrea's studio scene. Here the artist is the central protagonist of the work, indeed of an entire œuvre. Just as the superstars – Marilyn Monroe, Elvis Presley, Mick Jagger – entered the museum by way of Pop Art and its practitioners, artists

Gilbert & George

Gilbert Prousch
1943 Dolomiten,
South Tyrol
Lives in London

George Passmore
1942 Devon,
England
Lives in London

▲ **Gilbert & George**
Drunk with God,
1983

*Overpainted
black and white
photographs
482 x 1102 cm*

Ludwig Collection

DRUNK
WITH
GOD

themselves have advanced to the status of stars; the modern art museum has become a privileged locale for their ultimate apotheosis. Gilbert & George exploit this situation to openly address topics that are usually tabooed in the world of art: homosexuality and drugs. The revelation of the stars' private sphere becomes a sociopolitical weapon. Yet unlike other artists of the 1980s and 1990s who concern themselves with sexuality, such as Jeff Koons or Robert Mapplethorpe, Gilbert & George do not wish to be seen as provocateurs, but as advocates of a new frankness and openness with respect to marginal social groups.

Girke, Raimund

1930 Heinzendorf,
Silesia, Germany
Lives in Cologne

Since 1958, Raimund Girke has employed only white, greys, or black in his paintings. In 1964 he began to concentrate exclusively on a serie of works in white, which he termed "white spaces", or "fluctuations". All of these shared in common a highly subtle use of various gradations and nuances of the non-color white.

Twelve Horizontally Graded Progressions of 1971 consists of twelve horizontal bands of white gradations which delicately modulate the surface. Girke is concerned with investigating the interrelationship of two aesthetic concepts: texture or structure, and monochromy. "Structure is predicated on differentiation of color," explains J. Ahrens. "Strict monochromy precludes structure, in that only a pure, unarticulated white plane would remain. This, so to speak, is point zero. Hence, Girke's problem is to develop pure monochromy to the point of structure by means of a minimal differentiation of hue." Fine modulations of the non-color white are especially difficult to perceive as substantial changes in color, and yet they evoke in the viewer an impression of meditative calm and a transcendental space.

Domenico Gnoli
hoe in Profile, 1966
carpa di profilo

il on canvas
0 x 139.5 cm

Ludwig Donation,
976

"For me, the everyday object itself, enlarged by the attention bestowed
on it, is more significant, beautiful, and terrible than any invention or
imagination could have made it," Domenico Gnoli once said. "It tells
me more about myself than anything else, filling me with fear, nausea,
and delight. This single object in front of me, alone in front of me,
with me alone, right opposite me like I would wish to have someone
who really interests me, in a good light so I can see them better:
what more can you ask? For me – quite certainly – nothing."

Gnoli's words convey the same message as his art: the deper-
sonalization of human beings in the contemporary era. The paintings
are dominated by objects, represented either in whole or in detail.
A good example is Gnoli's series of six *Shoe* paintings from 1966–1969.
As in *Shoe in Profile*, the footwear is expanded to monumental propor-
tions, shows no trace of wear, and is lent almost sculptural presence
by a suggestion of perspectival depth. When Gnoli depicted people,
it was without a face or from behind, usually in close-up and cropped.
It was not the person but the pattern the clothing that fascinated him.
Just as the shoe stands abandoned and isolated, Gnoli's ornament-
clogged compositions give a disquieting impression of emptiness,
despite the abundance of detail they contain.

**Gnoli,
Domenico**

1933 Rome, Italy
1970 New York

Götz, Karl Otto

1914 Aachen
Lives in Wolfenacker

▲▲ **Karl Otto Götz**
Painting of
9/14/1954, 1954
Bild vom 14. 9. 1954

Oil on canvas
90 x 120 cm

Loan of
Cologne
Art Association

Karl Otto Götz, representative of the German stream of Art Informel, studied at the Aachen School of Applied Arts from 1931 to 1934. In the 1930s and 1940s he retained a semi-abstract, figurative approach which was not superseded until 1948–1949. In 1949 he became a member of the Cobra group, and in 1952 a co-founder of Quadriga in Frankfurt.

That year also marked the appearance of Götz's first abstract expressionist works, composed of rhythmic swaths of paint that, in keeping with the action painter's philosophy, emerged spontaneously from the automatism of the subconscious mind. Götz's dynamic compositions, such as *Painting of 9/14/1954* illustrated here, were executed within a matter of seconds. "Rapidity", the artist noted, "was a necessary means for me to reduce the degree of conscious control to a minimum. This rapidity also gave rise to blends of form, passages and textures (streaks and spatters) which I could never have produced using a slower, more controlled process."

Bruno Goller
Various Pictures,
1955
Verschiedene Bilder

Oil on canvas
170 x 140 cm

Ludwig Donation,
1976

Bruno Goller discovered the magic of simple objects and numbers in the 1920s, long before trivial, everyday things were raised to aesthetic status by the more ironic and detached Pop artists. "Goller was out of step with the times throughout his career," concluded Werner Schmalenbach, who by no means wished this to be taken in a negative sense.

With his invariably empathetic and painstaking depictions of hats and umbrellas, flowers and cats, coffee grinders and cups in muted colors, Goller never figured among the more spectacular protagonists of modernism, but quietly and consistently went his own way. As in *Various Pictures* (1955), he isolated objects and figures from their accustomed context, juxtaposed and frequently separated them by means of painted frames, alienated them – but without any attempt to establish Surrealistic interrelationships. The volume of objects and their characteristic surface textures were abandoned in favor of flatness and defined color planes. Despite their decorative tendency, Goller's paintings convey a unique vision of a highly personal milieu.

Goller, Bruno

1901 Gummersbach,
Germany

Lives in Düsseldorf

Goncharova, Natalia

1881 Laditshino,
Tula, Russia
1962 Paris

The majority of the works of Natalia Goncharova in the Ludwig Collection, Cologne, are considered key exemplars of artistic developments in early-twentieth-century Russia. She was one of the many creative women who actively contributed to the advance of modern art, and who by no means stood in the shadow of their male colleagues. Together with the brothers David and Vladimir Burliuk, with Mikhail Larionov and Kasimir Malevich, Goncharova was a steadfast advocate of Neo-Primitivism, a movement to renew Russian culture which was inspired by folk art and bore fruit not only in painting but in literature and music as well (for example in the work of Igor Stravinsky or Maurice Ravel).

Still Life with Tiger Skin (1908) is a programmatic painting in this regard. Rendered in the warm, luminous hues of Fauvism, it is a composition of extraordinary power. It also contains a striking contrast between two images from quite different cultural contexts: a Japanese *kabuki* play with a sword-wielding samurai warrior, and a sarcophagus relief from classical antiquity.

Greek art, and by association the entire European tradition, is used to evoke enlightenment and rationalism. The tiger skin, in contrast, stands for the primeval vitality that many artists in the early years of the century associated with primitive art and non-European cultures. As Goncharova wrote in the introduction to her one-woman show in Moscow in 1913, "I rediscovered the East . . . and I shook the Western dust off myself."

The *Portrait of Larionov* (1913) marks the next phase in the artist's development. It was the outstanding work in the Rayonist exhibition of that year, and probably represents the sole surviving example of a portrait in this style. Rayonism was an attempt to capture the emanations of a personality – as opposed to those of inanimate things – by evoking the vitality of the face above all. In Goncharova's portrait, this is achieved by means of chromatic rays and sweeping diagonals, creating the impression of a man of great force and charisma. Despite its abstract tendency, those who knew Larionov considered the portrait a quite faithful likeness. Recently a new interpretation has been advanced by Ellen Thormann, who sees a dual portrait of Larionov and Goncharova in the depiction.

In 1916 Goncharova and Larionov accompanied Sergei Diaghilev and his Russian Ballet to San Sebastián in Spain. Deeply impressed

▶ Natalia
Goncharova
Portrait of Larionov,
1913

Oil on canvas
105 x 78 cm

Ludwig Collection

Ill. p. 245:
Natalia
Goncharova
The Orange Vendor,
1916

Oil on canvas
131 x 97 cm

Ludwig Collection

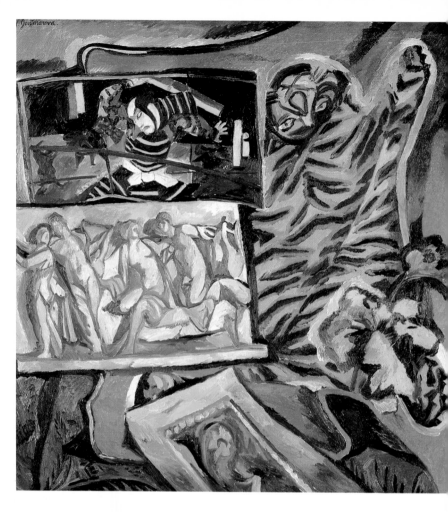

by the country, Natalia Goncharova began to paint Spanish motifs. *The Orange Vendor* (1916) was done immediately after this journey, probably in connection with costume designs for Diaghilev productions of two Spanish ballets, *Espagna* by Maurice Ravel and *Triana* by Isaac Albéniz.

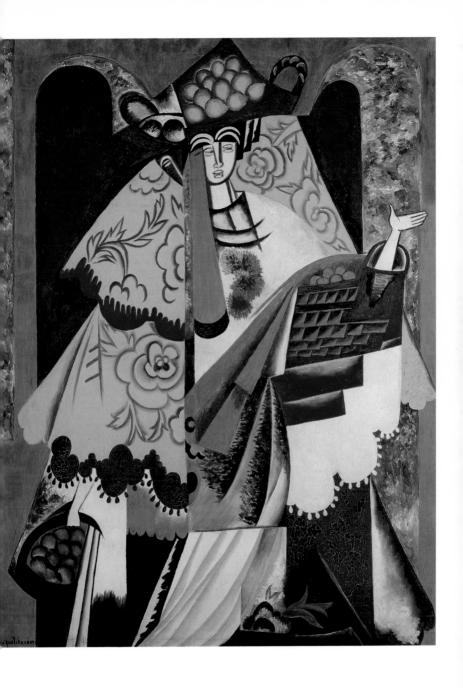

Graeser, Camille

1892 Carouge, near
Geneva, Switzerland
1980 Wald, near
Zurich

▼ Camille Graeser
Yellow-Blue Volume,
1:1, 1/18 Shift, 1974
Gelb-Blau-Volumen
1:1, 1/18 bewegt

Acrylic on canvas
120 x 120 cm

Graeser was a representative of the movement known as Concrete Art. From 1913 to 1915 he studied interior decoration at the Stuttgart School of Arts and Crafts, as a master pupil of Bernard Pankok. With Ludwig Mies van der Rohe, he collaborated on the design of a pioneering housing project, the Weissenhofsiedlung, Stuttgart, in 1926–1927.

In parallel with his professional work in interior and industrial design, Graeser produced drawings and paintings that ranged from a semi-abstract figuration to a rigorous geometric abstraction. After moving to Zurich in 1933, he began to concentrate exclusively on painting. In 1938 Graeser joined the Alliance, a group whose nucleus was formed by Max Bill, Verena Loewensberg, and Richard Paul Lohse. To describe their geometric, Constructivist approach they chose the term "concrete", as advanced by Theo van Doesburg in 1930 and defined by Max Bill in 1936. The salient point was that works of concrete art did not arise from a process of abstraction from reality, but were based on a direct employment of the "concrete" pictorial elements of plane, line, volume, space, and color. These elements stood only for themselves, and had no referential character.

Graeser's compositions of geometric forms developed in the direction of an increasing reduction to rectangles and squares, accompanied by increasing complexity of structure. By about 1974, what the artist

described as the "folded-out square" had become his principal theme. The series of paintings devoted to this theme, done during the final years of Graeser's life, included *Yellow-Blue Volume 1:1, 1/18 Shift*, illustrated here. One-eighteenth of the total picture area, a yellow square, has been detached from the symmetrical yellow and blue plane and, as it were, folded over into the blue. Thanks to its displacement, the yellow square dominates the entire composition, evoking movement and introducing a momentous kinetic factor.

Gotthard Graubner's *Color-Space Bodies* have the effect of manifestations of the infinite, for they are images that seem to expand and encompass the viewer, inducing a mood of meditative contemplation. Color is an emanation of light, and the space penetrated by light waves is immeasurable – but Graubner's corporeal imagery captures their vibrations and returns them to the eye.

Anticipating the *Color-Space Bodies*, Graubner in 1968 filled rooms with mists of color, then turned to canvas to produce a series of still planar *Color-Spaces* and the haptic *Color Bodies* or *Cushion Paintings*. In the *Color-Space Bodies* it is the paint itself – veils of hovering, flowing, visually advancing and receding, modulated color incredibly rich in delicate nuances and transitions – that functions as the space-creating element.

Graubner works on canvas spread out on the floor, saturating it with layers of oil paint thinned with turpentine or acetone, frequently spraying it on irregularly and spreading the paint with circular motions of a long-handled broom as he moves around the canvas.

Graubner, Gotthard

1930 Erlbach, Vogtland, Germany
Lives in Düsseldorf

▲ **Gotthard Graubner**
Color-Space Body, Diptych, 1977
Farbraumkörper-Diptychon

Oil on canvas over synthetic wool
248 x 248 x 15 cm each

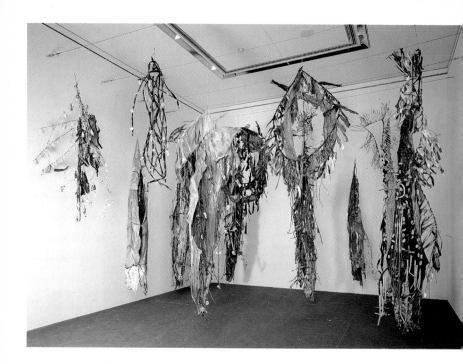

Graves, Nancy

1940 Pittsfield,
Massachusetts
1995 New York

▲ Nancy Graves
Shaman, 1970

*Steel, latex, gauze,
oil paint, marble
powder, acrylic
Ten objects of
various size
Overall dimensions
of installation
425 x 425 x 365 cm*

Ludwig Donation,
1976

In 1968–1969, Nancy Graves made a sensational entrance on the art scene by exhibiting camels – life-size, and at first glance, real camels. Since then such sculptures have come to figure as prototypes of a stream in art some critics have dubbed "clue detection". Underlying the camel sculpture, and indeed all of Graves's works, is a painstaking study of the clues and traces left by the objects of her artistic involvement in the history of both nature and mankind. Rather than realistic depiction, Graves was concerned with the process from which form emerges. The resulting works combined objective reference with abstract structures.

In *Shaman* and *Ceridwen, out of Fossils*, the artist succeeded in her aim of penetrating "into the inside" of a sculpture. Both pieces essentially rely on what she termed an "inside-outside" situation. *Shaman* consists of ten suspended configurations – two of them circular – made up of feathers, bones, birds' wings, insects, and ropes resembling dried skins. The components, according to Graves, were intended to be viewed simultaneously as integral and as divided units.

This description of the aesthetic and perceptual aspect of the artist's work also applies to *Ceridwen, out of Fossils*. As far as its content is concerned, Graves, with reference to *Shaman*, once noted the piece's link with the culture of the Kwatziutl, an Indian tribe of the American Northwest that became extinct in the nineteenth century. She discovered that in every so-called primitive culture there existed a person who played a psychological, religious and medical role – a medicine man or healer. Graves set out to represent this cult in terms of an abstract object, each of the ten parts of which related to the shaman's figure or clothing.

Ceridwen is the old Welsh name for the goddess of death and immortality. The reference to fossils in the title indicates that the piece was based on Graves's own 1969 sculpture of an Ice Age skeleton, which in turn referred to archaeologists' discovery of a fossilized pleistocene camel. The artist challenges us as viewers to concern ourselves with the relationship between our own age and the prehistoric past, to become cognizant of the primeval sources of technological civilization.

Gris, Juan
(José Victoriano
Gonzales)

1887 Madrid, Spain
1927 Boulogne-
sur-Seine, France

Spanish painter, sculptor and graphic artist Juan Gris attended the
Madrid School of Decorative Arts from 1902 to 1904. In 1906 he
moved to Paris, and found a studio in the Bateau Lavoir, where
Pablo Picasso and Guillaume Apollinaire were neighbors. Initially
Gris worked as a caricaturist for the satirical journal *Charivari*.
In about 1911 he gave up his decorative, Art Nouveau-inspired
style and turned his attention to Analytic Cubism, within which Gris
developed an original, emotionally reserved style with a tendency to
monochromy.

Instead of succumbing to the influence of Picasso or Georges
Braque, Gris took his point of departure in the compositional
structure developed by Paul Cézanne, whose work he intensively
studied and creatively ramified. Like the two great Cubists, however,
he experimented with the collage technique, using materials such as
newspaper clippings or shards of mirror in place of painted imitations
(though limiting this technique mainly to painting, unlike Picasso and
Braque). During this period, Gris characteristically divided the picture
plane into a grid, each field of which contained a different object,
rendered in terms of its own, logical perspective within the field.

His methodical, abstract thinking made Gris an ideal interpreter
of Synthetic Cubism, out of which he developed an original form
of image based not on existing objects but on imagination. His method
was deductive. "Cézanne," Gris once stated, "made a cylinder out of
a bottle; I make a bottle out of a cylinder."

Beginning with pure, abstract formal elements, he developed a
pictorial architecture of planes and color fields, out of which, finally,
an objective, emblematic shape appeared, as in the still life *Syphon,
Glass and Newspaper* (1916). "It is not the painting 'X' that attempts to
achieve conformance with an object," explained Gris, "but the object
'X' that attempts to coincide with my painting." The artist described
this method of lending objective definition to an otherwise purely
abstract image after the fact as "the humanization of the mathematics
of painting."

Gris's friendship with sculptor Jacques Lipchitz encouraged him,
in 1917–1918, to make a number of figurative sculptures, most of them
consisting of flat metal plates. After the war he began to devote
himself increasingly to drawing and lithography, designed stage sets
for Sergei Diaghilev's Russian Ballet, and wrote theoretical essays.

▶ Juan Gris
Syphon, Glass and
Newspaper, 1916
Syphon, verre
et journal

Oil on canvas
55 x 46.5 cm

Donation of
Trustees and
Supporters
Association of the
Wallraf-Richartz-
Museum and
Museum Ludwig,
Cologne, 1964

◀ **Mikhail Grobman**
Generalissimo, 1964

*Collage and ink
on paper*
60 x 44.8 cm

Ludwig Donation,
1994

**Grobman,
Mikhail**

1939 Moscow
Lives in Tel Aviv,
Israel

Like many protagonists of what has come to be known as the second
Russian avant-garde, an underground movement active primarily
in Moscow after Stalin's death in 1953, Mikhail Grobman worked
not only in the visual arts but in the field of literature as well. This
dual activity soon led to a conceptualist approach critical of everyday
Soviet life.

In works such as *Generalissimo* (1964), for example, Stalin's portrait
and myth are employed in a new, ironic context. Stalin is compared with
the renowned Russian field marshal Alexander Suvarov (1729–1880).
Cut-out portraits of the two military men are laid over a silver back-
ground, an ironic allusion to icons. The picture of Stalin bears a strong
resemblance to propaganda portraits by Isaak Brodski. In Grobman's
view, *Generalissimo* and another collage, *Medal-Decorated Russia* (1964)
represent "the seeds from which the art movement known as 'Soc-Art'
grew in the early 1970s."

George Grosz, trained at the Dresden Academy (1901–1911) and the Berlin School of Applied Art (1912), became in the 1920s one of the harshest and most radical critics of social conditions in the Weimar Republic.

Grosz, George
(Georg Ehrenfried)

1893 Berlin
1959 Berlin

Grosz's milieu studies and satirical drawings began to appear in magazines before the First World War. In its aftermath, the revolutionary situation led him, like many German artists, to adopt a radical stance with respect to both art and society. With Johannes Baader, Raoul Hausmann, Richard Huelsenbeck, and John Heartfield, Grosz was among the leaders of Berlin Dada. The movement, formed in 1918, attacked the bourgeois values that had led to the war in a series of events and manifestos. Grosz also joined the Communist Party in 1918, and began to put his art in the service of the class struggle. In bitingly satirical drawings published in various journals and also in book form, the artist pilloried the bourgeoisie and advocated the cause of the revolutionary workers (though without much hope that they would ever take power).

During this period, Grosz demanded that artists shed their individualism and devote themselves wholly to socialist aims. In his own art, this led to a brief phase of "engineered" drawings which took their cue from Russian Constructivism, but especially from Italian Pittura Metafisica. Grosz described his aim as follows: "I am trying to give an absolutely realistic picture of the world again... The human being is no longer depicted as an individual, with penetrating psychology, but as a collective, well-nigh mechanical concept. Individual destiny is no longer important... I suppress color. Line is drawn impersonally, photographically, constructed to elicit plasticity." *Street Scene* (1920) dates from this period, even though the figures seem less "mechanized" than reduced to general types. Indicatively for Grosz, the "absolutely realistic picture of the world" he envisioned is counteracted by the surrealistic atmosphere created by the yellowish light in the windows, the cracks in the facade, the green moon, and above all by the fantastic shadows.

Power and Grace, done two years later, shows no trace of "mechanical engineering", despite the precision of the line and skillful use of color to evoke an erotic mood. The drawing technique, which corresponds perfectly to the title, indicates an attempt at sober objectivity. The hypocrisy and moral decay of the upper class are revealed, but with

◀ **George Grosz**
Dr. Eduard Plietzsch,
1928

Oil on canvas
110 x 79.5 cm

Haubrich Collection

▶ **George Grosz**
Power and Grace,
1922
Kraft und Anmut

*Watercolor,
pen and ink on
smooth pasteboard*
53.3 x 44 cm

Haubrich Donation,
1946

nothing of the anger that gripped Grosz when depicting the exploitation and suppression of the working class.

In 1925 he painted *Masquerade Ball*, a watercolor in which the sharp precision of the veristic pictures he created prior to that date has given way to a softer, more relaxed drawing with only suggestions of caricature.

Grosz's 1928 oil portrait of *Dr. Eduard Plietzsch* also bears more affinities with Neue Sachlichkeit than with aggressive Verism. Plietzsch (1886–1961) was an art historian on the staff of the Berlin Museums who later became manager of Galerie van Diemen, Berlin. The way in

▲ **George Grosz**
Masquerade Ball,
c. 1925
Maskenball

*Watercolor, reed pen
in brown ink,
on heavy paper*
52.5 x 64.8 cm

Haubrich Donation,
1946

▶ **George Grosz**
Street Scene, 1920
Strassenszene

*Watercolor, pen and
ink on rough wove
paper, 41.8 x 30 cm*

Haubrich Donation,
1946

which Grosz has slightly exaggerated the facial features suggests the influence of Otto Dix's portraiture.

Traces of caricature there, in the raised arm and the fingers holding the cigarette, and especially in the shift from a frontal to a higher vantage point, which makes the figure seem to sink into the chair, all point to an ironic transformation of a traditional portrait form aimed at underscoring the intellectuality of the sitter. The homogeneous palette and summary treatment of elements Grosz considered subordinate anticipate the style of his later period, which the artist spent as an emigré in the United States.

Guttuso, Renato

1912 Bagheria,
near Palermo, Italy
1987 Rome

A politically committed realist who addressed contemporary subjects in a blend of drastic verism and painterly finesse, Renato Guttuso had a great influence on the younger generation of realistic artists in Europe. During the war he produced significant anti-fascist works, then went on to treat themes from social, religious, and cultural contexts, as well as painting landscapes, portraits, and mythological and historical subjects in modern-day terms – pictures that inquired into the meaning of the artist's existence. In the 1960s Guttuso's technique grew more multifarious, as he began to combine heterogeneous pictorial elements, passages quoted from other artists, and photographic imagery in pictures of often very large format.

Caffè Greco (1976) was done in a similar manner. As Guttuso himself wrote, "One day I was sitting in the room I painted, and I realized that this was a theme that suited me. On one side sat de Chirico. I pursued the thought, and after it had matured a bit, I began making a drawing or two." Guttuso also began collecting a great number of inspirations, which he combined into a vivacious picture of life in the artists' cafe.

Caffè Greco, located on Via Condotti in Rome, was a traditional meeting place for artists, writers, and intellectuals, and Guttuso had frequented it for years. His picture represents his own memories and the historical circumstances of the place, against the contemporary background of the year of execution, 1976, including Japanese tourists, Swiss girls, and a lesbian couple. Giorgio de Chirico, too, still came to the cafe in the 1970s, and it was his presence that inspired Guttuso to record its significance in a monumental painting, prepared in numerous studies and a large-format *bozzetto*.

De Chirico appears twice over in the picture: the elderly gentleman seated at the left, and the younger man right behind him, turned toward the viewer, a quotation of one of de Chirico's own self-portraits. Further elements also refer to de Chirico, for instance, the man in the sunglasses seated at the round table in the foreground, and the landscapes on the walls, which replace the Tivoli landscapes actually displayed in the cafe. André Gide's head appears to the left of the man in sunglasses. Guttuso himself is present also, in the figure of the man reading a newspaper at the lower edge of the canvas. Marcel Duchamp is alluded to, based on a photograph showing him with bare torso, a cigar in his hand, though Guttuso quotes only the arm with cigar.

In the lower right corner we see William Cody, better known as
Buffalo Bill, who visited the cafe during his appearances with a circus
in Rome. The two prominently placed sculptures at the right and left
edges are the *Torso of Belvedere* and Pablo Picasso's *Head of a Woman
(Dora Maar)* of 1941.

In a wider sense, *Caffè Greco* belongs in the category of paintings
designed to serve as manifestos or confessions. Comparable works
were done by Henri Fantin-Latour, Maurice Denis, and Max Ernst
(*Au rendez-vous des amis*).

▲ **Renato Guttuso**
Caffè Greco, 1976

Oil on canvas
282 x 333 cm

Ludwig Collection

Hains, Raymond

1926 Saint Brieuc
Lives in Paris

▼ **Raymond Hains**
Torn Poster, 1961
Affiche déchirée

*Colored paper
on zinc*
200 x 100 cm

French artist Raymond Hains, a representative of the school known as Affichistes, was a co-founder of Nouveau Réalisme. In 1945 Hains attended an art institute in Rennes, where he met Jacques Mahé de la Villeglé. The following year he began experimenting in abstract photography, but in 1949 he turned, with Villeglé, to the technique of *Affiches déchirées* (torn posters).

These were pictures of billboards on which several layers of posters had been pasted. In the course of time the upper layers were torn off in various areas and to various depths, revealing the layers beneath. Actually this happened quite arbitrarily, uncovering random sections of the posters, fragments entirely divorced from the original context. Often, however, certain information and key words remained visible, such as artists' names, topographical references, numbers, advertising logos, etc., which in combination with other, alien information engendered new mental associations and different contexts of meaning.

Hains and Villeglé did not restrict themselves to reproducing posters they had found by chance. They used the technique to produce original, innovative imagery. Unlike Villeglé, however, Hains intended his poster montages not so much to elicit an aesthetic effect as to criticize the manipulations and false values of advertising. Towards the end of the 1950s Hains also executed series of "posters" entirely lacking in typographical elements, made of torn and layered colored papers in a manner that recalled Art Informel.

His décollage *Torn Poster* of 1961 belongs in this context. Here the torn and uncovered passages are relatively small in size, producing a finely articulated surface texture that recalls the gestural brushwork of Action Painting. Apart from black and white, Hains favored blue and red gradations that coalesce into larger color fields. Also, the tearing process in many places engendered thin, white, irregular contours that contribute to the vibrant, flickering, as it were impressionistic effect of the overall image.

Richard Hamilton
My Marilyn, 1964

Collage, photographs,
l, paper
0.4 x 61 cm

Ludwig Donation,
1976

In the 1950s Richard Hamilton and other artists founded the Independent Group, which concerned itself with modern urban life and the trivial culture inculcated by the mass media, and contributed materially to the emergence of English Pop Art. In *Towards a Definitive Statement on the Coming Trends in Men's Wear and Accessories* – the title was taken from *Playboy* magazine – Hamilton addressed the then-prevalent ideal of masculinity in a collage-like arrangement of typical symbols of the day.

My Marilyn (1964) was based on a contact photo series of the star that happened to fall into his hands. Hamilton accentuated the process of selection by emphasizing the cropping and rejection marks with wide strokes of color, by reproducing the rejected shots with a coarse screen, and by enlarging the "good" photo in sharp focus. With pictures such as *Trafalgar Square* (1965–1967), based on a section of a postcard, greatly enlarged and altered by means of painted passages and textures, Hamilton created an abstract symbol for the phenomenon of mass society, with whose specific cultural products and effects he continued to concern himself in a range of works.

A photograph also served Hamilton as the point of departure for *Bathers I* (1966–1967). To this he added the collage elements of a pink bathing cap and a piece of flower-patterned bathing suit – accessories that can be bought in any department store, along with the standardized beach vacation to match.

Hamilton, Richard

1922 London
Lives in Oxon

Ill. p. 263:
Richard Hamilton
Towards a Definitive Statement on the Coming Trends in Men's Wear and Accessories, 1963

Oil, collage, plastic sheet on wood
122.3 x 81.2 cm

Ludwig Donation, 1976

◀ **Richard Hamilton**
Bathers I,
1966–1967

*Photograph on
canvas,
bathing cap,
fabric*
84 x 117 cm

Ludwig Donation,
1976

▼ **Richard Hamilton**
Trafalgar Square,
1965–1967

*Oil and photograph
on wood*
80 x 120 cm

Ludwig Donation,
1976

Duane Hanson is counted among the Hyperrealists, who took their point of departure in Pop Art in the late 1960s and played an increasingly prominent role on the American art scene. Hanson's polyester figures were made by pouring the resin into plaster casts taken direct from the model. His aim was the highest possible fidelity to reality.

The figures were very naturalistic and illusionistic, Hanson once stated, which could lead to shock, baffled criticism, or even to a violent psychological reaction on the part of the viewer. He preferred simple, familiar, cliché subjects, even "stupid, empty, or grotesque" ones which, in the artist's eyes, reflected the imperfection of human beings living in a complex, confusing, and crazy world. He hoped to achieve a certain robust realism that would say something about the "fascinating idiosyncracies" of our era.

Hanson's figures represent prototypes of American society. They are captured in situations so banal that we normally do not even visually register them: a woman cleaning house, a man reading, or, as here, a woman on the street, clutching her purse. The link with reality is further strengthened by the fact that the sculptures have no pedestals or bases, but rest or stand right on the floor. The figure in the Museum Ludwig, Cologne, standing in a natural, relaxed posture, is accordingly often mistaken for a museum visitor.

Admittedly this effect of alienation is not new in art. Previous artists, however, have tended to incorporate their interpretations of the things depicted in the work. In sculpture, for instance, George Segal purposely left his plaster figures white; and in painting, we always remain aware of the two-dimensional character of the canvas – that is, we see what is depicted through the artist's eyes. Hanson keeps himself out of the picture.

Confronted with his sculptures, the viewer is left entirely to his or her own devices, and is given no opportunity of judging the piece in terms of aesthetic transformation or alienation. We are confronted, apparently, with sheer unadulterated reality. Hanson unmasks, as he says, the horror latent in our social environment. Yet in the process he also reveals a very humane attitude: When he restored the damaged sculpture in 1977, Hanson made the figure older, explaining that both it and he himself had aged three years in the meantime.

Hanson, Duane

1925 Alexandria,
Minnesota
1996 Boca Raton,
Florida

◀ **Duane Hanson**
Woman with a Purse,
1974

Polyester, synthetic resin, tallow, reinforced with fiberglass, oil paint, items of clothing, wig
height 163 cm

Ludwig Donation,
1976

Hartung, Hans

1904 Leipzig
1989 Antibes, France

Painter and printmaker Hans Hartung was a seminal figure in the Ecole de Paris. From 1924 to 1928 he attended the art academies in Leipzig, Dresden, and Munich. Persecuted by the Nazis, he emigrated in 1935 to Paris. During the Second World War, Hartung was interned several times in prison camps, then served in the Foreign Legion in Africa and on the Alsatian front, where he was seriously wounded and lost his right leg. In 1945 he was awarded French citizenship for his bravery in action.

Influenced by German Expressionism and above all by Wassily Kandinsky and Paul Klee, Hartung turned to abstraction as early as the 1920s. He developed an automatic, psychographic idiom based on accumulations of intersecting, colored lines, known as the "ink-line technique". This calligraphic style was an immediate expression of inner urges and states of mind, the concrete record of discrete moments in the artist's existence. The tendency to impulsive, emotional gestures inspired by subconscious processes was also characteristic of Surrealist art, in the context of which it was called *écriture automatique*. The Action Painting or Art Informel which formed the focus of the Paris School and of which Hartung was a foremost pioneer and representative, recurred to this Surrealist reliance on automatically elicited subconscious imagery.

Hartung's work was honored after the Second World War in numerous exhibitions. Instead of giving his paintings titles, he numbered them consecutively, as *T 56-21* of 1956, in the Museum Ludwig, Cologne. "T" stands for *tableau* (picture), "56" for the year of execution, and "21" for the painting's number within the year's production. Like the majority of the artist's works, this canvas has a translucent, almost monochrome background. Applied over this are two spontaneously brushed, energy-laden configurations consisting of black and brown lineatures. They appear to hover in space with a weightlessness that recalls Hartung's interest in astronomy, for which he had a lifelong fascination.

▶ Hans Hartung
T 56-21, 1956

Oil on canvas
180 x 114 cm

Heckel, Erich

1883 Döbeln, Saxony,
Germany
1970 Radolfzell,
Lake Constance

▲▲ **Erich Heckel**
Pheasant Manor
near Moritzburg,
1910
Fasanenschlösschen
bei Moritzburg

Oil on canvas
97 x 120.5 cm

Erich Heckel began training as an architect in 1904, at the Technical College in Dresden. In 1905, he joined with Karl Schmidt-Rottluff, Ernst Ludwig Kirchner, and Fritz Bleyl to form Die Brücke, or The Bridge, a group that soon became a key nexus of German Expressionism. Simplification of form, pure colors, and an emphasis on flatness were the stylistic means of the Brücke artists. In order to encourage the viewer's subjective reaction, they concentrated on depicting not so much the subject itself as their own personal experience of it, conveying their feelings solely through the pictorial elements of color, form, line and space.

In August 1910, Heckel, Kirchner, and Max Pechstein worked together at the Moritzburg Lakes, where Heckel's *Pheasant Manor near Moritzburg* originated. The idyllic and graceful character of this former summer residence situated in the park of Moritzburg

Castle is captured here in a compelling interplay of muted and brilliant color.

Heckel has been called the "lyrical poet" among the artists of Die Brücke. Many of his paintings reflect a great sensibility for the quiet presence of things. This is even, and especially, true of his depictions of Berlin. The city is not pictured, as with Kirchner, as a noisy, bustling place but, as in *Canal in Berlin*, almost as if devoid of human life. The trees stand silhouetted like skeletons against the frosty sky, whose cool, greyish-blue hue seems as if driven like a wedge into the composition. Every object in the picture is delineated with short, sharp, as if petrified strokes, creating the impression of bitter cold and an emptiness that is at once forbidding and oppressive.

▲ **Erich Heckel**
Canal in Berlin, 1912
Kanal in Berlin

Oil on canvas
83 x 100 cm

Haubrich Donation, 1946

◄ **Erich Heckel**
Beach (Bathers),
1912
Strand (Badende)

Oil on canvas
70.5 x 81 cm

Haubrich Donation,
1946

► **Erich Heckel**
Woman Resting
on a Bed, 1914
Frau auf Ruhelager

Watercolor and pencil
on smooth paper
36.1 x 48.1 cm

Haubrich Donation,
1946

The estrangement of urban civilization was evoked in many Brücke
artists' paintings as a foil to their ideal of a paradise in which humanity
and nature would coexist in harmony. Heckel's *Beach (Bathers)* of 1912
can be viewed in this light. The nude figures, rendered in the same
earthy colors as the setting, are made to appear integral parts of
nature.

In the 1914 watercolor *Woman Resting on a Bed*, a turn is evident
from the flowing line Heckel employed until about 1910 to more
angular contours. In the 1920s, his emphasis on the fundamental
compositional factors of line, plane and color made way for a more
reserved and homogeneous basic tone. In the still life *Figure and
Flowers* (1922), which appear in an ambiguous space partaking both
of interior and exterior, Heckel juxtaposes large areas of flat color
to elicit a sense of airiness and expanse.

Heerich, Erwin

1922 Kassel
Lives in Meerbusch

▼ **Erwin Heerich**
Untitled, 1989

Stainless steel
80.5 x 165.5 x 165.5 cm

Ludwig Donation,
1976

Calculated aesthetic means and a precisely measurable translation of construction drawings into three-dimensional geometric configurations are basic factors in the work of Erwin Heerich, a student of Ewald Mataré.

To an even greater degree than the Constructivists and De Stijl artists, he has divorced his work from visual and emotional references to retain only the pure, elementary form. Heerich employs the elements of cube and rectangular solid, pyramid, sphere, and cylinder, as well as parts and combinations of these. Unlike the American Minimal artists, he seeks to discover by means of his mathematically calculated pieces new modes of composition based on principles of logic and order.

The anonymous objectivity of Heerich's work is also reflected in his choice of a material largely free of aesthetic associations: cardboard. It is cut out in carefully designed shapes, folded, and assembled into three-dimensional configurations. Curved surfaces are produced by means of regular, tangential incisions. Heerich's

► Erwin Heerich
Cardboard Object,
1969
Kartonobjekt

Cardboard
60 x 60 x 60 cm

Ludwig Donation,
1976

point of departure is no longer the solid volume but the flat plan,
designed for development in three dimensions. The material serves
only to visualize an idea: "It is just this limitation in terms of material
stock," he explains, "that makes my intention perfectly clear:
The duration of my project does not lie in the area of the object as
made, but in the object as conceived. For me, sculpture is a mani-
festation of plastic thinking." Accordingly, Heerich's development
has led to an increasing monumentality of scale and reduction
of formal means, aspects evident to an exceptional degree in his
architecture-like outdoor sculptures.

The steel sculpture *Untitled* of 1969 was based on a cardboard
maquette of 1968, which no longer exists. The piece is among what
Heerich terms his "works in space". As Johannes Cladders noted
in 1979, "Heerich's works always remain self-referential. They do not
rely for support on any message that extrinsically shores up their
theme, but develop out of their own, intrinsic logic, in preplanned,
consequential steps. The thinking that underlies them is profoundly
based in the architectural, and thus it is no surprise that they all
culminate in definitions of 'space'."

Heizer, Michael

1944 Berkeley,
California
Lives in Nevada

Michael Heizer established his reputation with the series of *Earth Works* he began creating in 1967. Although the term is exclusively his own, it relates to the concept of Land Art, a movement of young American artists who, in the late 1960s, without any explicit sociocritical intention, shifted the making of art from established centers to the wild, wide spaces of the country.

Made at the cost of great physical effort, the *Earth Works* are huge negative shapes excavated in the ground, or positive masses raised up above it. In formal terms, these pieces bear affinities with the structures of the Mayas, Aztecs, and Incas, as well as with the great Indian petroglyphs or "earth signs". Heizer's *Earth Works* are integral parts of the planet, changing as a result of erosion and subject to the natural cycle, which eventually leads to their obliteration. In Heizer's eyes, according to Ellen Joosten, art does not emerge "among human beings in present space," but is situated "in the period of time between contemporary and present-day man. His *Earth Works* are almost like pilgrimage places." The artist's sculptures in wood, stone or metal are variable

▼ Michael Heizer
Adze Dispersal,
1968–1971

*Stainless steel,
variable floor
arrangement
c. 610 x 214 cm*

Ludwig Donation,
1994

in configuration, and, like the outdoor works, rely strongly on the principle of positive and negative form, the poles of mass and void. The piece *Adze Dispersal* (1968–1971), for example, consists of over 100 elements spread across the floor, steel bands of different sizes which, arranged in groups, continually repeat themselves and thus constitute an irrational order.

Circle I (c. 1976) continues a series of rectangle-based imagery done around 1967, the period at which Heizer was executing his first earth sculptures. In his view, the square, rectangle and circle, often cut into segments capable of veritably

infinite combination, possess an elementary, archaic force of a kind that can only be experienced in the desert. This is why the materials of his sculptures contribute so much to their intrinsic effect.

Heizer remains true to this conviction even when working in New York. Yet, as Ellen Joosten notes, "the mass of the 'impenetrable' big city of New York (mass as impenetrability) is different from that of the porous mass of stone in Nevada. It would seem possible to establish a link with this by digging canyons, piling up hills, leaving traces ... Or, as in the *Circle Series*, by seeking a continually changing relationship between large, 'inviolably' perfect circles and arc segments. When Heizer says, for instance, that he would 'like to make something organic,' he probably means that it must be possible for an artist to render 'mass' so transparent, so empty, that it can receive the universe within itself. Conceivably mass and void would then become indivisible, like order and chaos."

▲ **Michael Heizer**
Circle I, c. 1976

Mahogany
Eight parts,
diameter 244 cm

Ludwig Collection

◀ **Werner Heldt**
Still Life
on a Balcony, 1951
Stilleben auf dem
Balkon

Oil on canvas
57 x 71 cm

Haubrich Collection

Heldt, Werner

1904 Berlin
1954 Ischia, Italy

Werner Heldt's œuvre reflects a deep involvement with his native city of Berlin. In the 1920s he worked along the lines of Heinrich Zille's genre and milieu scenes, and remained uninfluenced by international trends. This changed in the early 1930s, with Heldt's acquaintance with French artist Maurice Utrillo. Paring his style down to essentials, he addressed the anonymity, loneliness, and tristesse of the big city. After the end of the war, Heldt's painting began to develop towards increasing abstraction and encoding, revealing a strong Cubist influence.

In *Still Life on a Balcony* (1951) two genres, still life and city view, are combined. This leads to a division of the image into three zones: the still life in the foreground, an expanse of lawn in the middle ground, and the city skyline in the background. The borderline between the private sphere of the balcony and the public sphere of the city is marked by the balustrade and green area. The dominating element, which also serves to link the three zones, is the large black pitcher. Like the toppled portrait and the black silhouette on the far building, the pitcher has a symbolic meaning as well, evoking mourning.

▶ **Peter Herkenrath**
Composition, 1963
Komposition

Oil on canvas
120 x 100 cm

Gift of
Dr. Andreas and
Lore Becker, 1979

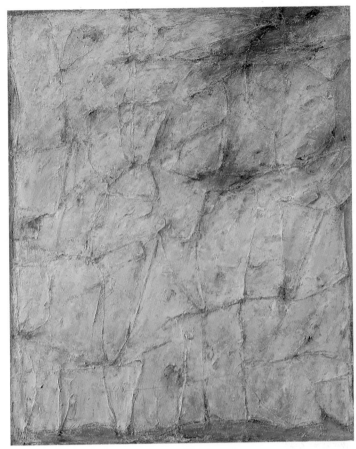

The painting of Peter Herkenrath, who was self-taught, was strongly
influenced by the Ecole de Paris. His approach was characterized
by sparing use of color, in rigorous compositions suffused with graphic
lineatures. Herkenrath's talent came superbly into its own in portrait
paintings, in which he veritably "dematerialized" the person represented
and the surrounding objects by reducing them to essentials, in which
he believed to have found their true being. As G. Aust notes, Herkenrath
"was not concerned with capturing characteristic traits of physiognomy,
pose, or gesture. Rather, the entire presence of the sitter was to enter
into a signlike formula, and thus condense into an image that tran-
scended reality."

**Herkenrath,
Peter**

1900 Cologne
1992 Mainz

Out of still-life motifs and figure groups Herkenrath developed layered and superimposed structures that generally floated free on the plane and still bore references to their objective origin. Over the following years, these elements began to spread and expand into an all-over pattern of loosely allied forms, in a relief-like layering that suggested shallow depth. The paint application grew more sumptuous, as the palette tended towards monochromy. The relief modelling of the surface was underscored by gradations of light and dark, and juxtapositions of cool and warm colors. *Composition* belongs to this phase of Herkenrath's work, which culminated in about 1960. By 1965 he had begun to paint still lifes with an unexpected degree of realism and a tendency towards Cubist facetting.

Hesse, Eva

1936 Hamburg,
1970 New York

Eva Hesse is considered one of the major proponents of Arte Povera. With her Minimal and Conceptual works she also became a pioneer of feminist art. Born in Germany, Hesse came to New York as a Jewish emigré at the age of three. In 1954 she began studying at the Art Students' League. Her earliest paintings, in an Abstract Expressionist vein, were done between 1954 and 1957. Hesse took courses at Yale University, and was one of the most versatile students of Josef Albers.

Apart from abstract, serial, and rebus-like paintings, Hesse executed numerous three-dimensional objects in a great variety of materials. These frequently consisted of ropes and strings, interwoven into suspended configurations, or fiberglass elements that created the impression of agglomerations of discarded materials. Hesse's sparing, solitary objects often evoke transience, like the last remaining relics of an affluent society.

Accession III consists of a cube of thick, milky fiberglass, drilled with a regular pattern of holes into which lengths of transparent plastic tubing are inserted. All of the tubes point inwards, into the box, the artist stated, and the exterior has a woven appearance. Characteristically for Hesse, the piece relies on a contrast between a hard external shell and a soft, as if living core. The title *Accession* also suggests organic growth processes taking place within a carapace. Later Hesse would describe such objects as too sumptuous, rectilinear, and aesthetically pleasing, and said she now preferred to adulterate things a little more.

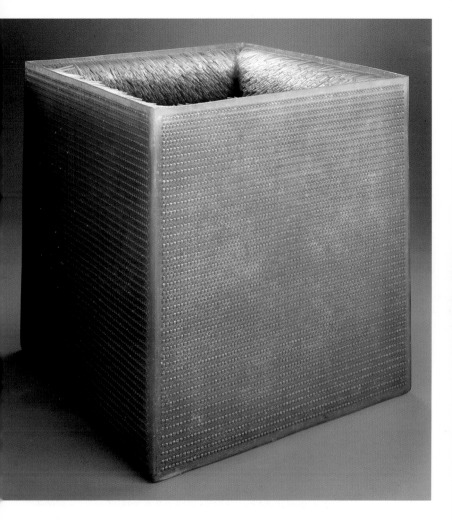

▲ **Eva Hesse**
Accession III, 1967–1968
Zuwachs III

*Fiberglass and
plastic tubing
80 x 80 x 80 cm*

Ludwig Donation, 1976

Hockney, David

1937 Bradford,
England
Lives in London
and Los Angeles

David Hockney was trained at the Bradford College of Art (1953–1957) and at the Royal College of Art in London (1959–1962). His work, initially influenced by Ronald B. Kitaj, contributed to the breakthrough of English Pop Art at the Young Contemporaries exhibition in 1961. Hockney introduced an inimitable touch of ironic narrative into art, his early drawings and prints in particular relying on elements of satire, banal illustration, and children's drawings to produce imagery marked by a sardonic, proverbially English humor.

In early 1964 Hockney moved to Los Angeles. His paintings lost their anecdotal, sketchy character, though they remained narrative in thrust despite a now carefully premeditated and aesthetically sophisticated composition. The artist addressed conventional themes such as landscapes, portraits, still lifes, interiors, and genre scenes, the latter located principally in the jet-set world. His intention to depict California as he saw it increased Hockney's tendency towards an idiosyncratic realism, which with its planar articulation and light, cool palette of artificial, acrylic paint has an atmosphere of unreality, indeed surreality.

From 1964 to 1967 Hockney produced the series of *Swimming Pool* paintings that are among his most famous, and in which he concerned himself with various ways of depicting water. Nude boys are shown lounging in or around the pools of California homes, embodying the leisure-time component of the American Dream. *Sunbather*, contrary to the expectations raised by the title, is dominated by the expanse of water that extends across three-quarters of the picture's area and relegates the young man lying in the sun to the far upper edge. The ripples in the water, treated in a highly abstract manner, appear as dancing, wavy lines, casting shadows on the bottom of the pool. These are taken up, in the upper part of the composition, by the curving lines of the paving on the edge of the pool.

Hockney's best-known paintings emerged in the 1960s. In the 1970s he began to devote himself increasingly to drawing, printmaking, and also to the design of stage sets and costumes, followed in the 1980s by photographic works.

▲ **David Hockney**
Sunbather, 1966

Acrylic on canvas
183 x 183 cm

Ludwig Donation, 1976

Höckelmann,
Antonius

1937 Oelde, Germany
Lives in Cologne

▼ A. Höckelmann
Trial Hop with Dice,
1971–1974
*Ink and wax crayon
on paper*
320 x 130 cm

Ludwig Donation, 1976

After training as a woodcarver, Antonius Höckelmann transferred to the Berlin College of Art in 1957. Until 1961 he studied sculpture with Karl Hartung, whose abstract style initially influenced him. The frequent sketches he made in the process of designing sculptures led Höckelmann to concentrate on the drawing medium for its own sake, and he began to produce graphic, frequently large-scale imagery on lengths of newsprint and packing paper. Höckelmann once described the function of drawing as "suggesting the all-embracing reality of a sculpture," giving the viewer "the important feeling of moving within the sculptural forms, and not merely staring at a sculpture from outside it." His early sculptures and drawings of the 1960s had the appearance of tortured configurations struggling to emerge from chaos. "Without sculpture, it would be impossible for me to make drawings," Höckelmann concluded.

His later drawings, from about 1968 onwards, were more elegant and dynamic, and revealed affinities with Italian Futurism. A large proportion of his recent work has been devoted to the theme of justice and lawsuits, using written language to various degrees as a conveyor of information. *Trial Hop with Dice* (1971–1974) and the fragment of text it contains relate to a quarrel Höckelmann had with the other tenants of an apartment building in Cologne, who were bothered by the noise made by the artist's little boy. Cited for disturbing the peace, Höckelmann was involved in a protracted legal battle, his opponents petitioning the court to forbid the youngster from jumping, hopping, and running around the apartment. Höckelmann and his wife were advised that if the boy needed exercise, they would "just have to send him out into the fresh air."

From beginnings in the mode of Tachisme and Art Informel, Gerhard Hoehme in the late 1950s produced a series of *Texture Paintings* in which a solid scaffolding was introduced to lend order to the composition. This consisted of graphic or calligraphic signs that formed a sort of grid, a cohesive sequence of marks that suggested infinite extent, as if the rectangle of the canvas were merely a section chosen at random. The textured effect was further amplified by heavy impasto paint application, producing a rough relief surface that caught the impinging light. Hoehme himself once described the marks, which bear more resemblance to grafitti than to fluent calligraphy, as "impulses suffusing the color fields". Forming an interlocking network, the graphic signs serve to contain the impulsive, gestural energies of the brushwork.

Incantation, a canvas done in Rome, reflects the artist's intention to achieve a dissolution of pastel pigments in light. Only the mushroom-like graphic marks remain, as a "relic of something once present". The title, pointing to a transcendental, hallucinatory realm, suggests an association of the graphic structures with an inexorable, universal proliferation.

**Hoehme,
Gerhard**

1920 Greppin,
Germany
1989 Neuss

▲▲ **Gerhard Hoehme**
Incantation, 1960
Beschwörung

*Mixed media
on canvas*
128 x 200 cm

Gift of Cologne
Art Association, 1961

Hoerle, Heinrich

1895 Cologne
1936 Cologne

▲ Heinrich Hoerle
Masks, 1929
Masken

Oil on canvas
68.5 x 95.5 cm

Haubrich Donation,
1946

Heinrich Hoerle was among the many artists (including Franz Wilhelm Seiwert, Gerd Arntz, and Gottfried Brockmann) working in a figurative, Constructivist style in the Rheinland during the 1920s and 1930s. A friend of Max Ernst and Otto Freundlich since before the First World War, Hoerle participated in 1919–1920 in the activities of Cologne Dada. In 1924 he joined with Seiwert, Freundlich, Arntz and others to form the Group of Progressive Artists, who set out to put Constructivist art in the service of their socialist and communist convictions.

In *Masks* of 1929, Hoerle transposed a traditional Rhineland theme, Carnival, into a hallucinatory and threatening sphere, by showing how human individuality can be hidden behind various stereotyped expressions. The masqueraders with their impenetrably dark eyes and mouths, and arms raised in a brutal salute, were traits of a current situation about which the artist attempted to make a universal statement, with the aid of a typified and supraindividual depiction.

Carl Hofer
asquerade, 1922
askerade

l on canvas
9 x 103 cm

aubrich Donation,
46

Before moving in 1913 to Berlin, where he was to have a material influence on the art scene for forty years, Carl Hofer studied at the Karlsruhe Academy and lived for long periods in Paris and Rome. From 1919 he taught at the Unified State Schools in Berlin, but was deprived of his post in 1934. It was not until 1945 that Hofer was able to resume his teaching activity, as head of the Berlin College of Art.

Hofer's principal subject was the human image, depicted realistically but always with an undertone of threat, anxiety, and isolation, as may

Hofer, Carl

1878 Karlsruhe
1955 Berlin

▶ Carl Hofer
The Sailor's Meal,
1922
Das Mahl des
Matrosen

Oil on canvas
116.5 x 89.5 cm

be seen in *The Sailor's Meal* (1922). The artist's involvement with the
theme led, under Nazism, to a decided committment to social justice

Masquerade (1922) is an early example of the circus and masquera
motifs which Hofer would subsequently depict in great numbers
of variations. It represents three classical characters from the realm
of circus and carnival, whose masklike expressions are, however,
unexpectedly sad and fearful. Hofer was inspired to this work by his
friendship with a Swedish choreographer, who was giving guest
performances in Berlin. His great interest in carnival masks of wood
and paper eventually led to an extensive collection, including the
artist's own, original designs.

▶ **Hans Hofmann**
Composition No. 1,
1952

Oil on plywood
76.2 x 60.9 cm

Ludwig Collection

After studying painting in Munich, Hans Hofmann spent ten years in Paris (1904–1914). Back in Munich in 1915, he opened an art school, and embarked on a teaching career that would continue over the next 43 years. Hofmann's influence on the development of modern art in the United States from the 1930s onwards was unparalleled. His Hans Hofmann School of Fine Arts, established in New York in 1934, has accordingly been called "the cradle of contemporary American painting."

Hofmann's art remained indebted to the German Expressionist tradition down through the 1940s. Then he turned to Abstract Expressionism, making color the dominating element in his compositions and subordinating form and line to spontaneous brushwork or, later, to carefully balanced color planes.

In *Composition No. 1* the brilliant passages of red, yellow, blue, and black congeal into flowerlike configurations. The impasto paint application and energetic brushstrokes, built up into thick encrustations, are characteristic of a group of paintings done between 1951 and 1954.

**Hofmann,
Hans**

1880 Weissenburg,
Bavaria, Germany
1966 New York

◀ **Rebecca Horn**
The Peacock
Machine, 1981
Die Pfauenmaschine

*Metal,
peacock feathers,
electric motor.
Installation with
three glass columns,
height 400 cm,
with text,
two glass cases
filled with caput
mortuum and ashes*

Horn, Rebecca

1944 Michelstadt,
Germany

Lives in Zell-Bad
König

The permeable borderline between dream and reality, between opening out to others and retiring into a shell, living life whole and succumbing to formalized ritual, between love and death – this is where Rebecca Horn's visual poems play themselves out. In her allusive film *La Ferdinanda,* objects were as important as the people whose actions they reflected. Here Horn addressed the isolation, self-deception, speechlessness masked by loose talk, and the self-perpetuating automatism of disturbed human relationships. As Germano Celant says, she showed "the interchangeability of things and human beings, of reality and illusion." The peacock played a key role in this film. The *Peacock Machine,* located in the basement of the house, reflected what was happening on the upper floors by expanding to its full glory, then shivering and collapsing upon itself like an exhausted bird's wing.

Action and sculpture – these are the poles between which Horn's art oscillates. Her objects and their installations, which include textual commentaries, distill emotion and reflection into poetic metaphors that reflect the romantic yet disillusioned thinking of a sensitive and intelligent artist.

► **Huang Yongping**
Kiosk, 1994

Newspapers and magazines, treated in cement mixer, and metal
370 x 240 x 265 cm

Ludwig Collection

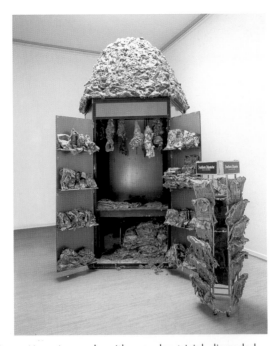

Chinese artist Huang Yongping works with everyday, trivial, discarded things. For his *Kiosk*, created for the 1994 Biennale of Art in Paper held in Düren, Germany, he used a cement mixer to transform newspapers and magazines into an unreadable pulp. Everything was jumbled up together – political news from around the world, crime reports, miscellaneous gossip – to produce an oppressive image of a typical big-city newspaper stand, bursting with garbled news and photos of miscreants and men of affairs, natural and human catastrophes.

"What history has left behind to us," notes the artist, "is a huge mass of writings and texts... We live in the midst of a gigantic refuse dump, which also includes culture – philosophy, religion and art. Culture can be arbitrarily manipulated and sorted out... If you do not extricate yourself from the refuse of texts (our history, our thinking, and our culture), we will be crushed by a plethora of theories, value-systems, and sermons." The central idea behind works of this kind is the birth of something new out of destruction.

Huang Yongping

1954 Quanzhou, China
Lives in Paris

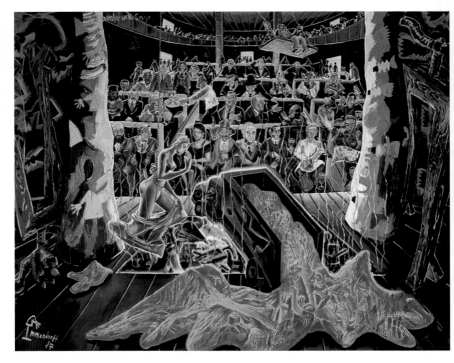

Immendorff, Jörg

1945 Bleckede
Lives in Düsseldorf

▲▲ Jörg Immendorff
Lehmbruck Saga, 1987

Oil on canvas
300 x 400 cm

Ludwig Collection

As a student Jörg Immendorff belonged to the politically engaged circle of artists around Joseph Beuys. On a trip to East Berlin in 1976, he met GDR artist A.R. Penck. Recognizing that they were both outsiders on their respective art scenes, the two joined forces in a German-German "Workers' League" to strive for common artistic ends.

Inspired by Renato Guttuso's *Caffè Greco*, Immendorff began in 1977 a series of drawings and gouaches that would lead to a major series of paintings, collectively titled *Café Deutschland*. Yet while Guttuso pictured a nostalgic gathering of painters and writers in a cozy cafe, Immendorff evoked a sleazy disco packed with figures and set-pieces from German politics and recent history. His friendship with Penck, and their separation by the opposing political systems in which they lived, provided other key motifs in Immendorff's composition.

Continuing the theme of the *Café Deutschland* series, the artist shifted his focus to the theater world in the *Lehmbruck Saga* of 1987. Among its allusions to the German question is the scene in the pits, a smithy which, as H. Behn points out, can be read as an allegory for the emergence of parliamentary democracy. The sculpture suspended above the stage on a rope represents Wilhelm Lehmbruck's bronze *Kneeling Woman* of 1911. Defamed as "decadent" by the Nazis, this key work of modernism also embodies a piece of the German past. The stage and the auditorium, where the artist, his friends and supporters are gathered, become the arena for Immendorff's involvement with the historical and artistic vicissitudes of his country during the twentieth century.

▲ **Jörg Immendorff**
Café Deutschland I,
1977–1978

Acrylic on canvas
282 x 320 cm

Ludwig Collection

Indiana, Robert

(John Clark)

1928 New Castle,
Indiana
Lives in New York

"Pop is everything art hasn't been for the last two decades," said Robert Indiana in an interview with G.R. Swenson; "Pop is a re-enlistment in the world." Indiana studied at the Art Institute of Chicago from 1949 to 1953, then went on to spend a year at the College of Art at the University of Edinburgh. His paintings are brightly colored, with hue set against brilliant hue without contours or transitions. The sharply defined color fields are reminiscent of Hard Edge painting, in which perspective and illusions of depth are dispensed with in an attempt to convey spatial relationships through color contrasts and tensions alone. Indiana paints emblems, letters of the alphabet, and numerals. In his first studio, in Manhattan, he found a large stock of copper

▶ Robert Indiana
Zig, 1960

*Wood, wire, iron,
enamel paint*
165 x 45 x 41 cm

Ludwig Donation,
1976

lettering stencils left behind by a shipping supply company. After initially combining the letters, numerals, and star shapes into assemblages, he later began to transfer them to canvas with brush and paint. In *USA 666 (Eat, Die, Err, Hug) II* – a picture of which another, 1964 version exists as well – the typography and highly effective, signal-like form and color both stand for themselves and convey a message. According to the artist, the X shape represents a railroad-crossing warning sign, the first "6" alludes to his father's month of birth, and the "66" to the Philipps 66 gasoline company where his father was employed. The bright complementary colors red and green correspond to those of the company's logo at the time. The number 66 also alludes to Highway 66, the embodiment of "going West" in many Americans' minds, as well

s relating to the black and yellow sign "Use 666," an advertisement
or a patent medicine for colds. The word "Eat" appeared on countless
oadside diners. *USA 666* is one of six paintings in which the artist
vokes the "sixth American dream."

Indiana's sculptures, such as *Zig* of 1960, recall northwest Indian
otem poles or ancient Greek herms, an association corroborated by
ne former designation "Zeus" for *Zig*. The wheels, found on almost all
f Indiana's sculptures, are existing objects, *objets trouvés*, integrated
nto the piece.

▲ **Robert Indiana**
USA 666 (Eat, Die,
Err, Hug) II,
1966–1967

Acrylic on canvas
Five parts,
91.5 x 91.5 cm each

Ludwig Donation,
1976

◄ **Rudolf Jahns**
White Divides and
Connects, 1927
Weiss trennt und
bindet

*Tempera on
cardboard mounted
on hardboard
37.2 x 33 cm*

Gift of
Friends of the
Wallraf-Richartz-
Museum and
Museum Ludwig,
Cologne, 1977

Jahns, Rudolf

1896 Wolfenbüttel,
Germany

1983 Holzminden

In addition to making Cubist figure studies, Rudolf Jahns began
working in the early 1920s in an abstract, Constructivist style.
The ensuing paintings were generally small-format panels with
large-area, simplified, geometric forms, rendered in muted colors
which included the "non-colors" black, white and grey. Frequently
the artist also exploited the visual effects of complementary and
simultaneous contrasts.

The painting *White Divides and Connects* belongs to a phase of
the late 1920s in which Jahn shook off the influence of late Cubism
and De Stijl to work with more strongly contrasting, as if cut-out and
collaged shapes, and to create a sense of spatial layering by means
of carefully chosen color values. Forms continuing from edge to edge
(as the white form here), served at once to separate the color planes
and to link them, bringing them optically back into the picture plane.
This effect was heightened by repeating their color elsewhere
(as in the thin white bands).

The first generation of contemporary progressive artists in Moscow, to which Vladimir Jakovlev belongs, frequently took up forms of Western modernism and sometimes even of the pioneering Russian avant-garde of the 1920s. After Stalin's death in 1953 and the ensuing "thaw" under Krushchev, young Russian artists were confronted for the first time with recent developments in American Abstract Expressionism and European Art Informel at a number of large exhibitions in Moscow. More than anything else, the Non-Conformists, as they were known, strived for a pure art that was free of all political ideology.

As early as the end of the 1950s, Jakovlev developed an abstraction with cosmic overtones in which the universe dissolved into a kaleidoscopic whirl of color. Light played a key role in these paintings. In *Cosmic Portrait* of 1959, for example, the human face is transformed into a stellar nebula in a dark sky. Instead of portraying a personality, Jakovlev evokes the diffuse, luminous nexus of energy he senses in the sitter.

Ilya Kabakov wrote of his friend and colleague in 1991, "Jakovlev's paintings recall a night sky full of stars. There is no light in the night; it is all in the stars ... Everything can be said to depend on the emergence of light, which always comes out of infinite depths and radiates in the paintings from the color white ... With his works Jakovlev, following in the footsteps of Matisse, might be saying that behind every color, behind every image, and interspersed among them, stands light."

Jakovlev, Vladimir

1934 Balacha, near Gorki, Russia
Lives in Moscow

◀ Vladimir Jakovlev
Cosmic Portrait, 1959

Gouache on paper
41.5 x 29.5 cm

Ludwig Donation, 1994

**Jankilevskiy,
Vladimir**

1938 Moscow
Lives in Paris

Vladimir Jankilevskiy's *Atomic Station* (1962) was included in the histor-
ical Manège exhibition, which opened in Moscow on December 1, 1962.
Organized to commemorate the thirtieth anniversary of the Moscow
branch of the Russian Artists' Association, its title derived from the
venue, the Manège, which was probably the most important exhibition
hall in Moscow at that time. A number of underground artists experi-
menting in new forms of abstraction were allowed to show their work
in a side room. Series and multipartite works are characteristic of
Jankilevskiy's œuvre. Intended to mirror reality, the cycles represent
various facets of contemporary life. The format permits him to ring
a great number of variations on a theme without being forced to focus
on any particular aspect.

According to O. Sviblova, the five parts of the pentatyptich *Atomic
Station* depict the reciprocal relationships among five very diverse facets
of contemporary life: *Landscape* (part one), *Creature* (part two), *Nuclear
Power Plant* (part three), *Genius* (part four), and *Premonition* (part five).
"The artist has found an extremely plastic language to evoke the recip-
rocal relationships that emerge from substantial and emotional conflicts,"
writes Sviblova. "He lets color, tone, structure, and texture clash ... In
1962 this work triggered fear and anger among all those who wished
the world would remain a logical and comfortable place. After Chernobyl
one inadvertently views the pentatyptich with different eyes."

Vladimir
Jankilevskiy
Untitled
from the sequence
"Kafkaesque
atmosphere"), 1969

Gouache and
crayon on paper
50.2 x 65 cm

Ludwig Donation,
1994

▲ Vladimir
Jankilevskiy
Atomic Station, 1962

Pentatyptich:
oil on hardboard
154 x 615 cm overall

Ludwig Collection

▼ Vladimir
Jankilevskiy
Woman, 1969

Oil, pastel and ink
on paper
50.8 x 41.5 cm

Ludwig Donation,
1994

Javlensky, Alexei von

1864 Torshok, Russia
1941 Wiesbaden, Germany

▼ Alexei von Javlensky
Still Life with Blue Pitcher and Figure, c. 1908

Oil on cardboard
50.2 x 68.8 cm

At the age of eighteen, Alexei von Javlensky began a career as an army officer. After seeing the International Art Exhibition in Moscow in 1880, he decided he wanted to paint, and began taking drawing courses in parallel with his military training. In 1896 Javlensky moved to Munich, where he met Wassily Kandinsky the following year. His style began to develop during the period when Art Nouveau was coming to the fore in Munich. Travels to Provence and Brittany opened his eyes for the world of Paul Cézanne and Vincent van Gogh.

A propitious event for the young painter was his meeting with Henri Matisse, in whose studio he worked for a brief time in 1907. Javlensky's admiration for the great Fauvist is quite evident in the two paintings *Still Life with Blue Pitcher and Figure* of 1908, and *Still Life with Vase and Jug* of 1909. The heavy contours around the separate elements point to the influence of Cloissonisme, a style inspired by the brilliant colors and leading of stained-glass windows. Also from this period is *Fairy-Tale Princess with Fan*, with its contrasts between lines converging at acute angles and a vibrant play of luminous, repeated bands of color.

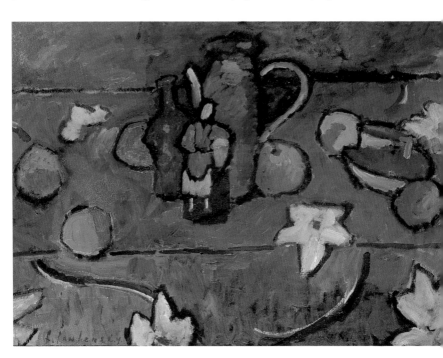

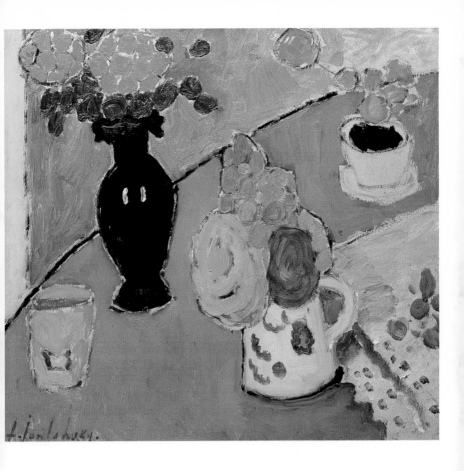

Javlensky's principal concern was to render inward experience visible. This is reflected especially in his landscapes, a genre to which he devoted himself almost exclusively from 1914 to 1917. In the series of *Variations*, Javlensky repeated a certain slice of landscape again and again, reducing it to fundamental forms like triangles, rectangles, discs and ellipses. The same procedure is evident in his sequence of *Heads*, begun in 1918. The human head was abstracted further and further, until finally it had been simplified to an archetypical form which has been termed the "modern icon."

▲ **Alexei von Javlensky**
Still Life with Vase and Jug, 1909

Oil on cardboard
49.5 x 43.5 cm

Haubrich Collection

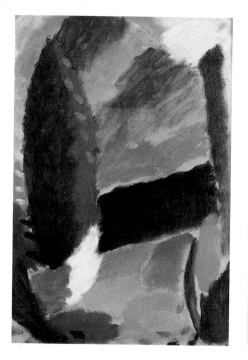

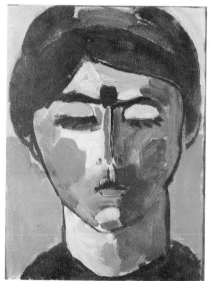

▲ Alexei
von Javlensky
Variation, 1916

Oil on canvas board
37.8 x 26.2 cm

Haubrich Donation,
1946

▲ ▶ Alexei
von Javlensky
Constructivist Head,
1930

Oil on cardboard
20.5 x 13 cm

Haubrich Collection

▶ Alexei
von Javlensky
Head of a Woman,
c. 1917–1918

Oil on canvas board
36.2 x 27.2 cm

Haubrich Collection

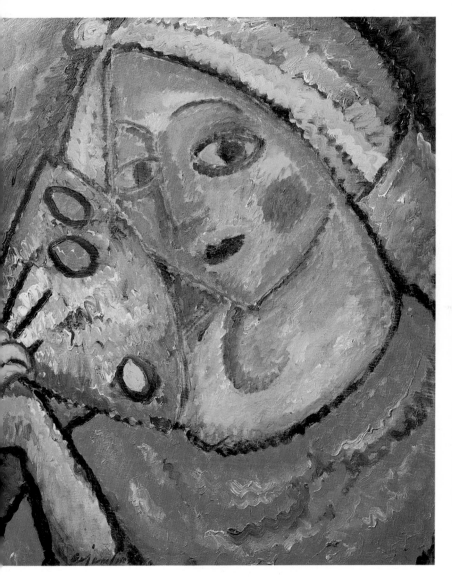

▲ **Alexei von Javlensky**
Fairy-Tale Princess
with Fan, 1912

Oil on cardboard
65.6 x 54 cm

Donation of Günther
and Carola Peill, 1976

Johns, Jasper

1930 Augusta,
Georgia
Lives in New York

► Jasper Johns
Passage, 1962

*Encaustic, piece of
a yardstick, metal
chain, fork, paper,
collage on canvas,
three parts*
178 x 102 cm

Ludwig Donation,
1976

▼ Jasper Johns
Painted Bronze
(Ale Cans), 1960
Painted bronze

*Two cans, height 12
cm, diameter 6.8 cm
each, pedestal*
12 x 20.3 x 2 cm

Ludwig Collection

Jasper Johns played a key role in the development of American art in the 1960s. Midway through the previous decade, when Abstract Expressionism still reigned unchallenged, Johns already began to depict objective subject-matter such as the American flag, targets, numerals and letters. Instead of altering these two-dimensional things and symbols, he adopted their design to create abstract paintings in which content, form, and support (the flat canvas) became inseparable. The consequence of this unity was that the "meaning" of the image resided solely in the surface qualities of the canvas or paper on which it appeared. The artist stepped into the background, not even allowing his brushwork to express his personality.

Jasper Johns went so far as to maintain that his works represented "information" pure and simple. These clearly readable yet nonetheless complex and ambiguous "facts" unsettled habitual modes of perception and visual association, compelling the viewer to think about the meaning of identity, and the relationship between depiction and reality. Johns gave no reply to the now-famous question, "Is it a flag or is it a painting?" The flag picture in the Museum Ludwig, Cologne, is in fact both a painted flag on an orange-colored field and an abstract painting.

In *Large White Numbers* of 1958, Johns depicted eleven numerals arranged in eleven vertical columns. The shift in their order from column to column follows a logical progression, yet is basically

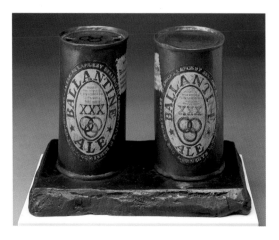

meaningless, because the numbers have been deprived of all function. They have the character of objects, while at the same time being abstractions; a number that refers to nothing beyond itself becomes a mere shape, void of content. The same issue is addressed in the great *Map* (1967–1971), which Johns created for the American pavilion at the Expo '67 world fair in Montreal and reworked in subsequent years. The composition is based

Ill. p. 304:
Jasper Johns
Large White Numbers, 1958

Encaustic on canvas, 170.5 x 126 cm

Ludwig Donation, 1976

Ill. p. 305:
Jasper Johns
Flag on Orange Field, 1957

Encaustic on canvas, 167 x 124 cm

Ludwig Donation, 1976

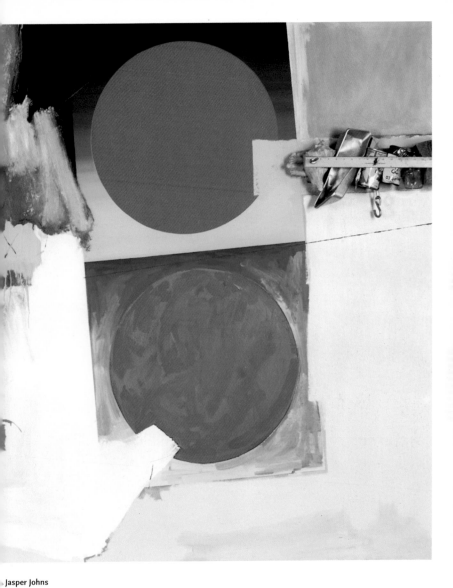

Jasper Johns
dingsville, 1965
il on canvas with objects
73 x 311 cm

udwig Donation, 1976

▲ Jasper Johns
Map, 1976–1971

Encaustic,
pastel and collage
on canvas,
22 parts
500 x 1000 cm

Ludwig Donation,
1976

on the Dymaxion world map developed by Buckminster Fuller, the architect of the pavilion. Johns projected his innovative typographical map, which reproduced the earth's surface without distortion in two dimensions, onto 20 equilateral triangles. While retaining the jagged outline of Fuller's map, Johns divided two of the triangles and separated them (lower left and far right). The names of countries, islands and oceans were applied to the encaustic surface by means of stencils.

Johns's works are based on the contradictions that result from
blurring of the borderlines between reality and art. Can beer cans,
cast in bronze and painted, be art? Does the artistic process transform
them into monuments to trivial culture, or do they simply remain
trivial relics? Such questions about the interrelationship between
reality and art become even more complex in the case of *Passage*,
painting of 1962. In keeping with the title, everything here is in flux.
The spelled-out primary colors – red, yellow, blue – actually appear

▲ Jasper Johns
Untitled, 1972

*Acrylic and
encaustic on canvas,
wooden slats,
wax casts,
and diverse materials,
four parts*
183 x 490 cm

Ludwig Donation,
1976

as greyed, mixed hues; that is, the color designations do not actually coincide with the depicted colors themselves. Moreover, the various passages continue across the borders of the three-part canvas and intermerge.

Edingsville (1965) represents an exception for Johns, in that a human leg, modelled in light and shade, appears on the two-dimensional surface. It is likely a variant on the cast of a leg, attached to an upside-down chair, used in the earlier combine-painting *Watchman* (1964). In *Edingsville* the cast of an arm and various real, everyday objects are hinged to the surface such that they can be folded out.

The four-part painting *Untitled* (1972) also echoes an earlier work. The red, black and white tile-like pattern was not invented, but, typically for Johns, observed on the wall of a building during a ride through Harlem. The crosshatched pattern covering the field on the

left also derived from a car trip, having been seen on an approaching vehicle. Using casts of parts of the body and relics of various human activities in the form he found them, Johns united apparently incommensurable elements and created visual correspondences among seemingly unrelated things.

Though Johns's sophistic philosophy, veiled as anti-intellectualism, remained inimitable, his work had incredibly far-reaching effects. His depersonalized approach, elimination of metaphor from art in favor of autonomous structure, serial order, repetition for repetition's sake, and isolation of the object and reification of the image – all of these innovations had a seminal influence on Pop Art, on the "non-relational" art of Frank Stella and Kenneth Noland, as well as on Color-field Painting and Minimal Art.

◄ **Allen Jones**
Figure Falling, 1964

Oil on canvas
273 x 244 cm

Ludwig Donation,
1976

Jones, Allen

1937 Southampton,
England
Lives in London

In the late 1950s Pop artist Allen Jones worked with semiabstract,
painterly forms, rendering objects solely in terms of certain schematic
details. *Figure Falling* (1964) emerged at the end of this phase. A fiery
red swath plunging down the picture like a comet brings movement
into the composition of flat, vividly contrasted yellow and blue fields,
demarcated by a wavy edge. The red band is flanked at the bottom
by patches of color out of which portions of a female figure emerge –
an arm and legs in high-heeled shoes. The sense of falling is evoked
not by means of agitated brushwork, but by juxtaposing large, quiet
planes to finely articulated passages of variegated color.

Perfect Match (1966–1967) was one of Jones's first paintings of a
full-length figure. Like an animated mannequin, this female has been
reduced to the secondary sex characteristics of long, shapely legs,
pointed breasts, tight buttocks, and pouting mouth. She was one of
a great number of Jones's variations on the theme of "Sexy Girls."
The mass-produced look, the passivity of a sex object lacking arms
and individual facial features and apparently made for consumption,
are further underscored by the division of the composition into three
sections.

Allen Jones
erfect Match,
966–1967

il on canvas,
iree parts
30 x 93 cm

ıdwig Donation,
976

Jorn, Asger

(Asger Jørgensen)

1914 Vejrum,
Denmark
1973 Aarhus,
Denmark

▼ **Asger Jorn**
Untitled, 1968

*Paper collage on
brown cardboard*
35.5 x 30.5 cm

Donation of
Günther and Carola
Peill, 1983

Danish artist Asger Jorn was a representative of Abstract Expressionism in Europe and a co-founder of the Cobra group.

His early paintings, of 1930 to 1935, were landscapes and portraits that bore traits of Scandinavian Expressionism in the wake of Edvard Munch. Jorn's style changed in 1936–1937, when he collaborated with Fernand Léger and Le Corbusier in Paris and was strongly influenced by the Surrealist imagery of Max Ernst and the fabulous creatures of Paul Klee. Using the Surrealist technique of automatism, Jorn was able to tap the wellsprings of imagery in the subconscious mind and reveal hidden aspects of human experience. His œuvre was suffused by the ideas and traditions of Nordic mythology and legends, in which all manner of grotesque demons, hobgoblins and trolls play an important role.

Jorn's *Mugwump* of 1957 shows just such a fantastic creature, part human, part beast, rendered with rapid, agitated strokes of garish color.

Apart from painting, Jorn also occasionally made collages. In the years 1967–1969, the period to which *Untitled* dates, these were done by the technique known as *décollage,* sections of posters torn off encrusted hoardings and recombined. In this regard Jorn was evidently influenced by artists such as Mimmo Rotella and François Dufrêne. Like his oils, Jorn's collages are primarily abstract in character, yet with suggestions of objective reference which, despite their ambiguity, trigger strong visual associations in the viewer's mind.

► **Asger Jorn**
Mugwump, 1957

Oil on canvas
80 x 60 cm

Judd, Donald

1928 Excelsior
Springs, Missouri
1994 New York

▼ Donald Judd
Untitled
(Eighth modular unit,
V-channelpiece),
1966–1968

Stainless steel,
eight parts
120 x 313 x 318 cm

Ludwig Donation,
1976

With Carl Andre, Sol LeWitt, and Robert Morris, Donald Judd represents the sculpture of Minimal Art in the Museum Ludwig, Cologne. His waiver of allusive titles in favor of mere straightforward description of the objects' outward form illustrates the rejection of subjective aesthetic statement which was characteristic of this school.

Judd employed highly reduced, basic geometric shapes in his sculptures, which were made of special industrial materials. They embodied a new aesthetic, intrinsic to forms of the plainest, most elementary character. For Judd, whose studies in art history and philosophy led him to an intensive involvement with theoretical issues in art, clarity was one of the principal factors in art of any variety. A shape, a body in space, a color, a surface were things in themselves, he once noted, concluding that forms and materials should not be alienated by their context. In addition to the objective nature of materials – evident especially when "they are employed unchanged" – Judd was interested in overcoming hierarchical systems in sculpture, the ranking and subordination of elements, by means of a more "democratic" composition that treated every object as a whole. He searched for what he called a "special quality."

Unconcerned with the distinction between thinking and feeling, Judd pursued the thing in itself, that entity known as a work of art. The quality of wholeness, he realized, was a very complicated matter, dependent on certain materials, certain arrangements and proportions of "things on the wall," and many other factors. What concerned him foremost was the object as a whole, and the particularities of this wholeness. To achieve this quality an object should above all be autonomous, which, Judd believed, would render it more expressive, clearer, and more powerful.

The anti-hierarchical, as it were egalitarian character of his sculptures was also reflected in the serial principle which Judd frequently employed. In the horizontal, wall-mounted piece of 1966, a combination of cubic and cylindrical forms, still evinces an irregular spacing between the convex and concave elements. The later, free-standing work, consisting of eight identical parts, combines a rectangular basic shape with V-shaped bands. The size of the sculpture and the way it both occupies the space and is permeable to it, like the serial arrangement, are further indicators of Judd's concern with the issue of the potentially infinite extension of a three-dimensional body in space.

▲ **Donald Judd**
Untitled, 1966

Stainless steel
37.5 x 194.5 x 64.8 cm

Ludwig Donation,
1976

Kabakov, Ilya

1933 Dnyepro-
petrovsk, Ukraine
Lives in New York

▼ Ilya Kabakov
Trumpet, Stick,
Ball and Fly, 1966

*Veneer, enamel and
ceramics*

130 x 180 x 20 cm

Ludwig Collection

Ilya Kabakov was the founder of a group of non-conformist Russian artists who in the early 1960s began to challenge official Soviet art and its aesthetic of Socialist Realism. Probably the most salient trait of the Moscow Conceptualists, as the group became known, was an ironic combination of visual imagery with texts. Kabakov had always shown a special preference for the narrative in art. Between 1970 and 1980 he produced fifty large albums, which were inspired by his work as an illustrator of children's books during the 1960s. Each album told the story of a lonely artist, and ended with several pages of empty, white paper, symbolizing his death. The three drawings with the motif of boys peering out of the corners of the picture were part of the album *Malygin the Scribbler*, executed between 1972 and 1975, and consisting of a total of 72 sheets. The album, in turn, belonged to a ten-part series titled *Ten Persons*.

In the paintings of the period, Kabakov employed a monochrome, green or white field to evoke an ontological space along the lines of Kasimir Malevich's white square – an enigmatic, metaphysical realm. Attached to the field, as in *Trumpet, Stick, Ball and Fly* (1966), were banal, everyday objects that were intended to mark the borderline between Malevich's "realm of the fourth dimension" and that of our own, workaday world.

The emptiness of the monochrome field is taken to extremes in Kabakov's *Before the Last Supper* (1988). Here, forty drawings are combined into a huge frame extending around a glossy, white expanse. The white field is repeated in each of the drawings, as it were forcing their depictions to the extreme edge of the sheet and leaving a void in the center. Flanking the frame of drawings are six paintings in the Socialist Realist style, each with a second, smaller image inserted, which serves to dispel the illusion of reality and depth, and to emphasize the flatness of the canvas. Attached to all four

corners of the paintings are plates, knives and forks, which transform the picture into a table set for supper. A seventh painting, equipped with wooden legs, becomes an actual table, standing before the installation.

In contrast to the idea of the "ready-made" as developed by Marcel Duchamp, Kabakov does not so much raise the trivial object to the status of art as bring painting, and by extension art in general, back down to mundane reality. By relegating Socialist Realism to banality, the artist clearly states his opinion on the functions and aims of official Soviet art. The empty white field, on the other hand, represents just the opposite – a space in which pure art, untrammeled by the dictates of ideology and politics, may unfold.

The motif of the void constantly reappears throughout Kabakov's œuvre. It was the central theme of *Red Pavilion*, the artist's contribution to the 1993 Venice Biennale. The high wooden fence in this work demarcates the edges of a Malevich square. Within this empty space stands a little pink pavilion, an ironic, pitiable temple embodying the

▲ **Ilya Kabakov**
Unhung Painting,
1982–1992

*30 drawings (1992)
in frames,
54.5 x 83 cm each;
One diptych,
"Abramsevo" (1982),
oil on canvas,
260 x 380 cm;
tools,
wooden ladder,
two light bulbs,
wooden floor and
door
500 x 875 x 310 cm*

Ludwig Donation,
1994

▲ **Ilya Kabakov**
Before the Last Supper, 1988

Installation of seven panels,
oil on canvas, porcelain plates,
silverware, 42 drawings,
colored crayon and ink on paper;
four table legs and
wooden frames; rear wall
450 x 900 x 40 cm

Ludwig Collection

erstwhile glory of the Soviet Union. The structure also questions the validity of Malevich's ideals, as represented in his *Black Square*. Neither the square nor the Soviet Union, which Malevich helped call into being, have apparently been able to fulfil the high expectations placed in them.

In what he calls his "total installations," which include *Unhung Painting* (1982–1992), Kabakov permits the audience to enter the domain of the painting. The viewer's role is made a subject of the work by the inclusion of a series of drawings that represent fictitious commentaries on the part of the public. The comments range from intellectually serious to banal. Painstakingly rendered flies, balls, and stools seem to hover over the surface of the drawings. The illusion of the work of art is simultaneously created and destroyed.

Ilya Kabakov
Row, 1969

*Ink and felt pen
on cardboard
20.6 x 29.9 cm*

Ilya Kabakov
Horse, 1967

*Colored pencil and
pencil on cardboard
20.7 x 30 cm*

Ilya Kabakov
Path, 1968

*Pencil and colored
pencil on paper
20.3 x 28.7 cm*

Ilya Kabakov
Little Houses, 1965

*Ink, felt pen and
colored pencil on paper
20.3 x 28.7 cm*

All four: Ludwig
Donation, 1994

▲ **Ilya Kabakov**
Red Pavilion, 1993
(detail)

Installation of wood,
partially painted,
loudspeakers, stereo set,
magnetic tapes
500 x 920 x 460 cm

Ludwig Collection

Menashe
Kadishman
Pietà, 1992

Iron
210 x 178 x 136 cm

Gift of
Friends of the
Wallraf-Richartz-
Museum and
Museum Ludwig,
Cologne, 1993

After receiving his artistic training in London during the 1950s, Menashe Kadishman spent periods in America. Since returning to Israel in 1972, he has lived and worked in Tel Aviv.

Kadishman's preferred material is heavy steel plate, from which he cuts simplified figurations with a blowtorch. The resulting silhouettes are either bent to form standing sculptures, or simply folded out of the slab, to create relationships of positive and negative form that are sculpturally extremely effective.

Pietà of 1992 evinces a subtle change in Kadishman's approach that lends a new dimension to his work. From a metal plate several centimeters in thickness a silhouette of the Pietà has been cut out and placed on the floor, while the plate containing the negative shape is raised to an inclined position, forming a space which in turn encloses the figure. The two silhouettes are superimposed, and the physical Pietà (the positive shape) and the spiritual Pietà (the negative shape) merge in the eye of the beholder.

**Kadishman,
Menashe**

1932 Tel Aviv, Israel

Lives in Tel Aviv

◄ Wassily Kandinsky
Riders on the Beach
1911–1912
Reiter am Strand

Watercolor on paper
31.5 x 48 cm

Haubrich Collection

Kandinsky, Wassily

1866 Moscow
1944 Neuilly-sur-Seine, France

Wassily Kandinsky had already graduated from law school when, seeing French Impressionist paintings in Paris and Moscow, he decided to devote himself to art. He went in 1896 to Munich, where he attended Anton Ažbé's private school of painting, then Franz von Stuck's class at the Academy, where Paul Klee was a fellow student. Older than most of the students, Kandinsky was keen to pass his experiences and insights on to his younger confreres. He was an amazingly versatile man teaching, publishing theoretical essays on art, organizing exhibitions, establishing contacts with painters, writers, and composers in Germany, France and Russia.

Shortly after the turn of the century Kandinsky founded the Phalanx School, followed in 1909 by the New Artists' Association of Munich, and in 1911, after a falling-out with that association, the Blauer Reiter (Blue Rider). His influential book, *Concerning the Spiritual in Art,* was completed in 1910. Kandinsky's painting style developed through several stages, incorporating features of Impressionism, Symbolism, Art Nouveau and decorative folk art, before burgeoning into pure abstraction.

Riders on the Beach belongs to the artist's early phase. It shows a woman and man on horseback, galloping upwards from the lower center of the composition, in opposite directions – symbols, perhaps, of an unrequited romantic longing. The symmetry is underscored by the upright pose of the riders, which, as it were, puts a visual stop

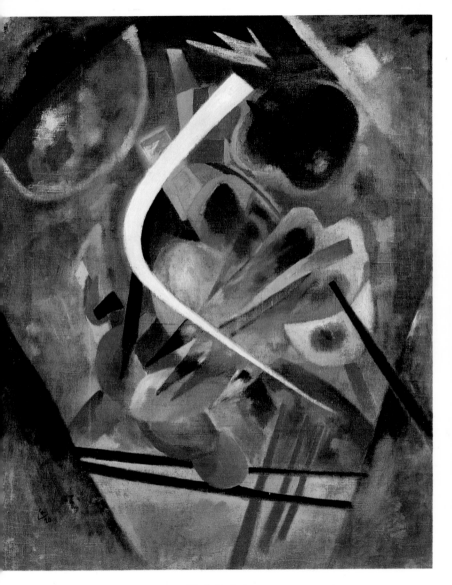

▲ **Wassily Kandinsky**
White Line, 1920
Weißer Strich

Oil on canvas
98 x 80 cm

▶ **Wassily Kandinsky**
Sharp-Quiet Pink,
1924
Scharfruhiges Rosa

Oil on cardboard
63.6 x 48.2 cm

Haubrich Collection

on the diagonal movement to left and right. The unpainted portions of the paper, evoking a sandy beach, occupy the greatest area of the composition. Also hovering there, apart from the riders, are flecks of watercolor in bright blue, green, yellow and red, which seem on the verge of dissolving and vanishing like clouds. Amorphic strokes accentuate horses and riders, yet without modelling them in three dimensions. The transparency of the diaphanous watercolors, divorced from objective description, anticipates Kandinsky's attempts to dematerialize the things in his painting and evoke a transcendence beyond all earthly ties.

On the outbreak of the First World War, Kandinsky left Germany and returned for a time to Moscow, where after the revolution he was active in cultural affairs and the reorganization of Russian museums. In the course of defining his personal artistic stance within the revolutionary Russian avant-garde, Kandinsky painted in 1920–1921 a series of extraordinary works. One of these, *White Line* (1920), was done on coarse, rough-woven, apparently unprimed burlap. The oils were applied wet-in-wet, the colors scumbled into one another in many passages. The dynamic, ebullient, varicolored scene with the dominant white, curving stroke in the center plays itself out within a trapezoidal frame against a neutral, greyish-brown background. It is if one were looking through a window into imaginary color-spaces, which the artist intended to strike a chord within the beholder and lead the way into a spiritual realm.

This composition belongs to a transitional phase in Kandinsky's work, in which the initial, playfully organic forms gradually began to be supplanted by solid, geometrically rigorous configurations. This was the style of the artist's years at the Weimar Bauhaus, where he took a teaching post in 1922. The changeover to more thoughtful composition and sophisticated color relationships is evident in *Sharp-Quiet Pink* of 1924, which is dominated by an acute triangle reminiscent of a key element in the Suprematist vocabulary. The Bauhaus emphasis on aesthetic principles and the functionality of art echoes in the abstract forms in the painting, which reflects the theories expressed by Kandinsky in his essay *Point and Line to Plane*.

Kanovitz, Howard

1929 Fall River,
Massachusetts
Lives in New York

▼ Howard Kanovitz
Journal, 1972–1973

*Acrylic on canvas
273 x 243 cm*

Ludwig Donation,
1976

Howard Kanovitz frequently works with enlarged photographs projected onto the canvas. Yet he alters their texture, rearranges motifs, and combines them with elements of painting and sculpture. A former student of Franz Kline, the action painter, Kanovitz was influenced by Pop Art and Photorealism. His interest in realism, the artist once explained, was partially due to an event in his biography. When his father died in 1963, Kanovitz was confronted with piles of family photographs, with which he then began to work as a means of coming to terms with the past.

A key focus of the artist's work, life in American society, appeared with regularity in the paintings of the 1960s. Pop Art, with its simplifications of form, garish color, and ironic transformations of mass-media imagery and technology, also left its traces on Kanovitz's approach.

Journal, a large-format canvas done in 1972–1973 in London, was based on the cover of the August 1968 issue of *Ladies Home Journal*, showing actress Mia Farrow. The magazine page has been enlarged almost to billboard proportions. The woman pictured seems doubly robbed of individuality and privacy, once by the blow-up process, and again by the microphones of the press, into which "Mia Farrow talks... and talks." Yet the fact that not even the best photographic and printing techniques can make a real person totally accessible to the public is indicated by the subtly alienated painting approach employed. It includes an enigmatic blue background, the blurred, flickering effect of the headlines and edges of the magazine, and the reflection in the actress' eyes of a strange, unknown world.

A key thrust of art in the 1950s was an attempt to integrate art and life. Allan Kaprow, intellectual father of Happenings and Environments, was probably the major proponent of this new direction. In numerous writings which constituted a key contribution to the contemporary theory of art, Kaprow traced the emergence of these innovations back to the principle of collage.

Stained Glass Window confronts the viewer with a plethora of visual signs, arranged to evoke a vibrant, diaphanous space. In collages of this type the relationship of painting to object is reversed, as existing elements are entirely integrated in the painting process. The eye takes in sign after individual sign, finally arriving at a perception of an interlocking, complex whole.

Kaprow, Allan

1927 Atlantic City,
New Jersey
Lives in San Diego,
California

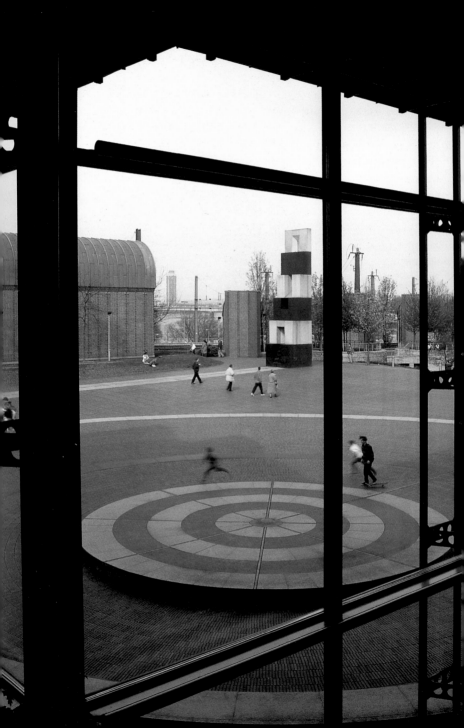

Dani Karavan attended art schools in Tel Aviv and Jerusalem, then went
to Florence to devote himself to an intensive study of the frescoes and
reliefs there.

In 1981 the city of Cologne commissioned Karavan to design the
open area bordered by the museum building and restoration depart-
ment on the north and south, and by the cathedral choir and Rhine
Gardens on the west and east. In accordance with the artist's design
principles, the resulting plaza is oriented in terms of both form and
materials to the surrounding topography and architecture. The materials
employed relate to those already present in the environment: granite
to the paving of Roncalliplatz, brick to the masonry of the museum
building, iron to the structure of Central Station and Hohenzollern
Bridge with railroad line, and grass and trees to the vegetation of the
Rhine Gardens.

The two focusses of the plaza are a 10.8 meter-high, stepped
element of cast iron and granite, and a low, circular platform consisting
of concentric rings of the same, contrasting materials. "My aim," said
Karavan, "was a plaza that, as such, was a work of art, an environment
– a meeting place of the directions west-east, northeast-southwest, and
north-south, a combination of materials, forms, and vistas, memories
and associations, a place for people to look around and spend time."
The harmoniously balanced proportions of the square were achieved
by relating the dimensions of each element to a standard module.
All measurements go back to the number 18, whether as fractions or
as multiples, reflecting Karavan's involvement with the numerology and
laws of proportion which were rediscovered during the Renaissance
and passed on to succeeding generations of artists. His plaza thus
presents itself as a well-considered synthesis of architecture and
sculpture, city-planning and natural environment.

Karavan gave the environment the Hebrew name of *Ma'alot*,
which refers to the Psalms of David, 129–133, and their musical steps
or intervals. This established a relationship in terms of content both
to the stepped sculpture on the plaza and to the concert hall located
beneath it.

Karavan, Dani

1930 Tel Aviv, Israel
Lives in Tel Aviv
and Paris

◄ **Dani Karavan**
Museum Plaza
(Ma'alot).
Environment
for the Wallraf-
Richartz-Museum/
Museum Ludwig,
Cologne, 1981–1986

*Bricks, granite, rail-
road rails, cast iron,
grass and trees
Area 5000 square
meters, highest point
10.8 meters*

Kassák, Lajos

1887 Ersekujvar,
Hungary
1967 Budapest

▼ Lajos Kassák
Pictorial
Architecture, 1922

Oil on cardboard
26 x 24 cm

Donation of
Günther and Carola
Peill, 1976

Though Lajos Kassák did his first paintings while still employed as a metalworker, it was a stay in Paris, from 1907 to 1909, that truly inspired him. He launched into a variety of activities, not only painting and making prints, collages and reliefs, but writing poems and prose, doing commercial art and typography, and designing stage sets. Finally Kassák became the publisher and editor of a number of anthologies and journals. Stimulated by contacts with the Futurists and Dadaists, he formed his own Dada group in Vienna (1920–1926). In 1926 Kassák returned to Hungary – despite his connections with the Bauhaus, especially with László Moholy-Nagy, with whom, in 1922, he had co-edited the *Buch neuer Künstler* (Book of New Artists).

The widespread striving of the period for a universal language of art led Kassák, like others, to tackle architecture. Unlike the Russian Constructivists, however, he designed no practicable projects. The issue seemed to him of a more theoretical nature; he discussed it in essays and addressed it in drawings and paintings, such as *Pictorial Architecture* (1922). Kassák envisioned a "creativity nourished by strict, intrinsic laws," which would be cleansed of emotional and mental processes and lead to an absolute image. The picture, in other words, was to be neither a representation nor an abstraction, but, like the New Architecture, something whose design principles developed out of the conditions of its existence themselves.

Pictorial Architecture, as Kassák called his paintings, was building on the two-dimensional plane. As seen here, the superimposed shapes and colors engender no illusionistic perspective, but seem to emerge into the real, surrounding space. The artist's rationalistic approach is also reflected in the use of simple, plain forms, and a narrow range of clearly demarcated colors.

► Ellsworth Kelly
Three Panels:
Blue Yellow Red,
1966

Oil on canvas
210 x 153.5 cm

Ludwig Donation,
1976

Towards the end of the 1950s, Ellsworth Kelly, Leon Polk Smith, and other young American artists set out to undermine the predominant style, Abstract Expressionism. In reply to the spontaneous, idiosyncratic, gestural painting of artists like Jackson Pollock, they searched for new ways of engendering form, and arrived at a geometric, systematically constructed type of composition. The reduction of form and color to their essence played a key role in this regard. Kelly's *Three Panels: Blue Yellow Red* of 1966 is a salient example of this new direction, which became known as Color-field Painting. The form of the painting was its content, said Kelly. The works consisted of one or more panels, rectangular, rounded, or square. The traces on the panels, he went on, interested him less than the "presence" of the panels themselves. They represented an idea that could be repeated at any time in the future.

Kelly, Ellsworth

1923 Newburgh,
New York
Lives in Spencertown,
New York

Cuban sculptor Alexis Leyva, alias Kcho, is the youngest artist represented in the Museum Ludwig, Cologne. His work came to international attention through his participation in the Fifth Havana Biennale. Kcho's career began as early as 1986, when he was only sixteen, with his first one-man show at the Centro de Artes Plásticas in his home town. There followed numerous solo and group exhibitions, including the Third and Fourth Havana Biennales, and participation in shows of Cuban art in Mexico, Venezuela, Brasil, Germany, the Netherlands, and the United States.

Kcho's works focus almost exclusively on a typical Cuban problem – escape, the only form of emigration possible from a country that since 1959 has stood under the communist rule of Fidel Castro. Yet a certain biographical aspect is also evident. Since Kcho grew up on Isla de la Juventud, a small island south of the Cuban mainland, the ocean has always been at the center of his life.

The boat, symbol of an insular life, has become the artist's trademark. Like the Chilean artist Alfredo Jaar, Kcho translates current political events into works of art with a universal message. Starting point of his large-scale floor installation *Regatta* was the mass exodus of thousands of Cubans to the US in 1994. A regatta of countless miniature boats, rafts, canoes, and dingies made of wood, lead, plastic, clay, and styrofoam, interspersed with flotsam, industrial waste, cardboard boxes, and old shoes, forms the shape of a stranded ship. A microcosm becomes a macrocosm, and vice versa.

Kcho's *Regatta* evokes the hope of his fellow Cubans, but also their despair. It is a tribute to the refugees who lost their lives, as it were twice over – once, if only metaphorically, under the restrictive regime and poverty of the island nation; and again literally, on their attempted escape through the dangerous Caribbean waters. But the work is also a monument, composed of relics and souvenirs, to the courageous persistence and fearless bravery of politically persecuted people. The boat symbolizes the hope they place in American democracy, as well as the intertwining of Spanish and African roots in Cuban culture, which has been shaped by its dual origin in European conquest and African slavery.

Kcho
(Alexis Leyva)

1970 Isla de la
Juventud, Cuba
Lives in Havana

◄ **Kcho**
Regatta, 1994
La Regata

*Assemblage of wood,
flotsam, industrial
waste, lead, and clay
Variable dimensions*

Ludwig Collection

Kiecol, Hubert

1950 Bremen,
Germany
Lives in Cologne

▼ Hubert Kiecol
Five Sculptures,
1986
Fünf Skulpturen

Concrete, five parts
199 x 27 x 27 cm;
197 x 28 x 24 cm;
197 x 26 x 25 cm;
196 x 27 x 27 cm;
204 x 27 x 22 cm

Loan of
Dr. Reiner Speck

Since the early 1950s Hubert Kiecol, who attended the Hamburg College of Art, has increasingly concentrated on the relationship between architecture and sculpture. *Five Sculptures* of 1986 was shown at La Raó revisada, a 1988 exhibition at the Centro Cultural de la Fundació Caixa de Pensiones in Barcelona. In terms of its monumentality the piece recalls primeval monoliths, yet its simplicity of form also suggests rigorous modern architecture. The columns vary only slightly in size, and their shafts are identical. Only the capitals differ considerably in design. By the use of simple materials and an extremely reduced outline, Kiecol creates the impression, as Annelie Pohlen said in 1982, of a "sculptural, miniature architecture."

The columns have been deprived of their utilitarian function – they have nothing to support. They stand right on the floor, without a base, rudimentary architectural elements which refer aesthetically to nothing beyond themselves, shapes pared down to the essentials.

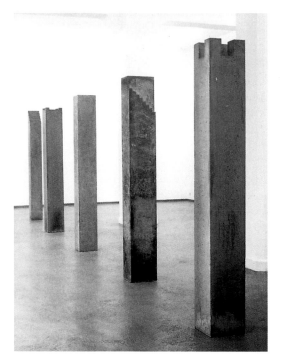

Kiecol attempts to define the form of every object he uses in his work beyond the limits of its natural, everyday context. As this implies, a sculpture will never be identical with the object and function from which it derives, in this case an architectural phenomenon.

In terms of theme, the artist addresses the problematical aspects of modern architecture, and contemporary city planning and design, in a frequently very subtly allusive way. His primary concern is with what Alexander Mitscherlich termed the "inhospitable nature of our cities," to which the grave failings of modern architecture have contributed not a little.

Natural vegetation is not normally found in an urban environment. But where it does occur – as on the occasional vacant lot – someone is bound to declare it should be protected as an ecological niche. Anselm Kiefer's interest in just such an area, however, goes beyond its plant life to include its historical significance. The plants employed in his triptych *Eco Niches* of 1992 originate from a site in Munich where a National Socialist building once stood. When plans to rebuild there became known, environmentalists attempted to protect the vegetation that had grown there since the war. Ironically, as Kiefer sees it, they also managed to protect a reminder of Nazi dictatorship from being suppressed or forgotten. To reflect this irony of history, the artist arranged – against a background suggestive of an urban skyline – plants that are used as medicinal herbs, including cardiac stimulants which, in larger doses, are toxic and can lead to death.

Airplanes are taken for granted nowadays. At the risk of seeming obvious, they may be called our link between earth and sky. They enable us to temporarily leave our earthbound existence and to over-come the formerly determining factors of space and time, to leave great expanses of land and sea behind and beneath us. The airplane is both a symbol and a means of the human conquest of the earth and atmosphere. But it has also become a symbol of the dangers that lurk in our exploitation of natural, physical forces.

In making *Elisabeth* (1990), Kiefer purposely chose very heavy materials – steel, glass, and lead – to create an ironic image of an aircraft. The dangers involved in flying are evoked by applied human hair. *Elisabeth* is one of a series of lead airplanes Kiefer has done. The title is inscribed on its fuselage, along with the name "Berenice." This is an allusion to the legendary daughter of the King of Cyrene, who is also known as the wife of Ptolemy III Euergetes. One day, while he was journeying to Syria, Berenice sacrificed her hair to the goddess Venus, in order to ensure her husband's safe return. She brought her hair to the temple of Zephyr, where it inexplicably disappeared. A mathematician and astronomer thereupon explained the phenom-enon simply by saying the hair had been taken to heaven, and was now beneath the stars. The title of the work is important for an understand-ing of Kiefer's intentions. Elisabeth, the Austrian empress Sissi, for years fled from all responsibility by incessantly travelling. By analogy, Kiefer's *Elisabeth* symbolizes the restlessness of the modern age.

Kiefer, Anselm

1945 Donau-
eschingen, Germany
Lives in Barjac,
France

▲ **Anselm Kiefer**
Elisabeth, 1990

Lead, glass, charcoal,
female hair,
photograph
230 x 595 x 622 cm

Ludwig Collection

◄ **Anselm Kiefer**
Tree with Wing, 1979
Baum mit Flügel

Oil on canvas
and lead wings
285 x 190 cm

Ludwig Donation,
1994

An extremely knowlegeable employment of history, especially German history, is characteristic of all of Kiefer's work. The *Hermannsschlacht*, for example, appears in many variations. According to legend this battle, in which the Cherusci under Arminius vanquished the Roman legions under Quintilius Varus, thus liberating Germany, took place in Teutoburg Forest.

Kiefer's concern with German history and Teutonic legend has inexplicably earned him the reputation of harboring fascist sympathies. His painting has frequently sparked heated debate. "Evidently the titles . . . have had such a suggestive effect on hasty critics," notes Zdenek, "that they have read blatant ideological content into them. Such readings are usually quite superficial, for they overlook the fact that Kiefer's involvement with German mythology and history can by no means be equated with an invocation of the dark Teutonic spirit. Rather, the myths and historical events, as content of manifold meaning, are part of Kiefer's speculative painterly method."

The motif of flight began to preoccupy Kiefer as early as the 1970s. Wings have been a central and recurring motif in his art since 1974.

In a group of works to which *Tree with Wing* belongs, the artist alludes to the Lay of Völund in the *Edda*, which tells the story of the skilled swordsmith, Völund. In order to keep him at his court, King Nidud orders him hamstrung. Völund takes revenge on the king by raping his daughter, killing his sons, and making drinking bowls out of their skulls. Then he escapes by means of self-fashioned wings. Behind the figure of the smith stands Daedalus, of Greek mythology. In most of Kiefer's paintings the wings (of Völund) are made of lead, an element to which the artist has always attached great significance. As C. Inboden points out, "Lead is most closely allied to the earth. From ancient times both have figured as comparable, primeval materials, and as that 'confused mass' in whose inertness the volatile spirit is imprisoned, and from which it can be liberated."

▲ **Anselm Kiefer**
Eco Niches, 1992
Öko-Nischen

Plants, clay and emulsion on canvas, in glazed steel frame
170 x 250 cm

Ludwig Collection

Without formal artistic training, Edward Kienholz began in 1953 to make reliefs of scrap wood and other materials. These were followed in the early 1960s by his first environments. His *Portable War Memorial* had its starting point in a photograph taken by Joe Rosenthal on the morning of February 23, 1945. It shows six men of the 28th Marines raising the American flag on Mount Suribachi on the island of Iwo Jima after the defeat of the Japanese. Due to its stirring patriotic character, the photo was widely exploited in art, including the largest bronze sculptural group in the world, the Marine Corps Monument at Arlington National Cemetery, Virginia, by Felix de Weldon (1945–1954). A real flag is raised above the sculpture every morning and taken in at night.

The same photo formed the basis of Kienholz's *Portable War Memorial*. But instead of emphasizing the grandeur and monumentality of the group or using bronze and granite, the artist employed simple materials, a naturalistic approach, and a context carefully conceived and fraught with meaning.

The work can be read like a book, from left to right. The left side, said Kienholz, contains the "propaganda clichés." It begins with a black and white reproduction of the famous war poster of 1917, reading "I WANT YOU / FOR U. S. ARMY / ... NEAREST RECRUITING STATION," with a figure of Uncle Sam. The poster was part of a huge campaign to mobilize support for the war, for America had no conscript army at the time. The female figure standing in front of the poster represents singer Kate Smith (born 1901), whose great girth has been squeezed into a garbage can. Her head is cast in polyester resin, a macabre way of simultaneously fixing and conjuring up the singer's enormous voice. During the Second World War, Kate Smith was very active in maintaining army morale and raising money for war bonds. Her fame began in 1938 with a moving rendering of "God Save America" at a troop entertainment show. The song became America's covert national hymn, an appeal to the hearts and conscience of the nation. The original recording of the sentimental music is heard in Kienholz's sculpture, played on an endless-loop tape concealed in the garbage can.

The group of soldiers to the right also relates to the Second World War. They are clad in actual, period uniforms, sprayed with metallic paint, and fully equipped. Only their heads are missing, as if to say

► **Edward Kienholz**
Night of Nights,
1961

Zinc, steel wool,
plaster head
77 x 74 x 20 cm

Ludwig Donation,
1976

no man, or everyman, could be wearing the steel helmets. Behind the
group on a large black gravestone are inscribed the names of about
475 formerly independent countries that once existed, before war led
to the redrawing of borders. The names were gleaned from an ency-
clopedia by the artist's wife. Affixed to the top of the gravestone is
an inverted crucifix, bearing the American eagle and the inscription
'A PORTABLE WAR MEMORIAL COMMEMORATING V… DAY 19…'"
Any new victory and its date may be entered with the piece of chalk
dangling on a string.

Kienholz dubbed the right-hand half of the piece "Business as
usual." Originally the viewer was encouraged to take a seat in the snack
bar, which can no longer be permitted for reasons of conservation.
On the far right is another gravestone, this time without inscription,

but with a small, foam rubber figure at its base. This is Tarzan, the
indomitable noble savage – but his limbs have been scorched away,
a reference to the continual threat of atomic war that overshadows
every peaceful, everyday scene. The figure, said Kienholz, represented
the fate and the responsibility of mankind in the atomic age.

The objects in every part of the monument are realistically
rendered, and every sense is addressed: sight, hearing, taste, and
touch. The idea behind it was to overcome the aesthetic barrier by
making the environment actually usable. Kienholz has diagnosed

social and political ills critically and with great commitment, but
without sermonizing or pedantic analysis.

His statement is merciless and frank, couched in the language
of a moralist and humanitarian. This is also evident in *Night of Nights*,
one of Kienholz's many assemblages of *objets trouvés*, or existing every-
day objects. The piece makes reference to the tragic fate of Kathy Fiscus,
a girl who fell into an abandoned well in a small town near Los Angeles
and could not be rescued.

Convinced of his calling, Ernst Ludwig Kirchner devoted himself entirely to art after graduating from architectural school. In 1905, he and his friends Fritz Bleyl, Erich Heckel, and Karl Schmidt-Rottluff founded Die Brücke (The Bridge), a group whose program Kirchner incised in wood, as if on the tablets of the law: "As youth, we carry the future and want to create for ourselves freedom of life and of movement against the long established older forces. Everyone who reproduces that which drives him to creation with directness and authenticity belongs to us." The painters and poets of Expressionism attacked the inhumanity of what they considered an overcivilized world, and threw off the shackles of bourgeois life and academic tradition.

The small group of artists met once a week for what they called "quarter-hour nude." Their model changed her pose every fifteen minutes at the latest, and was encouraged to avoid any attitude that looked arty or unnatural. Thanks to this practice in rapid sketching, Kirchner's figures soon took on an amazing vitality. This is seen in *Female Half-length Nude with Hat* (1911), a picture of the artist's Dresden girlfriend, Doris Grosse, or Dodo, in which the sensuality of the female body is captured in a few, powerfully sweeping strokes. The newly achieved sexual freedom of the day is demonstrated here with a zeal that verges on the propagandistic, the girl offering her bared breasts over the lowered dress like fruit in a bowl. The curve of the shoulders combines with the dress neckline to form an oval that frames the breasts. The face, in turn, is framed by the round hat, with a a transparent section in the brim that reveals the girl's forehead and eyes. The delicate glow of the skin is effectively heightened by contrast to the intense, flat blue of the background. With this work Kirchner introduced into art a motif previously unknown: the partially unclad female figure.

The expressive, geometrically simplified forms of Kirchner's *Still Life with Tulips, Exotic Sculpture, and Hands* (1912) attest to the artist's admiration of the French Fauves and the primitive art of Africa and the South Seas, one of the ideals by which he sought to divest his work of academic, sophisticated form.

A short time later, Kirchner's move to Berlin confronted him with the blandishments and temptations of modern civilization. The advocate of unsullied simplicity became a chronicler of city life. His Berlin picture *Five Women on the Street* (1913) in the Museum

Kirchner, Ernst Ludwig

1880 Aschaffenburg, Germany

1938 Davos, Switzerland

◄ **Ernst Ludwig Kirchner**
Five Women on the Street, 1913
Fünf Frauen auf der Straße

Oil on canvas
120 x 90 cm

Haubrich Collection

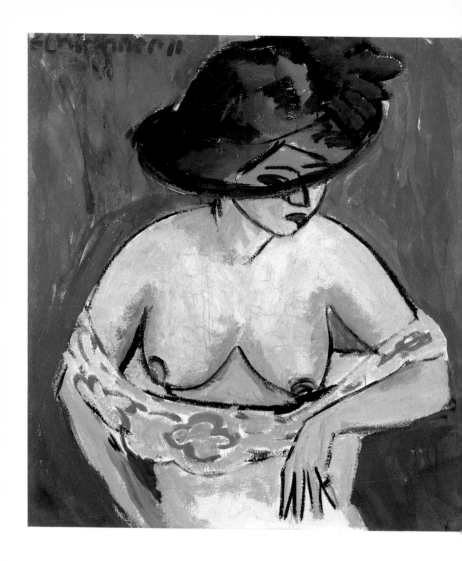

▲ **Ernst Ludwig Kirchner**
Female Half-length
Nude with Hat, 1911

Oil on canvas
76 x 70 cm

Haubrich Donation,
1946

Ludwig, Cologne, was the first of his famous street scenes. "As if uni-formed, garishly made up, dressed in chic evening gowns, feather boas and fashionable hats," writes U. Schulze, Kirchner's streetwalkers call exotic plants in a greenhouse to mind. Seemingly aimlessly, they saunter along "attempting to make eye contact in every direction, themselves becoming part of the merchandise on display in the great

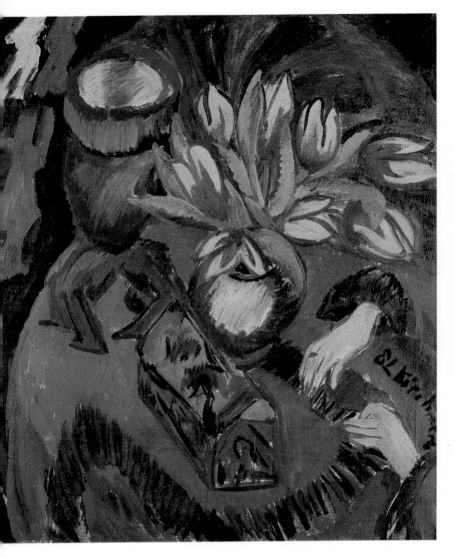

▲ **Ernst Ludwig Kirchner**
Still Life with Tulips, Exotic
Sulpture, and Hands, 1912
Stilleben mit Tulpen,
Exoten und Händen

Oil on canvas
78.5 x 68.5 cm

Haubrich Donation, 1946

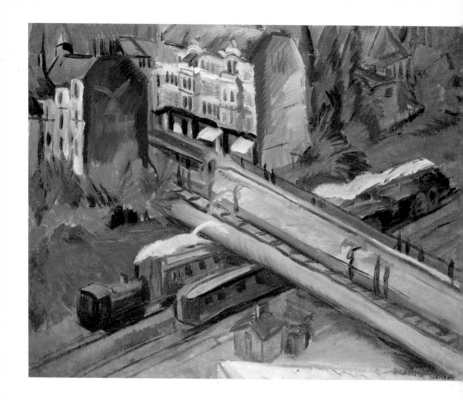

downtown department store, erotic mannequins in the grip of barely concealed mental anguish." By exaggerating the fashionable attire, Kirchner has condensed its details into an effective symbol of a society rife with self-deception, Imperial Germany dancing on the volcano of imminent war.

The Railroad Viaduct (1914) shows the view from the window of Kirchner's studio in Berlin. The bold diagonals that almost seem to burst out of the frame, and the nervously agitated brushwork, exhibit the composition and attack of Expressionism at their most forceful.

Group of Artists (The Painters of the Brücke) (1925–1926) is one of the finest pictures of its type, the friendship painting. With it Kirchner set a monument to his confreres (from left to right: Otto Mueller, Kirchner, Heckel, and Schmidt-Rottluff). When the picture was painted the group had already been disbanded for twelve years. A reunion with

his old friends was probably the sentimental occasion of the painting, which was done from memory after Kirchner's return to Switzerland, where he underwent treatment for severe depression.

A key to an understanding of Expressionism is provided by the artist's drawings and their unmistakable touch – lucid and fluent, in a typically abbreviated style, as in *Sleeping Woman* (c. 1911–1912). Not only line and sparing color, but the white of the paper itself are used to evoke the image.

In the watercolor *Nude Girl by the Stove* (c. 1913–1914), the tense, as if engraved crayon strokes, rapid zig-zag hatching, and the constricted space with its interlocked forms invoke an electrified atmosphere. Here Kirchner's indebtedness to African and South Pacific sculpture is much in evidence.

Kirili, Alain

1946 Paris
Lives in New York
and Paris

▲ Alain Kirili
Commandment I,
1979
Commandement I

*Wrought iron,
26 parts of various
configuration and
size, height from
22.5 to 37 cm, width
from 10 to 28 cm,
depth from 5.5 to
18 cm*

Ludwig Collection

Alain Kirili is indubitably one of the most interesting sculptors of
the younger generation. His controversial stance with regard to the
claims to objectivity raised by Minimal and Conceptual Art in the
1960s, and his active involvement with the binding tradition of
Classical Modernism, made him a major proponent of the art of
the 1970s.

Kirili's sculptural environment *Commandment I* was conceived for
installation in an enclosed space. He created five variations on the
theme between 1979 and 1981. Common to all was a maximum height
of the elements of 37 centimeters, whereby their number varied from
15 to 26. Arranged at random, the rune-like configurations seem to
sprout like plants out of the floor. Each is a small, unique, autonomous
sculpture. Kirili himself gave the following explanation of his work:
"I finished the sculpture *Commandment I* in October 1979, in New York.
I can't say anything special about it, except that it reminds me of Jewish
ritual objects – the *rimonim*. These are objects made of silver which
are placed on the torah. Rimonim is the Hebrew word for pomegranate,
a fruit that grows in the Orient. The explanation for this is that the fruit
contains as many seeds as there are commandments in the torah.
So the sculpture is a tranposition of signs, a field of signs."

Kirkeby, Per

1938 Copenhagen
Lives in Copenhagen

Per Kirkeby's monumental sculpture *Gate II*, conceived in 1986 and cast in bronze in 1987, is like a door opening into the artist's diverse and prolific work in the fields of painting, sculpture, literature, and film-making. A gate, depending on where we stand, can provide a view into something or beyond it, can serve as a passage between the familiar and the strange, between the present and the future. As such, the motif has played a determining role in Kirkeby's painting and sculpture. "I am gradually beginning to realize," he once wrote, "that all of my paintings have to do with holes, or caves. Holes in matter, like living in a cave and looking out. Or looking into a cave. These weird, vertiginous glances right through solid matter..."

In his painting Kirkeby attempts to come to terms with this unsettling perceptual experience, but not so much on site as from memory. Occasionally he cannot escape the feeling that "the only true reality is that created by human beings in images. So-called 'real reality' is not to be trusted, it is just unbounded matter... I cannot make my holes or caves by rationally planning them. Of course I can say to myself, Now I'm going to do a cave, but that doesn't make it real – all that emerges is a naturalistic illusion of a cave, not a real, actual hole in substantiality."

This orientation towards subjective feelings and their stimuli indicates a romantic tendency in Kirkeby's approach. Imagination sparked by certain circumstances in the past is essentially determined by the individual perception, subjective emotion, and mental reflection of the artist as a personality. In Kirkeby's own words, "The cave and the grotto are magical architecture, a reminiscence of the very first dwellings, as man began to take shape" as a species. Naturally the magical character of these archaic dwellings extends to their entrances, as the artist's *Gate II* symbolically indicates. Actually the form of Kirkeby's bronze, and even more the idea behind it, suggest a torso – a three-dimensional excerpt from an imagined reality, reflecting an aspect of nature that the artist saw and remembered and re-evoked, to call forth our own mental associations with experiences of nature.

Thus both geomorphic and anthropomorphic, the sculpture evokes mental images of the kind we associate particularly with Nordic and Romantic mythologies and legends, in which stones and minerals were thought to possess magic powers or contain indwelling gods or

demons. This relates Kirkeby's piece, in terms of content, to Auguste Rodin's *Gates of Hell* (1880–1917), which was inspired by Dante's *Divine Comedy*.

The reference to natural configurations is clearly present in Kirkeby's modelled sculptures, and also is related to the intentions behind his nature-inspired, only apparently abstract paintings. In view of Rodin's sculpture, we can better understand Kirkeby's desire to create *Gate II* as a self-contained "geomorphological sculpture" as a quotation from nature, independent of architectural relationships and appealing directly to the imagination. Its proximity to the "image," with all the metaphorical meanings inherent in this term, and thus its link with Kirkeby's expressive paintings is evident.

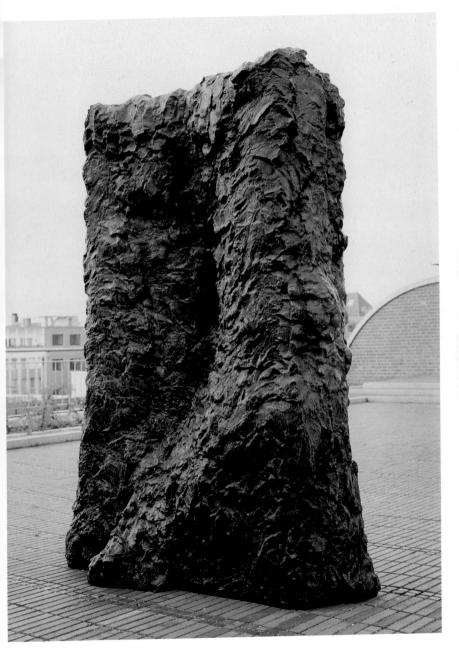

Kitaj, Ronald B.

1932 Cleveland,
Ohio
Lives in London

American painter Ronald B. Kitaj has had a life unusually rich in experiences. After studying art in New York and Vienna, he settled in London in 1958. Apart from travelling extensively (including voyages as a seaman to South America), Kitaj has immersed himself in modern poetry, the cinema, information theory, and iconography, the historical study of images and figures in art. His early works, such as *Austro-Hungarian Foot Soldier*, are characterized by nervous, broken line and patchy paint application, and a range of color that still reflects the influence of Viennese artists such as Gustav Klimt and Egon Schiele.

The picture in fact reflects Kitaj's impressions of Vienna, being based on nostalgic post-cards from the period of the Danube monarchy. In *Casting*, the collage of heads, handwriting and symbols calls to mind the approach of various London Pop artists, especially Richard Hamilton and David Hockney. Neither the fictitious heads nor the words placed next to them convey any straightforward meaning; rather, the picture is a symbolic representation of a method of connecting certain verbal meanings with certain types of people associatively, or even arbitrarily. With these exaggerated character types the artist gives an ironic commentary on the all-too human tendency to pigeonhole people and things without thinking.

▶ **Ronald B. Kitaj**
Casting, 1967

Oil on canvas
250 x 91.5 cm

Ludwig Donation,
1976

▶▶ **Ronald B. Kitaj**
Austro-Hungarian
Foot Soldier, 1961

*Collage and
oil on canvas*
152.5 x 91 cm

Ludwig Donation,
1976

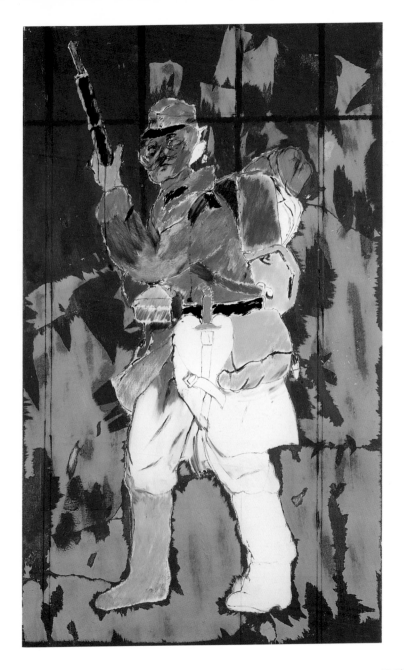

◄ Konrad Klapheck
The Ancestors, 1960
Die Ahnen

Oil on canvas
115 x 125 cm

Ludwig Donation,
1976

**Klapheck,
Konrad**

1935 Düsseldorf,
Germany
Lives in Düsseldorf

That Konrad Klapheck is patient and persistent, a perfectionist,
and, yes, even a pedant, is immediately apparent from his paintings.
For years he "expunged everything that smacked of work" from
his pictures, Klapheck once stated. "Only when one arms oneself
with the coolness of precision does one gain access to the fires
of the soul."

In the matter-of-fact hard-edged depiction of machines Klapheck
surpasses even his teacher, Bruno Goller, who composed poetic still
lifes of everyday things. Yet Klapheck does not present us with any
brave new world, as the pristine surface of his work might suggest.
The first of his machines was a typewriter, painted in 1955, in a
"super-objective" style intended as a reply to the lyrically abstract
Tachisme that then prevailed in Europe. Later came adding machines,
sewing machines, cash registers, telephones – all of them everyday
and strangely antiquated appliances that had long lost that power
which technology sometimes has of instilling anxiety. These ironically

▲ **Konrad Klapheck**
Soldiers' Girls, 1967
Soldatenbräute

Oil on canvas
120 x 170 cm

Ludwig Donation,
1976

alienated objects – Klapheck listed ten types – were effective, as it were in proxy portraits of the desires and hopes, fears and dependencies of modern man. *The Ancestors* (1960) shows a typewriter, greatly abstracted in form and divorced from its normal context, against an atmospheric background in merging light and dark tones. All that remains is a keyboard whose rows of keys are meant to suggest the schematic diagrams of family trees, in which human lives are reduced to a codified system. Only the top two rows of keys are illuminated by an imaginary light source, symbolizing the living generations, while those which preceded them have been extinguished, and extend downwards rank by rank into the infinite dark realm of the past.

The model for Konrad Klapheck's *Soldiers' Girls* of the year 1967 was a Singer sewing machine of the type used, among other things, to sew military boots. Marching in apparently endless ranks past the viewer, the machines recall women's figures, bent over and clad in long, hooded coats. According to the artist, these figures were intended as a

▲ Konrad Klapheck
The Dictator,
1967–1970
Der Diktator

Oil on canvas
120 x 170 cm

Ludwig Donation,
1976

criticism of the "army of female exploiters who dog the soldier" – camp-followers who sell food and liquor, or themselves, to armies, and, in a figurative sense, women employed in manufacturing war materiel. Due to the low vantage point, the first row appears monumentally large, and the extreme perspective gives an impression of inexorability.

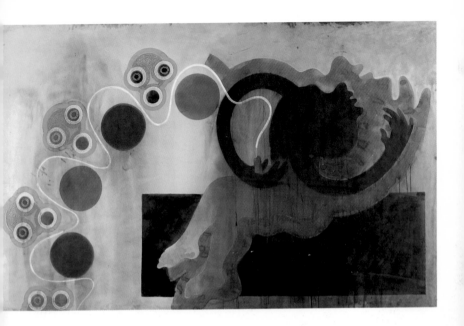

The trivial and the sublime are concepts that enable an iconographical interpretation of Jürgen Klauke's vocabulary of form, and a characterization of his position without reference to style or aesthetic, and without the need to classify it in terms of any particular painting genre. For what is central to him is the attitude or stance he takes, which Klauke describes as "the most important thing in my painting." Thanks to this stance, he is able to observe his fellow humans and their rituals with a dispassionate eye. Fundamental patterns engrave themselves on his mind, out of which Klauke's paintings and drawings emerge continuously and almost automatically, as if out of an urge to disburden himself of disturbing imagery.

Yet his works are never merely commentaries on social or environmental ills, nor do they represent symbolic depictions of personal thoughts and feelings. Rather, Klauke creates what might be called counter-images, a world of fictitious imagery that takes shape as he "looks around," observes, "catches what is going on." His works contain both reactions and counter-reactions. They might be compared to a visual relay station in which transmitter and receiver are one.

Klauke, Jürgen

1943 Kliding, near Cochem, Germany
Lives in Cologne

▲ Jürgen Klauke
Autoerotic
Projection, 1985
Autoerotische
Projektion

*Mixed media
on paper*
150 x 230 cm

Gift of
Hypo-Kulturstiftung,
Munich, 1988

Klee, Paul

1879 München-
buchsee,
near Berne,
Switzerland

1940 Muralto,
Locarno

In 1911, the year Paul Klee drew *Head of a Woman*, he met Wassily Kandinsky, Franz Marc, and August Macke in Munich. The following year Klee took part in their exhibition, The Blue Rider. This pen and ink drawing marks the end of Klee's early phase, yet it also anticipates some of the graphic devices and inventions that would soon bring him fame. The simplified contour, which captures the essence of the model and whose harshness is softened by delicate washes, depicts not only what the artist's eye sees but also what it makes him feel. Indeed the whole of Klee's work was based on his credo, "Art does not reproduce the visible, it makes visible." Key events in his career were a confrontation with Cubism and with Robert Delaunay's Orphism (1912, in Paris), as well as an experience of the Mediterranean region (on his Tunis journey of 1914). Klee's art was equally based in the study of nature and the study of art itself.

The light-flooded composition *Highroad and Byroads* is one of a series of works done in 1928 and 1929 under the impression of a trip to Egypt. The rigorous structure of horizontal strips and rectangular fields reflects the approach of Klee's Bauhaus period (1920–1931). The linear scaffolding, also present in many other works of the late 1920s, follows the rational principles of design which the artist had worked out for purposes of instruction at the school. His experience of the brilliant Egyptian sunlight, the expansiveness of its countryside, and the traces of its ancient culture, are all translated into compellingly simple form and clear color. The horizontal strips and lines evoke fields and terraces; the unbroken blue and violet bands at the top convey an impression of a horizon and distant sky, but might also be read as the Nile. By shortening the colored bands towards the top, Klee suggests a landscape receding in space without, however, going so far as to create a perspective illusion that would destroy the flatness of the picture plane. The light color harmonies wonderfully suggest desert sand and soil, water and vegetation, without being at all realistic. Beyond the impression it gives of the Egyptian landscape and atmosphere, the picture would also seem to contain a metaphorical, universal reference to streets and roads, symbols of the hierarchical order of social life, but also of its secrets and vicissitudes, its errors and confusions.

In the watercolor *Tone from Sicily* – an island Klee visited in 1924 – details are indicated by means of what he called "squaring." The

▲ **Paul Klee**
Highroad and Byroads, 1929
Hauptweg und Nebenwege

Oil on canvas,
83.7 x 67.5 cm

▲ Paul Klee
Tone from Sicily,
1924
Klang aus Sizilien

*Watercolor, silver foil
strips top and bottom*
17.2 x 22.2 cm

▶ Paul Klee
Fool in Trance, 1929
Narr in Trance

Oil on canvas
50.5 x 35.5 cm

mountains are covered with groups of short brushmarks of a kind
that would reappear in the Divisionist paintings of the 1930s.
Underscored by the title, the forms and colors of the painting
evoke a mental picture – or conjure up a memory – of gleaming,
sun-warmed villages overhanging Mediterranean bays, under a
perpetually blue sky. The mosaic-like interior structure and the strips
of silver foil at top and bottom lend the composition a touch of
preciousness, and bring reminiscences of the art of the past in this
region to mind.

Klee's *Fool in Trance* (1929) belongs to a long series of works on
the subject of theater, circus, and variety shows. The figure, built up
principally of linear arabesques, appears against an indeterminate
background of light browns and greys. It seems translucent and almost
weightless, evoking the state of trance. This intention is underscored
by emphasis on the gesture of the hands, open as if in supplication,

and the facial features of overlarge eye and open mouth, which suggest
the appearance to the figure of a dream or vision.

Expelled by the National Socialists from his teaching post at the
Düsseldorf Academy in 1933, Klee emigrated to Berne, Switzerland.
It was here that he did his late work, whose subject-matter was often
ambiguous or gently ironic, as in the tempera and watercolor *Über-Blick*
(Over-View, or Super-Gaze). Continuing to explore the borderline zone
between objective reference and abstraction, Klee evoked an ambivalent
relationship between nature and its creatures. Here the image oscillates
between a mountainous landscape and a face, whose *Super-Gaze*
seems to fix us impassively but threateningly.

Klein, Yves

1928 Nice, France
1962 Paris

Yves Klein was born into a family of artists. His father, Fred Klein, was a landscape painter; his mother, Marie Raymond, was one of the first artists in Paris to work in the abstract style known as Art Informel. Growing up in such a creative atmosphere, there was no need for the young Yves to study art in the traditional way. In fact, he himself once remarked that he had "imbibed the taste of painting with my mother's milk."

The contrasting styles and principles of his parents' art, which represented the issue of figuration versus abstraction, introduced Klein at a very young age to the most crucial problem facing the avant-garde. Perhaps it was just this early and intensive involvement with the art world that initially caused him to reject his parents' profession.

In 1945 Klein enrolled in the Ecole du Génie Civil in Paris to prepare himself for the merchant marine examination. After failing it the following year, he never again entered an academic institution. In 1947 he took a course in judo at police headquarters in Nice, where he met the young poet Claude Pascal and fledgling artist Armand Fernandez (Arman). The three friends got together regularly in Arman's basement, which they called their "temple," one wall of which Klein had painted blue. Filled with the spirit of rebellion, the three worked out plans for a complete reordering of the universe, and divided it up among themselves: Arman was to be ruler of the earth, Pascal the emperor of words, and Klein the lord of the space above the earth – the void, empty of all material things. This concept of the void would subsequently come to determine the character of Klein's entire œuvre.

IKB (International Klein Blue) designates a special variety of the color – a matte and yet brilliant, intense, saturated ultramarine blue. Klein experimented for a long time, aided by chemist Eduard Adam in Paris, before he found the right mixture in 1955. Instead of combining the powdered pigment with a normal painter's medium, Klein used thinned "rhodopas," a petroleum substance employed as a fixative. In 1957 he had the color patented as "International Klein Blue".

Before deciding to apply the paint with a roller, Klein used natural sponges for his monochrome paintings from 1956 onwards. One day, noticing how beautiful a sponge soaked in blue was, he affixed it to the painting surface, reasoning that sponges were predestined by nature to be saturated with and carry a liquid element. The first *Sponge Reliefs*

▶ Yves Klein
Blue Sponge Relief
(RE 19), 1958

Pigment in synthetic resin on sponges, gravel, and composition board
200 x 165 cm

Ludwig Donation, 1976

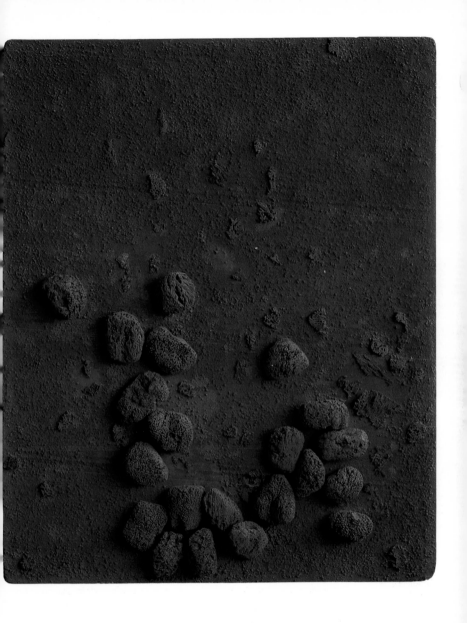

▲ Yves Klein
Monochrome Blue
(IKB 73), 1961
*Pigment in synthetic
resin, cotton duck, ply-
wood, 194 x 140.5 cm*

▲ ► Yves Klein
Monogold (MG 18),
1961
*Gold leaf and pigment
in synthetic resin,
cotton duck, plywood
78.5 x 55.5 cm*

► Yves Klein
Anthropometrie
(ANT 130), 1960
*Body imprint with
pigment in synthetic
resin on paper,
mounted on canvas
194 x 127 cm*

All three works: Lud-
wig Donation, 1976

were done in 1957–1959, in the context of Klein's collaboration with architect Werner Ruhnau and his team on a new building for the state theater in Gelsenkirchen, Germany.

There followed a group of works created by making imprints direct from the human body, known as *Anthropometries*. The name was spontaneously coined by art critic Pierre Restany after a demonstration on February 23, 1960, during which Klein instructed a model covered in blue paint to press herself against a sheet of paper on the wall. By means of such "living brushes" the artist hoped to let the vitality of the body and the immediacy of the creative idea flow immediately into art.

Shortly before his death in 1962, Klein recalled an episode from his youth which had determined the further course of his life. "Back then, as a teenager in the year 1946," he said, "I had a 'realistic-imaginative' day-dream in which I signed the far side of the vault of heaven. On that day I began to hate the birds that flew back and forth across the sky, because they were trying to punch holes in my greatest and most beautiful work."

In the 1940s Franz Kline was still painting mostly small-format, objective pictures in a Cubist manner, which frequently treated the theme of the big city. Around 1950 he suddenly emerged into the public eye with a series of very large, abstract, black and white canvases. They were composed of expansive swaths of opaque paint with very little interior texture, set off from one another by geometric edges, the black and white areas worked into alternately in an attempt to achieve equilibrium. Applied with great force and rapidity using a broad brush, the fields recall calligraphy enlarged to a monumental scale.

Kline was, with Jackson Pollock, one of the leading representatives of Action Painting within the New York School. His decision to limit himself to black and white was not arrived at intellectually, but resulted from a long series of brush drawings. Later, in 1955, he would return to color. Like the expressive form, the effects of color relied on the workings of spontaneous gesture, for as Frank O'Hara noted, the strokes were abrupt and coarse and not done with an eye to the effect of the finished picture. Kline himself once said that he had no particular intention of using color in the lights and shadows of a black and white painting, although it may have appeared so. Sometimes a black, on account of its quantity, its mass or volume, would look like a blue-black, as if it had been mixed with blue; at other times it might appear brownish-black or reddish-black.

Reviewing a series of his drawings, Kline would choose interesting configurations and transpose them to unstretched canvases, which allowed him to determine the final format in the course of reworking. Some of his paintings remained untitled, others were given evocative titles such as the names of American cities (as *Scranton*, in Pennsylvania). By way of explanation, Kline once noted that abstract forms need not be entirely without mental associations. When one used long lines, the only thing they could be, he said, was either highways or architecture or bridges. There are indeed reverberations of a mechanized dynamic in *Scranton*, with its almost uniform areas of black and white along the edges working against each other in interlocking passages of stark contrast and tension.

Kline, Franz

1910 Wilkes-Barre, Pennsylvania
1962 New York

◄ **Franz Kline**
Scranton, 1960

Oil on canvas
177 x 124.5 cm

Ludwig Collection

Kliun, Ivan

1870 Bolshie Gorki,
near Kiev, Russia
1942 Moscow

In the early years of the century Ivan Kliun painted aesthetically decorative, often Symbolist-oriented compositions. It was not until about 1912 that he developed the Cubo-Futurist approach seen in *Still Life* (c. 1914).

Under the influence of Kasimir Malevich, Kliun became an ardent advocate of Suprematism in 1915. Not only did he begin to work in this innovative style, but made a name for himself as theoretician. Kliun's *Suprematist Composition* of 1916 is a characteristic example of his work in this phase. The completely non-objective composition consists of variously colored and different sized geometric elements, interlocked and overlapped, to fill the entire picture plane. In the works of this period Kliun investigated the relationships of color to plane, color to light, and color to form. His involvement with these problems of design and perception is also evident in the painting of 1917, *Suprematism*, and in the untitled gouache of the same year.

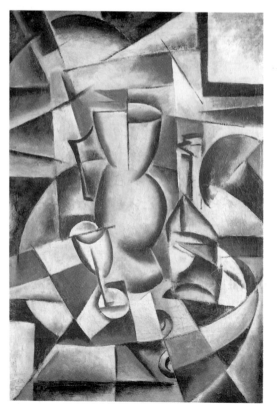

Very soon, however, the artist arrived at conceptions that clearly diverged from those of his mentor, Malevich. For instance, he criticized the circumstance that Malevich had not understood the essential meaning of color, and moreover, had insisted on linking paintings with a transcendent level of existence. During the first years after the October Revolution Kliun was active in several of the newly established cultural institutions, and also contributed as a teacher to the dissemination of non-objective forms of art. The early 1920s saw the emergence of what he called "cosmic images," one of which is the astonishing *Spheric Composition* in the Ludwig

▶ **Ivan Kliun**
Suprematist
Composition, 1916

Oil on canvas
79 x 45.5 cm

Ludwig Collection

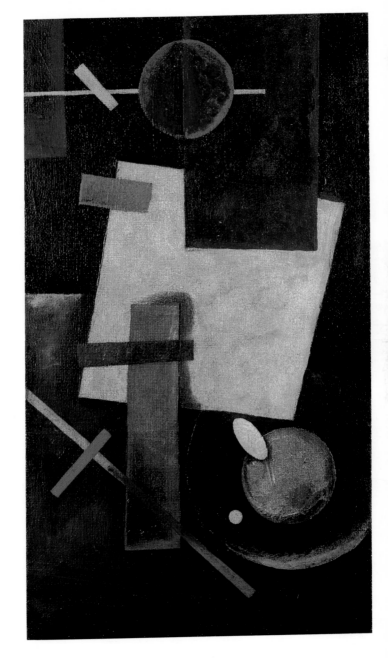

◀ **Ivan Kliun**
Still Life, c. 1914

Oil on canvas
82.5 x 56 cm

Ludwig Collection

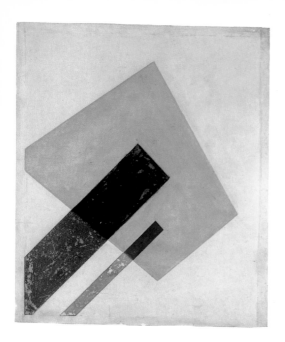

◄ **Ivan Kliun**
Untitled, 1917

Gouache on paper
32.6 x 28.5 cm

Ludwig Collection

► **Ivan Kliun**
Suprematism,
c. 1917

Oil on panel
35.2 x 35.8 cm

Ludwig Collection

Collection. (The adjective in the title refers to the heavenly spheres, as in "stratospheric".) We see a ray of white light shooting diagonally through an indeterminate greenish space. An interest in radiation, matter, and astronomical phenomena was widespread among Russian artists of the day. In addition to Kliun, Moscow artist Ivan Kudriashov was a member of a large group who were fascinated by the idea of space travel and the nature of the universe.

▲ **Ivan Kliun**
Spheric Composition,
1923

Oil on canvas
64.5 x 64.5 cm

Ludwig Collection

Kluzis, Gustav

1895 near Wolmara,
Latvia
1944 Kazachstan

▼ **Gustav Kluzis**
Dynamic City, 1919

*Collage, ink and
photomontage
on paper*
55.7 x 45.7 cm

Ludwig Collection

Gustav Kluzis retained a lifelong enthusiasm for the Russian Revolution and the Soviet regime. His artistic ideas were clearly influenced by Suprematism, especially by its later architectural manifestations, such as Kasimir Malevich's models, the *Architektona*. The group of works collectively titled *Dynamic City* (1919) is an outstanding example of how an apparently non-objective Suprematist composition can include objective references while retaining a high level of abstraction. In an oil painting on this theme (in the Costakis Collection) Kluzis still combined planes and shapes into a dense, abstract construction. With the introduction of photomontage, as in *Dynamic City* in the Museum Ludwig, Cologne, the underlying architectural idea behind such rigorously articulated constructions became clearly evident.

The color fields in the painting are transformed into high-rise buildings and steel beams. Ranged around them are figures of construction workers, indicating that what we see is a new microcosm with its own center of gravity which enables them to stand firmly on their feet even "on the bottom of the world." The ultramodern buildings and the technologies that dominate the image have the air of an allegory of the new, ideal city envisaged by communism. Kluzis enthusiastically accepted the tasks which the new society assigned to artists. The tragic thing is that he increasingly became a *persona non grata* to the regime, until he was arrested in 1938, on the grounds of being a Latvian. Kluzis died in a work camp in Kazachstan in 1944.

▶ Imi Knoebel
Summer Picture,
1984

Acrylic on hardboard
203 x 171.5 cm

Gift of
Dr. Reiner Speck,
1993

Imi Knoebel was a master student of Joseph Beuys's at the State Art
Academy in Düsseldorf. Between 1964 and 1977 he created a series
of black and white *Line Paintings* consisting of arrangements of vertical
and occasionally horizontal lines.

In his white paintings, done in the mid-1970s, Knoebel addressed the
problem of the interaction of simple rectangular shapes. Such imagery,
rather than merely representing an objectively describable phenomenon,
included a host of mental projections on the part of the viewer as well.
One is put in mind of Kasimir Malevich's proclamation, "In the white
space of cosmic celebrations I erected the white universe of Suprematist
non-objectivity as a manifestation of liberated nothingness."

The current phase of Knoebel's work, to which *Summer Picture*
of 1984 belongs, began in the early 1980s with pictures made by super-
imposing numbers of drawings on transparent foil, usually in three
layers. In subsequent works Knoebel translated his experiences into
large-format panels whose surfaces were incised with a power drill,
thus calling the distinction between two- and three-dimensionality into
question. Since 1985 he has pursued this aim by purely painterly means.

**Knoebel, Imi
(Wolfgang)**

1940 Dessau
Lives in Düsseldorf

Nina Kogan was one of the most outstanding women artists in post-revolutionary Russia. While conducting the preliminary course at the Vitebsk School of Art in 1919, she became an eye-witness to a controversy between two pioneers of the avant-garde – Marc Chagall and Kasimir Malevich. In Malevich's opinion, the only truly revolutionary art was non-objective. He challenged traditional painting with Suprematism – compositions of flat, geometric shapes in a very limited range of color. Malevich's black square on a white field represented, in his own eyes, the "naked, unframed icon" of the modern age. He accused Chagall, the founder the Vitebsk Art School and advocate of French painting, of being mediocre, and fought to eliminate everything "old" and "decrepit," including individualistic lifestyles and established religion.

Kogan, Nina

1887 Vitebsk, Russia
1942 Leningrad

Like the majority of the students and teachers in Vitebsk, Nina Kogan was convinced by Malevich's eloquence, and devoted herself wholeheartedly to Suprematism and to the revolutionary outlook. She helped establish the artists' association UNOVIS (Advocates and Founders of the New Art), which set out to translate the Suprematist system into real life. The didactic program of UNOVIS began on February 6, 1920, with a performance of the futuristic play *Victory Over the Sun*. The same day saw the premiere of the first Suprematist ballet, conceived and choreographed by Nina Kogan. The "plot" of the ballet consisted in showing the transition of one geometric form into another. A straight line was transformed into a cross, then developed into a star and circle, and finally into a square. Such artistic experiments were linked with Malevich's conception of a fundamental principle of non-objective logic, which posited energies capable of transcending the boundaries of form.

Suprematist Composition, in the Museum Ludwig, Cologne, belongs to this phase of the artist's career. Here, not only a single form is set in relationship to the picture format, as in Malevich's *Black Square,* but a whole series of shapes, which appear to move towards and away from each other across the white plane. This impression of dynamic movement, and of a continually changing configuration, are similar to the effects achieved in Kogan's kinetic ballet.

◀ **Nina Kogan**
Suprematist
Composition,
c. 1920–1922

Oil on canvas
72 x 54 cm

Ludwig Collection

Kokoschka, Oskar

1886 Pöchlarn, Austria
1980 Montreux, Switzerland

▼ Oskar Kokoschka
Portrait of
Peter Baum, 1910

Oil on canvas
65.5 x 47 cm

Oskar Kokoschka grew up in the rich cultural climate of Vienna shortly after the turn of the century. While studying at the School of Decorative Arts he became familiar with the work of Gustav Klimt and Egon Schiele, and maintained contact with the designer Josef Hoffmann, in whose Wiener Werkstätte he took on commissions from 1907, and whose assistant he became in 1911. At this period Kokoschka also began writing Expressionist poetry and plays. In 1910 he was called to Berlin as a contributor to Herwarth Walden's journal, *Der Sturm*. Kokoschka's early phase, marked by psychologically penetrating characterizations of individuals, extended to an Italian journey undertaken in 1913 with Alma Mahler, which led to a new emphasis on color.

The reason for the great influence Kokoschka exerted on twentieth-century portraiture is evident from his two early portraits, of Berlin poet Peter Baum (1869–1916) and of actress Tilla Durieux, who was born in Vienna (1880–1971). Both were members of the Sturm circle. The painter attempted to capture his sitters as comprehensively as possible, observing not only their physiognomy and clothing but typical gestures and anything that would reflect their way of thinking and behaving. The complexity of these observations necessitated a degree of abstraction which, in Kokoschka's hands, became truly radical. Facial features were transformed, contours and interior detailing became symbolically charged, graphic abbreviations. Passages of juxtaposed or interpenetrating color were used to evoke characteristic moods.

The sitter is brought to life by means of a paint surface built up of three layers: an agitated

Oskar Kokoschka
ortrait of
lla Durieux, 1910

il on canvas
5 x 65 cm

aubrich Donation,
946

Oskar Kokoschka
iew of Cologne
om the "Messe-
arm", 1956
nsicht der Stadt
öln vom Messeturm
us

il on canvas
5 x 130 cm

ift of
he Cultural Affairs
ommittee,
ederal Association
f German Industry,
957

background, consisting of veils or lava-like flows of paint; then, emerging from this, an incipient form, composed of rough, loosely juxtaposed paint textures; and finally, a third layer, frequently made up of thin strokes of black or color, or – as in the portrait of Baum – of marks scratched into the wet paint to give final definition.

In 1917 Kokoschka was wounded in the war. He came to Dresden, where from 1919 to 1924 he held a professorship at the academy. This period saw an emphasis on large compositions of several figures, done in strong, brilliant colors often applied to the canvas in broad strokes of the spatula. The artist's friends from Dresden intellectual circles modelled for these paintings – in the case of *The Heathens* (1918), actress Käthe Richter and poet Walter Hasenclever. They appear as lovers, nude, reclining in an embrace, surrounded by a vortex of green, blue, and yellow. The longing expressed here for an exotic, paradisiacal life seems tempered by an ironic stab at the blasé morals of a clericalist society.

▼ Oskar Kokoschka
The Heathens, 1918
Die Heiden

Oil on canvas
75.5 x 126 cm

Haubrich Collection

Kokoschka's concurrent landscapes are likewise suffused with swirls and patches of uncontoured, luminous paint. *Dresden Neustadt III* is part of a series of cityscapes depicting the panorama of the Elbe River bank across from his academy studio at Brühl's Terrace. The view

s transfigured into a mosaic of brilliant colors, regularly structured in
he rendering of the architecture, but entering an agitated flux in the
ky and water. The dominating bright blues convey the feeling of a hot
ummer day.

The *View of Cologne*, done in 1956, shows Kokoschka's predilection
or a high vantage point in depicting urban scenes. The style of his late
ityscapes is characterized by the rendering of architecture in vibrant,
lashing strokes, whose detail is set off by extensive areas of light color
n which remnants of paint are scumbled over the surface to create an
ffect of shimmering air and light. Dominating the vibrant city center
re the outstanding landmarks of Cologne, the Cathedral and the Rhine
Bridge.

Kollwitz, Käthe

1867 Königsberg
1945 Moritzburg,
near Dresden

▼ **Käthe Kollwitz**
"...Rests in the
Peace of His
Hands," 1936
"...ruht im Frieden
seiner Hände"

Tinted plaster
36 x 32 cm

During her studies with Karl Stauffer at the Berlin School for Women Artists (1884–1885), Käthe Kollwitz was inspired by the etchings of Max Klinger. In 1888–1889, while learning painting under Ludwig Herterich in Munich, her talent for printmaking was furthered by the Munich Society of Etchers. Kollwitz decided to concentrate on graphic art. Her breakthrough came in 1898, when she showed the etching sequence *A Weavers' Revolt* at the Great Berlin Exhibition of Art. Kollwitz went to Paris, where in 1907 she attended the Académie Julian in order, as she said, to acquaint herself "with the fundamentals of sculpture." She reports having made good progress, and from 1912 onwards, Kollwitz devoted herself exclusively to sculpture.

In the year 1914, her son, Peter, was killed in Flanders. This event transformed Kollwitz into a committed antiwar artist. On December 1 of the same year, she conceived a plan for a sculptural memorial to her dead son. The models, figures of a *Father and Mother* reduced to essential, blocklike form, were not to be completed until 1931. In 1932 the two figures were rendered in granite by Fritz Dietrich, and erected at the Roggenvelde Military Cemetery outside Essen, Belgium. (They have since been relocated to the Vlaadslo Military Cemetery near Dixmuiden.) In 1954 copies of *Father and Mother* were made by students of Ewald Mataré and installed in the ruins of St. Albans, Cologne, in memory of the dead of both world wars.

The relief *Lament* was made in 1938, as a monument for the grave of Ernst Barlach, who died that year. Kollwitz expressed her great personal reverence for Barlach by giving the sculpture her own facial features. The visible traces of modelling further increase the poignancy of the piece.

Kollwitz's entire œuvre is marked by a deeply felt concern with developments in the world around her. Yet she avoids senti-

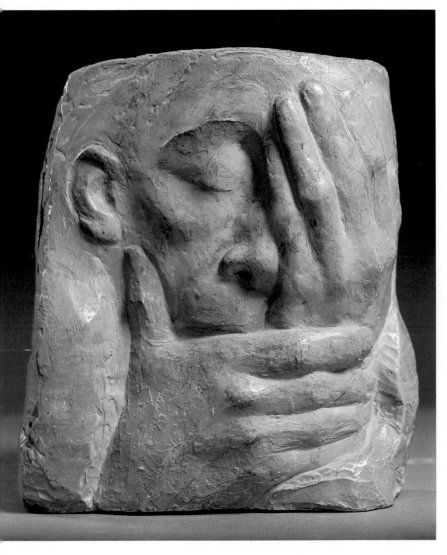

mentality. Her evocations of human misery are silent appeals. Only rarely is the lament voiced, but when it is, it is like a reverberating outcry. Kollwitz's depictions are seldom conventionally "beautiful," and in face of them we realize what an extraordinary degree of realism she expected her contemporaries to understand.

▲ **Käthe Kollwitz**
Lament, 1938
Klage

Tinted plaster
28 x 25 cm

Komar & Melamid

Vitali Komar
1943 Moscow
Lives in New York

Alexander Melamid
1945 Moscow
Lives in New York

▼ Komar & Melamid
Stalin and the
Muses, 1981–1982

Oil on canvas
173 x 132 cm

Ludwig Collection

The leading protagonists of the so-called second Russian avant-garde include Ilya Kabakov, Erik Bulatov, and the artist-duo Vitali Komar and Alexander Melamid, who produce ironic commentaries on the painting of Socialist Realism. In *Stalin and the Muses* they present a satirical revision of propagandistic art. As in Gustav Kluzis's and Wassily Ermilov's portraits of Stalin, the dictator in Komar & Melamid's picture is identified with the State. But it is far from glorifying either him or the Soviet Union, quite the contrary – it amounts to a veritably blasphemical provocation. The book being handed to Stalin by Clio, the muse of history, is a revised history of his reign.

The fact that contemporary artists from the former Soviet Union evoke the feared dictators of the past cannot, however, be seen solely as evidence of a critical involvement with history. Especially in works done in the 1990s, after the demise of the USSR, a different under-tone is detectable, a certain nostalgia for the dead leaders and their emblems, symbols, and codes. Komar & Melamid's *Lenin Mausoleum* of 1994–1995 is just such a work. The artists' memories of Lenin are fond ones: "He was our first love, the foundation of our lives. We can't get rid of him so easily."

In order to save Lenin's tomb, the artists suggested a modernization, and designed an electronic billboard to be installed over the inscription "Lenin" on the tomb. Similarly to the flickering and continually changing neon signs on Times Square in New York or Picadilly Circus in London, their envisaged Lenin Mausoleum would display running texts, conveying both propagandistic and public-relations messages.

According to the artists, these texts would "symbolize the rapidly passing time of human life and the absurdity of utopia." The meaninglessness of utopian myths is indeed a key theme of the installation. One of its many elements is a three-part painting that depicts Lenin with a skeleton on his back.

▲ **Komar & Melamid**
Lenin Mausoleum,
1994–1995

*Multipartite
installation, oriented
to given space;
work in progress,
dimensions variable*

Ludwig Collection

**de Kooning,
Willem**

1904 Rotterdam
1997 New York

After emigrating to the United States in 1926, Willem de Kooning soon met and befriended Arshile Gorky. In the early 1940s he met Jackson Pollock and became a leading representative of Abstract Expressionism. De Kooning's drawings and paintings are characterized by ambivalence, whether the subject be the figure – predominantly the female figure – landscape, or pure abstraction. All three areas continually intermerge in his work.

In the 1980s de Kooning again addressed pictorial issues that had already concerned him in the 1940s and 1950s. His large-format charcoal drawing *Woman* (1983), in which spontaneity and rapidity of attack leap to the eye, perfectly exemplifies the artist's approach to depicting the human figure. Focussing on the idea that the body had "two eyes, a nose, a mouth and a neck," he once said, as soon as he tried to capture the rest of the anatomy he realized he could never complete it.

The result was an exciting, almost violent contradiction between objective form and abstract expressionist lineature.

Objective references are hardly detectable in the painting *Untitled VI*. This is one of a series of canvases begun in 1980, in which the artist's late style came to culmination. Using sparingly applied strokes and color fields, the surface is set into rhythmic motion, and seemingly becomes transparent to an infinite space behind. Sweeping lines in the primary colors of blue, red and yellow suggest shapes that are open and as if mutually permeable, like tenuous membranes.

◄ **Willem de Kooning**
Woman, 1983

Charcoal
on white paper
146 x 98 cm

Ludwig Collection

▲ **Willem de Kooning**
Untitled VI, 1984

Oil on canvas
202 x 178 cm

Ludwig Collection

Kosuth, Joseph

1945 Toledo, Ohio
Lives in New York

▲ Joseph Kosuth
Frame –
One and Three, 1965

Four parts:
collage on cardboard,
12.5 x 7.5 cm
(certificate);
wooden frames,
69 x 60 cm;
two Formica panels,
100 x 100 cm each

Ludwig Donation,
1976

Even before he joined the English artists' group Art & Language in 1969, Joseph Kosuth had concerned himself with an investigation into the nature of art and the problems of perception – reality, identity, and the definition of the object. The insight that the essence of a thing lay less in its appearance than in its conceptual definition led Kosuth to present, instead of images of things, the words that designated them, in the form of dictionary entries. *Frame – One and Three* (1965) belongs to the artist's first group of "proto-investigations." The constituents of the work explain or investigate the concept and the visual phenomenon of the picture frame: in its material form (wooden frames), as an image of a frame, and finally as a definition of the concept "frame," with an excerpt from an English-German dictionary entry under the word "frame." The original dictionary article, signed by the artist, is kept in the museum archive as a proof of provenance.

Kosuth's work combines theoretical considerations with practical realization. His series devoted to "Art as Idea as Idea" was likewise based on extensive theoretical investigation. In 1967 Kosuth explained the relationship between his approach and Conceptual Art by stating that all the works he produced were models, and represented ideas. It did not depend on who actually made the model, he said, or where it left off. In so far as these model objects were concerned with art, they were objects of art.

Born in Greece and a resident of Italy for over 40 years now, Jannis Kounellis is a proponent of Arte Povera. This primarily Italian movement, which emerged in the late 1960s, has concentrated on "poor," or commonplace materials such as iron, lead, coal, hemp, burlap, and even rice and coffee. Previously Kounellis employed numbers and words, to create small-format, symbol-like imagery. His concern was not with symbolic or metaphorical reference but with elementary signs that stood only for themselves.

After his first one-man show in 1960 at Galleria La Tartaruga in Rome, Kounellis participated in a number of important group exhibitions in Italy and abroad. His success seemed assured. Yet in 1965 he began to doubt that he was on the right track, and ceased working entirely for two years. Since then, although never abandoning painting, Kounellis has continually attempted to transcend its limits and expand its range.

Kounellis is involved in an apparent contradiction that is characteristic of Arte Povera. On the one hand, he evokes a certain poetry, which contains within itself a timeless or archetypical status. Fire, lead and gold allude to the ancient pseudo-science of alchemy, which attempted to transform common substances into gold. On the other hand, history plays a key role in Kounellis's art. Yet he himself denies

Kounellis, Jannis

1936 Piraeus, Greece
Lives in Rome

▼ **Jannis Kounellis**
Untitled, 1989

Steel, mixed media, four parts
200 x 360 cm

Loan of
VAF-Foundation,
Switzerland

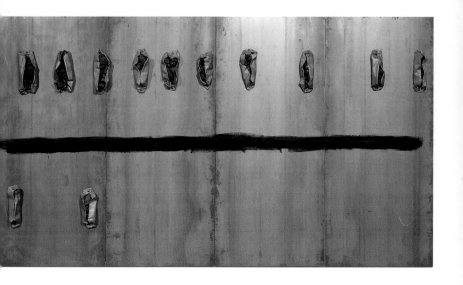

▲ Jannis Kounellis
Rana, 1961

Oil on canvas
113 x 161 cm

Loan of
Pro-Museum-
Stiftung,
Frankfurt am Main

any link with alchemy. It is at this point that the contradiction in his work resolves itself, for Kounellis's brand of alchemy does not attempt to flee from history but embraces and celebrates it. "Since the [Second World] War," he states, "our culture has thrived on contradictions; contradictions are all we have."

Bruno Corà writes about Kounellis that he "creates signs which he arranges into an image, guided by a radical sense of social and creative responsibility, by an ideology in which an identity is reflected that has at its disposal a language suited to representing history. In the process he moves within forms, colors, and odors, within the fundamental elements of nature and matter to be transformed into poetic energies, within the mechanisms of imagination, myth, culture, the classical and religious ideals, the passions. The goal of his wanderings is to find an individual path which has its roots in the folk epic; that is, an individual and choric Odyssee."

Attila Kovács
Coordination P
–14–1974, 1974
acrylic on canvas
on wood
50 x 100 cm

Attila Kovács came to Germany in 1964 and studied from 1965 to 1969 at the Art Academy in Stuttgart. During this period he began his first experiments with synthesized structures (since 1965) and with mathematically programmed processes (since 1967).

The central concept in Kovács's work is the "sequence." The series of *Coordinations* (1974) represents a sequence of images which, all based on the same initial design, investigate the relationship between a plane (generally black) and a grid system. Alterations in the grid lead to changes in the planar form. "Since I can select various factors," Kovács explains, "what is visualized will always appear in terms of the coordinates chosen, because values can be defined at will."

Kovács, Attila

1938 Budapest,
Hungary
Lives in Cologne

◀ **Lee Krasner**
Vernal Yellow, 1980

*Oil and collage
on canvas*
150 x 178 cm

Ludwig Collection

Krasner, Lee

1908 Brooklyn,
New York
1984 New York City

Lee Krasner's painting had its roots in the Abstract Expressionist aesthetic. She was a close friend of the main representatives of the movement – Willem de Kooning, Arshile Gorky, Franz Kline, Adolph Gottlieb, Mark Rothko, Clyfford Still, and Jackson Pollock – and exhibited with them from the 1940s onwards. In 1945 she became Pollock's wife. Influenced by Hans Hofmann, whose school in New York she attended from 1935 to 1940, but even more by way of Henri Matisse and Piet Mondrian, Krasner developed an increasingly abstract idiom based on organic and arabesque-like forms. In contrast to her husband, she showed no reluctance to include references to landscape or figures in the all-over pattern of calligraphic networks and color flecks that filled her canvases. Krasner gave top priority to the integrity and unity of the picture plane, to which a haptic factor was added by means of shapes cut out of paper, affixed to the canvas and painted over. Another key emphasis was on sensuous color, as seen in the painting *Vernal Yellow* (1980). Here as in all of Krasner's work the pulsating rhythms of the spontaneous brushwork and collage elements communicate themselves to us with veritably physical immediacy.

Dimitri
Krasnopevtsev
Skull in Broken Vase,
1963

Oil on hardboard
x 41.7 cm

Ludwig Donation,
1994

Skull in Broken Vase (1963) represents a genre that was typical of Dimitri Krasnopevtsev's œuvre – the still life. His palette, too, grey-in-grey in the manner of grisaille painting, remained unchanged after 1961. The elements of his compositions have no geographical or temporal characteristics.

"I do not paint from nature, although sometimes I do turn to it for information," Krasnopevtsev once noted. "All kinds of vessels, of clay, glass or metal, stones, seashells, starfish, twigs and branches, leaves and books, things preserved or destroyed, splinters and shards – this is my nature, these are my models."

By retaining a certain range of colors, working in a single genre, and depicting the same objects over and over again, the artist consciously drew a line between the flux of life and the permanence of art. To maintain its autonomy was a prime concern. "When you depict an object, you divorce it from life and transform it into an object of art," said Kranopevtsev. "True art is always unreal. It is not a mirror of nature and life; rather, it is a highly complicated system of prisms and mirrors ... Life provides the raw material for art."

Krasnopevtsev,
Dimitri

1925 Moscow
1995 Moscow

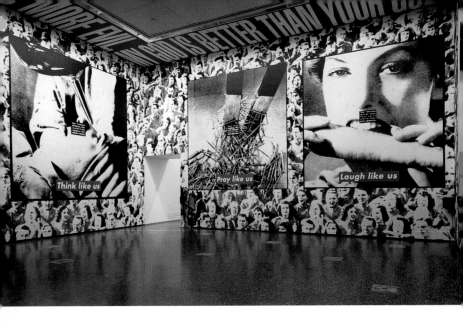

Kruger, Barbara

1945 Newark,
New Jersey
Lives in Los Angeles
and New York

Barbara Kruger became known for feministic photomontages composed of advertising pictures and slogans. The use and abuse of power is one of the key themes she addresses in her installations, which do not merely comment on power relationships but analyze the way they function as well. Kruger's critical analysis of political and social power goes far beyond the feminist issue to include all minorities, whether they be defined by race, religion, political affiliation, sex, or sexual preferences. The norm demands the adaptation, integration and assimilation of everyone outside its boundaries. Only those who conform with this norm are considered worthy of participating in the privileges of power.

Positions of power are maintained in contemporary society in subtle ways, for instance, through advertising. It projects an image of the normal human being as white, male, upper-middle-class, Christian, and heterosexual. Kruger comments on the mechanism behind power relationships in many of her texts, which accuse a general "You" of lacking empathy, desiring to find oneself in others, waging erotic battles and having a "selective memory."

Often the abuse of power is a result of xenophobia, a fear or hate of those unlike ourselves. A black and white photo showing a man

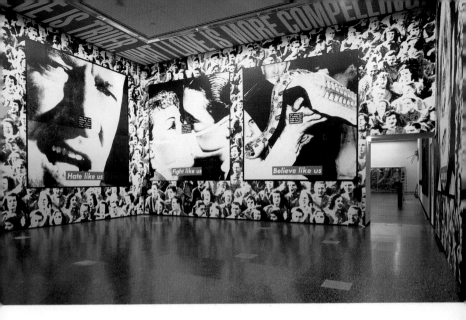

and woman kissing through doctors' operating masks plays on such anxieties, triggered for instance by the outbreak of Aids. The accompanying caption serves as a slogan, to supplement the fear instilled by the image: "Fight like us." As Susan Sontag emphasized in her book *Aids and its Metaphors*, this illness has engendered a whole series of military metaphors, becoming an "enemy" against which we are waging a "war."

One of the key images in Kruger's installation (1994–1995) represents a magnet attracting hundreds of nails – a metaphor for the crowd, malleable, easily influenced, motivated, and controlled. Any number of dictators, religious leaders, and politicians have exploited this malleability of the masses for their own ends. But is it not so, the artist asks, that people in the mass wish to be controlled? The crowd in Kruger's work applauds the words of the invisible leader speaking down to them, whether he praises or insults them. The masochistic tendency of the masses is also addressed in a black, sadomasochistic mask which is accompanied by the slogan "Fear like us." So who is ultimately to blame when those in power use the power handed to them by those who feel powerless? No one is only a victim, or only guilty.

▲ **Barbara Kruger**
Untitled, 1994–1995

Installation related to the given space; photographic serigraphs on paper; dimensions variable

Ludwig Collection

Kupka, František

1871 Opočno,
Bohemia
1957 Puteaux,
near Paris

▼ František Kupka
Music Box, 1946
Boite à musique

*Oil on Gaboon
plywood*
51.4 x 50 cm

Acquired with
the aid of former
Federal President
Theodor Heuss
in memory of
Dr. Joseph Haubrich,
1961

After studying in Prague and Vienna, Czech artist František Kupka went to Paris in 1895. From an early involvement with Symbolism he arrived at entirely abstract imagery in 1910–1911. Kupka was also versed in various areas of science, and devoted himself to music and spiritism. His abstract style did not derive from Cubism, as did Robert Delaunay's, despite its more than superficial resemblance to that artist's Orphism. Kupka's abstraction grew out of his initial Art Nouveau and Symbolist approach. He once compared the emergence of non-objective forms with developments in architecture, music, or even semantics. As he stated in 1913, it was not enough to "perceive a picture merely optically. The viewer must mobilize all of his senses. I am still fumbling in the dark, but I believe that I shall find something that lies between the visible and the audible, and can produce a figure – or fugue – out of colors as Bach created these out of musical notes."

In 1912 Kupka painted the oil *Amorpha, Fugue in Two Colors*, preceded the year before by *Cosmic Spring I. Cosmos*, a work on paper of 1911–1912, is one of the many preliminary studies to these two paintings. "Yes, fugues," wrote Kupka in 1926–1927, "where notes arise like actual physical entities which intertwine, come and go."

He considered the motifs of his cosmic images to be "chaotic forms circulating in spaces never before seen, bizarre and sometimes immense worlds, created out of nothingness by the poetic imagination of the artist."

Although the drawing *Cosmos* was done in France, it had its aesthetic source in Viennese Art Nouveau and Bohemian folk art. Kupka learned drawing in his home country, with a teacher who, being a specialist for ornament, emphasized the importance of circles and spirals, ovals and curves. This teacher also introduced Kupka to color

► František Kupka
Cosmos, 1911–1912

Watercolor, gouache,
ink and pencil
on white paper
23.7 x 25.8 cm

Gift of
Dr. Andreas and
Lore Becker, 1979

theory and psychology, and, believing art must not imitate nature,
he particularly valued the subtle, non-referential colors of Moorish art.
By expressing movement in space through line and thus creating an
extremely dynamic composition, Kupka put into practice what the
poet Hugo von Hofmannsthal said painting must do – generate a
world of colors which has "a power over the soul equal to that of the
art of music."

Music Box (1946), done during Kupka's membership in the
Abstraction-Création group, takes up the approach of his earlier works
composed of regular, rectilinear elements. In terms of both design
and color, the work alludes to the relationship in music between
macro- and microstructures – from movements to melodies, chords,
and notes.

◄ **Lászlo Lakner**
Anonymous
(Isapur es...), 1982

*Copper acrylic
and spray paint
on cotton sheet
220 x 260 cm*

► **Mikhail Larionov**
Still Life with Lobster
1907

*Oil on canvas
80 x 95 cm*

Ludwig Collection

Lakner, László

1936 Budapest
Lives in Essen and
Berlin, Germany

Anonymous (Isapur es...), painted on a bed sheet, goes back to key experiences Lászlo Lakner had during a period of existential crisis in the early 1980s. "Three things," he wrote, "affected me very deeply at that time: 1) The death of my good friend Lörinczy... 2) the graffiti in the streets of New York; and 3) the Halotti Beszéd," an ancient Hungarian funeral oration that is considered to be the earliest written document in the Hungarian language. It begins with the words "Isa Pur es...," those which Lakner has inscribed on the cloth. Wandering around in New York, he murmured the *Halotti Beszéd* to himself for days on end, until he "recognized a new reading of it – as a slogan, as writing on the wall, as if it had emerged right here, in this Babel. Suddenly this 'Isa Pur' seemed to me just as clear and obscure, just as strange and 'at home' as the other slogans sprayed everywhere on the walls by Puerto Ricans, Black Americans, Mexicans. And just as forlorn." The emotionally charged, gestural paint handling immediately conveys this feeling, calling up mental associations with fire, ashes, dust and human transience.

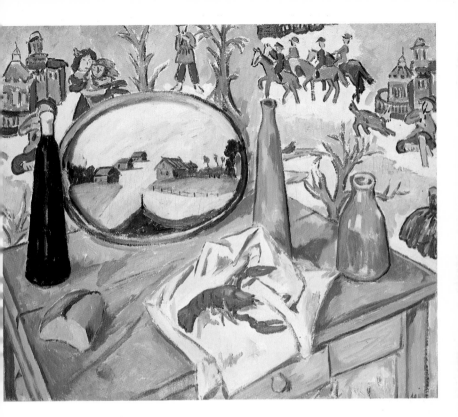

Artist-couple Mikhail Larionov and Natalia Goncharova played a leading role in the Moscow art scene before and after the revolution, the movements of Neo-Primitivism and Rayonism both being closely associated with them. Initially they were strongly influenced by French painting, with which they became acquainted in Paris in 1906, and well as through the works of Paul Gauguin, Henri Matisse, and Paul Cézanne in the great private collections of Moscow.

Larionov's *Still Life with Lobster* of 1907 combines elements that were decisive to his development. The palette employed, as well as the arrangement of table, tablecloth and objects, reveal the influence of Cézanne. Quite un-French, in contrast, are the motifs on the painted tray in the middle and on the joyously garish wallpaper in the background, which recall Russian folk art. These stand in delightful contrast to the exotic lobster in the foreground.

Larionov, Mikhail

1881 Tiraspol, near Odessa, Ukraine
1964 Fontenay-aux-Roses, near Paris

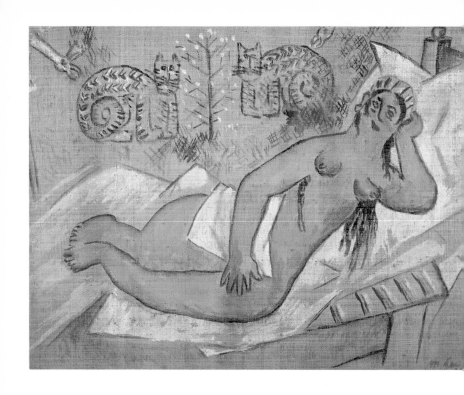

Rustic traits are also seen in Larionov's portraits of the period, such as that of a hefty man painted around 1910. Probably a portrait of the poet and critic Nikolai Burliuk, the picture still shows certain Expressionist influences. The figure has been reduced to the simplest terms, and rendered in strong, brilliant colors out of which the white shirt at the center shines. A strange sense of movement arrested is conveyed by the rapid brushwork and the slight incline of figure and background with respect to the canvas edges. The gesture of the man's hands – the left inserted in a trousers pocket, the right holding a book to his chest – and the way he turns his head slightly to one side, convey the impression of an energetic and yet thoughtful intellectual.

After 1910 Larionov developed a decidedly primitivist style that included decorative elements from folk art, forms borrowed from children's drawings, and inscriptions recalling graffiti. *Venus* of 1912

▲ **Mikhail Larionov**
Rayonism Red and
Blue (Beach), 1911

Oil on canvas
52 x 68 cm

Ludwig Collection

is a characteristic example of this phase. It shows a translation of
a classical motif of Western art into a consciously primitive idiom.
The figure of the reclining woman is as if inscribed, in simple con-
touring strokes, on the unprimed, heavy canvas. The ornamental
motifs of the two stylized cats emphasize the flatness of the entire
composition, which, like the subdued colors, stands in stark contrast
to the Fauvist sumptuousness of the earlier *Still Life with Lobster*.
Every classical form has been reduced to schematic and primitive
terms here.

Larionov's *Still Life*, a horizontal format rendered in warm tones,
originated in the period of 1907 to 1912. The partially sketchy character
of the canvas contains hints of elements that would appear in later
pictures, around 1910 and 1912. Relying on scientific theories on the
material nature of light, Larionov and Goncharova began, in 1910–1911,
to do paintings they were later to term "rayonistic." The compositional
principle of this style was to dissolve the subject into concentrated

sheaves of light rays (*rayons*) which fanned out into the pictorial space in almost prismatic refractions, and lent the resulting image an extremely dynamic effect. Larionov went further, attempting to evoke the electric or magnetic fields intrinsic to all matter, which he called the "radiation of things." The objects themselves became secondary to him. This is evident from his *Rayonist Sausages and Mackerel* of 1912, in which we can just detect the tails of a few fish in an open, brownish tin in the middle, and sausage halves around them. The whole is definitely dominated by the intersecting rays in which the objects appear to disintegrate.

▲ **Mikhail Larionow**
Rayonistic Sausages
and Mackerel, 1912

Oil on canvas
46 x 61 cm

Ludwig Collection

◀ **Henri Laurens**
Guitar, Glass and
Pipe, 1918
Guitare, verre
et pipe

*Collage, gouache and
charcoal on paper*
49 x 62 cm

Laurens, Henri

1885 Paris
1954 Paris

Henri Laurens came into contact with the Cubist artists in 1911.
In addition to sculptures, he made pictures of pasted paper, *papiers
collés*, which were closely related to works from the Synthetic Cubist
period of Pablo Picasso and Georges Braque. Here, in an oval of heavy
grey paper, Laurens has created a still life of paper shapes, overlain
with black and white lines. The colors are subdued, largely neutral.
The emphasis is definitely on the composition. In keeping with the
principles of the late phase of Cubism, *Guitar, Glass and Pipe* of 1918
evinces not only a synthesis of various materials but a visual and
intellectual synthesis of different objects as well.

While here various aspects of the objects are reduced to largely
planar terms, a Cubist sculpture like *Guitar* of 1914–1918 actually
occupies space and can be seen from all sides. On the front, the
complex composition of black, sheet-metal shapes is accented by
details that characterize the instrument: the curves of the sound box,
strokes of paint suggesting strings and the frets on the neck. The
back of the sculpture continues to reflect a Cubist employment of
sharp-edged, facetted, interlocking rounded forms.

In the course of the 1920s Laurens increasingly turned to organic
or biomorphic configurations, favoring the female figure and characters

▲ Henri Laurens
The Guitar,
1914–1918
La guitare

*Sheet iron, painted
height 44 cm*

Ludwig Collection

rom mythology. This may be seen in *The Farewell*, a sculpture of
940–1941. This figure adopts certain developments made by sculptors
ke Aristide Maillol or Constantin Brancusi, who abandoned the
ramatic, space-dominating gestures of Auguste Rodin's approach
o concentrate on creating self-contained, often crouching figures.
'et while in their case the sculptural energies seem to remain enclosed
vithin the volume, Laurens's piece shows a countermovement.

 After Cubist dissolution in form and content, Laurens's late phase
rought a return to the self-contained sculptural values of the human
gure. His works reveal an attempt to give an impression of calmness
nd tranquillity. The emphasis is not so much on vitality as on compo-
ition. The harmony and sculptural laws that determine the pieces, the
ystem by which their volumes seem mutually to engender each other,
ne fact that the empty space around them counts as much as the
nasses – all these factors are aimed at lending the sculptures stability.
he affinity with forms of female fertility idols from prehistorical and
arly historical eras points to a specially humane element in Laurens's
culpture: the invitation they offer both to perception and touch.

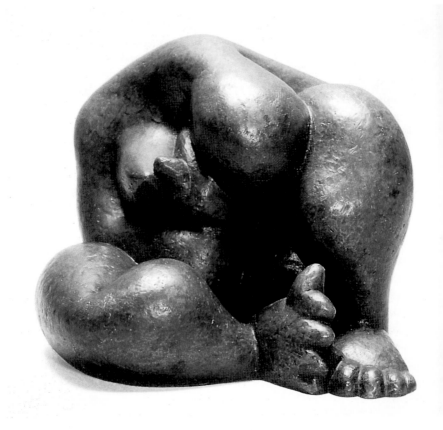

▲ **Henri Laurens**
The Farewell,
1940–1941
L'adieu

Bronze
70 x 85 x 82 cm

Fernand Léger's involvement with Cubism led to the development of
a highly individual style that relied strongly on geometric elements.
His machines and the machine-like people that worked them were built
up of tube or pipe shapes, which brought him the nickname of *"tubiste".*
The Pink Tugo (1918) shows an appreciation of modern technology,
which, as Karl Ruhrberg writes, "Léger not only did not reject, as his
Cubist friends did, but lent… joyous and optimistic form in a
coloration based on bright, sometimes almost garish red, blue and
yellow." The human figure at the left edge of the canvas resembles a
robot, as if he were part and parcel of the smokestacks, anchor chains,
sirens, silos and warehouses of the harbor where the tugboat has
moored. Looking at the picture one has the sense of being able to hear
the sirens wail, the pipes spout steam, and the machinery clatter.

 The Twins (or *Gemini*) (1929–1930) is a composition resembling
a still life, consisting of diverse contrasting shapes and elements
floating in space. The human figures set against a dark background,
which have the appearance of quotes from another picture or visitors

Léger, Fernand

1881 Argentan, France
1955 Gif-sur-Yvette,
near Paris

▲▲ **Fernand Léger**
The Pink Tugo, 1918
Le remorqueur rose

Oil on canvas
65.5 x 92 cm

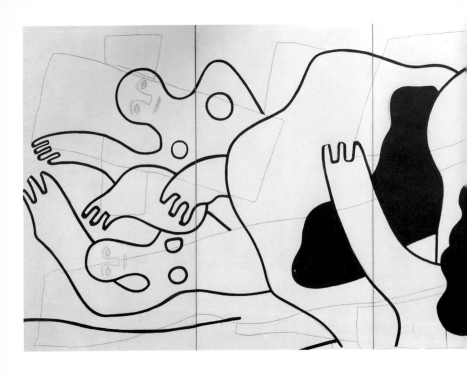

from some obscurely remembered dream, call up associations with dancers, or a constellation in the night sky.

The oil and charcoal picture *The Divers* was done in 1942 for the private residence of Wallace K. Harrison, an architect, on Long Island. The inspiration for the motif came to Léger as he was walking on the beach at Marseille, in 1940. "The idea ... occurred to me in the South," he recalled. "Immediately afterwards I travelled to the United States, and then one day I went to a swimming place." There Léger saw not just five or six divers, but two hundred. "You could no longer tell to whom any particular head, leg, or arm belonged ... So in my picture I jumbled the limbs, and realized that in this way I was being much more honest than Michelangelo when he concentrated on each individual muscle."

With time Léger's art took on an increasing social commitment, becoming an expression of solidarity with the nameless members of a mass society. At the end of this development stood the projection

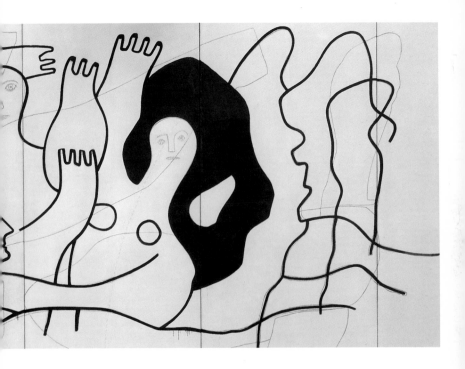

of a concrete utopia, a free world without repression or exploitation in which labor and leisure would be equal sources of joy. A favorite venue for this vision was the circus, where work and play seemed indistinguishable. In these paintings Léger's dancers and acrobats again and again assume a certain pose: one hand raised above their head, as if waving to or saluting someone. The drawing *Head of a Woman* (1937) is an example from the series. Here the spontaneous gesture has become one of serenity and passive musing.

The neoclassical scheme in depicting the figure, which Léger worked out in parallel with Pablo Picasso and Alexander Archipenko in the 1920s, anticipated his 1954 rendering of a *Country Outing*, a salient example of Léger's late style. It is one in a long series of artists' evocations of Sunday, the day of rest on which plain people come closest to realizing an earthly paradise. It is also a "group picture with ladies," in which the figures are expanded to monumental proportions and given idealized features.

▶ **Fernand Léger**
The Twins
(or Gemini)
1929–1930

Oil on canvas
73 x 92 cm

Gift of the Trustees
and Supporters
Association of the
Wallraf-Richartz
Museum

▼ **Fernand Léger**
Head of a Woman,
1937

Pen and brush
in ink and pencil
on wove paper
40.5 x 31.5 cm

Haubrich Collection

▼▶ **Fernand Léger**
Hand, 1951

Pen and ink
with grey wash
43.8 x 30.8 cm

Haubrich Collection

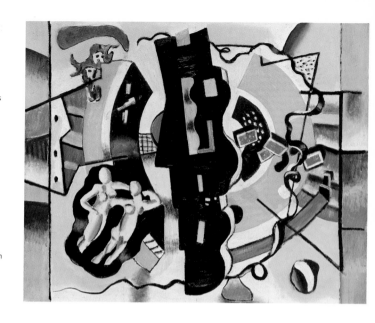

The colors are applied in great unbroken areas, without nuances or visible brushstrokes, and the contours heavily emphasized. Even in his late work Léger continued to be intrigued by the motif of building and construction workers. His Olympians were proletarian in origin. The pen and ink drawing of a strong, work-hardened *Hand* in the Museum Ludwig, Cologne, probably belonged to a construction worker raising his arm or waving. Yet rather than conveying an individual gesture, this hand is like a universal symbol of the laboring hands of all humanity.

▲ **Fernand Léger**
The Country Outing,
1954

Oil on canvas
194 × 195 cm

Loan of the Trustees and Supporters Association of the Wallraf-Richartz-Museum and Museum Ludwig

Lehmbruck, Wilhelm

1881 Duisburg, Germany
1919 Berlin

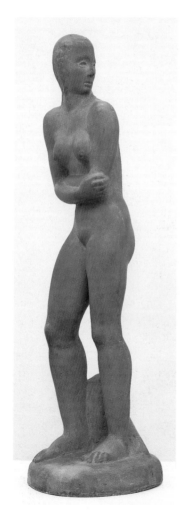

Wilhelm Lehmbruck's work found early international recognition through exhibitions in Paris (beginning in 1907) and at the legendary Armory Show in New York (1913). He was among the founders of modern sculpture, who continued to influence younger generations through and beyond the mid-century. Lehmbruck's style was decisively shaped during a stay in Paris (1910–1914), where he met with the artists at the Café du Dôme and exchanged ideas with Henri Matisse, André Derain, Alexander Archipenko, and Constantin Brancusi. But his break with academic sculpture had already begun in Germany, inspired by the works of Michelangelo and Auguste Rodin.

Lehmbruck's *Female Torso* of 1910 still reveals the influence of Aristide Maillol. Yet he was less interested than the French sculptor in representing plastic masses, creating an impression of statuesque gravity or classical form. Instead the emphasis is on the softly flowing lines of the torso, on the slightly inclined head and only sparingly mod-elled face, all of which contribute to evoking a reserved, lyrically melancholy mood. Lehmbruck departed from his ideals, the Greek and Roman depictions of Venus, by almost entirely concealing the anatomical structure and its details under a softly modelled surface. He also replaced Rodin's agitated treatment by a quiet serenity.

The two later works, *Inclined Female Head* (1911) and *Head of a Youth* (1913), though independent sculptures in their own right, are actually details from larger pieces. These are the now-popular *Kneeling Woman*, which in the 1920s could still be toppled from its pedestal in the name of morality, and *Ascending Youth*. The "Gothic" elongation of the boy's slender limbs was an Expressionist device intended to heighten emotional effect and to spiritu-alize the figure. *Inclined Female Head*, an embodi-ment of modesty, reverence, and dignity, represents a new form of religiously inspired sculpture. The elongated face is shared by *Head of a Youth*, which

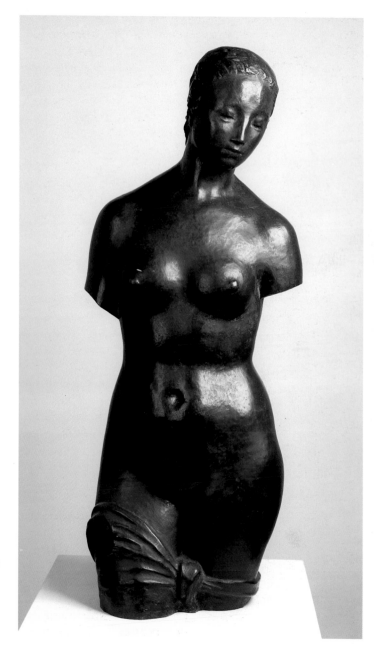

► Wilhelm
Lehmbruck
Female Torso, 1910
Frauentorso

Bronze
height 115 cm

Donation of
Louis Hagen, 1925

◄ Wilhelm
Lehmbruck
Figure Glancing
Backward, 1914–1915
Rückblickende

Stone casting,
brownish patina
height 92 cm

Haubrich Collection

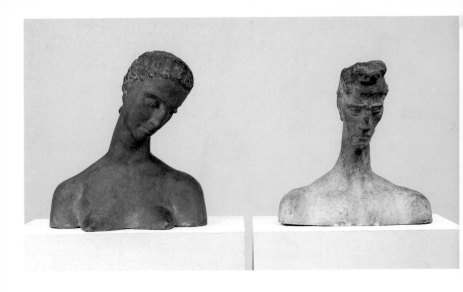

has an aura of even deeper melancholy and spiritual concentration. The gaze is empty, seemingly turned inwards. The roughly modelled surface of the face and hair anticipate a dissolution of solid volume which would be achieved not by Lehmbruck himself but by Alberto Giacometti.

Like many of Lehmbruck's female figures, *Figure Glancing Backward* (1914–1915) bears the features of his wife, Anita. The way the figure tentatively steps forward while looking back over her shoulder gives the piece two opposing directions of movement. But the step is only suggested, for the legs are heavy and as if fixed to the ground. The result is a sense of suspended animation, a poise not based on a self-confident and balanced standing position but arising from a moment of indecision, an inability to move. The impression of involuntary passiveness is increased by the arms, clasped across the breast as if to ward off cold.

Lehmbruck's sculpture in general is characterized by just such a tension between expression and introversion. He himself viewed his art in an absolute sense, as conveying "the essence of things, the essence of nature, that which is eternally human."

Aristarch Lentulov combined elements of Fauvism with Cubist brush-work in a very individual way. Despite their high degree of abstraction his compositions never lack references to real things, and a tectonic construction inspired by Paul Cézanne. Although Lentulov did not adopt the Neo-Primitivist approach of Mikhail Larionov and Natalia Goncharova, his entire œuvre shows the influence of Russian folk art and its color schemes, and is frequently devoted to the Russian land-scape.

The *Sketch of a Girl before a Fence* was done in 1911–1911 under the impression of an extended trip that took Lentulov to Paris in 1911. The Cubist treatment of the figure and the warm palette clearly reveal the effect that Cézanne's portraits had on the Russian artist. In mastering the modern painting techniques Lentulov developed an inimitable style which reflected the revival of interest in art in Russia at that time.

His *Landscape with Cypresses* belongs to a series of landscapes with architecture painted between 1913 and 1917. It shows evidence of Lentulov's involvement with popular Russian and Turkish picture-sheets, which he treasured especially for their bright colors.

Lentulov, Aristarch

1882 Vorona, Nishniy-Lomov, Pensa District, Russia
1943 Moscow

◄▲ Aristarch Lentulov

Sketch of a Girl before a Fence, 1911–1912

Oil on canvas
85 x 66 cm

Ludwig Collection

▲ Aristarch Lentulov
Landscape with Cypresses, 1913–1917

Oil on canvas
64 x 60.5 cm

Ludwig Collection

LeWitt, Sol

1928 Hartford,
Connecticut
Lives in New York

Sol LeWitt is a leading representative of Minimal Art. His work in sculpture and his theoretical statements helped pave the way for Conceptual Art. After studying in New York, LeWitt worked in commercial art, among other things serving as a designer at the Museum of Modern Art, New York. In 1962, under the influence of the Bauhaus, de Stijl, and Constructivism, he began free sculptural work, producing floor and wall-mounted pieces with purely geometrical configurations. Initially these occupied a position intermediate between wall-panel and object, but later they burgeoned increasingly into three-dimensional, space-defining terms.

Red Square, White Letters of 1963, in the Museum Ludwig, Cologne, is one of LeWitt's earliest works, done prior to the serial objects in space. Initially he made three-dimensional works that contained words and shapes, the artist explained, the forms being based on the form of the frames that Muybridge used in his serial photography. But just as the colors visually progressed and finally vanished, the forms, too, progressed across the front of the painting to disappear behind the back. These works could be termed structures, said LeWitt, because they were neither painting nor sculpture, but both. The painting illustrated here consists of four each red and white squares of canvas, mounted in a wooden framework such that the center remains open. Red and white squares alternate with white and red words: red, white, square, letters, in various combinations.

▼ Sol LeWitt
Red Square, White
Letters, 1963

Oil on canvas
100 x 100 cm

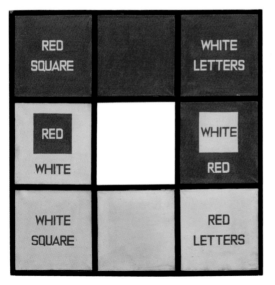

As the theoretical underpinning of his works and their links with certain mathematical principles indicate, LeWitt went beyond the aesthetics of Minimal Art to address conceptual issues. "Ideas alone can be works of art; they are in a chain of development that may eventually find some form. All ideas need not be made physical," he stated in his *Sentences on Conceptual Art,*

published in 1969. Put differently, the intellectual conception of the work was primary, and its realization only secondary. The work should reveal no individual touch whatsoever, LeWitt believed, and consequently he had his pieces executed by others.

The square, and its three-dimensional counterpart, the cube, are frequently employed in LeWitt's sculptures. In 1966 he began a series of "modular structures" (grid or cage-like configurations of open or closed cubes made of lacquered steel), one of which is *Three-Part-Set 789 (B)*. The work is a study of the relationships of a horizontal grid of squares to a cubic form. The square serves here as a module or a reference measurement. The floor plate is divided into 13 x 5 squares. Arranged along its longitudinal axis, at intervals of three squares, are a flat plate, a cube, and an upright rectangular solid. The open cubes placed over these are indicated only by edge lines, as in an isometric drawing, to render the interior relationships visible.

▲ **Sol LeWitt**
Three-Part-Set 789 (B),
1968

Painted steel, tape strips
80 x 208 x 50 cm

Ludwig Donation,
1976

Lichtenstein, Roy

1923 New York
1997 New York

▼ Roy Lichtenstein
Explosion No. 1,
1965

Lacquered metal
251 x 160 cm

Ludwig Donation,
1976

Roy Lichtenstein's works should be understood as pictures of pictures. He finds his motifs in printed matter – comic strips, commercial illustrations (which indirectly inspired the landscapes), and reproductions. Like Jasper Johns, Lichtenstein is concerned to bridge representational art and abstraction. By exaggerating banal imagery whose content has grown meaningless, and concentrating on its formal values alone, he raises these to aesthetic status and makes them the true subject of the painting.

What distinguishes Lichtenstein from Johns and makes him a Pop Artist is his interest in the "anti-sensibility" that pervades society, the "brazen and threatening characteristics of our culture," its apathy and lack of compassion – but also in the energies mobilized by a "commercialized landscape." Lichtenstein and the Pop Artists are convinced we live in a world in which people let their emotions be developed rather than being truly emotional. It is this indifference, this conventional, stereotyped, and ultimately empty emotion Lichtenstein says he wishes to convey. Thus his interest in comics, which,

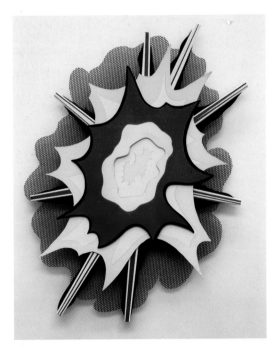

he said in an interview in 1963, "express violent emotion and passion in a completely mechanical and removed style." This is evident in the scenes chosen and in the frenetically insistent yet somehow resoundingly hollow words issuing from the mouths of the characters in *Takka-Takka* (1962), *Mad Scientist* (1963), and *M-Maybe (A Girl's Picture)* (1965).

The gap between the hackneyed content and the high aesthetic culture of these paintings can be extremely provoking. Yet Lichtenstein's aim, as Wieland Schmied notes, is precisely to take these "idealized wish-images of consumer society" as starting points for the development of

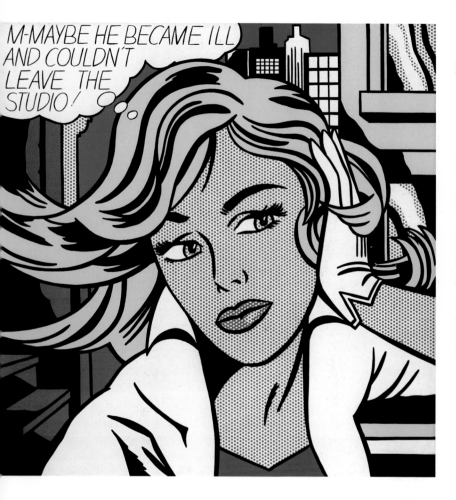

"a well-nigh classical form." This is perhaps why he limits himself to the primary colors and strong light-dark contrasts. When we compare *Takka-Takka* to the original comic frame, the extent to which Lichtenstein condenses individual forms and raises the event shown to a universal level becomes clear. In addition, he accentuates the similarities comics have with past styles in art. The flames shooting from the machine-gun muzzle, or the wavy blonde hair of the girl in *M-Maybe*, call the sinuosities of Art Nouveau to mind. *Mad Scientist* also contains an ironic allusion to fine art. The action is shifted into

▲ **Roy Lichtenstein**
M-Maybe
(A Girl's Picture),
1965

Magna on canvas
152 x 152 cm

Ludwig Donation,
1976

THE EXHAUSTED SOLDIERS, SLEEP-
LESS FOR FIVE AND SIX DAYS AT A
TIME, ALWAYS HUNGRY FOR DECENT
CHOW, SUFFERING FROM THE TROPICAL
FUNGUS INFECTIONS, KEPT FIGHTING!

▲ Roy Lichtenstein
Takka-Takka, 1962

Magna on canvas
143 x 173 cm

Ludwig Donation,
1976

the vicinity of a museum, where, indicatively, the scientist is worried
not about a potential art theft but about the theft of souvenirs.

Lichtenstein's working procedure seems almost Dadaist, not only
because he blows up miniature images to monumental scale. He
projects a free sketch of the original image, rather than the original
itself, onto canvas, then proceeds to restore it to a mechanical look
approaching that of the original. Then he applies the printing screen
(or Ben Gay) dots with a stencil. Lichtenstein uses Magna paints
soluble in terpentine so that alterations remain invisible and every
hint of a personal hand is expunged.

In 1964 Lichtenstein began painting landscapes. In addition to
sunrises and sunsets, he was particularly interested in clouds, because,
as he said, their representation in comic strips had become so unreal
that they fascinated him as a concretization of an abstract idea.

▲ **Roy Lichtenstein**
Mad Scientist, 1963

Magna on canvas
127 x 151 cm

Ludwig Donation,
1976

Explosions intrigue him for similar reasons, since they have no fixed form but change rapidly over time. Lichtenstein translates the symbolic depictions of comic-book artists into plastic terms in order, he once said, to create something absolutely concrete out of something transient.

The year 1967 marked a turn to the aesthetic of the 1930s, Art Deco (as seen in the *Study for "Preparedness"*). The imagery became correspondingly more geometric and heroic in effect. According to the artist, he searched for what was shared in common by the architectural forms of that epoch, its fashions and the works of painters like Theo van Doesburg. The art of the 1930s, he concluded, obeyed a meaningless logic based on circle, angle and triangle. Lichtenstein thought it must have been the first time in history that people consciously attempted to be modern. They believed they were modern much more

▶ **Roy Lichtenstein**
Study for
"Preparedness",
1968

Magna on canvas
142.5 x 255 cm

Ludwig Donation,
1976

◀ **Roy Lichtenstein**
Red Barn II, 1969

Magna on canvas
112 x 142 cm

Ludwig Donation,
1976

▲ Roy Lichtenstein
Landscape with
Figures and
Rainbow, 1980

*Oil and Magna
on canvas*
213 x 304.8 cm

Ludwig Collection

were modern much more strongly than we today do, and their art
presented a naive and innocent falsification that appealed to him.
While the four-part work seems to demonstrate the structural
misunderstanding arising from a systematic arrangement of four
unified elements ("meaningless logic"), the *Study* can be seen as
a satirical homage to America's military-industrial complex. The
utopian reconciliation of nature with industry envisaged by Léger has
been transformed by Lichtenstein into its very opposite, despite the
close affinities that Lichtenstein's harsh, industrial formal language
displays with that of Léger. Remember, in 1968 the Vietnam War was
at its high point, as were the protests of enraged and saddened
Americans at home.

Beginning in the late 1970s Lichtenstein painted a series of pictures
relating to German Expressionism, such as *Landscape with Figures and
Rainbow*. It is remarkable that here, for the first time, the artist has left
visible brushwork in several passages of the composition.

◀ **Richard Lindner**
Leopard Lilly, 1966

Oil on canvas
177.8 x 152.4 cm

Ludwig Donation,
1976

▶ **Richard Lindner**
Target No. 1, 1962

Oil on canvas
152.4 x 101.5 cm

Ludwig Donation,
1976

Lindner, Richard

1901 Hamburg
1978 New York

Richard Lindner emigrated from Germany in 1933, going first to
Paris and then, in 1941, to the United States. Living in New York in
the 1950s, he developed a personal style that partook only marginally
of the concurrently emerging Pop approach. From German Neue
Sachlichkeit of the 1920s he took the cool, objective view of the
human figure and its occasional exaggeration to the point of grotesque
caricature, and combined these with the bright, expansive color fields
and borrowings from commercial art and consumer goods of the
new American art.

Lindner stylized characters and symbols of the big city and Ame-
rican society in general into composite, as if montaged fetish objects,
such as *Target No. 1* of 1962. Here the confrontation between male
and female is compared to taking aim at a bull's-eye.

Leopard Lilly of 1966 is also concerned with motifs from the urban
environment, and especially with the relationship between men and
women. The oil has the look of a painted collage, composed of
abstracted, alienated, and superimposed sexual symbols.

Lipchitz, Jacques (Chaim Jacob)

1891 Druskieniki, Lithuania
1973 Pietrasanta, on Capri

After attending a trade school, Jacques Lipchitz moved in 1908 to Paris, where he studied at the Ecole des Beaux-Arts and the Académie Julian (1909–1913).

Influenced by his acquaintance with Pablo Picasso and other Cubists, and encouraged by his friends Juan Gris and Diego Rivera, Lipchitz began making Cubist sculptures in early 1913. But at this point he still concentrated on the front view alone.

It was not until about two years later that Lipchitz succeeded in opening out all sides of the piece to the surrounding space, creating a simultaneity of different aspects while suppressing details, and achieving a new compositional structure of autonomous formal complexes. The sculptures of this period were characterized by a reduction of the figure to basic geometric shapes and a rigorous tectonic articulation.

The 1919 sculpture *Woman Reading* originates from a phase in which Lipchitz had already begun to abandon his previous Analytical Cubist, strongly abstract approach and the strict verticality of his earlier sculptures. This change in style expressed itself in what A. M. Hamacher has termed a "zig-zag rhythm, a greater agitation that calls Boccioni to mind. But that remained superficial ... With Lipchitz every detail is completely plastically resolved and remains simple. Baroque movement is present only in the overall design ... In 1918 a synthesis occurred which lent more volume to the slender, tectonic earlier approach and rendered the detailing richer and more agitated. The reference to the figure became more immediate."

In the 1920s Lipchitz tended towards organic, gently swelling forms that in some respects recalled monumental idols and that eventually developed into baroque configurations suffused with movement. This vital and vivid formal language is reflected in the portrait of *Théodore Géricault* of 1932, a vigorously modelled head whose surface seems to vibrate in the impinging light. So alive does it seem that it is difficult to believe that Lipchitz based the sculpture on the French painter's death mask.

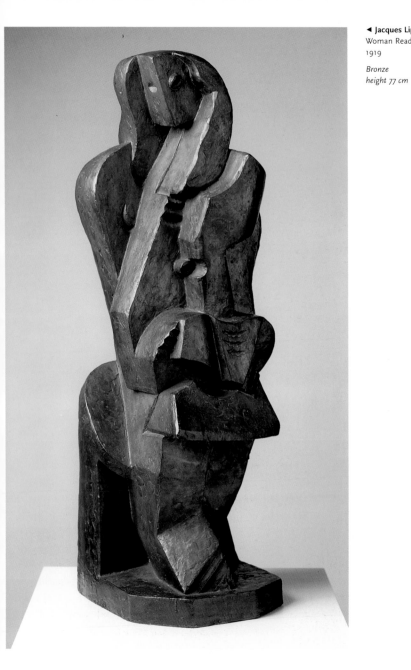

◄ **Jacques Lipchitz**
Woman Reading,
1919

Bronze
height 77 cm

Lissitzky, El
(Lasar M.)

1890 Portshinok,
near Smolensk
1941 Moscow

El Lissitzky was one of the major artists of the Russian avant-garde, whose diverse activities in the fields of painting, architecture, typography, and photography were a seminal contribution, both theoretically and practically, to the realization and dissemination of Constructivist ideas.

After completing his education as an architect and engineer at the Technical College in Darmstadt, Germany, Lissitzky returned to Russia at the outbreak of World War I. Initially he worked in a number of architectural offices in Moscow. In 1916 Lissitzky created figurative book illustrations which combined Expressionist and Cubo-Futurist influences. After taking a teaching post at the art school in Vitebsk in 1919, he turned away from objective art to adopt various formal

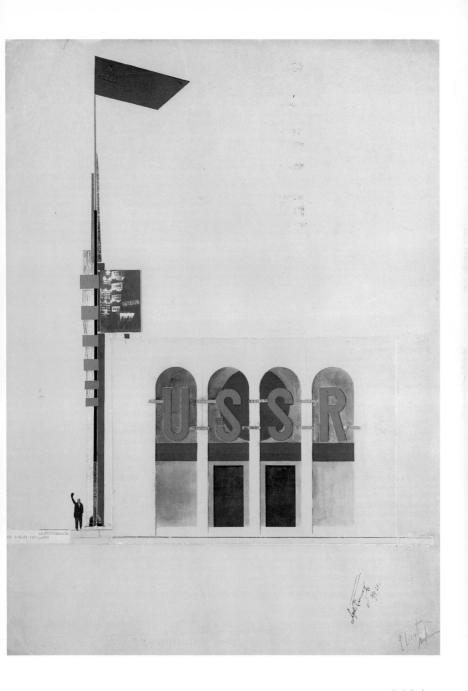

elements of Suprematism (whose mystical, irrational aspects, however, he rejected). Beginning in about 1920 he produced his first *Proun* designs (an abbreviation of the Russian for "Project for the Affirmation of the New"), which are among his art-historically most significant works.

The extant *Prouns*, most of them in the mediums of lithography or watercolor, but some in oil or relief, are composed of simple geometric shapes to produce a strongly architectural effect. Among their salient features is a waiver of traditional perspective. The diverse elements, be they lines, planes, or volumes, are depicted from different vantage points, engendering a dynamic interplay of movements in various directions through space. A particularly important specimen is *Proun* of 1923, which in terms of composition, color scale, and configuration bears a great similarity with the famous painting of the same year, *Proun 12 E*, in the Busch-Reisinger Museum, Cambridge, Massachusetts.

One of the major architectural projects executed by Lissitzky was the Soviet Pavilion at the international press exhibition, "Pressa," held in Cologne, Germany, in 1928. Under his supervision a team of more that 35 Soviet artists worked on the project, which was intended to demonstrate the achievements and successes of the Soviet press.

Initially Lissitzky planned to redesign the neoclassical facade of the exhibition building by adding a flag stand of gigantic dimensions, but its execution was ultimately prevented by the exhibition director. Lissitzky conceived the interiors to reflect the "dynamism" of revolutionary Russia, with various kinetic objects installed in the hall on which visual and textual information was presented. The innovations included a photomontage frieze 24 meters in length based on Lissitzky's designs.

For the "Pressa" catalogue he made similar collages composed of newspaper clippings and photographs, five of which are now in the Museum Ludwig, Cologne. The collages include photos of the exhibition pavilion alongside pictures of social life in the Soviet union, views of the Rhine at Cologne alongside a map of the USSR, photos of workers reading alongside views of the laboring masses – all linked with one another by explanatory lines of print and newspaper articles. This quite new form of typographical and photographic design was to prove enormously influential on design to come. The interplay between actual objects (newspapers) and photographed reality lends the collages a high degree of immediacy and authenticity. They represent a successful merger of aesthetic design, documentary validity, and political manifestation.

▲ El Lissitzky
Design for the
"Pressa" exhibition,
1927

*Collage of
photographs and
newspaper clippings,
gouache
30 x 57 cm*

Long, Richard

1945 Bristol,
England
Lives in Bristol

Richard Long is associated with the movement known as Land Art. One of his first works in the landscape, *A Line Made by Walking*, was done in 1967. It was a linear walk through the countryside, documented by means of diagrams and photographs. Even the earliest works reflected Long's fundamental principles. Unlike his American colleagues Walter de Maria and Michael Heizer, Long made no incursions into nature and employed no non-natural materials in his art.

In 1970 Long began developing sculptural conceptions for interior locations. Like the outdoor pieces, these works were based on fundamental geometric configurations, symbols that have played a long role in cultural history – lines (paths), circles, spirals, and crosses. *A Crossing Place* (1983) also exists in a second, counterpart version, made of pieces of wood found outdoors. The piece in the Museum Ludwig, Cologne, consists of 534 unaltered stones, arranged in a cross shape with two equally long and wide beams intersecting at an angle of 90 degrees. The title alludes to the marked intersection of a busy street or road. In 1983 the artist prepared a certificate that established the dimensions of the floor sculpture and the placement of the stones.

Apart from clay and water, stones are a material frequently used in Long's interior and outdoor sculptures. In keeping with their natural variety, the stones vary in color, surface texture, size and shape. When working outside, always alone and without mechanical assistance, Long employs the rocks just as he finds them. The material for interior locations is usually taken from local quarries. The simplicity of the material, the clarity of its forms, and the immediacy of its employment, all play a special role in Long's work. He works with stones, he says, because he loves them and because they are easily obtained, because they are nothing special but so common that they can be found anywhere. There is also a practical aspect, Long adds. No particular ability or talent is required to work with stones. He need not add anything to them, but can simply take them and make a sculpture. It is sufficient to employ stones for their own sake, Long concludes.

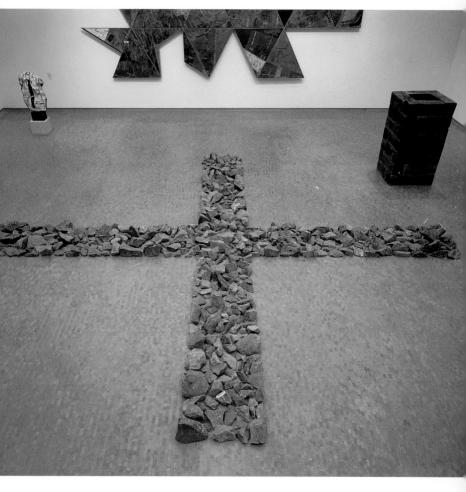

▲ **Richard Long**
A Crossing Place,
1983

534 stones
Each crossbeam
1050 x 125 cm

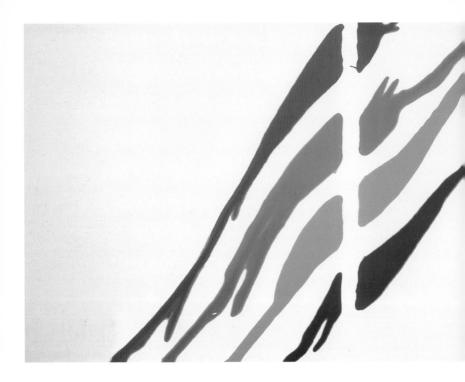

Louis, Morris

1912 Baltimore,
Maryland

1962 Washington,
D.C.

American painter Morris Louis is widely considered to be one of the major representatives of Post-Painterly Abstraction and Color-field Painting. He trained from 1927 to 1932 at the Maryland Institute of Fine and Applied Arts in Baltimore. After living for a time in New York (1936–1940), Louis returned to his home town of Baltimore.

Influenced by the Abstract Expressionism of Jackson Pollock, but even more by Helen Frankenthaler's expansive color fields, Louis developed a style of great lyricism in which color itself was the theme. Together with Kenneth Noland, a friend since 1952, he began to experiment with new materials and methods, especially the technique of letting thinned paint flow across and soak into unprimed canvas, as Frankenthaler had done.

The result was a series of paintings titled *Veils*, done between 1954 and 1959. Since the color veils penetrated the canvas and became identical with it, wrote critic Barbara Rose, foreground and background

merged into one. The images took shape like natural phenomena emerging from the mist. No idiosyncratic forms or harsh contours hindered their enigmatic flux.

A further group of works, done in about 1960–1961, comprised 150 canvases collectively titled *Unfurleds*. Only two were given individual titles, *Alpha* and *Delta*, since they were to be shown in an exhibition. All of the other titles based on these Greek letters were determined by the estate administrator after the artist's death. In this series Louis employed a special paint, which since 1961 had been manufactured for him and Noland by the Bocour Company, New York. It was an acrylic made to a formula that increased its fluidity. In these works the colors run in separate, parallel bands, starting either from the corners of the canvas, leaving the middle free, or from the center.

In *Alpha-Ro* (1961), four bands extend diagonally across the canvas, separated in the middle by a vertical, unpainted gap. The free flow of paint has created tributaries which lead the viewer's eye upwards and downwards, keeping the eye in constant motion. Since the paint bands are intersected by the top and bottom edges of the canvas, one has the sense that the diagonal movement continues beyond the boundaries of the picture.

◄ **Morris Louis**
Alpha-Ro, 1961

Acrylic on canvas
267 x 546.5 cm

Ludwig Donation,
1976

Lüpertz, Markus

1941 Liberec, Bohemia
Lives in Berlin and Düsseldorf

▲ Markus Lüpertz
Helmets Sinking
(Dithyrambic I),
1970
Helme sinkend
(dithyrambisch I)

Distemper on canvas
260 x 450 cm

Loan of
Dr. Michael and
Dr. Eleonore Stoffel

▶ Markus Lüpertz
Titan, 1985

Bronze, painted
253 x 59 x 196 cm

Loan of
Dr. Michael and
Dr. Eleonore Stoffel

Painter and sculptor Markus Lüpertz attended the School of Applied Arts in Krefeld and the State Art Academy in Düsseldorf from 1956 to 1961. In 1976 he became professor at the State Academy of Visual Arts in Karlsruhe, and in 1986 was named director of the Düsseldorf Academy.

After moving to Berlin in 1963, Lüpertz developed a style he termed "dithyrambic painting," an expressive, figurative approach that stood in stark contrast to the abstract tendencies of the day. In 1970 his compositions began to take on the character of still lifes, being based on objects such as soldiers' helmets, snail shells, coats, and painter's palettes. These motifs called up manifold associations from the history of art and ideas, as well as containing direct political references.

Lüpertz's employment of motifs like Wehrmacht helmets and officer's caps in the canvases of 1970–1974 caused a furore. One such work was *Helmets Sinking (Dithyrambic I)*. It stood at the beginning of the artist's involvement with German motifs, which culminated and came to a close in 1974 with the painting *Black-Red-Gold (Dithyrambic)*. With these pictures, as Siegfried Gohr noted, Lüpertz "entered the path towards a redefinition of his painting, by facing up to the greatest emotional barrier, the taboo of silence imposed on the Nazi period, and breaking through it with his German motifs."

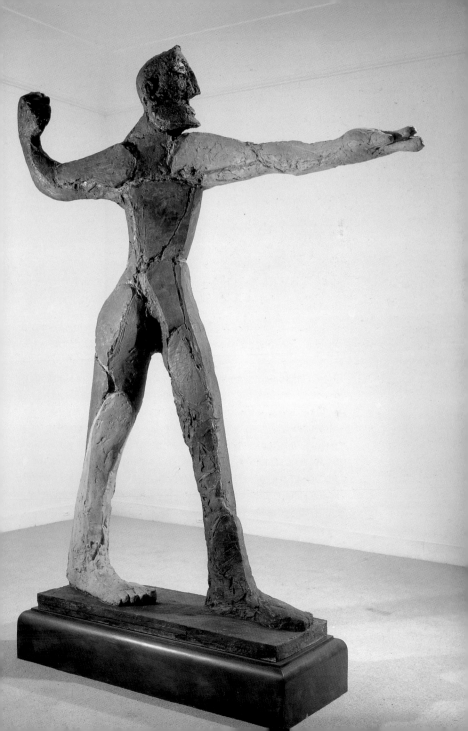

Since the early 1980s Lüpertz has supplemented his painting by work in sculpture. Following bronzes inspired by the Cubists' rendering of Black African sculpture, *Hand, Head, Foot* and *Nymph* (1981), *Standbein-Spielbein* (Supporting Leg-Relaxed Leg, 1982), and six works related to *Alice in Wonderland* (1983), the third group of Lüpertz's sculptures comprised six heads entitled *The Burghers of Florence.* These fantastic and grotesque portrayals, ranging from historical figures (the Medici) to present-day tourists, are grouped into a configuration purposely reminiscent of Auguste Rodin's *Burghers of Calais.*

The sculpture *Titan* dates from the year 1985. The entire figure, writes Gohr, "is captured in a poignant sign, evoking energy concentrated in space ... Every detail serves to define a figure that is treated as an allegory of power and directedness ... The work can be perceived only in statuesque terms, not in terms of motion halted in time, as in the counterpoise of ancient Greek and Roman sculpture."

After attending the Düsseldorf Academy from 1950 to 1953, Heinz Mack joined with Otto Piene in 1957 to form the Zero group, of which Günther Uecker became the third member in 1961.

Mack, Heinz

1931 Lollar, Germany
Lives in Mönchen-
gladbach

In addition to Uecker's nail reliefs and Piene's smoke paintings, Mack's "reliefs in light" and kinetic objects are among the best-known productions of the group. Describing the emergence of his reliefs, the artist wrote that "an unexpected possibility of making aesthetic movement visible arose when I accidentally stepped on a piece of thin metal foil that lay on the hemp carpet. When I picked up the foil, the light had an opportunity to shimmer across it. Since the carpet was mechanically woven, the imprint naturally remained mechanical and decorative, too... My metal reliefs, which I prefer to call reliefs in light, and which are formed solely by pressure of the fingers, require light instead of colors to come alive. Polished to a mirror finish, a low relief is enough to disturb light at rest and set it in vibration. The potential beauty of this configuration would be a pure expression of the beauty of light."

Mack's preferred materials are glass (or plexiglass) and aluminum, the former transparent, the latter highly reflective when polished. Aluminum is also a contemporary material, which the artist often employs in prefabricated form. In a series devoted to the wing motif, which includes *Five Wings of an Angel* (1965), the metal elements consist of a high-tensile aluminum grid employed in the aircraft and missile industry. Cut into square sections, the material has been pulled by hand and distorted into fan or semicircular shapes. The result is a filigree configuration that, like an organic cellular structure, reacts to the slightest pressure and seems almost divested of material presence by the light reflections playing across its surface. The title *Five Wings of an Angel* also alludes to a link with the supernatural. Mack himself makes reference to Leonardo da Vinci, who "was an engineer, and painted angels." The elements of the piece, which shimmer most effectively in natural light, evoke a search for transcendence, in a modern version which cites the iconography of the angel in art and contains echoes of the spirituality of ornamental medieval seraphim.

▶ Heinz Mack
Five Wings
of an Angel, 1965
Fünf Flügel
eines Engels

Aluminum on wood,
under plexiglass
200 x 103 cm

Ludwig Donation,
1976

In a letter of 1911 to August Macke, Franz Marc addressed his friend with a nobilitating "August Vonderfarbe" (as who should say, Monsieur de Couleur), very aptly characterizing Macke's principal artistic concern. The two had met the year before in Munich. Their friendship, by which their art mutually profited, brought Macke in contact with the painters of the Blauer Reiter (especially Wassily Kandinsky and Alexei von Javlensky). However, Macke never shared their tendency to mystical considerations and metaphysical speculation. Rather than attributing abstract values and significances to colors as Marc did, Macke used them solely to express his own personal feelings and ideas.

When Marc praised him in his obituary as "the one who gave colors the brightest and purest tone of us all," he meant the elemental lucidity, order, and harmony that pervaded Macke's art. It was not a spiritualization of nature, but what he called a "joyful living through of nature" that determined his approach. This explains why seeing a show of the works of Matisse, in Munich in 1911, was so important to Macke, for it confirmed his own love of brilliant color and simplified

Macke, August

1887 Meschede,
Germany
1914 Killed in action
in Champagne, France

▲ **August Macke**
Fashion Window, 1913
Modefenster

*Watercolor over pencil
on wove paper
29 x 22.7 cm*

form. The decisive influence on his work, however, came after he had become familiar with Cubism and Futurism, and seen the paintings of Edvard Munch. This influence was Robert Delaunay, whom he and Marc visited in Paris in 1912.

A combination of German and French influences is seen in *Clown in the Circus* of that year, a rare example of a decidedly graphic and caricaturist approach in Macke's watercolor work. What intrigued

▲ **August Macke**
Lady in a
Green Jacket, 1913
Dame in
grüner Jacke

Oil on canvas
44 × 43.5 cm

Haubrich Collection

him in Delaunay was that artist's *Window Pictures* (1912), with their transparent, facetted planes of pure color and their definition of space by means of color alone. Creating "living" color, wrote Macke, and discovering the "space-defining energies of color... that is our finest goal."

He already achieved it in his watercolor *Fashion Window* of 1913. The prismatic hues, complementary color contrasts, and the prominent use of lettering, in the "Mode" sign, all strongly recall Delaunay, but the effect of the whole is inimitably Macke. Unlike the French artist, he did not search for "a new reality" (Delaunay's words) behind the window but attempted to create a visual metaphor for a beautiful, sunny, yet very real and ordinary day.

▼ **August Macke**
Man Reading
in the Park, 1914
Lesender Mann
im Park

Oil on canvas
86.5 x 100.3 cm

Haubrich Collection

Lady in a Green Jacket, done during a stay at Thun Lake in 1913, shows an especially harmonious arrangement of form and a fine equilibration of color. A year later, the alternation among statuesque figures, softly rendered foliage and grass, and blocky, Cubistic houses in the background, gave way to the more atmospheric approach of *Man Reading in the Park* (1914). Here, as G. Vriesen notes, "corporeality dissolves in light and ambient atmosphere... without, however, forfeiting vital objective presence. An organic vibration of air, space and illumination, an emerging and passing away, a blurring and intermerging, dominate the picture."

One of Macke's last paintings was the unfinished work that now bears the title *Farewell*. "With absolute clarity," Vriesen states, "the picture reflects the gloom and numbness that befell public life" before the first year of war was out, "the mood of uncertainty and disquiet which took possession of Macke as well."

▲ **August Macke**
Farewell, 1914
Abschied

Oil on canvas
101 x 130.5 cm

Haubrich Collection

Magritte, René

1898 Lessines,
Belgium
1967 Brussels

In a letter to Harry Torcyner, René Magritte gave the following inter-pretation of his 1960 painting *Presence of Mind*: "Since to my way of thinking an illusion of the theme of science, scientific research, humanity, could only be a (if you will, harmless) joke, I have painted a picture and called it 'Presence of Mind'... In purely factual terms, the picture shows heaven and earth, a bird, a man, and a fish – aspects of the world, in other words, with which science concerns itself (which attempts, for its adherents, to find out what all of this is). My picture says nothing about this..., it merely shows aspects of the world with which a scientific mind concerns itself in its own way. Having said this, one can, I believe, go on to state that these aspects of the world relate to humanity... The idea of humanity, which belongs to the program here, can in turn be represented by the fact that the man depicted symbolizes the unity of humanity. Also, another reason why the picture is called 'Presence of Mind' is because this is indispensable for a program that encompasses 'science, scientific research, and humanity'."

Along with Max Ernst and Salvador Dalí, Magritte was a major representative of Surrealism. Yet unlike Dalí, who painted his personal visions and hallucinations, Magritte depicted ordinary things from the real world, combined in strange and unexpected ways. Magritte's alienated images play, as it were, on a theoretical level, and find their extremely cryptic expression in pictures that compel one to think.

This thought-provoking tendency is very evident in *The Giantess* (1929–1931), in which the shift in normal proportional relationships sheds doubt on our habits of perception. An enormous nude woman and a tiny man in a black suit confront each other in a bourgeois room. The literary counterpart to the picture story appears on the black field at the right. It is a poem in French, which translates "The Giantess. At times, when a bad yet merciful world cradles in its colors the vain hopes of your eyes, a giantess grows up in the midst of my life, in arrogant mask, disdaining your gods. Passing away only for me, her great body struggles for breath, languishing only to rise anew in a dark flame that disperses the hovering mists in her eyes. Forever striding through her limbs' glory I have ascended her powerful knee. Some-times in summer, when malign suns plunge her, the weary one, into my dreams, I sleep serenely in the shadow of her breast, with no other dream but that into which her dream submerges me."

▶ René Magritte
Presence of Mind,
1960
La présence d'esprit

Oil on canvas
116 x 89.5 cm

Loan from
a private collection

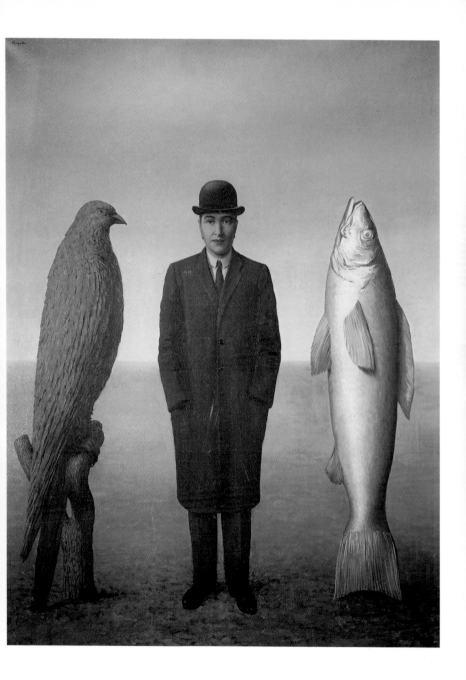

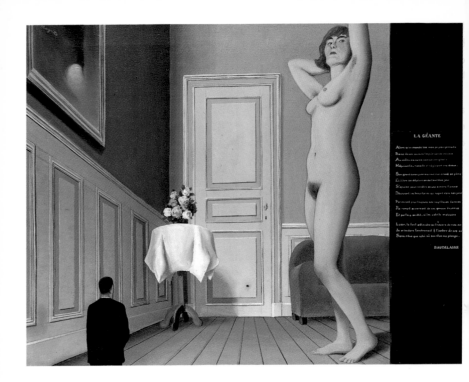

▲ René Magritte
The Giantess,
1929–1931
La géante

*Tempera on paper,
cardboard and canvas*
54 x 73 cm

The original text, from *Les Fleurs du Mal* by French poet Charles Baudelaire (1821–1867), has been considerably altered by Magritte. Though the imagery, sequence, and sonnet form conform largely to Baudelaire's, the words themselves are quite different. Apart from this example, Magritte is not known to have rewritten poetry or written poems of his own. But the idea of plagiarism played a key role in the Belgian Surrealist's approach. His friend, Paul Nougé, did a number of Baudelaire plagiarisms, and Magritte himself painted pseudo-Renoirs in the 1940s. The connection with Nougé is also evidenced by the fact that the model for *The Giantess* was not his own wife, Georgette, but, as old photographs indicate, Marthe Nougé.

Initially a painter, Aristide Maillol began working in sculpture shortly before 1900, when Auguste Rodin's style largely determined the taste of the day. Maillol's modest beginnings contained no indication of the key position he would soon assume as an antipode to Rodin.

After several applications were turned down, Maillol was finally accepted in 1885 into the Ecole des Beaux-Arts in Paris. In 1893 he entered the circle of the Nabis, followers of Gauguin, and began designing tapestries that were shown at exhibitions. In parallel Maillol did Symbolistic paintings, ceramic works, and a few figurines. After the turn of the century he turned entirely to sculpture, now practicing a style which recurred to the classical harmony of earlier periods. Maillol's works, which were initially recognized in Germany and only later in France, were first publicly exhibited after the First World War.

One of the artist's early works is *Female Standing Bather* (1900) in the Museum Ludwig, Cologne. It is characterized by an emphasis on the vertical, a simple, natural pose, and quiet, self-contained volumes. Maillol concentrates on pure, full form, developed from the masses of the figure in a tectonic, static sense. "I search for architecture and forms in space," Maillol once said. "Sculpture is architecture, the equilibrium of the masses is a dispensation of taste. This architectural aspect is difficult to achieve. I try to arrive at it in the way Polycleitus

Maillol, Aristide

1861 Banyuls-sur-Mer, France
1944 Banyuls-sur-Mer

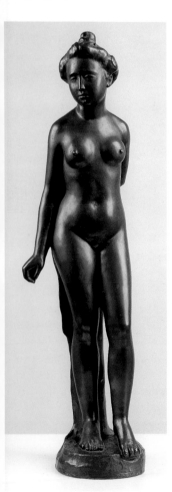

◄ Aristide Maillol
Female Standing
Bather, 1900
Baigneuse debout

Bronze
height 66 cm

Haubrich Donation,
1946

succeeded in doing. I always begin with a geometric shape – a rectangle, rhombus, triangle – because these are the forms which assert themselves best in space." Maillol's ideal was early Greek sculpture of the fifth century B.C. – the bronzes rather than the pieces in white marble.

In *Leda* (c. 1902) he dispensed with the swan in the myth and concentrated instead entirely on the expression and gesture of the girl, frightened and recoiling from the swan's advances. The head, turned aside and down, and the raised left hand are justified in their own right, quite apart from the subject depicted. They are purely expressive elements of a vital approach to the human body marked by a calculated tension between calm and motion, precise detail and self-contained volumes. Although his choice of motifs was limited – Maillol devoted himself almost exclusively to the female nude – the southern French sculptor revived the Mediterranean tradition in sculpture to new, pulsating life, and set his naturalism against the northern Frenchman Rodin's dissolution of the human form.

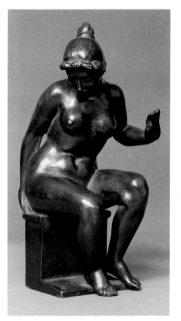

▼ **Aristide Maillol**
Leda, c. 1902

Bronze
height 28.5 cm

Haubrich Donation,
1946

The large sculpture *Ile de France* (1925) illustrates Maillol's style on the scale of life. It is the figure of a shapely young woman, depicted in the act of stepping forward. The surface texture is soft and flowing, and anatomical details are glossed over. The scarf the girl holds behind her back links the hands and arms, giving the impression of an unbreakable bond which counteracts the force of the torso, arched forward as tense as a drawn bow. The female figure is raised to the level of a type or ideal, the title, too, indicating an allegorical reference to femininity and Mother Earth. This sensuous country girl recalls the full-blooded women of Paul Gauguin, as well as the nudes painted and sculpted by Maillol's friend, Auguste Renoir, in his late period. Yet in Maillol the southern French type of female beauty predominated.

◀ **Aristide Maillol**
Ile de France, 1925

Bronze
height 166.5 cm

Donation of
Kunstverein
der Rheinlande,
Düsseldorf, 1954

Malevich, Kasimir

1878 Kiev, Russia
1935 Leningrad
(now St. Petersburg)

▼ Kasimir Malevich
The Wedding,
c. 1907

Watercolor,
ink and pencil
on paper
23 x 20 cm

Ludwig Collection

Containing 62 works (paintings, objects, watercolors, and drawings), the Kasimir Malevich collection in Cologne is one of the largest in the world outside Russia. It documents every phase in the development of his art over a period of about 30 years. *The Marriage*, a watercolor done around 1907, is among the earliest Malevich works in the Ludwig Collection. It compellingly illustrates the artist's Symbolist phase. Many elements derived from late-nineteenth-century French painting blend here with archaic imagery from rural life in Russia. Similarly, other works of the period, such as *Washerwoman, Golgotha*, and *Women Scything Grain*, contain motifs that refer, respectively, to Gustave Courbet, to Paul Gauguin, and to Russian church frescoes of the seventeenth century.

The correct dating of a number of Malevich's drawings and paintings has troubled art historians for over 20 years now. In many cases the opinions still vary considerably. The artist himself was partially responsible for the confusion, because he frequently predated his works. Some of those in the Ludwig Collection are cases in point, including one of Malevich's major paintings – *Landscape (Winter)*, which bears the date 1909. The stylized form of the trees, and especially the motif of the striding man, are indeed found in some drawings and paintings

of around 1910; however, the brushwork is generally softer than that of Malevich's "Primitivist" pictures of 1910–1912. The composition, with its horizontally overlapping shapes that lead the eye from the foreground into the depths, is likewise unusual for the early period, being more characteristic of that around 1930.

Malevich's Cubist phase of the year 1913 is exemplified by an important sketch for the painting *Lady at a Streetcar Stop* (Stedelijk Museum, Amsterdam). The significance of this sketch lies in its abundance of details

► **Kasimir Malevich**
Landscape (Winter),
1909 or after 1927

Oil on canvas
48.5 x 54 cm

Ludwig Collection

which were not included in the painting. Spirals, ramps, and angles seem to evoke a diagram of endless traffic arteries. In the final version, the only remaining reference to a streetcar stop is a sign bearing streetcar numbers. *Suprematist Composition* was shown at the legendary "Last Futurist Picture Exhibition 0.10," held in 1915 in Petrograd. It was one of the works with which Malevich surprised the public by revealing for the first time the new direction in art he had developed alone in his studio – Suprematism.

 A high point in the collection is the canvas *Dynamic Suprematism No. 57* of 1916. Malevich selected it for one of the lithographs in his book *Suprematism – 34 Drawings* (Vitebsk, 1920), which illustrated the evolution of his idea in key examples. "By Suprematism," the artist explained, "I understand the supremacy of pure sensibility in visual art." Suprematism was inspired by the new scientific theory of matter as consisting of energy. Beneath the world of objects we perceive, thought Malevich, existed a primal state, that of energy, which must now be made visible through art. In *Red Square on Black* (c. 1922), the square,

► **Kasimir Malevich**
Head, c. 1930

*Colored pencil and
pencil on paper
35.8 x 22.5 cm*

Ludwig Collection

►► **Kasimir Malevich**
Figure with
Arms Spread,
Forming a Cross,
1933

*Pencil on paper
36 x 22.5 cm*

Ludwig Collection

► **Kasimir Malevich**
Cabaret, 1930

*Pencil on paper
19.2 x 13.7 cm*

Ludwig Collection

►► **Kasimir Malevich**
Suprematism,
c. 1914–1915

*Pencil on paper
16.5 x 11.1 cm*

Ludwig Collection

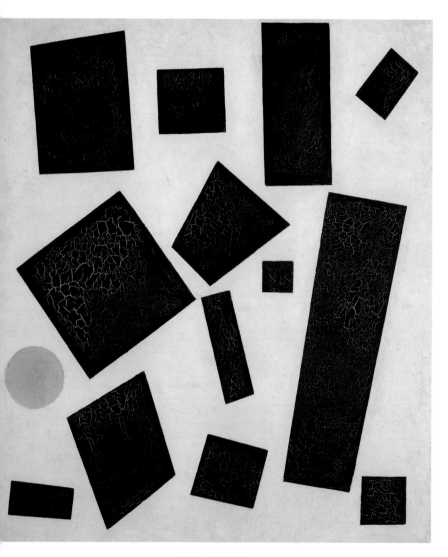

▲ **Kasimir Malevich**
Suprematist
Composition, 1915

Oil on canvas
70 x 60 cm

Ludwig Collection

primal symbol of Suprematism, appears as a luminous, concentrated pigment mass against a black field suggesting ineffable space. As in all of Malevich's other pictures, no mathematics or precise calculations have been used in the composition. The square stands free on the plane, and only at first glance does it seem symmetrically placed; actually, it is shifted a few centimeters to the right. *Suprematism* is one of a series of drawings done between 1914–1915 and the mid-1920s in which a great range of possibilities and variations of Suprematist composition were tested.

Malevich's late work has come in for a reappraisal in recent years. Much in it should be understood symbolically. The drawing *Cabaret* of 1930 belongs to a group of works in which the artist varied the cross form as a symbol of the martyrdom suffered by "the innocent and insignificant of this world."

In the colored-pencil drawing *Head* (c. 1930) a cross has replaced the facial features. Towards the end of his life Malevich expressed the wish to be buried with outspread arms, giving his body the form of a crucifix (according to Marcadé). Although this wish could not be fulfilled, the idea lives on in the sketch *Figure with Outspread Arms*, done in 1933.

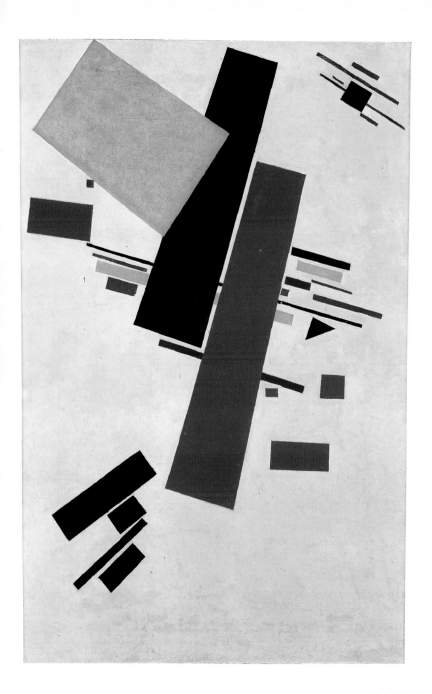

◄ **Alfred Manessier**
The Fire, 1957
Le feu

Oil on canvas
80.5 x 100 cm

Manessier, Alfred

1911 Saint-Ouen,
France
1993 Orléans

The religiously inspired abstract art of French painter Alfred Manessier has made him a leading representative of the Ecole de Paris. After studying architecture in 1929 at the Ecole des Beaux-Arts in Paris, Manessier went in 1935 to the Académie Ranson, where he was a pupil of Roger Bissière.

During the 1930s Manessier's art was strongly influenced by Cubism and Surrealism, but in 1943 he began to paint in an entirely abstract manner. His compositions, usually based on religious ideas, are characterized by mosaic-like patterns and luminous colors, which made him one of the major ecclesiastical artists of the postwar period. In 1948 he designed his first stained-glass windows, followed the year after by his first tapestries. The link with stained glass is quite obvious in a picture such as *The Fire* of 1957. The composition of brilliant, flickering colors seems to hover, held in check by a heavy black grid. Although the title may suggest the skeleton of a building caught in a conflagration, many other associations are possible, as is the case with the other paintings in the small group of works done in 1956–1957, which likewise are dominated by black, grid-like structures and for the most part treat religiously oriented themes.

Pavel Mansurov was passionately interested in music and musical themes. His painting *The Wedding* (c. 1920–1923) relates to a folk song which Igor Stravinsky used in his choral composition *Svadyebka* (The Wedding). Composed from 1914 to 1919 in Switzerland, the work treats the theme of a Russian peasant wedding, employing the forms of old, epic ballads which were sung in Russia from the eleventh century down to the revolution.

Russian artists and composers in particular continued to revere popular art of this kind. Like the tradition of icons and popular illustrated broadsheets, the ancient songs seemed to them to express the inexhaustible spirit of the people, and they turned to them as a source of new vitality for Russian art. The wedding song *Svadyebka*, which inspired Stravinsky's composition, contains both deeply religious and secular motifs. The choral work with instrumental music and Russian dance scenes was premiered in Paris in 1923, in stage sets designed by Natalia Goncharova.

Mansurov, Pavel

1896 St. Petersburg, Russia

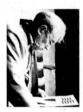

1984 Paris

In his picture Mansurov included a traditional text of the wedding song, which contains Old Slavic phrases. Like Stravinsky, Mansurov was concerned to combine ancient Russian with modern elements, in an attempt to infuse traditional forms with new, creative imagination. The interlocking shapes in gradations of strong color, arranged on a narrow, vertical format which was characteristic of Mansurov's art at this period, make the image into an extremely compelling example of Russian art in the 1920s.

◄ **Pavel Mansurov**
The Wedding,
c. 1920–1923

Oil on wood
135 x 57 cm

Ludwig Collection

◀ **Piero Manzoni**
Achrome, 1960

*Sewn fabric,
lightly primed*
80 x 60 cm

Ludwig Donation,
1976

Manzoni, Piero

1933 Soncino, Italy
1963 Milan

Despite the shortness of his life, Italian artist Piero Manzoni left
a considerable body of work behind. Influenced to some extent by
Yves Klein's monochrome blue paintings, he began in 1957 to produce
Achromes, a series of "colorless" – actually white – textured canvases.
But in contrast to Klein's striving to express the universal, Manzoni
attempted to make paintings without referential character or symbolic
value.

The painting in the Museum Ludwig, Cologne, belongs to the
series described above, which emerged between 1957 and 1962.
A subgroup within the series was formed by Manzoni's *Sewing Machine
Pictures*, in which the sole compositional element was a grid of seams
produced by sewing together squares of canvas which had been primed
with glue and white paint. The idea and the significance of achromy
in painting was explained by Manzoni in an essay of 1959, titled
Free Dimension. "The totality of space, infinity, is monochrome; or even
better, achrome," he wrote. "White is not a feeling, or a symbol of any-
thing else. A white surface is a white surface, and that says everything:
Existence."

Giacomo Manzù was born in 1908 as the twelfth child of a shoemaker. He led a committed life, which included both fighting with the Italian Resistance movement during World War II and contacts with representatives of the Catholic Church in its aftermath. Manzù's œuvre cannot be classified in terms of any particular style. His realistic sculptures treat both Christian and secular themes, and they continue the classical tradition which is still very much alive in Italy, while combining it with influences from the Impressionism of Auguste Rodin or Medardo Rosso.

The subject of the *Cardinal* intrigued Manzù for years. It went back to his arrival in Rome in 1934, when he attended a papal audience.

Manzù, Giacomo

1908 Bergamo, Italy
1991 Rome

The sight of the Pope seated on his throne, flanked by two cardinals, reminded Manzù of the rituals and ceremonies he had witnessed as a boy. By 1949 the motif had become a key part of his repertoire. Manzù gave no individual features to the heads of the cardinals he depicted, intending them to represent, as he said, "not the majesty of the Church, but the majesty of form." In other words, the figures had something of a still-life character in his eyes, and he accordingly simplified, abstracted, and raised them to monumental status. The picturesque ornament and rustling movement of a cardinal's robes were translated into an unbroken plastic volume, a conical form extending upwards to and including the mitre. The crossed hands and the sharply modelled face emerge as the sole details from the self-contained volume of the figure.

◄ Giacomo Manzù
Standing Cardinal,
1949–1951

Bronze
height 172 cm

Marc, Franz

1880 Munich
1916 Verdun, France

► **Franz Marc**
Wild Boars, 1913
Wildschweine

Oil on canvas,
mounted on
cardboard
73.5 x 57.5 cm

Gift of Autohaus
Fleischhauer, 1954

▼ **Franz Marc**
Three Deer
at a Spring, 1911

Charcoal, ink and
white tempera on
cardboard
41 x 49.5 cm

Haubrich Donation,
1946

"My goals do not lie in the special area of animal painting. I am looking for a good, pure, and lucid style, in which at least a part of what modern painters will have to tell me can completely enter... I see no more promising means to 'animalize art' than the animal picture." These remarks, written by Franz Marc in 1910, stood at the beginning of a stylistic transition, marking a changeover from depictions from the natural model to an approach to design that would overcome the egocentric standpoint and relativize the objective world. Marc now began to try to understand the natural environment, in particular the animal world, through empathy. This would help him to go beneath subjective appearances to discover a "sense of the organic rhythms of all things." In addition to "essential color" – that is, not the natural colors of things but the colors suited to expressing their essence – the category of "rhythm" was to become a central focus of his art.

In 1911 Franz Marc and Wassily Kandinsky founded an artists' group they called Der Blaue Reiter (The Blue Rider). All of the artists who belonged to the group or who exhibited with them (Alexei von Javlensky, Paul Klee, Gabriele Münter, August Macke) believed in the idea of pure color and form as expressions of the spirit of nature.

Cattle and *Wild Boars* (both 1913) mark the apex of Marc's artistic development. "All of my effort is devoted to becoming insightful, to giving every color and form that occurs in the picture an inner, unprovable necessity," he wrote in 1911. Marc built up his imagery according to clear compositional principles, such as the circles very much in evidence in the sketch *Three Deer at a Spring. Cattle* is dominated by arc-shaped and elliptical lines, which are inter-sected and set off by rectilinear elements. The outlines of the animals are integrated in this rhythmical pattern, and in the passages of vibrant color that extend across and beyond their forms. The *Wild Boars* (also known as *Boar and Sow*) show an even greater degree of abstraction, their bodies having been trans-

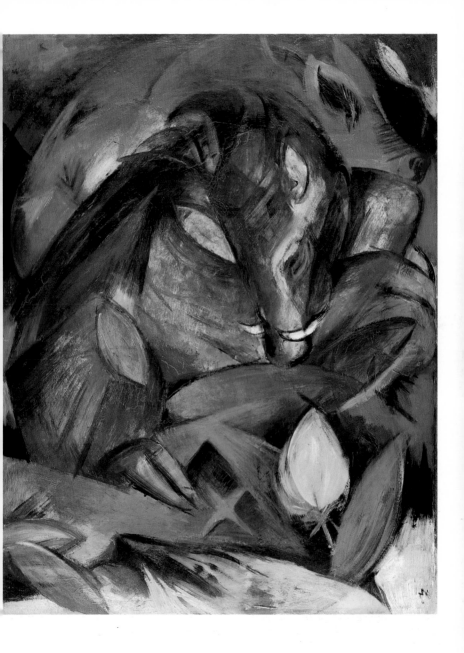

lated into a rotating, spiral movement. The color, applied in facetted shapes, develops from the green of the vegetation in the foreground, to the blue of the animals' bodies, to the reddish-browns in the upper half of the picture, each passage overlapping the next and serving to link the separate elements of the composition.

This facetting of the composition reveals the influence of Robert Delaunay, whom Marc and Macke visited in Paris in 1912, as well as that of French Cubism and Italian Futurism. In 1914 and 1915 this tendency led to well-nigh abstract compositions in which objective reference was almost entirely waived in favor of the expressive values of pure form and color.

As Marc wrote in 1912/1913, "Things speak: things contain will and form. Why should we want to interrupt them?... Everything is one; space and time, color and form, are only ways of seeing things which emerge from the mortal structure of our minds — space is our mental projection of being — time is an equation of being into which we introduce the concept of 'the present' as an imaginary value."

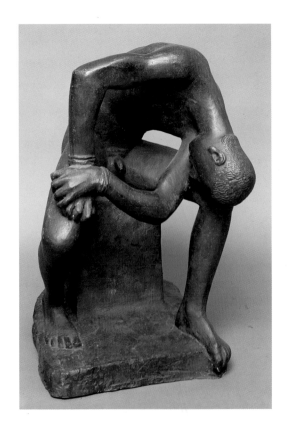

▶ **Gerhard Marcks**
Prometheus
Bound II, 1948
Gefesselter
Prometheus II

Bronze
78 x 51 x 44 cm

In post-World War II Germany, Gerhard Marcks' sculptures – figures, portraits, nudes, and animals – came to represent the quintessence of a modern sculpture derived from the classical tradition. Marcks was asked to teach at the Bauhaus by Walter Gropius in 1919. But he soon left the school when its emphasis on technology, industrial art, and mass culture assumed too much importance in his eyes. After an initial involvement with Expressionism, a trip to Greece in 1928 brought a decisive change in his style. Early Greek sculpture in particular seemed to him to embody the heritage of European culture and time-less form. This, however, did not save Marcks from persecution at the hands of the Nazis as a "degenerate artist."

His *Prometheus Bound II* of 1948 shows the direct influence of a sculptural tradition based on antique Greek models. A first, plaster

**Marcks,
Gerhard**

1889 Berlin
1981 Burgbrohl, Eifel

version of the *Prometheus* was done in 1943, but it was destroyed that same year when the artist's Berlin studio was struck by a bomb. After the war, Marcks returned to the motif of the young man in fetters, which had concerned him ever since he received news of the death of his son in Russia. Numerous design sketches and model studies ensued. He tried to repeat the destroyed sculpture, again in plaster, titling it *Prometheus Bound I*, but then rejected it. In 1948, finally, he addressed the theme once again, on a larger scale. In the resulting figure, Marcks' attempt to come to terms with the horrors of the war years, the sense of suffering is extremely strong. Like the Greek hero who rebelled against the dispensations of the gods, this human being seems helpless in the face of his adversaries, his head sunken in despair on his knee. The compelling force of the composition derives largely from the space enclosed by the figure, in which his inmost feelings and fears seem to be contained.

Marden, Brice

1938 Bronxville,
New York
Lives in New York

American painter Brice Marden studied from 1958 to 1961 at the Boston University School of Fine and Applied Arts, and from 1961 to 1963 at the Yale University School of Art and Architecture in New Haven.

In a further development of Color-field Painting, Marden began a series of monochrome paintings in the mid-1960s which were usually composed of several color fields combined into a single work. Due to the use of encaustic – hot wax – the surfaces of the canvases have a matte appearance, not reflecting light, as the artist explains, but apparently both absorbing light and simultaneously emitting it.

Marden's *Humiliatio* belongs to a sequence of five works done in 1978 and collectively known as *Annunciations*. These are variations on a religious theme, and relate to a fifteenth-century sermon of Fra Caracciolo da Lecce, an Italian friar who describes the successive reactions of the Virgin Mary as she hears the glad tidings from the Angel Gabriel: *Conturbatio* (confusion, anxiety), *Cogitatio* (thoughtfulness, wonder), *Interrogatio* (questioning), *Humiliatio* (humiliation, submission), and *Meritatio* (worthiness). The paintings are all horizontal in format and consist of four monochrome fields, two narrow and two double their width. The color value of these images suffused

with spiritual innocence is blue throughout, Mary's color. By varying
the sequence of bands, Marden achieves an effect in keeping with
the emotions described above. In *Humiliatio* the sequence of bluish-
white, bluish-black, ultramarine, and bluish-green corresponds to a
2:1:2:1 ratio.

In the mid-1980s Marden began to turn away from this rigorous
monochrome approach and introduced into the color fields sweeping
lines that spread across the canvases like networks and were inspired
by Far Eastern calligraphy.

▲ **Brice Marden**
Humiliatio, 1978

*Oil and encaustic
on canvas*
213 x 244 cm

Ludwig Donation,
1994

de Maria, Walter

1935 Albany, California
Lives in New York

Walter de Maria, who established his reputation with Earth Works and Minimal sculptures, has been a leading representative of Minimal and Land Art since the 1970s. His *Vertical Earth Kilometer* at the 1977 Documenta VI in Kassel attracted international attention. De Maria started making wooden objects in the early 1960s, including the wood version of *Statue for John Cage*. The happening-like performances of the American composer and his involvement with Zen Buddhism were to take on prime importance for de Maria's work. By 1965 the increasing interest of collectors had enabled the artist to execute metal versions of existing or planned sculptures in wood.

The floor sculpture *Pentagon*, dating from 1973–1974, belongs to the series 5 *Through* 9, and consists of five geometric figures from pentagon to nonagon. The sequence of forms shows a progression in the number of sides, yet their dimensions remain the same. Instead of being represented by a closed metal volume, the basic geometric shapes are open at the top, forming a kind of canal or track for balls made of the same, shiny metal. The balls are loose and can roll, be set in motion, which counteracts the effect of a rigid, definitive form, and engenders a mental tension, a perceptual irritation. The visibility of the static, hard-edged body is partially obscured by the spherical body and its potential movement. The balls can be set in motion by the viewer, yet there is little sense of play involved. Rather, one's participation in the sculpture tends to become a quiet, concentrated activity, indeed almost an act of meditation. The question why the artist should have begun with a pentagon is easily answered, for after addressing the absolute and basic "symbols of civilization" – circle, square, and triangle – in earlier groups of works, de Maria went on to the polygons. These geometric figures go back to numbers which are freighted with historical, religious and cultural values. But they also represent established principles of order, being self-enclosed and self-contained – the ball runs along a closed, endless, and endlessly repetitive track.

▶ Walter de Maria
Pentagon
(5 Through 9),
1973–1974

Polished aluminum with aluminum balls Five parts, 121 cm diameter each

Marini, Marino

1901 Pistoia, Italy
1980 Forte dei Marmi

▶ **Marino Marini**
Rider, 1947

Bronze
97 x 38 x 68 cm

▼ **Marino Marini**
Lamenting Horse,
1950

Bronze
52 x 28.5 x 38.5 cm

Haubrich Collection

Horse and rider is a theme with an ancient iconographical tradition in art, and Marino Marini's treatment of it established his international reputation in the postwar period. Yet the Italian sculptor neither celebrated a hero's victory on the model of Marcus Aurelius, nor did he transform the horse into a kind of legendary beast, in the manner of Odilon Redon, Pablo Picasso, or Giorgio de Chirico. Marini wished to express a tragedy, the collapse of the unity of rider and horse, man and nature.

Aesthetically, *Rider* of 1947 in the Museum Ludwig, Cologne, was influenced by the austere style of Etruscan tombs and archaic Roman sculptures. Yet it, too, shows an equilibrium gone awry. "If you look at my rider statues of the past twelve years one after the other," Marini explained, "you will notice that the rider is progressively less able to control his horse, and that the animal grows ever more petrified by fear rather than rearing up. I believe – and I am deadly serious about this – that we are approaching the end of a world... My rider statues express the anxiety caused by the events of my epoch." The noble and mythical equestrian monument dissolves into fear-stricken man and horse, a tragic symbol of a world in jeopardy.

The tectonic, pyramidal composition of *Lamenting Horse* of 1950 leads the eye inexorably to the animal's head. Its anatomy has been only summarily suggested. The process of working is still very much evident in the marks of the sculptor's fingers on the surface. *Lamenting Horse* is a compelling symbol of the "scream of the tormented creature."

Marisol

(Marisol Escobar)

1930 Paris
Lives in New York

Although Marisol's playfully ironic figurative imagery is related
to Pop Art, her approach is a great deal more critical of society.
Marisol was profoundly influenced by the painting of her teacher,
Hans Hofmann, but also by the work of Jasper Johns and Robert
Rauschenberg. Her sculptural works clearly reveal an admiration of
Pre-Columbian art – Mexican cultic masks and other aspects of the
culture of the ancient Americas. Her life-sized figurative assemblages,
which often resemble three-dimensional pictures or posed photographs,
are lent a high degree of realism by the integration of mundane, every-
day objects in the design.

Marisol herself is frequently present in her works, as in the assem-
blage *The Visit* (1964), where she has depicted herself in the seated
figure at the left. The gentle sarcasm of this dubious family idyll is
quite evident. The stiff pose of the three ladies, their impersonal facial
expressions, and the little girl, relegated to the margin of the group
and, as it were, stuffed into a barrel, all indicate a total lack of inter-
personal communication.

► **Albert Marquet**
Bou Regreg, Rabat,
1935

Oil on canvas
50 x 61 cm

After finishing his studies in Paris, Albert Marquet set out, in 1897, on a series of journeys that took him, among other places, to North Africa, Egypt, and Russia. In 1905 he exhibited at the Salon d'Automne in Paris alongside the Fauves. Although he was a friend of Henri Matisse, whom he had met back in 1900, when they both worked on decorations for the World Fair in the Grand Palais, Marquet increasingly diverged from Matisse's Fauvist directness in the use of form and color.

The view of the harbor town of Rabat was painted in 1935, when the artist again travelled in Morocco. The key difference between Marquet's style and Fauvism, as clearly seen in *Bou Regreg, Rabat*, is his Impressionist treatment of light and atmosphere. The houses on the harbor are bathed in brilliant light; water and landscape alike emanate an intense brightness. Although the composition is expansive and open, it is still a great deal more differentiated and finely articulated than Marquet's earlier landscapes, which were based on an orchestration of luminous color planes. The vantage point is high, providing a panoramic view over the roofs of the blocky, interlocking houses in the foreground, to the harbor, docks and ships on the Bou Regreg River, and the distant strip of land that shimmers in the mists on the horizon.

Marquet, Albert

1875 Bordeaux
1947 Paris

Masson, André

1896 Balagny, Oise
1987 Paris

The depiction of violence was a key theme for the Surrealists, and it played a great role in the work of André Masson. While serving in the army during the First World War he had been wounded in an air raid, and left behind helpless in a bomb crater. This first-hand experience of physical violence and suffering contributed to Masson's belief that all men were mutual enemies. The idea gripped him to the point of obsession, and he attempted to come to terms with it in his art. In 1922 Masson moved to Paris, where he joined the avant-garde circles around Daniel-Henry Kahnweiler, Joan Miró, Michel Leiris, Antonin Artaud, André Breton, and Pablo Picasso.

In Masson's work the memory of the merciless carnage of war is generally evoked and embodied by animals. For *Horses Devouring Birds* (1927) the artist chose a narrow, vertical format, then applied a light, warm ground on which he spontaneously inscribed rhythmic lines – "Before you paint your picture, dance it!" Masson once exclaimed. The heavy strokes were allowed to taper into hair-thin marks, which in turn were anchored in the composition by colored shapes in matte red and green. Then Masson added the "eyes," and finally pasted birds' feathers onto the canvas, to conjure up a poignant image in the viewer's mind.

The year 1927 saw Masson paint a series of pictures in which fish, horses, and birds were locked in combat – creatures of water, earth and air, figures in a new and disquieting myth of the elements. Involved in a kind of permanent metamorphosis, the creatures blur into one another in a play of continuous movement, then suddenly reappear – the contours of a horse's head, a bird, eyes large and small – only to vanish again. Fragmentary actions and suggestions of objects materialize and disappear. The result, quite in contrast to the subject itself, is imagery of an extreme grace, graphic elegance, and sophisticated nuances of color. The pictures were created in a trancelike state, and, in accordance with Masson's artistic credo, with "energy, not brutality," for in his eyes, there could be no great art without *délicatesse*. For Masson, the moment when life and death meet was a moment of eruption, when the individual physical life returned to a state of amorphousness, as expressed in the bodily parts scattered across his canvases. Masson's passionate imagery recalls the Surrealist doctrine that "Beauty will be convulsive, or it will not be at all."

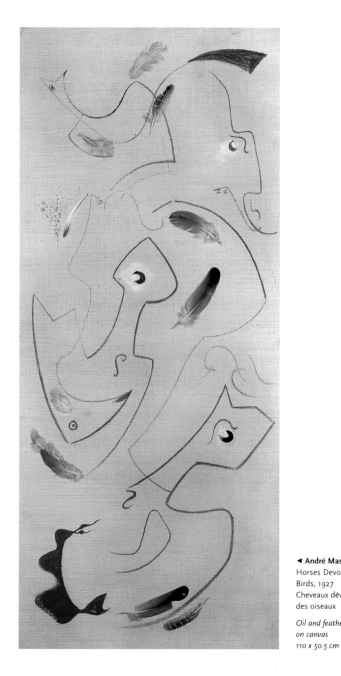

◄ **André Masson**
Horses Devouring
Birds, 1927
Cheveaux dévorant
des oiseaux

*Oil and feathers
on canvas*
110 x 50.5 cm

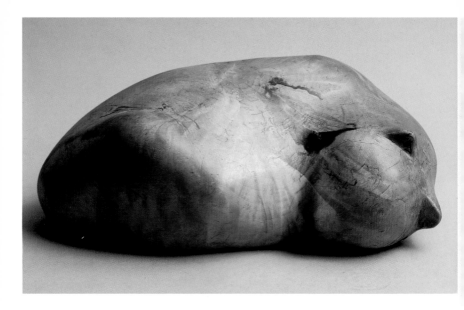

Mataré, Ewald

1887 Aachen,
Germany
1965 Büderich,
Düsseldorf

▲▲ Ewald Mataré
Sleeping Cat, 1929
Schlafende Katze

*Poplar wood
height 16 cm*

Haubrich Donation,
1946

It was not until 1922, after he had completed a training in painting
in Aachen and Berlin, that Ewald Mataré began to devote himself
to sculpture. While in Berlin, in 1918, he had joined the November-
gruppe, and thus become acquainted with the revolutionary avant-
garde tendencies of the day. The focus of his sculptural work, which
resists classification in terms of style, was on depictions of animals,
done through the end of the 1940s.

The body of *Sleeping Cat* (1929) has been reduced to rounded,
self-contained volumes which, rather than reflecting the characteristics
of any individual animal, were intended to embody the cat in essence,
its archetype, as it were. In carving the piece Mataré paid special
attention to the given structure and grain of the wood. The surface
was worked in the direction of anatomical growth, and all visible traces
of the knife were carefully expunged. Mataré's early pieces emerged
after trips to the German coast and through northeastern Europe,
where he found pieces of driftwood, shaped and scoured by water
and sand, that inspired him to make his first plastic works.

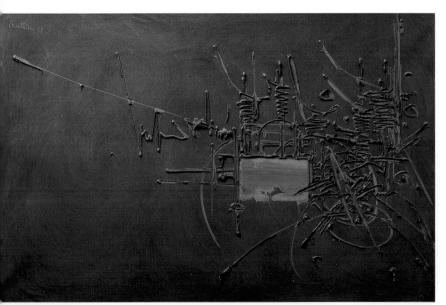

French painter Georges Mathieu is one of the leading representatives, and a co-founder, of Tachisme, a European tendency akin to American Action Painting. He began painting at the age of twenty-one, after desultory studies in law and philosophy.

Mathieu's philosophical interests were reflected in a phenomenology of the act of painting, into which he introduced the factors of speed and improvisation. He set up the following guidelines for himself: "I. The main thing is the speed of painting. II. Neither forms nor gestures must be predetermined or preconsidered. III. ... The artist must create something new, and not repeat what is familiar. Speed and improvisation represent the seminal forms of the new painting, in addition to liberated and direct music like jazz, and Oriental calligraphies ... Speed and improvisation imply a concentration of mental energies and, at the same time, a state of absolute emptiness."

Mathieu also concerned himself with Far Eastern painting and philosophy. His canvas *Dâna* (1958), the only monochrome blue painting in his œuvre, is part of a series which were designated by names from the Hinduist and Buddhist religions. Dâna is "the woman who gives," an allegory of charity to the begging holy man.

Mathieu, Georges

1921 Boulogne-sur-Mer, France
Lives in Paris

▲▲ **Georges Mathieu**
Dâna, 1958

Oil on canvas
65 x 100 cm

Haubrich Collection

▲ **Henri Matisse**
Seated Girl, c. 1909
Jeune fille assise

Oil on canvas
41.5 x 33.5 cm

The small Fauvist picture *Seated Girl* was painted in 1909, as Henri Matisse was gradually beginning to receive public recognition. After law studies and attendance at the Académie Julian and the Ecole des Beaux-Arts in Paris, Matisse was initially influenced by Impressionism and Post-Impressionism.

Matisse, Henri

1869 Le-Cateau-Cambrésis, France
1954 Cimiez,
near Nice

He broke away from these models in 1905, during one of his many sojourns on the Mediterranean. "In Collioure," Matisse recorded, "I began to concern myself with a theory, or fixed idea, of Vuillard's, the absolute application of color… This helped me very much, because I had a definite idea about the colors of an object. I put my first color down on the canvas, then a second one next to it, and then, instead of taking it away again if it did not seem to conform with the first, I added a third color that agreed with both. That went on until I had the feeling of having achieved a perfect harmony in my picture." The first Fauvist paintings, shown in 1905 at the Salon des Indépendants, caused an outcry of derision, but they also attracted the attention of collectors and critics, one of whom invented the label Fauves (Savages, or Wild Beasts).

Our painting of a girl sitting to the artist illustrates the Fauves' intention to cleanse motifs of content and reduce them to pure form – pure line, pure color, pure plane. This maxim, formulated by Matisse as the "wildest" of the Fauves, is put into practice here. Almost no attention seems to be paid to characterizing the space, the textures of materials, the atmosphere, the direction of the light source, or characteristic traits of the figure. The work is ornamental to an unusual degree; the corporeality of the seated figure is hardly suggested by the forms and colors, which exist for their own sakes. As this implies, the colors themselves are given the task of defining the pictorial space, something Matisse admired in the work of Vincent van Gogh and Paul Cézanne especially. The expansive planes of color in *Seated Girl* serve to lend stability to the composition.

In the course of his later development Matisse began to dispense with certain of these Fauvist features. Agitated brushwork and the visible marks it left gradually disappeared from the color fields and contours. Matisse began to juxtapose great planes of homogeneous color, frequently accented by continuous, ornamental arabesques of line, and accompanied by compositional elements of an increasingly geometric character.

▲ **Henri Matisse**
Women and
Monkeys, 1952
Femmes et singes

*Paper collage,
gouache, pencil*
71.7 x 286.2 cm

Ludwig Collection

In addition to painting and printmaking, the artist now turned to other techniques, such as sculpture, glass-painting, wall decorations, and designs in applied art. During the late phase of his career, Matisse also experimented with paper cutouts. A representative example of this series is the collage *Women and Monkeys* (1952). Although Matisse had earlier designed paintings with the aid of cutouts, it was not until 1943 to 1950 that the technique developed into an autonomous art form. Taking large sheets of white paper, Matisse covered them with colored gouache, then cut various shapes out of the paper and arranged and pasted them on a white ground. "The cutout enables me to draw in color," Matisse remarked. "It represents a simplification for me. Instead of drawing a contour and filling it in with color – whereby the one alters the other – I draw directly in color... This simplification guarantees a precise merger of the two means, which become one. I by no means recommend this form of expression for the purpose of practice. It is a result, not a point of departure. It is predicated on infinite subtlety and long experience." Matisse called this method "drawing with the scissors."

The resulting compositions are airy, graceful, delightful and sublime at once. Originally *Women and Monkeys* was designed for Matisse's room at the Hotel Regina in Nice. It was much smaller in format, consisting only of the seated female figures and pomegranates. Later,

when Matisse executed the large frieze *The Swimming Pool*, he altered
the present composition with an eye to hanging it above the door of
his room. He added the two monkeys at left and right, and also altered
the female nudes and the number and arrangement of the pome-
granates – a symbol of fertility, love and immorality since antiquity.
In order to lend rhythm to the composition, Matisse also changed the
position of the arms and legs, making them describe an ornamental,
wavy movement.

The highly abstracted figurative symbols of these cutouts – female
nudes, fruit, flowers, exotic birds, dancers, acrobats, and sirens –
emerged from an imaginative realm in which heaven and earth merge
and time seems to stand still. In 1952, the year in which *Women and
Monkeys* was done, the artist summed up his achievement by saying,
"I have arrived at a form distilled to the essence, and of the object,
which I earlier depicted in the fullness of its volume, I retain only
a sign." *Women and Monkeys* is a work from the artist's final years
in which an earthly paradise full of happiness and *joie de vivre* is evoked
with sublime insouciance.

**Matiushin,
Mikhail**

1861 Nishniy
Novgorod
(now Gorkiy),
Russia
1934 Leningrad
(now St. Petersburg)

Mikhail Matiushin was a versatile man, not only painting but composing music, writing, publishing, and teaching. He was very much attached to his younger colleague, Kasimir Malevich, and in 1915 published, under his own name, Malevich's book *From Cubism and Futurism to Suprematism*. Artistically, however, the two went separate ways. Matiushin focussed on nature, the development of its forms and colors, and the laws of organic growth. He endeavored to understand and depict the essence of the organic realm, and with it, the universal design.

Matiushin's special relationship to nature is very much in evidence in *Dunes: The Baltic Coast*, done in about 1910. One has the impression that the picture is actually a slice of the environment, as if its elements – color, surface texture, and lineature – had emerged analogously to natural phenomena. A musical element as well is subtly present, in the waves rhythmically breaking on the shore, whose rhythm continues into the dunes.

Self-Portrait "Crystal", a composition of 1917, is based on a crystalline form bounded by six rhombuses, which resembles a head in shape. The rendering of the facets and the refracted, many-hued light lends the self-portrait a extreme degree of abstraction.

The canvas *Color Chart* was reproduced along with texts by the artist in a 1932 portfolio titled *Principles of the Changes in Color Combinations, a Reference Work on Color*, which addressed the use of color in architecture, textile design, porcelain painting, and the printing industry.

▶ **Mikhail
Matiushin**
Self-Portrait
"Crystal", 1917

*Oil on canvas
69 x 37.5 cm*

Ludwig Collection

► **Mikhail Matiushin**
Dunes: The Baltic Coast, c. 1910

Oil on canvas on wood
45 x 61 cm

Ludwig Collection

◄ **Mikhail Matiushin**
Color Chart, 1926

Oil on canvas
29 x 33 cm

Ludwig Collection

◄ **Matta**
Nude in an
Ensemble, 1965
Nu d'ensemble

Oil on canvas
156 x 200 cm

Matta
(Roberto Sebastian
Antonio Matta
Echaurren)

1911 Santiago
de Chile
Lives in Paris and
Tarquinia

A South American representative of the Surrealist movement, Matta
initially studied architecture and worked for a time in the office of
Le Corbusier. It was his acquaintance with the Paris Surrealists that
finally decided him to devote himself to painting.

Right from the very beginning Matta's work has reflected a pro-
found vision: that man is one with the universe, that microcosm and
macrocosm are identical. Developing his own personal version of
Surrealist automatism, Matta projected his conception of space into
evocatively atmospheric imagery that veritably swarmed with abstract
forms.

Under the influence of World War II the artist began to lend his
work an additional, political dimension, by introducing the human
figure into his cosmic landscapes. The vegetative-crystalline idiom of
the early period made way for an anthropomorphic-technological one,
leading to a demoniacal vision of a utopian future, a highly stylized
version of contemporary technological civilization. As in *Nude in an
Ensemble*, the human figures were subjected to divergent stresses
which reflected actual social and personal conditions. We feel that
they must mount resistance if they are to survive the incessant tests
imposed on them in Matta's multiperspective spaces.

Wolfgang Mattheuer long played a significant role in the official East German art scene. His work was also appreciated and recognized in West Germany after it was shown at the 1977 documenta VI in Kassel. Mattheuer's intelligent art is marked both by precision of thought and by a visual idiom based on solid objectivity. An emphasis on contour and line – graphic qualities, in a word – is something he has retained throughout his career, and in every medium in which he has worked.

Mattheuer, Wolfgang

1927 Reichenbach, Vogtland, Germany
Lives in Leipzig

In the course of the 1960s certain fundamental motifs began to crystallize in Mattheuer's art – landscapes, automobiles, roads, expanses of sky above a low horizon, human figures, masks. The ancient theme of the mask occurred in both paintings and sculptures, as seen here in *Man with Mask* in the Museum Ludwig, Cologne. "Citizen Everyman with a sheep's mask," H. Schönemann has called the figure. The artist's wife, Ursula Mattheuer-Neustädt, gave the following description in 1971: "He removes his mask… inhibited, insecure in terms of attitude, the expression on his face, yes, even his clothing – but showing incipient resistance in the clenched fist of his right arm pressed tightly to his body. Resistance to his own fear, to the compulsion he had previously submitted to; but fear of what, compulsion exerted by whom? The piece remains silent on this point; it evokes fear in general, compulsion in general."

◄ **Wolfgang Mattheuer**
Man with Mask, 1971
Mann mit Maske

Plaster, painted
64 x 17 x 17 cm

Ludwig Donation, 1994

◄ **Ludwig Meidner**
Portrait of the Poet
Ernst Wilhelm Lotz,
1914
Bildnis des Dichters
Ernst Wilhelm Lotz

Pencil
38.6 x 33.6 cm

Meidner, Ludwig

1884 Bernstadt, Silesia, Germany
1966 Darmstadt

Ludwig Meidner was a painter, printmaker and writer who began in an Expressionist style which would gradually take on increasingly realistic traits. It was in Berlin, on the eve of the First World War, that Meidner's main themes emerged – apocalyptic cityscapes, prophetic figures, and above all, compelling portraits. The approximately 150 portraits and self-portraits in oil and on paper done between 1905 and 1916 reveal Meidner's irrepressible urge to penetrate the mysteries of the human soul, others' and his own.

The artist concerned himself not only with the expressionistic evocation of extreme mental states. He was also a master of facial features, with a keen eye for the typical in his sitter. The *Portrait of the Poet Ernst Wilhelm Lotz* depicts an author who is today entirely forgotten. He was a friend of Meidner, who not only portrayed him but described him verbally in a very personal way: "What a vibrant fountain! His nervous poet's body caromed around our flats like a burning torch. That small sandpiper's head, the very narrow eyes, sharply incised as cracks in a wall, and all overlain by a childlike candidness."

Carlo Mense's early work was influenced by Post-Impressionism and Fauvism, but his breakthrough came with the Expressionistic paintings he began to exhibit in 1912. After his return from the First World War, Mense adopted the cool, objectively recording style known as Magic Realism, in which his finest work would be produced. Before the war and in the early 1920s he frequently spent periods in Munich. It was there that he joined with Georg Schrimpf, Alexander Kanoldt, and Heinrich Maria Davringhausen to form a faction within the Neue Secession, devoted to countering the crassly veristic tendencies of the Neue Sachlichkeit (New Objectivity) by emphasizing a more poetic approach to subject matter. At this period Mense focussed especially on portraiture. Mutual portrayal was a common practice among the artists of the Neue Sachlichkeit, who used it to test their own and their friends' position.

In his 1922 *Portrait of H.M. Davringhausen*, Mense depicts his colleague – like him, of upper-middle-class origin – in dapper street attire, against the background of a rather depressing suburban street in Munich. The neoclassical elements in the picture probably go back to the influence of Italian Pittura Metafisica and to Mense's contacts with the *Valori plastici* group, which whom he exhibited in Milan in 1922. The austerely graphic, stiff and cool style of rendering, particu-

larly obvious in the way the half-figure is placed like a foil against the background, reflects the unsentimental standpoint of many early-1920s artists, who concentrated on capturing, as accurately as they could, the *plastic values* in the sur-rounding reality.

Mense, Carlo

1886 Rheine, Germany

1965 Bad Honnef

◄ **Carlo Mense**
Portrait of H. M. Davringhausen, 1922

Oil on canvas
86.5 x 59.5 cm

Haubrich Donation, 1946

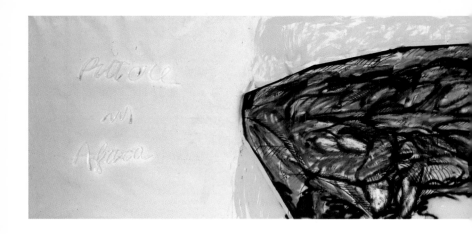

Merz, Mario

1925 Milan, Italy
Lives in Turin

After an initial phase of more or less traditional painterly techniques, Mario Merz began in the mid-1960s to use existing or reworked materials, such as soil, brushwood, glass, and neon tubing. He became one of the major proponents of Arte Povera, an Italian movement devoted to revealing the complexity and creative potential contained in ordinary things. At first Merz was primarily interested in emphasizing the contrast between natural and man-made materials, but with time, his work began to move on a symbolic level. He launched into an investigation of the fundamental structures engendered by a confrontation between natural principles, such as those expressed in the numerical growth series of mathematics, and culturally developed artifacts, such as writing. The ethical goal of Merz's art was to inspire the viewer to link the two symbolic levels in a humanly-oriented way, and so to have an effect on his life.

But the artist's ambition went even farther. As Merz wrote in 1981, "Our standpoint at the end of the present century consists in reaccepting absolutely all of the earlier, great myths of mankind. I am convinced that with these great myths, imagination too will reenter [our lives] with a vengeance." Merz believes in the necessity of struggle – but not, like the Dadaists, with destruction in mind. He is out to reinstate things in their rightful place, to make order, or, as he himself said in 1984, "I want to put the things back in" to art, and our lives.

The relationship of humans to nature, and to culture, is also addressed in *Painter in Africa*. The glass and neon sign stand for products

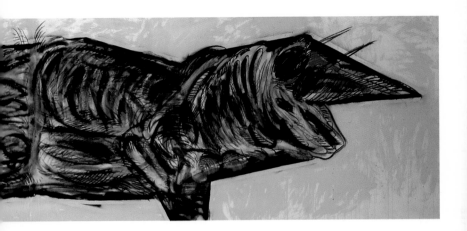

of human civilization; the fabric image represents vegetable forms which are connected by a kind of umbilical cord to the head of a man. The spatial extension of the leaf-like motif alludes to the creative forces of nature. Merz employs symbolic models to convey his message: the necessity of renewing the disturbed relationship between man and environment. Since the artist considers non-Western cultures an ideal in terms of this integration, his interest focusses on the artistic traditions of Africa, Asia and Australia.

The neon tubing superimposed on the image creates an interesting contrast, which Merz describes as "like two eras intersecting." "I want to introduce electricity into the New Landscape of today," he stated in 1981. The way in which the plantlike forms proliferate across the picture recalls the artist's involvement with the organic, symmetrical organization of the numerical series invented by Leonardo Fibonacci, a medieval mathematician. "Mario Merz shapes the present by turning back to the past and rethinking it, in order to propagate the rediscovery of elementary imagination," wrote Dieter Ronte.

▲ **Mario Merz**
Painter in Africa,
c. 1981
Pittore in Africa

Dispersion and
oil on canvas,
neon tubes
240 x 260 cm

Gift of
Dr. Reiner Speck,
1995

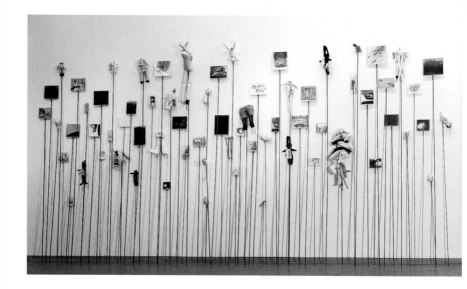

Messager, Annette

1943 Berck, France
Lives in France

Since the early 1970s Annette Messager has been one of the most significant contemporary artists in France. She evokes a world of obsessions, a very personal world expressed through art of an extremely complex and radical nature.

A key feature of her art is the combination of banal, ordinary things. *The Pikes* of 1992 is one of a series of works of the same title. The piece in the Museum Ludwig, Cologne, consists of 68 pikes, or spears, 47 drawings, and 26 dolls. The handmade dolls are attached to the spears, whose points rest against the wall. The dolls are reminiscent of folk art, as if taken from votive images intended to give protection against the dangers of everyday life. The artist's œuvre is concerned with the human body, with love and desire. She denounces the way in which the female body has been fetishized, and speaks of the hidden feelings which many women suppress out of a sense of shame.

▲ Annette Messager
The Pikes, 1992
Les piques

68 pikes, 47 drawings,
26 handmade dolls
Dimensions variable

Loan of
Friends of the
Wallraf-Richartz
Museum and
Museum Ludwig,
Cologne

Messager's art emerges from intimate personal experience, lending visual form to a marginal realm, a covert world which almost always remains outside the bounds of culture. She employs photography as one means of exploring the enigmatic depths of the unconscious mind, the fantasies of waking dreams, the physical details of our bodies that we prefer not to see.

After a series of *Tube Paintings*, Rune Mields arrived in the 1970s at an abstract approach based on mathematical systems, whose sequences she recorded in predominantly large-format, multipartite canvases.

Concerning the Color White is one of nine works from the series *Concerning Color*, which dates from 1984. Each of the works is devoted to exploring the numerous and diverse designations given to a particular color. "The colors in use in the German-speaking countries over the past two centuries were collected and classified according to color and number of color names," Mields explains. "The resulting nine most important colors were recorded on nine paintings, all of the same height, but differing in width depending on the frequency of designations."

A characteristic feature of the artist's entire œuvre is a categorical waiver of the colors of the spectrum. Even in paintings devoted to these colors Mields employs only black and white, and gradations of these, explaining that bright colors had such a strong intrinsic value that they were "simply not suitable for my purposes."

The format of the works is determined by the number of names existing for a certain color. Thus *Concerning the Color White*, like its counterpart *Concerning the Color Black*, is a narrow vertical format, while other colors, whose pigments and shades are more diverse and their names thus more numerous, require broader fields to list them on. Reading the color names calls forth a range of associations in the viewer's mind (e.g., White Nothingness, White Earth, Cologne White).

The basic intention of the image is to represent an order discovered within an existing order by the artist herself.

Mields, Rune

1935 Münster
Lives in Cologne

Weißes Nichts Kölnerweiß Bleiweiß Charltonweiß Atlasweiß Federweiß Birkenweiß Tirolerweiß Pariserweiß Berlinerweiß Wolframsaurerbaryt Blanc fixe Sulfobleiweiß Blankasit Neuweiß Griffithweiß Brillantweiß Clichyweiß Marmorweiß Deckweiß Permanentweiß Klagenfurterweiß Edelweiß Dyckerhoffweiß Ewigweiß Englischweiß Elkadur Emulsionsweiß Elfenbeinweiß Durablanc Glanzweiß Schwefelzinkweiß Holländerweiß Hamburgerweiß Kremserweiß Kreide Echtweiß Meudonerweiß Lilienweiß Asbestweiß Naturweiß Metallweiß Kremnitzerweiß Bologneserkreide Malerweiß Lithopone Manganweiß Mineralweiß Druckweiß Milchweiß Alfaweiß Meißnerweiß Bakolaweiß Bariumsulfatweiß Pergamentweiß Kalkweiß Silikatweiß Amianthweiß Schneeweiß Wienerweiß Mischweiß Spatweiß Diamantweiß Zinkblumen Antimonweiß Champagnerkreide Schieferweiß Schwefelweiß Ponolith Thenardsweiß Steinweiß Silberweiß Titanweiß Ulmerweiß Spanischweiß Neuburgerkreide Französischweiß Perlweiß Blanc de Troyes Lackweiß Zinnweiß Farboxyd Venetianerweiß Wismutweiß Zinkweiß Dänischweiß Transparentweiß Magnesiaweiß Barytweiß Lithoweiß Wolframweiß Zementweiß Alabasterweiß Pariser Kreide Chinesischweiß Puppenweiß Pattinsonbleiweiß Genueserweiß Schlohweiß Albinitweiß Orleanweiß Fleur de Neige Ölweiß Weiße Erde

◄ **Rune Mields**
Concerning the
Color White, 1984
Über die Farbe Weiss

Aquatec on canvas
200 x 95 cm

Miró, Joan

1893 Barcelona, Spain
1983 Palma
de Mallorca

Catalonian painter Joan Miró, one of the great pioneers of modern art, came to painting by a circuitous route. His ancestors were peasants and artisans, and his father was a goldsmith.

Miró began drawing at a young age, as a way to escape the strictures of family life. His choice of motifs – tufts of grass, insects, tiny birds – revealed an early affinity for the organic, a love, as one commentator says, of "the little things" of this world. After finishing his military service Miró worked in an office, and attended crafts courses in his spare time. "I was a paragon of awkwardness," he confessed. In painting, too, judged by academic standards, Miró was entirely unsuccessful. "I was very unhappy," he wrote, "and in my feeling of rebellion, I became an ever greater dreamer." It was as such that he was to go down in the history of art, as a teller of lyrical and fabulous tales whose pictorial idiom was shaped out of allusive signs and symbols derived from subconscious depths.

In 1919 Miró travelled to Paris, where he met Pablo Picasso and made friends with him. From 1920 onwards he participated in Dadaist manifestations and became a close friend of André Masson, who lived in the next studio. This period saw Miró consciously attempting to forget the principles of art he had been taught, or, as he himself put it, "to kill painting." He became involved in Surrealism, adding to it his own, inimitable touch of playful humor. One aesthetic source of Miró's new approach, as Bonnefoy notes, lay in "the paintings and sculptures of archaic cultures, which do not seek similarities, but rather in which symbol and metaphor form the essence of the work."

Love belongs to a group of works of 1925–1927, collectively referred to as "dream paintings," which were done in Paris after Miró's stylistic breakthrough in 1923–1924. The artist himself described the picture as follows: "It is a work that I love very much, and which caused me a great deal of worry, because I thought it had been lost... The idea for the painting came during my Christmas holidays in Barcelona, as I was watching a dancer – the vertical, upward line and the circles describe her movements. In a notebook I had in my pocket I drew a few rapid sketches, which I developed after my return to Paris in the Rue Blomet" (the address of Miró's studio at the time).

▶ Joan Miró
Love, 1926
Amour

Oil on canvas
146 x 114 cm

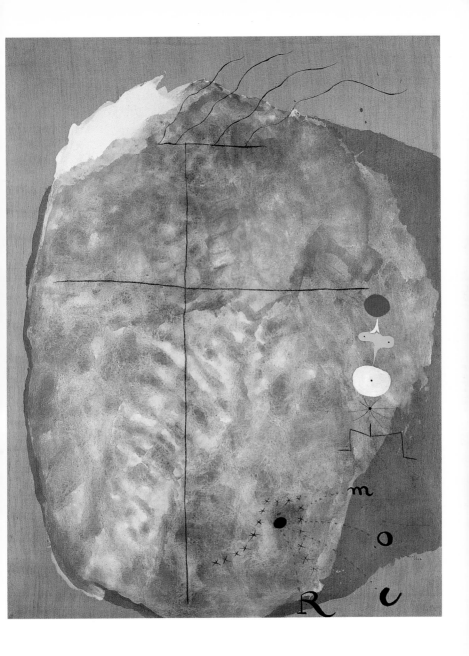

Modersohn-Becker, Paula

1876 Dresden
1907 Worpswede

In 1897 Paula Becker became acquainted with a group of artists working in the northern German village of Worpswede. A year later she moved there herself. In 1901 she married Otto Modersohn, a landscape painter and member of the artists' colony. The painting *Landscape in Worpswede*, which shows a strong influence of her husband's style, is a good example of the "lyrical approach to nature," developed out of Art Nouveau, for which Worpswede became known. With a restrained stylization of natural forms and a delicate heightening of colors, Modersohn-Becker evokes that poetic mood which the moors and heaths surrounding the village instilled in the artists who worked there.

Yet the artist soon abandoned and went beyond this atmospherically evocative style. After 1900 she travelled several times to Paris, where she studied the work of Millet and van Gogh, whose expressive colors fascinated her. But her great ideal became Cézanne, and the simplicity and lucidity of his form. Her diary note, "Striving for the greatest simplicity while observing most intimately, that is greatness," also applies to her own Worpswede paintings after her from Paris. The smooth

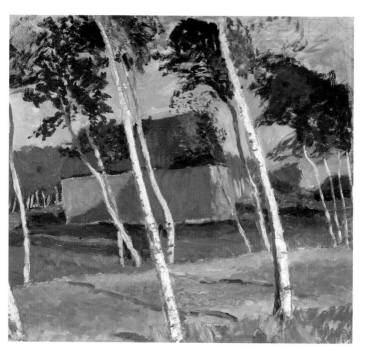

◄ Paula
Modersohn-Becker
Landscape in
Worpswede, c. 1900
Worpsweder
Landschaft

Oil on painting board
61.5 x 67.8 cm

Haubrich Collection

► **Paula
Modersohn-Becker**
Self-Portrait, 1906
Selbstbildnis

*Oil on cardboard
45.7 x 29.7 cm*

Haubrich Collection

finish of her earlier pictures was replaced, as the artist herself noted, by a "heavy impasto" colors molded with sensuous force.

In the 1906 *Self-Portrait* the composition is imbued with great vitality by using a small number of simplified color-forms. The facial features, too, are reduced to their essential form. The almost monumental austerity of contour corresponds to the unpretentious, straightforward palette. Unlike the perhaps rather sentimental stylization seen in the early, lyrical landscapes, the stylization found in the artist's later works embodies the result of a deeply serious artistic quest. By inquiring into the fundamental forms of the things around her, Modersohn-Becker succeeded in laying bare their essence.

Italian painter, draughtsman and sculptor Amedeo Modigliani studied painting in Livorno (1898) and at the academies in Florence (1902) and Venice (1903). In 1906 he went to Paris, where, apart from stays in Livorno (1909–1910) and Nice (1918), he was active for the rest of his short life. Modigliani made the acquaintance in Paris of many artists and men of letters, including Pablo Picasso, Guillaume Apollinaire, Max Jacob, Jacques Lipchitz, and Chaïm Soutine.

In 1909 he became the friend of Constantin Brancusi, who encouraged Modigliani to try his hand at sculpture. The result was a series of archaic heads, busts and caryatids carved in stone, which revealed the influence of Brancusi and the interest in primitive cultures Modigliani shared in common with him.

In painting, devoting himself almost exclusively to nudes and portraits, Modigliani had brought his original style to full fruition by about 1914. Even the paintings of his final years, nearly without exception, continued to reflect the clarity and simplicity of his early sculptural œuvre; occasionally the lucid oval of the faces even recalled Brancusi's *Slumbering Muse* (1909–1910). Modigliani's figures, with their typically elongated bodies and elongated, slightly inclined heads with almond-shaped eyes, were surrounded by an aura of lyrical melancholy.

Modigliani suffered from ill health and spent his entire life in straightened circumstances. He found his models on the streets, and among his bohemian friends. The exotic beauty of the young Algerian woman portrayed here, whose name was Almaisa, so fascinated Modigliani that he painted her two more times: in a seated pose, visible to the knees, clad in a black dress and white blouse, necklace, and long earrings; and as a reclining nude wearing only a necklace. By comparison to these two other portraits, that in the Museum Ludwig, Cologne, brings the face into the middle of the picture, and into a close-up view. The model wears the same black dress, white blouse, and jewellery as in the knee-length portrait, and in both, a framed picture is visible in the background. Despite the abstraction of the facial features which was characteristic of Modigliani, the physiognomic individuality of the young Arab woman with her large eyes, sensuous mouth, and short-cropped hair is unmistakably conveyed.

Modigliani, Amedeo

1884 Livorno, Italy
1920 Paris

◄ **Amedeo Modigliani**
Woman of Algiers, 1917
L' Algérienne

Oil on canvas
55 x 30 cm

Moholy-Nagy, László

1895 Bácsborsod,
Hungary
1946 Chicago,
Illinois

▼ László
Moholy-Nagy
Grey-Black-Blue,
1920

*Collage on
brownish paper*
70.6 x 50.2 cm

Haubrich Collection

László Moholy-Nagy initially studied law in Budapest. After being treated in a field hospital during World War I, he began to devote himself to drawing. In 1919 he moved to Berlin, where he became intensively involved with the work of the Russian Constructivists living there, especially Kasimir Malevich and El Lissitzky. In 1923 he was given a teaching post at the Bauhaus in Weimar.

Moholy-Nagy was an artist who explored in many fields. He experimented with new techniques in photography and cinematography, created "light machines" and kinetic objects. His *Telephone* paintings, executed according to directions given over the phone, caused a sensation in 1922.

The collage *Grey-Black-Blue* of 1920 belongs to a group of such works which served the artist as sketches for drawings and paintings. On close view, the colored bands can be seen to be not painted or drawn but, in most cases, cut out of paper or foil and pasted to the ground. Not that Moholy-Nagy was particularly interested in using materials previously foreign to art, however. The paper strips, slightly shifted this way and that, helped him to find exactly the "right" composition.

From 1921 onwards the artist occupied himself with the problem of light in painting, and the associated transparent effects of colors. In his 1923 painting *On White Ground* the elements of his innovative "painting in light" are clearly evident – a dynamic interplay of translucent and opaque abstract shapes that relies strongly on the effects of diagonals. The earlier collage, in contrast, is still based on an entirely rectilinear geometry.

▲ **László Moholy-Nagy**
On White Ground,
1923

Oil on canvas
101 x 80.5 cm

Mondrian, Piet

1872 Amersfoort, Holland

1944 New York

In 1912, when Piet Mondrian arrived in Paris, the art of Pablo Picasso and Georges Braque was just entering a phase of increasing emphasis on structure. Mondrian took this Synthetic Cubist scaffolding and reduced it to a division of the canvas surface into planes, rendered in a limited range of color modulations. Mondrian's favorite motif, the tree, gradually developed into an abstract network of lines. Following this process to its logical end, the artist finally dispensed with objective reference altogether, and developed a painting in which form was completely autonomous.

Tableau I is one of the works which marked the culmination, in 1921, of Mondrian's search for an abstract, geometric, "plastic" style. From that point onwards the artist progressively reduced his palette to pure, unmixed primary colors – blue, red and yellow, bounded by lines in the non-colors black, grey and white. The linear framework began to change as well, the black bands growing wider and, in some cases, ending at a point just adjacent to the canvas edge. All this might suggest that Mondrian followed some stringent, mathematical scheme, but this was not so. He worked intuitively, letting the composition take shape as he worked at the easel. The final composition, with its equilibrium of colors and planes, developed in a process of trial and error on the painting surface itself.

In 1917, together with Theo van Doesburg, Mondrian founded a group called De Stijl, which set itself the task of developing an art of Neo-Plasticism. What this implied was a renewal of art on a broad scale, a new, abstract approach to design that extended even to architecture. Mondrian's understanding of the adjective "plastic" differed from its use in sculpture. He meant by it not design in three dimensions but "an aesthetic relationship depicted with precision," as he said. And Mondrian associated the creation of carefully balanced design with the ethical goal of exerting a positive effect on people's lives. Horizontals, verticals, right angles, and primary colors were intended to embody a universal harmony. In his attempts to express this harmony, Mondrian paradoxically resorted, in the wake of *Tableau I*, to ever more complex compositions, in which the black lines were rendered in parallel pairs which formed a dense, gridlike framework.

▶ Piet Mondrian
Tableau I, 1921

Oil on canvas
96.5 x 60.5 cm

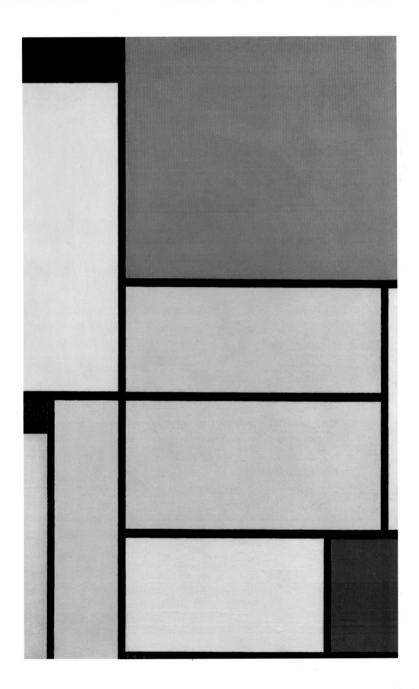

Moore, Henry

1898 Castleford,
Yorkshire, England
1986 Much Hadham,
Hertfordshire

▲▲ Henry Moore
Draped Reclining
Figure, 1952–1953

Bronze
102 x 152 cm

The beginnings of Henry Moore's sculptural work, in the 1920s, were marked by diverse influences. As early as 1922 he made mother and child groups whose simplicity and self-contained volumes recalled Pre-Columbian art. Then came elongated, columnar torsos which revealed the influence of Constantin Brancusi. Moore's first reclining figures – with mother and child, a leading theme that would preoccupy him throughout his career – emerged in 1927.

During the Second World War, Moore served as a war artist, making drawings in air-raid shelters and coal mines. His war experiences were also apparently the source of the small sculpture *Warrior with Shield* of 1952–1953. It all began with a pebble found on the beach that reminded him of a leg amputated at the hip, Moore recalled in 1972. This led to the idea of the warrior, similarly to the way in which, as Leonardo wrote in his sketchbooks, a painter could find a battle scene in the lichen growing on a wall. Moore added the body, leg and one arm, he recorded, and there was his wounded warrior – which at this point was still a reclining figure. Two days later he added a shield and changed the pose to a seated one, altering the passive figure into one of a man who

though wounded, was still challenging. The head showed a dull, steer-like force, Moore wrote, but at the same time an animal-like patience in enduring suffering. Possibly the figure, as one critic suggested, had some connection with his feelings and thoughts about England during the critical first phase of World War II, the artist concluded. At any rate it was his first individual male figure, and, as he said, it amounted almost to the discovery of a new theme when executed on its final, large scale.

Among Moore's major innovations was the integration of hollows and concavities – negative volumes – in the organic, sculptural volumes of the figure. In an interplay of such material and immaterial volumes Moore discovered new aesthetic qualities. This treatment of space had already become apparent in the *Family Group*, although in this case the negative volume remains limited to the hollow of the seat.

Manifold spatial relationships are developed among the figures: The parents sit at right angles to one another; one child stands in

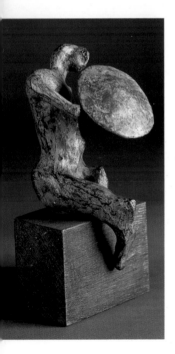

its mother's lap and turns to face her, while the other is associated with the father, but turns to look at the viewer. The gestures and glances of the parents describe just the opposite direction, the man turning towards the woman, who in turn faces the viewer. Since the piece is a preliminary study, its surface texture is accordingly rough and unfinished in character.

The drawing *Studies for a Reclining Figure* is actually not a study in the sense of a sketch, but a carefully executed and time-consuming drawing that has almost the character of a painting. Yet the pen and ink contouring and hatching leave

◄ **Henry Moore**
Warrior with Shield,
1952–1953

*Bronze
height 18 cm*

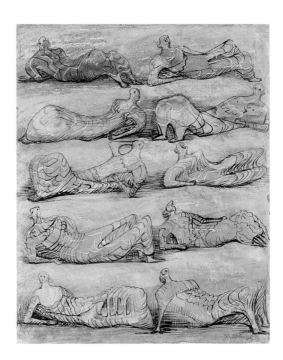

◄ **Henry Moore**
Studies for a
Reclining Figure,
1949

*Pen and ink,
watercolor, gouache,
oil crayon and pencil
29 x 24.2 cm*

no doubt of the basically graphic nature of the work. The contrast
between the two principal colors, grey and cadmium orange, calls up
the sense of cool, heavy stone resting on sun-warmed clay.

In *Draped Reclining Figure* (1952–1953), the surface treatment plays
an important role in the overall effect. The figure is clad in a garment
resembling a Hellenistic toga that clings to the body like a second skin,
forming sharp folds. By comparison to the treatment of the naked skin,
which is rough-textured and reveals marks of the sculptor's tools,
the garment has a crimped texture that is partially ornamental and
partially resembles a network of veins. As so often, Moore does not
dispense with the observation of the tiniest details in his environment.
Sometimes one even has the impression – despite his almost exclusive
limitation to the human figure – that the swelling forms of his sculp-
tures represent microscopic landscapes translated into monumental
dimensions.

► **Giorgio Morandi**
Still Life, 1921

Oil on canvas
44.7 x 52.8 cm

Loan of
VAF-Foundation,
Switzerland

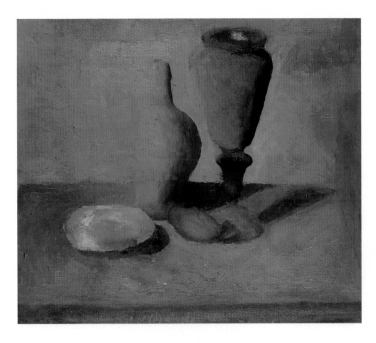

When he painted this *Still Life* in 1921, Giorgio Morandi had arrived at turning point in his career. In the early 1920s he had retired from public life and had begun depicting little else than bottles, vases, and jugs, a concentration that would shape his life's work. Ending an intensive involvement with the avant-garde movements of the day, Cubism and Metaphysical Painting, Morandi developed his own very personal and lyrical style. In *Still Life* we already see the classical harmony of form, richly nuanced, subdued and, as it were, melancholy colors, and the tone-in-tone gradations that were to characterize Morandi's entire œuvre. The predominant terracotta hue and the classical amphora are reminiscences of Greek and Roman art. The amphora itself seems almost absorbed into the background, as its contours blur and the colors merge. Morandi's reserved and sensitive works, in which time seems to stand still, made a great impression on his colleague Giorgio de Chirico, who praised Morandi's ability to infuse everyday objects with a sense of magic and eternity.

**Morandi,
Giorgio**

1890 Bologna, Italy
1964 Grizzana,
near Bologna

◄ **Malcolm Morley**
St. John's Yellow
Pages, 1971

Oil on canvas,
electric bell
159 x 137 cm

Ludwig Donation,
1976

Morley,
Malcolm

1931 London
Lives in New York

Malcolm Morley attended the Royal College of Art in London concur-
rently with the young artists who were to launch English Pop Art.
Then he went to New York, where he developed a style that might be
characterized as Proto-Photorealism. This involved not only reproduc-
ing photographs in paint on canvas – usually motifs from advertising
brochures, telephone book covers, or postcards – but an integration
of real objects in the picture. In *St. John's Yellow Pages* (1971), for
instance, a real doorbell merges with the painted image. The two sailing
ships with their tangle of masts and rigging, the water and sky, are all
rendered in nervous flecks of impasto paint that lend the whole an
agitated, opalescent appearance. A further aspect of visual irritation
is introduced by the double frame – the edges of the image do not
coincide with the edges of the canvas. Morley's intention was to show
us that perception and the definition of painted reality are ambiguous
things. In an interview concerning a similar picture, he once said that
painting was a way of losing oneself, of losing one's self-confidence.
The idea, said Morley, was that we cannot hope to possess a definitive
visual image of anything.

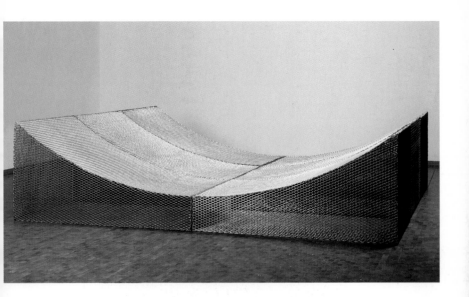

The sculptor Robert Morris attended the Kansas City Art Institute and the University of Kansas City from 1948 to 1950. After spending the year 1951 at the California School of Fine Arts in San Francisco, he continued his studies from 1953 to 1955 at Reed College in Portland, Oregon. Morris soon proved to be one of the most versatile artists of his generation.

In 1964 he began a series of sculptures in the vein of Minimal Art, one of which was the six-part piece *Untitled* of 1968. In this key phase of his œuvre Morris created three-dimensional geometric objects using diverse materials, such as metal or plastic, plexiglass and fiberglass, and even strips of felt suspended from wall or ceiling. The reinforced wire mesh employed in the work illustrated here offered Morris the opportunity to describe physical volumes arranged in a serial manner in space, and at the same time to exploit the transparency of the surface to develop interior volumes.

His involvement with the factor of space eventually led Morris, in the late 1960s, to begin working in the medium of Land Art.

Morris, Robert

1931 Kansas City,
Kansas/Missouri
Lives in New York

▲ **Robert Morris**
Untitled, 1968

*Aluminum wire
mesh, six parts*
92.5 x 360 x 360 cm

Ludwig Donation,
1976

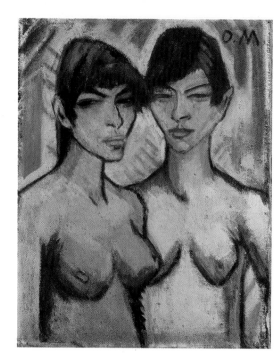

◄ **Otto Mueller**
Two Nude Girls,
c. 1919
Zwei Mädchenakte

Distemper on burlap
87.5 x 70.6 cm

Haubrich Donation,
1946

► **Otto Mueller**
Two Gypsy Women
with a Cat,
1926–1927
Zwei Zigeunerinnen
mit Katze

Oil on canvas
144.5 x 109.5 cm

Haubrich Collection

Mueller, Otto

1874 Liebau, Riesen-
gebirge, Germany
1930 Breslau

Inspired by the rough surfaces of ancient Egyptian paintings, Otto
Mueller used the medium of distemper on heavy canvas, and some-
times even ordinary burlap. This gave his colors a matte, subdued
character, and lent the paintings a flat, fresco-like effect. Although
Mueller is counted among the Expressionists, he differed from them
to the extent that instead of passionate emotion he strived for a harmo-
nious simplicity of form, balanced color schemes, and flowing contours.
Yet like the artists of Die Brücke, with whom he joined forces in 1910,
Mueller aimed at expressing a sensibility and love of life that tran-
scended all social conventions.

His preference for gypsy motifs went back to impressions gained
during his travels in Dalmatia, Hungary and Romania. Despite the
simplicity of a painting like *Gypsy Hut with Goat* (c. 1925), the delicate
violet tone of the walls evokes an intimate, homey atmosphere. In the
two women conversing in the doorway, and the goat lying quietly in
front of the house, Mueller has captured moments of the kind that
go to make up a humble but happy life.

◄ **Otto Mueller**
Gypsy Hut with
Goat, c. 1925
Zigeunerhütte
mit Ziege

Distemper on canvas
115.5 x 90 cm

Haubrich Donation,
1946

► **Otto Mueller**
Nude Girl on a Sofa,
c. 1921–1923
Mädchenakt
auf dem Sofa

Black and colored
crayons on ivory
paper
62 x 47 cm

Haubrich Donation,
1946

The canvas *Two Gypsy Women with a Cat* (1926–1927) provides
a view of an interior, where two women at a table gaze straight out at
the viewer. Behind them, a cat sits on the window ledge, silhouetted
against the light outside. The women's facial expressions are almost
identical to those of the *Two Nude Girls* (c. 1919), indicating the artist's
reduction of the female face to a typical scheme: lozenge-shaped head
with angular contours, dark hair and narrow eyes, a strong linear
emphasis on eyebrows, bridge of the nose, and lips.

Like Paul Gauguin's escape to the South Pacific, Mueller's involve-
ment with the gypsy world was an attempt to break out of a constrict-
ing middle-class life with its conventions and hidebound values. His
devotion to an outcast social minority in Europe led the Nazis, after
his death, to confiscate 357 of his paintings as "degenerate."

Nauman, Bruce

1941 Fort Wayne,
Indiana
Lives in Pasadena,
California

▼ Bruce Nauman
Plaster Cast Based
on Neon Templates,
1966

Plaster, gold paint
185 x 26 x 25 cm

Ludwig Collection

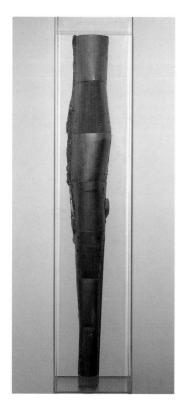

Bruce Nauman concerns himself with an investigation and trans-
formation of the inner logic of sensory perceptions. Inspired by
contemporary philosophical theories, he attempts to introduce contra-
dictions into completely closed systems. To this end he employs a
great diversity of media: photographs, holograms, audio and video
tapes, performances, books, plaster casts, and neon-light sculptures.
Nauman's significance for American art has often been compared
to that of Joseph Beuys for the art of the European continent. Nauman
originally studied mathematics at the University of Wisconsin, Madison,
before turning to painting, which he studied with Italo Scanga.

In the late 1960s Bruce Nauman made a plaster cast of the ear of his
friend H. C. Westermann, a sculptor and painter. Adding a length of
rope, he then produced a convoluted configuration aimed at investigat-
ing the affinities between the shape of the human ear and the twists
and loops of a rope.

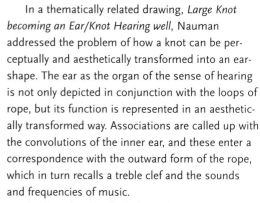

In a thematically related drawing, *Large Knot
becoming an Ear/Knot Hearing well*, Nauman
addressed the problem of how a knot can be per-
ceptually and aesthetically transformed into an ear-
shape. The ear as the organ of the sense of hearing
is not only depicted in conjunction with the loops of
rope, but its function is represented in an aesthetic-
ally transformed way. Associations are called up with
the convolutions of the inner ear, and these enter a
correspondence with the outward form of the rope,
which in turn recalls a treble clef and the sounds
and frequencies of music.

On the other hand, the looped rope in *Wester-
mann's Ear* could be read as the vague outlines of a
human head in profile, to which a cast ear has been
attached. This would make the piece a portrait of
Westermann, characterized as an open-minded man
who remains receptive to impulses from every side,
and who has the rare gift of being a good listener.
As an artist with an ability to integrate innovative
ideas in his imaginative conceptions, Westermann
in fact had a great influence on Nauman. This form
of portrait recalls Dadaist or Surrealist thinking

◄ **Bruce Nauman**
Westermann's Ear,
1967–1968

*Plaster, paint,
fiberglass rope
length of rope 450 cm*

Ludwig Donation,
1976

games, and it also reflects Nauman's interest in Marcel Duchamp's earnestly playful employment of objects and ideas. To his own way of thinking, Nauman's entire œuvre represents an open-ended experiment with forms as objects, or with object as persons, and with the things that happen to someone in various situations.

Plaster Cast on Neon Templates (1966) emerged from the early phase of Nauman's work in sculpture, which Franz Meyer has described as "communication through riddles." The artist began by making plaster casts of heads, other parts of the body, or objects of various kinds. Some of these casts were then developed into fiberglass sculptures, such as one of stairs tipped up into a vertical position. Others were not manifested as a visual repetition, but were given presence by means of a sculptural representation of the surrounding space, for instance, the space under a chair, as defined by its legs and seat. Positive form became negative form, or vice versa, depending on the viewpoint of the spectator. Nauman concerns himself little with the traditional artist's role. Being an artist, he says, is a matter of lifestyle, because you can decide every day what you want to do. Free will and flexibility are essential conditions for the making of art in his eyes. And the process of making must always remain visible, for all to see.

Nay, Ernst Wilhelm

1902 Berlin
1968 Cologne

▼ **Ernst Wilhelm Nay**
Jacob's Ladder, 1946
Die Jakobsleiter

Oil on canvas
96 x 81 cm

Donation of
Günther and Carola
Peill, 1976

Art historian Werner Haftmann once described his friend, Ernst Wilhelm Nay, as one of the "most significant coloristic talents" in contemporary art. Nay was a master student of Carl Hofer at the Berlin Art Academy from 1925 to 1928. His early work was in a figurative vein that combined influences from the German Expressionism of Ernst Ludwig Kirchner and Emil Nolde with the Cubism of Juan Gris.

Writing about *White Steer* of 1934, one of Nay's many mythical depictions of animals, Haftmann noted a "transformation of the animal configuration as seen in nature into a magical sign, linked with a new structuring... of the plane. The newly introduced white shapes induce spatial movement into the plane... The spatial energies of the plane are brought... to aesthetic autonomy."

The pictures of this phase still show a subdued palette. This would change with Nay's 1937–1938 series of *Lofoten* canvases, landscape and figurative motifs rendered with the incredibly dynamic and forceful color that would become the hallmark of his work. In the paintings done after his service in the Second World War, collectively known as the "Hecate period" (1945–1948), the pictorial space is set in melodical vibration by means of rhythmic arrangements of color.

The often-noted relationship between Nay's painting and music is very apparent in *Jacob's Ladder* (1946). Although the color combinations and nuances do not designate real objects, they can call up real associations – in this case, the Old Testament story of the ladder to heaven, and the choirs of angels surrounding it.

As color grew ever more important in Nay's work over the following years, objective reference decreased, resulting, in 1950, in purely planar abstraction. This is seen in his canvas *Rhythms in Blue and Red* of the

► **Ernst Wilhelm Nay**
Arrival of the
Fishermen, 1937
Ankunft der Fischer

Oil on canvas
105 x 136 cm

Donation of
Günther and Carola
Peill, 1976

year 1953, in which swaths of color are brought to abstract juxta-position. "The fundamental chord of the painting," wrote Werner Haftmann, "consists of the two voices of blue and red. The blue voice comes in at the left with a dominating weight, and sounds across the plane towards the right. Here is the realm of red, which in turn radiates towards the left, into the area of blue. These meeting and interpenetrating main voices are underlain and suffused in their intervals – the negative shapes – by a warm yellow, which, like a gilt ground, causes the color chord to resonate. A passage of golden ocher links the yellow voice to the dominant red, and a corresponding passage of brownish-red to purple links it to the blue dominant. A superbly tuned, imaginatively rich, but definitely controlled and calculated range of hues instrumentalizes the plane."

The year 1955 marked the onset of Nay's most significant and prolific phase, that of the *Disk* paintings, in which the picture surface is rhythmically articulated solely by means of color. "Painting," the artist once stated, "means forming the image out of paint."

In *Parable* (1958) we see the juxtaposed and superimposed colored disks in light and dark values of various colors, which are typical of this

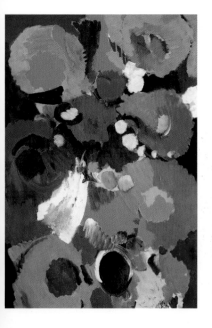

phase of Nay's work. *Blue Flood* is another example of the *Disk* paintings. The title characterizes the strong dominance of the color blue in the composition, a color with which Nay was intensively concerned from 1957 to 1960.

The hatchings Nay used to render the disks beginning in 1961 led in 1963 to the series of *Eye* canvases, three of which were exhibited at documenta III in Kassel, Germany.

The artist's late work, from 1965 onwards, shows an emphasis on flat, ornamental, biomorphic configurations that strongly recall the paper cut-outs of Henri Matisse. Certain motifs from earlier phases apparently reoccurred here. "Paintings come from paintings," as Nay once said.

◄▲ **Ernst Wilhelm Nay**
Parable, 1958
Parabel

Oil on canvas
117 x 81.5 cm

Bequest of
Günther and Carola
Peill, 1976

▲ **Ernst Wilhelm Nay**
Diamond, 1965
Karo

Oil on canvas
200 x 162 cm

Donation of Elisabeth
Nay-Scheibler, 1986

Nevelson, Louise

1899 Kiev, Russia
1988 New York

American sculptor Louise Nevelson was born into a Jewish family in Kiev. In 1905 her family moved to Rockland, Maine, where her father had opened a junk shop three years previously. In the 1920s Nevelson initially devoted herself to dance, music, and dramatic expression, before studying sculpture in New York and Munich. While travelling through Europe she received important impulses for her work from Constantin Brancusi, Jacques Lipchitz, and Henri Laurens. Her early works of the 1930s and 1940s, Cubist in thrust, reflected Nevelson's involvement with archaic and American Indian cultures. *Royal Tide IV* belongs to a series of works, also called *Golden Walls*, which the artist created from 1959 to 1965. The prevailing gold color of the *Royal Tide* series was preceded by pieces in monochrome black or white. Nevelson's preferred point of departure was the *objet trouvé*, the used and discarded jetsam of civilization. She carefully composed these relics of affluence or trivial things in boxes, affixed them with nails, and sprayed the whole with a thin gold solution. The Cologne piece consists of 35 various-sized boxes. The assemblage of mundane components, largely pieces of

▶ Louise Nevelson
Royal Tide IV,
1959–1960

Wood,
spray-painted with
gold-colored solution
323 x 444.5 x 55 cm

Ludwig Donation,
1976

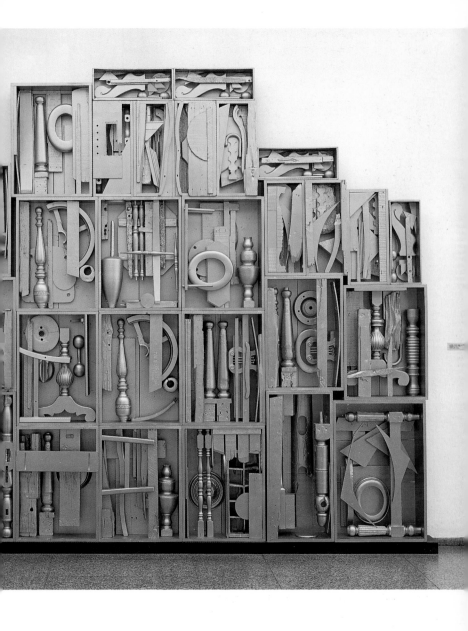

furniture, rises like a monumental, Baroque shrine, surrounded by an aura of magic. As the artist said, she wanted to show that wood picked up off the street could shine like gold. *Royal Tide* indeed has the effect of a contemporary secular reliquary, sublimated by the gold dust of imagination and memory.

**Newman,
Barnett**

1905 New York
1970 New York

In Barnett Newman's *Midnight Blue* (1970), the picture plane is covered with a homogeneous dark blue which abuts on a white band at the left edge and is intersected at the far right by a vertical stripe of turquoise blue. Yet despite this description in terms of location, the bands actually have no space-defining function.

Rather, they serve to increase by contrast the intensity of the basic color in its seemingly infinite extent, and make its density and apparent depth all the more powerfully apparent. One has the sense of being magically drawn into the image as into an endless space, suffused by ineffable color.

The full meaning of Newman's painting is explained in his theoretical writings, in which "the sublime" is a key concept. For Newman the purpose of painting consisted in giving the viewer an experience of the sublime, which implied an experience of unlimited freedom; he wanted to help us to escape for a moment from the constrictions of the world around us. Newman envisaged his art as a means of overcoming the limitations of rational experience, in order to make an untrammelled, unhindered spiritual experience possible.

With this aim Newman, and other American artists such as Adolph Gottlieb, Mark Rothko, and Clyfford Still, consciously broke away from the European tradition of non-objective painting. He dispensed with the ideal, abstract order and the defined formal relationships of modern European art. Instead Newman confronted the viewer with huge, flat, monochrome expanses which called up no mental associations with familiar ideas or things, but referred the viewer back to himself and back to his own role as observer. Looking at Newman's paintings we leave the solid ground of rationally categorized experience and are made immediately aware of the existence of our own selves.

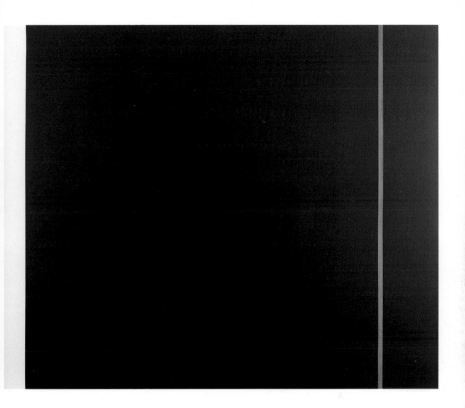

▲ **Barnett Newman**
Midnight Blue, 1970

*Oil and acrylic
on canvas*
193 x 239 cm

Newman himself considered his large-format paintings, which he said ought to be viewed at close proximity, objects for meditation, media for a self-forgetful contemplation which, on a transcendental level, would lead us back to ourselves, and to an experience of the unlimited nature of self. *Midnight Blue* dates from the last year of the artist's life.

A year before his death he amended his statements about his own creative process. Although referring to the work *Who's Afraid of Red, Yellow and Blue, I* (1966), what he said also holds for *Midnight Blue*. Newman now admitted intentions rooted in the psyche, whereas earlier he had written that he began to paint without any preconceived idea. So his works do contain a formulated intention after all: the expressive-ness of color rather than "didactic" color, color for the sake of its own, intrinsic qualities.

Nitsch,
Hermann

1938 Vienna, Austria
Lives in Vienna

Flagellation Wall is one of a series of action paintings done between 1960 and 1963, in the course of manifestions which Hermann Nitsch characterized as part of his *Orgy Mystery Theater*. This utopian vision of a perhaps never-to-be achieved unity formed the most complex, difficult, and also most fascinating chapter in contemporary Austrian art.

From 1953 to 1958 Nitsch attended the Graphic Arts Teaching and Experimental Institute in Vienna. "As soon as I started working at the Technological Museum," he recalled, "I wanted to write a drama that would last an entire week. That was the real beginning of my true, personal creative activity." At that time Nitsch already began to conceive the idea of the Orgy Mystery Theater, a festival lasting six days in which real events would be staged and all five senses of the participants would be directly involved. "Naturally influenced by Richard Wagner, and by music in general, I wanted to develop a total work of art. I was very strongly interested in myths, the various gods of the most diverse religions..."

One of the outstanding representatives of the Vienna Actionists' group, Nitsch is an advocate of Dionysian celebrations involving a sensuous and sensual intoxication. Dionysus was of course the ancient Greek god of wine, who according to myth held riotous revels with his followers which, thanks to the effects of alcohol, led to sexual acts. Among the god's female adherents were the Maenads, who were known, in ecstasy, to tear animals limb from limb. So not only wine but blood flowed at these orgies.

▲ **Hermann Nitsch**
Flagellation Wall,
1963
Geisselwand

*Dispersion
on gesso ground*
200 x 900 cm

Gift of
Dr. Arend Oetker,
1992

Nitsch's actions are intended as an expression of a similar attitude to life and art. Links with mysticism, the Christian liturgy, and the Passion of Christ, with which the artist empathizes to the point of suffering "the lust of torment" and "the lust of joy," are communicated in his actions, which also include allusions to animal sacrifice and concomitantly to the blood of the Lamb. Such large-format works as *Flagellation Wall* represent a translation of these themes into painting.

A work of Nitsch's early period, *Flagellation Wall* is a typical example of Viennese action painting. Since Nitsch strives to create a comprehensive work of art, various levels of meaning are combined, merged, and interchanged in the work. Blood and paint are mixed to make the painting both a fact and a symbol simultaneously (although in this case the evocative flows of red color are only paint, a simulation of blood).

"For Nitsch, being an artist means enduring the world, taking the Passion upon himself, vicariously living through the stations of the Holy Week, being accused and condemned, wearing the Crown of Thorns and bearing the Cross, being derided and tormented, empathizing with the death struggle and entombment of Christ, but also celebrating the Last Supper and the Resurrection," writes Wieland Schmied. Perhaps today we tend to experience the painting more as a majestic image in which traces of archaic gestures are compellingly recorded.

**Noland,
Kenneth**

1924 Asheville,
North Carolina
Lives in New York

After studying with Josef Albers at Black Mountain College, Kenneth Noland went in 1948 to Paris, where he spent two years working in the studio of Ossip Zadkine, a sculptor in the Cubist tradition. By 1949 Noland was already able to mount his first one-man show. Before the year was out he was asked to teach art courses in Washington, D.C., where he met Morris Louis. In 1953 the two artists moved to New York. An acquaintanceship with Jackson Pollock led Noland to begin experimenting with the dripping technique, which, however, he soon abandoned. When Noland and Louis saw Helen Frankenthaler's work and recognized the potential of thinned, flowing paint, they began to work in this technique.

Noland, being the more rational, cool-headed of the two, developed Color-field Painting to the logical limits. Texture played a subordinate role in his approach, for, as he once said, texture was an element that should be respected, but if you adhered to it too closely, as the Cubists did, you were in danger of ending in stagnation. Noland set out to apply the paint so thinly that paint and surface merged, saying that everything was color and surface, and these must become indissolubly one. In Noland's work this flat extension of color, dispensing with haptic values, took on geometric forms, although these emerged from

► **Kenneth Noland**
Provence, 1960

Acrylic on canvas
91 x 91 cm

Ludwig Donation,
1976

▲ **Kenneth Noland**
Shadow Line, 1967

Acrylic on canvas
217.5 x 610 cm

Ludwig Donation,
1976

intentions quite different from those of Noland's teacher, Albers, or of the De Stijl group.

The first system into which Noland integrated color in order to manifest its objective qualities had the form of concentric rings. The resulting circle or disk paintings marked the beginning of Noland's mature work. *Provence* of 1960 is representative of this phase. The image is symmetrical and focusses on the center of the canvas. The color scheme, rather than representing the spectrum or being based on complementary contrasts, is intended to convey the "light-energy values" of color. As one critic notes, "By locating the 'dark, dense energy' of blue in the expanding outer concentric ring, and the 'bright, open, expanding energy' of red at the constricted center – the opposite of their normal positions," Noland creates "a pulsating, radiating effect." Separated by thin white intermediate bands, the colored rings seem to hover free in space, with the blue ring open to the outside. Thanks to the contrast between open and closed form, limitation and expansion, the image gives rise to the impression of a dynamic interplay of centrifugal and centripetal forces.

In the subsequent phases of his work – based on ellipses and V-shaped paint bands – Noland increasingly reduced this dynamic effect, finally arriving at large-format configurations of parallel bands which, suggesting the intrinsic movement of thinned paint, appeared virtually to continue beyond the canvas edge, as in the 1967 painting *Shadow Line*.

▲ **Emil Nolde**
Fanatics, 1916
Schwärmer

Oil on canvas
100.7 x 86.4 cm

Haubrich Donation, 1946

Emil Nolde, whose real name was Hansen, was born into a farming family in the far north of Germany. In 1902 he dropped the family name, which is very common in the area, and replaced it by the name of his native village.

Nolde, Emil
(Emil Hansen)

1867 Nolde,
Schleswig, Germany
1956 Seebüll

Nolde arrived at fine art by way of a training in woodcarving and applied art. He completed his studies at the Académie Julian in Paris, in 1900. The most profound influence on his development, however, would come with a journey of 1913–1914, which took Nolde through Russia to Korea, Japan and China, and finally to the South Pacific. His involvement with the art of these regions and cultures bore fruit for his entire œuvre.

Nolde's love of the exotic is clearly noticeable in the watercolor *Head of a Spanish Woman*. Characteristically, instead of portraying an individual the artist has concentrated on delineating a type – an intention expressed in the title, as in the titles of other Nolde heads, such as *Peasant, Italian Man, South Sea Islander, Young Girl*. The woman's profile suggests both thoughtfulness and sensousness, and her expression and nationality are underscored by the colors black, yellow and red. Yet nationality is less important here than the typical, high-colored complexion of the Mediterranean people in general. The choice of colors and contrasts reflects the artist's search for unspoiled, free human beings, a reaction against bourgeois life born of a disgust with Northern European civilization which Nolde shared with many other Expressionist artists.

The theme of the *Dancer*, too, relates to Nolde's penchant for the exotic, although, as in the *Head of a Spanish Woman*, the reference is not blatant. Nolde was fascinated by dances of every type – peasant, cabaret, gypsy, Far Eastern – whereby the latter two probably intrigued him most. In dance he found intoxication, ecstasy, and an anarchic sense of life that was capable of breaking through social conventions. It was not so much the outward form of the dance as the inner urges of the dancer that concerned him. Though the dancer's pose in Nolde's watercolor is reminiscent of classical ballet, the emphasis is definitely on a physical expression of strong emotional sensations. The opposition between submission and resistance, between relaxation and tension, is expressed in the counteracting movements of the figure, as well as in the contrast of light colors against glowing, dark hues. "When I heightened the colors to full chords," the artist wrote, "it sometimes seemed to others that form had vanished – it is always there, but deep below the surface."

Nolde's watercolors of dunes, clouds, and ocean vistas on the North Sea coast of Germany are executed with an equally compelling painterly force. As in his figures and heads, the artist set out in his landscapes to transform nature by an infusion of the emotions it awoke in him. *Marshy Landscape* (c. 1920–1925) and *Sunset over the Sea* (1939–1940) are cases in point.

The painting *Fanatics* belongs to a group of works with a religious and mystical content. Yet rather than relating to traditional motifs in this field, they tend for the most part to reflect a very personal mythology that grew out of Nolde's own artistic imagination. The title of the work is ambiguous. Besides the connotations of fanaticism or passionate devotion, the German noun *Schwärmer* also suggests swarms or multitudes, and a related verb even designates, in a military context, a dispersal of troops. In view of the painting's date, 1916, these references are salient. But perhaps even more so is the meaning of *Schwärmer* in Northern German folklore – the spooks or kobolds that played a very real role in Nolde's imaginative world. *Young Woman and Men* of

1919 is another example of the mythical and Biblical aspect of Nolde's work, although here again, the content and iconography are not absolutely definable. The painting was acquired in 1933 by Josef Haubrich, under the title *Christ Among the Scribes*. Later commentators have tended to interpret it as representing Susannah and the Elders. At any rate, what we see is a young woman surrounded by old men who obviously desire her. Their lustful grins are rendered with a few, harsh strokes. In stark contrast to their grotesquely grimacing faces, that of the young woman is clear and calm, like a bright, peaceful island in the midst of a threatening sea.

◄ **Emil Nolde**
Marshy Landscape,
c. 1920–1925
Marschlandschaft

Watercolor on
japan paper
35 x 47 cm

Haubrich Collection

► **Emil Nolde**
Sunset over the Sea,
1939–1940
Sonnenuntergang
über dem Meer

Watercolor on
medium-thick
japan paper
34 x 47.7 cm

Haubrich Donation,
1946

◄ **Emil Nolde**
Dancer
Tänzerin

Watercolor on
japan paper
47.5 x 35.4 cm

Oelze, Richard

1900 Magdeburg
1980 Posteholz,
near Hameln

▼ Richard Oelze
Growing Silence,
1961
Wachsende Stille

Oil on canvas
98 x 125 cm

Gift of
Cultural Committee,
Federal Association
of German Industry,
1974

In the phantasmagorical paintings of German Surrealist Richard Oelze, references to nature are combined with visionary, hallucinatory elements. The prime medium used to convey his generally somber message is what the artist called *Inner Landscapes*, reflections of the mental reality of both personal and collective feelings, whether of anxiety or hope. *Growing Silence* of 1961 is one of a series of depictions of imaginary walls, executed with a dry brush, in subdued monochrome hues which create the impression of a flat, shallow space. The suggestion of a multitude of eyes and eerie heads peering out of the masonry makes this space, with its references to landscape and architecture, seem even more forbidding. The composite, pale-greenish anthropomorphic forms can be read as an impenetrable, threateningly mysterious forest, which promises little refuge for the viewer. A traditional motif in Romantic art, the forest appears here as an organically Surrealist counter-image to a rational society alienated from nature, and existing in an only apparently thoroughly explored and secure world. The impenetrability of the landscape visualizes human fears of the strangeness and otherness of the natural environment surrounding our outposts of civilization. But it also symbolizes the enigmatic, boundless depths of our own minds, which remain closed to any attempt at rational, analytic understanding. "The forest as it appears in Oelze's painting," writes Wieland Schmied, "is one which has undergone many metamorphoses and harbors many more to come... Is the forest dissolving into the grotesque masks of anonymous masses... or will it become a means for the individual to find refuge?" Oelze's interpreters have placed him in a long tradition extending from the visionary imagery of Hieronymus Bosch, through Mannerism and Romantic art, all the way down to French Surrealism.

American artist Claes Oldenburg was born in Stockholm, as the son of a Swedish diplomat. From 1946 to 1950 he studied English literature and art at Yale University, New Haven, and took courses in life drawing and composition. Then, until 1954, Oldenburg attended night courses at the Art Institute of Chicago, while working days in bookshops and for advertising agencies. In 1956 he moved to New York, where he was influenced by Abstract Expressionist painting. Around 1958 Oldenburg came in contact with Alan Kaprow, Lucas Samaras, and George Segal, in whose innovative attempts to bridge the gap between art and life, happenings and environments, Oldenburg participated.

The artist's development since 1960 can be described in terms of certain themes, with which certain techniques or media are associated. The year 1960 saw the emergence of *The Street*, an environment consisting of various representations of figures, symbols, and objects made of burlap, cardboard, newspaper, and various second-hand materials. The piece was exhibited from January to March 1960 at the

Oldenburg, Claes Thure

1929 Stockholm, Sweden
Lives in New York

▲ Claes Oldenburg
The Street, 1960

Environment: figures, symbols and objects made of burlap, cardboard, newspaper, and discarded materials, 15 parts, dimensions variable

Ludwig Donation, 1994

Judson Gallery in New York, supplemented by Oldenburg's performance of his happening *Snapshots from the City*. The objects in the work can be seen as just such snapshots from everyday urban life. In May 1960, a revised version of *The Street* was shown at the Reuben Gallery, New York.

A further theme in Oldenburg's work since 1960 is *The Store*, with which the objects in the Museum Ludwig, Cologne, are associated: *Green Legs with Shoes, Success Plant,* and *White Shirt and Blue Tie.* As early as fall 1960 Oldenburg began sketching all sorts of mundane consumer goods he saw in his neighborhood, and the next year, he translated his observations into sculptural terms in his show "Ray Gun Mfg. Co."

▼ **Claes Oldenburg**
Success Plant, 1961

Burlap with wire, glue, oil paint, tin can, wood
height 98 cm

Ludwig Donation, 1976

▶ **Claes Oldenburg**
White Shirt and
Blue Tie (Big White
Shirt with Blue Tie),
1961

Wire, fabric, plaster,
enamel paint
120 x 80 x 30 cm

Ludwig Donation,
1976

◀ **Claes Oldenburg**
Green Legs with
Shoes, 1961

Plaster, wire, fabric,
metal frame,
enamel paint
149 x 100 x 20 cm

Ludwig Donation,
1976

In late 1963 the artist began producing a range of household objects and appliances, each in three versions and sizes: *Hard Models* (in corrugated cardboard), *Ghost Versions* (in fabric), and *Soft Versions* (in vinyl). These were part of a project called *The Home*, as exemplified by the objects in our collection, *Bathtub (Hard Model)* and *Soft Washstand (Ghost Version)*. In the latter piece Oldenburg unsettles our habitual perceptions by translating a normally hard and solid ceramic object into a limp fabric bag, a washbasin from which, as it were, the air has been let out by pulling the plug. This transformation encourages the viewer to stop and think about the existence and form of something he uses every day, and is aware of only in terms of function. In *Bathtub (Hard Model)* the upended position of the tub divorces it from its normal context of perception and utilization, and again makes us

conscious of it as an object and configuration. Since 1965 such pieces have been accompanied by Oldenburg's large-scale projects for monuments, based on mundane things like lipsticks and clothes pins blown up to gigantic scale.

Oldenburg resists the critics' tendency to pigeonhole his work. As far as he is concerned, Pop Art is too narrow a category, and no other label can really be made to stick. What Max Horkheimer and Theodor W. Adorno once said applies well to Oldenburg: "The great artists were never those who embodied a style in unflawed, perfect form... [but those who] retained a distrust of style and, when it came to the point, adhered less to style than to the logic of the enterprise." There is only one point, but an important one, at which Oldenburg's work can still be seen to converge with Pop Art: the rehabilitation and monumentalization of the trivial, and its integration in visual imagery that dispenses with hierarchical orders.

▲ **Claes Oldenburg**
Restaurant Objects
(Ghost Dinner),
1964

Metal, fiberglass,
plaster, cardboard,
ten parts
28 x 73.5 x 36 cm

Ludwig Donation,
1976

◀ **Claes Oldenburg**
Soft Washstand
(Ghost Version),
1965

Linen, kapok,
paint, wood
height 135 cm

Ludwig Donation,
1976

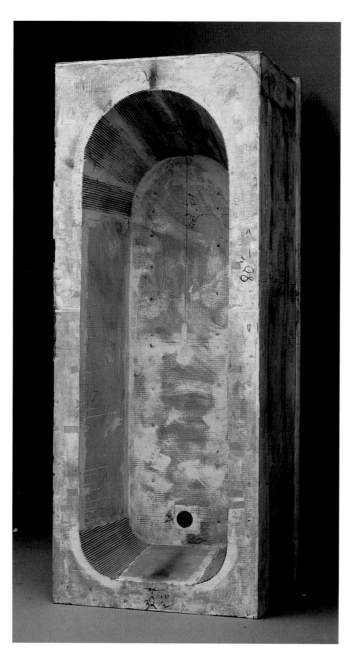

◀ **Claes Oldenburg**
Bathtub
(Hard Model), 1966

*Corrugated
cardboard, wood,
pencil, oil paint*
206.5 x 84 x 70 cm

Ludwig Donation,
1976

Existing ordinary things – fruit boxes, metal parts, hay, feathers, fabric, newspapers, junk and wire – are the raw materials from which Claus-Otto Paeffgen fashions his painterly and sculptural works. *Black on White* belongs to a series the artist calls *Wire Wrappings*.

At first glance the piece has the appearance of an enigmatic formal puzzle. Actually it represents a very witty and slightly self-ironical confrontation which leaves us as viewers plenty of room for speculation. The left half of the picture is occupied by the fundamental geometric shapes, circle, square, and triangle. These are separated from the right half by a vertical "stick," which forms a sort of borderline to what, as W. Krüger notes, are "trivial symbols of daily life," including a heart and moon as the counters of cheap, sentimental literature and "hair-curlered housewife's fantasies." What the artist projects here, in large-scale black and white, are symbols of romantic feelings, of sexuality, and of religious faith of the kind that are ubiquitous in our contemporary environment – sprayed on house walls, scribbled in restrooms, and carved on school desks.

Paeffgen, Claus-Otto

1933 Cologne, Germany
Lives in Cologne

▲ **Claus-Otto Paeffgen**
Black on White, 1969–1972
Schwarz auf Weiss

Styrofoam, hay, wire mesh, steel wool, matte black lacquer, 12 parts
300 x 400 cm

Paik, Nam June

1932 Seoul, Korea
Lives in Düsseldorf
and New York

Nam June Paik is a father-figure for contemporary artists working in the video medium. He was a pioneer of video installations, which, along with the production of videotapes, has been his prime means of expression since 1963. No other artist has contributed more than Paik to the development of this medium into an autonomous art form. Trained as a musician and composer in Seoul and Tokyo, Paik began performing musical happenings in the late 1950s, inspired by John Cage, among others. These events brought him into contact with the visual arts. As a composer of electronic music Paik decided to supplement his scores by visual effects, and began experimenting with television sets. These were included in his first one-man show in 1963, held at Galerie Parnass in Wuppertal, Germany, and indicatively titled "Exposition of Music – Electronic Television."

Over the following years Paik began to distort the television image with the aid of magnets. His presentations, which he termed "participation television," were intended as demonstrations for the right of viewers to influence television programming. From 1965 onwards these manipulations were recorded using a video camera. It was not until 1970, with the aid of a video synthesizer jointly developed by Paik and Japanese electronics engineer Shuya Abe, that television reception could be altered in terms of form, color, and motion sequences directly at the receiver. Paik's video installations extend from gigantic agglomerations of TV screens like *Brandenburg Gate*, which inundate the viewer with visual and acoustic collages, to smaller, more contemplative objects.

▼ **Nam June Paik**
Shigeko's Buddhas,
1986

*Video installation
with wooden figures
approx. 300 x 200 cm*

A key example of the latter is *Shigeko's Buddhas*, which is dedicated to Paik's wife, Shigeko Kubota, a Japanese video artist. Here three antique Buddha figures of wood are confronted with three small television sets. What they are "watching" on the monitors are films about the artist's three mentors, from the fields of dance (Merce Cunningham), music (John Cage), and visual art (Marcel Duchamp). Whether monumental or inti-

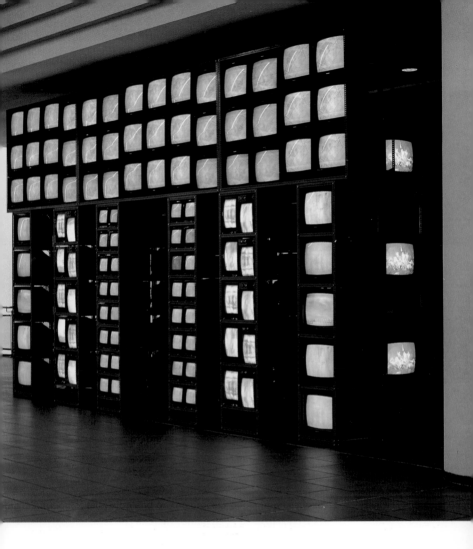

mate, bombastic or serene, all of Paik's video installations have a sculptural character. For him, the monitor is an object, which should be perceived as such.

Paik's works, from videotapes and installations to paintings, drawings and prints, shed light in a both critical and entertaining way on the institution of television and on the process of communication. With his video installations and environments in particular, he makes

▲ **Nam June Paik**
Brandenburg Gate,
1992

Video installation

Ludwig Donation,
1994

us aware of the dangers involved in our daily consumption of a flood of television imagery that reduces content of every kind, from tragic to trivial, into an amorphous mass. Paik once put his philosophy in a nutshell, in this often-quoted statement: "Television has attacked us our whole lives long – now we're hitting back!"

Palermo, Blinky
(Peter Heisterkamp)

1943 Leipzig
1977 Sri Lanka

▼ **Blinky Palermo**
Points of the
Compass I, 1976
Himmelsrichtungen I

*Acrylic on aluminum,
four parts*
26.7 x 21 cm each

Ludwig Donation,
1994

When Blinky Palermo transferred in 1962 from the Münster School of Commercial Art to the Düsseldorf Academy, he entered the class of Bruno Goller. Here he began a series of paintings and drawings employing highly reduced forms, schematic figures and suggestions of geometric or organic objects. Palermo's early work reflected the influence of Joseph Beuys, whose master student he was from 1963 to 1967. With time Palermo increasingly abandoned figurative and formalistic approaches to turn to pure painting, an exploration of the material character of the painted surface itself. A close friend of Gerhard Richter and Sigmar Polke, the artist adopted his pseudonym, Blinky Palermo, after the gangster of that name in 1963. The year 1966 saw him launch into a series of images composed of parallel bands of industrial fabric. He also produced sequences of *Wall Paintings* and *Wall Drawings,* and, beginning in 1972, a number of *Metal Paintings.* Here the relationship between paint and material support changed, in that now the surface was no longer altered by foreign textures, but merged with the paint and lent it an extremely lucid effect. As Palermo wrote, "If I had worked with canvas and stretchers, the image of the paintings would be a completely different one. Instead of aluminum I could just as well have painted on copper or steel."

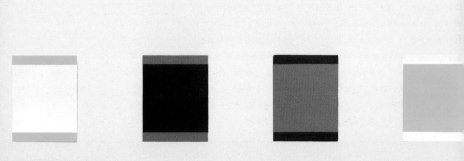

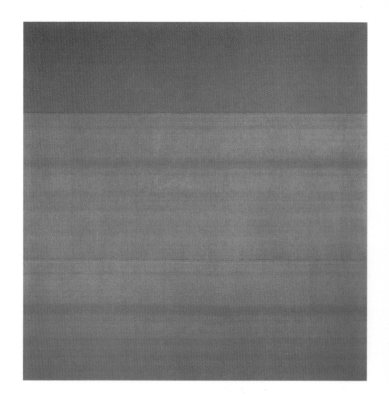

► **Blinky Palermo**
Untitled, 1967

Industrial fabric
198 x 198 cm

Loan from
a private collection

Points of the Compass I belongs to a series of paintings on metal
in which the form, arrangement, and mounting on the wall are all
strictly determined. The work consists of four upright rectangular
plates hung at equal intervals (based on their width), each divided
into a central rectangle and two narrow bands at top and bottom.
While the geometrical system is clearly established (in analogy to
universal physical laws), the colors (as the subjective, emotional
element) seem to be subject to a continual and unpredictable trans-
formation. "The aluminum plates are painted in acrylic colors over
a white ground," said Palermo. "Usually there are several super-
imposed paint layers, since the original conception often changed
during the process of painting, and the finished painting generally
consists of a color sequence, or color chord, which I was not able
to predict or imagine when I began working."

Paolozzi, Eduardo

1924 Edinburgh
Lives in London

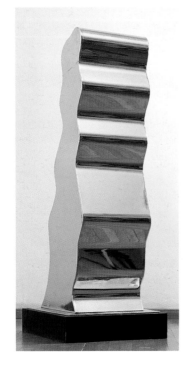

The artistic development of Eduardo Paolozzi, who was born in Scotland to Italian parents, took place in a continual interplay with the postwar environment and its prevailing technology, automation, and consumption – factors that reappear throughout his œuvre. His first sculptural works, open-structured configurations, were still marked by the impressions Paolozzi gained during a stay in Paris (1947–1949). In the 1950s there began to emerge anthropomorphic figurations with seemingly corroded surfaces, many of which were built up of serial, technical components.

The Last of the Idols, which has been called "a totem pole for the mechanical age," belongs to the artist's *Tower* series. It was done in 1963 and given its present polychrome finish in 1966. Out of mechanical-looking building blocks Paolozzi has shaped a fetish whose utility would seem questionable. The sculpture obviously bears anthropomorphic traits, as indeed the word "idol," strictly speaking, means a piece of insentient matter shaped by human hands and infused with life, to form an active counterpart to man.

According to Paolozzi, the title was intended to convey an idea. Just as earlier societies worshipped images or symbols representing some supernatural power, the artist feels that certain parallels to the present day can be found in the fact that he makes precise or specific images that in some way represent the human power involved in the creation of certain man-made objects with which he has concerned himself.

The lower portion of the figure alludes to the contrast between static immobility and rolling movement. Above this is a zone of regular, boxlike elements which converge in a large, ring-shaped configuration. Its concentric, sculpted rings give the impression of a magic eye. The piece is topped by a configuration reminiscent of an electrical insulator or an antenna. The color scheme not only serves as a means of articulating and emphasizing the structure of the piece; its brilliant contrasts also form an exciting and visually compelling signal.

▶ **Eduardo Paolozzi**
The Last of the Idols,
1963

Aluminum, oil paint
244 x 71 x 64 cm

Ludwig Donation,
1976

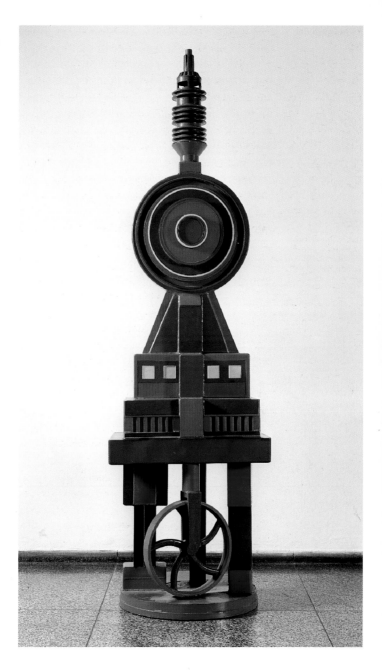

Pechstein, Max

1881 Zwickau,
Germany
1955 Berlin

▼ Max Pechstein
In the Studio
(Schmidt-Rottluff
and a Man in a
Yellow Suit),
c. 1908–1910
Im Atelier (Schmidt-
Rottluff und Mann
im gelben Anzug)

Brush and ink,
and colored chalk
16.5 x 14 cm

Haubrich Donation,
1946

In 1906 Max Pechstein joined the Brücke group of artists in Dresden, to which Karl Schmidt-Rottluff, who appears in the drawing *In the Studio* (c. 1908–1910), also belonged. This small-scale work shows the characteristic traits of Expressionism as practiced by the Brücke artists: A preference for primary colors, strong color contrasts and homo-geneous color areas; a suppression of details in defining form; the heavy black contours demarcating fields of color; the tendency of the line to angular or zig-zag shapes; and finally, the impulsive strokes of the chalk, which continually change direction. Form and color applied to paper in this way have produced a compact image of enormous vitality which would appear to contradict the basically calm and tranquil nature of such a scene.

The simplicity of expansive, integrated forms which would come to characterize Pechstein's further development, is seen to good effect in the canvas *The Green Sofa* (1910). The key motifs of the painting are evoked by a few, decisive lines: The sofa with its bulging, quilted back-rest; the cat rolled up in the corner; and the girl with a blue ribbon

in her hair, seated at the other end of the sofa and smiling as if lost in a daydream. The orange and red tones of her complexion contrast strikingly with the green of the sofa, which is subdued by means of black strokes. The girl's pose – left arm and left leg drawn in, right arm and leg extended, torso inclined to the right, head in counterpoise to the left – engenders an overall outline of great interest and vitality, which is underscored by the sweeping contour lines. The already womanly curves of her body are emphasized by the stripes of her short, clinging chemise.

Pechstein's art found more ready acceptance on the part

of contemporary audiences than that of his Brücke confreres, Ernst Ludwig Kirchner or Erich Heckel – probably because his visual point of departure, the characteristic forms of things, always remained strongly apparent in the finished image.

▲ Max Pechstein
The Green Sofa, 1910
Das grüne Sofa

Oil on canvas
96.5 x 96.5 cm

Haubrich Collection

▲▲ **A. R. Penck**
Large World Picture,
1965
Grosses Weltbild

Oil on hardboard
180 x 260 cm

Ludwig Collection

▲ **A. R. Penck**
A Possible System,
1965
Ein mögliches
System

Oil on canvas
95 x 200 cm

Ludwig Donation,
1976

To A. R. Penck's mind, pictures are part of a cybernetic system. As he once stated, "Signals control behavior. Signals trigger urges or inhibit them, signals cause excitement, produce the body's overall physical tone. Existence, development, success, decay – all are controlled through signals." Based on such considerations, Penck produced several large-format paintings in the mid-1960s in which diagrammatic depictions akin to prehistoric art were used to visualize possible cybernetic models and systems. "What I envisage," Penck wrote to Georg Baselitz, "is a kind of physics of human society, or, say, society as a physical body."

His *Large World Picture* of 1965 has long been considered a key work in Penck's œuvre. As Armin Zweite notes, the picture deals with "communication processes in their simplest form, and the hierarchical principles of order underlying a primitive social community." Penck has explored every conceivable situation in the relationship between individual and society, simulating these in cardboard models of impressive force. In the early 1970s, searching for solutions to aesthetic problems by reducing them to the elementary categories of perception and thought, he began working in a serial and conceptual manner. Yet his primary concern continued to be not with eliminating

Penck, A. R.
(Ralf Winkler)

1939 Dresden
Lives in Berlin

▲ A. R. Penck
Untitled (Group of Friends), 1964–1965
Ohne Titel
(Freundesgruppe)

Oil on hardboard
170 x 275 cm

Ludwig Collection

▲ A. R. Penck
Me in Germany
(West), 1984
Ich in Deutschland
(West)

Dispersion on cotton
600 x 1200 cm

Ludwig Collection

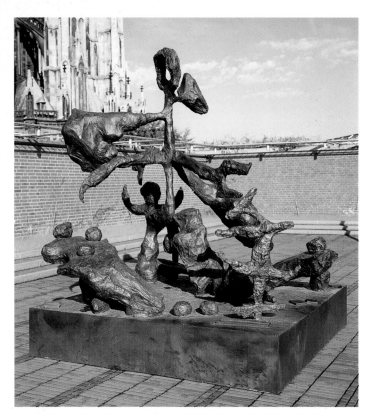

Ego – Self-
Confidence, 1987
Ich – Selbst-
bewusstsein

Bronze
278 x 245 x 226 cm

Ludwig Collection

▶ **A. R. Penck**
The Spirit of Europe,
1987

Poplar wood
height 885 cm

Ludwig Donation,
1994

the ego from the artistic process, but with analyzing its position within
a systematic artistic process.

What Penck tested in his *World Picture* bore fruit in his work of
around 1970, even though the means were now less "romantic."
Yet the symbolic idiom of his early work, recalling Paul Klee or the
Art Brut artists, remained a constant, the figure reduced to simple
linear configurations and accompanied by attributes defining the
context continuing to dominate even the large formats. Penck's art
hovers on the borderline between figure and concept. It finds poetic
metaphors for dilemmas confronting the individual in modern society,
but without forgetting that the individual is in incessant and ubiquitous
jeopardy.

558 | Penck

**Pevsner,
Antoine**

1886 Orel, Russia
1962 Paris

With his brother, Naum Gabo, Antoine Pevsner belonged to the founders of Constructivist sculpture. After studying in Kiev and St. Petersburg, and travelling to Paris (1912–1914) and Oslo (1915–1916), Pevsner initially devoted himself to painting. He began working in an abstract vein even before the 1917 Revolution, which encouraged the brothers to return to Moscow. Pevsner's investigations into an aesthetic based on logical and rational principles and into a design in space derived from natural, physical laws, led him to write a *Realistic Manifesto*, published in conjunction with Gabo in 1920. In 1922 the two artists left Russia and went to Berlin; the following year, Pevsner moved to Paris.

As G. von der Osten writes, "*Dernier élan* marks the end of a long sequence of creative work strictly based on the guidelines Pevsner set forth. It is his final work, dating from 1961–1962, and it exists in two casts. One of these stands over the artist's grave in Paris, which is why his widow titled it *Final Impetus*." The second cast is in our museum. In contrast to the emotional interpretation reflected in its present title, the same critic claims that "the piece attests to the coolly constructivist self-limitation that adopts the forms, for example, which produces forms of the Eiffel Tower or aircraft design, as well as reflecting the great enthusiasm of the sculptor's spatial imagination."

The piece is built up of curving, interlocking forms whose surface is incised with radial lines that follow the direction of the development of the forms in space. The piece has no front view, being equally effective from all sides. Two curved planes rise up into the surrounding space then abruptly break off, as below, a new sheaf of vectors seems to emanate from the pedestal between them.

▼ Antoine Pevsner
Final Impetus,
1961–1962
Dernier élan

*Bronze, gilt
height 66.8 cm*

▶ **Francis Picabia**
The Bride, c. 1929
La mariée

Mixed media
on plywood
121.5 x 96.5 cm

Haubrich Collection

The son of a Spanish father and a French mother, Francis Picabia was
among the most versatile artists of early modernism. His art contains
a great many elements that anticipated postwar avant-garde develop-
ments by decades.

The 1922 painting *Spanish Night* marked the beginning of Picabia's
Surrealist-oriented phase. The figures are reduced to silhouettes – the
flamenco dancer in black on a white ground, the female figure white
on black. By this simple expedient alone the artist ironically illustrates
the polarity between playfully aggressive, dark Spanish masculinity
and bright, seemingly passive and self-contained, and possibly French
femininity. At the same time he makes the couple, and with them the
canvas itself, into a target riddled with painted bullet-holes, and calls
up erotic associations which were the source of the picture's earlier
title, *Spanish Love*.

The Bride of 1929 is a work from Picabia's series of "transparent
paintings," which continued until 1939. In these images we see dream-
like superimpositions of various figurative forms and ornamental sym-

Picabia, Francis

1879 Paris
1953 Paris

◄ **Francis Picabia**
The Spanish Night,
1922
La nuit espagnole

Enamel on canvas
162.5 x 131 cm

Ludwig Collection

► **Francis Picabia**
The Fool, 1948
L'insensé

Oil on wood
153 x 110 cm

Gift of
the Association
for Modern Art
at the Museum
Ludwig, Cologne,
1988

bols, partly in the shape of colored lineatures, partly underlain with color areas. Picabia often employed quotations from other artists in this series, the female head in *The Bride*, for instance, having been taken from a Botticelli drawing.

In his late work, from 1945 onwards, the artist returned to abstraction. *The Fool* of 1948 is a major work of this late phase. Its warm, reddish-brown palette, given further accentuation by the brilliant white of the rectangular and triangular forms, make this an extremely compelling image. The composition is based on individual geometric shapes which are connected by lines in such a way as to suggest a figure.

Picasso, Pablo

1881 Malaga, Spain
1973 Mougins, near
Cannes, France

Pablo Picasso painted many landscapes, depictions of animals, and still lifes, such as *Still Life with Newspaper and Violin* and *Mandolin, Fruit Bowl, Marble Fist*. Yet at the center of Picasso's many-facetted œuvre stand human beings and all their psychological implications, depicted with an extraordinary formal and substantial diversity. Picasso's art is like a stage, on which the amateur players move just as convincingly as the familiar professional actors from the fields of drama, literature, mythology, or art. His *teatrum mundi* encompasses the whole range of human roles, from lovers to mourners and beggars, from acrobats and harlequins to musketeers, and – a very important subject – artists and their models.

The small-format oil *Café in Montmartre*, like many works of the Blue Period that shortly ensued, reflects Picasso's observations and experiences in Paris. He concerned himself above all with the marginal

groups of society, the homeless, the indigent, the blind or crippled, the despairing denizens of the big-city suburbs and slums. Picasso projected a view of humanity marked by a hopelessness of soul, a mood that seemed to figuratively reflect the fate of the hungry and homeless he witnessed. The summer of 1910 saw him paint *Woman with a Mandolin*. At first sight a non-objective composition, it actually represents a highly abstracted human figure. Apart from Picasso's formal experiments, which manifested themselves in the development of Cubism, this approach to the figure possessed a certain logic with respect to the pessimistic image of humanity seen foremost in the Blue Period. Picasso's theme now became the dissolution of individual corporeality. Here the isolation and loneliness of the individual were manifested in a disintegrated pictorial structure in which human existence seemed to be annulled.

According to Franz Meyer, the motif of the painting goes back to Gustave Corot's *Girl with a Mandolin*: "In works like *Woman with a Mandolin* Picasso attempted to bring the impression of enigmatic nobleness and dignity possessed by Corot's figures to life in a new pictorial idiom."

Inspired by a trip to Italy in 1917, Picasso made a radical break with the flatness of Cubism. He began to paint monumental figures and nudes in a style that employed three-dimensional modelling and warm colors. A picture such as *Woman in a Green Dressing Gown* stands near the end of this, his "neoclassical" phase. The palette is similarly reserved as in the still life *Mandolin, Fruit Bowl, Marble Fist*. *Harlequin with Folded Hands* also dates from this phase.

Woman with an Artichoke is one of the most compelling Picassos in our collection. Painted in the midst of World War II, it depicts woman as the victim of physical and mental terror. The fragmentation of the figure becomes a symbol of humans subdued and broken by unimaginable suffering, humans forced to live in a world that robs them of their composure, their very outward form. Yet the gesture of *Woman with an Artichoke* seems to express resistance, even aggression, the artichoke mutating from a plant into a weapon, like a spiked club. The figure, depersonalized by the fragmented representation, stands as a symbol for the horror and cruelty of war. Another painting that reflects the war mood is *View of Notre Dame de Paris – Ile de la Cité*. Even those who know Paris well will have difficulty detecting that the

◄ **Pablo Picasso**
Café in Montmartre, 1901
Brasserie à Montmartre

Oil on cardboard
44.5 x 53.5 cm

Ludwig Collection

◄ **Pablo Picasso**
The Family,
or Parents with
Child, 1904
La famille
ou le ménage
et l'enfant

Pencil and watercolor
36 x 26 cm

Ludwig Collection

► **Pablo Picasso**
Woman Combing
her Hair, 1906
Femme se coiffant

Bronze
42 x 31.2 x 29.2 cm

Ludwig Donation,
1994

artist has depicted Notre Dame as seen from the quay, through one of the stone bridge arches over the Seine. The almost Cubist facetting of the objects, the waiver of local color, and the reduction of spatial depth, all contribute to a certain visual irritation. Yet this was precisely Picasso's intention. "I didn't paint the war, because it is not my habit to go in pursuit of a subject like a photographer," he said. "But I have no doubt that the war is in these pictures. Later the historians may prove that my style changed under the influence of the war. I myself don't know."

The same year as *Woman with an Artichoke*, but taking an entirely different approach to the human image, Picasso made *Head of a Woman (Dora Maar)*. Here he dispensed with the fragmentation of the figure and the dissolution of form, to produce a head whose monumental calm once again seems almost classical.

◄ **Pablo Picasso**
Portrait of
Max Jacob, 1907

*Gouache on
Ingres paper
62.7 x 48 cm*

Ludwig Collection

In 1950, leaving all artistic conventions far behind, Picasso created
the assemblage *Woman with a Baby Carriage*, a provocative symbol
of the most elementary of human relationships, that between mother
and child. The theme had already played an important role in earlier
phases of Picasso's work, but now he treated it for the first time
in sculpture, producing what was also his first sculptural group.
Questions of content or message were less important to the artist,
however, than the chance to experiment in combining diverse existing

objects, as may be seen in his use of the same objects in different contexts.

It would be hard to name a single artistic technique which Picasso did not employ. He is as famous for his virtuoso drawings as for his inventive and vital etchings, lithographs, and linoleum cuts. In Vallauris, where Picasso lived from 1948 to 1955, he began working in ceramics, a technique that fascinated him and in which he became a master, as *Bowl with Fauns' Heads* shows.

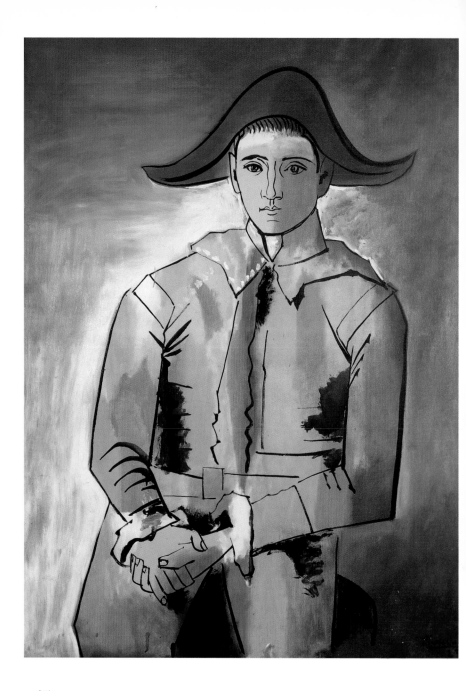

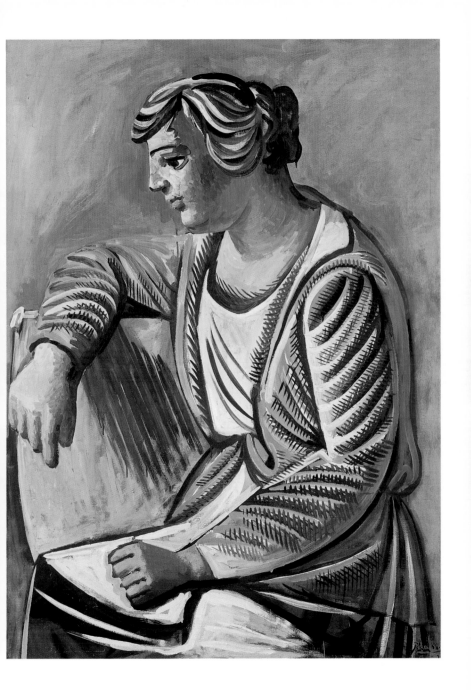

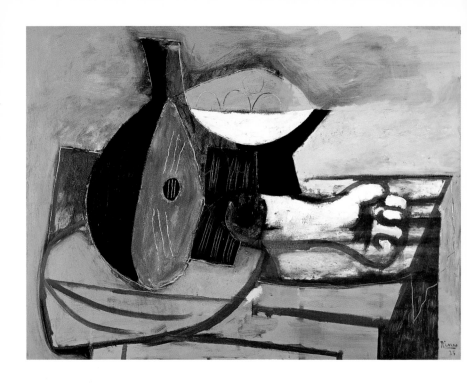

Picasso also devoted himself to the study of other artists' paintings. His involvement with *Le déjeuner sur l'herbe*, Eduoard Manet's painting of 1862–1863, began in August 1955, and did not end until 1962. In this version, as in most of the others, Picasso retained Manet's basic composition. But unlike Manet he placed great emphasis on the painting's subtheme of "painter and model." The figures dominate with respect to the landscape. Picasso's aim was, as it were, to disassemble the original, exchange or rearrange the figures, and assign new roles to them.

This is also true of his variations on paintings by Eugène Delacroix, Diego Velázquez, and Gustave Courbet, to name only a few of the artists Picasso paraphrased. The role of these works should not be misunderstood as representing originals Picasso attempted to copy. Rather, they served him as points of departure, sources of inspiration. Picasso's formulations are neither imitations nor interpretations in the narrower sense.

◄ **Pablo Picasso**
Mandolin,
Fruit Bowl,
Marble Fist, 1925
Mandoline,
compotier,
bras de marbre

Oil on canvas
97.5 x 131 cm

► **Pablo Picasso**
Head of a Woman
(Dora Maar), 1941
Tête de femme
(Dora Maar)

Plaster
80 x 42 x 55 cm

Ludwig Collection

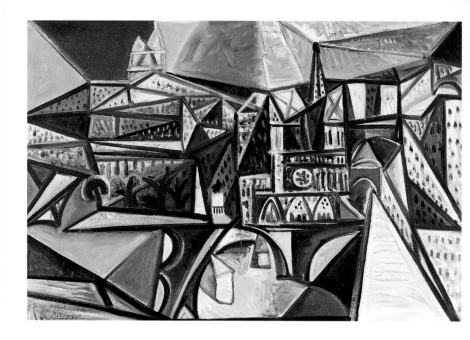

▲ Pablo Picasso
View of Notre-Dame
de Paris –
Ile de la Cité, 1945
Ile de la Cité –
Vue de Notre Dame
de Paris

Oil on canvas
80 x 120 cm

Ludwig Donation,
1976

▶ Pablo Picasso
Woman with an
Artichoke, 1941
La femme à
l'artichaut

Oil on canvas
195 x 130 cm

Ludwig Donation,
1994

The artist's late work is characterized by painterly variety and an intoxicating lust for life. In addition to the major theme of "painter and model," Picasso devoted himself in smaller series of works to subjects like *Melon Eaters* and *Musketeers*. In *Melon Eaters* of 1967 the canvas is covered with sumptuously applied paint, and the nudes convey a sense of untrammelled *joie de vivre* and sensuality. By comparison to this image, the palette of *Musketeer and Cupid* of 1969 is brilliantly heightened. Here Picasso produced a bizarre combination of a mythological figure, Amor or Cupid, with the seventeenth-century musketeer, embodiment of masculinity, which had appeared in his work with increasing frequency since 1967. With the painting *Reclining Nude with Bird* of 1968 Picasso confronted the viewer with a classical motif treated in a quite unclassical manner. The motif of the woman playing with a bird became an occasion for Picasso to address, once again, his love of the female body. Very probably the composition represents a version of Rembrandt's *Danae*. In addition, Picasso's figure has an air of being larger than life, almost a giantess, recalling a goddess of antiquity in her combination of majesty with playful insouciance.

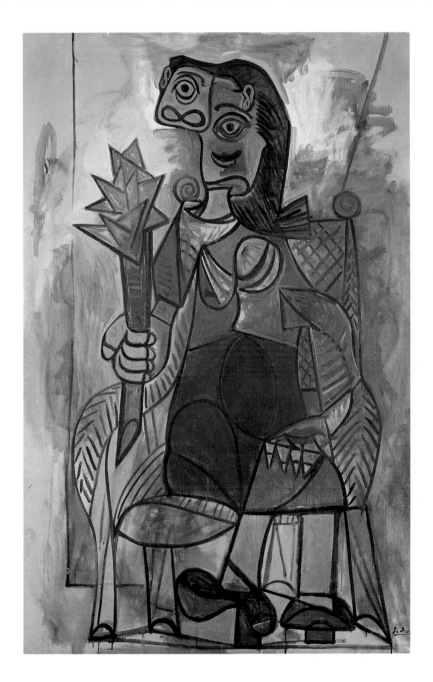

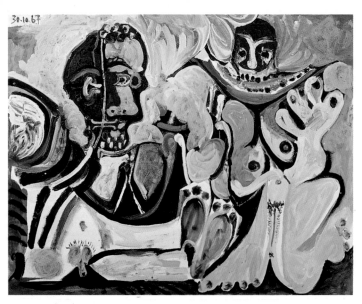

◄ **Pablo Picasso**
Melon Eaters, 1967
Mangeurs de
pastèque

Oil on canvas
114 x 145 cm

Ludwig Donation,
1976

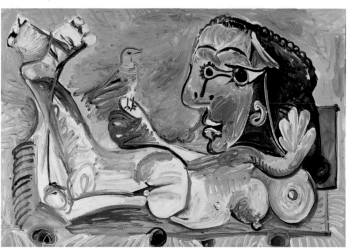

◄ **Pablo Picasso**
Reclining Nude
with Bird, 1968
Nu couché
à l'oiseau

Oil on canvas
130 x 195 cm

Ludwig Collection

► **Pablo Picasso**
Woman with Baby
Carriage, 1950
Femme à la voiture
d'enfant

Plaster, terracotta,
ceramic elements,
metal, cake molds,
and baby stroller seat
203 x 145 x 61 cm

Ludwig Donation,
1994

▶ **Pablo Picasso**
Bowl with Fauns'
Heads, 1961
Vasque ovale avec
têtes de faune

Faience, slip painted
under glaze
22.5 x 72.5 cm

Ludwig Collection

▶ **Pablo Picasso**
Luncheon on the
Grass
(after Manet), 1961
Le déjeuner sur
l'herbe

Oil on canvas
60 x 73 cm

Ludwig Collection

◀ **Pablo Picasso**
Musketeer and
Cupid, 1969
Mousquetaire
et amour

Oil on canvas
194 x 130 cm

Ludwig Donation,
1976

◄ **Otto Piene**
Fire (Red and Black on White), 1962
Feuer (Rot und Schwarz auf Weiss)

Oil and pigment on canvas
110 x 110 cm

Piene, Otto

1928 Laasphe, Germany
Lives in Boston, Massachusetts

Shortly before executing *Fire (Red and Black on White)*, Otto Piene published, in 1961, a programmatic text called *Ways to Paradise* in the journal *Zero*. "A glance into the sky, into the sun, over the ocean," he wrote, "is enough to show that the world outside man is larger than the world within him, that it is so enormous that man needs a medium that transforms the power of the sun into a luminosity." The founder of the Zero group – a name suggestive of the tense countdown before a missile launch – intended his paintings in light and smoke, his *Light-Ballets*, and his sculptures floating free in space, to convey the beauty of the natural elements to a wider audience.

The technique of drawing with smoke was suggested to Piene by the sight of candle soot flowing through perforated foil and settling on its edges. In 1960 he began to ignite pigments on paper and canvas. For the work in the Museum Ludwig, Cologne, a circle of red pigment was burned from the center outwards, and then treated with fixatives and varnishes such that the sooty black surface became partially reflective, picking up nuances of light, and giving the circle the appearance of a pulsating "black sun."

After working as a restorer of paintings from 1947 to 1958, Michelangelo Pistoletto began in 1962 to make mirror-pictures of highly polished steel with collage elements, in which the mirror image of their immediate surroundings and the viewer were integrated.

Our sense of being part of the image is increased by the life-size scale of the works. Viewing *Demonstration No. 2* (1965), we have the choice of joining the ranks or remaining an uncommitted bystander. The work is part of a series employing shapshots of political events by Renato Rinaldi. "One of the most consistent of Pistoletto's groups of works," wrote M. Friedmann, "shows marching men and political demonstrators. Yet these paintings are intended to be apolitical, and are generalized to such an extent that, in addition to their environment, they include almost all polarities between active and passive. These polarities, as various and contradictory they may be, are abstracted on the same impersonal level... The figures depicted, in their evident devotion to their cause, seem to gaze into themselves rather than into the outside world. They are like archetypes of loneliness. Isolated from their original context and self-contained, they become participants in

every new situation in which they find themselves. These invariably and uniformly dignified individuals are independent of their fellow humans, and seem to exist in a vacuum."

Pistoletto's work challenges us to consider the ways life can be reflected in art. "The meaning and the result of my mirror-paintings," he stated, "was to carry art to the borderline of life."

Pistoletto, Michelangelo

1933 Biella
lebt in Turin

◄ **Michelangelo Pistoletto**
Demonstration No. 2, 1965
Comizio No. 2

Collage on polished steel
215 x 120 cm

Ludwig Donation, 1976

Plessi, Fabrizio

1940 Reggio Emilia,
Italy
Lives in Venice

▼ Fabrizio Plessi
Electronic Ruin, 1995
Rovina elettronica

*Video installation
approx.*
110 x 800 x 300 cm

Loan of
Ursula-Blickle-
Stiftung

Fabrizio Plessi adamantly refuses to be labelled a video artist, preferring the longer but more exact description, "an artist who uses television monitors." Unlike most of his colleagues, the Italian artist has had no technical training in the field of video or film. His employment of the medium grew out of his experiences with Arte Povera. In an interview with Evelyn Weiss, Plessi said, "I have always used the electronic media – or, more precisely, television – as nothing more than a material, just any material, more or less like iron, coal, straw, or marble."

Plessi relies on the principle of simulation to explore the way in which we perceive nature today, in the age of virtual reality. His *Electronic Ruin* alludes to the concept of artificiality. The stone walls of the sculpture are real, but the water flowing down the video screens between them is pure illusion. This incessant contradiction between reality and simulation in Plessi's works has placed his installations at the center of the late-twentieth-century philosophical debate. For those living in the post-industrial age, it is often difficult to distinguish the real from the artificial. Our experience of nature is mediated through technology – television and film, simulated natural habitats like those in gardens, zoos, and theme parks, through artificial aromas and food coloring, synthetic fibers and fur coats.

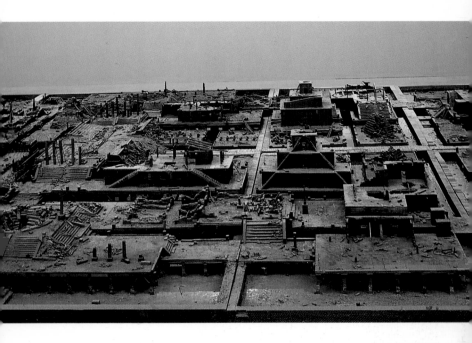

Ausée, the Black City is the first of six large constructions made of thousands of pieces of burnt wood and charcoal by Anne and Patrick Poirier. This series of black architectural models, or "black rooms," as they call them, were made in 1975–1978 as a result of the artists' studies of the labyrinthine, burned-out ruins of Nero's palace in Rome, studies they collectively title *Domus Aurea* (Golden House). For the Poiriers, the Domus Aurea with its long, subterranean corridors and sequences of blackened rooms, symbolizes the dreams and myths of cultural memory. The artists describe their works as "mental land-scapes" or "mental architectures." They set out to create "spiritual" or "poetic spaces." Each architectural element or quarter of *Ausée* has its own purpose, which in connection with the other elements takes on an expanded meaning, in accordance with the political functioning of a city. Each of these model-like sites has its "history," which consists either in a myth or a utopia. The city of *Ausée* at once reflects and produces both.

Poirier, Anne and Patrick

Poirier, Anne
1942 Marseille, France
Lives in Paris

Poirier, Patrick
1942 Nantes, France
Lives in Paris

▲ **Anne and Patrick Poirier**
Ausée, the Black City, 1975

Cork sheets, drawing charcoal approx. 1000 x 500 cm

Ludwig Donation, 1994

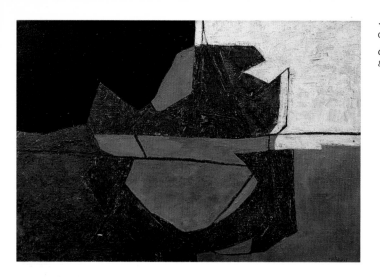

◄ **Serge Poliakoff**
Composition, 1952

Oil on jute
89.5 x 130.5 cm

Poliakoff, Serge

1906 Moscow
1969 Paris

It was not until 1930 that Poliakoff, who had settled in Paris in 1923, turned from music to painting. He was encouraged to do so by Wassily Kandinsky, Otto Freundlich, and Sonia and Robert Delaunay. Poliakoff soon developed an original abstract style based on flat, interlocking geometric and free forms, arranged in carefully balanced compositions.

This approach is seen to good effect in *Composition* of 1952, which Helmut Leppien has described as follows: "The construction of the picture is simple, almost heraldic. A complex central form appears against four fields, black and a light, ocher-tinted sand color, ultramarine blue and an intense, matte wine red; the form in the center, projecting, rent open, is horizontally divided into red below and dark green above... This conjunction and collision of forms is played around by a sparing linear network, which emphasizes the division of the fields by means of a few verticals and horizontals, and underscores the broad, poised, quiet appearance of the central form by means of two almost parallel horizontals... The image emanates... an austere calm. This results not only from the lapidary formal idiom, from the precision and concentration of the composition, but above all from the fact that Poliakoff achieves an equilibrium among manifold tensions, brings drama to the point of stillness."

► **Sigmar Polke**
Head, 1966
Kopf

Oil on canvas
197.5 x 305 cm

Trained at the Düsseldorf Academy, Sigmar Polke painted a series
of mostly large-format pictures from 1962 to 1969 in which mundane
imagery from press or advertising photos, articles of clothing or vaca-
tion motifs, were translated into screened patterns and superimposed
on the surface, usually in several levels.

When seen in close proximity, the screen dots appear to be ran-
domly distributed across the surface, but with increasing distance they
begin to cohere into objective configurations. The moiré effects created
by their partial overlaps engender a sense of depth, and also bring
about perceptual irritation.

Polke's painting *Head*, done in 1966, derives its tension principally
from a contrast between the amorphous mass of pastel-colored screen
dots and the flowing, expressively distorted outlines of a head which
they pull together to form. The image does not have the appearance
of something final, but merely of a momentary condensation of a
matrix of dots, in which other formative possibilities are inherently

Polke, Sigmar

1941 Oels, Lower
Silesia, Germany
Lives in Cologne

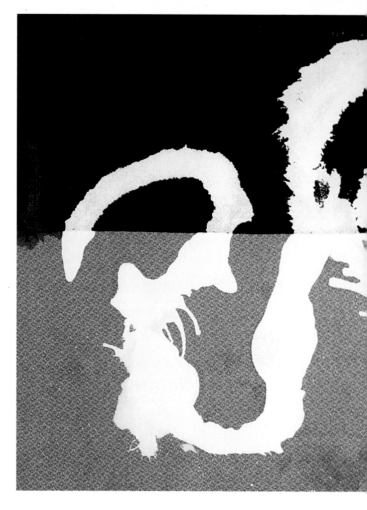

present. The lineatures, recalling the after-images of moving light sources, likewise underscore the transitory nature of the perceived image.

Potential change and ambiguity of perception also play a key role in Polke's huge work *Untitled* of 1986. Here, white paint was poured across the surface, in an act partly determined by chance, and partly controlled by conscious will. The result is an abstract arabesque which nonetheless contains many suggestions of objective reference. One

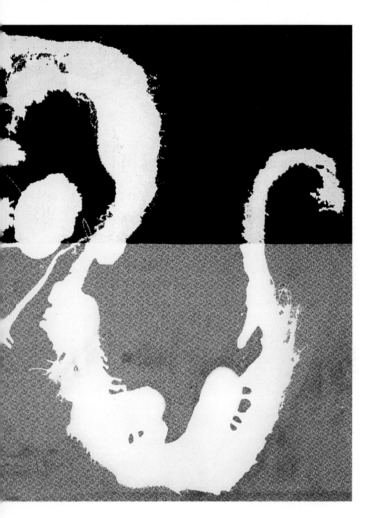

◄ **Sigmar Polke**
Untitled, 1986

*Dispersion on
tweed and woven
Persian lamb fabric
300 x 500 cm*

Gift of
Association for
Modern Art at the
Museum Ludwig,
Cologne, 1990

commentator points out its similarity to a ram's skull, a reference that,
together with the surface consisting of imitation Persian lamb and
tweed fabric, gives much food for thought concerning the processes
of organic growth and transformation, and the interplay of reality and
illusion.

Pollock, Jackson

1912 Cody, Wyoming
1956 East Hampton, New York

▼ Jackson Pollock
Black and White No. 15, 1951

Synthetic lacquer on canvas
142.2 x 167.7 cm

In late 1951 Betty Parsons showed about 22 paintings by Jackson Pollock in her New York gallery. All of them were done in a single year, using Duco lacquer on unprimed canvas, and bore only numbers as titles. Pollock was quite aware that these paintings marked a decisive turning point in his development. While the phase prior to and around 1945 had still been clearly figurative in thrust, from 1945 to 1950 Pollock painted large-scale abstract compositions, huge canvases to which the paint was applied in wildly spontaneous gestures recalling Surrealist automatism, to produce a sense of labyrinthine webs or proliferating growths.

It was during this period of Action Painting, from 1946 onwards, that Pollock systematically developed his famous "dripping technique." The technique had already been tested in the experimental workshop

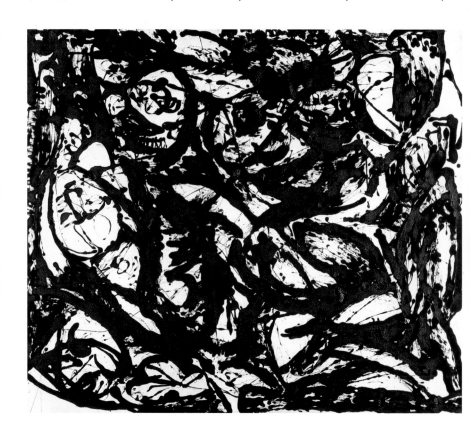

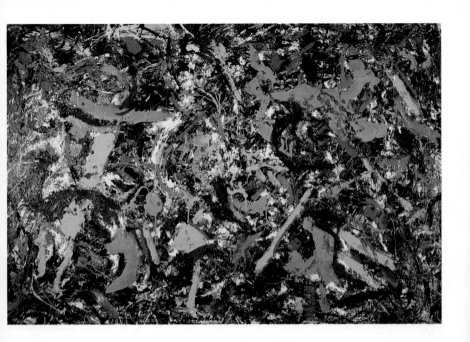

of David Siquieros, where Pollock worked in 1936 after studying with
landscapist Thomas Hart Benton (1931–1932), and Hans Hofmann,
at whose painting school Pollock's wife, Lee Krasner, had been a student,
had experimented with dripping as well.

 As critic Barbara Rose noted, Pollock worked on his canvases on
the floor rather than on the wall. He did not prime the surface but let
the paint drip and flow directly onto the raw canvas, which absorbed
the first paint layers. Since he approached the painting from all sides,
he could give every part the same weight, and did not need to orient
or balance the composition in any particular direction. Though the
creative act was radical and spontaneous, said Rose, it nevertheless
allowed of alterations. One of Pollock's last decisions was to determine
the final dimensions of the painting by cutting it out of the canvas and
attaching it to stretchers.

▲ **Jackson Pollock**
Unformed Figure,
1953

Oil on canvas
130 x 195.5 cm

Ludwig Collection

Pomodoro, Arnaldo

1926 Morciano
di Romagna, Italy
Lives in Milan

▼ Arnaldo Pomodoro
The Mathematician's
Table No. 2, 1961
La tavola del
matematico No. 2

Lead
59 x 39.5 cm

After completing his training in architecture and an apprenticeship as a goldsmith, Arnaldo Pomodoro went on to work in sculpture and stage-set design. In 1954 he joined forces with his brother, Giò, and Georgio Perfetti to establish the Studio 3P in Pesaro, where they devoted themselves to decoration and goldsmithing. Pomodoro's earliest sculptures were reliefs, followed by free-standing pieces, mostly in bronze. These monumental works were usually conceived for an architectural context, as for example the 24-meter-high bronze and concrete relief Pomodoro created in 1964 for the Josef Haubrich Court at the Volkshochschule, Cologne. In the early 1960s three-dimensional geometric shapes began to characterize Pomodoro's style. By this time his international reputation had been established, when his work was shown at the 1956 Venice Biennale. Pomodoro's *The Mathematician's Table No. 2* (1961) combines

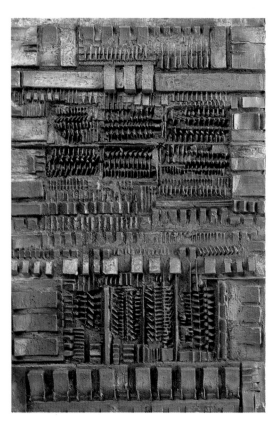

a vital play of form with a system of finely articulated textures. Modular boxes and tablets alternate with incisions and apertures, which in turn are drawn together by means of polished spheres and columns. The result is a cellular configuration which evokes a contemporary technological vocabulary for the description of natural, human, and cosmic systems of order. Such structures are condensed in *The Mathematician's Table* into a sign system, a process analogous to the development of the semantic systems with which individual cultures attempt to make themselves understood to their neighbors. In various of the shapes one can detect echoes of technological relics, which call to mind associations with instruction diagrams, circuit boards, or computing machines.

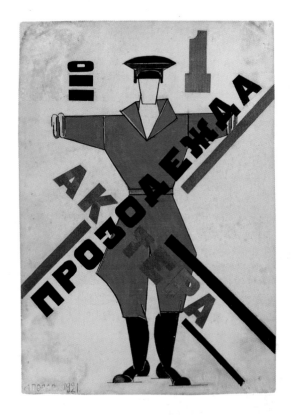

▶ **Liubov Popova**
Actor's Costume
No. 1, 1921

Collage and gouache
on paper
34 x 24.1 cm

Ludwig Collection

Liubov Popova's œuvre has now come to be considered a culmination point of the Russian avant-garde. In addition to Cubist influence, her development was lastingly shaped by Italian Futurism, especially as practiced by Umberto Boccioni. Boccioni's central concern was to define the relationship, and describe the tension, between objects and the surrounding space. By the same token, Popova's *Seated Female Nude* evinces a complete integration of the figure in space, created by allowing the planes to penetrate the figure, whose dynamic forms in turn are echoed across the entire pictorial field.

Popova's great mastery of the Cubist idiom is seen in the highly condensed 1914 composition *Still Life with Violin*, in which letters and word fragments are integrated in a way that alternately underscores and counterpoints the dynamic movement of the whole. In 1915 the artist took a further, logical step along lines demonstrated by Boccioni.

Popova,
Liubov

1889 Ivanovskoye,
near Moscow
1924 Moscow

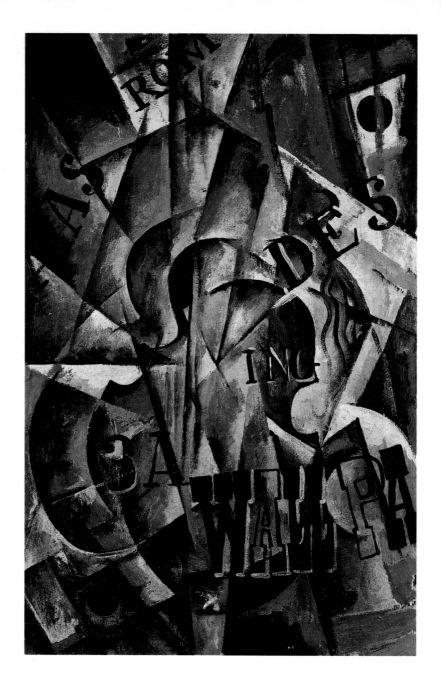

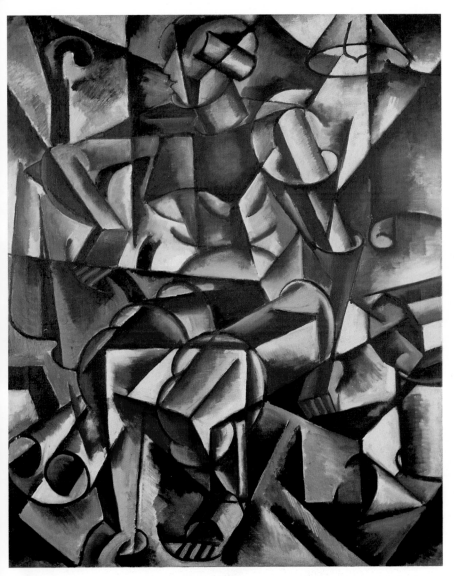

◀ **Liubov Popova**
Still Life with Violin,
1914

Oil on canvas
88 x 57.5 cm

Ludwig Collection

▲ **Liubov Popova**
Seated Female
Nude, c. 1913–1914

Oil on canvas
106 x 87 cm

Ludwig Collection

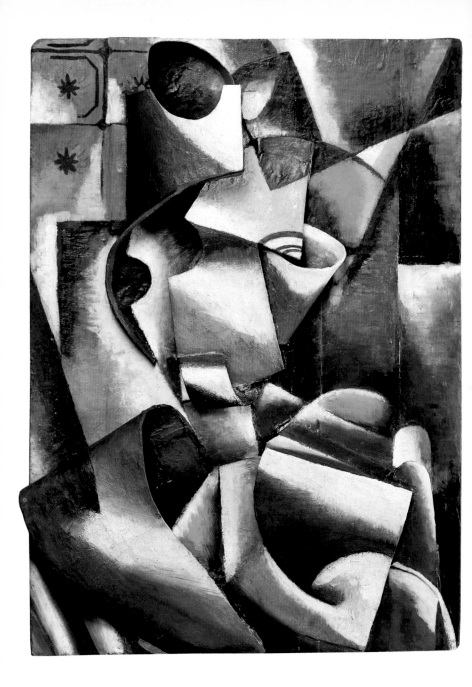

◄ **Liubov Popova**
Portrait of a Woman
(Relief), 1915

Oil on paper,
cardboard and wood
66.3 x 48.5 cm

Ludwig Collection

► **Liubov Popova**
Painterly
Architectonics,
c. 1920

Oil on canvas
57.5 x 44 cm

Ludwig Collection

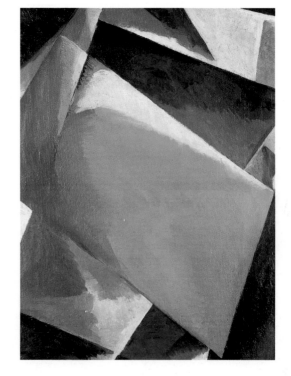

She banned objective elements entirely from the painting, and developed the surface into three-dimensional relief. Popova's 1915 *Portrait of a Woman (Relief)* is a unique blend of painting and sculpture, a system of interlocking, brilliantly hued forms. Among the last paintings she executed before turning to designs for porcelain, textiles, books, and stage sets, was *Painterly Architectonics* (c. 1920), which bears a direct relationship to Kasimir Malevich's Suprematism. Although the work is completely abstract, it nevertheless possesses a very strong emotional undertone. Popova's *Actor's Costume No. 1* (1921) was done in connection with stage designs for the play *The Cuckold,* premiered in Moscow in 1922, which marked the artist's breakthrough after two years of theater work.

◄ **Enrico Prampolini**
Magic Vision, 1931
Visione magica

*Oil on canvas
on hardboard*
109.5 x 137 cm

Loan of
VAF-Foundation,
Switzerland

Prampolini, Enrico

1894 Modena, Italy
1956 Rome

Enrico Prampolini's manifesto, *Let's Bomb the Academies,* drew
the attention of Futurist Umberto Boccioni to the young artist. He
contacted him, and soon Prampolini joined the Futurist movement.
Until his death in 1956, Prampolini remained true to the principles
of Futurism, while continuously developing his own art theory with
a view to the latest technological and scientific insights in the fields
of space travel, biochemistry, and geology.

Magic Vision (1931) was done in Paris, where the artist had lived
since 1925. During this period, under the influence of French Surrealism,
he turned to psychological themes and relinquished his previous,
strictly tectonic approach to composition. In the present work a shape
resembling a continent hovers in space, confronted by a visionary
head with the features of a humanoid ape. Its gaping mouth seems
to receive nourishment from a tube like an umbilical cord, as if the
insatiable creature were drinking the continent dry. Between them
floats the diaphanous, light-blue figure of a woman, which seems
to merge into the depths of the universe. The scene of the events
portrayed recalls much of Prampolini's cosmic imagery, yet the
objective references of *Magic Vision* place it firmly within the Surrealist
orbit.

Dimitri Prigov studied at the Stroganov Institute of Art and Design, then was employed in the Moscow Department of Architecture and at the Lichatshov Automobile Factory as a teacher and architect. He belongs to the group of Moscow Conceptualists led by Ilya Kabakov. A sculptor, graphic artist, and poet (by 1988 he had written over 12,000 poems), Prigov concerns himself with the reciprocal relationship between word and image. As a support for his generally large-format works on paper, he usually employs the Soviet newspaper *Pravda*.

By isolating individual words from their context Prigov intends to transform them into autonomous concepts, that is, names. "Power resides in names – call something by its name and it will complete everything for you of its own accord," states Prigov. "On the whole, Russian culture tends to this kind of verbal magic – it places great store by names. For instance, in Russia it is enough to say, 'We are building Communism,' to make us all believe we have already built it. As soon as a word has been uttered twice, it becomes an incantatory formula. This is what happened with the much-proclaimed 'glasnost' – an overuse of the word led to a loss of meaning, changed it into a magic spell. My job is to reflect this dangerous process."

Germany – Russia of 1989 not only alludes to the political, economic, and cultural relations between the two countries but reflects the personal biography of the artist, who since the mid-1980s has been living and working in both Moscow and Berlin.

Prigov, Dimitri

1940 Moscow
Lives in Moscow
and Berlin

▲ Dimitri Prigov
Germany – Russia,
1989
Deutschland –
Russland

Ink, ballpoint pen,
and gouache
on newspaper,
plastic covers
90 x 235 cm

Ludwig Collection

Puni, Ivan
(Jean Pougny)

1894 Kuokkala,
Russia
1956 Paris

The young Ivan Puni was intended for an army officer's career, but at the age of 18 he left the military academy and rented a studio in St. Petersburg in 1909. The following year Puni went to Paris, to study art at the Académy Julian. He returned to St. Petersburg in 1912.

Puni's early work was influenced by the French Fauves; later he turned to Suprematism. His *Sculpture (Archive 546 B)* is one of a major group of reliefs created in 1915–1916, in which the principle of collage is translated into three dimensions. These constructions of ordinary materials (wood, cardboard, tin) and existing objects (in this case, a piece of corrugated metal) show a limitation of formal means and clarity of composition that brings them into proximity with Suprematism. Though some of the components appear movable, they are actually fixed. Yet their apparent mutability serves to suggest the potential variety of pictorial possibilities. Convex shapes alternate with flat planes, untreated material with sparsely painted passages.

In 1919, a year before his move to Berlin, Puni began a series of paintings with letters of the alphabet, which, with his reliefs, mark an apex of his creative work. That same year saw the emergence of *The Clock*. The focus of the composition is on a clock face, shifted slightly off-center, from which the Roman numerals appear to be detaching themselves and floating away. The hand protruding from the clock face takes on the character of an autonomous, Constructivist element, just as the remainder of the shapes serve not so much to convey specific content as to determine the formal design. One name, P. Bure (in Cyrillic) is easily readable. As this indicates, the painting was likely intended as an advertising sign for a watchmaker, one of the many commercial jobs Puni took on in Russia, as later in Berlin and Paris.

The 1919 *Composition with Playing Cards* is likewise legible, this time as dealing with the theme of gambling. The player's hand at the left, and his head with monocle and cigar above, are just as immediately present as the green gaming table and the cards themselves. The Russian words designate the cards ace of clubs (above) and ace of spades (below).

▶ **Ivan Puni**
Sculpture
(Archive 564 B), 1915

*Sheet tin and
cardboard on wood,
painted*
70.5 x 40.5 x 12 cm

Ludwig Collection

◄ **Ivan Puni**
The Clock, 1919

Oil on cardboard
43 x 65.5 cm

Ludwig Collection

◄ **Ivan Puni**
Composition with
Playing Cards, 1919

Oil on cardboard
72 x 45.7 cm

Ludwig Collection

Low Floor Works is the collective title of the sculptures David Rabino-witch has created since 1966. They continue one tendency within Minimal Art towards "horizontal" sculptures, which made their mark at the sculpture department of the 1977 documenta VI. Yet rather than representing a new stylistic direction, these pieces, as Manfred Schneckenburger notes, embody "a possibility of making the actual experience of space" as one walks around them "an integral part of the sculptural effect."

As the detailed title indicates, relationships of various kinds play a key role in *Elliptical Plane*. In order to discover these relationships and the variety of their external appearance, the viewer is compelled to walk around the piece. And since *Elliptical Plane* is based on an asymmetric scheme, it continually changes with our changing view-point, confronting us with ever-new relationships between the three constituent forms and the overall form. In an amazingly simple way, the piece demonstrates the reciprocal dependence between a whole and its parts. Like the Cubists, writes Th. Lawson, Rabinowitch employs his construction of an "illusion" as an element to define and articulate the structure of perception itself. Certainty about the "reality" of his art is achieved only by way of distortions. Here, distortions veritably form the basis for a definition of the real.

Rabinowitch, David

1943 Toronto
Lives in New York

▲ **David Rabinowitch**
Elliptical Plane
in 3 Masses and
2 Scales, 1973–1974

Solid steel
7.7 x 305 x 274 cm

Radziwill, Franz

1895 Strohhausen,
Weser, Germany
1983 Dangast

Franz Radzwill is considered a leading representative of Magic Realism and Neue Sachlichkeit (New Objectivity). These styles emerged in reaction to the excesses of Expressionism, and frequently had a social-critical tendency, as in the work of Radzwill's friends in the Berlin Novembergruppe, to which George Grosz and Otto Dix belonged.

Radziwill concentrated on the theme of humans living in an alienated environment. A significant example of his approach is *The Street* of 1928, with its forbidding brick building illuminated by cool, pale light and street almost devoid of human activity. The buildings have the appearance of fortresses jutting into the preturnaturally dark sky, where a biplane circles. The precise, if you will cold-blooded rendering draws the viewer inexorably into the scene. Architecture, technology, and the hallucinatory effect of the silvery plane against the pitch-black clouds add up to an aesthetic vision of imminent threat and destruction. Like his colleagues in Berlin, Radziwill was defamed as a "degenerate artist" and was released from his post as professor at the Düsseldorf Academy.

Experimental painter Arnulf Rainer was self-taught, beginning in 1947 to make surrealistically objective drawings which gradually burgeoned into abstract structures with a nearly monochrome black coloration. He became known in 1953 with the first of a series of "overpaintings," to which *Violet-Red Vertical* belongs. In these works Rainer obscured existing paintings, his own and other artists', in a destructively creative process he himself explained in 1977 as follows: "Painting develops in order to absorb painting, to devalue and bury it. The art scene in the big cities is increasingly becoming a battlefield, a massacre – a free-for-all, every man for himself... The tendency of this black painting: To annul everything impermanent, fuzzy, pedantic, nervous by permanent overpainting."

Describing his working procedure, Rainer said, "In contrast to action overpainting, monochrome overpainting unfolds slowly. Because... the painter has to patiently wait and watch until the next spot to be overpainted makes itself unpleasantly felt."

In 1964 Rainer began to experiment with drugs, which resulted in hallucinatory figurative drawings and painted, distorted photographs. Enlarged snapshots of his own grimacing face, and later, photographs of female acrobats, lesbians, women in trance or a state of sexual ecstasy, death masks, and rock formations inspired him to an increasingly rapid, impulsive, and sketchier style, and led to an expansion of Rainer's visual vocabulary. The use of the human body as a means to express psychological states, and a belief in the value of altered consciousness and the capability of the mind to transcend the human condition, link Rainer with Yves Klein. The two artists also share the belief in the healing power of art for society.

Rainer, Arnulf

1929 Baden, near Vienna, Austria

Lives in Vienna and Vornbach Monastery

◄ **Arnulf Rainer**
Violet-Red Vertical,
1961
Violettrot vertikal

Oil on canvas
200 x 130 cm

Ludwig Donation,
1994

Rauschenberg, Robert

1925 Port Arthur, Texas
Lives in New York

Texas-born Robert Rauschenberg has become one of the major American artists of the postwar period. In his early "combine paintings," done in 1953–1954, Dadaism celebrated a revival, and the emergence of Pop Art was anticipated. After a comparatively academic course of studies in the US and Paris, Rauschenberg turned his back on the Abstract Expressionism that then dominated the art scene. Instead of refusing to address the realities around him he began to quote things and events from the mundane environment, to integrate real objects into his paintings, and, concomitantly, to inquire into the nature of human perception.

Rauschenberg's *Odalisque* alludes to the painting of that title by Jean Auguste Dominique Ingres, of 1808 (Paris, The Louvre). As we walk around the three-dimensional piece, a multiplicity of associations come to mind: The pierced, crushed pillow recalls the beautiful silk cushion on which the nude in Ingres's painting sits. A stuffed but still proud rooster, perhaps standing for a papagallo or macho male, perches atop a box whose rickety, temporary character cannot be belied. The exquisitely decorated salons of the neoclassical era have evidently been reduced here to a makeshift container illuminated by flickering light, suggesting some sleazy bordello. On the other hand, the box has been interpreted as symbolizing the odalisque's body. The collages of pin-up girls might indeed be the successors of Ingres's lovely ladies, and they are confronted with icons of exaggerated masculinity – boxers, baseball players, bullfight scenes.

In his three-part work *Allegory* Rauschenberg showed his close affinity with Kurt Schwitters. The inclusion of an actual, red umbrella and a piece of battered sheet metal expanded the visual means at artists' disposal. By combining brushwork in the mode of Action Painting, collaged paper, torn fragments of posters, fabric and metal, Rauschenberg produced a whole that is both rife with tension and strangely homogeneous, a work that straddles the borderline between object and painting.

The combine-painting *Wall Street* represents the world-renowned financial center not in terms of its familiar image of soaring office buildings but in terms of its sleazy side. The artist has integrated elements of the anything-but-idyllic downtown life of New York: a barrier running right across the picture and connected to a worn fire hose, which extends into the surrounding space, linking pictorial world with real world.

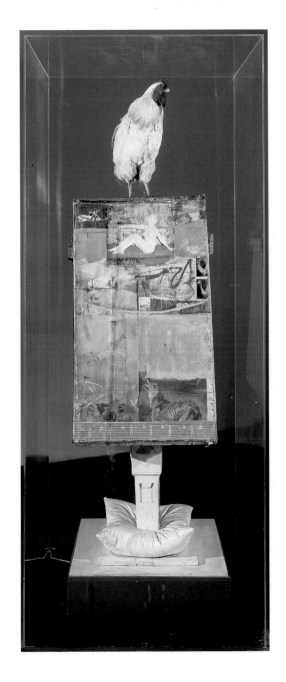

► **Robert
Rauschenberg**
Odalisque,
1955–1958

*Wood, fabric,
wire, grass, paper,
photographs,
metal, cushion,
stuffed rooster,
four light bulbs
205 x 58 x 58 cm*

Ludwig Donation,
1976

This endeavor to bridge the gap between art and life is even more apparent in the contemporaneous work *Black Market*. Rauschenberg wanted to release museum visitors from their role of passive observers and encourage active participation in the work. On the floor beneath the combine-painting of found objects he placed a suitcase, filled with everyday utensils, rubber stamps, and stamp pads. Onlookers were invited to exchange one of the four objects for something they had brought with them, and to record the swap on the painting (hence the "black market" reference). By including viewers in the work's process of emergence, the gap between viewer and artist could be overcome, thought Rauschenberg. Yet since his own drawings, also in the suitcase, were soon found missing, the experiment had to be abandoned.

In the early 1960s Rauschenberg began to experiment with new techniques, especially with serigraphy and offset printing. An example of the former is *Axle*, which focusses on events of the year 1964, the most notorious and harrowing of which was surely the assassination of John F. Kennedy.

Bible Bike is part of the series *Borealis*, executed for the most part between 1989 and 1991. With this sequence the artist once again

▼ **Robert Rauschenberg**
Allegory, 1959–1960

Oil on canvas, metal, umbrella, three parts 183 x 305 cm

Ludwig Donation, 1976

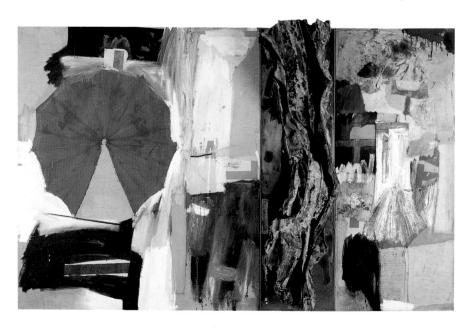

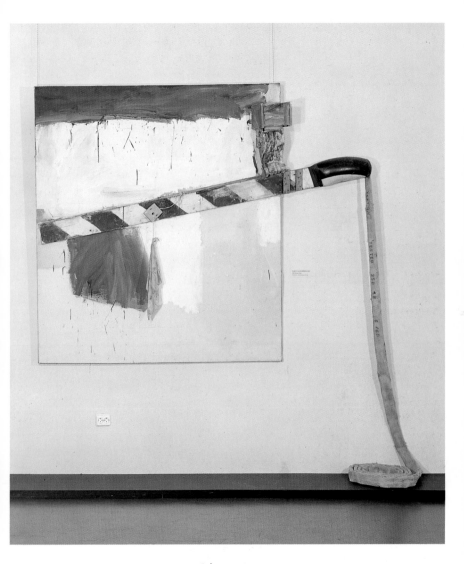

▲ **Robert
Rauschenberg**
Wall Street, 1961

*Canvas, paper,
sheet zinc, wood,
fire hose, oil paint
182 x 226 cm*

Ludwig Donation, 1976

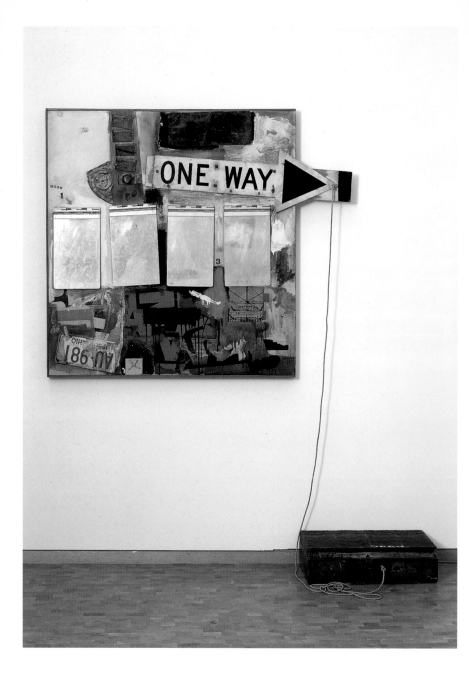

expanded both the range of his media and his technique of a multiple superimposition of visual levels. The slightly reflecting surface of the metal plates was treated with acid, and partially painted and printed over. Rauschenberg allowed the acid to flow across the surface or distributed it in a manner akin to paint on canvas.

The title *Borealis* refers to the Aurora Borealis, the Northern Lights, which the artist saw for the first time on a trip to Sweden. The play of light in the atmosphere reminded him of the rainbow opalescences of his corrosion paintings. The dark-hued and yet shimmering *Bible Bike*, stringently composed yet overlain with violent gestural brushwork, is ambivalent in terms of style and message. Though at first glance the beauty of the colors seems to triumph over the debris of civilization pictured, a closer view reveals the corrosively destructive source of the iridescent surface effects.

▲ **R. Rauschenberg**
Bible Bike (Borealis), 1991

Brass plate, copper, bronze
246.4 x 337.8 cm

Loan of Trustees and Supporters Association of the Wallraf-Richartz-Museum and Museum Ludwig, Cologne

◄ **R. Rauschenberg**
Black Market, 1961

Canvas, wood, metal, oil paint
152 x 127 cm

Ludwig Donation, 1976

▲ **Robert
Rauschenberg**
Axle, 1964

*Oil and silkscreen
on canvas, four parts
274 x 610 cm*

Ludwig Donation,
1976

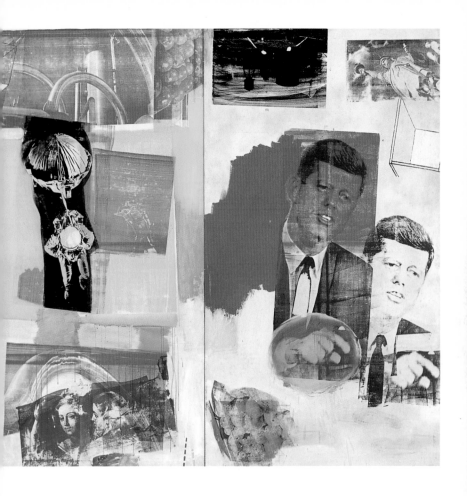

Ray, Man

1890 Philadelphia
1976 Paris

▼ **Man Ray**
Lampshade, 1919
(1964)

*Sheet steel, painted
white*
height approx. 87 cm

A number of unprecedented art forms go back to the experiments of Man Ray, whose career began as a commercial artist in New York. After beginning a collaboration with Marcel Duchamp in 1916, Ray soon advanced to become a major proponent of Dadaism and Surrealism. In 1918 he introduced the technique of aerography, or airbrush painting, into fine art, and in 1922 he invented Rayograms, photographic images produced by placing objects directly on the photo paper and exposing them. Ray also developed innovative techniques in the fields of film-making and photomontage, and he participated in numerous Dada publications. His painting and drawing skills resist stylistic categorization. Following the initial, Cubist-influenced paintings, Surrealist and Constructivist elements came increasingly to the fore. Ray's sculptures were generally made by the assemblage method, a combination of prefabricated elements – ready-mades – whose unfamiliar juxtaposition sparked new, often Surrealist meanings. His best-known works, apart from the mysterious, wrapped object and the antique Greek or Roman sculptures tied with string, include the *objets dangereaux* – objects whose familiar functions are altered to the point of risk to life and limb.

In 1919 Man Ray hung a damaged, spiral-shaped paper lampshade from the ceiling of his New York studio (where he worked from 1921 to 1940, going to Paris in 1951). In the 1920s he had several reproductions and enlarged versions of the *Lampshade* made in metal. The version illustrated, which comes packed in a hat box, is a later copy, a reproduction of a ready-made. The spiral, a frequent shape in Man Ray's repertoire, can be set in motion by the slightest touch or draft of air.

▶ **Man Ray**
Return to Reason,
1936
Retour à la raison

Oil on canvas
200 x 124.5 cm

**Raynaud,
Jean-Pierre**

1939 Courbevoie,
near Paris
Lives in La Celle-
St. Cloud, near Paris

In 1993 Jean-Pierre Raynaud designed the French Pavilion at the 45th Venice Biennale, covering the walls with white tiles on which a single motif was repeated 13,000 times: a Neolithic skull. These white tiles became Raynaud's trademark in 1988 at the latest, when he used them to furnish the interior of a private house in Paris, from top to bottom. His black-grouted tiled spaces multiply perspectives to infinity, but at the same time they point up the total absence of perspective embodied in clinically clean prison cells, death chambers, and morgues.

The relics of a sterile society, which marginalizes or eliminates abnormalities, have been employed by Raynaud from the beginning in what he calls his "psycho-objects," flower pots, traffic signs, emergency exits, or fire extinguishers altered to produce the most eerie effects.

Human Space (1995) is a variation on the untransportable interior installation Raynaud designed for the Biennale. According to the artist, the work was intended to "create a link with our soul, which is a faithful reflection of our body, which engenders our desires and troubles." Indeed the piece lays bare the human soul as if in a panorama, but one which, unlike those popular in the nineteenth century, has no ambition to tell a story. Though the skull may be readily understood as an over-

▼ Jean-Pierre
Raynaud
Human Space, 1995
(detail)

worked and overly obvious symbol of the vanity of human effort, the true complexity of the work is felt when one actually stands inside it, surrounded by countless images from the early era of human existence which gradually gel, in one's own mind, into an emblem of an artistic endeavor to express an experience of the elemental nature of life and death in space and time. In this way, the mental space functions as a bridge between past and present.

Another path of transition opens between the apertures

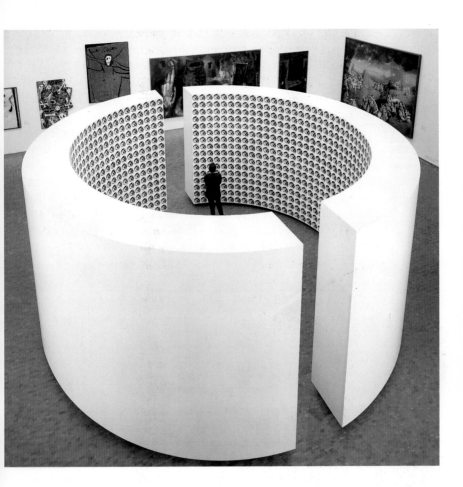

situated on opposite sides of the two tiled semicircles, which mitigate
the hermetically sealed character of this mental enclosure. Interior
and exterior, subjective feeling and circumscribing physical reality,
can enter a dialectical relationship, such that the panorama of personal
traumas and longings, the exploration of the psyche intended by
Raynaud, ultimately proves to be a mirror of societal conditions.
With his multiplication of a prehistorical relic, the artist becomes an
archaeologist exhuming the here and now.

▲ **Jean-Pierre
Raynaud**
Human Space, 1995

*Installation:
ceramic tiles
on aluminum
height 340 cm, inside
diameter 600 cm,
wall thickness 80 cm,
each tile 20 x 20 cm*

Ludwig Collection

Raysse, Martial

1936 Golfe-Juan,
near Nice, France
Lives in Nice,
New York, and
Los Angeles

▼ **Martial Raysse**
She, 1962
Elle

*Fluorescent paint
on cardboard and
photograph*
182.5 x 132.2 cm

Ludwig Donation,
1976

French painter and object-artist Martial Raysse was among the founding members, in 1960, of the Nouveau Réalistes group of artists. At that time he began to make assemblages by integrating real objects from the realm of consumer goods and advertising into his paintings, an approach that brought him into proximity with American Pop Art.

She is based on a cut-out, enlarged, and thinly overpainted photograph. The background is entirely covered with a bright fluorescent red in which the face appears to float. Raysse purposely chose a cliché image of femininity, a model with a bouffant hairdo and mascaraed lashes who gives us a come-hither look from beneath slightly lowered eyelids. Hair and mouth are set off from the blue complexion by strongly contrasting green and red. Cut off from the painting edges and the surrounding space, *She* hovers like an ironic and faded cult-image in the shimmering visual interferences of the surface, whose hues, even in the area of the mouth, seem so blatantly unreal.

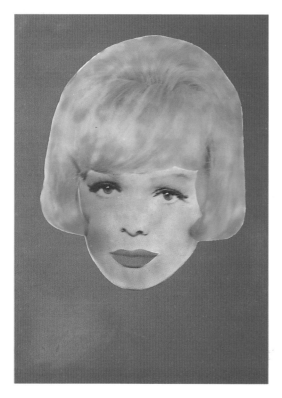

Critics have described Raysse as the proclaimer of a myth of happiness and beauty, which eliminates transience and death with aseptic precision. In this dream everything is artificial: artificial light (neon), artificial colors, artificial flowers, artificial women. Raysse truly moves masterfully in this borderline realm of dream and illusion. Otto Hahn has described the French artist as one of the few creators of "myths incessantly in search of the paradise lost that never existed."

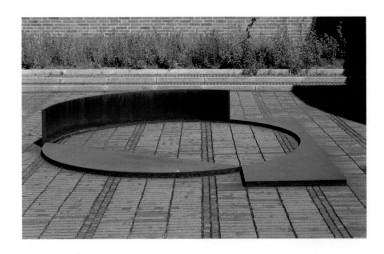

▶ **James Reineking**
Edge Cut/Core Cut/
Remainder, 1985
Randschnitt/Kern-
schnitt/Gebliebenes

Shipbuilding steel,
three elements
diameter 300 cm,
height 41 cm,
thickness 5 cm

James Reineking's sculpture *Edge Cut/Core Cut/Remainder* was done
in 1985 on commission from the Museum Ludwig, Cologne. It was
manufactured at a Hamburg shipyard, under the supervision and with
the collaboration of the artist, in the course of a single day. The piece
is an extremely straightforward design, whose material and form are
reduced to essentials. It is defined by three elements, cut from a rectan-
gular steel plate: an arc segment (core cut), a curved band (edge cut),
and what was left of the plate when these two elements had been
removed (remainder). In combination they add up to an entity which
has no clearly defined principal view or direction. The basic shapes
– rectangle and circle – appear in a fragmentary form which encour-
ages the viewer to intuitively complete them to ideal shapes, and they
therefore convey the conditional nature of source and execution. Sensory
and imaginative perception blend, suggesting a philosophical contem-
plation of the sculpture, for it demonstrates that we perceive not only
with the physical eye but with the mind's eye as well. The linkage or
unification of visual and cognitive apprehension becomes an ideal,
rendering art independent of object and material, making autonomy
its only goal.

**Reineking,
James**

1937 Minot,
North Dakota
Lives in Munich,
Germany

Reinhardt, Ad

1913 Buffalo,
New York
1967 New York City

▼ **Ad Reinhardt**
Abstract Painting,
1954–1959
Oil on canvas
276 x 102 cm

Ad Reinhardt was born in the year Kasimir Malevich painted his first geometric abstraction. He studied art history in New York and in 1937 became a member of the American Abstract Artists. Reinhardt's relevant work began in the 1930s with highly colorful and luminous abstract paintings whose formal stringency revealed the influence of Cubism and the Constructivist tendencies of Piet Mondrian. In subsequent years, red, white, grey and blue canvases emerged, to be superseded by Reinhardt's decisive phase – for thirteen years, until his sudden death, he devoted himself to black paintings exclusively.

Reinhardt's visual thinking anticipated the much later tendencies of Minimal and Conceptual Art. His black paintings can truly be described as aesthetic events, for they contain in essence the painterly experiences of many years, including experience of colors. We as viewers become aware of this when we immerse ourselves in the velvety, shimmering black – not by looking for the most favorable lighting or best angle to detect the cross or rectangular shapes concealed in the texture of the surface, but by simply standing still and intensively contemplating the silent plane. *Abstract Painting* dates from a year after Reinhardt did his first black canvas. He worked on it for five years. The strangely shimmering, matte yet velvety surface was achieved with the aid of a special method of paint application. As Thomas Kellein records, Reinhardt used white-grounded Belgian linen made by the Rosenthal Company, and Boucour pigments considerably thinned with turpentine. After applying numerous layers of glaze, the artist finished with a usually distemper-based layer which increased the desired non-reflectiveness and above all the velvety translucency of the picture surface. The narrow upright format is characteristic of Reinhardt's pre-1960 works, prior to his decision to limit himself exclusively to a square format in the *Ultimate Paintings.*

▶ Germaine Richier
The Claw Creature,
1952
Le Griffu

Bronze
height 91 cm

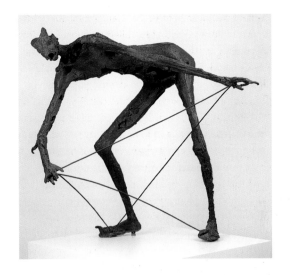

The emaciated, sinewy, eerily frightening nude figure of *The Claw Creature* has traits that distantly suggest the hybrid creature, the griffon, which echoes in the French title *Le Griffu*. It has spun a sort of cage around itself, a barrier that separates it from the viewer. But the figure's immobility is deceiving, for the right leg is slightly lifted, and the cage could just as well be a mysterious trap beckoning to anyone who draws near.

These webs of wire, which are often found in Germaine Richier's work, do not merely serve to support the thin limbs of the sculpture. They delineate and help to generate the space surrounding the figure, and have the appearance of geometric projections of its movements.

The surface treatment of the bronze consciously dispenses with the charm of rounded, smoothed volumes, and with the delicate shimmer of patinated metal. Instead the viewer's eye is brought up short by sharp angles and edges, by fissures, concavities and interruptions that recall the bronze sketches of Auguste Rodin, with whose pupil and assistant, Henri Bourdelle, Richier studied for a long period. Still, fifty years lie between Auguste Rodin and Richier, fifty years in which wars and disasters presented to the artist's gaze a terrible range of injuries and cruelties inflicted on the human body by unprecedented means. Richier has fixed such experiences mercilessly in plaster and bronze.

**Richier,
Germaine**

1904 Grans,
near Arles, France

1959 Montpellier

Richter, Gerhard

1932 Waltersdorf,
Oberlausitz, Germany
Lives in Cologne

Gerhard Richter attended the Dresden School of Visual Arts in East Germany from 1952 to 1957, then worked as a billboard painter, photo lab technician, and stage-set painter in Zittau. In 1961 he enrolled in the Düsseldorf Academy. After a guest lectureship in Hamburg, he was employed as an art teacher in Düsseldorf, where he became professor at the Academy in 1971.

The medium of photography has played an important role in Richter's œuvre. Since the early 1960s he has employed mundane photos from advertising brochures, glossy magazines, and illustrated books, transferring them to canvas in blurred grey and sometimes colored tones, and frequently painting directly over the photograph. Later Richter began using photos he had taken himself. His subject matter was initially borrowed from the realm of public relations and the tabloid press, but then increasingly came from private family snapshots or pictures of banal objects. Subsequently Richter painted a series of "out of focus" paraphrases of famous paintings or of portrait photos of historical figures. In 1968 he expanded his repertoire to include cityscapes, landscapes, and cloud formations. These were soon followed by series of monochrome grey texture-paintings, then by abstract, brilliantly colored images based on broad strokes, smears, and spatters, and a series of color charts and color fields – all of which increasingly interspersed the largely objective paintings that dominated the artist's work until 1970.

Ema – Nude on a Staircase (1966) was based on a photograph of the artist's wife. The painting's title recalls Marcel Duchamp's famous *Nude Descending a Staircase* of 1912. This is one of Richter's few early paintings in color. The luminosity of the nude figure seems to bring light into the dark stairwell, an effect engendered by blurring the quite faithful depiction throughout before the paint was dry. This alienation of the photographic image was Richter's way of unsettling habits of perception and questioning the meaning we attach to reality.

In 1972 the artist was chosen to exhibit at the West German pavilion at the Venice Biennale. The originals on which he based his contribution, a series of *48 Portraits* of philosophers and writers, composers and mathematicians, physicists and biologists, were picked at random from various encyclopedias, said Richter. Actually his "accidental" selection added up to a panorama of cultural and scientific greats of the late nineteenth and early twentieth centuries, a period that evidently was dominated by men.

▶ **Gerhard Richter**
Ema – Nude on
a Staircase, 1966
Ema – Akt auf einer
Treppe

Oil on canvas
200 x 130 cm

Ludwig Donation,
1976

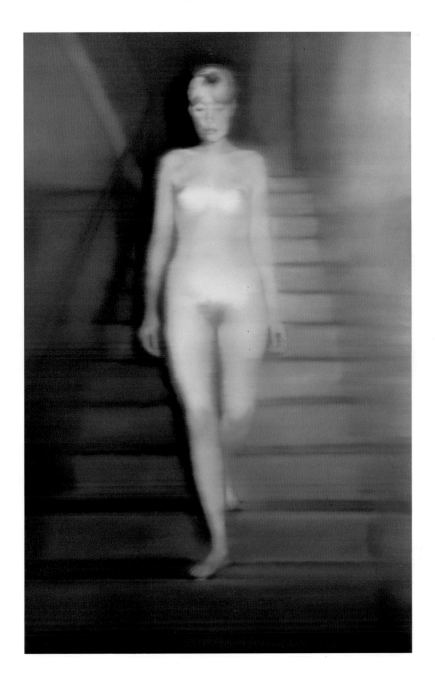

▶ **Gerhard Richter**
48 Portraits,
1971–1972
48 Porträts

Oil on canvas
48 parts
70 x 55 cm each

Ludwig Donation,
1994

From 1977 Richter's non-objective work was dominated by what he termed "soft abstractions," before spatula-paintings like *Abstract No. 599* came to the fore. "Abstract paintings," Richter wrote in the catalogue of the 1982 documenta VII, "are fictitious models, because they visualize a reality which we can neither see nor describe... We attach negative names to this reality: the un-known, the un-graspable, the in-finite..."

Klaus Rinke, since 1974 professor at the Düsseldorf Academy, belongs to the middle generation of German artists now active.

In the nine drawings titled *Expansion – Angular* of 1973 Rinke addressed the issue of space. On an open space a point was selected at random and marked with a steel nail, to which an approximately 25-meter-long cord blackened with graphite was attached. Then a blank sheet of paper was placed next to the central point and marked with the graphite cord to record radial lines of extension from the center. The next sheet was placed at a distance of 0.5 meters, the next at 1.0 meters, and so on, until the 20-meter mark was reached (a random limit, theoretically infinitely extendable). The distances do not correspond to any mathematically exact progression, being determined by Rinke on the basis of dimensions he "feels are natural." With increasing distance the expansion also increases, such that the section of it recorded on the sheet, a constant format, becomes progressively smaller. At the farthest distance the radial lines approach the parallel. The photos beneath the drawings document the same process as recorded by the camera eye.

Rinke, Klaus

1939 Wattenscheid, Germany
Lives in Haan

▲ **Klaus Rinke**
Expansion – Angular, Extension from Any Random Standpoint from Zero to 20 (to Infinity), 1973

Nine graphite drawings on paper 70 x 100 cm each Nine photographs (black and white, one-off prints) 18 x 24 cm each

Riopelle, Jean-Paul

1923 Montreal
Lives in Paris

Jean-Paul Riopelle was a student of mathematics when, in 1940, he discovered painting and transferred to the art academy in Montreal. In 1947 he went to Paris, where Surrealist automatism cast its spell on him. Riopelle's œuvre developed along the lines of the Ecole de Paris and French art informel, with affinities to American Action Painting. His earliest works consisted of large-format canvases executed in the dripping technique. In the early 1950s Riopelle began working with palette knife and spatula, which led him to his inimitably distinctive style around 1952.

According to his biographer, Pierre Schneider, the series of paintings dating from 1952 to 1956, to which *Robe of Stars* belongs, is among the most significant in Riopelle's œuvre. The gestural element predominates, which has led him to be called the French counterpart to Jackson Pollock. Yet Riopelle's working method involves the superimposition of several paint layers. First the paint is flung onto the canvas using

▼ **Jean-Paul Riopelle**
Robe of Stars, 1952

Oil on canvas
200 x 150 cm

Ludwig Donation, 1976

a broad brush, and then swaths are drawn through the wet paint with a spatula, creating a heavily textured, opalescent surface. In a third step Riopelle applies dense, free-form networks consisting of thin threads of light-colored paint. Werner Schmalenbach compares this painting process with a battle with the canvas: "The painter's tools are wielded like weapons. Painting becomes fencing... The surface develops into an agitated relief." Riopelle's paintings seem boundless, the hues and textures appearing to continue beyond the canvas edge. The titles of his abstract works are freely invented, and extremely suggestive; *Robe of Stars* evokes a shimmering, magnificently hued image of the universe.

Alexander Rodchenko's career began in 1918 with a series of Black Paintings which were shown in 1919 at the Moscow exhibition "Non-Objective Art and Suprematism." *Black on Black* was one of the series, which marked a key phase in the artist's investigations of color, which finally led him to give up painting entirely in 1921. Here the color black is used to unify the visual statement, and linear elements and nuances of tone serve to reveal forms and render the image perceptible as image. Rodchenko was conscious of the ambivalence of these paintings, for he once said that in the works of his Black Period it was difficult to determine what the space was and how it could be described, what the form in it was and how the form existed, even though it still retained weight.

Rodchenko, Alexander

1891 St. Petersburg
1956 Moscow

Also in 1918 Rodchenko launched into a series of three-dimensional geometric works that represented a new departure in sculpture. Originally he conceived of making these, as he termed them, "white non-objective sculptures," in white, light metal, but as no processed metal of the kind was then available, Rodchenko employed thin, white-painted plywood instead.

The next series of works, done from 1919 onwards, represented an even more radical and absolute approach to sculpture. Each work was based on a modular principle, and, as in *Spacial Construction No. 16*, the traditional base and main aspect were dispensed with. The originals were made of the cheapest materials, for instance plain square slats, which could be combined easily and in many ways.

A further step in the development of the 1920–1921 series of objects were *Suspended Constructions* hung from the ceiling of a room. The original versions of these were built of thin plywood, sawn into various geometric shapes – squares, hexagons, ellipses, etc. Then concentric bands of constant width were cut out these shapes, such that the final configuration automatically opened out to form a three-dimensional sculpture. In movement the aspect of the pieces and the effects of impinging light constantly change.

In collaboration with his wife, Varvara, Rodchenko devoted himself untiringly to artistic experiments. In fact he was also a researcher and scientist, who focussed primarily on structure, system, and a use of materials fitted to the task. Rodchenko and Varvara Stepanova were key figures in the second phase of the Russian avant-garde, Constructivism, with its emphasis on technological development, industrial production,

◄ **Alexander Rodchenko**
Black on Black, 1918

Oil on canvas
105 x 70.5 cm

Ludwig Collection

► **Alexander Rodchenko**
Composition, 1919

Gouache
60 x 44 cm

Ludwig Collection

and the utilitarian applications of art. Yet for all its practical emphasis, Rodchenko's Constructivist theory contained overtones of utopian thinking, a belief in an absolute and immutable order.

An example of the artist's Constructivist phase is seen in *Composition* of 1919. In terms of the arrangement of the circle and arc segments, and above all the way in which the "ray of light" penetrates the disk and lends a strong diagonal accent to the overall composition, the gouache is highly characteristic of Rodchenko's approach.

▲ **Alexander Rodchenko**
Suspended Spacial Construction No. 10, Hexagon, from the Series "Light-Reflecting Surfaces," 1920
Reconstruction, 1982

Aluminum
59 x 68 x 59 cm

Ludwig Collection

▲▲ **Alexander Rodchenko**
Oval Suspended Construction No. 12, from the Series "Light-Reflecting Surfaces," c. 1920–1921
Reconstruction, 1973

Aluminum
85 x 55 x 47 cm

Ludwig Collection

▲ **Alexander Rodchenko**
Spacial Construction No. 16, c. 1920–1921
Reconstruction, 1980

Brass
94 x 45 x 45 cm

Ludwig Collection

▶ **Ottone Rosai**
The Hunchback
at a Window, 1938
Il gobbo alla finestra

Oil on wood
174 x 144.8 cm

Loan of
VAF-Foundation,
Switzerland

Almost forty years have passed since Ottone Rosai's death, yet his work still remains as good as uninvestigated. The apparently idyllic character of his paintings is deceptive. Rosai was a passionate man, torn by conflicting emotions and prone to fits of deep depression, and yet filled with an insatiable need to search for truth.

Accordingly, Rosai's *Hunchback at a Window* is rife with tensions and contradictions. The soft chromatic colors which invoke the warm light of the Tuscan landscape and suffuse the entire painting are an immediate delight to the eye. Yet we soon become aware of the closeness of the room, in which the figure seems imprisoned – how different from the harmonious landscape beyond the window, or is it actually only a painting on the wall? We are made almost painfully aware of the contrast between the beauty of art and the awkward, misshapen body of this unfortunate man. Perhaps he stands for the artist, indeed for all of us, as he looks out into the world, longing for freedom, for truth – for art.

Rosai, Ottone

1895 Florence, Italy
1957 Ivrea

Rosenquist, James

1933 Grand Forks, North Dakota
Lives in Aripeka, Florida, and New York

James Rosenquist is one of the leading representatives of American Pop Art. He trained in 1953–1954 at the University of Minnesota and in 1955–1956 at the Art Students' League in New York, while supporting himself by working as a billboard painter.

Rosenquist employs fragments of imagery from advertising and the realm of mundane things, usually cutting them out of newspapers, magazines, or brochures, enlarging them, and placing them in new, provocative contexts. The random juxtaposition of visual elements plays a crucial role in Rosenquist's art. When one of the glass panes in *Rainbow* (1961) broke during transport, the artist insisted this new state be retained. In this work, which consists of a great variety of materials, the paint appears to have dripped from a window ledge down the side of a house, forming pale, rainbow-hued traces. The shutters are open;

▲ James Rosenquist
Starthief, 1980

Oil on canvas
518 x 1402 cm

Ludwig Collection

one pane is broken; behind the other appears, instead of a face, an oversized fork. It stands there solitary and strange, as it were in proxy for the person who we might imagine living behind the shabby facade. And yet there is poetry and hope in the rainbow, even though it may only represent an accidental smudge that no one has bothered to remove.

In the late 1950s Rosenquist was employed as a billboard painter, standing on a scaffold to cover endless square yards of hoardings in Brooklyn and Manhattan with paint. Perched high above Times Square, he did giant salamis and political slogans, whiskey bottles and bank advertisements, movie posters and billboards of all kinds. As he was involved in his work (which, incidentally, was well-paid), Rosenquist felt the relationship of reality to illusion begin to reverse: the people and

▲ James Rosenquist
Rainbow, 1961

*Oil on canvas,
wood, glass*
121.3 x 153 cm

Ludwig Donation,
1976

▶ James Rosenquist
Untitled
(Joan Crawford
says . . .), 1964

Oil on canvas
242 x 196 cm

Ludwig Donation,
1976

cars far below him became a remote microcosm, while their outsized billboard images, designed to be viewed from a distance, came tangibly near. As the artist himself said, he had the chance to see a huge composition develop, and to study how surface textures were made and what happened to painting when pigments mixed. A few years later these billboard motifs held interest for Rosenquist only as *objets trouvés*, no different from any other subject.

In 1963–1964 Rosenquist painted a series of apparently realistic images, but, as he said to Gene Swenson, "If I use a lamp or a chair, that isn't the subject, it isn't the subject matter. The relationships may be the subject matter, the relationships of the fragments I do. The content will be something more, gained from the relationships. If I have three things, their relationship will be the subject matter; but the content will, hopefully, be fatter, balloon to more than the

subject matter. One thing, though, the subject matter isn't popular images, it isn't that at all." Thus it would be mistaken to consider Rosenquist's *Untitled (Joan Crawford says...)* a portrait of the actress. It represents a cigarette ad in which she appeared. This is a case of human alienation twice over – a woman stylized into a star, a star stylized into a means of selling a product.

Rosenquist's *Horse Blinders* of 1969–1968 was one of his first Environment Paintings. It tells no story, has no fixed direction of reading, no focal point, no beginning or end. In the enormous depiction we can detect a piece of butter melting in a frying pan, with a stop-watch to its left and rippling water to its right, then a mixer whipping a white mass of some sort, then a cut telephone cable with colorful wires protruding from the end.

Rosenquist's gigantic *Starthief* dates from 1980. Against the back-ground of a starry night sky floats a collage of huge strips of bacon, machine components, a fragmented female portrait, and, again, loose sheaves of electric wires. Here, too, trivial, everyday things are blown up to such a monumental scale, their size relationships so

altered, and such unfamiliar sections and details are emphasized, that they seem to take on a new form of existence and assume an alien but intrinsic life. Rosenquist was convinced that commercial and media-transmitted imagery contained more force, more clout, than the mind of anyone painting pictures in a studio could produce. "How can I justify myself," he asked, "how can I make my mark, my 'X' on the wall in my studio, or in my experience, when somebody is jumping in a rocket ship and exploring outer space?"

Rosso, Medardo

1858 Turin, Italy
1928 Milan

▼ **Medardo Rosso**
Bookmaker, 1894

*Wax and plaster
height 48 cm*

Loan of
VAF-Foundation,
Switzerland

Medardo Rosso learned the craft of sculpture at an young age, by working as a marble-cutter's assistant as a schoolboy. He was also an early rebel against academicism in the field, which caused him to be expelled from the Brera Academy in Milan after only one year there (1883). The year before, Rosso had begun to produce sculptures with a nervously agitated, furrowed surface which engendered a vital play of light and shade. Expressive facial features were another emphasis of the young artist's figurative work of the time.

The *Bookmaker* represents not just any heavyset gentleman at the racetrack tensely following his horse's progress. This is Eugène Marin, son-in-law of the sculptor Henri Rouart. His battered top hat, perched at a rakish angle on his round skull, like the rest of his only vaguely suggested dress, gives rise to the impression of a careless elegance. Rosso, known as the "sculptor of light," has planted his *Bookmaker* solidly, standing squarely with legs apart, and has evoked the setting with a few generalized details. Dynamic diagonals from above to below and from right to left underscore the inclination of the figure and, at the same time, create the impression of a snapshot of a moment in the busy career of a vital man. This rapid capturing of a slice of life and the agitated surface modelling of Rosso's sculptures, which contain the essence of a personality as if seen in a flash of insight, bring his works into proximity with those of his contemporaries, the French Impressionists. A pose very similar to that of the *Bookmaker* is found in the bronze figure of Honoré de Balzac created by Rodin in 1897 (one version of which is in the Wallraf-Richartz-Museum, Cologne).

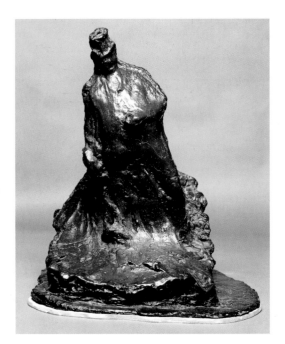

► **Mimmo Rotella**
Cinemascope, 1962

Décollage
173 x 133 cm

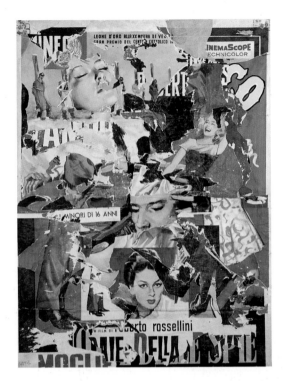

Mimmo Rotella began in 1954 to work with torn and fragmented posters, a technique he dubbed *décollage*. Detaching posters from walls with the aid of a knife, he pasted them on a support of cardboard, wood, or canvas. From 1959 to 1963 Rotella made a series of décollages with figures, based on movie posters and various other bills posted in the streets.

In 1962, at Galerie "J" in Paris, Rotella exhibited a series entitled *Cinecittà* after the famous film lots in Rome. In his introduction to the show, the artist stated: "In the dynamic process of tearing off [posters] the sudden illumination of a smile, the emergence of a face, the outlines of a body, unexpectedly appear... These power-images [*immagini-forze*] which have descended from the walls of Rome obtain, thanks to their source, a demythologizing super-presence. They have become more real than the myth they pretended to embody. The star, injured by the tearing process, is less a star and more of a woman."

Rotella, Mimmo

1918 Catanzaro,
Italy
Lives in Milan

Rothko, Mark

1903 Dvinsk,
Lithuania

1970 New York

A radical refusal to consider the imitation of nature the mission of painting led Mark Rothko to abandon his previous figurative style for a painting of color fields hovering in juxtaposition. These canvases exerted a great influence on an entire generation of artists working in monochrome abstraction.

In *Earth and Green* of 1955, Rothko's choice of carefully mixed, contrasting colors has led to a sense of depth in flatness. It belongs to a series of large-format works begun in 1950, which are characterized by wide, horizontal rectangles usually arranged in parallel. These color fields have no clear demarcating outline; rather, they seem simultaneously to merge with the basic hue of the painting and to float at some distance before it. A muted reddish brown and a light, greyish green are juxtaposed against the deep blue of the canvas. The apparent simplicity of the composition is misleading, because the mutual visual interference of the colors creates a sense of virtual movement.

Every trace of the painting process has been expunged – no brushstroke, no clue as to the motions of the artist's hand, remains. The dissolving edges of the shapes elicit an evocatively meditative effect that is typical for Rothko's painting: the colors seem to vanish into space. In fact, color and space had a well-nigh metaphysical, religious meaning for the artist. As he once stated, behind space there was nothing, and in front of it, there was no possibility of escape to anything else. The viewer has a sense of being able to immerse himself in the expanding fields of color, succumb to the hypnotic effect of their nebulous borderline zones.

Influences of Zen Buddhism, a receptivity to mysticism rooted in the Jewish tradition, the Surrealism of Joan Miró, the psychology of Carl Gustav Jung, and an American feeling for the wide open spaces, all combined and entered a synthesis in Rothko's art. As Karl Ruhrberg noted, his canvases could be described as "variations on the theme of infinity." With Barnett Newman, Rothko is considered one of the few twentieth-century artists who infused new life into religious painting.

► **Mark Rothko**
Earth and Green,
1955

Oil on canvas
231.5 x 187 cm

Rozanova, Olga

1886 Melenkach,
Russia
1918 Moscow

The relatively muted chromatic colors of Olga Rozanova's paintings of the early Cubo-Futurist phase, such as the 1913 *Landscape (Disjunction of Forms)*, distinguish them from the more brilliantly hued compositions of Liubov Popova or Alexandra Exter. Rozanova's reputation was established above all by her innovative book designs and illustrations.

An example is *The Universal War*, an album of 1916 with a text by her companion, the poet Alexei Kruchenikh. The images are characteristic of Rozanova's idiosyncratic translation of Suprematist principles into the collage technique, and the album itself, a new synthesis between poetry and painting, word and image, represents a unique contribution to twentieth-century book design. Illustrated with twelve colored collages, the album was planned to be issued in an edition of 100 handmade copies. How many were actually completed and survived, we do not know. Since each portfolio contains one-off works, the compositions vary from copy to copy. The texts and poems – which predict the outbreak of a terrible war in 1985 – were separately printed at the beginning of the volume.

In *The Universal War* Rozanova broke completely with previous traditions of book design and typography. As H. Gassner notes, "The cut-out, bizarre zig-zag contours tend initially to be read as positive figures against a blue ground, but suddenly flip over into negative shapes which have the effect of holes, splits, or fissures in the ground. By comparison to the tendency to a systematization of the Suprematist formal repertoire, [these shapes] augment the anti-systematic,

▼ Olga Rozanova
Landscape
(Disjunction
of Forms), c. 1913

Oil on canvas
57 x 40 cm

Ludwig Collection

irrational aspect of intuitive creativity, which found an outstanding advocate in Olga Rozanova." The four collages illustrated – *Germany's Vanity, Germany's Demise, Prayer for Victory,* and *The Military State* – reveal little direct connection with the theme addressed in the titles. Like the remainder of the images in the album, they attest to a great freedom with respect to any established style or ideological tendency. Though Rozanova attempted to mitigate the radical demands of Suprematism by adopting a more decorative approach, the public reaction was largely one of bafflement.

That she remained undaunted in swimming against the stream of the period style is clearly seen in her texts on the role of the artist. "Brilliant work requires the greatest and sharpest comprehension of the real and an extraordinary will-power," wrote Rozanova, "in order to consistently avoid mixing hypocritical and decrepit patterns of the past with that which must newly develop... The critics are most afraid of that which is 'not a good likeness.' Perched in their high armchair, they bandy about with outmoded material."

▲ **Olga Rozanova**
The Universal War,
1916
Four sheets
from the album of
Alexei Kruchenikh

*Colored paper,
tracing paper,
and fabric*
Various dimensions,
c. 24 x 30 cm

Ludwig Collection

Rozhdestvyenski, Konstantin

1906 Tomsk, Siberia
Lives in Moscow

▼ Konstantin
Rozhdestvyenski
Farmwoman in a Field
(Suprematist Figure),
1931

Oil on cardboard
62.5 x 43.8 cm

Ludwig Collection

Konstantin Rozhdestvyenski, a faithful pupil and assistant of Kasimir Malevich, was not yet 30 when he watched at his mentor's deathbed. After a long training period that had infused him with the Suprematist doctrine, Rozhdestvyenski had experienced the final phase of Malevich's development after his return from Germany, a recurrence to an idiosyncratic version of a traditional figurative style. It was this late style of Malevich's that had the greatest influence on him. But what in the master's hands often seemed the tragic expression of a subjective mood and artistic situation, became in his student's a care-free evocation of an entirely different feeling for life. This more opti-mistic attitude on the part of the young artist was surely one of the reasons for his successful career. Having apparently made his peace with the regime, Rozhdestvyenski received important commissions. Yet he kept his painting a secret, working in seclusion for over 60 years. Only recently has this private œuvre come to light.

The solitary figures, viewed from the back, standing in vast spaces with only a near-abstract band of color to indicate the hori-zon – much in Rozhdestvyenski's compositions recalls Malevich. The geometrized figure in *Farm-woman in a Field (Suprematist Figure)* of 1931 is a case in point, though the brilliant palette exudes a freshness seldom found in Malevich. The head, torso, and sheaf of hay are treated as abstract, strongly contrasting color planes, and rendered with an almost Post-Impressionist delicacy of paint application that recalls Paul Cézanne.

► **Ulrich Rückriem**
Untitled, 1990
Ohne Titel

Black Swedish granite
120 x 120 x 120 cm

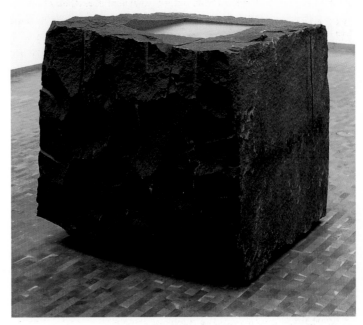

In Ulrich Rückriem's eyes, stone is more than a material for works of art. The granite he prefers is suffused with primeval forces, and yet at the same time is highly fragile. These considerations lead Rückriem to work the stone only sparingly, splitting, grinding or cutting it with the aid of methods normally used in the industrial processing of stone. In this way the characteristic qualities of the material are retained, in sculptures that for all their raw look are aesthetically extremely compelling.

Despite the many features in Rückriem's approach that recall Conceptualism or Minimalism, the results are sensuous in the highest degree. "The material, its form, its properties and dimensions define my artistic activity," says the sculptor. Nature and culture enter a symbiosis in his work, reciprocally influence one another, merge and become one. Rückriem sees the artist's task as making the essence of stone visible, penetrating to its inmost core without destroying it.

Rückriem,
Ulrich

1938 Düsseldorf
Lives in Frankfurt
am Main

Russolo, Luigi

1885 Portogruaro,
Italy
1947 Cerro di Laveno

▼ **Luigi Russolo**
Perfume, 1909–1910
Profumo

Oil on canvas
46.5 x 66.3 cm

Loan of
VAF-Foundation,
Switzerland

Painting was only one of the fields in which Luigi Russolo was active. He wrote poetry, read extensively in philosophy, and invented a music composed of noise – the everyday sounds around us, the sounds of animals and human voices, the growling and rumbling of machines, the clatter and horns of traffic on the street, all of which he imitated and arranged in rhythmic sequences. Russolo's home-made instruments, or noisemakers, marked the inception of electromechanical music. In a quite different vein, the artist assisted in the restoration of Leonardo da Vinci's *Last Supper* in 1908.

Although he is not widely known today, Russolo belonged to the Futurists of the first hour. In 1910, with Umberto Boccioni, Carlo Carrà, Giacomo Balla, and Gino Severini, he was among the signatories of the *Manifesto of Futurism. Perfume* dates to this early phase, when the Futurists had not yet arrived at their typical, vibrating, dynamic style. Russolo's canvas represents an attempt to use a divisionistic technique borrowed from Pointillism to render visible an olfactory impression. The brushstrokes undulating around the woman's head are not so much descriptive as evocative of the invisible perfume in the air. With this theme Russolo addressed a key concern of the Futurist movement: "Until the nineteenth century," wrote Carrà in 1913, "painting was an art of silence. Painters . . . never recognized the possibility of reproducing sounds, noises and odors with the means of painting, not even when they chose . . . flowers, ocean storms, or stormy skies as subjects." According to Carrà, "every sequence of sounds, noises and odors" mentally suggested "an arabesque of forms and colors," which the artist should intuitively grasp and transfer to canvas.

▶ **Reiner Ruthenbeck**
Glass Plate in
Fabric Bag II, 1971
Glasplatte in
Stofftasche II

Glass, red fabric
100 x 100 cm

One of the key components in the art of Reiner Ruthenbeck, a student of Joseph Beuys, is fabric of a dark reddish-violet hue. He uses lengths of this textile material to create environments, combines it with other materials in tensile configurations, or stretches it into simple geometric shapes and affixes these to the ceiling of a room. Rigid and elastic or flexible materials are brought into diverse interrelationships in his art.

Glass Plate in a Fabric Bag II exemplifies such a relationship. By being suspended in fabric, the glass enters a state of instability, while its rigid dimensions lend the bag a solid form. The work, part of a series of suspended objects of glass and textiles, serves to sharpen our perception of the mutability of material characteristics, but also to trigger an immediate psychological reaction. We sense the fragile nature of the glass and the protection afforded by the fabric, which, however, seems in immediate danger of being severed by the sharp edges of the heavy pane.

**Ruthenbeck,
Reiner**

1937 Velbert,
Germany
Lives in Ratingen

▶ **Niki
de Saint Phalle**
Black Nana,
1968–1969

*Polyester, painted
293 x 200 x 120 cm*

Ludwig Donation,
1976

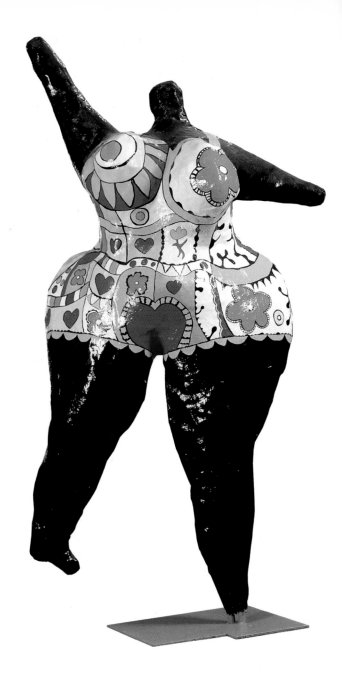

French painter and sculptor Niki de Saint Phalle, who attended parochial school in the United States and joined the Nouveaux Réalistes group in 1961, is one of the most original women artists of our times.

Her reputation was established above all by the *Nanas* she began to create in 1965 – voluptuous, carefree, and garishly colored female figures made of polychrome polyester resin. Seated or standing, reclining or doing headstands, playing ball or dancing, the *Nanas* represent woman in all her moods and activities, and are meant to communicate a sense of joyous euphoria to the viewer. "I see them," explains the artist, "as heralds of a new matriarchal age. They represent the independent, good, giving and happy mother." As Pontus Hulten remarks, Niki de Saint Phalle never "separates the male from the female aspect. She takes great pleasure in reconciling the two, by according them their proper and definite place. Thus she remains true to her non-conformist rebelliousness without letting herself be appropriated by feminism, which has attempted to use her to its ends."

A great number of de Saint Phalle's works were executed in collaboration with Jean Tinguely, her second husband, who died in 1991. In 1966, together with him and Swedish artist Per Olaf Ultredt, she created a giant *Nana* called *Hon* (Swedish for "she") for the great foyer at the Moderna Museet in Stockholm. Visitors could walk into the figure, to find machines they could play with, goldfish, a bar, and other entertaining things. "*Hon* was like a marvellous mother-figure who received everybody into herself in order to give them a wonderful experience of joy," said the artist.

In 1979 de Saint Phalle and Tinguely set out to make their life's dream come true, beginning the construction of a "Tarot Garden" in the Tuscan town of Garavicchio. The magical garden, which was completed in 1993, contains 22 sculptures, many of them enterable and even habitable, based on the mysterious tarot card figures. "Above all," wrote Hulten, the garden is "a great monument to *joie de vivre* and to the good forces in the world."

de Saint Phalle, Niki

1930 Neuilly-sur-Seine, France
Lives in Milly-la-Fôret, near Paris, and Garavicchio, Tuscany, Italy

Salle, David

1952 Norman,
Oklahoma
Lives in New York

▼ David Salle
Blue, 1993

*Oil and acrylic
on canvas*
215 x 152 cm

Loan from
the collection of
Dr. Michael and
Dr. Eleonore Stoffel

David Salle studied in the early 1970s with Conceptual artist John Baldessari at the California Institute of Arts, then began working in the medium of photography. After a phase of involvement with video, he commenced in the late 1970s a series of large-format paintings, generally composed in the form of diptychs or triptychs. The motifs of these conceptually oriented works were taken from everyday life, art history, pornography, and dance theater. They stood in no predetermined relationship to one another, instead recalling the stream of consciousness technique in literature, as practiced above all by James Joyce and Virginia Woolf. Each motif in Salle's paintings stands only for itself; together they produce no comprehensive meaning, as the artist repeatedly emphasizes.

Three different levels of meaning are combined in Salle's *Dual Aspect Picture* of 1986. The fact that each level exists for itself is empha-

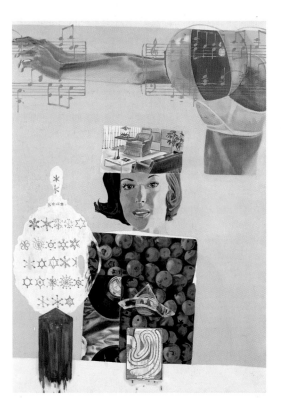

sized by the employment of different supports, combined only after the process of painting was completed. A frequently seen motif is the semi-naked torso of a dancer, and Salle's penchant for such provocative imagery has caused him to be denounced as sexist and misogynist.

The painting *Blue* is characteristic of Salle's most recent phase. Here the influence of Pop Art, especially as practiced by James Rosenquist and Robert Rauschenberg, is especially apparent. In this case the individual motifs have been juxtaposed on a single support. The colors are more subdued than in Salle's earlier work, calling the aesthetic of the 1950s to mind. A certain mellowing, a more poetic and less consciously provocative approach, has made itself evident.

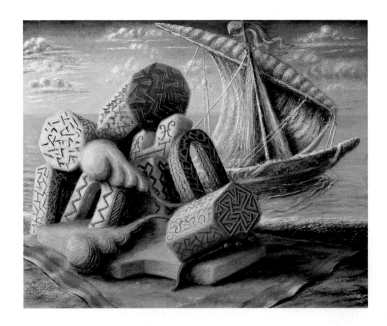

▶ **Alberto Savinio**
Odysseus and
Polyphemus, 1929

Oil on canvas
65 x 81 cm

Loan of
VAF-Foundation,
Switzerland

Alberto Savinio's painting until recently stood very much in the shadow of his brother, Giorgio de Chirico's. Although foremost a musician, he was also a gifted writer and painter, as art historians today are increasingly realizing. Savinio, who adopted this pseudonym in 1914, studied music at the Athens conservatory and, from 1906, in Munich with Max Reger. The late 1920s were the most important years in Savinio's artistic activity. It was at this time that he received a commission from the famous art dealer Léonce Rosenberg to execute a number of paintings for a room in his house, other rooms of which had already been decorated by Francis Picabia, Gino Severini, and – Giorgio de Chirico.

In this connection Savinio created a series of "monuments to toys," to which the picture in the Museum Ludwig, Cologne, belongs. These are colorful and light-hearted accumulations of things that, while they evoke the children's world, also suggest magically transformed architectural elements. Savinio's images are like allegories from an unknown realm, in which ghost ships ply brilliant blue seas and strange objects populate the landscapes of paradise in place of human beings.

Savinio, Alberto
(Andrea de Chirico)

1891 Athens, Greece
1952 Rome

Scherer, Hermann

1893 Rümmingen,
near Lörrach,
Germany
1927 Basel,
Switzerland

Hermann Scherer began his training at the age of 14, when he was apprenticed to a stonemason of Lörrach. His early work there, carving gravestone, already showed him to be a skilled artisan. After completing his apprenticeship Scherer went to Basel, to work with Karl Gutknecht, who specialized in architectural sculptures and fountains. In 1912 and 1913 the young stonemason went on the journeyman's wanderings that are traditional in the trade. In the years that followed, he continued his training with sculptors working in conventionally naturalistic styles. In the year 1918 he was engaged by the then renowned Swiss sculptor, Carl Burckhard, to assist him in executing two monumental stone figures. The income from this work permitted Scherer to move into a larger studio, where he began to work in a style similar to that of his employer.

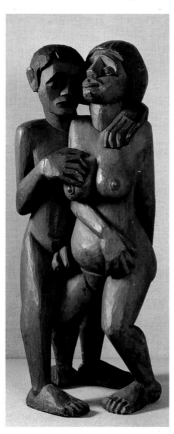

The Couple in the Museum Ludwig, Cologne, dates from the year 1924. The embracing figures are carved from a single block of juniper wood and painted. Apart from the erotic theme, the gestures of the figures can be interpreted as those of a husband protecting his wife, who yields herself to him with implicit trust. The rather squat proportions of the figures might almost seem childlike, were it not for the expressively emphasized traits of maturity. The flexed knees of the female figure recall certain African sculptures, though the pose and composition seem to have been determined primarily by the proportions of the block.

► **Hermann Scherer**
The Couple, 1924
Liebespaar

Juniper
112 x 45.8 x 39.3 cm

Ludwig Collection

▶ **Egon Schiele**
Crouching Female
Nude, 1917
Kauernder
Weiblicher Akt

*Watercolor and
crayon on buff paper*
45.9 x 29.7 cm

Gift of
Friends of the
Wallraf-Richartz-
Museum, 1966

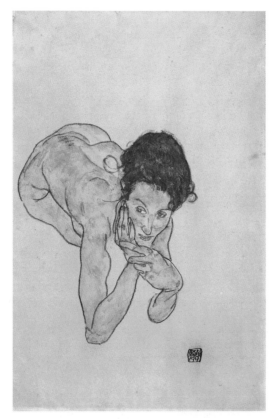

The mercilessly precise art of Egon Schiele reflects the effects of the profound transformations that took place in the capital city of the moribund Hapsburg Monarchy around the turn of the century. Taking his point of departure in the work of Gustav Klimt, Schiele penetrated to the depths of the human psyche. With incise, nervous, relentless line and sparing but evocative and sometimes provocative color, he depicted sinewy figures seemingly consumed by insatiable desire, creatures of compelling magnetism and breathtaking frankness. The present nude, drawn in extreme foreshortening as she bends forward and supports her chin in her slender hands, probably represents Schiele's wife, Edith, or perhaps his sister-in-law, Adele Harms.

Schiele, Egon

1890 Tulln, Austria
1918 Vienna

◄◄ Oskar
Schlemmer
Red-Brown Mural
Study I, 1928
Rot-Braun-Wandbild-
studie I

*Oil on cotton
on plywood panel
100.5 x 24 cm*

Loan of
C. Raman Schlemmer

◄ Oskar Schlemmer
Yellow-Red Mural
Study II, 1928
Gelb-Rot-Wandbild-
studie II

*Oil and tempera
on cotton on plywood
panel
110.8 x 25.5 cm*

Loan of
C. Raman Schlemmer

**Schlemmer,
Oskar**

1888 Stuttgart,
Germany
1943 Baden-Baden

Oskar Schlemmer was active not only as a painter, but as a sculptor, muralist, and stage-set designer. In 1925 he became head of the experimental stage at the Dessau Bauhaus. The companion-pieces *Red-Brown Mural Study I* and *Yellow-Red Mural Study II* date from 1928. Concerning the idea behind such compositions, Schlemmer once stated, "The human figure, in its simple functions such as tilting the head, raising an arm, gesturing with a hand, position of the legs, etc., offers such an abundance of expressions for the visual artist, that themes like standing, coming, going, turning around, and the like are enough to

fill an artist's life." When an increasing sociopolitical orientation was
demanded of the Bauhaus stage, Schlemmer left Dessau in 1929 and
went to the Breslau Academy.

 Group of Fourteen in an Imaginary Architecture can be said to repre-
sent people in modern mass society. The figures form a sort of organic,
human architecture which relegates the built architecture to the back-
ground. The poses and gestures reveal much about the feelings of
those represented and their relationships to one another: mutual
attraction, physical contact, confrontation, or inward-directedness. In
order to increase the prototypical appearance of the figures, Schlemmer
added a final paint layer of grey shading, which reduced the effect of
plastic volume and muted color contrasts, making the figures appear
as if spotlighted in low relief.

▲ **Oskar Schlemmer**
Group of Fourteen
in an Imaginary
Architecture, 1930
Vierzehnergruppe
in imaginärer
Architektur

*Oil and tempera
on canvas*
91.5 x 120.5 cm

Schmidt-Rottluff, Karl
(Karl Schmidt)

1884 Rottluff, near
Chemnitz, Germany
1976 Berlin

▼ **Karl Schmidt-Rottluff**
Kneeling Woman
with a Red Towel,
1913
Kniende Frau
mit rotem Tuch

*Brush and ink with
watercolor wash on
buff wove paper*
46 x 58.2 cm

Haubrich Donation,
1946

Karl Schmidt-Rottluff was a major representative of German Expressionism who worked in painting, sculpture, and printmaking. His training began in architecture, which he studied in 1905 at Dresden Technical College. But Schmidt-Rottluff soon turned to painting and, that same year, co-founded the group Die Brücke with Erich Heckel, Ernst Ludwig Kirchner, and Fritz Bleyl.

By the time the group disbanded in 1913, Schmidt-Rottluff's style had undergone a change, the initial wildly agitated paint application and angular contours having given way to more tranquil and trenchant compositions. Of all the Expressionists, Schmidt-Rottluff perhaps played the key role in assimilating influences from non-European, so-called primitive art. His interest in African sculpture culminated between 1911 and 1915, as reflected in an increasing simplification of form and inclusion of a self-contained, blocky element in the landscapes, still lifes, nudes, and portraits he concentrated on at that period.

The year 1913 saw the emergence of a series of still lifes with African motifs. *Still Life with Negro Sculpture* shows two carved wooden pipe bowls in front and side view, set off by a brilliant blue bowl on a fiery red ground which, according to M. M. Möller, "captures the incantatory, mythical aura of the cultic objects." The sculptures were modelled on terracotta pipe bowls from Cameroon which are still in the Museum of Ethnology in Munich. Schmidt-Rottluff had probably seen them in reproductions in catalogues or other publications on

African art. The ink and watercolor and crayon drawings done in summer 1913, in the village of Nidden on the Baltic, likewise reflect the artist's involvement with African art. As exemplified by *Kneeling Woman with a Red Towel*, Schmidt-Rottluff depicted individual or groups of nude figures in every conceivable pose, simplified to the point of monumentality and dominating the image. By ignoring correct proportions and eliminating correct perspective

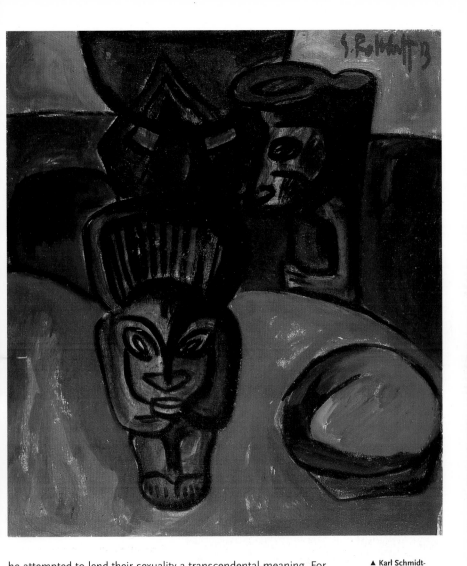

he attempted to lend their sexuality a transcendental meaning. For according to Schmidt-Rottluff, "there is a true and a right drawing. A true drawing that shifts certain relationships and thus diverges from correct drawing, but that reproduces the essence of what is seen and by so doing conveys the impression more convincingly and with greater truth."

▲ **Karl Schmidt-Rottluff**
Still Life with Negro Sculpture, 1913

Oil on canvas
73 x 68.5 cm

Haubrich Donation, 1946

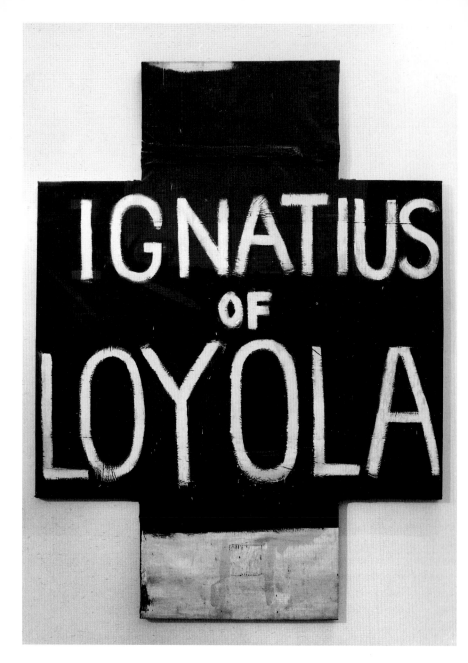

Julian Schnabel became known in the late 1970s for paintings composed of broken plates and deer or elk antlers, which he affixed to the canvas and employed as painting grounds for expressive, fragmentary compositions. There was no clear relationship between the objects and the superimposed motifs. As this implies, the heavy, relief-like paintings had less to do with the concept of collage than with that of the palimpsest, a type of ancient tablet with several superimposed inscriptions. Traces of the various paint layers combined with the diverse sources of the individual objects to form a new reality. The old (the objects fixed to the surface) and the new (the motif painted over them) merged to create a third level of meaning, which amounted to more than the sum of the elements actually present. As Schnabel explained, these paintings emerged from a very personal choice of motifs and cross-references among things that had a similar emotional weight. The subject was not only that which was depicted, but also the psychological resonance that echoed in the objects and motifs.

In 1986 Schnabel began a series of large-format pictures titled *The Recognitions*, after a novel by William Gaddi, and subtitled *Stations of the Cross*. In contrast to the earlier, highly expressive works, these images are strongly minimalistic in character. The *Stations* consist merely of inscriptions of names or concepts, such as *Ignatius of Loyola, Pope Pius IX, Charity* or *Mercy*. Contrary to the expectations such titles raise, however, the works were not intended to convey any religious message. The artist wished Ignatius, for example, to be understood not as a spiritual figure or an idol or symbol of the Christian church, but merely as the name of a famous man, a star. Thus the name of Mohammed Ali, the boxer, was also included in the series. As Schnabel pointed out, Duccio and Giotto painted in a society in which belief in God actually existed. People experienced paintings on a religious level. Artists linked human beings with something greater than themselves, greater than individual existence. Schnabel believes that people still experience imagery on a religious level, the only difference being that today, religion is no longer organized or prescribed, but represents a kind of consciousness. Religion today, concludes the artist, means becoming conscious, becoming receptive to human sensibilities.

Schnabel, Julian

1951 New York
Lives in New York

◄ **Julian Schnabel**
Ignatius of Loyola,
1987

*Oil and stucco paint
on sailcloth*
457 x 335 cm

Ludwig Donation,
1994

◄ Nicolas Schöffer
Chronos 5, 1960

*Duralumin,
plexiglass,
electric motor
height 200 cm*

Ludwig Donation,
1976

**Schöffer,
Nicolas**

1912 Kalocsa, Hungary
1992 Paris

After moving to Paris in 1936, Nicolas Schöffer took three principles of design – space, light and time – and developed them to their logical end in architecture. What had begun as an experiment, with László Moholy-Nagy's *Light Modulator*, embodied for Schöffer a comprehensive aesthetic renewal of the human habitat. He developed kinetic "light towers" and "light spaces" in which optical and motoric processes took place according to certain aesthetic principles, works of art suited to the age of technology whose stringent reliance on physical laws was belied by their fascinating play of light and movement.

Schöffer titled a series of sculptures consisting of moving, reflecting metal elements and various rotating colored plexiglass vanes *Chronos*, after the Greek god personifying time.

► **Georg Schrimpf**
Female Nude Before
a Mirror, 1926
Mädchenakt vor
dem Spiegel

Oil on canvas
70.5 x 53 cm

Haubrich Donation,
1946

Georg Schrimpf materially contributed to the neoclassical tendency
within the Neue Sachlichkeit (New Objectivity) movement in Germany.
A trip to Italy in 1922 led to deeper contacts with the Pittura Metafisica
artists and the group centered around the journal *Valori plastici*.
Already in the early 1920s Schrimpf began concentrating on figurative
depictions characterized by monumental, veritably sculptural form and
calm, stable composition. Lucidity and simplicity were the fundamental
traits of his art, whose subject matter was invariably derived from
impressions of nature, especially the landscapes of southern Germany,
and from ordinary daily life.

Female Nude Before a Mirror shows a young woman at her morning
toilet in a humble room. With a practiced yet completely natural gesture
she gathers up the hair at the nape of her neck. The artist has treated
the time-honored theme of the nude at a mirror in such a way that it
neither has erotic overtones nor evokes the traditional *vanitas* motif.

Schrimpf,
Georg

1889 Munich
1938 Berlin

Schultze, Bernard

1915 Schneidemühl,
Prussia, Germany
Lives in Cologne

▼ **Bernard Schultze**
Rubyrr, 1957–1958

Wire mesh, textiles,
plastic mass,
oil on canvas
120 x 100 x 3 cm

A pioneer of Art Informel in Germany, Bernard Schultze succeeded in the early 1950s in linking postwar German art with the international trends in gestural abstraction. To the lyrical abstractions of Wols, to Jean-Paul Riopelle's heavy spatula-applied impastos, and to the drips and swirls of Jackson Pollock's Action Painting, Schultze added an original version of expressive abstraction characterized by a balance between spontaneous gesture and continual control. Subsequently he began to build up the painting surface into high relief, expanding gestural abstraction into three dimensions.

In works such as *Rubyrr*, wire mesh, fabric, and sometimes tree branches were affixed to the canvas, then covered with a vibrant paint skin that fused them with the painting surface to create an organic unity. With time the sculptural elements became increasingly autonomous, projecting out of the surface far into the surrounding space. This development led to Schultze's *Migofs*, free-standing configurations that partook of animal, plant, and human forms which evoked the incessant cycle of birth and decay to which all matter is subject. In such works a gestural idiom combined with Surrealist configurations to produce manneristic metamorphoses. Prepared by a series of limited-palette, grey-in-grey compositions of Old Masterly skill, Schultze began in the early 1980s to create manifold and bizarre color spaces on large-format canvases which seemed equally to mirror his own psyche and to represent a slice of the universal design. As in *Magna mater*, the artist marshalled the entire range of his painterly achievements to project a complex scenario of evocative forms, calling up associations with anything from mossy rock formations to light-flooded spaces.

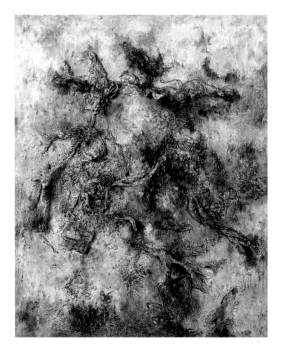

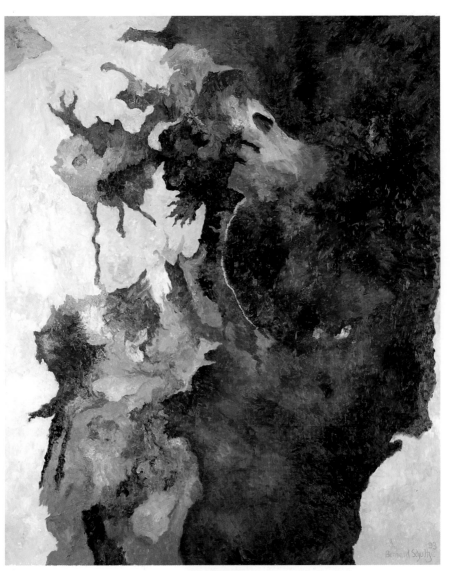

▲ **Bernard Schultze**
Magna mater, 1993

Oil on canvas
240 x 200 cm

Ludwig Collection

Schumacher, Emil

1912 Hagen, Germany
Lives in Hagen

Emil Schumacher's development, after being interrupted by the war, came to full fruition in the context of emergent Art Informel in the early 1950s. Schumacher was one of the major protagonists of this international postwar style, though his art never entirely lost its specifically German character. He was a member of the groups Zen 49, which included Hubert Berke, Ernst Wilhelm Nay, and Fritz Winter, and Zero, of which Schumacher was a co-founder in 1958. The serious, even somber character of his work arose from a preference for dark, earth colors and the employment of built-up relief surfaces, which distinguished Schumacher's canvases from those of French Art Informel. Another frequent device was the framing of the center of the image by means of a broad, impasto contour line.

Joop of 1963 is a good example of the diversity of surface effects Schumacher was capable of achieving. While the upper, black zone has a matte and relatively flat appearance, the dark-red passage below is dense, encrusted, fissured, and opened out in broad swaths to reveal the black ground beneath. A further formal link between the two halves

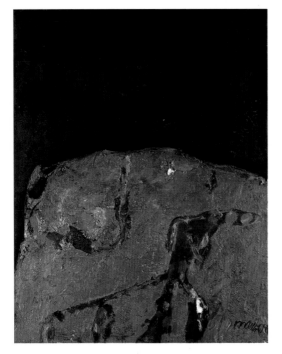

of the image is provided by the black wedge descending from the upper field down the far left edge of the canvas. Schumacher, who also was active as an art college instructor in Hamburg (1958–1960) and Karlsruhe (1966), has been described by Werner Schmalenbach as an artist who addresses the dualism between two antithetical elements: the solid, material nature of paint as against the fluidity and spontaneity of application. The artist himself, in his 1972 *Buch mit sieben Siegeln* (Book of Seven Seals), stated his aim as retaining "formlessness" allied with defined form.

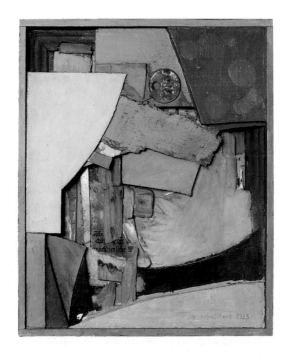

▶ **Kurt Schwitters**
Relief, 1923

*Collage of
various materials
on wood
35.5 x 30 cm*

Influenced by Wassily Kandinsky, Kurt Schwitters abandoned his early Expressionist and Cubist styles to adopt pure abstraction. In 1918 he invented Merz, an offshoot of Dada in Hanover. Dada was a literary and artistic movement aimed at attacking the hypocrisy of outmoded bourgeois art, without initially striving for anything – except The New – to put in its place. With Hans Arp, Max Ernst, Marcel Duchamp, and Richard Hülsenbeck, Schwitters was a major protagonist of this international movement, which filled the gaping voids in the 1920s zeitgeist with an anti-art of humor, bluff and irony.

At first, then, the Dadaists consciously set out to make art that was not art. Schwitters's works of the period were no longer paintings but compositions built up of random, ordinary things, collages of nails, twine, shards of glass, cloakroom tickets, newspaper clippings, and the like. A fragment of an advertisement for a bank, the Commerzbank, which Schwitters had used in an earlier work, provided the title for *Merzbild 9 b (The Big Me Picture)*. "I called my new designs using practically any material, *Merz*. This is the second syllable of *Kommerz*,"

Schwitters, Kurt

1887 Hanover,
Germany
1948 Ambleside,
near Kendal, England

or commerce, the artist explained. "It emerged in a picture in which, among abstract shapes, the word *Merz* was legible."

In this major work of his early phase Schwitters interwove snippets of paper, tickets, fragments of letters and advertisements into a Cubo-Futurist composition. He himself described the situation in which his *Merz Cycle* emerged as follows: "You might as well yell for joy using junk and waste, and that's what I did, by gluing and nailing it all together. I called it *MERZ*, but it was my prayer about the victorious outcome of the war, because peace had managed to win again. Everything was smashed anyway, and it was a matter of building something new out of the pieces. And that was *MERZ*. I painted, nailed, glued, made poetry, and experienced the world in Berlin."

Schwitters launched into his life's work, a small fragment of his third attempt at which is seen in the *Sculpture from the Third Merz-Bau, in Elterwater* (1947). The Merz-Bau was a Constructivist labyrinth, originally conceived to soar several stories high. In the 1923 collage of

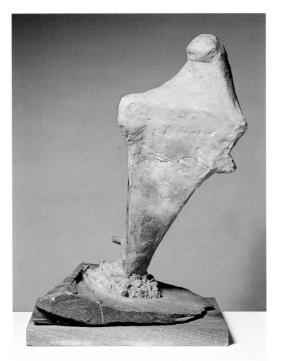

various materials, *Relief*, Kurt Schwitters treated ideas inspired by the work of the Dutch De Stijl group to produce a composition of greater stringency and geometric emphasis than his earlier approach. His continual search for correspondences between the color values and forms of collage elements led, in the later *Glass-Flower*, to a pictorial structure in which the individual *objets trouvés* are given more room to develop their effect. This freedom in the use of found objects was much admired by those American artists of the 1950s who set out to break the hegemony of abstract art by adopting the strategies of Dada.

▲ **Kurt Schwitters**
Glass-Flower, 1940
Glas-Blume

Assemblage and
oil on wood
77.5 x 67.5 cm

Ludwig Collection

▶ **Kurt Schwitters**
Charming Portrait,
1942
Liebliches Porträt

Oil on canvas
on wood
126 x 101 cm

Ludwig Collection

**Seehaus,
Paul Adolf**

1891 Bonn, Germany
1919 Hamburg

Paul Adolf Seehaus was associated with the Rhenish Expressionist group. In 1911 he studied with August Macke, whose friend he became, then in 1913 went on to take courses in art history in Bonn and Munich, obtaining his degree in 1918. Among those Seehaus met in the seminars of Paul Clemen was Max Ernst.

Whether during his travels, which included trips through Scandinavia (1911 and 1914) and to Wales and Ireland (1913), or at home in the Rhineland, Seehaus devoted himself primarily to landscape. His views of the open countryside, or of towns and villages, combine stylistic elements of Expressionism with a Cubist solidity of form, rendered in a palette based on hues that, while generally dark, possess a great luminosity.

In 1915 the Cubist tendency in Seehaus's landscapes grew still stronger, the elements taking on greater compactness and an almost crystalline structure, as seen in the oil *Mountain Town*. "The divisions and cutting edges of the color planes form the basis of the vertical upthrusts and parallels of the compositional framework," writes K. F. Ertel. "Houses, rocks, and mountains seem as if folded out. Their surfaces stand vertical, horizontal, and in Gothically pointed angles."

In *Mountain Town* Seehaus has distilled impressions of a landscape in which human habitation involves a never-ending struggle against rough and desolate terrain. The year before, in *Scottish Landscape* of 1914, he evoked the powers of nature in much the same way, but using a more intense palette.

► **Arthur Segal**
The Harbor, 1921

Oil on canvas
147 x 187.5 cm

Ludwig Collection

In *The Harbor*, a composition that is typical of Arthur Segal's most important phase from about 1920 to 1928, the key traits of his style and his unique approach to composition are very much in evidence. As the artist himself explained, the composition has no main or subsidiary centers of interest. Our eye sees everything in it as of equal weight, no one part dominating, each part being as significant as the next. According to Wolfgang Hilberseimer, "The eye must devote itself equally to every passage in the picture. There are no longer any differences... By means of gradations in color and brightness [Segal] attempts to achieve equality, an equality of value produced by purely painterly means. Even the frame is given a new meaning. Instead of closing off, the frame leads beyond itself – illuminating a relationship with the cosmos. It becomes an integral part of the image, and is painted accordingly. Its function of bounding the image is invalidated. It leads the image beyond the limits of the painting, instead of back into itself as in the case of centralistic composition, where the frame encloses the image and severs its link with the cosmos."

Segal, Arthur

1875 Jassy, Rumania
1944 London

Segal, George

1924 New York
Lives in New Brunswick, New Jersey

▼ George Segal
Woman Washing her Feet in a Sink, 1964–1965

Plaster, sink, chair height 152 cm

Ludwig Donation, 1976

Originally a painter, George Segal began to experiment in sculpture in 1958. Using wire, burlap, and plaster he built figures whose lifesize scale and white color already anticipated key traits of his plaster casts to come. With his friend, Alan Kaprow, Segal discussed the potentials of an art that would encompass every form and requisite of the environment without discrimination. The two put their ideas into practice in happenings performed at Segal's chicken farm in New Jersey. These events had been immediately preceded by the artist's first cast from a living person, which was made almost by accident in 1960. A friend had brought along a new type of medical bandage impregnated with plaster, which Segal immediately applied to his own body, then asked his wife to put on more. Soon he was using the procedure on his close friends.

In making his sculptures Segal focussed especially on everyday, mundane activities, such as washing or shaving oneself, walking down the street, drinking a cup of coffee, sitting at a table – banal activities that are celebrated as essential parts of life in the artist's arrangements. The lifesize figures demonstrate these activities in poses that appear spontaneous and natural. On first sight one in fact has the impression of being confronted with crassly naturalistic illustrations. Closer scrutiny reveals this impression to have been erroneous. One notices, for instance, that details such as facial features have been suppressed. Then too, the surface of the figures, instead of having the texture of skin or fabric, has a coarse, sometimes even lumpy look, and in certain passages one detects traces of Segal's hand as it shaped the plaster, or the texture of the underlying gauze. Such features only serve to increase the real, as opposed

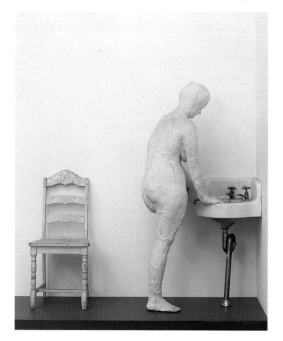

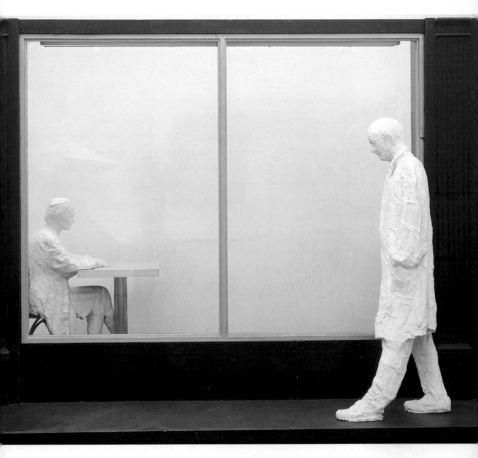

to realistic, character of Segal's objects. The figures are not naturalistic portraits but generalized depictions of people going about their everyday lives.

Since 1960 Segal has been combining his plaster figures with actual, existing objects. His *Woman Washing her Feet in a Sink* uses a real washbasin, and his *Restaurant Window I* employs a real window. Segal's figures are surrounded by objects from an environment man has created and from which he cannot escape, which lends them the character of symbols of human self-emprisonment in the adamant edifice of civilization. The employment of actual, everyday objects serves to augment the reality content of Segal's figure tableaux.

▲ **George Segal**
The Restaurant
Window I, 1967

Plaster,
restaurant window,
wood, metal,
plexiglass,
fluorescent lights,
chair, table
244 x 340 x 206 cm

Ludwig Donation,
1976

Seiwert, Franz Wilhelm

1894 Cologne
1933 Cologne

▼ Franz Wilhelm
Seiwert
City and Country,
1932
Stadt und Land

Oil on plywood
70.6 x 80.7 cm

With Heinrich Hoerle, Franz Wilhelm Seiwert in 1924 founded the Group of Progressive Artists, Cologne, whose leading theoretician he is considered to be. A devout Catholic, Seiwert became a convinced Marxist after his experiences in World War I. "Since that time I have stood on the side of the workers' revolution, for which I also hope to provide support through my art," wrote the artist in 1929.

On the basis of an objective, constructive pictorial form that consciously endeavored to evoke the flatness of medieval painting, Seiwert sought to depict a reality stripped of all vestiges of sentimentality and incidental factors. He envisioned capturing within the picture frame the functions, principles, relationships, and tensions of reality as he saw it. In fact, his attempt amounted to nothing less than a visualization of the Marxist view of the world. Seiwert accordingly reduced individuals to types, which stood for certain situations or classes in society. Similarly to the Constructivists in the wake of the Russian revolution, Seiwert hoped to unite a political stance with an artistic program.

In *City and Country* a strict formal scheme determines the relationship of the figures to each other. At the center of the picture, two men with hammer and sickle shake hands, against the background of a highly abstracted industrial and agrarian landscape. Every element is reduced to a stylized scheme, and the figures are deprived of all individuality. The cityscape is treated merely as a juxtaposition of dark-hued architectural shapes, while the countryside appears as a series of light-hued rectangular fields. The schematic forms in Seiwert's work owed much to the course of his career. His initial plans to practice architecture were certainly not without effect on the reduction and stylization seen in his painting. Seiwert's pictures might in fact be characterized as architecture in two dimensions, so obvious

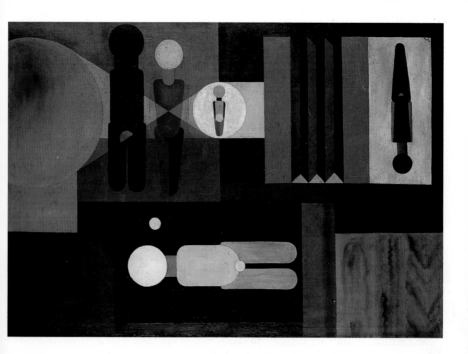

is their conception in terms of masses and proportions. Other influences came from the Cubist geometries of the cityscapes of Robert Delaunay and Lyonel Feininger.

Using the same formal means, but this time without any overt political message, Seiwert's *Wall-Painting for a Photographer* was created in 1925 and dedicated to his friend August Sander, a photographer active in Cologne. The work represents and portrays the function of photography in terms of an enumeration of facts. At the left we see the photographer's model, at the right the camera, with the motif projected upside-down on its ground glass back. Depicted below is the darkroom, with the photo lying in the developer and the color values of the motif reversed. In Seiwert's opinion the task of photography was to document current events, while painting would produce projections of an utopian future.

▲ Franz Wilhelm Seiwert
Wall-Painting for a Photographer, 1925
Wandbild für einen Photographen

Oil on canvas
110 x 154.5 cm

Loan from
a private collection

Serra, Richard

1939 San Francisco,
California

Lives in New York

The notion of sculpture as drawing in three dimensions has played a key role in Richard Serra's work from an early date. The working of metal, altering it by means of rolling, cutting or fitting, even by casting in lead or plastic molds, amounts in his eyes to an act of drawing. As Serra once stated, the creation of sculptural form by whatever means was akin to drawing within the physical transformation of the material from one state to another.

When he came to New York, Serra met painters of the New York School (Robert Rauschenberg, Frank Stella, and others) and Minimal artists like Carl Andre and Donald Judd. He began working on sculptures that derived their aesthetic qualities solely from the properties of the material and its form, rather than from any symbolic or functional context. Serra's works in neon tubing, simple geometric or scriptural lineatures whose graphic forms are surrounded by an atmospheric shimmer, should also be understood against this back-

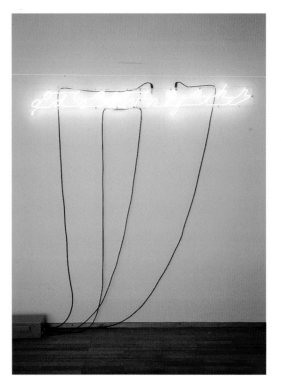

ground. This series of pieces was executed in New York beginning in 1966.

In the late 1960s Serra began employing heavy steel plates to make sculptures. In 1969 he collaborated with a California steel company, aided by the experience he had gathered working in steel factories to earn his living as a student. Serra's steel plates and iron cubes articulate walls or spaces, intersect the landscape; their sheer weight and monumentality lends them an architectural effect.

Serra's sculptures are composed of basic geometric forms, as seen in *Moe*. Three five-centimeter thick plates are inserted into a slotted roll of steel on the ground, the middle element on the vertical, the two others

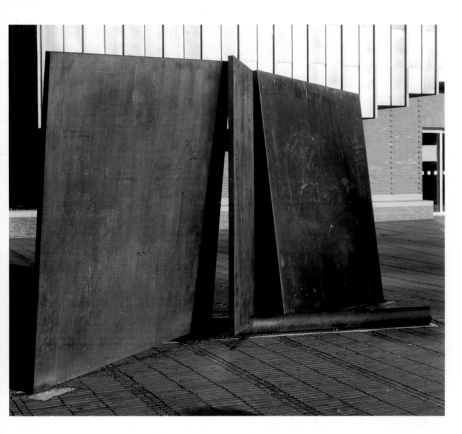

leaning at slight angle against it. The overall impression this gives
is one of delicate and even precarious balance, but actually the weight
of the configuration maintains its stability. After rust was removed by
sandblasting and the surface was treated, the sculpture was installed
on a bed of dark gravel in front of the south entrance of the Museum
Ludwig, Cologne. *Moe* is an outstanding example of the large-scale
sculptures of Minimal Art, and it stands in good company with other
Minimal works by Andre, Judd, and Robert Morris. Every element of the
piece was industrially prefabricated, to eliminate all traces of aesthetic
artifice.

▲ **Richard Serra**
Moe, 1971

Hot-rolled steel
244 x 610 x 366 cm

Ludwig Donation,
1976

◄ **Richard Serra**
God is a Loving
Father, 1967

Neon tubing
25 x 200 cm

Ludwig Donation,
1976

Severini, Gino

1883 Cortona, Italy
1966 Paris

Italian artist Gino Severini was introduced to French Post-Impressionism in Rome in 1901, by Umberto Boccioni. In 1906 he moved to Paris, the birthplace of Cubism, where he met Georges Braque, Juan Gris, Fernand Léger, and Pablo Picasso. During a later stay in Rome, in 1910, Severini signed Filippo Tommaso Marinetti's *Manifesto of Futurism* together with his compatriots Boccioni, Carlo Carrà, Luigi Russolo, and Giacomo Balla. On his return to Paris Severini devoted himself to Cubism exclusively.

His *Collage* is a still life whose most salient element is a musical instrument. Characteristic motifs of Synthetic Cubism, such as sheet music and cut-out, painted or printed papers, are combined with the aid of the collage technique, drawing, flecks of color, and light-dark contrasts into a vital composition of spatially interpenetrating and interlocking elements. The result is a configuration that appears outwardly stable while being pervaded with internally divergent motions and forces.

In 1970 Charles Simonds began to erect miniature dwellings for an imaginary "little people" in the streets of depressed areas of New York City. Set in building entrances or gaps in walls, these architectures of clay bricks, small stones, sand and wood were inspired by the idea of dwarfs, kobolds, and homunculi from Western and American Indian mythology. Simonds's references to the past, whether evoked by the artforms of archaic cultures or by the demise of his miniature dwellings through erosion or vandalism, are the artist's way of challenging us to ensure a more humane and natural urban environment in the future. *Park Model/Fantasy* represents the development of a people in three phases, a reference to the present-day situation being given by photographs of New York building facades on the side walls. In one description of the work we learn that it represents the remains of a people whose architecture was laid out at a 45-degree angle to the axes of New York City – part of a village that was a signal station.

**Simonds,
Charles**

1945 New York
Lives in New York

The three sections of the work show this village of dwellings and ritual sites. In the first, the houses and towers are still serving their function; in the second, they are abandoned, only parts of a ritual site being in use. In the third state a portion of the village is occupied, and the religious structures are again being used. Simonds's intention is to symbolically visualize, through architecture, the rhythms of development and demise in the historical evolution of humanity.

◄ Charles Simonds
Park Model/Fantasy,
1974–1976

Clay, photographs
Three parts, 81 x 51 x
18 cm each

Ludwig Collection

Sintenis, Renée

1888 Glatz, Silesia,
Germany

1965 Berlin

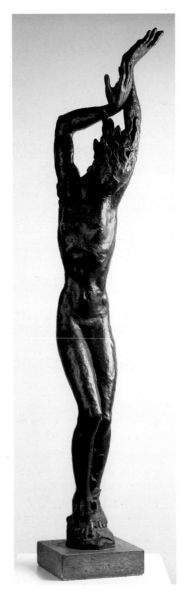

► Renée Sintenis
Daphne, 1930

Bronze
height 145 cm

The focus of Renée Sintenis's œuvre, apart from sculptures of animals, was on the female figure. *Daphne* of 1930 is one of her major works. The theme goes back to a tale passed on by Ovid, in his *Metamorphoses,* about how Apollo, crazy with love, pursued the nymph Daphne. Having no wish to relinquish her virginity, Daphne fled from her ardent admirer, and invoked the gods to transform her into a laurel tree. Sintenis has chosen to illustrate the climax of the story, as the metamorphosis begins – laurel leaves sprout from Daphne's feet, armpits, and head.

The sculpture was commissioned by Carl Georg Heise, then director of the Museum of Art and Art History in Lübeck. Heise had the figure installed in the museum's sculpture garden next to a tree, such that *Daphne's* arms extended into its lower branches. The expressive gesture of the figure, says B. E. Buhlmann, conveys "an emotional ambivalence between sorrow at the loss of human existence and joy at the retention of virtue."

▶ **Mario Sironi**
Yellow Airplane with
Cityscape, 1915
Aeroplano giallo con
paesaggio urbano

Collage and gouache
71 x 53 cm

Ludwig Collection

Mario Sironi's *Yellow Airplane with Cityscape*, executed in the wake of
his voluntary service in World War I, reflects both personal experiences
and the artistic influences to which Sironi was exposed during the
immediately preceding years.

We see a biplane climbing diagonally into the sky, which is divided
by an opposing diagonal into a black and a bluish-grey field, against
which the yellowish-brown airplane stands out in high contrast. Both
this basic geometric composition and the cubically rendered cityscape
below, with its interplay of building walls that are brightly illuminated
or sunk in deep, greyish-black shadow, reveal an attempt to come to
terms with impressions of Cubism. Color, form and motif combine in
this collage to produce an overall effect of hallucinatory reality which
reflects Sironi's affinity with Italian Pittura Metafisica.

Sironi, Mario

1885 Sassari,
Sardinia
1961 Milan

Smith, David

1906 Decatur,
Indiana
1965 Bennington,
Vermont

In the mid-1920s David Smith studied art and literature at Ohio and George Washington universities, supporting himself by working as a welder and solderer at the Studebaker automotive plant. After moving to New York in 1933, he began to make sculptures in wood, wire, stone, and aluminum bars in a Cubist and Constructivist vein. Influenced by works of Pablo Picasso and Julio Gonzalez, Smith also launched into sculpture in iron at this period. Indicatively, he referred to his studio as a "factory." It was remarkable that from the start, as G. Inboden notes, Smith "strove to formulate a conception of art based on the Surrealists' aim to unify art and life, and in which life was to figure as the social and art as the anti-aesthetic [factor]."

In the 1940s an iconographic change occurred in Smith's work. Many drawings of the 1950s have a free-form structure that recalls Surrealist automatism. Among the sculptures that were based on the calligraphic gestures of such drawings is *Untitled* of 1953. A homogeneous configuration when viewed from a distance, the piece loses its unity when seen close up, dissolving into its components – the various knives, sawblades, metal elements, and different types of pliers of which it is built up. In *Volton XV*, similar elements are employed to evoke a sense of physical aggression. The lack of any main viewpoint involves us as spectators, by challenging us to discover how the sculpture metamorphoses as we move around it.

Sonnier, Keith

1941 Mamou,
Louisiana
Lives in New York

▼ Keith Sonnier
Wrapped Neon
Piece, 1969

*Neon tubes, wiring,
transformer*
248 x 187 x 151 cm

Ludwig Donation,
1976

After attending the University of Southwestern Louisiana (1959–1963)
and spending a year in France (1963–1964), American artist Keith
Sonnier came to Rutgers University in Brunswick, where he studied
from 1965–1966 and received an instructorship in 1966.

Sonnier's art is remarkable not only for its diversity of materials
but also for its formal and substantial complexity. Sonnier became
known especially for his colored neon pictograms, and a series of
installations in neon and glass which emerged in 1968 and became
a focus of his work.

The object illustrated here, done in Cologne in March 1969 and
given the working title *Wrapped Neon Piece*, consists of four twisted
neon tubes combined into a three-dimensional, calligraphic lineature
which produces shimmering, atmospheric effects of color. This "writing
in space" would appear to be a legitimate continuation of Abstract
Expressionist painting in another
medium.

Since the early 1970s Sonnier
has also systematically devoted
himself to film and video installa-
tions. It was this involvement
with such contemporary media,
the artist recalled, that led him
to redefine his role as an artist in
modern society, for he considers
it very important to react in his
work to these new structures
which fundamentally influence
our daily lives.

▶ Jesús Raphael
de Soto
White Curves
on White, 1966
Courbes blanches
sur le blanc

*Composition board
on wooden frame,
metal rods,
nylon filament
106.5 x 106.5 cm*

Venezuelan artist Jesús Raphael de Soto is an outstanding repres-
entative of both Op Art and Kinetic Art. "Soto's paintings are not
intrinsically kinetic, at least not essentially so," writes P. Wember;
"they obtain their movement through the viewer. The structures are
static planes and static compositions, but combined in a way as to
induce movement. They are brought into a conscious behavioral
relationship."

What this means is very much in evidence in the 1966 piece
White Curves on White. Mounted on a square panel are three smaller
wooden panels, a white rectangle on the right, a yellow square at the
upper left, and below it a square bearing a series of close, parallel
horizontal lines. Suspended in front of the lower half of the compo-
sition are thin white metal rods, attached by nylon filaments of increas-
ing length to the center of the picture. The fact that these rods curve
slightly downwards at the ends and begin to oscillate at the slightest
breath of air, results in a continually changing pattern of lines, both
as the rods intersect their own shadows on the right, and as they and
their shadows intersect the parallel, drawn lines on the left. These
movements are in turn compounded by our own motion in front of
the image.

de Soto,
Jesús Raphael

1923 Cuidad Bolívar,
Venezuela
Lives in Paris

◄ **Pierre Soulages**
Painting 12/31/1964, 1964
Peinture 31. 12. 1964

Oil on canvas
202 x 143 cm

Ludwig Donation, 1976

Soulages, Pierre

1919 Rodez, Aveyron, France
Lives in Paris

Pierre Soulages views painting as a physical and poetic experience. It was just this great "need for aesthetic and intellectual intensity," as he himself put it, that made Soulages the representative of the Ecole de Paris par excellence. He continues to uphold the traditional virtues of French painting: formal balance, a sophisticated employment of the paint substance, a controlled spontaneity, lyrical combinations of color.

Soulages's compositions consist of powerful, usually rectilinear and opaque bands of paint that intersect and overlap one another. In *Painting 12/31/1964* the broad swaths of black lie in practically the same visual plane as the earth-colored passsages, against the illuminated depths evoked by the white ground shining through in places – a visual event of compelling simplicity and self-evidence. Soulages was a master in emphasizing the spontaneous act of painting, the gestural factor, while never relinquishing solid form.

When Daniel Spoerri joined the Nouveaux Réalistes in 1960, he had just gained his first experiences in art. Yet thanks to his previous activities as a fruit vendor, laborer, waiter, poet, dancer (initially in a Zurich jazz club, then at the Bern Opera), pantomime, tour guide

Spoerri, Daniel

1930 Galati,
Rumania
Lives in Seggiano

(to Lourdes), and director in the field of absurd theater, Spoerri was well-equipped to "shape life into a work of art," as he himself put it. Taking as his guidelines Marcel Duchamp and his ready-mades, and the Dadaist reliance on chance, Spoerri began in 1960 to create what he called *Trap Pictures*. Here is his own definition, which would do honor to any dictionary: "Objects which are found in random, unordered or ordered situations, are affixed to their chance support (table, box, drawer, etc.) in precisely that situation in which they were found. Only their level is altered: by declaring the result a painting, horizontal becomes vertical."

Spoerri and Fluxus artist Robert Filliou worked and ate at *Robert's Table* one day in 1961, in the course of their preparations for a show to be held in Filliou's Copenhagen apartment.

◀ **Daniel Spoerri**
Robert's Table, 1961
Le table de Robert

*Wooden board
with mounted objects*
200 x 50 cm

Ludwig Donation,
1976

◄ **Nicolas de Staël**
The Shelf, 1955
L'étagère

Oil on canvas
88.5 x 116 cm

De Staël,
Nicolas

1914 St. Petersburg
1955 Antibes, France

Being members of the Russian nobility, Nicolas de Staël and his family were compelled to leave the country in the wake of the 1917 Revolution. De Staël's training in art began in 1932, when he entered the Brussels Academy.

The Shelf, painted in 1955, is among the artist's last works. The shelves holding various everyday objects are shifted slightly upward and to the left of composition center, yet the color emphases keep the whole in balance. Perspective effects are waived. The paint is applied heavily, using a broad bristle brush and palette knife, lending the surface an almost haptic texture. Instead of painting reality, de Staël has, as it were, recreated it through the movements of the brush. In Karl Ruhrberg's eyes, "the light colors ... [and] the, so to speak, aggressive paint application with brush and palette knife" attest to "the artist's struggle to find the truth of reality. Because he believed himself incapable of capturing it and thought he was making no progress as an artist, he committed suicide in despair."

About these torments de Staël himself wrote, "I lose contact with the canvas every moment, I re-establish it, then I lose it again."

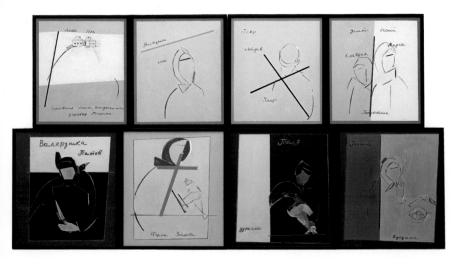

The geometrical, Suprematist-influenced compositions of Edward Steynberg reveal him to be perhaps the most important artist in the older generation of the second Russian avant-garde. His first experiments in abstraction were influenced by the spontaneity of the Western art he had seen in Moscow in the late 1950s. However, Steynberg soon turned to the rigorous approach of classical Russian avant-garde painters like Kasimir Malevich and El Lissitzky, whose works he discovered in the early 1960s, at the house of collector Georges Costakis. From then on his style was based on purely geometric shapes: crosses and circles, triangles and rectangles.

In the eight-part painting *Seasons (The Living and the Dead)* Steynberg tells the story of the small village of Pogorelka and its inhabitants. He is well aquainted with the place, because he regularly spends the summer months there. "River, mountain, forest, field, meadow, gorge, trees, fences, vegetable gardens, wells, animals, and people – all of these together form a cosmos," says Steynberg. "At the same time it's a family, a tribe, a piece of history. Pyotr Lebedev, Fisa Saizeva, Lida Titova, Pyotr Deretchev, Lyoscha Suloyev – every one of them embodies his or her story. The stories of old peasant families, the sad story of the Russian village, and with it the history of Russia."

Steynberg, Edward

1937 Moscow
Lives in Moscow

▲ **Edward Steynberg**
Seasons (The Living and the Dead), 1985–1987

Oil on canvas
Eight-part polytyptich
90 x 320 cm
(four-part upper row)
97 x 360 cm
(four-part lower row)

Ludwig Collection

Stella, Frank

1936 Malden, Mass.
Lives in New York

▼ Frank Stella
Seven Steps, 1959

Enamel on canvas
215.9 x 156.5 cm

Ludwig Collection

In the late 1950s a generation of American artists emerged who practiced an abstraction entirely devoid of the expressiveness of their predecessors' work. One of the most radical was Frank Stella, with his first series of *Black Paintings*, to which *Seven Steps* belongs. The matte black enamel has been applied directly to the unprimed canvas, whose whitish ocher tone shines through in places. The black is treated as an objective quality, no importance having been attached either to the evocativeness of the color or to the emotional associations of the form it describes. Like Morris Louis, Stella reached a point at which visual figure and ground coincide. The painting's title refers to a lesbian bar in New York; the entrance was below street level, with seven steps leading down to it.

Between 1967 and 1969, an involvement with fundamental architectural configurations led to Stella's *Protractor* series, comprising a total of 93 works, of which *Ctesiphon III* is one. The titles of the series were derived from the names of ancient cities in Asia Minor, and were meant to evoke their typical circular layouts and round-arched city gates, which suggested the idea for the configurations seen here. The composition consists of a full circle and two centrally intersecting semicircles. In combination with the brilliant, harmonious play of color, the result is a definitely decorative work. Stella himself admits that his focus has always been on a truly decorative painting in the positive sense, as the term is applied to the work of Henri Matisse.

Probably in reference to that artist's *La Danse* (Barnes Foundation, Merion), Stella once said that he would like to combine the relaxation of dance with the absolute rigor and formal

inspiration of Matisse's Moroccan painting. His most recent works, he added, were so strongly concerned with painterly issues and considerations that they were by no means decorative in the conventional sense.

Inspired by the herons of the Bonin Islands, *Bonin Night Heron No. 1* is part of a mid-1970 series of paintings opened out into space collectively titled *Exotic Birds*. Here the artist's previously stringently geometrical approach has apparently flipped over into its opposite. The compositional elements consist of metal bands, cut in shapes resembling volutes or draughtsman's curves, and painted in loose brushwork. Emphasized by colorful graphic textures, the shapes seem to emerge from the plane as if floating in front of the pictorial field.

▲ **Frank Stella**
Bonin Night Heron
No. 1, 1976

Acrylic on aluminum
275 x 350 x 65 cm

Ludwig Collection

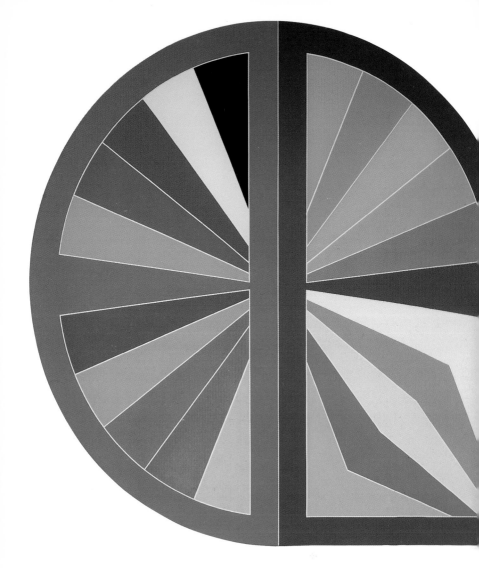

▲ **Frank Stella**
Ctesiphon III, 1968

Fluorescent acrylic
on canvas
300 x 600 cm

Ludwig Donation,
1976

▶ **Varvara Stepanova**
Gaust Chaba, 1919

(Edition of 50 and
four numbered
copies; copy no. 3)

*Sixteen collages,
gouache on newspaper*
17.5 x 27.5 cm

Ludwig Collection

◀ **Varvara Stepanova**
Figure No. 29, 1921

Oil on plywood
124 x 81 cm

Ludwig Collection

Varvara Stepanova's *Gaust Chaba* is a significant and famous example
of Russian avant-garde experimental book design, a first culmination
of which came with the work of Olga Rozanova. For her one-off books
Stepanova used sheets of newspaper as a ground, then inscribed these
with brushed lettering such that the gesture of writing dominated over
the printed page. The prosaic newspaper articles were confronted with
the lyricism of what the artist termed "transrational" poems in an
invented language. Some sheets were adorned with geometric collages
that seemed to anticipate later Constructivist book designs.

In 1920–1921 Stepanova, in collaboration with Alexander Rodchenko,
materially contributed to the theoretical development of Constructivism.
That period also saw the emergence of her sequence of *Figures*. Over
thirty works from this sequence are visible in a 1921 photograph of
Stepanova and Rodchenko's studio. Stepanova began by analyzing
the motion sequences of the human figure. Then she reduced these
studies to simple, flat, geometric shapes to create a range of variations
on the figure whose mechanical but lively look calls robots or mari-
onettes to mind.

**Stepanova,
Varvara**

1894 Kovno, Lithuania
1958 Moscow

Still, Clyfford

1904 Grandin,
North Dakota
1980 New Windsor,
Maryland

Before moving to New York in 1951, Clyfford Still was part of the Pacific School, a group of artists active in San Francisco that included Mark Tobey and Mark Rothko. According to Still, an artist's greatness depended on the profundity of his insight and the courage to realize his own, personal vision. This statement amounted to a definition of the aims of Abstract Expressionism, one of the major representatives of which Still became. For all their individualism, the artists working in this style agreed on one thing: the necessity to jettison traditional figurative and structured approaches to painting, and instead to concentrate solely on the act of making, with a spontaneity that would tap deep unconscious wellsprings of creativity. Each work was to reflect a unique and unrepeatable mental state. It was essential to divorce the process of image-making from every preconceived idea, and to let the image emerge out of the painting process itself. During this process the artist would, in turn, discover himself.

Many of the Abstract Expressionists, once they had found the form of image that fulfilled these ends, concentrated on repeating and ramifying it like a meditational formula. In Still's case this was the wedge-shaped or ragged, lightning-like form that split open an expansive field of usually darker color. In his untitled painting of 1948–1949, a brownish black flows down the canvas from the upper edge, penetrated by coal-black wedges. In many places the impasto surface is sundered to reveal a ragged dark red line. At the lower edge passages of orange and blue lie exposed, not yet engulfed by the expanding black. On the other hand, these brilliant color areas could be read as themselves expanding in resistance to the all-pervading obscurity. Such counteracting forces engender a sense of dynamic motion that is further amplified by the intrinsic vitality of the impasto paint application and its runs and textures. One senses the vehemence with which the artist handled the paint, infusing matter with emotion.

▶ **Clyfford Still**
Untitled, 1948–1949

Oil on canvas
206.6 x 172.7 cm

Ludwig Collection

The result is a painting which seems to possess corporeal presence, an impression that is increased by the sheer size of the canvas. The painting forces us to abandon the spectator's detached viewpoint, for it confronts us with a pure and immediate physical reality.

Suetin, Nikolai

1897 Kaluzhskaya,
Gubenia
1954 Leningrad
(now St. Petersburg)

► **Nikolai Suetin**
Composition,
c. 1922–1923

Oil on canvas
65 x 48 cm

Ludwig Collection

▼ **Nikolai Suetin**
Female Figure, 1927

Pencil on paper
60 x 29.5 cm

Ludwig Collection

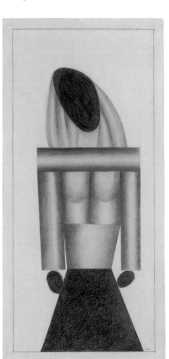

Nikolai Suetin, a close collaborator of Kasmir Malevich, was concerned like no other to put the principles of Suprematism into practice. He made designs for a great variety of utilitarian things, from porcelain to furniture, and developed conceptions for the application of Suprematist ideas to architecture and exhibition design.

Suetin's compositions of around 1920 to 1922 exhibit an astonishing range of variations on the Suprematist idiom. On first glance his two oils, *Suprematism* (c. 1920–1921) and *Composition* (c. 1922–1923), may seem related to Malevich's pre-1920 Suprematist compositions. *Composition* consists of a diagonally oriented conglomeration of abstract geometric forms on a light-colored ground, dominated by a red configuration composed of three abutting and intermerging rectangles. On closer inspection, however, this composition turns out to differ from Malevich's works in several respects.

Suetin gives more emphasis to graphic and structural elements than Malevich, his paintings having the appearance of carefully considered and well-ordered architectonic designs. The spatial and metaphysical aspects are almost entirely absent.

These works of Suetin's were executed in Vitebsk, where, after Malevich's arrival in 1919, the artistic community had been gripped by a kind of Suprematist euphoria. For Suetin, however, Suprematism was to be only a waystation on the road to his further career.

In 1927 he began a series of drawings that reflected his involvement with Russian icon painting, and which was to continue until 1929. One of these drawings was *Female Figure*, a unique combination of flowing line and mechanical form whose most salient feature is the strangely expressive oval of the figure's inclined head.

◀ **Nikolai Suetin**
Suprematism,
c. 1920–1921

Oil on canvas
68.5 x 50.5 cm

Ludwig Collection

▶ **Mark di Suvero**
Martian Ears, 1975

Steel
Two parts,
200 x 170 x 180 cm

Ludwig Donation,
1994

In the steel sculpture *Martian Ears* two plates have been cut with a
torch, bent, and fitted together such that the object can be easily set
in a rotating or swinging motion. The ornamental cut-outs and the
bending of the material in opposite directions further contribute to
a sense of lightness and malleability not usually associated with steel.
Nevertheless, as the arrangement of the individual elements and the
opening of the piece to the surrounding space indicate, the sculpture
is actually based on an intrinsic static principle. This is expressed, first,
in the broad floor plate with "ears" protruding on two sides; then in the
open, pyramidal support construction; and finally in the upper element
with its two depending, outwardly tapering steel flaps which echo the
protrusions on the base. Di Suvero can be said to have continued and
ramified the approach of David Smith, who was still planning to create
very large-scale steel sculptures until shortly before his death.

Di Suvero, Mark

1933 Shanghai, China
Lives in New York

Tanguy, Yves

1900 Paris
1955 Woodbury,
Connecticut

Yves Tanguy joined the merchant marine at the age of eighteen and travelled to Africa, South America, and Great Britain. He began to paint in 1923, without having had academic training. After meeting André Breton in 1925, Tanguy threw in his lot with the Paris Surrealists.

Though his style was influenced by Giorgio de Chirico, Max Ernst, Joan Miró, Paul Klee, and Hans Arp, Tanguy's imagery was unmistakably his own. The emergence of his pictures relied strongly on chance. After preparing the canvas Tanguy would let himself be inspired by its random textures and begin spontaneously to populate the usually shallow space with Surrealistic "object-beings" (the term is Breton's) which elude classification in any category of existing living creature.

▼ Yves Tanguy
Out of the Blue,
1929
Derivé d'azur

Oil on canvas
110 x 73 cm

Loan from
a private collection

In the works of the early phase, to which *Out of the Blue* belongs, a dividing line separates two areas or levels of the picture, which seem observed from a bird's-eye view and are distinguished only slightly in terms of color gradation. The viewer gains the sense of a world in slow motion, as in a dream. The things or beings that exist there are like words in a language that eludes rational understanding, but that speaks directly to the unconscious mind.

Clear and unequivocal interpretations of Tanguy's imagery are accordingly well-nigh impossible. The figurative vein of Surrealism in general tends to displace the existing world into a realm where neither place nor time remains valid. Yet Tanguy handles his invented, cryptic formal language as if it were the most natural thing in the world. In fact, the iconography of the present painting was influenced by the artist's trip to North Africa, where the high plateaus of the Atlas Mountains and the rugged rock formations left a lasting impression on his mind.

Self-taught except for a two-month attendance at the Nolasc Valls academy, Antoni Tàpies came in contact with contemporary art in 1934 and began not only to paint but to immerse himself in the art and philosophy of the Far East. His mature work in particular is suffused by a profound seriousness, born of the desire, as he says, to help "people remember who they really are, to give them a topic to think about, to give them a shock that will waken them from their wrong-minded delusion..." Tàpies devotes his work "to helping human beings overcome the state of self-alienation, by surrounding them in their daily lives with objects which confront them, in a 'touchable' way, with the ultimate and deepest problems of our existence." In its invocation of the healing powers of collective memory, Tàpies's art is certainly at the very least, as Werner Schmalenbach has said, an art of meditation.

Tàpies confronts us with complex configurations resembling great slabs or walls, grey and rough, and on first sight melancholy and deeply earnest in effect. The material appearance of these paintings cannot be separated from their pictorial expression. The secrets of humble

Tàpies, Antoni

1923 Barcelona, Spain
Lives in Barcelona

▲ Antoni Tàpies
Grey Relief in
Four Parts, 1963
Relleu gris en
quatre parts

*Mixed media,
with sand,
on canvas*
150 x 217 cm

materials, the sumptuousness of paint masses, the expressive force of sand textures, folded cloth, wood, paper and lacquer are skillfully deployed to the artist's ends and put in the service of his message. The simple and elementary nature of his media, believes Tàpies, will encourage us to concentrate on what is essential in us and our world. "The means I use for the necessary inspiration should be as direct as possible. Instead of giving a sermon on humility, I often prefer to depict humility itself. At times it may be better to show a pile of countless indistinguishable sand grains than to expatiate on solidarity among men." The devices and symbols in Tàpies's art are never solely aesthetic in intent; they invariably suggest the presence of living creatures, usually human beings, who leave traces of their lives wherever they are and whatever they do.

▲ **Antoni Tàpies**
Signs on White
Ovals, 1966
Signes sobre ovals
blancs

Sand, glue,
paint on wood
196 x 260 cm

Ludwig Donation,
1976

◄ **Antoni Tàpies**
Large Black and
Crackled Brown, 1966
Grand negre i marró
craquelat

Oil, canvas,
sand, cement
260 x 195 cm

Ludwig Donation,
1976

Paul Thek has created environments rife with enigmatic symbols: cult relics, stuffed animals, burning candles... in which the realms of classical, Far Eastern, and Christian mythology are punctuated with elements of hippiedom. "The more intensively and comprehensively life is lived," wrote J. C. Ammann, "the more strongly does it imply its opposite pole: death. The marriage of these poles by means of symbols, in the form of a life beyond these symbols, is seen in the environments of Paul Thek. This entails, in particular, the employment of ideologically undetermined symbols... Paul Thek's vision of death and of a rebirth out of death is a hymn that unifies the archetypical and the religious in an incomparably compelling plastic realization."

After studying in New York from 1951 to 1954, Thek went to Italy in 1962, then returned to the US for a three-year stay (1964–1967). When he again went to Europe, Thek commenced a series of pieces consisting of extremely naturalistic reproductions of chunks of meat and parts of the human body. These, confronted with strange and enigmatic objects, engendered a new realm rife with myths and symbols. The severed arm adorned with feathers and jewellery in Thek's 1967 piece calls to mind the reliquary of some unknown cult. Similar associations, triggered by a confrontation of legible symbols with irrational, subconsciously evocative objects, are called forth by the artist's *Sedan Chair*. The symbol of royal privilege, in connection with the suspended, blood-spattered child and the meat presented on a plate, evoke ritual acts such as blood sacrifices and offerings.

Thek, Paul

1933 New York
Lives in Paris
and on Isola Ponza

▲ **Paul Thek**
Untitled, 1967

*Plastic, metal,
feathers, paint*
23 x 87.5 x 23 cm

Ludwig Donation,
1976

◄ **Paul Thek**
Sedan Chair, 1968

*Wood, plastic,
paint, metal*
200 x 100 x 100 cm

Ludwig Donation,
1976

◄ **Wayne Thiebaud**
Cake Counter, 1963

Oil on canvas
93 x 183 cm

Ludwig Donation,
1976

Thiebaud, Wayne

1920 Mesa, Arizona

Lives in Sacramento,
California

Wayne Thiebaud is part of the Pop Art scene on the American West Coast. Many of his paintings are still lifes of bakery goods, candy, or great scoops of ice cream. Thiebaud shows us a world of normal everyday pleasures in which it is hard to draw the line between life and art. Yet his choice of subject matter also prompts thoughts about the transience of things, their daily consumption and replacement. *Cake Counter* presents two shelves full of prettily decorated cakes, the lower row, cut off by the edges of the canvas, suggesting an infinite continuation of sweet temptations. One is inadvertantly put in mind of an abundance just within our grasp, a tempting realm of milk and honey. The oil paint has been applied thickly, with broad brushstrokes, spread over the cakes like icing, then adorned with garlands and flowers in colors that leap to the eye. "In a process bordering on alchemy," writes K. Tsujimoto, "Thiebaud has apparently worked not with oil paint but with a substance consisting of flour, butter, egg white, and sugar." The special qualities of the surface, decorations, and shapes of the cakes – subject to imminent destruction by eating – are presented with an aesthetic heightening that suggests permanence, for, as Dieter Ronte notes, "the viewer recognizes formal elements which he would not perceive while simply consuming" the cakes. What Thiebaud once said when asked what interested him about a hamburger is revealing in this connection. It was "its contour, its architecture," he replied, adding that a hamburger was like a miniature building by Frank Lloyd Wright.

► Jean Tinguely
Large Water
Machine, 1966

Iron, rubber hose,
lamp, wood,
electric motor
height 220 cm

Ludwig Donation,
1976

For Jean Tinguely, movement meant life: "As soon as life is fixed, it is no longer true," he believed; "it is dead, uninteresting... everything incessantly changes."

As a logical consequence he began as early as 1947 to divest objects and sculptures of their material nature by suspending them from the ceiling and setting them in fast rotation by means of electric motors. These experiments were preceded by four years of sporadic attendance at the Basel Trade School, years in which Tinguely became involved in the art and writings of such pioneers of abstraction and machine-related art as Wassily Kandinsky, Kasimir Malevich, Naum Gabo, Antoine Pevsner, Hans Arp, Kurt Schwitters, and Alexander Calder.

But it was not until he moved to Paris in 1953 that Tinguely began to develop true machine-sculptures. The first of these, the *Métamé-caniques*, were mobile constructions of wire and relief elements that

Tinguely, Jean

1925 Freiburg,
Switzerland
1991 Bern

permitted endless variations of form. There followed reliefs that produced noises, and robot-like painting machines that parodied Action Painting. In 1959, from an airplane over Düsseldorf, Tinguely scattered 150,000 copies of his manifesto *For Statics,* which put his attitude to art and life in a nutshell: "Everything is in motion. There is no stasis. Don't let yourselves be enslaved by outmoded notions of time. Throw hours, seconds and minutes out the window. Stop resisting mutability... Resist the anxious attacks of weakness [which make you try to] stop moving things, petrify moments, kill what is alive... Take a deep breath, live in the Now, live on and in time. For a beautiful and absolute reality." In view of this plea, it is no wonder that Tinguely became one of the leading lights of the Nouveaux Réalistes.

▶ Jean Tinguely
Balouba No. 3, 1961

Wood, metal,
light bulb,
electric motor
height 144 cm

Ludwig Donation,
1976

▲ Jean Tinguely
Charriot No. 8, 1968
Char No. 8

*Metal, wood,
electric motor*
79 x 267 x 100 cm

Ludwig Donation,
1976

Balouba No. 3, a piece of 1961, is a colorful and awkwardly grace-
ful mechanical creature built of spare parts and old objects, which
begins to rattle, twitch, and shake when the electric motor is turned
on. The title, the name of a Bantu tribe in Central Africa, calls up
associations with ritual mask dances. At the same time, this insou-
ciant sculpture – like all of Tinguely's apparatuses entirely without
meaning or purpose – would seem to poke fun at an affluent society
in which perfection, progress, and personal advancement are the
prime values. *Large Water Machine* is built along similar lines to
Balouba, but instead of making noise and displaying flashy colors it
flails around, spraying water in every direction. The back-and-forth
movement of *Charriot No. 8* appears more sedate, even cumbersome,
by comparison. Yet like the others, this piece perfectly illustrates
Tinguely's playful approach to the golden calf of the modern age,
the machine. It would be hard to name a second artist who took
Constantin Brancusi's words more to heart: "When you're not a child
any more, you're already dead."

Tobey, Mark

1890 Centerville
1976 Basel

▼ Mark Tobey
Hurrying Patterns,
1970

*Tempera
on cardboard*
98.5 x 69.5 cm

American painter Mark Tobey was largely self-taught. From 1909 to 1917 he worked as a fashion designer in Chicago and New York.

A key event in his artistic development was Tobey's trip, in 1934, to China and especially to Japan, where he received, as he put it, "the decisive calligraphic impulse" which led to his famous *White Writings.* Tobey began to dissolve views of big-city streets and crowds of people into a texture of tiny shapes, lines, and grid patterns. Towards the mid-1940s the objective motifs were eliminated entirely, and the paintings became a dense network of thin, usually white lines and miniscule particles. The meditative aspect of Tobey's imagery was further increased by a monochrome contouring of interior forms. As he once stated, Tobey believed that painting should emerge more through the paths of meditation than through the channels of action. The main issue of painting, to him, lay in rhythm and plastic form, as well as in a sensibility for paint application that might be termed texture or fabric.

Hurrying Patterns dates from a later period, when Tobey began to open up or expand the surface texture in his work. The composition is built up of small geometric and fragmentary forms overlain with hatching in various widths and shades of grey. The red interstices, some hatched in white, call to mind a network of complexly branching canals.

Drawing on his experience of two cultures, the widely-travelled Joaquín Torres-García developed, around 1930, an approach he called Universalismo Constructivo, which combined his personal version of Piet Mondrian's Neo-Plasticism with the magic symbolism of the Latin American world.

The *Woodconstruction (Console with Cup)* dates to a few years before this attempt at a synthesis. It was done in Paris, where the artist lived from 1926 to 1932. The faintly Constructivist piece, possibly an *objet trouvé*, shows a cup and saucer painted in simple outline. But contrary to the expectations raised by the title, the cup does not rest on the shelf but seems to float beneath it, in space. Torres-García chooses to ignore the laws of gravity and real appearances, demonstrating instead that the representational potential of art, even when it employs a highly simplified idiom, is greater than, and in fact entirely different in quality from, the conditions of reality. By calling the construction a "bracket," the artist also questions Mondrian's dogma of pure geometric abstraction, for both the title and the depiction of a cup make direct reference to the real world and its objects. Though Torres-García shared Mondrian's rigorously intellectual stance, he criticized his predecessor's works as being too standardized and impersonal. Just as important to him as geometry and rules were unpredictable, intuitive visions, which lent Torres-García's art variety, vitality, and a magically incantatory force. Like all of his other works, *Woodconstruction (Console with Cup)* appeals to the emotions, and the subtle harmony of its structure recalls certain still lifes by Georges Braque or Juan Gris.

Torres-García, Joaquín

1874 Montevideo, Uruguay
1949 Montevideo

▲ ◀ Joaquín
Torres-García
Woodconstruction
(Console with Cup),
1928
Repisa con taza

Oil on wood
48.3 x 22.6 cm

Ludwig Collection

Trier, Hann

1915 Düsseldorf-
Kaiserswerth
Lives in Mechernich

Hann Trier's work occupies a singular position between lyrical abstraction and Action Painting. Although he relies strongly on gesture and the painting process itself, Trier's dissolution of form in favor of texture does not take place arbitrarily, but at once expresses and corresponds with certain ideas, generally of an intellectual or philosophical nature.

Underlying the monumental *Triumph of Painting* (1984–1985) was the idea, as the artist put it, of the "creative intelligence of the brush's language." Trier was inspired, for example, by the teeming movement in the art of Tintoretto, but also by the ideas of Federico García Lorca, Friedrich Hölderlin, Michelangelo, Paul Eluard, and George de Nerval. Lines of their poetry are inscribed in the painting, and although they are not legible, they do, as Karl Ruhrberg notes, "determine the intellectual temperature, point to the spiritual background against which the Cologne painting, as indeed Trier's entire œuvre stands."

In June 1984 Trier was commissioned to provide a painting for
the north wall of the stairwell in the Museum Ludwig, Cologne, which
has an area of 66 square meters. The idea was to create a transition
between the earlier art represented in the Wallraf-Richartz-Museum and
the more recent art of the Museum Ludwig.

Trier's composition is characterized by a Baroque exuberance
tempered with Rococo delicacy, qualities that would have entered a
fascinating dialogue with the large-format Baroque paintings of the
Wallraf-Richartz-Museum, had these been hung on the flanking walls as
originally foreseen. In addition to allusions to medieval altar paintings,
Trier's work contains a reference to local tradition, the title echoing
that of Eduard von Steinle's *Triumph of Painting*, which adorned the
stairwell of the Wallraf-Richartz-Museum until its destruction in the
last war.

▲ **Hann Trier**
Triumph of Painting,
1984–1985
Triumph der Malerei

Egg-emulsion tempera
on gesso ground with
sand, on canvas,
three parts
Upper left:
360 x 1120 cm
(four parts)
Upper right:
360 x 280 cm
Lower frieze:
120 x 1120 cm
(three parts)

Gift of
Friends of the
Wallraf-Richartz-
Museum and
Museum Ludwig,
1986

Trockel, Rosemarie

1952 Schwerte/Ruhr
Lives in Cologne

Rosemarie Trockel is one of the most important figures on the German art scene. Classifiable neither in terms of style nor of genre, she continually produces new and surprising series of works in ever-changing materials and mediums. Trockel belongs to no school, no group; clear influences on her work are difficult to detect, apart, perhaps, from certain aspects of Pop Art. There are also hints of a serious involvement with the work of Joseph Beuys, or of a fascination by the irony and playfulness of Sigmar Polke.

In her young years Trockel experienced the period of increasing feminist concerns, in art as in life, which led to heated controversy and debate. She developed a subtly feminine perspective that not only addressed the social and sexual identity of women but above all pointed out the compulsions to which women are subject in contemporary society. Good examples of Trockel's approach are the series of sculptures based on electric ranges, developed over the past few years. She tipped white enamel stove tops into the vertical plane, varying the number and arrangement of the burners. These cool and strangely abstract wall-pieces recall certain elements of the Russian avant-garde or of Neo-Geo, but bear even greater affinities with Minimal Art.

◀ **Rosemarie Trockel**
Untitled (Six Right
Numbers), 1988
Ohne Titel
(6 Richtige)

Iron, electric stove
burners, steel
100 x 54 x 54 cm

Ludwig Donation, 1988

▲ **Rosemarie Trockel**
Untitled, 1987

*Silkscreen print
on fabric*
190 x 279 cm

Ludwig Collection

Despite the degree of abstraction the burners remain clearly identifiable both visually and tactually, and the clinical coldness of the black and white surfaces is counteracted by the association of the burners with heat. The gleaming white surfaces with their black, as if floating circular forms convey a sense of cool beauty and harmony. But they also recall the rituals of personal and domestic hygiene, which can become obsessions. The ambivalence between critical social statement and ironic quotation from art history, between the wittiness of an *objet trouvé* à la Marcel Duchamp and cool, abstracted form, is characteristic of Trockel's strategy of making the trivial appear sublime and vice versa.

In her 1987 painting, the series of printed figures of a Russian peasant woman holding a sickle is a conscious borrowing. As the artist herself said in an interview, "In this picture I took a figure designed by El Lissitzky for the 'Pressa' world exposition of 1928 in Cologne, with Lenin's statement: Every cook must learn to govern the State. In accordance with the changed situation I shortened the statement by the learning process, to read: Every cook must govern the State."

Tübke, Werner

1929 Schönebeck,
Germany
Lives in Leipzig

▲ **Werner Tübke**
Deposition from
the Cross, 1983
Kreuzabnahme

Oil on canvas
300 x 400 cm

Ludwig Collection

Werner Tübke belongs to the first generation of East German artists who grew up before German division following World War II. Along with Bernhard Heisig, Wolfgang Mattheuer, and Willi Sitte, Tübke was the fourth in a group of artistic loners, dubbed the Quadriga, who largely determined the direction of art in the former German Democratic Republic. All four sought inspiration in the great northern masters of the past, such as Otto Dix and Lovis Corinth, Oskar Kokoschka and Max Beckmann, sometimes even going as far back as Lucas Cranach or Albrecht Dürer, Matthias Grünewald or Pieter Brueghel, or to the Italian Caravaggio.

Tübke's paintings are unashamedly mannerist and staged, populated by dolls and marionettes, actors who play their role superbly but dispassionately. A good example is *Deposition from the Cross* (1983), in which Christian symbolism is blended with a carnival atmosphere. The painting emerged at a period in which Tübke was working on a great panorama depiction, *Pre-Bourgeois Revolution in Germany*, for the Peasant War Monument in Bad Frankenhausen, Thuringia.

▶ **Richard Tuttle**
Wheel, c. 1964

Wood
79 x 20.5 x 76.5 cm

Ludwig Collection

Richard Tuttle studied from 1959 to 1963 at Trinity College, Hartford, and in 1963–1964 at the Cooper Union, New York. His sculpture *Wheel* is an early work, from which it would be difficult to predict Tuttle's later pieces based on fabric stretched through space, or his meditative wall-objects. Sandwiched between two octagonal wooden frames is a series of water-wheel paddles with an eerie resemblance to teeth – a construction that on the one hand recalls ancient artifacts of unknown function, and on the other possesses the tactile and visual qualities of existing, worn and weathered material.

The year 1967 saw the emergence of Tuttle's first monochrome-tinted polygonal fabric works, designed to be mounted on the wall or laid on the floor at will. Later he began to concentrate on octagonal forms, leading in 1969 to paper octagons that were cemented direct on the wall. These were followed, beginning in 1971, by a series of fragile signs in space, consisting of a thin wire nailed to the wall, the resulting cast shadow, and a pencil line. The "strange charm" of these pieces, as M. F. Brehm noted, "resulted from the tension between their immediate material presence and a non-availability and fleetingness that eludes all description."

Tuttle, Richard

1941 Rahway,
New Jersey
Lives in New York

Twombly, Cy

1929 Lexington,
Virginia
Lives in Rome

Cy Twombly's painting relies on a very personal and cryptic symbolic language – a synthesis of Surrealist automatism and Abstract Expressionism – which has been compared with children's doodles and grafitti. In the mid-1950s the artist began covering large-format canvases with layers of off-white, into which, as in the Renaissance *sgraffito* technique, he spontaneously incised networks of graphic patterns. Twombly's version of the technique, as seen in *Crimes of Passion II*, should not be confused with graffiti in the now popular sense of the word.

As C. Huber notes, the term is "technically correct where Twombly scratches the signs into the wet paint layer... but where graffito is understood in Brassaï's sense, as public-toilet scribblings in general, there is a grave misunderstanding involved... The fact that genitals also occur in Twombly's work is beside the point... They stand as abbreviations for characters to whom various things happen in his pictorial narratives."

The title and inscriptions of *Crimes of Passion II* relate to the literary

œuvre of Donatien Alphonse François Marquis de Sade (1740–1814) and the tortures described therein, which are characterized as sexual obsessions. The scriptural signs and traces – scattered apparently chaotically across the surface, just as little children might scribble – seem to float and hover weightlessly within the indeterminate space of the image, and convey no absolutely definable message.

Treatise on the Veil, a work of 1968, consists of six panels of equal size hung side by side. Over the black ground lies an irregular whitish film, a veil that recalls the look of a school blackboard that has just been erased with a damp sponge. Along the bottom third of the canvas stretches a series of six chalk rectangles, "snapshots" of a form in the process of shrinking and vanishing. The formal and substantial reference here is to the famous photo sequences of Eadweard Muybridge (1830–1904), of which Twombly owned a picture of a woman in bridal gown and veil striding to the right. If the rectangles are read as this veil, Twombly's image represents an unveiling: the veil falls, to reveal – nothing. As A. Schug points out,

▲ **Cy Twombly**
Treatise on the Veil, 1968

Oil and chalk on canvas
254.5 x 750 cm, six parts

Ludwig Donation, 1976

▲ **Cy Twombly**
Crimes of Passion II,
1960

*Oil, chalk and
pencil on canvas
190 x 200 cm*

Ludwig Donation,
1976

"The *Treatise* gives us a lesson concerning time and space and motion, and veils the lesson twice and thrice over… This is the conceptual lesson we learn."

► **Nadezhda Udaltsova**
Cubist Composition, c. 1914–1915

Oil on canvas
63.5 x 49.5 cm

Ludwig Collection

Nadezhda Udaltsova was an ardent advocate of the new directions in painting from Cubo-Futurism to Suprematism. Unlike most of her Constructivist colleagues, however, she remained faithful to the medium of the easel painting. In the course of the 1920s Udaltsova returned to a naturalistically figurative style which she would retain throughout her career. The style of her earlier work invariably shows a greater proportion of Cubist than of Futurist elements.

The delicately-hued *Cubist Composition* (c. 1914–1915) reveals an independence of French Cubism in terms of the more rigorous formal canon of Suprematism which begins to make itself felt here. The painting stems from one of the artist's most interesting stylistic phases, in which she concerned herself with the theories of Kasimir Malevich and Vladimir Tatlin. As a result, Udaltsova created an entire series of studies devoted to the relationships of color to form in space, and the tensions intrinsic to these relationships.

Udaltsova, Nadezhda

1886 Orel, Russia
1961 Moscow

► Günther Uecker
Nail Relief, White –
White, 1961
Nagelrelief weiss –
weiss

*Oil, canvas on
composition board,
with nails
(spray-painted
in white)*
120 x 120 cm

**Uecker,
Günther**

1930 Wendorf, Meck-
lenburg, Germany
Lives in Düsseldorf

After studying art in Wismar and Berlin-Weissensee, Günther Uecker
left East Germany in 1953 to continue his training at the Düsseldorf
Academy of Art. It was there, in 1957, that his first nail-paintings were
made. These works, designated *Clouages*, possess a rhythmic
articulation that engenders a highly differentiated play of light and
shade, as seen for instance in *Great Spiral I*, a nail-painting of 1968.
Here Uecker consciously disposed with color as a compositional
means, instead creating an effect of space and movement solely by
means of the spiral arrangement of innumerable protruding nails.
For Uecker, the nail is the basic element in a personal visual language.
Like the point of a sundial, each nail casts a shadow, and in combi-
nation these shadows produce complex and continally changing
textures that are entirely uncorporeal. In 1961, the year he executed
Nail Relief, White – White, Uecker said of his work, "My attempt to
activate a real space by means of structural sequences, to make it

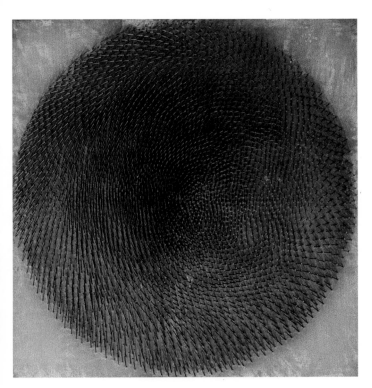

tangible as a state of purity of an objective aesthetic, led me to new means of composition. When I use nails as structural elements, I do not wish them to be understood as nails. My concern is to use these means and their ordered interrelationship to engender a vibration which disturbs their geometric order and is capable of irritating it. The white objects should be understood as a state of extreme intensity, [objects] which are in a process of continual change as a result of light reflections."

That same year, 1961, Uecker joined the Zero group, and alongside Otto Piene and Heinz Mack began to play a leading role in its activities. Participation in documenta III, held in Kassel in 1964, and in exhibitions in London and New York, brought Uecker's international breakthrough. Today he is among the best-known of German contemporary artists.

Uhlmann, Hans

1900 Berlin
1975 Berlin

▼ **Hans Uhlmann**
Bird, 1954
Vogel

*Burnished steel
height 47.5 cm
(one-off piece)*

Haubrich Collection

Until he was forty-five, Hans Uhlmann worked as an engineer. His early experiments in art, done in seclusion, were informed by a fundamental insight of engineering: that the solidity of a structure is independent of its mass. The resulting sculptures were accordingly light and transparent, configurations open to the surrounding space which were inspired by wire sculptures of the type made by Alexander Calder and a number of Cubist and Constructivist artists.

The turning point to a professional career came in 1950, when Uhlmann was appointed professor at the Berlin College of Art, where a short time later he began to teach a class in sculpture. He received a spacious studio with all the necessary equipment and tools, as well as the assistance of a trained ironworker. Now in a position to experiment with new methods of construction and welding, Uhlmann turned

to sculpture in steel. Initially he devoted himself to uncomplicated subjects, in order, as Werner Haftmann noted, "to try his hand and test the scope of the difficult material." Uhlmann tried to keep the number of elements and welds to a minimum, striving to shape the obstinate metal in as few steps as possible. By cutting and bending thin steel plates in one piece, he produced compellingly stark and expressively symbolic forms. The graceful, seemingly weightless *Bird* (1954) belongs to a somewhat later group of works in this vein, done when Uhlmann had achieved a great freedom and mastery of the medium.

► **Ursula**
Cologne Picture,
1972
Köln-Bild

Oil and gold on wood
88.7 x 129.7 cm

Ludwig Donation,
1976

Ursula, whose creative potential Jean Dubuffet discovered in 1954
for his legendary "Musée de l'art brut," realizes her enigmatic visions
in complex compositions rendered in sumptuous and sometimes
morbid color. "I force my visions on reality," the artist says, "I'm
quite artificial." Ursula combines memories, associations, and bizarre
fantasies with mythological elements to produce imagery of great
originality and uniqueness, which at best could be compared with
that of James Ensor or Henri Rousseau. Their moods ranging from
insouciant playfulness to sensuousness and dark demonology, the
paintings juxtapose vitally sumptuous to icily petrified configurations,
engendering a beauty that is never without an element of threat.
Apart from painting, the artist has devoted herself since the late 1950s
to making objects, often shrine-like configurations in which fur plays
a key role, which have shown her to be master of assemblage. Whether
in Ursula's objects, her Pandora's boxes, or in her graphic and painterly
œuvre, the dialectics of beauty and transience finds diverse and com-
pelling expression. As seen in her *Cologne Picture*, observation and
fragments of experience enter a transformation along the lines of an
individual mythology.

Ursula
(Ursula Schultze-
Bluhm)

1921 Mittenwalde,
Germany
Lives in Cologne

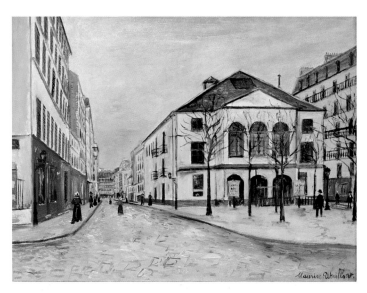

◄ **Maurice Utrillo**
Théâtre de l'Atelier,
Place Dancourt,
c. 1920

Oil on canvas
60 x 81 cm

Utrillo, Maurice

1883 Paris
1955 Dax,
South France

Maurice Utrillo was the illegitimate son of artist Suzanne Valadon and Utrillo y Molins, a Spanish painter, archaeologist, and engineer. His mother, herself self-taught, began giving Maurice painting lessons at the age of nineteen. He worked in an Impressionist vein, but with a tendency to realism that reflected his interest in representing the world around him rather than in making art. Utrillo's reality included the emotions and moods it induced in him, especially those of melancholy and loneliness. Such feelings lent his sparsely populated street scenes and townscapes a pensive, poetic atmosphere that is not always without a touch of the sentimental. The key phases in Utrillo's development came with the White Epoch, marked by the use of countless gradations of greyed or tinted white, and the Colored Epoch, which began in 1920 and was characterized by a brilliant palette that sometimes, especially after 1927, verged on picture-postcard garishness.

In fact Utrillo not only painted a great deal from memory but occasionally from postcards as well. The studio theater on Place Dancourt – founded in 1885 by Charles Dullin, its director – had a reputation in Paris as a progressive stage. Utrillo painted the same motif another thirteen times between 1914 and 1935.

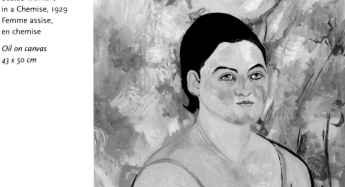

► **Suzanne Valadon**
Seated Woman,
in a Chemise, 1929
Femme assise,
en chemise

Oil on canvas
43 x 50 cm

Before becoming an artist's model who was much in demand, Suzanne
Valadon worked as a seamstress and circus acrobat. Encouraged by
Henri de Toulouse-Lautrec and sponsored by Edgar Degas, she began
drawing at the age of eighteen, and soon developed into a painter
of great vitality and earthy force. Beginning in an Impressionist vein,
Valadon pared down forms and solidified contours until she had
arrived at a personal style which, as Werner Haftmann notes, had a
"touch of awkwardness that retained the character of the naive."

Valadon never concealed her plebeian origins. A strong and heavy-
set woman herself, she chose models with the same proportions,
and in her portraits preferred plain, uncomplicated faces with broad,
unbroken planes and forms. This is very much in evidence in the 1929
Seated Woman, in a Chemise. Revealing a certain Fauvist influence, the
picture was earlier titled *Portrait of a Woman* (based on Paul Pétridés'
1971 catalogue raisonné) and erroneously dated to 1921. According to
new information uncovered by Johanna Brade, it is actually a cut-down
version of the 1929 work *Seated Woman, in a Chemise.* Nor, says Brade,
is it a self-portrait of the artist, as widely assumed, but represents her
favorite model, whom Valadon frequently portrayed.

**Valadon,
Suzanne (Marie-
Clémentine)**

1865 Bessines,
near Limoges, France
1938 Paris

Victor de Vasarély studied medicine in Budapest before deciding to make his career in art. In 1928 he entered Sandor Bortnyik's private school of graphic art, where the ideas and approaches of the Bauhaus played a prime role. Bortnyik soon recognized the young artist's extraordinary graphic skills, and encouraged Vasarély, who at that time was wholly committed to a naturalist style, to try his hand at geometric abstraction. Ultimately this advice was to prove decisive for Vasarély's entire career.

▼ Victor de Vasarély
Calota MC,
1965–1967

Tempera on canvas
150 x 100 cm

Ludwig Donation,
1976

In 1930 he moved to Paris, where, as previously in Budapest, he worked as a commercial artist. Vasarély had little contact with the Paris art scene. In 1943 he entered a phase of great productivity. Looking back in 1969, however, Vasarély denigrated the oils of 1944 to 1946: "After two years of floundering about in the waters of Post-Cubism and Surrealism, the early impulses from Budapest turned out to be decisive for the further course of my œuvre." In 1955 Vasarély exhibited his first kinetic objects, and in the 1960s his art began to receive a popular acclaim unusual on the contemporary scene.

The title of *Calota MC* alludes to a small town in Hungary. The composition is built up of elementary geometric shapes in contrasting colors, rendered with extreme precision, whose arrangement and hues engender an optical effect of perpetual motion.

► **Emilio Vedova**
Ciclo '61 – N 5, 1961

Oil on canvas
149 x 200 cm

Loan of
VAF-Foundation,
Switzerland

Many of Emilio Vedova's works, part of the European stream of Action Painting, reflect the characteristic moods of his home city of Venice. Self-taught, Vedova concerned himself from about 1935 with architectural studies foremost. During the war years he was active in the anti-facist movement, and in 1942 became a member of Corrente, a group of Milan artists who outspokenly resisted the official neo-classical style of the day. This political commitment became an integral part of Vedova's work. As he himself stated, painting should contribute "as much as possible to a strengthening of the autonomy of sensibility, the ability to make a choice, within a broadly defined framework where every human talent can breathe free – therein lies the responsibility of the artist."

In addition to the black and white that dominate the majority of Vedova's paintings, *Ciclo '61 – N 5* employs red, blue, yellow and green color accents applied in strokes of great force and immediacy. With Vedova, writes R. Fuchs, the canvas "is like the skin of a drum: when the paint comes in contact with it, it sets the image in vibration. It is truly amazing the way Vedova's pictures sing."

Vedova, Emilio

1919 Venice, Italy
Lives in Venice

for Vesnin, Alexander see page 748

◀ Maria-Helena
Vieira da Silva
The Port, 1953
Le port

Oil on canvas
97 x 131 cm

Vieira da Silva, Maria-Helena

1908 Lisbon, Portugal
1992 Paris

French painter and sculptor Maria-Helena Vieira da Silva, a representative of the Ecole de Paris, based her work on an Impressionist conception of light as the medium by which form and color are conveyed. In the 1930s, a phase of searching for graphic means to render the environment, fantastic and visionary elements entered her art. Vieira da Silva developed a very personal abstract idiom, in which graphic scaffoldings were used to evoke imaginary geometric constructions in space which were not without certain Surrealistic tendencies.
In a wider context, the fragile, as it were Gothic architecture of her dream-cities (train viaducts, metro stations, harbors) and their transparent interweave bear certain affinities with the work of Alberto Giacometti and Paul Klee. *The Port* of 1953 presents a network of filigree lineatures accented by a mosaic of vibrating color fields. "Thus a grid of predominantly blue and white brushstrokes," writes I. Schulz, "can call up the memory of a view of a sunny Mediterranean harbor."

for Vialov, Konstantin see page 752

► Jacques Villeglé
Avenue de la Liberté
(Charenton), 1961

Décollage
160 x 229 cm

Everyone has seen billboards or hoardings encrusted with layers of torn
and peeling posters. Jacques Villeglé uses such observations and the
technique known as *décollage* derived from them to illustrate the
destruction of human communication caused by the mass media.
An aesthetic heightening of the waste and ugliness of the modern city
becomes a symbolic revolt against the increasing commercialization
of the cityscape.

Villeglé was a member of the Nouveaux Réalistes group and the
most radical in approach of the artists bluntly known as "poster
rippers." He has always vehemently opposed the notion of originality
and the personal touch in art. In Villeglé's own words, "I distance
myself from the act of painting or of collage. Isn't inadvertance one
of the inexhaustible wellsprings of art, and I mean an art that is worthy
of the museum? I take a positive view of the result that some chance
passerby leaves behind when he rips off a poster without the slightest
aesthetic intention." Villeglé's artistic activity is consciously limited to
selecting certain random configurations of this kind and saving them
from destruction.

**Villeglé,
Jacques**

1926 Quimper,
France
Lives in Paris

Viola, Bill

1951 New York
Lives in Long Beach,
California

The Greeting belongs to a group of five video works collectively titled *Buried Secrets*, which were conceived as the American contribution to the 1995 Venice Biennale.

The piece was inspired by the famous depiction of the Visitation by Mannerist painter Jacopo Carrucci, better known as Pontormo. Viola transformed this picture into a video sequence, translating its monumentality into contemporary terms. The city backdrop was precisely reconstructed down to the last detail, and the camera placed at the same low vantage point used in Pontormo's composition. Viola reduced the number of figures to three, and dressed them in current garments and shoes, managing to create classical costumes which spirit the women into a timeless realm without disguising the fact that they are our contemporaries. The film was made with a 35 mm camera, then projected at a reduced speed such that the 45-second sequence becomes a 12-minute scene. This slow-motion effect seems to transform the meeting of three women at a street corner into a ritual act, a timeless metaphor in which the biblical story of the Visitation is brought home even to the uninitiated.

◄ **Bill Viola**
The Greeting, 1995

*Audio-video
installation,
projection
282 x 241.3 cm*

Ludwig Collection

▶ **Maurice
de Vlaminck**
Still Life with
Flowers and Fruit,
1911

Oil on canvas
60 x 73 cm

Haubrich Donation,
1946

Maurice de Vlaminck was a professional racing cyclist and musician
before coming to painting. After meeting André Derain in 1900 and
Henri Matisse in 1901 he became one of the most exuberant of the
Fauve artists. Vlaminck's paintings range from dark and luminous to
brilliantly polychrome, in works done by squeezing the paint straight
out of the tube onto the canvas. Also active as a writer throughout his
career, Vlaminck once stated, "My passion urged me to every sort of
daring audacity against the traditional in painting... I transformed all
of the feelings I was capable of perceiving into an orgy of pure colors.
I was an enamored, impetuous barbarian. I composed by instinct."

Still Life with Flowers and Fruit is one of the more reserved of
Vlaminck's works, and reveals the influence of Paul Cézanne. An apt
description was provided by G. von der Osten: "The table rises up,
indeed veritably tips forward towards us... Jug, fruit bowl, vase with
flowers – they seem aflame with color... One sees subtle gradations
of blue, white and ocher... Thus what initially appears quite random
turns out to be carefully constructed. The Fauve painter de Vlaminck
has subjugated his revellings in color to a form that owes its character
to the compelling force of Cézanne."

**De Vlaminck,
Maurice**

1876 Paris
1958 Rueil-la-Gadelière

◀ Friedrich
Vordemberge-
Gildewart
Composition
No. 122/1941, 1941
Komposition
Nr. 122/1941

*Oil on canvas
60.5 x 80.5 cm*

Haubrich Collection

**Vordemberge-
Gildewart,
Friedrich**

1899 Osnabrück,
Germany
1962 Ulm

Friedrich Vordemberge-Gildewart, like Kurt Schwitters, was a co-founder of the artists' group Die abstrakten hannover (1927) and one of the few German members of the De Stijl and Abstraction-Création groups.

His painting was characterized by a reliance on principles intrinsic to art and a waiver of every reference to the external world. Vordemberge-Gildewart veritably built his works by shifting pieces of colored paper on a white ground until they formed an arrangement that struck him as ideal. Only then would he transfer the composition to canvas. "I want order, not the liberty of chance," the artist stated. "The work of art develops through calculation... Only by means... of logic is it possible to reduce the principles and functions of a previously unfamiliar material or means of design... to an elementary, new formula."

Nevertheless, *Composition No. 122/1941* with its sparing arrangement of colored, mostly yellow rectangles and triangles on a green plane, possesses a rhythmic equilibrium that, as Karl Ruhrberg notes, lends the composition a "reserved, musically lyrical atmosphere." It is this that distinguishes Vordemberge-Gildewart's sensitive, high-strung painting from the puristic grids of a Piet Mondrian.

"In the ideal case my paintings are harrassing fire, warnings, threats, protests, recollections, question marks," says Wolf Vostell, revealing a definite sociocritical attitude that distinguishes him from the American Pop artists. Though his imagery is similarly derived from the contemporary urban, commercial, or technological environment, Vostell does not rest with merely reflecting its realities. Nor does he take an anti-aesthetic or anti-societal stance of the kind represented by Marcel Duchamp and the Dadaists. Vostell himself once concisely described the difference: "Duchamp declared the object to be a work of art; I have declared life itself to be art." Still, Vostell does employ the Dadaist strategies of provocation and ironic commentary, as well as relying on the irrational and the workings of chance.

In *Miss America* (1968), not content with a merely thought-provoking image, Vostell unashamedly launches into political agitation. The painting was done in the same year as the worldwide dissemination of the photograph employed, of the execution of a Vietcong prisoner (by Edward T. Adams), which like no other came to symbolize the brutality and injustice of the Vietnam War. This barbaric act is confronted in Vostell's work with the picture of the winner of a beauty contest.

Her figure rising above the prisoner's head likely stands for a society that has lost sight of human dignity and can no longer distinguish between reality and illusion. It is not the dying man but the beauty queen who wears a blindfold, and it is a mask like a smear of blood.

◄ **Wolf Vostell**
Miss America, 1968

Photographic print,
glazes, and
serigraphy on canvas
200 x 120 cm

Ludwig Donation,
1976

Vostell, Wolf

1932 Leverkusen,
Germany
Lives in Berlin and
Malpartida de
Cáceres, Spain

Warhol, Andy

1928 Pittsburgh,
Pennsylvania
1987 New York

Practically from the beginning, standardization was the subject of Andy Warhol's art. In 1962 he transferred banknotes, soup cans, match covers, paint-by-numbers paintings, and celebrities like Marilyn Monroe and Elvis Presley to canvas, and rapidly became the quintessential Pop Artist. In his hand-painted works Warhol usually limited himself to reproducing banal things from the commercial realm. Yet it is remarkable how often he showed traces of human use of these things: the dollar bills wrinkled, the matchbook (as in the version in the Museum Ludwig, Cologne) with scratch marks on the sandpaper striking surface, the paint-by-numbers landscape partially filled in.

Warhol quite faithfully reproduced his chosen motifs, without alienating them, except as regards enlargement. He seemed to have a sympathetic attitude to such trivial everyday things. Even the dubious activity of producing an oil painting by matching premixed, numbered paints to the numbers printed on a canvas board – entailing a suffocation of creativity, if not the end of art per se – turned in Warhol's hands into a landscape that is not without its charm and humor.

In the case of his silkscreen works we are confronted with an entirely different world. Repetition lends the banal motifs an anonymous and somehow threatening character. They become less real, as if the artist had consciously placed them at a farther remove from reality. When we compare the color schemes of the hand-painted imagery with those of the serigraph-printed canvases, we see that the colors in the matchbook and the landscape are bright, warm, and saturated, while those of the silkscreens seem cool, faded, and without body.

◀ **Andy Warhol**
Two Dollar Bills
(Front and Rear),
1962

Silkscreen on canvas
210 x 96 cm

Ludwig Donation,
1976

▶ **Andy Warhol**
129 Die in Jet
(Plane Crash),
1962

Acrylic on canvas
254.5 x 182.5 cm

Ludwig Donation,
1976

FINAL ★★ 5¢ **New York Mirror**

WEATHER: Fair with little change in temperature.

Vol. 37, No 296

MONDAY, JUNE 4, 1962

C

129 DIE

(UPI RADIOTELE photo)

IN JET!

say "Pepsi please"

CLOSE COVER BEFORE STRIKING

AMERICAN MATCH CO., ZANSVILLE, OHIO

Ill. p. 742:

Andy Warhol
Close Cover
before Striking
(Pepsi-Cola), 1962

Acrylic on canvas,
sandpaper
183 x 137 cm

Ludwig Donation,
1976

Ill. p. 743:

Andy Warhol
Do it Yourself
(Landscape), 1962

Acrylic on canvas
178 x 137 cm

Ludwig Donation,
1976

◄ **Andy Warhol**
Two Elvis, 1963

Silkscreen on canvas
206 x 148 cm

Ludwig Donation,
1976

► **Andy Warhol**
Red Race Riot, 1963

Silkscreen on canvas
350 x 210 cm

Ludwig Donation,
1976

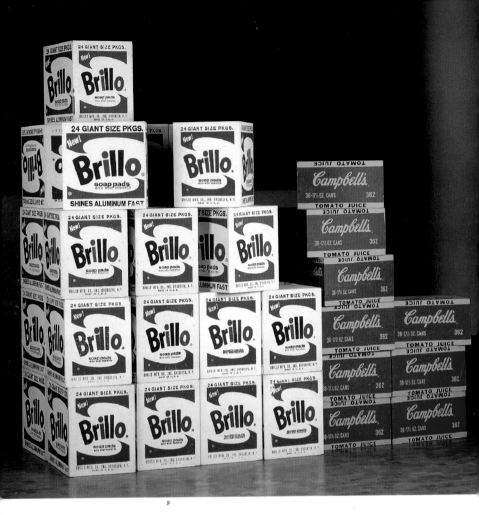

Form is no longer determined by color; rather, the form appears to dissolve in the translucency of the color. Whether you take the pale green of the dollar bills or the theatrical red merging into cloying pink of the *Race Riot*, the color heightens the unreality of the image, which now is no longer depicted from reality or nature but is based on a reproduction, and thus can be considered a "second-hand reality" at best. The perversion of human values in a mechanized world is implied particularly in the portraits Warhol began making after he adopted the serigraph technique. All of these were based on photographs, usually

▲ Andy Warhol
Flowers, 1964

Acrylic on canvas
208 x 328 cm

Ludwig Collection

made for public-relations purposes, and the printing method only served to heighten the cool, impersonal, idol-like character of the person represented. Warhol's silver *Two Elvis* shows no flesh-and-blood human being but the product of a commercialized society.

A series of motifs related to violence and death began with *129 Die in Jet*, a canvas that was still painted freehand. The newspaper article describes the death of 129 American tourists as a result of a plane crash at Paris-Orly. The huge, blatant headline and the word "Final" which cold-bloodedly bracket the illustration contrast to its painted rendering, whose mood of despair and hopelessness recalls the Romantic artist Caspar David Friedrich. By comparison, the serigraph work *Red Race Riot* resists emotional empathy despite the equally disturbing nature of the event depicted. The image, based on two newspaper photos of a police action against black demonstrators, is composed like a film sequence. Yet there is no political statement implied. As Susan Sontag said, pictures consume reality; the more often one is confronted with pictures, the less real the event concerned appears. It is precisely this loss of reality that Warhol addresses in his œuvre.

Vesnin, Alexander

1883 Yuryevez, Russia
1959 Moscow

▼ Alexander Vesnin
Composition,
c. 1921–1922

*Oil and quartz sand
on cardboard
90 x 68.5 x 8 cm*

Ludwig Collection

From about 1912, Alexander Vesnin and his brothers, Leonid and Viktor Vesnin, were the leading representatives of Architectonic Constructivism in Moscow. Thanks to his studio-sharing with Vladimir Tatlin, Vesnin met Liubov Popova, with whom, in 1921, he began to teach a course on the relationship of art and architecture at the Higher State Art-Technical Studio (Vkhutemas). After Popova's death in 1924, Vesnin worked exclusively as an architect for several years, before turning back to painting in about 1935.

The most fruitful phase of his career as regards painting, theater work, and an involvement with avant-garde theories and conceptions was the ten-year period from 1913 to 1923. Among the relatively small number of Vesnin's paintings, *Composition* of 1921–1922 can be considered a major work. It is dominated by a combination of formal rigor and dynamism, with geometric forms and planes gripped in a gridwork of black lines, and shading used to engender a strange tension between the apparent movement of the circles and semicircles and the stasis of the linear framework. Doubtless the painting was influenced by Liubov Popova's last great series of 1921, in which the background color frequently remained visible and was integrated into the composition. In Vesnin's work we observe a radical reduction of palette to primarily brown-to-white gradations. His addition of quartz sand to the paint finds a parallel in the powdered marble which Popova employed in her final paintings.

Since the early 1960s Tom Wesselmann has been concerned with a prime aspect of American society, the sex and star cults disseminated by advertising and the visual media. By integrating existing photographs, reproductions, or actual objects in his works, the Pop artist expanded the easel painting into a three-dimensional configuration in space.

Bathtub 3 combines a painted canvas with real bathroom furnishings: a wooden door with towel rod and towel, a light switch, a laundry basket, a bathmat and a red shower curtain. The latter recalls a stage curtain pulled aside to reveal the scene to the audience. This is a painted rendering of a woman standing in the shower and drying herself. The figure embodies the slim, feminine prototype favored in advertising, but presented here in a cool, faceless version with an emphasis on sexual details.

Wesselmann, Tom

1931 Cincinnati, Ohio
Lives in New York

▲ **Tom Wesselmann**
Landscape No. 2,
1964

*Paper, photograph,
oil, mastic, canvas*
193 x 239 cm

Ludwig Donation,
1976

The emotionless character of the depiction corresponds to the clean, almost sterile atmosphere of the bathroom, which implies a sacrifice of human factors to hygiene and brashly impersonal interior decoration. The image may be a slice of life, but it is a life of inanimate objects rather than of human individuals.

The world of advertising clichés also appears in Wesselmann's *Landscape No. 2* of 1964. The practically full-size billboard picture of the Volkswagen and the tree built up of mastic overwhelm the landscape proper and the miniaturized family in the background. Artifice takes precedence over nature.

The iconography of contemporary advertising is even more clearly quoted in *Great American Nude No. 98*, of 1967. This outsized still life is arranged in three superimposed levels. H. Roosen detects multiple meanings in the work: firstly, a reference to the American consumer goods industry (filter cigarette, Sunkist orange, Kleenex tissues – familiar set-pieces with which one automatically associates certain brand names). Secondly, the subliminal desires awakened by advertising, as in the burning cigarette as an incitement to enjoy the pleasures of smoking. Thirdly, an evocation of physical desire, by the depiction of the woman with a half-open mouth and swollen nipple, a standard iconographical motif. In this context the Kleenex box, the burning

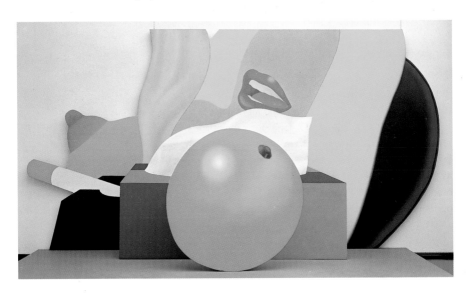

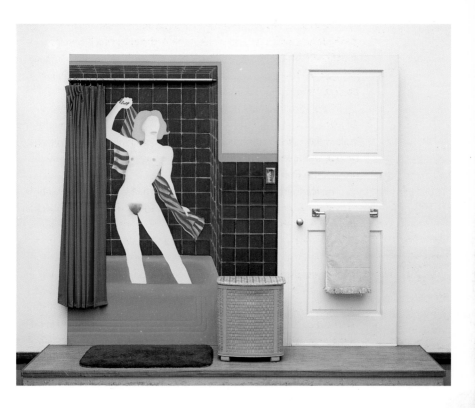

cigarette as a secularized *memento mori,* and the orange, which often appeared in medieval art as a symbol of the Fall from Grace and of fertility, take on additional meanings.

"If we see these pictures of Wesselmann's as a travesty of the original sin motif, the temptation of Eve," Roosen adds, "the now 'natural fruit' from the Tree of Knowledge takes on life-giving powers. Except these powers are just as little 'innocent' in the heathen sense as the swelling breasts are metaphors of fertility; the enjoyment of the orange implies the use of the Kleenex, which in turn finds a correspondence in the cigarette filter."

▲ **Tom Wesselmann**
Bathtub 3, 1963

Oil on canvas,
plastic, objects
(bathroom door,
towel,
laundry basket)
213 x 270 x 45 cm

Ludwig Donation,
1976

**Vialov,
Konstantin**

1900 Moscow
1976 Moscow

▼ **Konstantin Vialov**
Construction, 1919

Wood, metal and wire
40 x 47.5 x 19.5 cm

Ludwig Collection

Construction of 1919 is one of the few surviving three-dimensional objects made by artists of the Russian avant-garde. Due to subsequent developments in socialist art, the majority of such works were no longer valued, and the apparent inferiority of their materials caused them, in many cases, to be destroyed.

Vialov has combined diverse existing materials which were previously foreign to art – wood, metal, wire – into a lucid and tectonic configuration. After his studies at the Stroganov Institute of Industrial Art in Moscow, Vialov worked during the period to which *Construction* dates in the studios of Aristarch Lentulov, Alexei Morgunov, and Vladimir Tatlin. Apart from Alexander Rodchenko, it was Tatlin who exerted the greatest influence of Vialov's work. Like these artists he consciously refrained from finishing and altering the appearance of the raw materials he employed. *Construction* (1919) was executed under Tatlin's supervision, and a similar work was made as part of a theater model. In fact, Vialov's artistic affinity with his teacher went so far that this second piece was for many years considered to be a work by Tatlin.

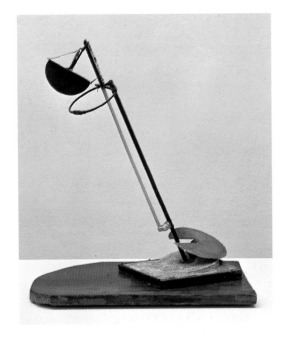

Vialov's œuvre encompasses a number of heterogeneous phases. After his period with Tatlin, the artist turned to the compositions and abstractions of Wassily Kandinsky, adapting Kandinsky's idiom in a number of what he termed improvisations on canvas. As a leading member of the OST group Vialov later advocated the revival of easel painting, which the previous avant-garde had declared defunct. Vialov's abandonment of abstract art, including his *Constructions*, led him to a representational painting in the mode of Socialist Realism.

► **Wols**
The Tapestry, 1949
La tapisserie

Oil on canvas
54 x 73 cm

Ludwig Donation,
1976

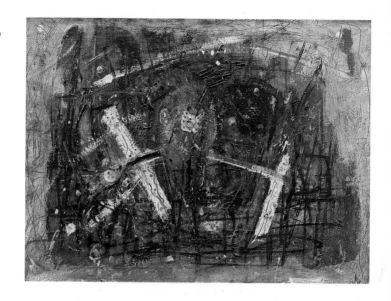

Wols is considered a pioneer of Art Informel, a painting approach that emerged in the 1950s and, like American Action Painting, relied on subconscious impulse rather than on any preconceived idea, sketch or design.

A man of many talents, Wols went to Paris in the early 1930s. He wrote, made drawings, played music, worked as a photographer and a drawing teacher, and made contact with many and various circles of artists. In 1939, after the outbreak of war, he was interned as an enemy alien, an experience that spurred Wols's productivity in the fields of drawing and watercolor.

His earliest drawings still stood under the influence of Surrealism. Not without subliminal references to Paul Klee, Wols transformed elements of reality into phantasmagorical imagery. In the ensuing works, line gradually lost its descriptive function, as the lineature began to emerge directly from the movements of the artist's hand. The line became a seismographic trace of moods and emotions, finding its most dramatic expression in the oil paintings which began to emerge in 1946–1947. Shapes and lines inscribed with passionate fervor or actually incised into the paint layer formed records of the painting process itself, became signs of their own genesis. One basic, recurring

Wols
(Alfred Otto
Wolfgang Schulze)

1913 Berlin
1951 Paris

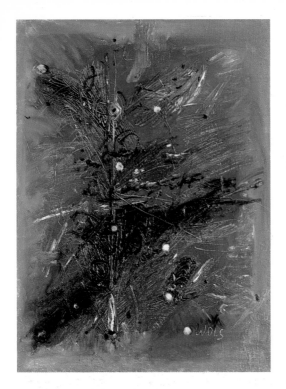

▲ **Wols**
The Vowels, 1950
Les voyelles

Oil on canvas
61 x 46 cm

Ludwig Donation,
1976

configuration in Wols's work is a shape that seems to organically expand from a nucleus and diffuse into the surrounding plane. The paint seems to congeal, then burst open, spraying brilliant fragments, appearing to come into being and vanish in a single, intoxicating moment.

As Werner Haftmann points out, Wols "loved Rimbaud's *Bateau Ivre* above all else, and used to carry Traven's *Ship of the Dead* around with him. The drunken ship with its cargo of slowly decaying life was an image that continually preoccupied him." The eternal process of growth and decay found a universal, abstract expression in Wols's works. He himself alludes to this in one of his aphorisms: "A painting can have a relationship to nature like that of a fugue of Bach's to Christ; then it is not an imitation but an analogous creation."

The darker side of the modern sense of life is oppressively present in the imagery of this *peintre maudit*, a brother of the *poètes maudits* Arthur Rimbaud and Stéphane Mallarmé. Its expression is "detectable in the colored flecks and the nervous, palpitating 'psychograms'" of Wols's paintings, and "at times his anxieties and feelings of threat reappear in fantastic and Surrealistic form" in late works such as the major and psychologically revealing canvas *The Blue Phantom* of 1951.

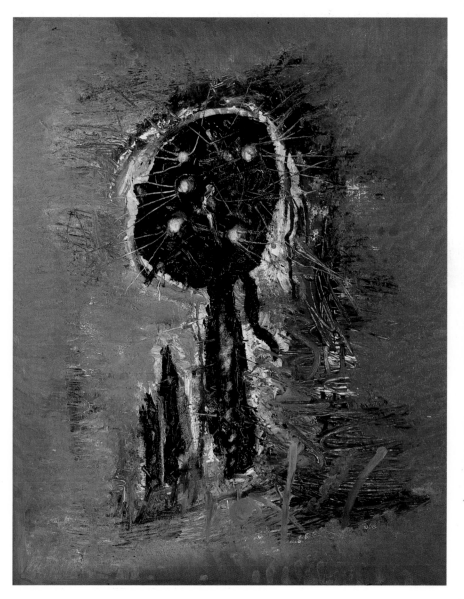

Wols
The Blue Phantom,
1951
Le fantôme bleu

Oil on canvas
73 x 60 cm

Yan Pei Ming

1960 Shanghai, China
Lives in Dijon, France

Yan Pei Ming was born in a Buddhist monastery and lived there until the age of eight, when the Red Guards stormed the monastery during the Cultural Revolution. He emigrated to France in 1980, finishing his art studies in Dijon and Paris. Despite his European training, Yan Pei Ming sees his work in the tradition of Chinese propaganda art: "In China I learned propaganda painting, and basically that is what I am still doing."

For his large-format portrait of Chairman Mao Tse-tung the artist employed the principles underlying the portraiture of Socialist Realism to depict the former leader of the Chinese Communist Party in a monumental vein. Yet Yan Pei Ming's style also shows the influence of ancient Chinese calligraphy, as indicated, for instance, by the reduction of the color range. Viewed from a close vantage point, the portrait takes on the appearance of an abstract composition, and it is only with increasing distance that we begin to perceive the image as representing a head.

▲ **Yan Pei Ming**
Mao . . . , 1991

Diptych, oil on canvas
300 x 400 cm

Ludwig Collection

Ossip Zadkine made a material contribution to the development of twentieth-century sculpture, which shed the constrictions of past styles and turned to the emergent Expressionist and Cubist movements. Living in Paris from 1909 onwards, Zadkine frequented the ateliers and cafés where the avant-garde foregathered. He was drawn into the debates on Cubist fragmentation of form, Futurist dynamism, and Fauvist expressionism, also studying Romanesque sculpture and the art of "primitive" cultures, which found a strong echo in his work. In his late phase Zadkine employed the Cubist idiom, not as a dogma but as the point of departure for a synthesis of opposing approaches to design.

Zadkine, Ossip

1890 Smolensk, Russia
1967 Neuilly-sur-Seine,
France

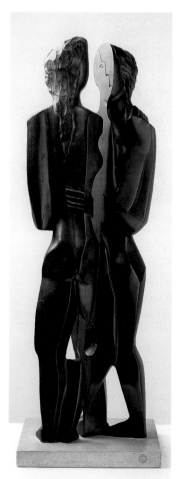

Zadkine had already become familiar with his favorite material, wood, as a child. Growing up in a forested area he developed a deep link with this material, which he did not forsake even during the final period of his career, as evidenced by a great number of sculptures in wood, above all ebony.

One of these is *Intimacy (Narcissus)* of 1950. The sculpture is part of a group of compositions with two and three figures which largely retained Cubist stylistic means. The emphasis on the symmetrical vertical axis serves to symbolize the harmony and intimacy of the two figures.

◄ **Ossip Zadkine**
Intimacy (Narcissus),
1950

Ebony
height 75 cm

Haubrich Collection

We wish to thank the staff of the Museum Ludwig and of the Rheinisches Bildarchiv, both of Cologne, for their generous support in preparing this publication. The copyright for the works illustrated, if not otherwise indicated, is held by the artists, their heirs or estates, or their assignees. Despite intensive research not all rights to intellectual property could be determined. Any reader who has such information is kindly requested to contact the publishers.

Photographs of Artists

In the same series:

**20th Century Photography
Museum Ludwig Cologne**
760 pp.
880 ill.
3–8228–8648–3

The Museum Ludwig in Cologne houses one of the most
important international collections of contemporary
photography.
This publication provides an excellent introduction to a
unique collection. With 880 illustrations and biographies
of some 300 of this century's leading photographers,
from Ansel Adams to Piet Zwart, it is also a work of
reference on the history of photography.
Please see the four sample pages reproduced here.

20th Century
Photography

Museum Ludwig Cologne

TASCHEN

Cartier-Bresson, Henri

1908 Canteloup
Lives in Paris

▲ Henri Cartier-Bresson
Sunday on the Banks of the Marne, 1938

Gelatin silver print
27.5 x 39.9 cm
ML/F 1977/141

Gruber Collection

► Henri Cartier-Bresson
Rue Mouffetard, Paris, 1958

Gelatin silver print
37.2 x 25.1 cm
ML/F 1977/126

Gruber Collection

Henri Cartier-Bresson attended the Ecole Fénélon and the Lycée Condorcet in Paris before studying painting under Cotenet from 1922 to 1923 and under André Lhote from 1927 to 1928, both in Paris. After that, he completed his studies of painting and philosophy at Cambridge University. His career as a photographer began in 1931. After participating in an ethnographic expedition to Mexico, he began working as a freelance photographer. In 1932, gallery owner Julien Levy hosted his first solo exhibition. In 1935, he learned about motion picture photography from Paul Strand. After that he worked as a camera assistant for Jacques Becker and André Zvoboda and also for Jean Renoir. In 1937 he made documentary films in Spain, and in 1940 he became a prisoner of war of the Germans in the state of Baden-Württemberg.

After escaping in 1943, he joined the MNPGD, a French underground resistance movement. After 1945 he once again turned to freelance photography. He authored many books illustrated with his photographs, among them *The Decisive Moment, Changing China* and *The World of Henri Cartier-Bresson*. In 1970 he married the photographer Martine Franck.

From: 20th Century Photography. Museum Ludwig Cologne

From: 20th Century Photography. Museum Ludwig Cologne